Asian American Comparative Collection Research Reports
Series editor, Priscilla Wegars

No. 1, 2005
Asian Americans and the Military's Academic Training Programs (ASTP, ASTRP) at the
University of Idaho and Elsewhere during World War II
by Charles M. Rice

No. 2, 2007
Chinese Servants in the West: Florence Baillie-Grohman's "The Yellow and White Agony"
Edited, and with an introduction, by Terry Abraham

No. 3, 2010
Imprisoned in Paradise: Japanese Internee Road Workers
at the World War II Kooskia Internment Camp
by Priscilla Wegars

No. 4, 2013
As Rugged as the Terrain: CCC "Boys," Federal Convicts, and
World War II Alien Internees Wrestle with a Mountain Wilderness
by Priscilla Wegars

Also by Priscilla Wegars

Uncovering a Chinese Legacy: Historical Archaeology at Centerville, Idaho, Once the
"Handsomest Town in the Basin" (2001).

Golden State Meets Gem State: Californians at Idaho's Kooskia Internment Camp,
1943-1945 (2002).

Polly Bemis: A Chinese American Pioneer (2003).

As Editor or Co-Editor

Hidden Heritage: Historical Archaeology of the Overseas Chinese (1993).

Chinese American Death Rituals: Respecting the Ancestors, with Sue Fawn Chung (2005).

Major Articles

"Entrepreneurs and 'Wage Slaves': Their Relationship to Anti-Chinese Racism in
Northern Idaho's Mining Labor Market, 1880-1910." In *Racism and the Labour Market:*
Historical Studies, ed. Marcel van der Linden and Jan Lucassen (1995).

"Japanese and Japanese Latin Americans at Idaho's Kooskia Internment Camp." In *Guilt*
by Association: Essays on Japanese Settlement, Internment, and Relocation in the Rocky
Mountain West, ed. Mike Mackey (2001).

"From Old Gold Mountain to New Gold Mountain: Chinese Archaeological Sites,
Artefact Repositories, and Archives in Western North America and Australasia." In
Australasian Historical Archaeology (2003).

"Polly Bemis: Lurid Life or Literary Legend?" In *Wild Women of the Old West*,
ed. Glenda Riley and Richard W. Etulain (2003).

"Polly Bemis, a Chinese American Pioneer: Myth vs. Reality."
In *Wild West History Association Journal* (2013).

"Exposing Negative Chinese Terminology and Stereotypes." In *Chinese Diaspora*
Archaeology in North America, ed. Chelsea Rose and J. Ryan Kennedy (2020).

Polly Bemis:
THE LIFE AND TIMES OF A
CHINESE AMERICAN PIONEER

Author **Priscilla Wegars**, Ph.D. (History, University of Idaho), is a historian, historical archaeologist, artifact analyst, editor, and proofreader. She founded the University of Idaho's Asian American Comparative Collection (AACC), a unique resource of artifacts, images, and documentary materials essential for understanding Asian American archaeological sites, economic contributions, and cultural history, https://webpages.uidaho.edu/aacc/. She edited *Hidden Heritage: Historical Archaeology of the Overseas Chinese* (1993); wrote the biography for children, *Polly Bemis: A Chinese American Pioneer* (2003; Honorable Mention for Idaho Book of the Year); and co-edited *Chinese American Death Rituals: Respecting the Ancestors* (2005). Priscilla wrote *Imprisoned in Paradise: Japanese Internee Road Workers at the World War II Kooskia Internment Camp* (2010) and *As Rugged as the Terrain: CCC "Boys," Federal Convicts, and World War II Alien Internees Wrestle with a Mountain Wilderness* (2013; Co-Winner for Idaho Book of the Year). In 2017 the Idaho State Historical Society granted her its Esto Perpetua award "in honor and recognition of significant contributions to the preservation of Idaho History."

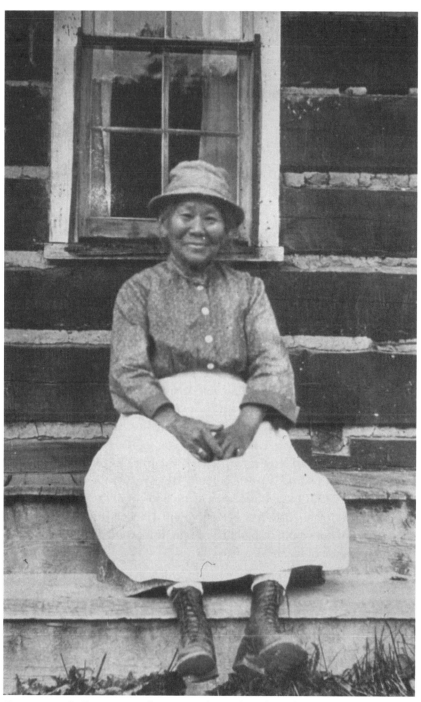

Frontispiece. Polly sitting on the steps in front of Fred Shiefer's cabin, Warren, Idaho, ca. 1923. Courtesy Idaho State Archives, Boise, 71-185.29.

Polly Bemis:
THE LIFE AND TIMES OF A CHINESE AMERICAN PIONEER

Priscilla Wegars

Caxton Press, Caldwell, Idaho,
in association with the
Asian American Comparative Collection,
University of Idaho, Moscow, Idaho
2020

Asian American Comparative Collection Research Report, No. 5

ISBN 978-087004-640-7

All author's royalties from the sale of this book benefit the
Asian American Comparative Collection (AACC)
Laboratory of Anthropology
Department of Sociology/Anthropology
University of Idaho
875 Perimeter Drive, MS 1111
Moscow, Idaho 83844-1111
https://webpages.uidaho.edu/aacc/

Dedication

In memory of
Terry Patrick Abraham
1944-2018

and

in honor of
Cort Conley

Contents

LIST OF ILLUSTRATIONS

Figures

Maps

PREFACE

He [a character in Dorothy L. Sayers's novel] thinks ... that the flippant and imaginative kind of biography has had its day, ... and that the time has come round again for solid facts and research.[1]

By now, many readers will have heard of the United States' most famous Chinese pioneer woman, Polly Bemis, who lived in Idaho for over 60 years. After her parents in China sold her, she was smuggled into Portland, Oregon; purchased by a Chinese pack train operator; and brought to Warren, Idaho, for her new owner, a wealthy Chinese merchant. By 1880 Polly had somehow gained her freedom. She began living with Charlie Bemis, a miner and saloon owner from Connecticut. They married in 1894 and settled on the remote Salmon River. Charlie died in 1922 and Polly died in 1933.

Since that time, numerous magazine and journal articles; several book chapters; four books, both fiction and non-fiction; and even a movie have presented versions of Polly's life. Most of these retellings of Polly's life history state that Charlie Bemis "won her in a poker game"; that her "Chinese name" was "Lalu Nathoy"; and some even insist that she was once a prostitute. All make Polly's story so intriguing that it is easy to believe everything.

My first indication that the "won in a poker game" story might <u>not</u> be accurate was in 1988 when a University of Idaho student needed my help to find information on the Chinese in Idaho for a term paper. The finished essay included the text of an interview she had with her uncle, Herb McDowell, who grew up in Warren and who knew Polly when he was a boy. McDowell stated categorically, "Polly wasn't won in no poker game." He credited this statement to information from long-time Warren resident Otis Morris whose stepfather had attended the Bemises' wedding in 1894.[2]

It surprised me to learn that Charlie Bemis might not have won Polly in a poker game, but since so many years had passed, could the truth be separated from myths and inaccuracies? Over two decades ago, the Idaho Humanities Council encouraged me to try, by awarding me a Research Fellowship to

investigate Polly Bemis's real life. That grant enabled me to make several presentations sharing my findings with the general public, which I continue to do through the Idaho Humanities Council Speakers Bureau.[3] In addition, the University of Idaho's John Calhoun Smith Memorial Fund awarded me a grant to study Polly's husband, Charlie Bemis, "Idaho's Most Significant Other."[4] My children's book about her, *Polly Bemis: A Chinese American Pioneer*, and my book chapter, "Polly Bemis: Lurid Life or Literary Legend?," were both published in 2003.[5]

My research began with the available primary sources, i.e., reference materials that were written or produced at the time an event occurred. Primary source materials on the couple include photographs in various repositories, occasional newspaper stories, US Census records from 1880, and 1900 through 1930, and Idaho County records documenting Charlie's property purchases and other business transactions. Interviews with Polly appeared in *Field and Stream* in June 1923; in the *Idaho County Free Press* on August 16, 1923; in the *Idaho Daily Statesman* on August 4, 1924; and in the *Sunday Oregonian* on November 5, 1933. Diaries kept by the couple's neighbor, Charlie Shepp, between 1902 and 1933 often mention Polly and Charlie Bemis, and other people who knew Polly provided helpful reminiscences. The chapters that follow present the information gained from these and other sources.

During Polly's lifetime there was a great deal of prejudice against people from China. Consequently, information quoted from contemporary accounts sometimes contains language that is now considered offensive, even racist. Rather than change it, i.e., from "Chinaman" to the cumbersome "[Chinese] man," it remains as originally written with my apologies for perpetuating the objectionable phrasing.

Inevitably, comparisons will be made with previous books and articles about Polly Bemis. However, it is emphatically not my intention to disparage any of these prior works in any way. Previous authors have done an invaluable service by bringing her to our attention, and exciting our admiration for her. Although I did locate a few sources that were formerly very obscure or even unknown, most of my information was also available to earlier writers. Where we differ is in how we interpret the materials available to us.

Chapter One, "Polly and Charlie Bemis through 1879," begins by discussing what little we know, or surmise, about Polly's life in China. Born about 1853 in northern China, she may have been a member of the Daur ethnic minority group. Like most Chinese women of her time, her feet were bound in childhood. When she was a teenager, her parents sold her during hard times. Brought to the US, she was resold and taken to Warren, Idaho. Charlie Bemis, who later became Polly's husband, was born in Windsor, Connecticut,

in 1848. He and his father, Alfred Bemis, came to Warren at separate times, perhaps in 1864 and in 1863, respectively, following gold discoveries there in 1862. Throughout the late 1860s and the 1870s Charlie Bemis owned mining properties and participated in Warren's civic life. By 1870, Chinese miners began to reach Warren, to take advantage of mining claim ownership opportunities that were previously denied to them. Occasional Chinese women also arrived in Warren; one of them, in 1872, was Polly, later Polly Bemis.

Chapter Two, "Polly and Charlie in Warren, 1880 through 1890," describes how, by the 1880 US Census, Polly and Charlie were living together, although they were not yet married. Charlie was a saloon owner and Polly was keeping house for him. Their home burned in 1887, incinerating all their possessions, but it was rebuilt. During that decade, Charlie was very active, purchasing property and fulfilling civic obligations, including serving as deputy sheriff. Although Warren's residents were overwhelmingly Chinese, Polly was often the only Chinese woman living there. In 1890 a part-Indian man shot Charlie in the face over a gambling debt. Polly, with the aid of local Chinese and Euroamerican doctors, nursed him back to health.

Chapter Three, "Life in Warren and on the Salmon River, 1891 through October 1902," begins with details of the trial and imprisonment of Charlie Bemis's assailant. During this decade, Bemis continued to buy and sell property, including placer mining locations, and both Charlie and Polly appeared in the Assessment Rolls for Idaho County. The couple married in August 1894 and moved down to the Salmon River, about 17 miles north of Warren. There Bemis took up a mining claim, not a homestead, as is popularly believed, and the couple settled in to their new life. During this time Polly received a Certificate of Residence, a document that US law required all Chinese residents to obtain. Living where they did on the Salmon River, they often encountered people who came down the river by boat or who crossed it to access various mining properties and mountain communities.

Chapter Four, "On the Salmon River, November 1902 through March 1910," follows Polly and Charlie Bemis from their earliest mentions, in late 1902, in diaries kept by miner Charlie Shepp, who had claims in the mountains across the Salmon River from the Bemises. He often came down to the river to buy garden produce from Smith and Williams's ranch across the river from the Bemises' place, and would occasionally cross the river to socialize with Polly and Charlie. During this decade he sometimes observed, and commented on, the Bemises' animals, their gardening activities, and other aspects of their daily lives. In March 1910, Shepp bought the Smith and Williams Ranch and began living there permanently, often with his mining partner, Pete Klinkhammer.

Chapter Five, "Life on the Salmon River, Spring 1910 through 1914," describes the increasing interactions between Charlie Shepp and Polly and Charlie Bemis. Shepp often went across the river to help the older couple with chores, such as cutting hay, and would be rewarded with "dinner," i.e., the noon meal. Shepp and Bemis borrowed tools and equipment from one another, helped people and horses cross the river, and entertained visitors with conversation and Polly's cooking. Polly's garden furnished produce for sale, for their meals, and for exchange with what Shepp grew. They and others celebrated holidays together, such as the Fourth of July, Thanksgiving, and Christmas. Shepp, a camera enthusiast, sometimes photographed the Bemises at their ranch. Polly often fished, and the men hunted. Both Shepp and the Bemises hosted travelers who came down the river in wooden boats piloted by the intrepid Harry Guleke.

Chapter Six, "Life on the Salmon River, 1915 to November 1919," highlights the Bemises' continuing reliance on their friends and neighbors to help them with the heavy work on their ranch. Despite living in such a remote area, Polly and Charlie had many visitors who crossed the river by boat between the two ranches; in winter, people crossed on the ice. Charlie Shepp's diaries from 1915 through 1919 detail the seasonal round of plowing, planting, and harvesting various crops, and transporting and selling Polly's fruits, vegetables, and eggs. During the summer of 1919, forest fires threatened the river dwellers and Charlie Bemis became increasingly frail and almost bedridden.

Chapter Seven, "On the Salmon River and in Warren, November 1919 to October 1924," describes some momentous events in the Bemises' lives. With Bemis confined to his bed, Polly relied even more on the kindness of her friends and neighbors, without whose assistance the couple could not have survived. Increasing river traffic brought writers, hunters, and adventurers to Polly's doorstep; their movies, interviews, and observations brought the Bemises' story to a wide audience. In August 1922, the couple's home burned down, probably from a stovepipe fire. When Charlie Shepp noticed the conflagration, he rowed over and rescued the bedridden Bemis. Shepp took the Bemises over to his place where they stayed until Charlie Bemis died in late October. Pete Klinkhammer then took Polly to Warren, where she lived for the next two years. During that time she visited Grangeville and Boise, resulting in newspaper interviews with her. Once Polly's home was nearly finished, Pete brought her down from Warren in October 1924.

Chapter Eight, "Polly Bemis's Last Years, October 1924 to November 1933," saw Polly's life resume its previous pattern of gardening and hospitality. Charlie Shepp, Pete Klinkhammer, and other friends continued to help out where needed, and Polly invariably rewarded them with her home-

cooked meals. Now in her 70s, Polly enjoyed reasonably good health, except for a lengthy bout of unexplained illness during late September and early October 1931. "Cougar hunter" George Lowe met Polly in January 1932; he described his visit with her for the *Lewiston Morning Tribune* in early May. In August 1933, Polly apparently had a stroke. Shepp found her outside her cabin, brought her across the river, put her to bed, and arranged for help to get her up the mountain by horseback to a waiting ambulance. Taken to the hospital at Grangeville, Polly lived for three more months, but finally died on November 6, 1933, and was buried in Grangeville's Prairie View Cemetery.

Chapter Nine, "Exposing Myths and Inaccuracies about Polly Bemis," explores the myths that swirled about Polly both during her life and after her death. Over time, people came to believe that Charlie Bemis had won her in a poker game, that her Chinese name was "Lalu Nathoy," that her Chinese owner's name was "Hong King," and that she had once been a prostitute. Census records, newspaper interviews, Chinese beliefs and customs, and other sources combine to refute these and additional inaccuracies.

Chapter Ten, "Epilogue: Polly Bemis's Legacy," discusses the written, artistic, and other embellishments of Polly's life story and exposes the disparities among them that, taken together, defy rational belief. Other elements of her legacy include the preservation of her home on the Salmon River; her exhumation and subsequent reburial; honors awarded to her; Polly's character and personality compared with Charlie's; frequently asked questions about the couple; contradictions about Polly's life; the Bemises' personal possessions, now held in various repositories; archaeological research related to Polly and Charlie Bemis; and miscellaneous additional remembrances and ephemera.

Acknowledgments

More than two decades ago the University of Idaho's John Calhoun Smith Memorial Fund kindly provided funding for my research into, and subsequent article on, Polly Bemis's husband, "Charlie Bemis: Idaho's Most 'Significant Other'" (*Idaho Yesterdays*, Fall 2000). In addition, the Idaho Humanities Council generously awarded me a Research Fellowship to investigate Polly Bemis's real life; to make several presentations sharing my findings with the general public; to write the children's book, *Polly Bemis: A Chinese American Pioneer* (Backeddy Books, 2003); and the chapter "Polly Bemis: Lurid Life or Literary Legend?" for *Wild Women of the Old West* (Fulcrum, 2003). Of course, the conclusions and opinions in those works, and in this one, which enlarges on them, do not represent the views of the granting agencies.

The phrase, "It takes a village," appropriately describes the assistance I've received from many, many individuals in the intervening 20 years. My deepest debt of gratitude goes to Johnny and Pearl Carrey, for sharing Johnny's childhood memories of Polly in such detail; to my late, much-beloved husband, Terry Abraham, for his companionship throughout this journey; and to Cort Conley, supporter, friend, and editor extraordinaire. Special recognition to Renae Campbell for obtaining permissions for the illustrations and to Melissa Rockwood for drawing the maps and designing the book.

Many, many other "villagers" greatly helped with this project, whether by referring me to persons with knowledge of Polly Bemis, assisting with my research in archives, publicizing this undertaking, agreeing to be interviewed, helping with translation, or sending me information. I gratefully acknowledge the assistance of the following individuals, listed alphabetically; sadly, some are now deceased. They are: Joan Abrams (*Lewiston Tribune*); Kathy Ackerman (Idaho County Courthouse); Marvin Ackerman; James Arlington (National Archives, Pacific Northwest Region); Thurman Arnold, Jr.; Rami Attebury (University of Idaho Library); Lisa Backman (Denver Public Library); Blaine Bake (Ricks College [now Brigham Young University-

Idaho]); Bob Baldwin; Steve Barrett (Idaho State Archives); Heidi Barth; Hope Benedict (Lemhi County Historical Society); Leland (Lee) Bibb; Jeff Blackmer (Blackmer Funeral Home); Carolyn Bowler (Idaho State Historical Society); Jim Brandenburg; Charles Brown (St. Louis Mercantile Library); Jayne Brown; Robert (Bob) Bunting; Maxine Burcham (Bicentennial Historical Museum); Garry Bush; Rudy Busto; Jim Campbell; Penny Casey (Idaho County Courthouse); Bailey Cavender; Shehong Chen; Claire and Lennard Chin; Sue Fawn Chung; Ann Copp; Rose Corum (Lemhi County Historical Society); Sam Couch; Heather Creamer (Amon Carter Museum of American Art); Lorraine Crouse (Marriott Library, University of Utah); Linda Sun Crowder; Theresa Dahmen (University of Idaho Library); Yingcong Dai; Carol Darragh; Margaret Davies; Mary Anne Davis; Sara Caroline Davis (Marriott Library, University of Utah); Mike & Lynn Demerse (Shepp Ranch); Pam Demo; Linda Dial; Gayle Dixon (Payette National Forest); Dan Eisenstein; Leah Evans-Janke (Alfred W. Bowers Laboratory of Anthropology); Jeff Fee (Payette National Forest); Peter Feng; Paul Filer; Harold Forbush; Samantha Franklin (Lewis-Clark State College Library); Duane Frasier (Joshua Project); Kathleen Whalen Fry; Shirley Gehring (The Historical Museum at St. Gertrude); Anne Gill; Jerry Glenn (Ricks College [now Brigham Young University-Idaho]); Denny Goodman (Idanha Hotel); Alisha Graefe (Idaho State Archives); Debra Graham (The Historical Museum at St. Gertrude); Christine Gray (University of Idaho Library); Rob Groom; Jacqulyn LeGresley Haight; Steve Hanks (*Lewiston Tribune*); Will Harmon (Farcountry Press); Carol Sue Hauntz; Kathy Hedberg (*Lewiston Tribune*); Sarah Heffner; Wendy Heiken (The Historical Museum at St. Gertrude); Amy Hietala (Wood Memorial Library); Joy Higgins (Idaho County Courthouse); Alice Hoge; Rachel Hollis (Idaho State Archives); Ginny Hopfenbeck; Abby Hoverstock (Denver Public Library); Abbie Hudson (Idaho County Courthouse); Jim Huggins; and Tina Huie.

Others were Marietta James, Ron James, Sue and Arnie Johnson, Linda McGrane Junes, Susan Karren (National Archives, Pacific Northwest Region), Karen Kennedy, Jenaleigh Kiebert (Idaho State Archives), Larry Kingsbury (Payette National Forest), Barry Kough (*Lewiston Tribune*), Diane Kromer (Idaho State Historical Society), Saffron Kruse, Shelley Kuther, Roscoe LeGresley estate, David Lei, Steve Light, Rachelle Littau (Idaho State Historical Society), Meg Lojek (McCall Public Library), Denis Long, Emma Woo Louie, M. Catherine Manderfeld (The Historical Museum at St. Gertrude), Lissa Marshall, Sandra Martin, Laura McCarthy (National Archives, Pacific Northwest Region), Ruthanne Lum McCunn, Herb McDowell, Louise McMahon, Alessandro (Alex) Meregaglia (Albertsons

Library, Boise State University), Walter Mih, Joanne Milot, Linda Morton-Keithley (Idaho State Historical Society), Lucille Moss, Vicki Murphy, Mary Ann Newcomer, Judy Nielsen (University of Idaho Library), Fred Noland, Pam Northcutt (Bicentennial Historical Museum), Ruth Oar, Jody Hawley Ochoa (Idaho State Historical Society), Joe Pava (South Windsor Public Library), Martin Peterson, Theresa Quinn, David Rauzi (*Idaho County Free Press*), Kate Reed and Troy Reeves (Idaho State Historical Society), Paul Resnick, Virginia Ricketts, Darcie Riedner (University of Idaho Library), Dick Rivers, Philinda Parry Robinson, Betty Roden, Randall Rohe, Mary Romero (Nez Perce County Historical Society), Herman Ronnenberg, Tom Saleen, Cindy Schacher (Nez Perce-Clearwater National Forests), Jamieson-Lee Scott, Nikki Sickels (Idaho County Courthouse), David Sisson (Bureau of Land Management), Joan Smith (The Historical Museum at St. Gertrude), Justin Smith (University of Idaho Library), Carmelita Spencer (Bicentennial Historical Museum), Darby Stapp, Harvey Steele, Erin Stoddart (University of Idaho Library), Honoré Storms, Charlotte Sun (Genesee Mountain Daoist Hermitage), Lynda and Gary Swift, Amy Thompson (University of Idaho Library), Julie Titone (*Spokesman-Review*), Joe Toluse (Idaho State Historical Society), Tom and JoAnn Trail, JoAnn Tsohonis, David (Dave) Valentine, Camilla Van Natter (University of Idaho Library), Melissa VanOtterloo (History Colorado Center), Mike Venso (*Lewiston Tribune*), Eleanor (Poofy) Wagner, Mark Warner, Eldene Wasem, Steve Wassmuth, Vera White (*Moscow-Pullman Daily News*), Marlee Wilcomb (Central Idaho Historical Museum), Jesse Daniel ("Tim") Williams, Frances and Jerry Wilson, Shirley Winter, Lyle Wirtanen, Wu Anqi (Institute of Nationality Studies, Beijing), Wu Chizhe (Inner Mongolia University), Yi-Li Wu (University of Michigan), Yixian Xu, James Zehner (Idaho County Courthouse), and Wenxian Zhang (Rollins College). My sincere apologies to anyone whose name was inadvertently omitted.

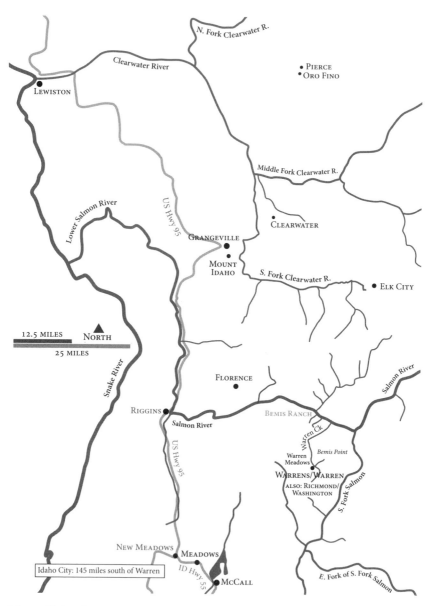

Map 1. Idaho place names mentioned in Chapter One. Items in gray did not then exist, but are included for context. Drawn by Melissa Rockwood.

CHAPTER ONE:
Polly and Charlie Bemis through 1879;
Polly, age 18-26

Although her Chinese name remains unknown,[1] the woman who became Polly Bemis was born in China in or about 1853 and arrived in Warren, Idaho,[2] in 1872 (Fig. 1.1). Her future husband, Charles (Charlie) Bemis[3] (Fig. 1.2), was born in Connecticut in 1848 and reached Warren about 1864. The lack of documentation about Polly's youth in China and her early years in

Idaho has led to overly romanticized versions of her life, perpetuating myths about her that are now difficult to dispel. The most prevalent legends are that she was once a prostitute, that Bemis "won her in a poker game," and that her Chinese name was "Lalu Nathoy." Such fantasies provide few glimpses of Polly's true character and personality and leave people unable to distinguish the real Polly Bemis from the fictional one. Instead, Polly's actual history is genuinely fascinating, contrasting with the popular perceptions of her that have distorted our understanding of this Chinese woman pioneer.

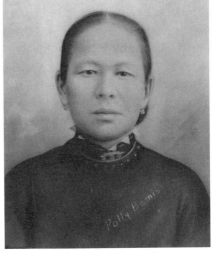

Fig. 1.1. Polly Bemis, date unknown. Courtesy Lemhi County Historical Society, Salmon, Idaho.

Charlie Bemis avoided an eventual descent into historical obscurity by marrying Polly Hathoy [not "Nathoy"] on August 13, 1894, in Warren. His wife, Polly Bemis, is well-known today through numerous sources,[4] but Charlie Bemis himself is a much more

1

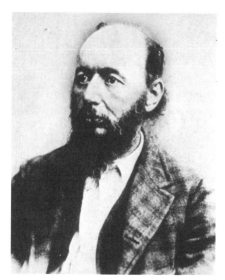

Fig. 1.2. Charlie Bemis, after 1890.
Courtesy Idaho State Archives, Boise,
75.228.44a.

obscure figure. His continuous relationship with Polly Bemis endured for over four, and into five, decades, so he was undoubtedly the principal person in her life. Because his story is thus inextricably entwined with hers, we'll become better acquainted with him as well, both as an individual and as Polly's most "significant other."[5]

Polly's Early Life in China, 1853-1872

The woman we now know as Polly Bemis was born in China on or about September 11, 1853,[6] the Year of the Water Ox in the 12-cycle Chinese lunar calendar.[7] Although there is no independent Chinese confirmation of her date or place of birth,[8] and despite conflicting information in English-language documents, that date is on her gravestone and is the one she herself used most consistently. Occasional corroboration for Polly's birthdate appears in the "Shepp diaries," records kept by her neighbor, Charlie Shepp, who lived across the Salmon River from the Bemises.[9]

The 1880 US Census lists Polly's birthplace just as "Pekin," later Peking; this is today's Beijing, in northern China.[10] She was not actually born in Beijing, but rather in a "hamlet" somewhere in the larger vicinity.[11] One account, that she reportedly "did not deny," stated that she was born "on the Chinese frontier near one of the upper rivers of China."[12] Therefore, rather than belonging to the Han majority population group, Polly was probably a member of a northern Chinese ethnic minority.

Although the specific minority is unknown, Polly may have been a Daur.[13] The Daurs are one of China's 56 officially recognized minority group nationalities. In 2010 there were nearly 132,000 of them, most living in Xinjiang and Inner Mongolia autonomous regions and Heilongjiang province (Fig. 1.3); Daur means "cultivator."[14] According to a chapter on the Daurs in *China's Minority Nationalities*, the Daurs' spoken language is related to Mongolian. Their traditional economy included raising grain, horses, and oxen; hunting; and gathering edible plants. For customs, they practiced monogamy, with arranged marriages, and mostly followed shamanism as their religion. Daur

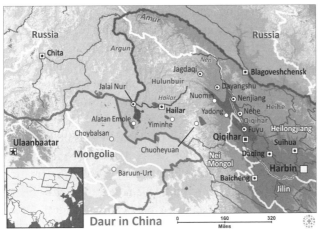

Fig. 1.3. Map of Daur population in China. Courtesy the Joshua Project, available at https:// joshuaproject.net/ people_groups /18433/CH (accessed November 17, 2019).

Spring Festival celebrations, held in May, provided an opportunity to honor both gods and ancestors, visit friends and neighbors, and exchange New Year food and gifts. Daurs, both men and women, smoked tobacco and shared pipes with visitors.[15] This latter information is relevant to Polly's life in Idaho, since we know that she smoked a pipe (Chapter Five, 1910).

The "neat" Daur villages were "usually built on mountain slopes and facing streams." The houses had courtyards surrounded by wickerwork fences. The women were "renowned for their needlework," which is also true for Polly. Daurs ate "millet or buckwheat noodles mixed with [cow's] milk, buckwheat cakes[,] and oat porridge cooked with soybeans." Game meat, a delicacy, included deer, duck, and pheasant. They also grew many different kinds of vegetables.[16]

Whether or not Polly was a Daur, as seems likely enough, there is still no evidence whatsoever for her early family life, except for a few tidbits from occasional interviews with her, or statements about her with which she agreed, collected by contemporaries.[17] All we know is that her parents were poor, raised various unidentified crops, and suffered from both drought and "the ravages of brigands."[18]

Footbinding

Interviews with Polly, and with people who knew her, sometimes mention that she once had had bound feet. In 1923, for example, she wore "boy's shoes on her tiny feet, bound in childhood," and in 1933 her feet "resembled stubs."[19] We thus know that when Polly was a child, her mother or other female relative bound her feet in accordance with an ancient Chinese custom dating back more than 1,000 years,[20] a fashion reportedly begun by dancers to the Chinese Imperial Court.[21]

Over time, the custom became entrenched in China's Han majority population. Indeed, various minority groups, such Daur people who farmed in Han areas, also adopted the practice.[22] In 1884 an American missionary to China estimated that "Taking all China together, probably nine-tenths of the women have bound feet."[23] By then, "Footbinding was not merely an announcement of status and desirability to the outside world, but also a concrete embodiment of self-respect to the woman herself."[24]

Footbinding was a cruelly painful practice inflicted on girls between the ages of three and seven; five to six was typical[25] (Fig. 1.4). Because the Chinese perceived tiny feet as attributes of feminine beauty, they evolved the practice of compressing the feet and binding them tightly to prevent their growth and to make them appear as small as possible; three inches long was ideal. A fact

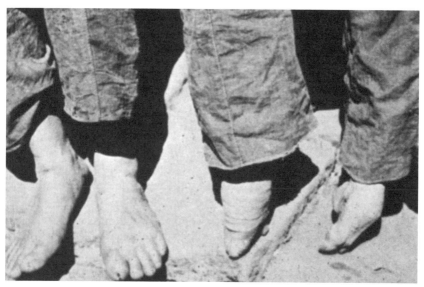

Fig. 1.4. Comparison of unbound feet, left, with bound feet, right. From Burton F. Beers, China in Old Photographs, 1860-1910 *(New York: Charles Scribner's Sons, 1978), 59.*

seldom mentioned, but one of the main reasons that the custom lasted so long, was that the bound feet, called "golden lotuses" or "golden lilies," were sexually attractive to men. Removing the exquisitely embroidered shoes to fondle, kiss, or suck the tiny foot became an integral part of making love, and a custom that is often depicted in Chinese erotic art[26] (Fig. 1.5).

Part of the mystique associated with footbinding was the way it forced the woman to walk. A bound-foot woman's mincing steps caused her body to sway gracefully. Men commonly believed that walking on bound feet caused

a woman's body to undergo admired physiological changes, such as larger buttocks and a tighter vagina.[27]

The tragic custom of footbinding became an indicator of the family's social position. Since bound feet rendered a girl useless for physical labor, only the wealthier or upwardly aspiring families could afford the luxury of women who were deliberately and fashionably crippled, reflecting their desire that their daughter might achieve a good marriage.

Recent scholarship, however, has disputed some of the traditional reasons for footbinding. Hill Gates,

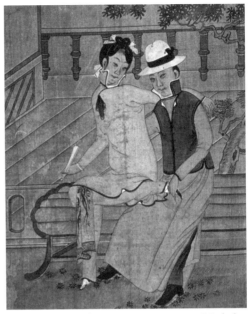

Fig. 1.5. Bound feet in erotic art. From Michel Beurdeley et al., Chinese Erotic Art *([Secaucus, NJ], Chartwell Books, [1969?]), 188.*

for example, argues that "footbinding was in fact a crucial means of disciplining ... little girls to lives of early and unremitting labor."[28] Scholars Gates, Laurel Bossen, and Melissa Brown

> ... reject the prevailing theories that bound feet in China were considered more beautiful, a means of male control over women, a sign of class status, and a chance for women to marry well. They also reject the widespread notion that such women couldn't work, and thus contributed little to their families and the larger economy, and [reject] the belief that campaigns against the practice were what ultimately put an end to it.[29]

Contrary to popular beliefs, the researchers found that women with bound feet didn't have significant upward mobility in marriage. Instead, they found an intriguing connection between bound feet and hand labor. While bound-foot girls could not help in the fields, their labor was important at home in making clothing and shoes for their families, and in producing cloth for the family as well as extra cloth to sell. Their labor in spinning, weaving, sewing, and embroidery contributed to the family coffers.[30] Then, with the advent of the Industrial Revolution, home cloth-making decreased dramatically,

leading to the abandonment of footbinding as a means of keeping girls and young women close to home.[31]

Because the custom lasted so long, Polly's footbinding experience was likely similar to that of another Chinese girl some 50 years later:

> At age six, my mother bound my feet. She followed the traditional way by using a long white cloth about 167 centimeters [65¾ in.] long and 9 centimeters [3½ in.] wide. She bound my four small toes underneath my foot, leaving only the big toe out. … The suffering I experienced and the tears I shed were unspeakable. From the beginning of the binding until the time I could 'walk' it took half a year. After that it was not even walking. I was only able to move by lifting the front part of my feet, using only the heel.[32]

As an adult, however, the same person commented, "I also think that my feet are pretty and I am grateful to my mother."[33]

Having begun the process, whether willingly or not, Polly later discontinued binding her feet, probably while still in China. The reason is unknown; perhaps poverty necessitated Polly's participation in her family's physical labors. Once unbound, her feet would have remained so misshapen that she would not have been able to walk normally. Contrary to popular belief, footbinding did not break any bones;[34] instead, the four smaller toes were folded under the foot. The bones changed little in shape, but the toes "adapted to their deformed manner and cannot be straightened, even by force."[35]

A woman who interviewed Polly in 1921 observed, "She rolls from side to side when she walks – the strangest, simian kind of gait."[36] Still, even formerly bound, but still small, feet may have made Polly more desirable to her subsequent Chinese owner. We should keep in mind that American clothing, such as tightly-laced corsets, and footwear fashions, i.e., pointed toes and stiletto heels, can have similar, crippling results (Fig. 1.6).

Fig. 1.6. "Cathy" cartoon, satirizing debilitating footwear fashions in the United States. CATHY © 1994 Cathy Guisewite. Reprinted with permission of ANDREWS MCMEEL SYNDICATION. All rights reserved.

Polly's Removal from Her Home

At various times, particularly when interviewed in 1921, 1923, 1924, and, through her nurse, in 1933, Polly gave somewhat contradictory accounts of how she happened to leave her home in China and come to the United States.[37] In a 1924 interview, Polly stated that an American woman enticed her "and two other young Chinese girls" from their home in China via Hong Kong to the United States. The woman "told them she wanted them to work in the gold camps of America, where they could pick gold coins from the streets." The year was 1869,[38] so Polly would have been fifteen or sixteen years old.

During a 1921 interview, published in 1923, Polly told a different story. She reported, "My folluks in Hong-Kong had no grub, … 'Dey sellee me … Slave girl. Old woman she shmuggle me into Portland. … Old Chinee-man he took me along to Warrens [later Warren] in a pack train."[39] Polly did not explain how her family happened to be in Hong Kong instead of in the north, where she was born. That account is similar to one from 1933, when she let stand a story that her father sold her to some bandit raiders "in exchange for enough seed to plant another crop."[40] Of course, bandits could simply kidnap a girl if they wanted one, but "paying" for her, even in such a small amount, could preserve both the legality of the transaction and the fiction that her family willingly sold her.

People in Western societies are often shocked to learn that, in China, a Chinese father could sell his daughter. As social and economic historian Delia Davin observed, "The sale of girl children [was] always a possible solution for impoverished families."[41] In the China of Polly's time, girls and women adhered to the "three obediences" – as children, to their fathers; as married women, to their husbands; and as widows, to their sons.[42] Polly surely would have been unhappy to have been torn from her family in that way, but Chinese custom dictated that she accept her fate, stoically and without complaint. This sense of filial obligation was so strong that it even caused one Chinese woman, as a wealthy concubine whose father had sold her when she was just six or seven, to seek out her family "to give them some of her riches."[43]

A girl in China at that time had a very difficult life, because her parents considered her to be a liability to her family. They undertook the expensive responsibilities of feeding, clothing, and housing their daughter, only for her to marry and enter her husband's family just at the time she became old enough for her work to contribute to the family's support … in her new household. Chinese sayings such as "Girls are maggots in the rice," "It is more profitable to raise geese than daughters," and "Feeding girls is feeding cowbirds,"[44] summed up the traditional Chinese attitudes toward female children. Other girls may have benefited from being called a more complimentary

term, *qiānjīn* ["1,000 gold"], meaning that they were worth a "thousand pieces of gold,"[45] but that still didn't prevent them from being sold if necessary to benefit the family during troubled times.

However and whenever she left her family in China, Polly surely had many adventures on her way to the United States. When encountering a talking parrot in 1923, Polly described seeing "talkee birds" in Shanghai (Chapter Seven). Since she also referred to Hong Kong several times, as mentioned earlier, that was her likely port of embarkation to the United States. Regarding Hong Kong, Mary Roberts Coolidge's classic work on Chinese immigration states, "After passage of the British Passengers Act in 1855, Hong Kong became the sole port from which the Chinese sailed to America."[46] From there, uncertainties arise. One account, based on Polly's conversations with her nurse in 1933, indicates that the bandit leader took Polly to San Francisco; then to Idaho City, Idaho; and then to Warren.[47] This story conflicts with the 1921 interview, published in 1923, where she stated that an old woman took her to Portland where she was sold for $2,500,[48] more than $50,000 today.[49] Whichever is true, Polly arrived in Idaho in 1872. There her life would eventually merge with that of her future husband, Charlie Bemis.

Charlie Bemis's Early Life, 1848-1864

The 1850 US Census for the community of South Windsor, in Hartford County, Connecticut, shows that Charlie Bemis's family then consisted of Alfred Bemas [*sic*], a merchant, age 32; his wife "Mirriam" [for Marian, sometimes Miriam or Marion], age 24; "Charly," age 2; and William, 5 months.[50] Alfred Bemis owned real estate worth $3,000 (nearly $88,000 today),[51] and all family members had been born in Connecticut. Two other people lived in the Bemis household: Mary Dunn, age 32, and Monroe Filley [*sic*, for Finley], age 24[52] (Fig. 1.7). Subtracting two years from 1850 gives 1848 as the year of Charlie's birth. An account of the birth of a son to Alfred and Marian Bemis gives a date of "May 1, [1848]" but the child's name is given as Alfred rather than Charles.[53] Since Charlie Bemis's middle name was Alfred, after his father, he is doubtless the same child. Unlike the other principals in this historical account (Polly Bemis, Charlie Shepp, and Pete Klinkhammer), Charlie Bemis's birthday is not mentioned in any of the existing Shepp diaries. In 1943, Bemis's friend Pete Klinkhammer told M. Alfreda Elsensohn that "Chas. A. Bemis was born in 1848 in Connecticut."[54] Oddly, however, "Born 1847" appears on his grave marker, but when that marker was made and placed is uncertain.[55]

By the 1860 US Census, for unknown reasons, the Bemis family had become fragmented. The South Windsor census did not list Alfred, Marian,

Fig. 1.7. 1850 US Census of South Windsor, Connecticut, showing the Alfred Bemis family and household. US Census, Seventh Census of the United States, 1850, Hartford County (part), South Windsor, Connecticut (National Archives Microfilm Publication M-432, roll 39, page 140, lines 32-37); Records of the Bureau of the Census, Record Group 29.

or Charlie at all. Instead, William Bemis, aged 10, was living with Daniel J. Foster and Amanda Foster, his maternal grandparents. Daniel Foster was 61, a grocer, and had been born in New Hampshire. His wife, Amanda, aged 56, was a native of Connecticut. Foster owned real estate valued at $1,200 and "personal estate" worth $1,500.[56] Inexplicably, and according to the 1860 US Census, Mary E. Beamis [sic], age 33, and Charles ["ditto," for Beamis], age 12, lived in New York; in November 1861, the New York Post Office was holding a letter for Mrs. Alfred Bemis.[57] We know these people are Charlie Bemis and his mother, because another member of the household is Monroe Finley, now age 34, who was 24 when he lived with the Bemis family in Connecticut in 1850.[58] Alfred was in Calaveras County, California, working as a "Quartz Operator," i.e., a hardrock mine owner or miner.[59]

Although Charlie Bemis has been described as the "scion of an old blue-blooded New England family,"[60] his ancestors' original prominence is now difficult to establish with certainty, given the intervening historical and physical distance. One source states that his father, Alfred Bemis, of East Hartford, Connecticut, was the son of "Dr. Bemis," presumably from the same place.[61] Other information corroborates Charlie's paternal grandfather as Dr. David Bemis.[62]

Charlie's mother died in New York in 1867 and his maternal grandparents both died in 1869.[63] By then, Charlie and his father both lived in Warren, Idaho. The 1870 US Census for South Windsor, Connecticut, shows William F. [for Foster] Bemis, age 20, living alone. His occupation was "Store Keeper." His "Value of Real Estate" was $1,500 and his "Value of Personal Estate" was $3,500.[64] With his maternal relatives all dead, and his father and brother

in Idaho, William may have been Daniel and Amanda Foster's sole heir. In 1872 William moved to California and by 1880 he was a "Bar Keeper" in Walla Walla, Washington.[65] William must have spent some of the intervening time in Warren, since in 1873 he is listed as owing $6.25 to the estate of A. J. Ripson.[66] Because Ripson, who died in the fall of 1873, was "one of [Warren's] oldest and best saloon keepers,"[67] the amount is "probably bar bills."[68]

Author Robert G. Bailey has described Bemis's "life story ... as one continuously of romance and adventure."[69] According to Bailey, Bemis was born "a Connecticut Yankee," and "as was the case with all youngsters born in the bleak New England states, his early life was one of hardships and privations."[70]

Lure of Idaho Gold

Gold discoveries at Pierce, Idaho, in 1860 enticed thousands to that as-yet-unnamed wilderness, where all hoped to "strike it rich." Most did not, so unsuccessful miners searched wider afield for the elusive precious metal. By 1861 they had discovered other gold deposits at "fabulous Florence." The rush of people to this new mining area dictated the need for organization and government. Consequently, the territorial council for what was then Washington Territory created Idaho County on December 20, 1861, and appointed various officials, including a county auditor, two county commissioners, a county sheriff, and a magistrate/justice of the peace.[71]

Supplies from Portland by boat via the Columbia River arrived in Florence following a circuitous route from Lewiston, at the confluence of the Snake and Clearwater Rivers.[72] On arrival in Lewiston, goods were taken to the mines in pack trains of mules or horses.[73] Some of these pack trains had Chinese owners or operators[74] (Fig. 1.8). In 1910 early Idaho historian John Hailey detailed the routes of two of the pack trails, and then stated, "The reader may wish to know how good these trails were. I will answer by saying I have packed over both of them, and each time I went over one, I wished I had taken the other."[75]

Gold Discoveries at Warren

Dissatisfaction with gold mining returns in the Florence Mining District prompted James (Jim) Warren to organize a prospecting party.[76] The group set out from Florence in the summer of 1862, and soon discovered the rich and valuable placers, at an altitude of about 6,000 feet, in what later became the Warren Mining District.[77] Their new prospects attracted a myriad of hopeful miners, some even leaving Florence placers paying $20 per day. The new diggings became known as Warren's Discovery.

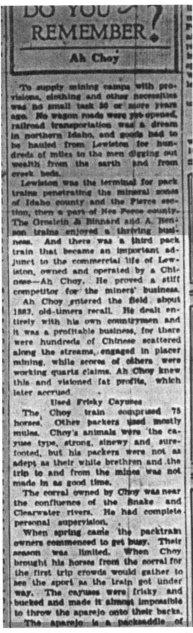

DO YOU REMEMBER?

Ah Choy

To supply mining camps with provisions, clothing and other necessities was no small task 50 or more years ago. No wagon roads were yet opened, railroad transportation was a dream in northern Idaho, and goods had to be hauled from Lewiston for hundreds of miles to the men digging out wealth from the earth and from creek beds.

Lewiston was the terminal for pack trains penetrating the mineral zones of Idaho county and the Pierce section, then a part of Nez Perce county. The Oroßein & Binnard and A. Benson trains enjoyed a thriving business. And there was a third pack train that became an important adjunct to the commercial life of Lewiston, owned and operated by a Chinese—Ah Choy. He proved a stiff competitor for the miners' business. Ah Choy entered the field about 1882, old-timers recall. He dealt entirely with his own countrymen and it was a profitable business, for there were hundreds of Chinese scattered along the streams, engaged in placer mining, while scores of others were working quartz claims. Ah Choy knew this and visioned fat profits, which later accrued.

Used Frisky Cayuses

The Choy train comprised 75 horses. Other packers used mostly mules. Choy's animals were 'the cayuse type', strong, sinewy and surefooted, but his packers were not as adept as their white brethren and the trip to and from the mines was not made in as good time.

The corral owned by Choy was near the confluence of the Snake and Clearwater rivers. He had complete personal supervision.

When spring came the packtrain owners commenced to get busy. Their season was limited. When Choy brought his horses from the corral for the first trip crowds would gather to see the sport as the train got under way. The cayuses were frisky and bucked and made it almost impossible to throw the aparejo onto their backs. The aparejo is a packsaddle of

Fig. 1.8. Chinese pack train owner Ah Choy operated from Lewiston, Idaho, from about 1882 to 1888. From Lewiston Morning Tribune, *February 25, 1934, sec. 1, p. 7. Used with permission.*

During the Civil War, people sympathized strongly with either the North or the South even though they often had come West to escape that carnage. Two separate towns thus became established along Warren Creek: Washington [later Warrens, now Warren] and Richmond. Their names reflected their inhabitants' Civil War sympathies.[78]

Richmond, "located unwisely upon some rich placer ground," soon disappeared as a community, "since it was necessary to remove the town in order to mine under the buildings."[79] That left Washington,[80] which received a post office in January 1868.[81] Mail came via the north, through Mount Idaho, and later from Meadows, to the south.[82]

Early Washington/Warren merchant Leo Hofen recalled that

... The first gold was discovered on Summit Flat, 8 miles above a town location called Washington and after more thorough prospecting good diggings were found to extend also 8 miles below Washington making in all 16 miles of rich diggings up and down [Warren C]reek and its tributaries. The claims were very deep, from 6 to 20 feet but very rich along the flat skirting the creeks. And also rich hydraulic claims were located on the rim. ... The gold was assayed at from 12 to 17

11

dollars per oz. and was kept in pickle jars or any convenient receptacle or put in an old rubber boot.[83]

...

These Warrens diggings lasted long and were worked regular and the camp was free from spasmodic excitements. One thing was peculiar that it was entirely free from the hordes of moneyless lazy adventurers that followed Florence and other strikes. The population was made up almost entirely of old steady California miners, and for the 10 years that I lived there, there was no murder or robbery committed, although society was a mite rough in some respects. The camp grew steadily until 1500 men were in the district - [18]65 - and then decreased to 500 in fall of -'67. Quartz then being found, a new impetus was given and in -'68 it arose to 1200.[84]

Charlie Bemis and His Father, Alfred Bemis, Reach Idaho

No contemporary records have yet been located that would provide confirmation of the date when Alfred and Charlie Bemis arrived in Idaho, or what route they took to get there. Whether they even came together has been a matter for some speculation.

Alfred Bemis was definitely there at least by 1863, since the name "A. Bemis" of Warrens, Idaho, appears on the Idaho Territorial voters poll list.[85] Since the list only gives names of voters, we cannot tell if Charlie Bemis actually accompanied his father to Warren, because Charlie, then 15, would have been ineligible to vote.

In March 1943, Peter Klinkhammer, formerly Charlie and Polly Bemis's friend and neighbor, stated to M. Alfreda Elsensohn that Charlie Bemis "came to Warren in 1865 with his father, who worked a placer claim with C. A. Helping."[86] With Alfred Bemis there in 1863, his son may have followed him two years later.

Another account suggests that Charlie did come later. In 1933, a newspaper reporter, quoting C. J. [sic, for J. A.] Czizek, stated, "Charlie Bemis was the son of [Alfred] Bemis for whom Bemis' [P]oint, the richest property in Warrens, was named. He [Charlie] was a jeweler in a Connecticut town and his father persuaded him to come out to the camp."[87] Whether or not Charlie was actually a jeweler, at the young age of 15 or 16 in 1863 or 1864, is debatable, but other sources agree that Alfred came first, and Charlie followed.

For example, author Robert G. Bailey believed that the younger Bemis first "went to the seacoast, got a job on a sailing vessel[,] and nearly a year later found himself in San Francisco."[88] There he heard "tales of rich gold diggings" and "decided that Idaho was the place for which he had been looking.

Ultimately he made his way to Lewiston and thence by various stages of travel through the different mining camps until he landed in Warrens, when that camp was at the height of its glory."[89]

Writer Ladd Hamilton later embellished that version with a few more details. He wrote that Bemis, who supposedly "shipped as a deck hand on a vessel bound around the Horn to California, was 20 years old when he stepped off his ship in San Francisco in 1871. A chance remark heard in a Golden Gate saloon sent him striking north to Portland and then turning eastward into the heart of the Idaho country."[90] That account is a bit exaggerated, since Charlie, born in 1848, would have been 23 in 1871, not 20, and he was already in Warren certainly by the fall of 1866, and arguably even earlier.

Historian M. Alfreda Elsensohn believed that the year of Charlie Bemis's arrival in Warren was possibly confirmed by a music book dated 1864 that reportedly had his initials on it.[91] She described the music book as measuring 13 by 8 inches with a canvas cover, noting that "[t]he words C. A. Bemis were sketched plainly on the outside with the C partially defaced.[92]

In November 1958, however, H. J. Swinney, then director of the Idaho State Historical Society, visited the music book's then-owner, Taylor Smith of New Meadows, in order to examine it.[93] Afterward, Swinney wrote a letter to Elsensohn in which he stated,

> I notice that the cover of the book is marked 'A B 1864.' Smith was of the opinion that the letter 'C' standing for 'Charles' and making the complete initials CAB, had been rubbed off. Privately, I could not see any trace of it, and it is my personal belief (which I would not repeat to Mr. Smith) that the book carried only the initials A B 1864. I also noticed that a good many of the songs had been received from someone in California. For these reasons I am not so sure that the book is absolute proof that Bemis was in Idaho earlier than you thought; is it not possible either that he was himself once in California and brought the book with him to Idaho when he came, or, alternatively, that it was someone else's book which he acquired, and that the letters A B are the other person's initials? Perhaps your intimate knowledge of Bemis would give you some corroboration of one or the other of these possibilities.[94]

Elsensohn replied, "In regard to the A. B. 1864 I feel very certain that it must have been C. A. Bemis. Of course I saw the book just once but I did scrutinize the name part very carefully."[95]

The music manuscript is now housed in Boise State University's Albertsons Library, Special Collections and Archives, and has been digitized.[96] The cover clearly shows only A. B. 1864 (Fig. 1.9). A. B. could well stand for Alfred Bemis,

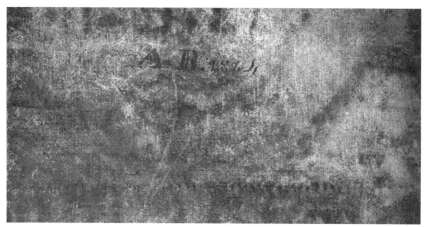

Fig. 1.9. Music book cover with A. B. initials. Boise State University, Boise, Idaho, "MSS 268 Beemer Manuscript," available at http://digital.boisestate.edu/cdm/ compoundobject/collection/beemer/id/227/rec/6 (accessed March 20, 2019). Used with permission.

Charlie's father, who, as mentioned earlier, was in Warren at least by 1863.[97] However, no evidence indicates that Alfred Bemis did, or did not, play a musical instrument; the initials may instead be from another, unknown, person.

Charlie Bemis, Miner and Citizen, 1866-1872

On September 2, 1866, Charlie Bemis's name, as "Bemiss," appears in a public document for the first time. He, C. Johnson, and four unnamed men recorded a quartz mining claim called the Bullion Ledge. It comprised "six claims of two hundred feet each on the Western Extension of the Bullion Gold and Silver quartz lead."[98]

Within a few more weeks, Charlie Bemis was a partner in several other, similar, mining claim transactions. On September 18 a group of eleven men headed by Joseph Griffith, and including both A. and C. "Bemiss," filed a series of mining claims called the Excelsior Ledge. These comprised "[four] teen Quartz claims of two hundred feet each on the Eastern Extension of the Excelsior Quartz lead or lode." The men "also claim[ed] all dips, Spurs angles, right of Dra[i]nage and all other rights allowed us by law"[99]

On the same day the same eleven men also filed another thirteen mining claims called the Mountain Buck Ledge, using similar wording.[100] Other claims filed at the same time by some of the same men, including C. A. "Bemiss," were for the Idaho Deposite Ledge,[101] and in October 1866 a group of men, including both Charlie and his father, filed 15, 200-foot quartz claims on the Pearce Ledge.[102]

In September 1869 William Andrews and C. A. Bemis were named on a mortgage from A. Bemis and A. H. Sanderson for "the Keystone gold and silver quartz ledge," also known as "the Keystone Gold & Silver mine." The claim comprised "two thousand feet liner extent upon said Keystone vein with all the improvements thereon" Alfred Bemis and A. H. Sanderson stated that they owed Andrews $398 for work he had already performed at the mine. He and Charlie Bemis were to receive $6 and $5 per day, respectively, for continuing work there. Alfred Bemis and A. H. Sanderson also agreed "to provide ample food for the support of said party of the second part [Andrews and Charlie Bemis] while employed at said work at the rate of one dollar per day in gold coin or gold bars to be deducted from the first proceeds of the ore from said vein[103]

It is thus obvious that both Charlie Bemis and his father were in Idaho well before the 1870 US Census; however, neither man appears in it. Perhaps they were away, or were mining in a remote region, out of reach of the census enumerator. Charlie, but not his father, did pay a $4 poll tax that year.[104]

In September 1870, A. H. Sanderson and A. Bemis executed the following document:

> ... we the undersigned in behalf of the Keystone G[.] & S. Q[.]. [Gold and Silver Quartz] Co. do grant sell and convey unto Wm[.] Andrews and Chas. A[.] Bemis all the Quartz now in the Ar[r]astra building also all the Quartz lying outside and near said Ar[r]astra likewise all the tailings now lying outside of said Ar[r]astra the proce[e]ds to be applied ... [in] the following manner[:] Wm[.] Andrews to receive three fourths of the amount accruing from the above named Quartz and tailings and C[.] A[.] Bemis the Balance.[105]

United States Commissioner of Mining Statistics, Rossiter Raymond, in reporting on mining activity for 1872 in the Warren Mining District, stated:

> The Keystone lode, owned by [Alfred] Bemis and Sanderson [by the time of publication it was owned by William Andrews and Charlie Bemis], has a shaft 53 feet deep, connected with a tunnel, driven in on the lode for a distance of about 300 feet. The crevice is 2½ to 3 feet wide, and contains 8 to 9 inches of ore, which is said to have yielded as high as $75 [per ton] in a stamp-mill.[106]

Despite Charlie Bemis's ownership of several mining claims, the hard life of a miner apparently did not suit him. His later neighbor, Peter Klinkhammer, once commented, "Not liking hard work, he [Bemis] took to the saloon business early in life. I do not believe he ever had much money at one time. He was a gambler and could make money and spend it too."[107]

Historian M. Alfreda Elsensohn described Bemis as "… a mining camp gambler. Soon he bought a place of his own with a small bar in front and a bedroom behind. Like most keen gamblers Bemis cared little for drink."[108]

Besides working as a miner, Charlie Bemis also fulfilled various civic obligations. The first known instance is when he was a trial juror in 1871. He served two days at $4 per day, plus reimbursement of 50 cents per mile for two miles of travel[109] (Fig. 1.10).

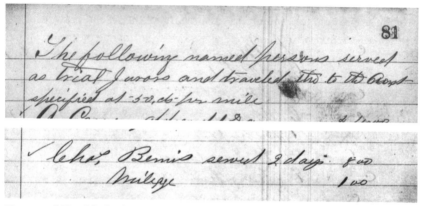

Fig. 1.10. "Chas." [Charles] Bemis listed as a trial juror, probably for the court that convened in June 1871. From Idaho County, "Commissioners Record," Book 2 (Idaho County Courthouse, Auditor-Recorder, Grangeville, ID, 1869-1877), 81.

Warren Eclipses Florence

Earlier, on March 4, 1863, President Abraham Lincoln signed the act that established Idaho Territory. In February 1864 the first Idaho Territorial Legislature reaffirmed the existence of Idaho County, with Florence as the county seat.[110] The ascent of Warren coincided with Florence's decline. In 1868, Warren was well-known as Idaho's "liveliest camp." The citizens "uniformly have their time-pieces one hour fast of mean time, … in order to ensure the earliest commencement hour of labor in the diggings … and to cause the boarding-house and restaurant folks to have early breakfast for the miners."[111]

That year, "it was decided, not by popular vote, to move the county capital from historic Florence to the new and boomingly lurid placer camp of Washington,"[112] later Warren. The community then had about seventy buildings, chiefly "stores, saloons, shops, and tenements." In addition, "a good bath house, a very fair public house, and an excellent restaurant," as well as "a barber shop and two hurdy houses" marked the town's "'civilizing' peculiarities"[113] (Fig. 1.11). In addition, a bank and an assay office indicated Warren's "financial prosperity." A "fire apparatus," together with an ample

Fig. 1.11. Warren, Idaho, 1880. Courtesy Idaho State Archives, Boise, 2833.

supply of water, guarded against disaster. Despite its size, Warren had no stable, compelling travelers to leave their horses with a ranch hand, who took them to a grazing ranch a few miles out of town.[114]

Farms and gardens on the Lower Salmon River, some 80 miles away, supplied Warren with fresh vegetables, butter, eggs, and other produce. Everything arrived by pack train, and the vegetables cost between four and ten cents per pound, at a time when wages were $5 per day, board was $10 per week, and gold dust was worth $13 per ounce.[115] By 1872 at least three or four vegetable gardens of twenty-five to thirty acres each were established on the South Fork of the Salmon River.[116] Because they were only twelve to fourteen miles away, they more easily supplied Warren's produce needs.

In 1875 the territorial legislature agreed to expand Idaho County, thus increasing the region's population base. That June an election established Mount Idaho, the region's trading center, as the new county seat,[117] indicating the decline of Florence and Warren after their initial boom.[118]

The Chinese in Warren, 1870-1872[119]

Briefly, Chinese began coming to the United States in the late 1840s in the wake of gold discoveries in California. By the early 1850s many Chinese, chiefly men, had emigrated to the western United States, mainly for gold-mining opportunities, first in California, and later in Oregon, Idaho, and elsewhere. As was customary in most western mining districts at that time, the Euroamerican miners did not permit the Chinese to mine in newly-discovered mining regions. However, once the Euroamerican miners had removed the easily-won gold, they wanted to move on to more productive

areas elsewhere. They then voted to admit the Chinese in order to sell them their supposedly "worked-out" placer mining claims.[120] Because the Chinese were satisfied with lower yields, the mines proved profitable for them as well.[121]

Warren was no exception. By late 1869, although the "placer mines continue to yield fairly, the side claims paying well," the middle of Warren Creek was worked out. The placers had become unproductive enough that "the camp will be open for [Chinese men]" in the spring of 1870."[122]

Indeed, the first Chinese reportedly arrived in Warren in the spring of 1870.[123] By May, Warren had "twenty places of business including the [C]hinese stores." The latter were "established on the meadows of Meadow [C]reek and their dwellings group along the hillsides. They have established a washhouse and are working diligently. They have their own pack trains …,"[124] which supplied the Chinese stores. The 1870 Washington [Warren] census, taken in July, two years before Polly arrived, counted 343 Chinese men and one Chinese woman compared with 241 Euroamerican men, women, and children.[125] The lone female was Ching Duc, a 31-year-old woman who was "Keeping House" for Ah Fong, a 37-year-old Chinese cook[126] (Fig. 1.12). There is no indication that she was, or wasn't, still in Warren when Polly arrived in mid-1872.

Fig. 1.12. *1870 US Census of Warren, Idaho, showing (line 3) Ching Duc* [Duc Ching], *Chinese female. US Census,* Ninth Census of the United States, 1870, *Idaho County, Washington* [Warren], *Idaho (National Archives Microfilm Publication M-593, roll 48, sheet 195, page 2, line 3); Records of the Bureau of the Census, Record Group 29.*

East of Warren, Chinese gardeners established terraced gardens at the lower elevations of the South Fork of the Salmon River.[127] From here, they supplied fresh produce to Warren's Chinese and non-Chinese residents alike.

Various deeds and bills of sale attest to Chinese miners' presence in the Warren Mining District from 1870 on. For example, in October of that year,

Ah Led and Company paid $500 to Frank and Owen Dowling and Peter McTeigue for three claims in Rabbit Gulch and three more in Rich Gulch.[128] At the end of the 1870 mining season, about 200 Euroamericans and 500 Chinese were expected to winter over in Warren.[129]

In January 1871, Ah Bu and Company paid three Euroamerican men $100 "for mining ground near Bloomer's mill" The sale also included "five sluice boxes and one blacksmith's bellows."[130] The same Chinese company bought more mining ground in August 1871 from John Mathinson, this time for $75, and in September, Mathinson sold another mining claim to Ah Jim and Company for $125; this claim adjoined one belonging to Ah Bu and Company.[131]

One source states that Warren had 1,200 Chinese in 1872, with an estimated 400 Euroamericans.[132] That information can probably be attributed to early Warren merchant Leo Hofen. Although Hofen didn't accurately remember the beginning of Chinese mining at Warren, he did recall other essential facts. In 1882 he stated,

> ... The quartz didn't pay and in fall of '72 [1872] but 400 men were in [the] district. The claims being generally worked clean and not paying to suit the "ounce a day" men a vote was taken and the Chinese were allowed to come into the camp to the number of 1200 men. They bought claims, paying as high as $8,000 for many of them and the owners took the installments out of the sluices each Saturday night, until claims were satisfied and deeds given. Many Chinamen threw up the claims the day after paying for them and as it cost them so much to live they made little or nothing, flour being cheaper than rice often, though latterly they have done better and a few have got rich and at present some 150 whites and 600 Chinese are still working.[133]

Warren's many hard-working Chinese men required other support services. Important ones were those related to leisure activities, such as gambling, opium smoking, and prostitution, all entertainments that removed gold from the miners' pockets and placed it into the hands of the Chinese merchants who controlled those businesses.[134] As these Chinese entrepreneurs became wealthy, they desired to improve their own standards of living. For one, this meant obtaining a concubine.

Polly Arrives in Warren, 1872

During 1872, the year of Polly's arrival in the United States, Ulysses S. Grant was reelected President;[135] Yellowstone became the world's first national park;[136] Victoria Woodhull was the first woman to be nominated

for President of the United States;[137] and in Louisiana, P. B. S. Pinchback became the first African-American governor.[138] Another important "first" in 1872 was the arrival of the earliest contingent of Chinese boys and young men in the group that later became known as "China's First Hundred." They embarked on a ten-year program of education in American universities and technical institutions, and returned home to use Western ideas and technology in modernizing China's navy, railroads, mines, and telegraph system.[139] Although Warren, Idaho, residents may not have been aware of most of these events, Polly's arrival would have been a significant event for that community.

A 1923 newspaper interview with Polly Bemis stated that she arrived in Warren "when in her 19th year,"[140] i.e., before her nineteenth birthday on September 11. She came "by saddle horse from Portland on July 8, 1872. As she alighted from her horse, she was greeted by a stranger who said, 'Here's Polly,' as he helped her from the saddle, and ever after Polly has been her name."[141] Although the appearance of another Chinese woman in Warren would have been an unusual event for that community, no mention of it has yet been found in any primary source such as a newspaper, a letter, or a diary from that era. Warren itself never had a newspaper, so far as is known,[142] and letters from Warren that appear in regional newspapers around that time do not mention Polly's arrival.

Because Polly's owner paid $2,500 for her,[143] he must have been wealthy, and more likely a businessman than a miner. In 1933, Jay Czizek, Polly's friend and former boarder, stated that Warren's Chinese leader "was 'Big Jim,' a tall and handsome man who ruled all the affairs of his colony. He wore elegant brocade silk robes and a mandarin cap with a scarlet button on top. He had brought half a dozen Chinese women to Warrens."[144]

If "Big Jim" brought any Chinese women to Warren, it may not have been personally and the number may be exaggerated. Polly told another, more likely, version in a 1921 interview, published in 1923, when she said that an old woman smuggled her into Portland where an old Chinese man bought her for $2,500 and brought her to Warren in a pack train.[145]

In Warren, Polly met her real owner, a wealthy Chinese businessman whose name remains a mystery. If there was such a person as "Big Jim," his Chinese name is unknown. Although Polly's owner is often called "Hong King" in various writings about her, there is no historical documentation for that name, either in the Warren census records or in Idaho County property ownership records. Chapter Nine presents a detailed discussion of this and other myths about her.

Secondary sources state that either one, or two, other Chinese women came to Warren with Polly. M. Alfreda Elsensohn wrote, "Two other Chinese

girls came with her to Warrens, but they did not stay."[146] Cheryl Helmers states, "Hong King, who owns a saloon here, has received with the last pack train, two Chinese women."[147]

Polly herself did mention that two other Chinese women came in the pack train with her. However, when interviewed in 1924, Polly stated that she and two other young Chinese girls were brought to Florence, Idaho.[148] Since Florence is on the way to Warren, it seems certain that the other two Chinese women were left there rather than continuing on to Warren with Polly.[149]

Women of all races, especially Chinese women, were scarce on the western frontier. Consequently, a Chinese man who wanted a woman, for whatever reason, had to pay a great deal of money for her. A price of several thousand dollars was not uncommon, particularly if the woman was attractive and had small feet. In America as in China, women with bound feet were more expensive than those with normal feet. Polly's formerly-bound feet may have contributed to her high selling price.

Polly's birthplace in northern China is significant, because it means that she probably could not communicate easily with her owner or with the other Chinese in Warren. Historically, most of the Chinese people who ventured to the United States for work during the late nineteenth century were from the Canton vicinity, today's Guangzhou, in southern China's Guangdong province. They spoke Cantonese, or some dialect of it. Because Polly was from northern China, she would have spoken Mandarin or some northern minority dialect rather than the Cantonese-related dialect spoken by the other Chinese in Warren. Whereas written Chinese is readable by anyone literate in it, spoken Mandarin and Cantonese are completely different languages; a speaker of Mandarin cannot understand a Cantonese speaker, and vice versa. Therefore, the other Warren Chinese, being from southern China, would not have understood Polly's northern Chinese language when she tried to speak with them. Census records indicate that Polly could not read or write, in either Chinese or English, so written communication would have been impossible for her as well.

Although Polly probably learned some Cantonese for day-to-day communication with her owner and with the other Chinese in Warren, she would have needed to learn English to successfully interact with patrons of her owner's business, and, later, with Charlie Bemis.[150] The business may have been some sort of entertainment establishment, where Polly was required to work, perhaps as a hostess, as a dance hall girl [but not actually dancing, given her once-bound feet], or merely as an "exotic curiosity."[151]

One small clue underlies these assumptions. In 1924 a newspaper reporter interviewed Polly and asked her opinion of modern women, then called

"flappers," and their use of makeup to attract men. Polly observed that she too used "paint," or makeup, until she began living with Charlie Bemis. Afterward, she no longer needed to wear it.[152] Her reference to "paint," or makeup, indicates that Polly's owner required her to conform to his patrons' criteria of female beauty. More than likely, the customers were Euroamerican miners, and the females upon which Polly modeled herself, or was ordered to do so, were makeup-wearing prostitutes or dance hall girls. Obviously, Polly regarded it as a burden, one that she happily abandoned once she and Charlie were together.

Charlie Bemis: Businessman, Citizen, and Property Owner, 1872-1879

Although Polly arrived in Warren in 1872, it was not until 1880 that her name was linked with that of Charlie Bemis. If they encountered one another in the intervening eight years, there is no record of it.

Meanwhile, Charlie participated in Warren's public and business life. In August 1872, shortly after Polly's arrival in Warren, he was one of 58 "petit jurors" for the District Court of Idaho County during the August term. He served 6 days, at $4 per day.[153] The following year, 1873, he was a Grand Juror for the same term.[154]

Besides the property transactions detailed earlier, Charlie Bemis and his father Alfred continued to do other business together. On August 15, 1873, Alfred purchased "all that property known as the Bemis Arraster Mill" [arrastra, an ore-grinding mill] from his son for "One thousand Dollars Gold Coin." According to the deed, with all its eccentric spelling and punctuation, the property consisted of

> ... the Mill building, two Arrasters, one Crusher and all the Machinery and Tools appertaining or belonging to said Mill. All Water rights and privileges belonging to said Mill. Also one Dwelling House and Store house, one Blacksmith shop building and one set of Black Smith tools. Also the undivided one half 2200 feet of the Quarts Ledge known as the Keystone Quarts lead or lode, situated in the Washington Gold and Silver Quarts Mining District.[155]

In mid-1874, Charlie Bemis found time to fulfill civic responsibilities. As a juror during the August term, he received $33.30.[156]

During the next two years Charlie may have been providing care for his ailing father. Alfred Bemis died in March 1876 "of consumption, after a long illness."[157] He is buried in the Warren Cemetery,[158] and is memorialized by Warren's Bemis Point, "the richest property in Warrens."[159]

Subsequently, Charlie Bemis ran for, and won, a public office in the November 1876 elections; C. A. "Bimis" became Warren's new Constable.[160] He probably still had some mining properties, since Idaho County records show no sales of those he had purchased earlier. In January 1878 his name appeared on a document with A. H. Sanderson, his late father's partner in the Keystone hardrock mine, meaning that Charlie had probably inherited his father's interests. Charlie and Sanderson filed a Notice of Location for "one claim of ... 1500 feet in length by 300 feet in width on either side of said ledge or lode. ... Located about four miles in a southeasterly direction from the town of Washington and notice posted on a post near the main shaft."[161]

In April 1878 Charlie Bemis made the lengthy trip to Lewiston, Idaho. The *Lewiston Teller* reported, "Charles Bemis from Warrens and A. Williams from Clearwater, are in town this week."[162] In late May Charlie returned to Lewiston. He visited the *Teller* editor, who wrote, "Chas. Bemis of Camas Prairie gave us a friendly call this week."[163]

Charlie does not seem to have entered the saloon business until after 1878, since a regional business directory for that year does not list him. Warren's businesses and services then included only G. Church, hotel; Tho[ma]s Clark, liquors; Croasdale and Williams, meat market; A. Fre[i]denrich, postmaster and general merchandise; Grosstein [*sic*, for Grostein] & Binnard, general merchandise; A. H. Sanderson, Justice of the Peace; M. Storens, general merchandise, and N. B. Willey, attorney.[164] In late November 1879, however, Charlie Bemis acquired Clark's liquor business at a sheriff's sale.[165]

The Chinese in Warren, 1873-1879

The Warren area's Chinese residents continued to be involved in placer mining operations, usually buying claims from Euroamerican miners. In August 1873, Ah Kee and Company purchased "mining ground situated in Rich Gulch near Rabbit Creek" from Peter Doran and A. E. Dewer, together with ditches, water rights, and six sluice boxes.[166]

While there is no direct news of Polly during this time, she certainly knew about, and perhaps even attended, the wedding of a Warren Chinese couple in March 1874, when Mary Ah You married Ah Wan. Probate judge C. W. Case officiated, "in the presence of B. F. Morris and Solon Hall," witnesses[167] (Fig. 1.13).

Other Warren Chinese residents whom Polly surely knew were the two principals to an intriguing deed dated May 1875. It recorded the sale, from Hop Sing to Wa Sing of [capitalized and unpunctuated as in original document] "all of one House and garden Situated in the Town of Washington [Warren] ... with all and Singular the tenements, the furniture fencing stove

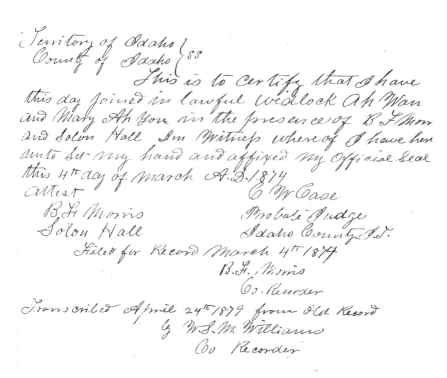

Fig. 1.13. Marriage record for Ah Wan and Mary Ah You, March 4, 1874. Idaho County, Marriages, "Marriage Record 1," Idaho County Courthouse, Auditor-Recorder, Grangeville, ID, [1877-1929], 8. This entry was "Transcribed April 24th[,] 1879 from Old Record," now lost (Idaho County Courthouse, Auditor-Recorder, Grangeville, ID.)

tables chairs china cups chop Sticks cookery utensils tea pots 1 wood Saw 2 wash tubs 1 Shovel 1 Pick."[168]

By October 1878 the *Lewiston Teller* newspaper reported, "The Chinese seem to have a pretty strong hold upon the camp."[169] Indeed, in early November 1879 there were reportedly 800 of them in the Warren area, paying "good cash prices" for farm products from as far away as Weiser, Idaho.[170]

Mid-November 1879 witnessed the hanging of two Chinese men from Warren. They reportedly had robbed a miner's cabin "of many articles of value." The loot included a pair of boots; soon found on one of the men's feet. He and his companion were arrested and jailed, but the next morning the jailer "found the jail door burst open and both of the prisoners gone." A lynch mob had hanged the unfortunate Chinese "near the old Pioneer mill on Slaughter [C]reek about a mile above town."[171] The same newspaper editor commented,

"among all of our acquaintances of that camp, and they are many, we cannot call to mind a single one who would mete out death to a man, not even a Chinaman, for such causes and in a manner as described above. Some new men must have come to the camp."[172] Whoever the perpetrators were, they were never apprehended.

The Chinese in Warren, including Polly, must have been terrified by this event. Although there is no evidence that any of them left town because of it, Polly's owner could well have done so, thus facilitating Polly's future relationship with Charlie Bemis.

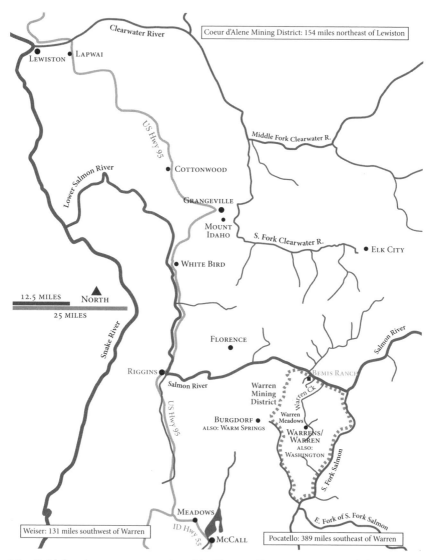

Map 2. Idaho place names mentioned in Chapter Two. Items in gray did not then exist, but are included for context. Drawn by Melissa Rockwood.

CHAPTER TWO:
Polly and Charlie in Warren, 1880 through 1890;
Polly, age 27-37

If Charlie Bemis had subscribed to an Idaho newspaper, he would have been knowledgeable about international, national, and statewide events, and could have communicated some of this to Polly. In the decade from 1880 through 1890, for example, they might have learned about, or even have felt, the earthquake of August 9, 1881, that was centered 20 miles east of Mount Idaho. In 1884 they would certainly have been intrigued by news of gold and silver discoveries in the Coeur d'Alene Mining District. Perhaps the biggest news of the decade occurred on July 3, 1890, when Idaho became the 43rd state,[1] signed into law by President Benjamin Harrison. George L. Shoup became the first governor.

Nationally, events relating to the Chinese in the United States had been occurring for over a decade; these circumstances would also affect Polly and Charlie. For example, in 1882, Congress passed the Chinese Exclusion Act. Aimed at Chinese laborers, it forbade any new ones from entering the United States. Of all the local, national, and international events of the 1880 through 1890 time period, the Chinese Exclusion Act is the only one, besides Idaho becoming a state, that would likely have caught Polly's attention.

From 1872 until mid-1880 there are no contemporary, written accounts of Polly's presence in Warren. Her "paper trail," or documentation, in the United States only begins with the 1880 US Census for the town of "Washington," as Warren was then named.[2] An entry in that record, dated June 4, 1880, lists Charlie Bemis and Polly living together in the same household[3] (Fig. 2.1). From then until the couple's marriage in 1894, only sporadic references mention Polly. However, the abundant details about Charlie Bemis's business and other activities in Warren provide glimpses of Polly's life with him.

Without knowledge of Polly's activities between 1872 and 1880, there is thus no reliable account of how and when she and Charlie came to be living

Fig. 2.1. 1880 US Census of Warren, Idaho, showing Charlie Bemis and Polly [no surname given]. US Census, Tenth Census of the United States, 1880, Idaho County, Washington [Warren], Idaho (National Archives Microfilm Publication T-9, roll 173, page 3, lines 44-45); Records of the Bureau of the Census, Record Group 29.

together by 1880. Many secondary sources state that Charlie won Polly in a poker game, but evidence, inferred from the 1880 census as well as from Polly's denial of the "poker bride" story just before her death in 1933, suggests otherwise (Chapter Nine).

Polly and Charlie's Relationship, 1880 Onward

Similarly, there is no reliable, contemporary evidence for the start of Polly's earliest acquaintanceship with Charlie Bemis. M. Alfreda Elsensohn wrote that Albert W. (Al) Talkington "used to recall Polly's first meeting with Bemis when she was bought into Warren. Someone called Bemis out of the saloon and said, 'Charlie, this is Polly.'"[4] However, Elsensohn also stated that Talkington first "went into the mines of Elk City and Warrens … around 1873."[5] If that date is correct, he could not actually have been in Warren at the time of Polly's arrival in July 1872, when she supposedly met Charlie Bemis for the first time.[6]

In surmising how the couple came together, Polly's owner must have died or returned to China sometime between 1872 and 1880. For example, one source states that at the time of their marriage in 1894, "Bemis had already cared for her as his lawful wife for more than 20 years,"[7] i.e., since at least 1874. If that statement is true, it would mean that they had been a couple for six years prior to the 1880 census where they are listed together for the first time. Whenever Polly did become available, Charlie may have made her "an offer she couldn't refuse," namely, to keep house for him;[8] by 1880, he was a prominent local citizen, with numerous business and other interests.

The 1880 census reports that Charlie and Polly resided in the same dwelling, but no address is given. Usually, when taking the census, the enumerator went from house to house, consecutively. If that was the case for Warren

in early June of 1880, Polly and Charlie lived between two households of Chinese men.[9]

Later in 1880, the location of their residence, perhaps a different one, may be inferred from documents in the Idaho County Courthouse at Grangeville related to Charlie Bemis's real estate transactions between 1880 and early 1892. An important entry, dated August 26, 1880, is a copy of the deed for buildings that Bemis purchased, for "two hundred dollars gold coin of the United States of America," at a sheriff's sale on November 29, 1879.[10] In September 1878 a court decree had ordered the previous owner, Thomas Clark, to pay a monetary judgment, and when he could not do so, Sheriff Charles Case seized Clark's property and sold it at public auction a year later in front of the Idaho County Courthouse at Mount Idaho, then the county seat.[11] Following the sale, Clark was allowed an additional six months in which to redeem it. He did not, and Charlie Bemis received a deed to the property in August 1880.[12]

The property was as follows:

Lot No 1 one building & Lot on north Side of Main Street known as the Ripson[']s Saloon building.

Lot No 2 one building & lot on North Side of [M]ain Street between Ripson[']s Saloon Building and Churches Hotell [*sic*]. Lot No 3 one building & Lot on North Side of [M]ain Street known as the old Court House Building. Lot No 4 one Building & Lot on South Side of Main Street known as the Ball & Whitman Store house. Lot No 5 One Building & Lot on South Side of Main Street and known as the Woods House.

All of the above described Real property is Situated in Warrens Precinct Idaho Co Idaho Territory.[13]

Today, it is difficult to ascertain the former locations of these properties, particularly since most of Warren's business district burned in 1904. Additionally, the lot numbers in the 1880 deed do not correspond to the lot numbers of the town on a 1921 plat, the earliest known; that document shows Lots 1 though 5 all located on the *south side* [emphasis added] of Main Street.[14] Nevertheless, there are some clues.

The property description clearly states that Lot 2, with a building on it, was on the north side of Main Street between Ripson's saloon (Lot 1) and Church's Hotel.[15] Later photographs, of a row of buildings on the north side of Main Street, identify the one on the left as both the Bemis saloon and as his house, where he and Polly were married in 1894. A smaller building separates it from a hotel on the right. The saloon and the smaller structure are probably the same as Lots 1 and 2.

Lot 3, "the old Court House Building," may be shown in an early photograph in *Warren Times*, captioned, "Warrens. The flagpole stands outside the old courthouse on the hill above Bemis Saloon, the hotel and Benson's store on Main [S]treet.[16] Specific locations on the south side of Main Street for Lot 4, the Ball and Whitman store house, and Lot 5, the Woods house, remain unknown.[17]

After Charlie received deeds to the properties, he and Polly may have moved out of the Chinese neighborhood, where they were living at the time of the 1880 census, into one of the other structures, either the saloon, Lot 1, or the Woods house, Lot 5.

Charlie Bemis: Businessman, Miner, and Citizen, 1880-1890

Although Charlie Bemis did not get the deed to what had been the Ripson Saloon until August 1880, six months after he purchased it, he was certainly running it by June, when the US Census was taken. He could even have begun operating it following his payment for it in late November 1879, while he waited to see if Thomas Clark could redeem it. Additional confirmation that he engaged in saloonkeeping came from a newspaper story dated early August 1881. By then, Warren's population was about five hundred, mostly Chinese, with just sixty-five or seventy Euroamerican men. Although both Chinese and non-Chinese women lived in Warren at that time, the article did not mention them. The town's sixty-odd buildings, including both log cabins and more substantial frame structures, clustered around the single street, and "Maj[or] Bemis" ran a saloon and a feed stable[18] (Fig. 2.2).

Fig. 2.2. Charlie Bemis mentioned in a newspaper article, 1881. From Nez Perce News, "On the Wing," 1(49):1, August 4, 1881.

One account suggests that the saloon was called "Bemis' Place," and that it had a special attraction, the "Hurdy Gurdy Girls," young women usually recruited from Germany who worked in saloons in groups of four to six; patrons bought tickets to dance with them to the music of a hurdy-gurdy[19] (Fig. 2.3). "Hurdies" began coming to the United States at the time of the California Gold Rush in the 1850s. Unfortunately, the young women

30

often endured many abuses; some were even forced into prostitution. By 1865 the German government began to strongly discourage the practice of recruiting hurdy-gurdy girls and sending them abroad;[20] however, some must have still been employed in 1879 or 1880 when Bemis opened his saloon.

Charlie also owned an arrastra (Fig. 2.4), for milling gold from quartz.[21] Of several in the vicinity in August 1881, his was one of only two then in use. Although there is no record of what Bemis charged for the use of his arrastra, there were also five- and ten-stamp mills nearby, and users of the five-stamp mill paid $3.50 per ton of ore processed.[22] Because an arrastra was

Fig. 2.3. An unidentified woman holding a hurdy-gurdy, circa 1868. Leon Crémière & Cie., Victoria, française, albumen silver print 84.XD.1157.69. Courtesy the J. Paul Getty Museum, Los Angeles.

Fig. 2.4. A horse-powered arrastra for milling gold, likely 1850s. "Gold Washing in Mariposa County, California," artist and date unknown, Honeyman (Robert B., Jr.) - Collection of Early Californian and Western American Pictorial Material, http://ark.cdlib.org/ark:/13030/tf4m3nb6fkBANC PIC 1963.002:0268--A, Bancroft Library, University of California, Berkeley.

technologically inferior to a stamp mill, and thus less efficient, mine owners presumably paid less to use it.[23]

During Polly and Charlie's time in Warren, letters from that place and articles about it appeared in newspapers published in other Idaho communities. These sometimes mention Charlie. For example, by mid-1882 Charlie was a deputy sheriff. In that capacity he "subscribed to the annexed instrument," i.e., a deed.[24] Then, the following October, he and several other men discovered the body of another man who had committed suicide by shooting himself in the head.[25]

By mid-July 1885 Charlie had either moved his saloon to a new building or "reconstructed" his old building.[26] In any event, one visitor stated appreciatively that "Bemis monopolizes the saloon business and knows how to 'treat' his friends."[27] Several weeks later, an article about Warren stated, "Bemis keeps a first-class saloon where you can get a good drink or a fine cigar and lots of music."[28]

Besides operating his saloon, Charlie continued his mining interests. In October 1885 he filed another location notice for the Keystone lode mine (Chapter One), this time as sole owner. He described his claim as being 1,500 feet long by 600 feet wide, and expected it to yield "gold, Silver and other precious Metals."[29]

Charlie Bemis's wealth was sufficient for him to appear on an 1886 list of "Our Solid Muldoons," described as "taxpayers in Idaho [C]ounty whose taxes amount to twenty dollars and upwards."[30] Bemis had property worth $1,170, on the low end of valuations ranging from just over $1,000 to nearly $15,000.[31]

By the spring of 1887 Polly and Charlie apparently lived in a separate building from the saloon, perhaps the former Woods house mentioned earlier, because when their home burned down in May of that year there was no mention of liquor or of saloon furnishings. Grangeville's *Idaho County Free Press* reported,

> … The fire caught in the roof in some unknown manner, and had gained such headway that next to nothing could be got out of the house. The loss is considerable; $500 in greenbacks were consumed and several costly gold watches belonging to various parties, and other jewelry worth about $2,000. A large sum of coin and gold dust was recovered from the ruins without much loss. All the provisions, household furniture, etc., went up in smoke[32] (Fig. 2.5).

The "several costly gold watches belonging to various parties" as well as the "other jewelry worth about $2,000" may mean that Charlie was acting as a pawnbroker,[33] with the valuables left as collateral for loans. If so, the

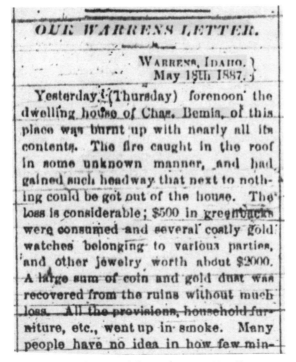

OUR WARRENS LETTER.

WARRENS, IDAHO,
May 13th 1887.

Yesterday (Thursday) forenoon the dwelling house of Chas. Bemis, of this place was burnt up with nearly all its contents. The fire caught in the roof in some unknown manner, and had gained such headway that next to nothing could be got out of the house. The loss is considerable; $500 in greenbacks were consumed and several costly gold watches belonging to various parties, and other jewelry worth about $2000. A large sum of coin and gold dust was recovered from the ruins without much loss. All the provisions, household furniture, etc., went up in smoke. Many people have no idea in how few min-

Fig. 2.5. Charlie Bemis's house burns, 1887. From Idaho County Free Press, "Our Warrens Letter," 1(51):4, June 3, 1887.

"large sum of coin and gold dust" on hand would either have been lent to people who pawned their goods, or received from those who redeemed their possessions.

By August 1887 Charlie had rebuilt his house.[34] The Grangeville newspaper reiterated that the heat of the fire had been "intense enough to fuse silver coins and melt gold watches and chains beyond recognition. The total loss was about $3,000," about $81,000 today.[35]

The lack of any reference to the saloon also being rebuilt implies that it did not burn. However, the rebuilt structure is later identified both as his house and as his saloon, so it may have served both purposes. Whether those functions were simultaneous, or not, is unknown.

In August 1887 Bemis's saloon hosted, surprisingly, a religious service. Leroy T. Weeks, an itinerant Methodist minister, conducted it.[36] In a letter to the Grangeville newspaper, Weeks reported that he "preached to a quiet, attentive audience … the first [M]ethodist sermon in Warrens." The amount of the collection, $17.75, about $500 in today's dollars, implies that the event was well attended.[37]

Another visitor to Warren, A. F. Parker, editor of Grangeville's *Idaho County Free Press*, described a few of the business establishments that existed in Warren in the late summer of 1887. He ended with, "all the old standbys are here as usual," and included Bemis in his list.[38] Later that month "C. A. Bemis Esq." went out to Grangeville on business and "brought us [the *Free Press*] news from our lost boss," implying that Parker was still touring the mining districts.[39]

Despite the heavy losses from his house fire, Charlie Bemis's name appeared again on an October 1887 list of "Our Solid Muldoons" for having taxable property valued at more than $1,000. His assessed value was $1,025, or $145 less than the previous year.[40]

By early February 1888 brothers Arthur and William "Will" Warden had bought a three-year contract to deliver mail between Mount Idaho and Warren. At Warren, Charlie Bemis was their local agent. Will accomplished the lengthy round trip on horseback once a week, until a paralyzing accident in June of that year put an end to his career.[41] On each journey, he stayed overnight in Warren, perhaps even with Polly and Charlie; in 1941 he "recalled the many splendid meals" Polly had cooked for him.[42]

A deed dated August 9, 1888, records Charlie Bemis's purchase of property on the South Fork of the Salmon River from three Chinese men named Ah Jake, Ah Kan, and Ah Ming.[43] For $500, Charlie obtained

all that piece or parcel of land on or near the South Fork of Salmon River about 7 miles South East of Warrens in Idaho Co. I.T. [Idaho Territory] known as the China Jake Ranch also improvements ditches water rights, crop and appurtenances also 6 Horses with rigging & all the farming [equipment].[44]

Later that August a Lewiston, Idaho, minister, Reverend J. D. McConkey, visited a number of settlements between Lewiston and Warren and wrote up his experiences for the *Idaho County Free Press*.[45] The main stops on the route included Cottonwood, Grangeville, Mount Idaho, White Bird, Florence, "Warm Springs" [later Burgdorf], and finally Warren. On reaching Warren, McConkey commented, "There are about 40 log buildings, the most of which are uninhabited. There are two stores owned by Lewiston men, Mr. A. Benson and Grostein & Binnard. There is a saloon [Charlie Bemis's] … and a blacksmith shop."[46]

In May 1889 Charlie Bemis was still an Idaho County deputy sheriff. He and Frank Smith visited Grangeville "on district court business and spent several very pleasant days with their friends on the prairie before returning home."[47] That same month C. A. Bemis appeared as a taxpayer on the Idaho County Assessment Roll. He had "imp[rovements] in Warren" worth $275; improvements on the Salmon River worth $50; stock in trade valued at $750; a mortgage and note, worth $350; six horses, worth $15 each; one cow, worth $20; and one head of cattle, worth $15.[48] Bemis's wealth, for tax purposes, thus totaled $1,550, or more than $41,000 today.[49]

The Warren property would have been his house and/or saloon, and the "stock in trade" was thus the value of the saloon's liquor. The Salmon River property was the China Jake Ranch on the South Fork, purchased in 1888.[50]

Most of the animals were probably housed there, since he obtained six horses with that transaction, but surely kept one in Warren for transportation.

An 1889-1890 business directory that includes Warren provides additional confirmation that Bemis owned a saloon at this time. His entry reads, "Beemis [*sic*], Charles, saloon."[51] In July 1889 Bemis figured prominently in Warren's Fourth of July celebrations. His horse, Dash, rider unknown, was

> ... matched against a prairie [Camas Prairie, i.e., the Grangeville area] horse owned by John Crooks. There was a great deal of preliminary skirmishing, betting[,] and jockeying for position. Before the start was made[,] twenty dollar pieces, silver dollars[,] and currency were freely offered and speedily taken; I never saw so much excitement in Warrens before on a horse race; the ladies spotted the winning horse and came out winners and jubilant; even the boys were betting as high as twenty-five dollars and showed good amateur skill in betting. Well, there were two heats, the Crooks horse winning both times. H. D. [R.?] Grostein won a hundred dollars and the writer ["Correspondent"] had nearly as much on the winner; then came cheering and yelling and liquid refreshments *ad libitum* ["at one's pleasure"].[52]

Between 1890 and 1894 a ledger for Warren's Mayflower Mining and Milling Company recorded transactions with a number of Warren residents.[53] Charlie Bemis is mentioned once, as C. A. Bemis. On July 6 of [probably] 1890, the entry for him reads "Dn [drawn?] to cash on act [account?] $10.00."[54]

During 1890, Bemis also retained some mining interests in addition to his saloon. In August 1890 an Owen McGinty sold, for $400, "a certain set of mining claims" to a partnership consisting of Grostein & Binnard, Benson & Hexter, A. Benson, Robert Keiton (Keathon), C. A. Bemis, and J[ohn] B. Chamberlain.[55] These claims totaled 2,000 feet in length, and were located in the Warrens Mining District.[56]

The Chinese in the Warren Area, 1880-1890[57]

In mid-1880 the town of Warren was overwhelmingly Chinese. The 1880 US Census counted a total of 467 people in 105 Warren dwellings, including 77 people who were "white," Indian, or "half-breed," and 390 who were Chinese.[58] Besides Polly, there was just one other Chinese woman. Ah Choy was listed as a thirty-five-year-old prostitute. She lived with Ah Wo, a thirty-eight-year-old packer. Ah Choy was single, whereas Ah Wo was married; his wife was doubtless in China.[59] Ah Choy may not actually have been a prostitute. At the time, it was a common belief among Euroamericans, of whom the census taker was one,[60] that all Chinese women were prostitutes.

Another local Chinese woman, whom Polly would also have known, is missing from the 1880 census because she died before it was taken. She appears in the 1880 mortality schedule for Idaho County, listing "Persons Who Died during the Year Ending May 31, 1880." To [Toc or Too] Hay was a married, thirty-year-old woman from Canton, today's Guangzhou, who had been "keeping house."[61] She died in early 1880 from "inflammation of the stomach," as certified by Doctor Lee Foo;[62] a sign at the Warren Chinese Cemetery spells her name as "Too Hay" and gives her age and the year of her death (Fig. 2.6). Although the name of To Hay's husband isn't known for certain, the only Chinese man listed as a widower in the 1880 census was Ah Ow, a thirty-five-year-old miner, also from Canton; he then lived in a household with fifteen other Chinese miners.[63]

With the Chinese population at 83.5% of the total, and the Euroamerican/Indian population at 16.5%, Warren in 1880 could well have functioned as an "ethnic village" for its Chinese inhabitants. This concept was first proposed by Peter Schulz for Chinese fishing camps in California,[64] and the present author later applied it to the town of Granite in northeastern Oregon, where, in 1870, the population was over 80% Chinese, most of whom were miners. There, Chinese support services included gambling houses and stores, and a butcher, doctor, and tailor.[65]

Occupations of Warren's Chinese population were quite varied, adding strength to the "ethnic village" argument. Although the 1880 census showed that most of the 390 local Chinese men

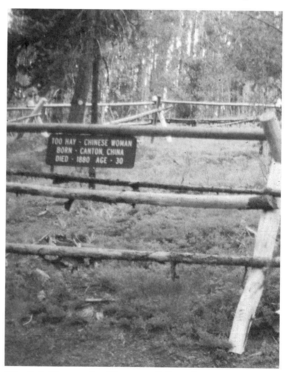

Fig. 2.6. Sign at the Warren, Idaho, Chinese cemetery mentioning the Chinese woman Too [also To or Toc] Hay, who died in 1880 and is assumed to be buried there. Photo by author.

were miners, plus a couple of laborers, others were gamblers (13), cooks (5), merchants (5), farmers (4), barbers (2), blacksmiths (2), doctors (2), gardeners (2), clerk in store (1), packer (1), "shoe maker" (1), "washman" (1), wood "choper" (1), and wood sawyer (1). Most of these occupations only served other Chinese, but a few could have served both Chinese and Euroamericans.[66]

By the summer of 1881 Warren had three stores run by Chinese merchants, but the Euroamerican-owned stores reportedly "g[a]ve the Chinese better treatment and prices than they c[ould] receive at stores conducted by their own countrymen." About 450 Chinese were "scattered all through the Warrens Basin," and Warren itself had "China gambling and opium dens in full blast."[67]

By 1885 the number of Chinese people in Warren had declined to about 270 individuals,[68] probably due to the influence of the 1882 Chinese Exclusion Act as well as to diminishing returns from the gold-fields. In 1885 Idaho County collected poll taxes [head taxes; not related to voting] from 545 people, "of which probably one-half were Chinese."[69] That year, two Chinese butcher shops competed with the Euroamerican-owned meat market.[70]

Warren's Chinese regularly paid taxes and are included in listings of Idaho County's "Solid Muldoons." In 1886 there were two individuals, or companies: Hong Sing Hong, with property valued at $3,405, and Hong Hing Hong, whose property was worth $6,660.[71] The 1887 list contained the Bow Wing Company ($1,100), Chung Kee ($1,100), Fook Sing Company ($1,100), Hong Hing Hong Company ($6,600), Hong Fook Hong ($1,250), Lune Wah Company ($1,000), Quang Sing Hong ($3,250), and Shune Lee Company ($1,000).[72] That year appears to have been the heyday of the Chinese in Warren; in 1888 the list only included Fook Sing Company ($1,100), Hong Fook Hong ($1,250), and Sing Yune ($1,250).[73]

Various celebrations attracted Warren's Chinese and Euroamerican residents. In August 1887 the Warren Chinese community held what an area newspaper referred to as:

> ... a grand festival ..., the occasion being the feeding of the dead. Several hogs and chickens were barbecued and taken to the burying ground and were then brought back and made a repast for the living. The streets were full of drunken Chinamen who acted all the same 'Melican [American] man on [F]ourth of July. About ten o'clock at night they burned a whole lot of joss [incense] sticks and colored paper and spilled lots of indifferent whiskey on the ground as an oblation to the evil spirits, the heathens meanwhile prostrating themselves and genuflecting like an East Indian dancing dervish [in a] fit.[74]

The Chinese in Warren regularly celebrated the Lunar New Year as well. For example,

> China new year was the event of last month [February 1888], and all the whites who paid their respects by making calls, were saluted at their arrival, and figuratively speaking, fired when they left [i.e., firecrackers were set off both times]. The heathen seems to attribute most all things to luck, good or bad, and perhaps they are about correct, since it is evident, their survival of a week's indulgence in China whisky, opium, salted water-melon seeds, dried cabbage leaves done in coal tar, and other delicacies which make up their bill of fare, that it is a streak of good luck[75]

The local Fourth of July festivities also attracted Chinese participation. In 1889, "a procession of 200 Chinamen, with gongs and stringed instruments, and dragon flags [held] up the rear end of the procession of Saxon citizens of the camp,[76]

In mid-1888, as mentioned earlier, Charlie Bemis had purchased the China Jake Ranch on the South Fork of the Salmon River,[77] an area renowned locally for its Chinese gardens. Lower elevations and south-facing slopes meant that fruits and vegetables were ripe there well before the snow melted in Warren. Ah Kan, the former part-owner of the ranch Bemis purchased, and a "legendary packer of the early Warren mining period (1870-1900)," used his pack train to bring rhubarb, strawberries, fresh peas, and new potatoes to Warren residents who greatly welcomed and appreciated the season's first fresh produce after their monotonous winter diet.[78] Although there is no evidence that Bemis worked the China Jake Ranch himself, he could well have leased it back to its former Chinese owners or to other Chinese.

J. D. McConkey, who visited Warren in August 1888, noted, "At present there are about 100 white men and 300 Chinamen around the camp." There was also "a Chinese gambling house."[79] In mid-November 1888, in preparation for the coming winter, several Chinese pack trains visited Grangeville stores to load up supplies for delivery,[80] presumably to Warren and other areas. Ah Kan's pack train could well have been one of them.

The Mayflower Mining and Milling Company ledger of 1890 to 1894 lists Chinese names in addition to Euroamerican ones. Polly surely knew Attoy [Ah Toy]; Ah Bet, "Chinaman"; Gee "Chinaman"; Leung "Chinaman"; and Ah Lee. The entries show that these men supplied the mine with pork, lumber, and "saurkrout"; and carried roofing shakes. One Chinese man worked as a mine laborer, and another man received $4.00 for fixing a watch.[81]

In November 1890 Ah Toy, "a Chinese merchant at the [Warren] Meadows," had his house and stock nearly burned out by a fellow Chinese.

The arsonist, "knowing Ah Toy was in town, poured coal oil over a wood pile and shed, joining the house, and set fire to the same, but did not get sufficient start before it was discovered and put out."[82]

Polly in Warren, 1880-1890

In a newspaper account, dated August 1881, "Mrs. Chas. Bemis" was one of only four women in Warren.[83] Although Polly and Charlie would not marry until August 1894, the reference to Polly as Mrs. Bemis implies not only that she and Charlie resided in the same household, as confirmed by the 1880 census, but also that the community considered them to be living together as husband and wife.[84]

Polly did have some non-Chinese female friends. One was Bertha Long, who accompanied her husband, John D. Long, when he moved to Warren in the spring of 1889 to work in the mines for a short time. Bertha met Polly and they became good friends. In later years, Bertha Long recalled

… She was a great friend of mine and quite often she would walk the mile in the afternoon to visit me at the Little Giant [M]ine and I visited her. When Bemis took her from the Chinese and gave her a home she was very happy. Bemis had a saloon and a one room house a little way from this saloon.

He built Polly a house by the side of his which consisted of two rooms downstairs[,] mainly a small kitchen and sitting room and dining room combined, a bedroom upstairs. She kept boarders and always the mail carrier. My brother, Theodore Swarts, carried mail for years and I knew her a long time before I met her. Her house was always immaculate. She was a great hand to crochet and all curtains and pillow slips were trimmed with her work.[85] She also washed for the miners, patched their clothes, replacing missing buttons. Tuesday she washed and Wednesday ironed. This was done rain or shine.

I asked, 'Why patch them while dirty, Polly?' She said, 'When I get 'em all clean and ironed, no have to muss 'em.'

Polly was a mite of a woman and weighed about 90 pounds. She wore a child's No. 12 shoe. I lived in Warrens a year and a half and never did I see Polly look dirty. She always had on a clean house dress and a pretty little white apron with crocheted lace on the bottom, starched and ironed.[86]

As mentioned earlier, the 1880 census listed Polly and Charlie as living under the same roof. However, Bertha Long's reminiscence, as well as another one from Taylor Smith mentioning "the twin cabins of Bemis,"[87] indicate that they later had separate dwellings; whether this is true or not, as a gentle fiction

to preserve Polly's reputation, is unknown. The 1890 census for Warren could certainly confirm whether they lived together or apart, but unfortunately it isn't available; a 1921 Washington, DC, fire consumed nearly all of the manuscript [handwritten] schedules for 1890.[88] Oddly, neither Polly nor Charlie Bemis could be located in the reconstructed 1890 US Census for Idaho.[89]

In early November 1887 the *Free Press* reported that Warren's other Chinese woman had "died verry [*sic*] suddenly here sometime ago--cause natural, or otherwise, not known."[90] This was surely Ah Choy, the only other Chinese woman, besides Polly, listed in the 1880 census.[91] If Polly had been friendly with her, this could well have been a devastating loss of female companionship; in August 1924 Polly observed that she had not seen another Chinese woman for more than 35 years.[92]

The Shooting of Charlie Bemis, September 1890

On September 16, 1890, Charlie, age 42, was the victim of a "shooting affray"[93] (Fig. 2.7). Several newspapers ran accounts of the assault, of the perpetrator's arrest, and of Charlie's subsequent recovery. For example, Grangeville's *Idaho County Free Press* reported that "Chas. A. Bemis ... was shot through the head Tuesday night at 7 o'clock The shooting was done by one Johnny Cox, a well-known hard case from Lewiston, who only recently shot a man to death somewhere in the Palouse country."[94]

The *Free Press* wrote,

Mr. Hutton arrived here [Grangeville] Wednesday afternoon from Warrens for medical attendance for Chas. A. Bemis Hutton left camp

News of a shooting affray at Warrens has been widely circulated here this week. The participants were Chas. A. Bemis and Johnny Cox both well known here. The shooting occured early last week and was the outcome of a gambling affray. A dispute over the amount due Cox by Bemis lead to a quarrel in which the former shot the latter through the head, the ball entering the cheek and ranging backward. The latest reports justify young Cox in the shooting by asserting that Bemis attempted to draw first, but Cox was too quick for him. Bemis exhonorates him, it is said, and will order no arrests made. Bemis, although the ball still remains in his head, is able to be about again and will probably recover,

Fig. 2.7. *Newspaper article describing the shooting of Charlie Bemis, 1890. From* Lewiston Teller, *"Tellings of the Week," 14(52):1, September 25, 1890.*

at midnight and made the trip in twelve hours, and Bemis was still alive. Mr. Hutton said the ball entered through the cheek and came out at the back of the head, and it was not known whether it would be fatal or not.[95]

A week later,

> Dr. Bibby returned from Warrens Tuesday night and informed us that Cha[rle]s Bemis's wound would probably be fatal, sooner or later, as the ball, on entering the head, struck the cheek bone and split, and he had only succeeded in finding and extracting one half of the ball and fourteen pieces of bone. The other part of the bullet is still in the head and in all likelihood will induce blood-poisoning, unless the system is strong enough to expel the remaining fraction of the ball. From all accounts, the shooting was entirely in self-defense, and so Cox was not arrested.[96]

Two sources report that Bibby charged the munificent sum of $500 to make the journey and to treat Bemis.[97] That would be more than $13,000 in today's dollars.[98] Although local legend, disproved by the above newspaper account, states that Bibby simply looked at Charlie's wound, charged a big fee, and left, Bibby actually treated Bemis effectively.[99]

Another report of the shooting indicated that Cox and a man named Freeman

> … had, by means of a 'marked' deck of cards, beaten the game dealt by Bemis out of $210. [Bemis] being out of cash agreed to pay on the following day. Freeman called for the cash next morning and compromised for $100, but Cox declared that he wanted the full amount and would have it or the life of Bemis. … Bemis [then] armed himself. Cox entered the saloon of Bemis and, walking to where [Bemis] was sitting at the card table, began the quarrel about the payment of the money. While talking, [Cox] lit a cigarette, and, as he carelessly threw away the match, he, with the same motion of his hand, snatched Bemis' revolver out of his breast pocket and threw it back over his own head, at the same time drawing his own, he shot Bemis through the head. On this state of facts it looks very much like cold-blooded murder.[100]

In 1923 Polly told her account of the shooting to a *Free Press* reporter. She related that the altercation involved the

> … loss of $250 belonging to the half-breed [Cox] and his partner. Bemis had won the money. The breed demanded return of $150, gave Bemis time until he rolled a cigaret [*sic*] to deliver the cash, or he would 'shoot his eye out.' Bemis failed to pay and the breed shot. The bullet missed [Bemis's] eye, but it shattered his cheek.[101]

Just before she died, in 1933, Polly corroborated her earlier account and added certain details, perhaps embellished by the reporter:

Bemis was a gambler and developed a bad reputation. [Would Polly have said this?] One day he had a row with John Cox, a halfbreed Lapwai Indian, over a poker game. The following day ... Bemis was reclining at full length on a bench, with his head propped up on one elbow, when the halfbreed suddenly appeared on the sun porch. Without warning he shot Bemis through the left cheek, the bullet going down through his mouth and out below one ear.[102]

Many years later, Taylor Smith of Warren provided an account of the shooting to J. Loyal Adkison. By 1890 Taylor Smith, age ten, had moved to Warren with his divorced mother and his two older siblings.[103] Smith recalled that he and Bemis "became warm friends." Bemis was Smith's "idol," and "became father councilor [sic] to the fatherless boy." Smith reminisced, "Charlie and Polly Bemis were like father and mother to me, but Charlie would never let me come into the saloon."[104]

In recalling the shooting, Smith missed a few details; for example, he thought that it happened on a July morning of 1893 rather than in September 1890. Nevertheless, Taylor Smith was actually present at the shooting, visiting with Bemis who was about six feet away from him; both were on the porch of the Bemis saloon. Then,

… John Cox came along, and lean[ed] against a porch post diagonally across from Bemis, sitting against the wall. As Cox started rolling a cigarette, he said to Bemis: 'When I get this cigarette rolled, if you don't give me back that $100 you beat me out of at Poker, I'm going to shoot your eye out.' Bemis, thinking it idle talk, paid no attention, continuing the conversation with the boy [Taylor Smith]. But Cox meant what he said. And finishing rolling the cigarette, he lit it. Then, reaching for his gun, he aimed at Bemis' right eye. He missed the eye by less than an inch, the ball slanting back and downward, lodged in the bony part of the skull back of the left ear.[105]

A comparison between Polly's account and Taylor Smith's version reveals some important discrepancies. Whereas Polly said Charlie was shot near the left eye, Smith recalled that it was the right eye. Both should know - Polly because she took care of him, though she was apparently not present at the shooting, and Smith because he was there. Polly's memory is probably more reliable in this instance. Smith's memory of the shot being on Bemis's right side could be because Smith was facing Bemis when Cox shot, thus Bemis received the bullet in the right side of his face as Cox faced him.[106] Smith

recalled that following the shooting, "A door leading to a back room of the saloon was taken from its hinges by the citizens and used as a litter to carry Bemis to his home, about 150 yards away."[107]

Cox's Escape and Capture

Cox fled on horseback. At "Salmon Meadows" [Meadows, Idaho], using the name J. C. Phin, he sold his horse and caught a stage to Weiser, Idaho. From there he took a stage or train to Pocatello, Idaho, intending to win money from the Pocatello railroad workers by gambling with them on payday. At Pocatello, Cox assumed the name Eaton, but the intrepid Harry Cone of Warren, in hot pursuit, captured Cox and arrested him entering a saloon, before his intended escape on an eastbound train. Using a circuitous route through Pendleton, Oregon, and Lewiston, Idaho, Cone and James McGrane brought Cox to the county seat at Mount Idaho for trial. They avoided traveling through Warren for fear that Cox might be lynched there.[108]

Reports had reached Lewiston "that Bemis has died of the wound but the rumor was not confirmed. He cannot recover, however, so his attending physicians say. Part of the ball still remains in his head and blood poisoning will soon cause death."[109]

At the time of Cox's arrest the *Idaho County Free Press* learned that "the story which was first told here, that Cox acted entirely in self defense[,] is at varience [*sic*] with the statement of witnesses, who affirm that he was the aggressor all the way through."[110]

In October 1890, once "necessary witnesses" had arrived from Warren, Cox was to undergo a "preliminary examination" in Grangeville.[111] Judge Case heard the evidence and fixed Cox's bond at $3,000, nearly $80,000 today.[112] The reporter noted, "It is doubtful if Cox can furnish the bond."[113]

Charlie's Recovery

By the end of October 1890 Charlie was "doing well."[114] The *Idaho County Free Press* editor visited him

> … and found him sitting up and dressed, and able to talk and smoke, but looking ghastly with that horrible bullet hole through his face. The wound is discharging pus freely, and it seems absolutely certain that blood poison and death will speedily result. The shooting was cold blooded and premeditated, and the camp raised $300 in twenty minutes by voluntary subscription for the purpose of pursuing and arresting the heartless scoundrel who fired the dastardly shot. Bemis is being attended by Mr. Troll, who combines in himself the happy faculties of doctor and nurse.[115]

According to a later article in the *Free Press*, "Mr." Troll was actually Dr. Charles Troll.[116] Embellished, romanticized versions of Charlie's care and treatment diminish Troll's role and emphasize Polly's:

> Stepping out of her character as a slave, she took command, and went to work to save the life of the man Bemis. A Mr. Troll helped some but Polly went to work with her Chinese herbs and remedies for the man who[m] she had learned to respect and even to love.[117]

Polly can certainly be credited with the tender, daily care that led to Bemis's recovery. In 1923, when she told her account of the shooting to an *Idaho County Free Press* reporter, he wrote, "Without friends because of his general demeanor in the camp, Bemis lay hovering between life and death. Polly came to his rescue, and after weeks of faithful care, nursed him back to health."[118]

Herb McDowell, who grew up in Warren and knew Polly when he was a boy, told how Polly and Lee Dick nursed Charlie back to health after he was shot.[119] Lee Dick, who mined for a long time in the Warren area, was also well-known as a physician. However, there is some question regarding whether he was in Warren in 1890, at the time Bemis was shot, or whether he came there much later. When Herb McDowell donated a photograph of Lee Dick to the Payette National Forest in McCall, Idaho, he dated it 1890 (Fig. 2.8).[120] However, when Lee Dick returned to China in November 1919, McCall's *Payette Lakes Star* said that he had been "a resident of Warren for the past 18 years," i.e., since 1901.[121]

Meanwhile, during the fall of 1890, Bemis continued to recover from his wound, Reuben "Rube" Besse ran the saloon for him, and Besse planned to keep it open until New Year's.[122] In early November 1890 there was "a grand ball at Bemis' hall," presumably the saloon, "with the largest turnout for years. An elegant supper was served in the hall by Mr. Shaffer. It was a farewell dance to Mr. and Mrs. Long, who go out this winter."[123] Since Charlie was still "doing well,"[124] and Bertha Long was Polly's closest friend, the couple may well have attended the event.

In late December 1890 another social event took place at Bemis's saloon. The Grangeville paper reported that "the dance and supper given by the Little Giant [Mine] boys at Bemis' hall was as good as could be expected with so few ladies in camp."[125] Following a dance there Christmas Eve, the "Old Crowd Club" made Christmas "lively" by celebrating "all day and night" for nearly three days. The Club "whooped things up," and had a "moonlight serenade to principal business houses of town"; Rube Besse, the operator of Bemis's saloon, and a reported violin player, led the orchestra. On the third day the

Fig. 2.8. Lee Dick, a Chinese physician in Warren, Idaho, 1890. From Jeffrey M. Fee, "Idaho's Chinese Mountain Gardens," in Hidden Heritage: Historical Archaeology of the Overseas Chinese, *ed. Priscilla Wegars, 65-96 (Amityville, NY: Baywood, 1993), 88. Photo in collection of Payette National Forest, McCall, Idaho, donated by Herb McDowell.*

group abandoned their festivities because "funds appropriated were about exhausted."[126]

Thanks to good care from Dr. Troll, Polly, and perhaps that of Lee Dick, Charlie Bemis's health continued to improve. The coming decade would see John Cox's trial and imprisonment for the shooting, Polly and Charlie's marriage, and the couple's move from Warren to the Salmon River.

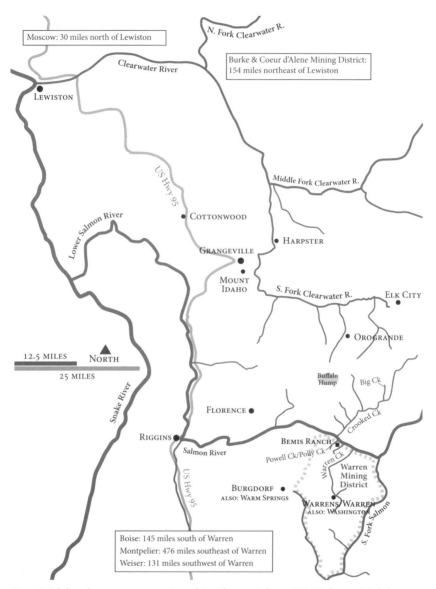

Map 3. Idaho place names mentioned in Chapter Three. US Highway 95 did not then exist, but is included for context. Drawn by Melissa Rockwood.

CHAPTER THREE:
Life in Warren and on the Salmon River, 1891 through October 1902; Polly, age 38-49

During this decade, Charlie Bemis and Polly may have become aware of certain important events in Idaho, national, and world history. For example, in mid-1892 dynamiting of the Frisco Mill near Burke in the Coeur d'Alene Mining District led to the imposition of martial law there, and in the fall of that year, the University of Idaho opened for students. During the "Panic of 1893," lead and silver prices collapsed, causing the Coeur d'Alene mines to close. In 1896 the Lewiston Normal School opened, and Butch Cassidy robbed the Montpelier, Idaho, bank. In 1898 Idahoans served in the Spanish-American War, and in 1899 federal troops suppressed a riot in the Coeur d'Alene Mining District.[1] In 1901, President William McKinley was assassinated and Queen Victoria died.[2]

Polly and Charlie, 1891-1894

From 1891 until their marriage in 1894 there is little documentation for Polly's presence in Warren. Fortunately, however, some details of her life can be inferred from mentions of Charlie Bemis in newspaper accounts and county records, beginning with the trial and imprisonment of Bemis's assailant, Johnny Cox.

Cox's Trial and Imprisonment

In February 1891 Cox's attorney, a Lewiston judge, complained that his client's $3,000 bond was excessive. He appealed to the district court at Moscow for a reduction, which Judge Piper granted, reducing it by half; Piper released Cox "on his father's recognisance" [sic].[3] A letter from a Warren "Observer," published in the *Idaho County Free Press*, stated,

> We understand that the bail on which Cox was held was reduced one-half, and the murderer turned loose to complete a reputation he seems

bound to make as a killer. The indignation shown by our people I will not attempt to describe. Yet it is all in the interest of economy, and the tax-payers should not complain! … Our people will remember this. The influences brought to bear in this matter will be brought to light. … The victim is not yet out of danger. In case of his death where will the criminal be found, and who is to blame?[4]

In late May 1891 the same newspaper announced that "the summons have been served on the jurymen" directing them to appear at the district court in Mount Idaho in June, for what would be the first court term in Idaho County since Idaho achieved statehood in 1890. "The principal case" on the agenda was Johnny Cox's trial "for assault with a deadly weapon."[5] Harry Serren and Dr. [Charles] Troll journeyed from Warren to testify before the Grand Jury in the Cox case.[6]

When the court met, in "The People vs. Cox, indicted for assault with intent to kill," the case was "continued by consent, and defendant remanded to the custody of the sheriff, in default of furnishing bail bonds to the amount of $3,000."[7] By the end of July "Johnnie" Cox was out on bail again.[8]

The case finally came to trial in late October, and the defendant's attorneys, Messrs. Rand and Howe, requested a change of venue and a continuance, both of which were overruled. After hearing the case, jurors deliberated, reaching an agreement in only half an hour. Returning to court the jury members presented their verdict: "We, the jury[,] find the defendant guilty of assault with a deadly weapon liable to produce great bodily harm."[9]

Several days later, "Judge Piper sentenced John P. Cox to a five year's term in the Penitentiary, being the maximum sentence for his assault on C. A. Bemis with a deadly weapon. Sheriff Wood started with Cox for the pen. [sic] on Tuesday."[10] Cox arrived at the Idaho State Penitentiary, Boise City, on October 31, 1891. The prison's description of him noted that he had several scars, including a large one "from gunshot wound" and possessed the sum of $3.50 plus "two gold or plated gold finger rings."[11]

In January 1892 Cox's then-attorney, James W. Reid, appealed to the Idaho Supreme Court requesting Cox's release on the grounds that "being indicted for 'assault with intent to kill,' and being found guilty of only 'assault with a deadly weapon likely to produce great bodily damage,'" should have resulted in a sentence of only two years instead of five.[12] The court ruled, however, that although the judgment was indeed erroneous, it wasn't void, and that Cox would have to serve two years. Despite obtaining this reduction in sentence, Cox's lawyer still intended to appeal the decision to the US Supreme Court.[13]

Although no record was located regarding the proposed appeal, Cox was released from prison in January 1893 after serving just 15 months for his

crime. The *Idaho County Free Press* observed, "Johnny Cox has been released from the penitentiary. Another miscarriage of justice! What wonder that Lynch law prevails when murderous devils who have been legally convicted are pardoned out before their sentence has hardly begun?"[14]

Charlie and Polly Bemis in Public Records

Meanwhile, after recovering from Cox's attack, Charlie Bemis continued with his business and mining pursuits. An Idaho business directory for 1891-1892 listed him as "Bemis[,] Charles, saloon,"[15] and by mid-1891 the owners of the Lucky Ben mine, on Steamboat Creek, had begun negotiating for the purchase of the nearby Bemis arrastra, a rudimentary mill for grinding ore to recover precious metals. The Lucky Ben, owned by B. B. Day and Jay A. Czizek, reportedly contained "very rich ore."[16] Bemis's arrastra was worth $150, according to the 1891 Idaho County Assessment Roll.[17]

Polly, with no last name given, was also listed in the 1891 assessment roll (Fig. 3.1). She had jewelry worth $560 [more than $15,000 today] and four head of cattle at $10 each [more than $1,000 today]. Her tax was $13.20 [nearly $360 today], which is marked "Paid."[18] Charlie's holdings included "town property in Warrens," worth $300; watches, $50; five horses, at $20 each; twelve cattle, at $15 each; money, $200; and gold dust, $400; for a total, counting the arrastra, of $1,380 [more than $37,000 today] and a tax of $30.36 [more than $800 today].[19] The fact that Bemis had money, rather than stock in trade, may mean that he was temporarily out of the saloon business.

In February 1892 "C. A. Bemis" was the "Mineral Recorder of Warren Mining District." As such, he recorded the claim of six men for the "Loan [*sic*] Star" mining ground.[20]

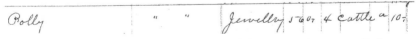

Fig. 3.1. Polly, with no surname, listed in the Idaho County Assessment Roll, 1891, Idaho County, Assessments, "Assessment Roll and Delinquent [Tax] List, 1891" (Idaho County Courthouse, Grangeville, ID, 1891), 127.

Meanwhile, Charlie was also busy with a mortgage foreclosure lawsuit that he had brought against N. W. Earl [sometimes Earle], E. F. Robinson, and H. R. Grostein for failure to pay a promissory note contracted in July 1889 for their purchase of the Edwards Hotel. The note was for $230, plus interest at the rate of one and one-half percent per month.[21] By March 1891 only $71.50 had been repaid, so Charlie hired an attorney to pursue his claim in court. He sued the defendants for the amount of the promissory note, plus interest and

costs.[22] District court convened on June 24, 1891, in Mount Idaho, the county seat, and Charlie Bemis received a default judgment because Earl hadn't filed an answer or an objection.[23]

When Earl hadn't paid up by March 1892, there was a sheriff's sale involving C. A. Bemis, Plaintiff, vs. N. W. Earl, Defendant. The announcement read:

Under and by virtue of an order of sale and decree of foreclosure and sale, issued out of the District Court, Second Judicial District, County of Idaho, State of Idaho, on the 15 day of March, A. D. 1892, in the above entitled action, wherein C. A. Bemis, the above named plaintiff, obtained a judgement [sic] and decree of foreclosure and sale against N. W. Earl, defendant, on the 24 day of June, A. D. 1891, for the sum of Two Hundred and Forty-one and 30-100 dollars, gold coin of the United States, besides, interest, costs[,] and counsel fees, amounting to the sum of One Hundred and Twenty-three and 93-100 dollars, which said decree was on the 15 day of March, 1892, recorded in judgement [sic] book 1, page 7.

I am commanded to sell all the certain lot, piece or parcel of land, situated, lying and being in Idaho County, Idaho, and more particularly described as follows, to-wit:

The Edwards Hotel, being the house and lot known by that name, situated on the east side of Main [S]treet in the town of Warrens, Idaho County, State of Idaho, with furniture and appurtenances thereunto belonging.

Public notice is hereby given that on Friday the 8 day of April, 1892, at 1 o'clock, P. M., of that day, in front of the court house door of the county of Idaho, State of Idaho, I will, in obedience to said order of sale and decree of foreclosure and sale, sell the above described property, or so much thereof, as may be necessary to satisfy said judgement [sic], with interest and costs, to the highest and best bidder, for cash in hand, gold coin of the United States. C. B. Wood, Sheriff Idaho Co., Idaho. By A. W. Talkington, Deputy. Mt Idaho, Idaho, March 18, 1892.[24]

The sale actually took place on April 30, 1892, when Charlie Bemis bought the building for $394.23 [more than $10,500 today].[25] As with his earlier purchase of property at a sheriff's sale, he had to wait for six months before he could receive title to it. He did so on December 28, 1892.[26] Nevertheless, the 1892 Assessment Roll, prepared in July, shows that Bemis had a "Hotel & other Prop[er]ty in Warrens" worth $400, as well as $400 cash, jewelry worth $200, an arrastra valued at $100, five horses worth $10 each, and 20 cattle worth $12 each, and totaling $1,390 [more than $38,000 today], for which his tax was $31.97 [more than $885 today].[27] He didn't own the hotel for long,

since on June 17, 1893, he sold it to Alex Johnson for $350, a loss of $50 from its purchase price. The quitclaim deed describes the property as "situated on the north side of Main Street in the town of Warrens Idaho, and formerly known as the Edwards Hotel."[28]

Meanwhile, in early 1892, Charlie had located and recorded a twenty-acre placer mining claim. It was 600 feet by 1,500 feet and included "the first right of water running in creek known as Steam Boat [sometimes Steamboat] Creek, and being the stream this claim is located on"; Bemis thus called his claim the Steam Boat.[29]

Bemis also disposed of his arrastra, doubtless the one he had sold to his father, Alfred Bemis, in 1873. Since there is no record of Alfred selling it before he died in 1876, Charlie must have inherited it. Sixteen years later, in the fall of 1892, he sold the arrastra to James A. Moore of Seattle for $575. The "Bemis & Willey Ar[r]astra" was "situated on Steamboat Creek about 3 miles from Warren." The sale also included "the Bemis Ditch taken from Steamboat Creek about above [sic] the ar[r]astra with all the appurtenances and belongings thereto."[30]

Both Charlie ("C. A.") Bemis and Polly, with no surname given, have separate entries in the 1893 Idaho County Assessment Roll. His holdings, for tax purposes, included improvements in Warren, $300; money, $100; solvent debts, $200; a note, $200; fifteen cattle, totaling $180; eight horses, worth $110; and a wagon, $40. These items totaled $1,130. Polly was listed separately, alphabetically, as "Polly," in quotes, with information provided "by C. A. Bemis." She had watches worth $100 and money, $100 [more than $5,400 today].[31] Charlie paid $12.15 in taxes and Polly paid $4.84.[32] One wonders what became of her $560 worth of "jewelry," possibly including some watches, that was listed only two years previously.

By the fall of 1893 Warren was "wakening." Located forty-five miles from Florence, travelers reached it by a state wagon road connecting Mount Idaho with Florence and "Warm Springs" [now Burgdorf]. At Warm Springs, the state wagon road, in places a "dangerous excuse that should not be tolerated," turned off for Weiser, to the southwest, and travelers continued the seventeen miles east to Warren on another wagon road.[33]

Although Warren itself

> then present[ed] a rather neglected condition, ... its inhabitants are buoyant with the assured prospects that next year will see the old camp in its former glory. ... The camp today contains about 100 whites and 75 Chinamen[34] and one Chinese women [sic, for Polly Bemis]. ... Chas Bemis, who formerly ran the hotel, has now a private boarding house and also a stable.[35]

Polly probably ran the boarding house for Charlie, since in 1924 she said that Jay Czizek was one of her boarders 32 years before, or about 1892. She also told how she silenced the miners who complained about her coffee by threatening them with a butcher knife. In the same interview, Polly remembered that when she started the boarding house she was unfamiliar with cooking, and there was no one who could or, would, teach her. Instead she found two American women whom she could watch and learned to cook from them.[36]

Charlie continued to be involved in mining property. In November 1893 he and seven other men claimed 160 acres of placer mining ground on Secesh Creek in the Warren Mining District. The claim, which measured 660 feet by 5,280 feet, was called the Elmore.[37] At the same time, the group located an additional 160 acres of placer mining ground, also on Secesh Creek, measuring 500 feet by 6,880 feet. This claim was known as the Elmira. The notice of location for each of these is signed by C. A. Bemis, in his capacity as Deputy Mineral Recorder of Warren Mining District.[38]

Charlie must have been out of the saloon business by the fall of 1893, because the same article commented, "There is not a gambling house or saloon in the camp, which speaks volumes for the morale of the place."[39] By May 1894 the *Idaho County Free Press* could say, "Warrens is at present the greatest temperance town in Idaho. Not a drop of anything stronger than cider can be had in the burg."[40] Charlie's assessment for that year included town property, for which no value was given, plus solvent debts, $400; 16 cattle, $160; saloon fixtures, $50; six stock horses, $48; a wagon, $50; and watches, $50;[41] for a total of $758 [more than $21,000 today].[42] Because the Bemises married in 1894, Polly is no longer listed separately.

Earlier, in 1892, the Geary Act extended the Chinese Exclusion Act for ten more years, and stipulated that every Chinese immigrant living in the United States must obtain, and carry, a Certificate of Residence, or risk being deported. Although the Chinese community waged a valiant fight against the new regulations, their protests were futile; not only did the revised laws make deportation easier, but increased funding also made enforcement more likely.

The Certificate of Residence had to include a picture of the person, so John A. Hanson of the Elite Gallery in Grangeville arranged to visit Warren and other towns to photograph the Chinese who were living there. In early April 1894 the *Free Press* reported, "The Chinese in Elk City and Warrens … intend to register, but are doubtless waiting for the trails to open for horses."[43] By implication, the Chinese awaited the arrival of both a photographer and the government's registrar. Later that month photographer Hanson was finally in Warren, "shooting [C]elestials for registration purposes."[44]

Hanson surely took a formal photograph of Polly at this time, the one that is shown cropped to just her face on her court case document and on her registration certificate. The full-length version of this image is often called her "wedding photo" although it was taken four months before that event (Fig. 3.2).[45]

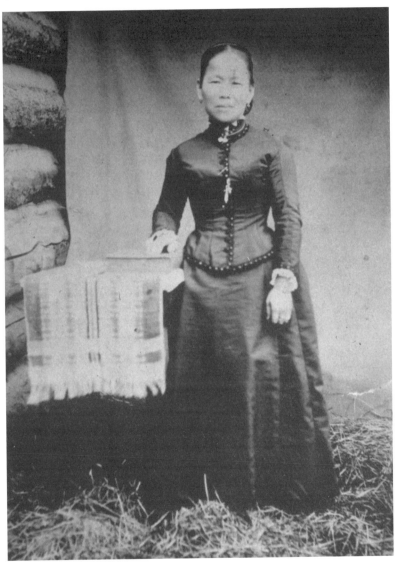

Fig. 3.2. Polly in a formal portrait (often called her "wedding photo," although it pre-dates that event), 1894, photo by John A. Hanson. Courtesy Asian American Comparative Collection (AACC), University of Idaho, Moscow, donated by Johnny and Pearl Carrey.

Hanson finally left Warren toward the end of May, having "enriched his gallery with photos of the camp and scenes along the Salmon [R]iver."[46] Polly appeared in one of his "photos of the camp" [Warren]. That image depicts some Warren residents gathered around the courthouse's flagpole (Fig. 3.3a); a closeup shows that it includes Charlie Bemis and Polly (Fig. 3.3b).

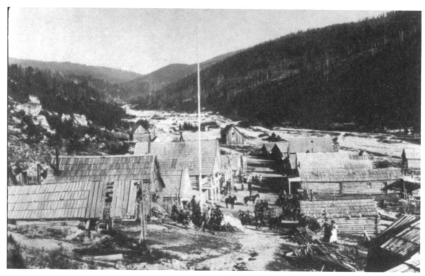

Fig. 3.3a. Warren, Idaho, residents gathered around the courthouse's flagpole, 1894, photo by John A. Hanson. Courtesy Idaho State Archives, Boise, 1263; 3.3b. Closeup of the group in Fig. 3.3a, showing Charlie Bemis and Polly, 1894, photo by John A. Hanson. Courtesy Idaho State Archives, Boise, 1263.

Hanson had reached Warren in time to photograph the local Chinese for the required registration documents. However, the government registrar was unable to visit Warren by the deadline of May 4, 1894, "the last day of grace" under the Geary Act for the Chinese to register.[47] This would later cause complications for Polly and for Warren's other Chinese residents.

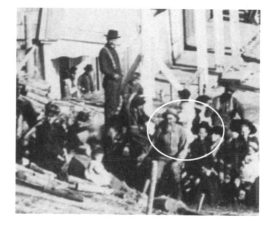

Polly and Charlie's Marriage, August 1894

There has been a great deal of speculation, much of it highly romanticized, about why Charlie and Polly finally decided to get married. Their decision could well have been related to the 1892 extension of the 1882 Chinese Exclusion Act, described earlier, and particularly its requirement that all Chinese had to obtain, and carry, a Certificate of Residence, or face possible deportation. The couple might have thought marriage, and their subsequent move to the remote Salmon River, would give Polly more protection from possible official harassment or the threat of deportation.[48]

Whatever the reason, Polly and Charlie wed in Warren on Monday, August 13, 1894.[49] Their marriage certificate reads, "This is to certify that on this 13th day of August 1894 I have joined in the holy bonds of matrimony Chas. A. Bemis and Miss Polly Hathoy (Chapter Nine discusses why her surname is "Hathoy" rather than "Nathoy," as some believe) at the residence of C. A. Bemis, Aug. 13th 1894, Warren, Idaho Co.[,] A. D. Smead, Justice of the Peace, Witness[es] W. J. Kelly, Geo. L. Patterson (Fig. 3.4)."[50]

Their original marriage certificate is now at The Historical Museum at St. Gertrude in Cottonwood, Idaho. That repository also owns a set of six mono-grammed tablespoons, engraved "Mrs. C. A. Beamis" [sic] that were probably presented to the newlyweds. A silver ladle may have been another wedding gift (Chapter Ten).

One account of the Bemises' marriage states, inaccurately, that after Bemis recovered from the 1890 shooting,

Fig. 3.4. Polly and Charlie Bemis's marriage certificate, 1894. Courtesy The Historical Museum at St. Gertrude, Cottonwood, Idaho.

... he purchased a ranch on Salmon [R]iver a few miles below Warrens and took [Polly] there as his common-law wife. Then in 1894 she married him, 'having papers.' That was when the Chinese deportation act was passed, putting her in danger of being sent back to China.[51]

Under Idaho law as it existed in 1894, the Bemis marriage was legal. However, if the couple had married before 1887, their union would have been illegal because Polly was born in China. Between 1864 and 1887 Idaho had miscegenation laws, ones that forbid race-mixing. These statutes made it a misdemeanor for any "Caucasian" person to intermarry, or cohabit, with any African-American, Native American, or Chinese individual. By 1887 Idaho law only prohibited marriages between "Caucasians" and African-Americans, so Polly and Charlie's 1894 marriage was legal. In 1921, though, in response to Japanese immigration into Idaho, "Mongolians" were added back in as another prohibited group.[52] This discriminatory law wasn't repealed until 1959.

By May 1894, before the couple wed in August, Charlie Bemis had obtained the property on the Salmon River where he and Polly would make their home after their marriage. A news item late that month noted that "C. A. Bemis and W. Helm started for Mr. Bemis' ranch near Salmon [R]iver a few days ago."[53] Before the Bemises could live there, they would need a dwelling and a garden; those requirements surely motivated the men's visit to Charlie's new acquisition. The property was about 11 miles from Warren "as the crow flies," but about 17 trail miles.[54] The Bemis Ranch was actually a mining claim, <u>not</u> a homestead as is popularly believed.[55]

Leo Hofen, a Warren resident, merchant, and assayer from 1864 to 1874, described placer mining on the Salmon River. He stated that it "was carried on all along Salmon [R]iver wherever there was a bar or flat, and colors [i.e., gold] in plenty could be scooped up in a shovel by wading out into the steam, ... and it abounds in fearful rapids and whirlpools and the scenery is awful and sublime."[56]

Some time after Polly and Charlie married in mid-August 1894 they moved down to the Bemis Ranch on the south side of the Salmon River (Fig. 3.5).[57] They may still have been in Warren as of August 22 because on that day Bemis recorded some mining claims for the Caswell brothers and their partners.[58] From then until November 1902, when a neighbor begins to mention the Bemises in his diaries, there is almost nothing known about their lives.

Johnny Carrey, who knew Polly in Warren when she lived there again from late 1922 to late 1924, remarked that after the Bemises moved to the remote Salmon River Canyon, Polly "soon learned to raise a garden" and "to provide a good home for her man."[59] By living in this isolated location, rather than in town, Polly may have felt safer from the specter of potential deportation.

Fig. 3.5. The Bemises' first house on the Salmon River, no date but before mid-1922. Courtesy Cort Conley.

The Bemises along the Salmon River, 1895-1902

We know that Charlie Bemis spent time in Warren after his marriage, attending to his business interests. Walter Hovey Hill met him "in his saloon at Warrens in August, 1895."[60] Unfortunately, there are no more details about this event; however, there is a photograph of Bemis's saloon taken about that time (Fig. 3.6). Taylor Smith of New Meadows gave it to M. Alfreda Elsensohn in 1958. In a letter accompanying the image, he stated that it was "a Picture of

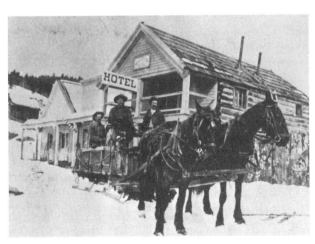

Fig. 3.6. Warren, showing Charlie Bemis's saloon, the white building, left, 1895. Courtesy The Historical Museum at St. Gertrude, Cottonwood, Idaho.

the Saloon where Bemis … was Shot. From Right to Left - Washington Hotel, Comer[']s Barber Shop and at corner Bemis Saloon. These Buildings were all Destroyed By Fire" [in 1904, Chapter Four].[61] Responding to Elsensohn's inquiry, Smith stated that the picture was taken in November 1895, a date confirmed by snow on the ground and a horse-drawn sled [a wagon on runners] carrying three men wearing coats, hats, and gloves.[62]

Elsensohn used that image as an illustration in *Idaho Chinese Lore*. There, the caption reads, "The white house to the left of the hotel belonged to Bemis; it is the place where he and Polly were married at Warren in 1894. Photo taken in 1895."[63] The couple's marriage certificate states that the Bemises were married "at the residence of C. A. Bemis,"[64] and according to Taylor Smith, this location was also Bemis's saloon.

A different photograph of a Warren street scene, including a small portion of Bemis's saloon, appears in Cheryl Helmers's *Warren Times*. The buildings in that image, from right to left, are the Kelly and Patterson's store, the Warren Hotel, Charlie Bemis's saloon, and the "old courthouse on the hill".[65] Helmers associated her photograph with an article in Grangeville's *Idaho County Free Press* dated July 31, 1896, thus suggesting that the image was taken that summer by Grangeville photographer John A. Hanson, who "has come to Warren with his photographic tent and plans to spend a month's sojourn."[66] After getting lost in the mountains, Hanson returned to Grangeville in mid-September.[67]

Polly's Court Case, 1896

As alluded to earlier (Chapter Two), Polly was affected by the 1882 Chinese Exclusion Act, renewed in 1892 as the Geary Act.[68] Among other provisions, the Geary Act required all immigrant Chinese to apply for a Certificate of Residence showing that they were legally entitled to reside in the United States. Because Polly missed the application deadline, her case was heard in the district court at Moscow, Idaho, on May 13, 1896.[69] The outcome would determine whether she would receive a Certificate of Residence or be deported.

Prior to her hearing, Polly was interviewed at an unknown location, probably Grangeville, according to Gayle Dixon, who has done extensive studies of Idaho County's Chinese residents. On April 10, 1896, a form was filled out for Polly. Subsequently, it was "subscribed and sworn" on May 7, 1896, and signed by W. A. Hall, US Circuit Court Commissioner for the District of Idaho. Because this is only six days before Polly's case went to trial in Moscow, Dixon is convinced that Polly, and twenty-two Chinese men who also waited until the last opportunity, had to travel to Grangeville rather than being interviewed in Warren, as others had been.[70] Confirmation of this comes from the

Idaho County Free Press, which on April 10 reported, "The last of the Chinese certificates for Idaho County celestials has been received."[71]

Possible confirmation of Polly's trip to Grangeville in 1896 is her reported gift of jewelry to Ada Smith, later Cyr, in Florence, Idaho. The three pieces of jewelry comprised a brooch and a pair of earrings that Polly supposedly brought with her from China.[72] Ada Smith, born in 1888, was the only child of Jay H. Smith and his wife, also Ada.[73] In 1896, when she was about eight years old, young Ada moved to Florence with her family and lived there for four years.[74] Perhaps Polly stayed overnight with the Smith family and offered the jewelry in gratitude for their hospitality to her.

In fact, there may be another explanation for the jewelry. In December 1937 Ada Cyr showed some artifacts, from Florence, to M. Alfreda Elsensohn. The items included

> ... a pair of encrusted earrings which had never been cleaned. These were three inches long, and one had a pearl set. There was a pin to match, but the setting was gone from that too. They were found in the mud-filled space between the walls of an old house."[75]

Curiously, no mention was then made of any jewelry coming from Polly Bemis. It is tempting to suggest that these two similar sets of jewelry are actually one and the same, later donated to The Historical Museum at St. Gertrude (Fig. 3.7).

The typed text of Polly's 1896 statement to the court contained the same wording as that used for other Chinese laborers who lacked Certificates of Residence, with blanks to record individuals' names and other details. The complaint against her stated that she "failed and refused to comply with the provisions" of the Geary Act. Her testimony reads:

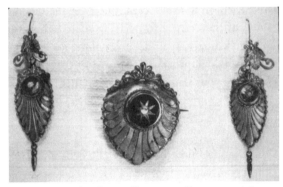

Fig. 3.7. *Jewelry that Polly reportedly gave to Ada Cyr. Courtesy The Historical Museum at St. Gertrude, Cottonwood, Idaho.*

> Q. [Typed] For what reason have you failed to procure a Certificate of Registration as provided in the Chinese Exclusion Act of May 5th, 1892?

A. [Typed] George Minor, a Deputy Internal Revenue Collector for this District in January and February, 1894, promised to come to Grangeville, Idaho, and register not only myself but all other Chinamen [*sic*] who were without Certificates. I relied on this promise. But Mr. Minor failed to come, and informed us that the roads were impassible owing to the snows and rains, and he could not visit Grangeville or visit Warrens [handwritten] where I resided. At this time in winter the snows were very deep, the roads impassible, and it was impossible for me to go to where the Collector was. In addition to this: I was poor and without means of travel and had no way of travelling; and I fully relied on Mr. Minor's promise to come and register me, which promise he failed to keep.[76]

A description of Polly follows; it contains some discrepancies with respect to other known details about her. For example, Polly's age was given as 47 which would mean that she was born in 1848 or 1849 rather than the more generally accepted date of November 1853. She also stated she had lived in Idaho County for 27 years, meaning that she would have arrived in 1869 instead of 1872. According to the document, she was a Chinese laborer, engaged in "laundrying." It states that she was five feet tall [other descriptions of Polly indicate that she was four feet, six or nine inches tall], with dark eyes, a dark complexion, and no identifying marks. A line below her description contains two handwritten Chinese characters. As these represent her name, they have been the subject of much debate (Chapter Nine).

As was then customary during such deportation hearings, a "white" person had to supply an affidavit vouching for the accused; again, this used a "fill in the blanks" approach:

Q. State your name, age and residence.

A. Harry Serren[77] Age 48 Residence Grangeville Idaho.

Q. Are you a white person?

A. I am[.]

Q. Do you know the defendant Polly Bemiss [*sic*]? If yes, how long have you known ~~him~~ her?

A. Yes, I have known ~~him~~ her for ten years [i. e., since 1886].

Serren's testimony continued. In common with other Chinese for whom the form was intended, Polly was "a peaceable law abiding Chinaman [*sic*], inoffensive, and has been continuously engaged in Laundrying for ten years in Idaho [C]ounty."

Serren also attested to the "condition of the roads from Warrens the residence of the Chinaman [i.e., Polly] to Grangeville in January and February 1894 by agreeing to the statement, "The roads at this season of the year as a

rule are almost impassible by reason of the snow, rain and ice. At the time mentioned, the winter was severe, and the roads were impassible." W. A. Hall, US Circuit Court Commissioner, signed Serren's testimony on the same date that he signed Polly's, May 7, 1896.[78]

On May 13, 1896, in the district court at Moscow, Idaho, Polly's case, together with those of some fifty Chinese men, came before District Judge James W. Beatty, who heard all the cases without a jury. For Polly and the others,

> the proofs having been offered and the evidence closed, and the same being by the Court duly considered, and it clearly appearing therefrom to the satisfaction of the Court that by reason of unavoidable cause to wit impassible roads and inaccessibility the defendant was unable to procure a Certificate of [Residence is crossed out] Registration[79]

> IT IS HEREBY ORDERED, That a Certificate of Residence be granted Polly Bemiss [sic] a Chinese laborer, lawfully in the United States,[80]

Judge Beatty signed the document. It also contained her description, as well as a photograph of her. (Fig. 3.8).

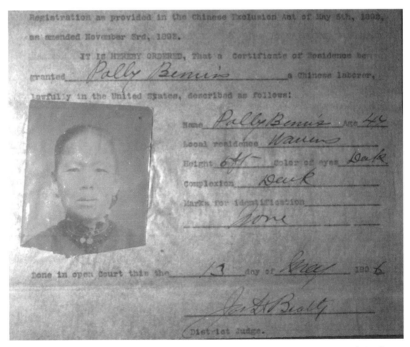

Fig. 3.8. Photograph of Polly Bemis from her court case, 1896. National Archives at Seattle, "Judgment: The United States vs. Polly Bemiss" [sic], Judgment Roll 181, Record Group 21, National Archives at Seattle, Seattle, Washington, 1896.

Subsequently, a Certificate of Residence, numbered 140059, was issued to Polly Bemis on August 10, 1896 (Fig. 3.9). The issuing office was in Helena, Montana, and the document was probably mailed to her. A photograph of Polly, the same image as that from her court case, is attached to its lower left side. The name "Polly Bemiss" [sic] is written on the left side of the image, and the document's number is written on the right side of the photo.[81]

Fig. 3.9. Polly Bemis's Certificate of Residence, 1896. Courtesy The Historical Museum at St. Gertrude, Cottonwood, Idaho.

In looking for more evidence of the little that is known of the Bemises' lives during this time, there was the possibility of visits from boatman Harry Guleke of Salmon, Idaho. Guleke made his first trip down the Salmon River below Shoup, Idaho, in October 1896 with the R. F. and J. V. Dwyer party from Omaha, Nebraska.[82] Whether Guleke stopped and met the Bemises for the first time isn't known, but in later years he often stopped to visit with them (Fig. 3.10).

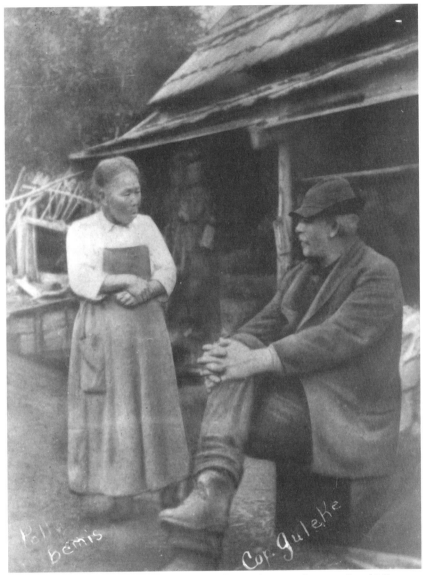

Fig. 3.10. Polly Bemis and Harry Guleke, date unknown. Courtesy Lemhi County Historical Society, Salmon, Idaho.

In May 1897 Charlie's acquaintance, Walter Hovey Hill, went on foot from Elk City to Warren, crossing the Salmon River "in a dugout piloted by Pete Mallick. ... Bemis and Polly were at their little garden spot and put up a fine lunch for Mike Sullivan, a mining expert, and for Mr. Hill."[83]

Even in their remote home on the Salmon River, the Bemises continued to be assessed for tax purposes. Although they hadn't been included in the

1895 and 1896 assessment rolls, in 1897 their property comprised seven milk cows, worth $11 each; four horses, at $10 each; one watch, worth $20; one wagon, at $25; and improvements on unpatented land, $350. Their taxes, on a total value of $552 (more than $16,000 today), amounted to $27.94 (more than $817).[84]

In October 1897 Charlie Bemis had more business dealings in Warren. Earlier, when he purchased his saloon building in 1880, he also obtained the property adjoining it on the east side, which consisted of a lot containing a building. In 1897 Bemis sold this property to James A. Comer. Comer paid just $75 for "the Cokane Lot," next door to "the building known as the Bemis Saloon."[85] Although no structure is mentioned, there must have been one because Comer used it as his barber shop, as shown in the November 1895 photo (Fig. 3.6, above, and p. 58).

The 1898 assessment roll for Idaho County shows that Charlie Bemis had fixtures worth $30 and merchandise worth $395, indicating that he was back in the saloon business,[86] although someone else must have been running it for him. The Bemises were also assessed $350 for improvements on unpatented land, most likely their Salmon River home. In addition, they owned three horses, $55; one watch, $40; and one wagon, $25. That year, they paid $41.62 (over $1,200) on property valued at $895 (more than $26,000).[87]

Finally, on November 24, 1898, Charlie Bemis officially located the placer mining claim on which he and Polly had made their home since August 1894 (Fig. 3.11). It comprised 20.66 acres and was situated in the Mallick Mining District on the main Salmon River. Charlie described it as follows [original spelling and punctuation have been retained]:

> Commencing at a notice posted about the mouth of what is known as Powell Creek [later Polly Creek] oposite Crooked R. or creek running thence 1200 ft. parallel with Salmon R. in about a South Easterly direction to stake or monument; Thence 600 ft in South westerly direction; Thence 1500 ft. in NW direction to monument; Thence 600 ft to river bank; thence 300 feet to place of commencement.
>
> Above location is situated on Salmon River about 17 miles from the town of Warrens, and is on the land known as the Bemis Ranch on the South West side of said River.[88]

Charlie recorded this placer claim in February 1899. By then, it was in the Warren Mining District. He signed a statement swearing that, to the best of his knowledge, he was recording a claim that had never previously been located, or, if it had, it was abandoned or forfeited. He added the following note to the printed statement: "and that I have opened new ground to the extent or depth of ten feet as required by the laws of Idaho."[89]

PLACER LOCATION.

Notice is hereby Given, *That the undersigned, citizen of United States, having complied with the requirements of Chapter VI, Title 32, of the Revised Statutes of the United States, and the local laws, customs and regulations of this district, ha.S...... located Twenty Acres of Placer Mining ground, bearing gold, silver, and other precious metals, situated inMallick............Mining District, Idaho County, Idaho; the location being described and marked on the ground as follows, to-wit:* [*Refer to stakes and monuments on exterior lines of discovery.*]

Commencing at a notice posted about the mouth of what is known as Powell creek opposite Crooked R. or creek running thence 1500 ft. parallel with Salmon R. in about a South Easterly direction to stake or monument; thence 600 ft. in South westerly direction; thence 1500 ft. in N W direction to monument; thence 600 ft. to river bank; thence 300 feet to place of Commencement; Above location is situated on Salmon River about 17 miles from the town of Warrens, and is on the land known as the Bemis Ranch on the South West side of said River.

The mining claim above described shall be known as the...Bemis Ranch Claim...

Located this 9th...... *day of* November...... 189.9.

Names of Locators { ...L. A. Bemis...

Fig. 3.11. *Excerpt from the Bemis Ranch [Mining] Claim document, located 1898, recorded 1899. From Idaho County, Mining Claims, "Placer Locations, Book 9" [1896-1899] (Idaho County Courthouse, Auditor-Recorder, Grangeville, ID), 522.*

By the end of May 1899, according to a Grangeville newspaper's description of Warren, Charlie Bemis still had his drinking establishment, E. S. Church also owned a saloon, and the hotel had one as well.[90] Other businesses included three general merchandising establishments, a meat market, an assayer, and two sawmills with another one planned. "There is neither doctor, lawyer[,] nor preacher in the place."[91]

Bemis's saloon in Warren is confirmed by the 1899 assessment roll. That year, their Salmon River property was still worth $350, plus three horses at $10 apiece. The bar fixtures at Charlie's Warren saloon were worth $75, and the liquors were assessed at $223. His total valuation, rounded up from $678, was $680 (more than $19,500 today), on which he paid $20.64 (more than $600 today) in taxes.[92]

The 1900 US Census of "Warrens Precinct," taken in June, lists "Peter" A. "Beamis," a farmer, living with Polly, his wife (Fig. 3.12). According to this document, Bemis was 50 and had been born in April 1850 [actually May 1,

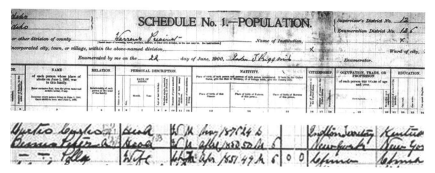

Fig. 3.12. 1900 US Census of Warren, Idaho, showing "Peter" [Charlie] A. and Polly "Beamis" [sic, for Bemis]. US Census, Twelfth Census of the United States, 1900, Idaho, Warrens Precinct, Idaho County, Idaho (National Archives Microfilm Publication T-623, roll 233, page 273, B6, lines 71-72); Records of the Bureau of the Census, Record Group 29.

1848; see Chapter One], whereas Polly was 49 and had been born in April 1851. This was another age discrepancy for Polly, who usually professed a September 11, 1853, birthdate. The couple had been married for six years, and had no children. They also had a boarder living with them. His name was Edward Clark, a 35-year-old mine laborer.[93]

In August 1900, election officials for the Warren precinct included Charlie Bemis, the "distributing clerk" [the person who handed the ballot to the voter], together with a registrar, three receiving judges, and three counting judges. Warren's polling place was to be the "old jail building."[94]

The 1900 Idaho County assessment roll for the Bemises showed that their valuation was less than half of what it was in 1899. The improvements on their unpatented Salmon River land were now worth only $150; these, plus improvements in Warren, $100, totaled just $250 (more than $7,150 today), with a tax of just $7.75 (more than $220 today).[95]

In 1901, Lewiston's Robert G. Bailey, "an Idaho writer, politician, and printing press operator,"[96] had an encounter with the Bemises. In Grangeville, Bailey engaged Joe Randall as "prospector-packer-cook-miner-guide-horse wrangler" for a trip through central Idaho. From Harpster they went to Elk City, then Orogrande and Big Creek, south and east of Buffalo Hump. They then followed Crooked Creek to the Salmon River, where

> We ... hailed a boatman on the opposite shore to ferry us across. He helped us make several trips over the river with the outfit, and then assisted when we drove the horses into the river to swim them. When all was over I asked him what I owed him and his answer was 'nothing.' Nor could I induce him to take any pay for his services.

He courteously invited us to his house to eat, but as we had our own outfit with us we were contented with a place to camp and directions as to where we could turn our horses out for the night. We spent the evening at the house of our host, and I was regaled with stories of adventure from real life more lurid than usually found in fiction. Midnight came all too soon. Our host introduced us to his wife, and while I did not say anything, of course, I did a lot of thinking when I noticed the woman was Chinese.[97]

Since Bailey doesn't describe any interaction with Polly, his description of the Bemises' life on the Salmon River would have come solely from Charlie. Therefore, unfortunately, Bailey credits Charlie with everything, and Polly with nothing, i.e., "He raised a few vegetables"[98]

The 1901 Idaho County assessment roll for the Bemises showed that their valuation was identical to that for 1900. Their improvements on their unpatented Salmon River land, $150, and improvements in Warren, $100, totaled $250 (more than $7,000 today), with a slightly lower tax of $7.25 (more than $210 today).[99]

Finally, the 1902 assessment roll lists the Bemises as owning "unsurveyed land," presumably their mining claim on the Salmon River; seven horses, valued at $51.32; $125 worth of "improvements on unpatented land"; and the same amount for improvements in Warren for a total value of $301.32 (nearly $8,500). Their tax on this was $9.49 (more than $265 today) , and the record is marked PAID.[100]

During the eight years from the autumn of 1894 until the autumn of 1902, the Bemises' relationships with the outside world are thus little-known; only a few reminiscences and documents mention the couple. That would soon change. Beginning in November 1902 a new acquaintance, Charlie Shepp, would interact with them often, and would write about it.

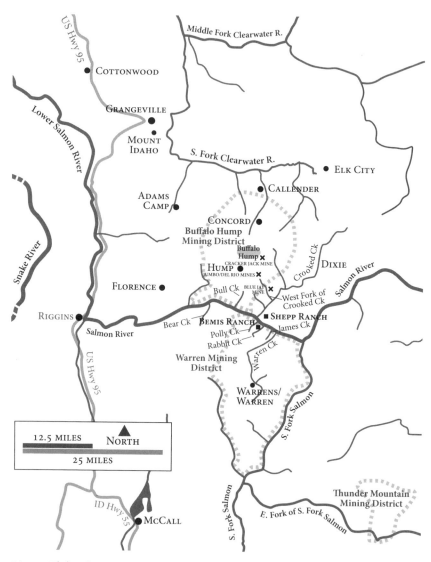

Map 4. Idaho place names mentioned in Chapter Four. Roads in gray did not then exist, but are included for context. Drawn by Melissa Rockwood.

CHAPTER FOUR:
On the Salmon River, November 1902 through March 1910; Polly, age 49-56

In early November 1902 Polly and Charlie Bemis begin to be mentioned in what are known as the "Shepp diaries" (Appendix), after their author, Charles [Charlie] Shepp[1] (Fig. 4.1). Shepp [originally Shupp] was born in Iowa on July 19, 1860.[2] As an adult he settled in Seattle, and prospected out from there for a few years. In 1898 he joined the gold rush to Alaska's Klondike.[3]

Fig. 4.1. Charlie Shepp, at the Shepp Ranch on the Salmon River, ca.1913. Courtesy Idaho State Archives, Boise, 79-98.17.

Shepp apparently came to Idaho's Buffalo Hump country in 1900 following that area's gold mining boom.[4] There, about 1904, he met Peter [Pete] Klinkhammer (Fig. 4.2).[5] Klinkhammer was born in Minnesota on November 4, 1880, as the sixth of twelve children in a German immigrant family; one source described his father as "a conservative Catholic disciplinarian."[6] In his early twenties, Pete made his way west, harvesting grain in Montana and working at a Spokane brewery.[7]

After meeting in the Buffalo Hump area, Shepp and Klinkhammer began the short-lived Hump Brewing Company,

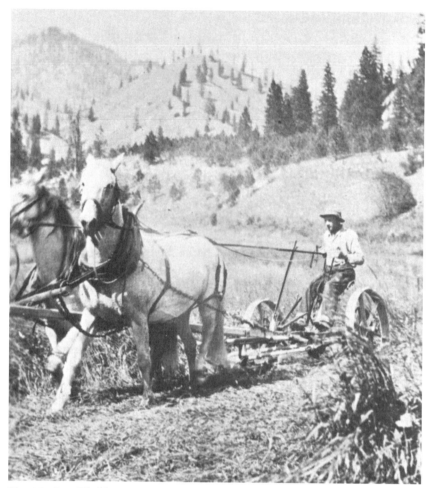

Fig. 4.2. Pete Klinkhammer cutting hay, 1915. From Johnny Carrey and Cort Conley, River of No Return (*Cambridge, ID: Backeddy Books, 1978), 214. Used with permission.*

producing only two batches and attributing their poor sales not to any defect in their product, but rather to a local mining slump that resulted in an exodus of potential customers.[8] In fact, Shepp may not have been directly involved with the brewery for long, since by November 1902 he already had a gold mining claim, the Blue Jay, on the West Fork of Crooked Creek, in the mountains on the north side of the Salmon River, seven miles above the river. Instead, the brewery, dating from late 1903 to 1905, was run by the more experienced Joseph Pelikan in partnership with Pete Klinkhammer.[9] On January 12, 1904, the Idaho County Commissioners granted the Hump Brewing Company, Hump, Idaho, a license "to sell intoxicating liquors" beginning December 10,

1903. The license cost $300 for 12 months,[10] or more than $8,300 in today's dollars.[11]

Most of Hump burned in late July 1905,[12] but the fire reportedly spared the Hump Brewing Company's building.[13] Although the brewery was still active that year,[14] the loss of most of the town must have ruined the business. In 1906 two sources listed the Hump Brewing Company under "Breweries Closed."[15] By 1913 just three buildings remained in Hump, one of which was a different brewery.[16]

Meanwhile, Shepp continued with his mining ventures. In order for him to prove that he was working his claims, and that they were profitable, he wrote daily entries in small pocket diaries.[17] Besides mining information, his notebooks include details about his personal life and often name his friends as well as other individuals whom he encountered. The diaries begin in November 1902 and record that he often came down to the Salmon River to purchase produce and other items from "Four-eyed" [he probably wore glasses] Smith and Charlie Williams, owners of a ranch at the mouth of Crooked Creek, almost directly across the river from Charlie and Polly Bemis's ranch[18]; this was a popular Salmon River crossing point.

Smith and Williams raised garden produce, and, using horses, they packed it out to mining camps in the area, where they sold it.[19] They also provided other services, such as blacksmithing, to local ranchers and miners. People visited them to obtain produce, and Shepp began to do so as well. For example, on November 10, 1902, Shepp went "[d]own after potatoes," and got 33 pounds of them.[20]

Shepp's first mention of either of the Bemises is in early November 1902.[21] From then until Polly's death in 1933 his diary entries tell us a great deal about the couple. Shepp writes about the Bemises' personal possessions, their garden and what they planted, and their ranch buildings. Like most neighbors in those days, they helped each other out, and entertained one another.

Shepp, or more often, his mining and later ranching partners, made regular and frequent trips to nearby communities and mines, as long as weather permitted. They took produce to sell, purchased goods they needed, and collected their mail. Besides taking Polly and Charlie's produce, they also mailed letters for the couple.[22] Although the Bemises would have received their mail at Warren in the early years that they lived on the river, by late 1903 they were getting at least some of it from post offices such as Concord, Dixie, and Hump, on Shepp's side of the Salmon River. Shepp didn't always have to travel all the way to those places for the mail; various friends who came down to his camp would bring his mail to him, plus anything for the Bemises for Shepp to relay to them.[23]

The Dixie post office was established in 1896. Others followed, at Buffalo and Hump in 1899, and at Callender and Concord in 1900. The Buffalo post office closed in 1900, Concord in 1903, Callender in 1904, and Hump in 1905; Dixie's lasted until 1960.[24]

Dixie, founded in 1867 as a mining camp, reportedly earned its name from that of "an early prospector, possibly from the South, nicknamed 'Dixie.'"[25] By 1901, Dixie was still "a promising mining district."[26] Concord, established in 1898, was "located by John Leffler … in the Buffalo Hump area …." Named for the Concord Mine, and a supply point for the Jumbo Mine,[27] it "vied for importance with … [Callender] and Humptown" [Hump].[28] Callender, two miles east of Buffalo Hump and named for Thomas O. Callender, was "once a thriving mining town."[29] Hump was "a mining campsite … named for the formation [Buffalo Hump] that also gave the mining district its name."[30]

Polly and Charlie Bemis as Seen through the "Shepp Diaries"

Because Shepp's diary entries provide the main record of the Bemises' life and activities for over thirty years, it is important to detail Shepp's own living situations and circumstances, in order to illuminate both his later encounters with the couple and also the extent of his subsequent relationship with both Polly and Charlie. Three main phases can be identified through the diaries. One is from 1902, when he first mentions the Bemises, through March 1910 (this chapter), before his move to the Smith and Williams Ranch after his purchase of it. The second phase begins in April 1910, when Shepp began living on the Salmon River, at what would later be known as the Shepp Ranch, and lasts until Charlie Bemis's death in the fall of 1922 (Chapters Five, Six, and Seven). The third phase covers the remaining eleven years of Polly's life, from late 1922 until her death in late 1933 (Chapters Seven and Eight).

In the earliest known diary, from November 1, 1902, through June 12, 1903, Shepp's first few entries mention that he left Hump with a rifle and horse, and reached "camp."[31] While that term isn't explained, it is probably a mining camp, possibly the Blue Jay, above where he actually lived, since he later writes both about going from home "up to camp" and also "down to Smiths"; with "Smiths" being Smith and Williams's ranch on the river.[32]

At the place where Shepp lived, he and his then-mining-partner, Tom, last name uncertain, built a house, or, more accurately, a log cabin.[33] Many years later, Pete Klinkhammer recalled that the cabin for the Blue Jay was "3 miles up Westfork Creek [West Fork of Crooked Creek] which drains into Crooked Creek about 7 miles from [the Shepp] ranch."[34] In early November 1902 Shepp wrote, "Tom started shaking house [applying wooden shakes to the roof] this afternoon."[35] Using the house as a home base, they staked, or

worked on, a number of mining prospects in the vicinity. Most of these seem to have been part of the larger Blue Jay claim. For convenience, and to be close to particular workings, they set up temporary tent camps as needed.[36] Besides Shepp and Tom, a number of other men helped with the mining at various times,[37] and they had visitors, down from either Hump or "camp," or up from the river. Apart from mining and working on the house, Shepp and Tom did many other things together or singly, including hunting, building furniture, constructing a shed, visiting Concord and Hump, and crossing the Salmon River.

Concord (Fig. 4.3) and Hump (Fig. 4.4) were both in the Buffalo Hump Mining District.[38] Travel there, even under the best of conditions, could take all day or even longer. For example, in March 1904, Shepp hiked to Concord to get "medicine for Smith & Mrs. Bemis." The next day, he and a friend left Concord at 8:00 a.m. but didn't reach his mining camp until 6:30 p.m. Shepp noted, "It stormed like the devil all day," with snow depths two feet and more.[39] More usually, he could make the return trip in one day, as he did the following May. From Shepp's home to Concord took five and a half hours, and Concord to home, downhill, took just three and a half hours.[40]

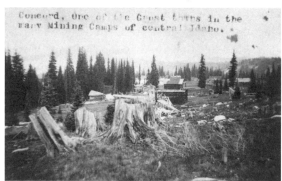

Fig. 4.3. Concord, Idaho, photo by George Ring, Forest Supervisor from 1908 to 1916. Courtesy Nez Perce-Clearwater National Forests, USFS Collection.

Fig. 4.4. Hump, Idaho, 1902. Image ownership unknown; see Note 38.

Late 1902 to early 1910

In placing Polly and Charlie Bemis and their neighbors into the context of the wider United States and the world, it is helpful to cite certain noteworthy events that occurred during this decade, whether or not the couple and their friends knew of them. In 1903, for example, Henry Ford organized his motor company, and an automobile traveled from San Francisco to New York in 52 days. Theodore Roosevelt was US president, *The Great Train Robbery* was the first western film, and the Wright brothers made their historic flight at Kitty Hawk, North Carolina.[41] In 1904 the Russo-Japanese War began, the New York City subway opened, and the United States commenced building the Panama Canal. Teddy bears were introduced, named after the president, and the first phonograph appeared.[42] 1905 saw the Russian Revolution; the founding, in Chicago, of the International Workers of the World, or Wobblies; and Albert Einstein's Theory of Relativity.[43] In notable events of 1906, Finland was the first European country to give women the right to vote, and San Francisco suffered a disastrous earthquake and fire.[44] In 1907 the second Hague Peace Conference attracted participation by 46 nations, Oklahoma became the 46th state, and radioactive dating determined that the Earth was 2.2 billion years old.[45] Events in 1908 included the beginning of petroleum production in the Middle East and the introduction of the Model T Ford, selling for $850, just over $22,000 in today's dollars.[46] In 1909, Robert Peary and Matthew Henson reached the North Pole, the National Association for the Advancement of Colored People (NAACP) was founded, and William H. Taft became president of the United States.[47] Finally, February 1910 saw the incorporation of the Boy Scouts of America.[48] Shepp mentions just a couple of these events in his diary: the San Francisco earthquake, and Taft's election.

From the Shepp diaries we learn that Charlie and Polly Bemis entered the rhythm of the seasons at their home on the Salmon River. The hard work of plowing and planting in the spring was rewarded by the harvests of summer and fall. Winter was a time to hunker down, repair tools, and survive until spring returned.

Together Polly and Charlie Bemis raised apples, blackberries, beans (both green and dried), cabbage, carrots, cherries, corn, cucumbers, currants, gooseberries, grapes, horseradish, lettuce, muskmelons, onions, parsley, parsnips, peaches, pears, peas, peppers, potatoes, radishes, raspberries, rhubarb, rutabagas, squash, strawberries, tobacco, tomatoes, and watermelons. Those crops are all mentioned in the Shepp diaries. M. Alfreda Elsensohn adds clover and plums,[49] and Frances Zaunmiller Wisner wrote how Polly "set out her chestnut trees, then tucked asparagus around the boulders."[50] A massive American chestnut (*Castanea dentata*) tree remains on the property,

as does a catalpa (*Catalpa sp.*) and a mulberry (*Morus sp.*), all trees that Polly planted. The chestnut provides nuts eaten by both humans and wildlife and the mulberry has edible fruits.

Besides the money they earned from the produce that Shepp and Klinkhammer later marketed for them, Polly and Charlie Bemis earned money by selling their extra fruits and vegetables to people who floated down the river in boats or who came down the mountain from Warren. Polly also raised chickens, both for meat and for eggs (Fig. 4.5). The Shepp diaries mention other animals, too, especially cats, dogs, and horses.[51] Other sources note that Polly kept ducks and one or more milk cows,[52] and that the Bemises had cattle.[53] For meat, Charlie hunted mainly bear, deer, and grouse,[54] and Polly liked to go fishing in the river or in the creek.

Besides these protein sources, there were many other animals in the Salmon River Canyon that Bemis could have hunted. Shepp and his friends trapped, shot, killed, hunted, caught, and/or cooked [prairie?] chickens,[55] otters,[56] porcupines,[57] bears,[58] ducks,[59] cougars,[60] and rabbits,[61] the latter for rabbit stew.[62] Some of the other wildlife that Shepp and others observed or killed included weasels,[63] skunks,[64] wild cats,[65] rattlesnakes,[66] "mosquitoes,"[67] eagles,[68] and wood rats.[69]

Fig. 4.5. Polly with chickens, date unknown.
Courtesy Idaho State Archives, Boise, 1091.

Shepp obtained many items from Polly and Charlie Bemis, as they did from him, and these will be detailed year-by-year. Other diary entries indicate some of Shepp's dwellings and outbuildings, and the food, tools, and household goods that Shepp either owned, obtained from others, or purchased on his trips to stores in town; the Bemises were probably similarly supplied. The following list, taken only from the diary that begins November 1, 1902, and ends June 12, 1903, illustrates an amazing variety of items that were available to people living in

this remote region of Idaho. For foodstuffs they could purchase hamburg[er], salt, and tea;[70] cooking oil, potatoes, and pepper;[71] sugar, coffee, flour, and baking soda;[72] lard;[73] and packaged soup.[74] Clothing comprised a shirt and overalls,[75] shoes,[76] and German "sox" and rubbers [rubber overshoes].[77] Household goods included pie pans,[78] bread-baking pans,[79] unspecified cooking and eating utensils,[80] tallow and wax ends [for candle making],[81] a shoe last [for shoe repair],[82] a keg,[83] a stovepipe [implies a stove],[84] matches,[85] and a feather bed[86] and bedding[87] for it. They also had access to personal grooming implements such as haircutting tools,[88] a "raisor" [razor] and shaving soap,[89] and to indulgences including chewing tobacco[90] and smoking tobacco.[91]

Their isolated lifestyle demanded many tools. Among those mentioned initially were implements for cutting trees,[92] a wedge and a "frow" [froe, a tool for splitting shingles from a block of wood],[93] a plane [for planing wood],[94] a saw,[95] wheelbarrows,[96] a graining knife [for hides],[97] bellows and an anvil [for blacksmithing],[98] a pick,[99] a mattock,[100] horseshoeing tools and supplies,[101] shears,[102] and nails [implying a hammer].[103] For hunting and fishing they required a Savage rifle [bullets for it are implied],[104] gunpowder,[105] traps,[106] fishing tackle,[107] and a boat.[108] When taking produce to sell in town or for collecting winter supplies they used mules [for packing],[109] sacks,[110] packs,[111] a saddle and a tent,[112] and even homemade snowshoes.[113] Storage for all these items required a house with a porch and "shelfs,"[114] certainly a shed,[115] as well as a door "catch" and other household hardware[116] for security. Diaries for other years, of course, mention many additional items that aren't included in this illustrative account.

While the diaries specifically mention many of Polly and Charlie Bemises' possessions and furnishings, there are many others that we can assume, by implication, that they also had. For example, Shepp and three other men ate Thanksgiving dinner at the Bemises' home in 1902,[117] thus implying that Polly and Charlie not only had a house, but also had a table, sufficient chairs, a stove, cookware, cooking utensils, serving dishes and utensils, plates, and eating utensils. Shepp occasionally got "mail to post for Bemis,"[118] meaning that Charlie Bemis gave Shepp letters to take to the post office, thereby indicating that the Bemises had letter-writing materials such as paper and envelopes, a pencil and/or pen and ink, and postage stamps, or money to pay for them.

Shepp frequently commented on Polly and Charlie Bemises' plowing, planting, and other gardening chores. Besides these, Shepp mentioned, or described, a number of other activities that he and his partner did occasionally or regularly, ones that Polly and Charlie would also have done. For activities related to cooking they made sausage,[119] made pies and roasted meat,[120] baked bread,[121] made "moonshine" [distilled alcohol for drinking],[122]

fermented wine,[123] made syrup,[124] baked doughnuts and pudding,[125] made [sauer]kraut,[126] put up meat and made lard,[127] cooked pigs' feet,[128] made mincemeat,[129] browned coffee [roasted green coffee beans],[130] made mince pies,[131] made vinegar in a 10-gallon keg,[132] and made beet pickles.[133] For other activities related to personal grooming, housekeeping, and daily life they cut hair and shaved,[134] washed clothes and body,[135] mended clothes,[136] made a pipe stem,[137] wrote letters,[138] feathered a bed,[139] aired blankets,[140] and blacked a stove [polished a wood-burning stove with a commercial mixture of graphite, lampblack, oil, and wax].[141]

Both Shepp and Tom regularly, or occasionally, performed numerous other chores. They nailed shoes,[142] sharpened tools,[143] made snowshoes,[144] fixed strap on gun,[145] put a sight on a gun,[146] sighted in a rifle,[147] fleshed a bear hide [scraped the flesh from it],[148] skinned a deer,[149] grained buckskin [scraped away the hair and the top layer of skin],[150] tanned buckskin,[151] burried [sic] rubbish,[152] worked on a water closet [an outdoor toilet, i.e., an outhouse or privy],[153] shod a horse,[154] salted the horses,[155] fed the chickens,[156] put up a blacksmith shop,[157] fixed anvil,[158] made axe and pick handles,[159] watered the garden,[160] cleaned the yard,[161] built a fence,[162] successfully placered for gold,[163] and melted gold.[164] Even though these activities aren't specifically stated for the Bemises, Polly and Charlie must also have done most of those things, making for very busy lives.

People living on the Salmon River were independent, inventive, and resourceful; they had to be. As we look at the diary entries, year by year, we can trace Polly and Charlie Bemises' own activities through time. In the early stages of their acquaintanceship with Charlie Shepp, they gave more to the relationship than he did. As they became elderly, however, his assistance, and that of others, became crucial to their survival, and enabled them to retain their dignity and independence. From November 1902, until Polly Bemis's death in 1933, Shepp's diary entries reveal much about the couple, enabling us to accurately reconstruct three decades of their lives on the Salmon River.

1902

Shepp's first entry regarding either of the Bemises is on November 8, 1902, when he states, "Bemis and Egan over this a[.]m. Egan went to Hump. I was over river"[165] Because the Bemis Ranch was directly across the river from where Shepp would cross, the phrase "over river" invariably implies that he visited Polly and Charlie Bemis even if he doesn't specifically mention them. Shepp's usual practice was to come down to Smith and Williams's ranch on the north side of the Salmon River from his own home seven miles away, up in the mountains, and then cross the river to visit with Polly and Charlie Bemis.

In November and December of 1902 Shepp paid five visits to the couple. On three of these occasions, including both Thanksgiving and Christmas, he had dinner with them; "dinner" was always the noon meal.[166] On one visit, not for dinner, he "got parsnips & onions & Tom pres";[167] perhaps a present for his then-partner, Tom, made by Charlie or Polly Bemis. Another time, he took an axe over. Perhaps he loaned it to the Bemises, or returned one he had borrowed from them, or had sharpened it for them.[168]

Because Polly and Charlie's home was situated at a natural Salmon River crossing point for miners and other travelers between the Warren and Buffalo Hump mining districts, the couple often had visitors. Travelers came on foot or by horseback down from Warren, on the Bemises' side of the river, or from Concord or Hump, across the river and up over the mountains. When people wanted to cross the river, Bemis would take them over in a boat, or row to the opposite side to get them. If the passengers had horses, the horses swam (Fig. 4.6). In December 1902, "Dick B. came down from Warrens last night with 1 pack horse";[169] he would have spent the night with the Bemises, or camped on their property, before crossing the river the next day. Boats coming down the river usually stopped at the Bemis Ranch or what later became the Shepp Ranch, and sometimes at both. So although isolated, the Salmon River region where Polly and Charlie lived was quite lively most of the year, except during the winter months when weeks could pass without sight of another person.

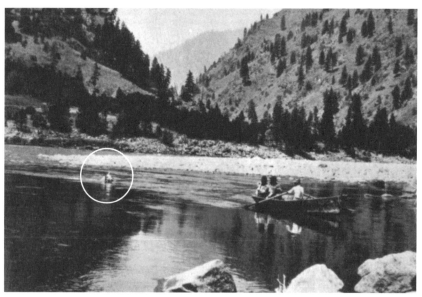

Fig. 4.6. Horse being brought across from the Shepp Ranch to the Polly Bemis place on the Salmon River, date unknown. Courtesy Idaho State Archives, Boise, 79-98.81.

Besides Shepp and his then-partner, Tom, other guests that the Bemises entertained, whether overnight or just for a meal, included "Four-eyed" Smith and Charlie Williams, their closest neighbors, who lived just across the river, at Crooked Creek;[170] another man called Dick, last name unknown, but maybe Dick B., above;[171] a man named Lawless; and one of the James brothers, usually Orson.[172]

1903

In January 1903 Shepp visited Polly and Charlie twice. The first time he had dinner there, and got cabbage, books, and 30 candles,[173] and the second time he got a jar of tomatoes, probably ones that Polly had canned.[174] For that visit, Shepp "crossed on the ice"; the Salmon River was completely frozen over. He found that Bemis and Polly were both "sick with colds."[175]

In February Bob Devine, from Hump, crossed the river on his way to Warren.[176] Surely he stopped in to visit with Polly and Charlie, or for a meal, although the diary doesn't record him doing either. Shepp himself had dinner with the Bemises on February 7 and 22.[177] A later listing of accounts shows that on the 22nd, Shepp obtained 16 pounds of sugar, six pounds of coffee, and five pounds of salt from them.[178] Polly and Charlie crossed the river and walked up to visit Shepp once, on the 26th.[179] Since he had been building a cabin near his mountain mining camp, he may have invited them to look at it.

In early March 1903 the Bemis place was in the news as a crossing point for people traveling between the Thunder Mountain and Buffalo Hump mining districts: "We came out to Warren, then crossed the Salmon at the Bemises' ranch, 8 miles below the South Fork [of the Salmon River], and then on to the [Buffalo] Hump [Mining District]. The road is in good shape for traveling."[180] Of course, anyone taking this route would have visited with Polly and Charlie, and Charlie would likely have helped them cross the river.

Shepp didn't visit the couple at all in March, although Tom went over for dinner, taking Pat Malaby and Jack Stone, who were visiting from Hump.[181] On the 30th, Charlie Bemis crossed the river and brought Shepp a fish.[182] Perhaps Polly caught it; she frequently fished, but Charlie seldom did so.

That April Shepp went over to Polly and Charlie's nine times, sometimes for meals, other times to help them, and occasionally to get things from them. For example, on April 2 he got 100 pounds of flour, 15 pounds of sugar, six pounds of salt, and one pound of baking soda.[183] Even when Shepp didn't go over there, he reported on the Bemises' activities, such as when "Bemis got 2 deer" in one day.[184] Although only two visits were specifically for dinner, Shepp probably had meals with them on other days, since from the 22nd through the 25th he went over daily, to help them. The first day he put up a fence, planted watermelons, and bought a coyote hide from them for $2.00; on the other

three days he cut house logs and planted a raspberry bush.[185] In exchange, for his help, they gave him a bucket of peach preserves.[186] Following his work stint, Shepp returned for Sunday dinner, bringing Tom and Smith with him.[187] Toward the end of the month, the Bemises also entertained "Goodpasture" and Hill from Warren [probably Bert Goodpastor and Walter Hovey Hill]. Local news, that Shepp might have shared with Polly and Charlie, was a report that "George Ashe shot and killed Honest John last Sunday."[188]

From early May to mid-June Shepp was busy mining, so didn't visit Polly and Charlie at all. He did report that Dick [B.?] and [Tom?] Ford crossed the river, so they presumably visited the couple, if only briefly.[189] There is no diary from mid-June to mid-July 1903, but Shepp was probably mining then, too, since he didn't report visiting the Bemises again until October 31, when he "killed deer on ridge above Bemis."[190] In the meantime, Polly would have had her 50th birthday, on September 11, 1903.

Some time that year, maybe in the summer, writer Robert G. Bailey made his first trip down the Salmon River with boat captain Harry Guleke.[191] The two men surely visited the Bemises at the time, particularly since both of them were probably already acquainted with Polly and Charlie (Chapter Three, 1896, 1901); in later years Bailey was instrumental in perpetuating myths about Polly (Chapter Nine).

After Shepp's mining operations ceased for the winter, his visits to Polly and Charlie became quite frequent. In November, he reported crossing the river and/or visiting them numerous times, stayed with them at least one night and probably more, and mentioned them specifically or by implication in fourteen of his daily entries. At mid-month he went over with Tom, and returned with 45 pounds of beans, 12 pounds of onions, and 56 pounds of potatoes, as well as "mail to post for Bemis."[192] Later that month, he got another 25 pounds of [dried?] beans.[193]

Shepp apparently purchased winter supplies at Hump for Polly and Charlie, since in early November 1903 he mentioned that Bemis still owed him $3.40 on a bill totaling $23.40,[194] perhaps from Shaw's in Hump. One of the stores that Shepp patronized there was that of D. D. Shaw, whose letterhead read, "D. D. Shaw, Groceries, Hardware, Boots and Shoes, Gents' Furnishings, Mining Supplies. Hump, Idaho."[195]

A few days later, Charlie Bemis went to Warren with [Four-eyed] Smith, [Tom] Copenhaver, and a man named "Schalkan," taking eight horses.[196] Most likely, they went up for additional winter supplies. Charlie and one of the men returned at 5:30 the following day.[197] Subsequently, Shepp went over the river and got a shoe last and a gallon of "booze" from the Bemises;[198] these may have been purchases that Bemis made on Shepp's behalf.

Now that he was not mining, Shepp also had more time to hunt. Sometimes he crossed the river to do this, and then might mention Polly and Charlie. On another hunting expedition, he observed Bemis shoot at a swan.[199] When Shepp killed three deer on a nearby ridge, Bemis went up with him the next day to help bring them down.[200] He doubtless received a share of the meat, adding variety to their meals, and perhaps even enough for Polly to can as well.

By November 1903 Shepp's mining partner, Tom, may have been living at the house alone, or at a different place, since Shepp occasionally wrote, "Up to Tom's."[201] Shepp also commented on Polly and Charlie's visitors. One day, for example, he saw that someone was there from Warren.[202] Another time, Tom and Smith visited them.[203] Shepp and a man named Boggs spent the night of Thanksgiving Eve with the couple, and had Thanksgiving dinner there the following day.[204] A few days later, Charlie Bemis went to Warren again, and Shepp accompanied him. They had to put their trip off for two days, on account of bad weather, but finally set off at 8:45 one morning. They didn't arrive until 9:00 p.m., having "had a very hard trip," battling snow as much as 18 inches deep, and cutting out "a good many" fallen logs.[205]

In December 1903 Shepp visited Polly and Charlie many times, sometimes alone and sometimes with friends, including one of the James brothers, probably Orson.[206] Again, Shepp helped with things that needed doing, i.e., he pulled Bemis's boat out of the water and fixed his froe.[207] By mid-December Shepp had started another "house" for himself,[208] and Tom helped him for a couple of days.[209]

Just before Christmas Shepp went up to camp and got the Bemises' mail that someone had brought down, and took it over the river to them the next day.[210] On the 25th, he, Tom, "Warner," Chris Smith, and Wm. [William] Smith crossed the river and had Christmas dinner at the Bemises; Orson James arrived at 2:00 p.m.[211] We can just imagine how Polly was "in her element," cooking a special meal for her "menfolks." Two days later, Shepp returned for his knife, and got 10 pounds of apples.[212]

Also in 1903, Charlie Bemis's name continued to appear in the Idaho County Assessment Rolls. That year, he paid taxes of $7.50, based on his ownership of buildings in Warren worth $150, and the Bemises' Salmon River home, valued at $100.[213]

1904

In January 1904 Shepp and Tom were busy mining again, so they went over the river to dinner just once. They crossed on the ice, and Shepp observed that it was "the first time any-one crossed [on the ice] this year or winter."[214] At the Bemises, the temperature was only four degrees above zero. Toward

the end of the month Shepp went over again with his friend Frank Yost, and got 65 pounds of potatoes from Bemis.[215]

Shepp visited Polly and Charlie only once in February. He, Pat [Malaby?], and Tom left their mining endeavors and had dinner with the couple. The diary implies that they were out of black powder, so borrowed 25 pounds from Bemis, but when they got back up to Shepp's house he found a small quantity that he had overlooked, so they took that up to camp and left Bemis's behind.[216]

In March Shepp went to Concord to get some more black powder, and also "got medicine for … Mrs. Bemis."[217] Several days later he took it over, and spent the night.[218] He stayed the night again in a couple of weeks, and reported "Alec there" also.[219] Three days later Shepp and Pat went over the river, and Alec was still there. It rained "off & on all day," so they "shot at stumps and stayed to dinner."[220]

Shepp only crossed the river once in April, to get 10 pounds of potatoes. Toward the middle of the month he heard that a cloudburst had partially covered the Bemis Ranch with gravel.[221] Perhaps a heavy storm had caused Polly Creek, or the Salmon River, to overflow its banks.

Although one source states that Pete Klinkhammer became Shepp's partner and helped him build a cabin at the Blue Jay,[222] Pete is actually not mentioned in the Shepp diaries until April 7, 1904. Shepp noted, "John & Pete [presumably Klinkhammer] got to house about 9."[223] John was likely John Becker, mentioned later in the diaries as "Becker." He had various mining interests in the Thunder Mountain and Warren areas during the early years of the twentieth century.[224] Pete was apparently just visiting for a few days, because on the 9th Shepp wrote, "Pete at tent for dinner, he goes up trail tomorrow."[225] That diary concludes on June 8, with no more mentions of Polly and Charlie in the daily entries.

On the last page of that diary, an account dated between January 8 and April 7, 1904, lists additional items that Shepp obtained from Charlie Bemis, not all of which were noted in the diary on the dates he got them. Together they added up to 177 pounds of potatoes, 27 pounds of cabbage, 29 pounds of [dried?] beans, and seven pounds of bacon, for a total of $9.25. Next to one entry for potatoes and cabbage is the notation, "on contract," meaning that Shepp had apparently contracted with the Bemises to supply produce for him and his mining partners at the Blue Jay. An accompanying note, "Cr by Mdse 7.00," implies that Shepp had purchased items at the store for the Bemises, and used the cost of them to offset his bill.[226]

In mid-September 1904 a "disastrous conflagration" consumed Warren's business district, and Charlie Bemis lost all his property there (Fig. 4.7). The

Idaho County Free Press reported,

... The entire business portion of the town was wiped out, causing a loss of fully $100,000 with practically no insurance. That it was the work of an incendiary there is little doubt. The fire was started between 2 and 3 o'clock Thursday morning in the back end of a saloon owned by Mrs. Stone. It spread rapidly and the town being compactly built in a narrow gulch there was little chance to save anything. The principal losers are Kelly & Patterson, general merchandise; [L]. R. Smith & Co., general merchandise; Thos. Wilson, two hotels; Richard Hawley, meat market; Alex Beaton, saloon; Sid Robbins, saloon; Wilson & Smith, livery stable; Chas.

DISASTROUS CONFLAGRATION

The Town of Warren Completely Wiped Out.

LOSSES WILL REACH NEAR $100,000

A Shortage of Supplies Will Drive Many From the Camp.

Fig. 4.7. Warren fire, 1904. From Idaho County Free Press, Grangeville, Idaho, Sept. 15, 1904, p. 1.

Comer, barber shop; and a number of buildings belonging to Charles Beamis [*sic*] who lives on Salmon [R]iver. The only insurance was carried by [L]. R. Smith & Co., and that is reported small. Many lost everything they had and are left absolutely penniless.[227]

The buildings Charlie lost would have been those that he purchased in 1880. These included his saloon (Lot 1), the old courthouse building (Lot 3), the Ball and Whitman store (Lot 4), and the Woods house (Lot 5). He had already sold the building housing Comer's Barber Shop (Lot 2). Following the 1904 fire, Bemis no longer had any "improvements in Warrens"; that year, for tax purposes, his only holdings consisted of the Salmon River property, valued at $200 and on which he paid taxes of just $6.00.[228]

If Charlie Shepp kept a diary between June 9 and October 29, 1904, it is now missing. The next available one begins on October 30, 1904. It has some notes written on the inside front cover, one of which is "Bolts for Bemis 1¼ [inch] - 16-thread."[229] Shepp began this diary with the entry, "Left Bemis' & came up to my camp."[230] Lacking the previous diary, there is no way to tell how long he spent with Polly and Charlie, or what he did there. However, Bemis must have asked Shepp to get some medicine for him, since Shepp went to Hump on November 1, and returned on the 2nd with "medicin [*sic*] from the Dr for Bemis."[231] Two days later, he crossed the river, no doubt to

deliver the medicine, and mentioned that [Orson] James and "Frenchy" were visiting the Bemises.[232]

The next day he "took all Bemis' stuff over river & got lumber up to house."[233] The "stuff" would have been the Bemises' food order, to last them all winter, and the lumber was likely for the shed that Shepp would build for the Bemises in mid-December. On November 6 Shepp wrote, "Mrs. B over river," meaning that Polly had crossed the river, and the following day, Charlie Bemis crossed with Shepp.[234]

During the rest of November, Shepp went over there several times. He went hunting on Bemis Ridge, a high point between the Bemis Ranch and Warren, and "got a fine deer, 95 pounds."[235] Others who visited the couple that month included Tom, ["Four-eyed"?] Smith, James, [Charlie?] Williams, and Ernest,[236] and possibly [Frank?] Jordan and a man named Guser.[237] One evening, "James got his hair cut" at the Bemises, implying that the Bemises owned haircutting implements,[238] and another day Tom, Williams, and Ernest had dinner there.[239] Charlie Bemis crossed the river again twice, once with Shepp, who had gotten peppers, parsley, and syrup from Polly.[240]

In early December Shepp "hauled down 3 logs" at the Bemises' place.[241] He must have spent the night, because he left the following morning. Once back across the river, he went to Tom's, and then both men went up to Shepp's house to leave for Hump the next morning. At Hump, Shepp "got mail etc for Bemis & Ernest. Paid 1.00 for nuts - gloves for Pollie,"[242] perhaps as a Christmas present for her. On the 8th, he and Tom went to Polly and Charlie's for dinner; James was there, too. After dinner, Tom went back home, but Shepp stayed for nearly a week. While there, he built a shed; hunted, unsuccessfully; and wrote letters to his brother, Henry, and his sister, Nellie. With Shepp able to look after Polly and take care of the heavy work, Charlie Bemis went to Warren on the 11th, probably for more winter supplies. On the 13th, Williams came over; he and/or Shepp "went up on trail & met Bemis." Shepp finally left on the 15th.[243] Although he didn't cross the river again, he reported that on the 23rd, with Christmas approaching, "Williams over river this afternoon to find out the day,"[244] thus implying that Polly and Charlie had a calendar.

Although the September fire in Warren had brought an end to Charlie Bemis's income, their ranch on the Salmon River, together with Charlie's hunting, Polly's fishing, and gifts of meat from friends, helped the couple remain nearly self-sufficient. In addition, Polly had some money saved from when she worked in Warren, and she also earned cash from sales of her fruit, vegetables, and eggs. Her customers included people who crossed the river at their place or who came down the river in boats. Other sales came from

nearby towns and mining camps, when Shepp and/or Klinkhammer sold produce on her behalf.

1905

In mid-January Shepp, Tom, [Orson] James, and Pat Lannan crossed the river, on the ice. James and Lannan continued on upriver, and Tom and Shepp had Sunday dinner with Polly and Charlie;[245] Polly surely would have cooked it. On the 28th, Shepp and Frank Yost crossed the river and ate dinner with Polly and Charlie.[246] The two men returned the following day and "fixed plow & hoe" prior to spring plowing and planting.[247] They also seem to have stayed for several days, mostly hunting. On the 31st "Bemis got a cold."[248] In early February Yost and Shepp were still there. Charlie was "sick with cold," so the two visitors filed a saw and spent some time cutting and sawing wood for the Bemises.[249] We can imagine that Polly welcomed the company, and enjoyed fixing meals for them.

On February 22, Shepp wrote, "Tom, Frank [Yost] & I over river to dinner. Ernest came over on ice this afternoon. Frank went back, got gun & cat. Over at Bemis' tonight."[250] At times when Polly and Charlie didn't have their own cat, mice could become a real problem. In this instance, they borrowed a cat from their friends.

This portion of the diary implies that Shepp and Frank Yost stayed with the couple until early March. If so, while they were there Shepp worked on their cider press and finished it; Frank worked in their blacksmith shop; Frank and Charlie Bemis went hunting on Warren Ridge, another high point between the Bemis Ranch and Warren, and got a grouse; Shepp hunted and got a deer; Shepp "fixed buckskin" by putting "3 hides in soap" for two days; the following day he "worked on buckskin"; Frank shot three more grouse and a pheasant; Williams came over twice, once to tell them about the bear he had killed across the river, on Bull Creek; and Frank and Bemis cut wood and plowed the onion patch. Shepp and Frank left the Bemises on March 4.[251]

The cat, Jerry, stayed with Polly and Charlie for nearly a month. In mid-March Shepp noted, "Tom brought Jerry home."[252]

On March 13th, Shepp, Pat [Malaby?], and Frank [Yost] went over the river, to go fishing. Several days later, Shepp, Pat, Ernest, and Yost were "all over river on chicken house." That day, they cut half the logs they needed. The following day they were "on hen house" and "put up 2 rounds." Shepp went over to Tom's, but Pat and Frank stayed at Polly and Charlie's place. During the following week, Shepp, and perhaps the others, continued working on the hen house. James and "Frenchy" brought down some lumber for it, and work finished on the 24th. That day, Frenchy brought fish to the Bemises, and Williams came over. [253]

The diary entries imply that Shepp stayed with the couple, or at least visited them, off and on until early April. He went hunting on Warren Ridge, and got two deer. He and Pat went over the river, possibly for tobacco. At the Bemises, Shepp made a gun sight, cut some logs for their house, fixed their harrow, pointed a pick, and got two cans of milk.[254]

On April 1, 1905, Shepp wrote that he had "put up all the logs on Bemis' [chicken] house" but that he needed six more. He also got some eggs from Polly.[255] He and Frank had Sunday dinner with Polly and Charlie the next day, and Shepp and Pat had supper with the couple a few days later.[256] The following week Shepp went back over, and got ten pounds of [dried?] beans, some potatoes, some eggs, and four pounds of butter. He also noted that "Bemis' horse, May, got a colt."[257]

Shepp spent the next two weeks working on his mining claims. On April 27th he and Tom went over the river. They found "Polly very sick," so Shepp stayed for at least the next couple of days. While he was there, Tom and Pat came over, and Winchester and Kirk visited.[258] Although Kirk is unknown, Steve Winchester was an "educated and eccentric" member of the Winchester firearms family, from whom he received regular remittances.[259] He worked as a miner in the Warren area between 1908 and 1910.[260]

Polly's illness lasted nearly a month. Finally, on May 25, Shepp wrote, "Mrs. B up and some better."[261] Perhaps she had had pneumonia. At the same time, the Bemises gave him a bottle for medicine and $2.00. By the end of May, Polly was well enough to catch six fish.[262]

During May, Shepp visited Polly and Charlie several times. One time, he got 35 pounds of potatoes from Charlie; later he got some cabbage plants, as well as some sauerkraut that Polly had doubtless made. He also "put up bellows" for Charlie's blacksmith shop, and another day he irrigated strawberries while Charlie worked in the garden.[263] Watering plants may have been one of Polly's chores that Shepp took over for her while she was ill.

The June 1905 entries are ambiguous, because it isn't always clear where Shepp is when he mentions some of the work he has done, such as fixing pans, a hoe, and mattocks; watering grapes; driving tomato poles; making tomato stakes; hoeing potatoes; plowing corn; setting a hen; cutting hay; and making a hay rake.[264] However, because these entries are interspersed with ones about the Bemises, Shepp was probably helping Polly and Charlie with some of their chores.

For example, he got mail for Bemis that Pete and Wagner had brought down from Hump.[265] Pat [Malaby?] came down from Warren, Tom and Ernest were over for dinner, and "some fellow [was] down from Warren with 3 horses." During June, Pat and Bemis plowed areas for corn and potatoes,

while Shepp hoed carrots. After Shepp finished cutting the hay, he turned water on the alfalfa, hoed corn, took a bath, made a cap extractor for his reloader, worked the cultivator, and fixed the floors in the Bemises' house, and finished one of them. Smith and Williams came over, Tom and Ernest arrived for dinner, and Tom visited again. Toward the end of the month, Andy Cavanaugh spent the night on his way to Warren, as did E. Aubrey on his way from Warren to Hump.[266]

Twice in June Shepp reported that Polly was sick; once, she was even "sick in bed."[267] When she was well, she fished on three occasions, and one time she "caught some pike."[268]

Although the US Census is taken only once every decade, in 1905 the Immigration Service compiled a census of Chinese people living in Idaho and Montana. Dated June 30, it is an alphabetical listing of Chinese residents in those two states, and provides each person's name, place of registration, Certificate [of Residence] number, date of Certificate, place of current residence, occupation, and remarks. A separate column is filled in with "female" where applicable. We know (Chapter Three) that Polly Bemis had a Certificate of Residence, No. 140059, issued at Helena, Montana, on August 10, 1896, but curiously, she doesn't appear in the 1905 Chinese census, whether under "B," "P," "H" [Hathoy], or "N" ["Nathoy"].[269] Perhaps the Bemis Ranch was too remote for the census taker to reach her.

Shepp finally left the couple in early July. On the 10th he reported that Smith was back from Hump, with some things for Bemis.[270] On the 12th he saw "Bemis watering corn."[271] The following day, he found one of his horses, "old Fanny," dead, so went over to Polly and Charlie's to get some milk for her colt.[272] On the evening of July 21, when it had been "102 in the shade at 2 this afternoon," Charlie Bemis "went up on the hill … and had a look over the garden"; two days later he shot two grouse.[273]

A week later "Bemis lost old Mac," probably a dog; "[Bemis] took him for a skunk last night [i.e., shot him by mistake]. We buried him this am."[274] The next day, "3 hard hail storms," with hailstones measuring ¾ in. in diameter, "cut up the garden bad."[275] On the 29th Shepp set a trap for a skunk at the Bemises.[276] He caught it, in the chicken house, and killed a small rattlesnake in the blacksmith shop.[277]

In August 1905, Bemis "tried to kill yellow jackets."[278] Shepp reported that it was "awful hot" - "114 in the sun."[279] He went over the river a few times, and Bemis crossed at least once also. On the 24th, Shepp was at Polly and Charlie's, where it was "awful hot and smoky." A few days later there was a fire on Rabbit Ridge, near Rabbit Creek, about three-fourths of a mile upriver from the Bemis Ranch. Shepp, [Charlie?] Williams, and McCarty went over

to fight it.[280] The Bemises' horses had been turned out to graze, but were dangerously close to the fire, so Charlie Bemis went up after them. Shepp joined him to help, and reported that they "had a hard time getting horses."[281]

By early September Shepp reported that the fire was nearly under control, with help from Williams, Pete, and Wagner. He, Pete, and Wagner went up to Rabbit Creek to check on it, and met James and Mallard, both of whom spent the night at the Bemises' place.[282] Shepp then worked at mining for the next two weeks. On the afternoon of the 21st he went down to the river and across it. Jordan was there, cutting hay for Charlie Bemis. Shepp spent the night, and left the next morning.[283]

On October 1 Shepp was at Polly and Charlie's, perhaps to get their winter food order, because several days later he went to Concord. Although he ordered 250 pounds of flour, 100 of sugar, a case of canned milk, a half-case of cooking oil, and 40 pounds of bacon, this was probably for himself and/or any others working at the Blue Jay, because the Bemises' order, which Shepp and Bemis got several days later, in two trips across the river, consisted of 100 pounds of sugar; 100 pounds of salt; and a case of oil, doubtless for cooking; they also took a scythe over.[284] About this time, Shepp went over to the Bemises and picked 200 pounds of peaches.[285]

On October 7, 1905, Polly and Charlie acquired a dog, that "some one down from Warren brought ... for Polly."[286] On the 8th Shepp "took order over" and on the 10th he "got wedge for Bemis."[287] At mid-month Bemis gave Shepp $10 to purchase a "watch, coat etc.,"[288] because Shepp was going "outside" to Seattle. That diary ends on October 21. The last page, which is undated, is headed "Bemis Mch [Merchandise?] 1905." Under that heading are listed some other things that Shepp must have obtained for them in Concord, Hump, Dixie, or elsewhere. The items were tincture of iron, two packages of codfish, an axe with a handle, a sprinkler, nuts, fish hooks, copper wire, nippers, "bolts for press 21½ and 24½," and Limburger cheese.[289]

Charlie Bemis apparently had a hernia, which he alleviated with the use of a truss that Shepp bought for him (Fig. 4.8). A typed transcript of the 1904-1905 diary lists "A slip for postage due from Sears, Roebuck & Co. On the reverse is written an order - No. 8E1342 Truss, 1.80, postage .20, (total) 2.00. Scrotal truss. 34 3/4 inches, left side. Sears Roebuck [sic] & Co., Chicago, Ills. Sears & Nov 28 06 Bemis 2.21."[290]

There is no diary for the time period between October 22 and November 12, 1905. The next one begins on November 13, when Shepp reported that he "left Seattle at 4 p.m."[291] On the 21st he went down to the river. Smith was at the Bemises' place, and "they took me across."[292]

Shepp mentions Pete Klinkhammer occasionally, particularly in March and September 1905.[293] By November 1905 Tom [Gallagher?] had a new "pard," Vance; they, and Pete, were Shepp's first visitors when he returned from Seattle that month.[294] By then, Ernest had become Shepp's mining partner.[295]

In early December Shepp got 25 pounds of sugar for Polly and Charlie.[296] A week later, on Sunday, he went down to the river. Smith crossed him over to the Bemises, where James and Mallard were also visiting. They must all have spent the night, because the next day he reported that James and Mallard had returned home.[297] On Tuesday Shepp was still there, because he "done nothing all day but load some cartridges for Bemis & myself." Shepp stayed several more days. He cut some wood and pulled Bemis's boat out of the water, and then crossed back over on the 15th with Smith, noting, "ice pretty bad."[298] On the 24th he went hunting with Bemis, unsuccessfully, and was over there hunting again on the 26th, again with no luck.[299]

The 1905 Idaho County tax assessment roll still lists Charlie Bemis. That year, improvements on his Salmon River property were worth only $100 and his taxes were just $2.75.[300]

Walker's Approved French Pad Single Elastic Truss, $1.95.

SINGLE,
$1.95

An exceptional fine elastic truss. Composed of fine strong, extra wide elastic, to which is attached the improved Walker pad or pads combined with strong elastic under-straps. It is by far the best elastic truss ever made. This truss is fitted across the body, the full part of the pad facing the center. The advantages of this style of truss over other elastic trusses are as follows:

First—By fitting across the body and fastening on the center steel posts on the back of pad a center draft over the top of pad is produced, insuring in all cases the right kind of pressure.

Second—By hooking on the tie strap the pad tips produce upward and inward pressure at the same time. Walker's Approved French Pad Elastic Truss is, therefore, especially adapted for rupture which comes out egg shape, usually known as inguinal hernia, or light cases of scrotal rupture, where the intestines go down into the scrotum, called inguinal scrotal rupture. Fitted with rubber tubing understraps. Can be furnished in stuffed pad or water pad. In ordering state which kind is desired. Made of the finest, extra wide and heavy web elastic. Handsomely trimmed and stitched. This truss is reversible and adjustable.

No. 8K3512 Walker's Approved French Pad Single Elastic Truss. (Be sure to state size and side.) Price........$1.95
No. 8K3513 Walker's Approved Truss, with Special Radical Cure Center Spring Pad. (Be sure to state size and side.) Price..................$3.10
If by mail, postage extra, 8 cents.

Fig. 4.8. Example of a truss, used to ease the pain of a hernia, 1908. From Sears, Roebuck and Co. 1908 Catalogue No. 117 the Great Price Maker, reprint, ed. Joseph J. Schroeder, Jr. (Chicago: Gun Digest, 1969), 802. Used with permission.

1906

In 1906 Shepp continued to visit Polly and Charlie frequently, often staying with them for several days at a time. On January 5 he crossed the river and spent a couple of days hunting. Shepp returned to their place on the 20th, and brought an oil can with him. He stayed with them for nearly a week, and reported that he had "rheumatism pretty bad" on the 21st. Nevertheless, he

"went hunting nearly every day," but "got nit," i.e., nothing.[301] On the 24th the Bemises gave him mail for Sears, Roebuck and Company, "& [for someone named] Peters," which he took with him when he left "for camp" on the 26th.[302] Shepp implies that he got two pieces of bacon, six cans of milk, a package of soda, and a can of cocoa from them. That night, he stayed at Tom's. The next day he encountered Wagner and Pete, who were on their way to Polly and Charlie's place.[303]

On February 8 Shepp went down to the Salmon River. He found Bemis at Smith and Williams's place. Bemis "crossed ice on lower eddy," while Shepp "crossed at boat landing." He stayed at Polly and Charlie's until the 10th, and then returned home and worked on one of his mining claims until the 19th. On the 20th Shepp came down to the river, crossed on the ice again, and stayed with the Bemises for the next few days. On the 22nd, Pete, Vance, Wagner, and McCarty came over to dinner, crossing on the ice; Pete and Wagner brought half a deer over. The next day, Shepp shot a deer on Warren Ridge; he left for home on the 24th.[304]

Shepp remained at home for the next couple of weeks. While he was there, on March 11, he reported that it was "awful cold all day." Although he didn't record the temperature, he noted that it was "the coldest last night I have ever seen in the Bitterroot Mts. ... Everything froze in house last night." On the 15th Shepp came down to the river and crossed in Bemis's boat. He stayed with them for nearly a week. He helped out by fixing their chicken roost and removing ice from their boat.[305] He also made a gauge of some sort, and shot his gun. Smith came over for dinner twice while Shepp was there. The second time, the three men "shot guns at 200 yds. Bemis beat us all" and Smith beat Shepp.[306] On March 20, Bemis took Shepp across the river in his boat.[307]

On the 28th Shepp returned. This time he "crossed river in scow." The next day he made a rake for Polly. He and Charlie "shot gun at 200 yds" and Bemis beat him again.[308] While Shepp was there he also went fishing at the boat landing, but "didn't get a bite," and "Charlie shot 4 times at 200 [yards]." He left the Bemises on the morning of the 31st; crossing in Smith's boat. Shepp mentioned that he got $5 from Polly,[309] but didn't say what it was for.

On April 9, Shepp visited Polly and Charlie overnight. Before leaving the next morning he got a package of "mush," probably cornmeal, and some eggs from Polly.[310]

In his diaries, Shepp occasionally commented on current events outside their immediate Salmon River sphere. In the early years of the journals, he obtained his news from visitors or from letters. Even so, his information was still quite current. For example, on April 18, 1906, San Francisco suffered a disastrous earthquake and fire. On April 21, Shepp's diary entry commented,

"Robinson back from Concord. He brought word that San Francisco was destroyed by earthquake."[311]

Shepp surely shared this news with Polly and Charlie on his next trip over there, during the afternoon of April 23. By then, Bemis had begun to plant potatoes. The next day was very rainy, but the following day Shepp "fixed fence & helped plow for spuds." He returned home on the 26th, with "3 cans milk & rhubarb."[312]

By May 10 Shepp was staying with the couple again. That time, he plowed furrows for corn and potatoes and put in tomato stakes. On the 14th he returned home with onions and two pounds of butter from Polly and Charlie.[313] Polly must have been ill, because on the 21st Shepp wrote, "Wagner back from Hump. Got medicine for Polly." The next day they had an opportunity to deliver it, since both men went over to the Bemises for dinner,[314] as usual, the noon meal.

On June 1 Shepp came down to the river and had dinner with Smith and Williams. Williams had shot a deer that morning, so in the afternoon Shepp took a piece of meat over to Polly and Charlie. He visited them again on the morning of the 11th; Smith, Williams, and McCarty also came over that afternoon. Shepp returned, with Pat [Malaby?], on the 18th, and the diary entries imply that they stayed for the next few days, helping to get in the hay. Cutting it took a day and a half, and that evening Shepp killed a rooster, probably for supper. The following day, they "hauled in lower patch hay." That morning, Polly was sick, so Shepp "got breakfast." They finished the hay the next day, and Polly was still sick. He and Pat stayed one more day, and then left on the 24th.[315]

Shepp didn't get back down there again until July 3, 1906, when he and Pat went together. They found "Polly very sick." Pete and Wagner joined them there for the 4th of July, and Tom Copenhaver and Frank Charcal were also down.[316] There were no more entries until the 19th, and Shepp spent most of the rest of the month mining. On the 28th Wegner [Wagner?] went down to visit the Bemises, and returned that evening. Shepp looked in on them the next day, but didn't spend the night.[317]

On Thursday, August 2, Shepp went down to the river, over to Polly and Charlie's place, and sharpened scythes. Ed Tremain was there, on his way to Warren.[318] Shepp spent some time cutting hay the next few days, probably for the Bemises. On the 13th, he, Pat [McCarty?], and Wegner [Wagner?] went down to the Bemises for dinner. He was there again on the 19th, when he spent the night, went home the 20th, and returned the 21st. He stayed there for several days, but only mentioned that he put a sight on Williams's gun, and "took 2 fellows with pack horse, burro across river" one evening. On the 27th, Bemis took Shepp across the river.[319]

Shepp didn't return to the Bemises until September 10. When he went over, "Wegner" was there. They spent the night, and had a chicken dinner the next day; Polly undoubtedly cooked it for them. Wegner left afterward, and Shepp remained until the 14th. He went over again on the 18th, when he reported that "James went to Warren. Charlie up to Rabbit [C]reek with 1 pack," meaning that Charlie Bemis probably took some produce to Orson James, for James to sell for him in Warren. Although Shepp stayed at the Bemises' place until the 22nd, he didn't mention what he did there, only that it rained, and that he got a bad cold. On the 28th he went back down to the river, crossed it, and stayed with Polly and Charlie until October 4. While he was there, [John] Becker was there one day, and Tom came over once.[320]

On October 9 and 10, 1906, Shepp was at the Bemis Ranch, where he "put B. [Bemis's] hay in barn." On the 14th he went to Concord until the 16th. There he received a couple of telegrams from Pete Klinkhammer, in Grangeville organizing winter supplies, notifying him that "Bemis goods left Grangeville." That day, Shepp went down to the Bemises to report, and spent the night. On the 20th, Pete returned from Grangeville, with the news that the Bemises' goods were being transported "by way [of] Florence." On Saturday the 27th Shepp went down to the river in the morning, and learned that Tom Copenhaver had been down, and had brought the Bemises' other freight from Warren.[321]

Shepp went down to the river again on November 2, and learned that the Bemises' freight from Florence had arrived at the river on October 31. How it got across to them isn't mentioned. Shepp stayed with them for several days, most of them rainy, but was finally able to dig potatoes on the 6th. He stayed that night and then returned home.[322] On the 16th he went back down to the Bemises, and on Sunday the 18th "Bemis started for Warrens with Nellie & Mary," the horses, but came back, because the trail was "full of logs." Shepp went up on the ridge with him, looking for deer, but "didn't see a track." On Monday Shepp returned home "after rubber shoes for Bemis." He went back down on Tuesday. Bemis then left for Warren and returned on the 23rd. While Shepp was staying with Polly he reported that there was snow at the Bemis Ranch. The day Bemis was expected back, Shepp went up on Warren Ridge to meet him. They came the rest of the way together, and Shepp returned home the following day.[323]

In early December 1906 Shepp spent some time making a bar and installing a back bar and foot rail for Paddy in Callender.[324] Paddy paid him $15 for the first five days' work, and Shepp "paid Olie 6.50 - 2.50 for Bemis."[325] "Olie," mentioned later in a similar context, had apparently brought down some freight for Polly and Charlie.

On Tuesday the 25th, Christmas Day, Shepp and Pete went down to the river; Smith took them across. James was there, too, and they all had Christmas dinner with Polly and Charlie Bemis. That afternoon, Shepp went looking for deer sign up on the ridge. On Wednesday, he and Pete went hunting, but shot and missed. James stayed behind and cut trees. On Thursday Pete and James hauled logs, while Shepp went hunting, again without success. The next day, Shepp and Pete returned to Shepp's with eight pounds of parsnips from Polly's garden.[326]

1907

Shepp visited Polly and Charlie for several days in early January, arriving on the 7th. On the 8th, Jordan and Green were also there for dinner.[327] Shepp went hunting a few times, once with Smith, who got a deer, but Shepp didn't get one himself. He returned home on the 12th.[328]

Not until February 3 did Shepp return to Polly and Charlie's, crossing on the ice. He was there more than a week, but may not have taken his diary with him, since there are no individual entries for that time. He left on the morning of the 12th and "crossed on ice, awful rotten, pushed stick through 3 times." He obtained eight cans of milk, five pounds of apples, and "a hand of tobacco" from Polly and Charlie, thus suggesting that the Bemises were growing the tobacco.[329]

On March 5 Shepp went back down to the river. The next day he crossed over "after caps and fuse," probably blasting caps. The following day, James came downriver to the Bemises' place; Smith came over as well. James helped Shepp cut a tree on the side of the hill below the house, for a sled, and Shepp cut James's hair. Shepp made some runners for the sled, and then on the 9th, Bemis took him back across the river.[330]

From April 6 to 8 Shepp visited Polly and Charlie again. On the 6th it rained all day. The next day he crossed the river and got one of the boats, but it was still raining so he didn't work on it. On the 8th, which was a "fine day," he fixed the boat, but didn't indicate what had been wrong with it. At mid-month, the 16th, he helped Bemis plow his garden. The next day he "started on chicken house," but it rained off and on all day. Despite the weather, Polly went fishing and caught a three pounder. In the afternoon Shepp went up to the boat. The following day he "cut & put in posts." James came down, bringing some trees for transplanting. The rain continued, and there was "snow down low on hills." On Friday Shepp finished the posts, and crossed the river to get eggs for James from Smith and Williams, while James plowed the orchard. On Saturday, Shepp continued working on the Bemises' chicken house, while James harrowed the orchard and the garden. James broke the

plow, though, so he went home in the afternoon. On Sunday and Monday, Shepp continued on the chicken house, while Bemis planted onions and peas. On the 23rd Shepp "finished chicken yard." James came down and "brought Jerry," probably the cat, needed again for mouse control. While still at Polly and Charlie's place, Shepp made a wrench [in their blacksmith shop], Tom came over to dinner, James "cut" [gelded] May's colt [May was one of the Bemises' horses; if this is the same colt, it was born in mid-April 1905], and Shepp got a pedometer from Bemis. Shepp also went hunting, but got nothing, and on the 26th he finally left.[331]

In May he went over to the Bemises on the 7th. On the 8th he made rows for corn, and on the 9th he planted corn. He also noticed that the Bemises' lilac bush was just about to bloom. He left on the 10th, and got cornmeal and eggs from Polly as well as fishing tackle and a half-pound of chewing tobacco.[332]

In Cheryl Helmers's *Warren Times*, under May 1907, she wrote: "Charlie Bemis has brought a load of vegetables from their garden spot on Salmon [R]iver and they are much welcomed."[333] Since the timing seems early for that much to be ripe yet, it is interesting to note that this statement didn't come from a contemporary newspaper, but from a description of the Bemises' life on the Salmon River from Robert G. Bailey's *River of No Return*:

> … He [what about Polly?] raised a few vegetables, which he was able to dispose of to the surrounding mining camps at prices which enabled him to buy the few necessities he and his wife needed. He also rocked some gold from the sands of Salmon River, and had a fairly good herd of cattle on the surrounding hills. These were limited in number, however, and only those cattle could be kept for which winter feed was provided for five months in the year.[334]

Shepp mined the rest of May, and into June. When he next went down to the river, on June 10, he saw Bemis, but the river was too high to cross. By implication, he went across again on the 25th and spent until the end of the month cutting hay; he also killed a rattlesnake and weeded some of the carrots.[335]

Shepp began July 1907 by continuing to cut the Bemises' hay. He then stacked it up and hauled it in. He made a hoe for James and fixed James's brush hook, cut brush out of the trail to the boat, made a trowel, made a dibble [an implement to poke holes in the soil for planting] for Charlie Bemis, and killed two chickens for a chicken dinner. Jordan came down and crossed the river, and Smith came over. Shepp left on the 7th, after getting "10$ [*sic*] from Bemis," perhaps in payment for his help. On the 13th Shepp went back down to the river, and on Sunday the 14th he visited Polly and Charlie again, where

he fixed the chicken house and stayed overnight. At home on the 29th, he and Pete Klinkhammer had huckleberry pie for dinner. The next day they went down to the river, crossed over, and spent the night with Polly and Charlie. Shepp noted that it was "awful hot, 98." They came back up to camp and Shepp put up a tent for Pete.[336]

On August 5, 1907, Shepp went back down to the river, first stopping at Pete's camp. He crossed over and took Polly and Charlie a piece of bacon. On the 6th he returned home, and "brought up potatoes & 4 cans milk from Bemis."[337] On the 7th Shepp came down to the river again. He brought some huckleberries, perhaps for Polly, since his diary implies that he went to the Bemises' place for a few days, to do the haying. While there he killed four chickens. He also crossed back over and got the Bemises' mail from Smith, who had picked it up in Hump. Back at Polly and Charlie's, Shepp made two pairs of calipers at their blacksmith shop and killed three more chickens. It rained, so he turned the hay, but when he was ready to put it in the barn, it was too wet, so he cocked it for a day to dry, and then got it in over the next several days. He also reported that Charlie Bemis was sick.[338]

So far Charlie Shepp's diaries haven't mentioned any women who might have interacted with Polly Bemis in this "man's world" of mining and ranching. However, on Tuesday, August 13, "Mrs. Robinson & 2 kids" came down from Rabbit Creek, about three-fourths of a mile away, a visit that would have been a rare treat for Polly, who could well have been lonely for female company.[339] "Mrs. Robinson" was probably the wife of the man named Robinson, first name unknown, who earlier told Shepp about the 1906 San Francisco earthquake. She and the children stayed with Polly for at least two days. On Thursday the 15th Shepp wrote, "Boy went to Rabbit Creek this AM."[340] This implies that the other child was a girl and that she and her mother remained at Polly's. Although Shepp didn't mention when they left, it is tempting to speculate that they fled an unstable family situation and that the boy returned home to see if things had calmed down there.

Shepp left Polly and Charlie's on August 18, taking three heads of cabbage and some beets with him.[341] From then until the 23rd, Shepp built a cabin, presumably up near his mining claim, with Pete Klinkhammer's help. Although it wasn't quite ready, Shepp moved in on August 28.[342] Earlier, on August 24, Shepp and Pete went down to the river, and returned on the 25th. Shepp got an adze from Bemis, and also noted in his diary, underlining it, that he was to go "down" on Friday. He did that, and mentioned that the Bemises' horses were down,[343] meaning that they had come down to the river.

Shepp didn't get back to the Bemises' place until September 18th, where he learned that Charlie had gone to Warren. Bemis came back the following day,

and in the meantime, Shepp killed a rattlesnake at the Bemises' corral. Shepp returned home on the 20th, with four heads of cabbage as well as 35 pounds of tomatoes, which he canned that afternoon.[344]

Shepp and Klinkhammer visited Polly and Charlie in early October 1907. They went hunting, saw a bear, and spent one night up Rabbit Creek. On the 3rd they were back for dinner, and "some one," Shepp didn't mention the person's name, was also there, from Warren. Shepp and Pete got 40 pounds of potatoes, two cabbages, some squash, and some rutabagas, but whether this produce was from Polly and Charlie, or from Smith, isn't clear.[345] Pete had moved in with Shepp; on October 6 he "got bear grass for bed."[346] Shepp spent most of the rest of the month mining, and wrote about little else.[347]

In November, on several occasions, Shepp and Klinkhammer did some more unsuccessful hunting across the Salmon River. Once, they went over and stayed nearly a week. During part of that time, they would have been company for Polly; Charlie Bemis had gone to Warren for several days. Since he took two horses, he probably returned with more winter supplies.[348]

Some time in 1907, or possibly before, Shepp seems to have arranged with Polly and Charlie to grow fresh produce on the Bemis Ranch, in exchange both for money and for helping the couple. In late November 1907 he and Pete Klinkhammer collected their share of the harvest. They obtained 50 pounds of carrots and rutabagas, 360 pounds of potatoes, 70 pounds of apples, 173 pounds of cabbage, 15 pounds of onions, 40 pounds of squash, 21 pounds of [dried?] beans, and 11 pounds of cornmeal. They took it home and then returned to the Bemises' place for two more days, one of which was Thanksgiving. They had a chicken dinner that day, surely prepared by Polly.[349]

On December 24, Christmas Eve, Shepp and Klinkhammer went down to the Salmon River and crossed in Bemis's boat. For Christmas dinner they had chicken again, and it rained all day. Although they stayed with Polly and Charlie until the 27th, the only work Shepp reported them doing was to "cut down tree at foot of garden." The day they left, Shepp "paid Bemis 20 [dollars] for vegetables."[350]

Other events for 1907 include Charlie Bemis's listing in the Idaho County tax assessment roll as "Beamis [sic], Chas." That year, improvements on his Salmon River property were worth $150 and his taxes, which he paid, were $4.87.[351] In addition, sometime that year or perhaps later, Charlie Bemis obtained a copy of *Farm Conveniences: A Practical Hand-Book for the Farm* (1907),[352] and wrote his name in it twice as C. A. Bemis. Although his copy isn't annotated, showing us which "home-made contrivances" he might have created, or tips that he might have used, the nearly 150 topics, accompanied

by 212 illustrations, include "Bins for Oats"; "Mired Animal, Extricating"; and "Nest for Egg-Eating Hens."[353]

1908

On January 11 Shepp and Klinkhammer came down to the river, crossing on the ice, and stayed with Polly and Charlie for several days. Smith came over on Sunday the 12th. On Monday, Shepp and Pete went hunting up on Warren Ridge. Although they got nothing, they did see all the horses. The following day they practiced shooting at 200 yards, then left the next day, the 15th. Once home, Pete shot a buck, and on the 21st both men came down, took some venison over to the Bemises, spent the night, and returned home after dinner the next day. Smith also visited Charlie and Polly that morning.[354] At home, Shepp made mincemeat and sausage, as Polly may have done, too.

In early February Shepp crossed on the ice to visit the Bemises, where he stayed for a couple of nights. While there, he went up on the ridge and saw all the horses. Smith came over, and Shepp got some apples from Polly before leaving. He returned from the 20th to the 23rd, again crossing on the ice. While there, he cut a tree, killed four chickens, fixed Polly's sewing machine (Fig. 4.9), and had another chicken dinner.[355]

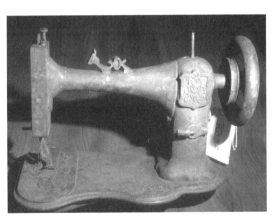

Fig. 4.9. Polly's sewing machine head; the machine burned in the 1922 house fire. This artifact (Chapter Ten) is at the Idaho State Museum, Boise, object number 1970.051.0000. Image used with permission.

In mid-March both Shepp and Klinkhammer went down to the river, where "Smith took us across in little boat." They stayed with Charlie and Polly for two nights. While they were there, Charlie "planted lettuce and radishes in a hot bed." When they were ready to leave, Smith took them back across the river.[356]

Shepp and Klink-hammer didn't return until April 3, 1908, when they crossed and spent just one night. Before leaving, they got a bucket of eggs from Polly. On Sunday the 12th, Shepp returned to the Bemises' place alone, because Pete was away. Pete came down the next day and got a deer on Warren Ridge, while Shepp caught some

bull trout. On Tuesday, while they fished, Charlie Bemis did some plowing in the new orchard, and on Wednesday, Shepp, and possibly Pete, pruned the Bemises' peach and apple trees. Shepp wrote, "buds on peach trees just starting in bloom." They left on Thursday, with lard, a can of eggs from Polly, and some cornmeal.[357]

On May 1 Shepp and Klinkhammer went down to the river. They met Andy Gans at the boat landing, and Shepp came over the river with him after dinner.[358] Before leaving the next day, Shepp got eight dozen eggs from Polly. The following Wednesday he took them "to town" to sell for her. He stopped at "Del Rio" [the Del Rio Mining and Milling Company], Concord, and the Jumbo Mine, while Pete went to the Cracker Jack Mine [also Crackerjack]; these were all possible markets for the eggs. On the 12th Shepp and Pete went down to the river and over to the Bemises. Smith was there, too. Shepp and Pete stayed overnight so Pete could go hunting the next day, but he got nothing. Shepp went back over the river and got 20 pounds of meat for Polly and Charlie. The two men left the following day, with some eggs from Polly. On Saturday the 30th Shepp visited Polly and Charlie again for a couple of nights, and wrote that Charlie "got one the 29," meaning that Bemis had killed a deer on August 29.[359]

On June 1 Shepp left with a piece of the meat from Charlie, together with eight dozen eggs, eight pounds of [dried] fruit, some radishes, and nine [pounds] of raspberries from Polly. He also got an order from the couple to Sears, Roebuck and Company for $11.25.[360] On Sunday the 7th he went up to the Del Rio Mine and Concord. He took up the eggs, dried fruit, "gooseberries" [raspberries], and radishes, but forgot Polly's letter to Sears, Roebuck. At Concord, the raspberries sold for 25¢ per pound. He went home on the 8th and came down to the river on the 10th, but it was too high to cross. Finally, on the 23rd Shepp went back down to the river and stayed at Polly and Charlie's all night. He had strawberries while he was there, and also paid Polly $5.50 for the eggs and dried fruit that he and Pete had taken up to local miner Gus Schultz in Concord. Shepp left the following day, with some more eggs from Polly. Near the end of June Shepp wrote that he had seen an eclipse of the sun at 7:30 a.m. on the morning of June 28, 1908. Although he wasn't visiting the Bemises then, Polly and Charlie would surely have seen this partial eclipse also.[361] By the end of the month it was time to get the hay in, so Shepp came down for that.[362]

Shepp was "on hay," that is, cutting it and cocking it up, until July 3. On Saturday the 4th he "finished cutting hay & hauled lower & middle patches in. Took 4 hours." He, Polly, and Charlie celebrated the 4th of July by dining on the rooster Shepp had killed the day before. On Sunday Shepp cocked

up some more hay and on Monday he finished hauling it. In preparation for leaving the following day, he got a five-pound bucket of strawberries, a five-pound bucket of gooseberries, and package of baking soda. The next day he went up to town and took the strawberries to sell.[363] According to a notation of accounts near the front of the 1908-1909 diary, he also, on that date, placed an order for a stove back "4½ X 8½ No 8" for Charlie Bemis.[364] On July 19 Shepp visited the Bemises again. Charlie brought the boat over to get him. It was Shepp's birthday, and he was 48 years old. Polly fixed a chicken dinner in his honor, and he killed a rattlesnake. He spent the night and went home the following day. On the way home he stopped off at Smith's and "got bottle alcohol for Polly," most likely, in this instance, for medicinal purposes.[365]

Shepp went back to Polly and Charlie's place and spent the night of Sunday, August 2. He returned home with three cabbages, five pounds of [green?] beans, and two pounds of onions. On the 11th he was back at the Bemis Ranch, "on hay" again. On the 13th it rained all night, so on the 14th he "fixed shoes" because it was "too wet to do anything," and went home the next day. He returned on the 20th, put part of the hay in the barn, and finished getting in the hay on the 21st. Shepp stayed the night there and then went home and spent the rest of the month mining.[366]

In early September 1908 Shepp went down to the river where he and Charlie worked on Bemis's boat for a couple of days. On Friday the 11th, a "fine day," he had a chicken dinner with them, and then Polly and Charlie both crossed the river. This was Polly's 55th birthday but it isn't mentioned. Shepp didn't visit them any more that month.[367]

Shepp began October by visiting Polly and Charlie. Bemis had intended to go to Warren on the 2nd, but it rained, so he postponed his trip until the next day. While he was away, Shepp stayed with Polly. Bemis got back on the 4th, and had a pound each of raisins and carrots for Shepp, plus 50 bullets, .22 caliber shorts. On the 8th Shepp noted that he owed Polly $4.00, without saying what it was for.[368]

A few days later Shepp's winter supplies, with some for Polly and Charlie, "arrived by Olie ... Bemis 233 @ 3¼,"[369] meaning that the Bemises' freight weighed 233 pounds and the freighting cost was 3¼ cents per pound, a total of $7.57. These supplies came from Alexander and Freidenrich in Grangeville; Shepp's bill with them was $115.92, and the Bemises' was $21.57. Shepp also "paid Olie for Bemis 7.77."[370]

On October 21 Shepp came over to the Bemis Ranch because Charlie Bemis was going to Warren the next morning. Bemis left at 9 a.m., taking three horses, Nellie, Mary, and Frank. Shepp went up on the hill with him, and then came down and "cut cabbage & husked corn." He husked corn again

on the 23rd, and Charlie came back from Warren on the 24th. On the 25th Shepp got a large amount of produce from Polly and Charlie and took it across the river: 200 pounds of potatoes, 97 pounds of cabbage, 40 pounds of apples, 25 pounds of onions, 17 pounds of carrots and beets, 42 pounds of [green? dried?] beans, and an oil box full of peaches. He left most of it at the foot of the trail and the next day Smith and Bemis helped get it up to Shepp's place.[371]

Preparations for winter survival involved logistics of ordering, packing, transporting, and storing. When Shepp and the Bemises obtained supplies from Grangeville, they didn't need to go there in person, but did have to hire a packer to load the goods onto his pack train of mules or horses and transport everything down to the Salmon River. Then the Bemises had to collect their supplies by boat. This required multiple trips from one side of the river to the other, and then everything had to be hauled up the river bank to their cabin. When Charlie Bemis took three horses up to Warren, he could shop in person and avoid paying a packer, but he would need to pay for a night in a hotel unless he could stay with friends. One advantage to purchasing goods in Warren was that he could take them directly home without needing to cross the river, but Grangeville, being a larger community, may have had lower prices that would have offset the transportation costs. Besides storing all these winter supplies, including hundreds of pounds of purchased goods such as canned milk, cooking oil, kerosene, flour, sugar, salt, baking soda, coffee, and tea, the Bemises also had to store equal or greater amounts of fresh, canned, or dried produce in a manner that kept it from freezing or becoming moldy.

Shepp "got a big 160# 3 point buck" on November 1, and on the 3rd he took a quarter of it down to Polly and Charlie, and mentioned that "Bemis got colt in yard." Shepp spent the night, and came home the next day. When Pete came back with the mail on the 10th he brought the news that Taft had been elected President.[372] For Thanksgiving, Shepp visited Polly and Charlie for a chicken dinner and stayed two nights. He took Teddy, his month-old puppy, with him, and reported that "the dogs had a great time."[373]

On December 13, Shepp came down to the river, and "crossed … in little boat. A lost Chinaman, Dick, at Bemis. Had been 4 nights out. Came up river from Bear [C]reek. Nearly all in."[374] "China Dick," also known as Goon Dick, wasn't the same person as the Warren Chinese physician, Lee Dick (Chapter Two).[375] "China Dick"/Goon Dick later became prominent in the Warren Mining District. For example, in 1917 and 1918 he reportedly owned mining claims with two different Euroamerican men.[376] Working independently for several years in the early 1920s, he would come from Grangeville to Warren in the spring, mine for at least six months, and then return to Grangeville in

the autumn, with visits to Seattle in 1919 and 1920 and a trip to San Francisco in 1924.[377]

Meanwhile, in December 1908, Shepp knew that Smith had butchered a pig a few days previously, so on the 14th he went over there and "got pork for Bemis."[378] Smith came over on the 16th, and he and Shepp took the Bemises' little boat out of the water. It had been 16 degrees above zero that morning, and the river was nearly closed by ice above the upper boat landing.[379] "China Dick" stayed with Polly and Charlie until the 17th, and then crossed the river with Shepp and went up to Shepp's house.[380]

On December 23, 1908, Shepp and Klinkhammer came down to the river and crossed in Bemis's boat; the river was frozen over below Polly and Charlie's place. They stayed for Christmas Eve and had a chicken dinner there on Christmas Day. Smith was there for dinner also, and Shepp took him back over the river in Bemis's boat, then returned. Shepp and Klinkhammer left on the 27th, using Bemis's boat to cross the river.[381]

At the end of the 1908-1909 diary Shepp included the following tables, for transactions with the Bemises in 1908:

Bemis		
May 1	8 doz eggs @33 1/3	Paid
June 1	8 doz eggs	
" 1	9 doz for camp up to date	
July 20	2 heads cabbage. can eggs	
Aug. 2	3 " " 5 " [cans] beans 2# onions [# = pounds]	
Oct. 25	1 oil box peaches 50 [pounds]	
	200# potatoes	
	97 [#] cabbage 42 [#] beans	339# [total pounds, Oct. 25]
	40 [#] apples 25 [#] onions	
	75 [#] carrotts & beats [sic]	
Entered separately, under the above:		
Oct. 14	To Bill from A & F	21.57
	" " Packing	7.77
	2# bkg powder .80	
	1 box currie .25	1.80 [total for 4 items]
	[Le]mon Ex .25	
	Maplene .50	

There are several cryptic entries under the date of October 14. "A & F" is the Alexander and Freidenrich store in Grangeville. "Packing" is the charge for freighting the Bemises' goods. The next two entries are for two pounds of baking powder and a box of curry powder. "[Le]mon Ex" is lemon extract flavoring, and "Maplene" [Mapleine] is imitation maple flavoring, for home-made maple syrup or maple-flavored candy.[382]

1909

Shepp celebrated New Year's Day with a chicken dinner at Polly and Charlie's, and returned home the following day, crossing on the ice. On the 15th, a Friday, he returned with his puppy, Teddy, who "walked all the way." He crossed on the ice again, and reported that both eddies were frozen over. Shepp "took hog head over to Bemis," probably one that he had gotten from Smith, who had butchered in mid-December. Smith came over for dinner on Saturday, and on Monday Shepp "cut down tree on rock." On Tuesday he went hunting on Warren Ridge, but "only saw a few tracks." On Wednesday, he "fixed emery machine," perhaps a grinder. While Shepp was at the Bemises' place, the almost-continual rain curtailed his outdoor activities, but he appreciated that it was helping to melt the ice in the river. He returned home on Saturday the 23rd.[383]

In early February Shepp and Pete went down to the river and crossed by boat. They spent the next couple of nights with Polly and Charlie. While they were there, Pete went up to see the horses, Shepp and Bemis cut down a tree, and Shepp and Pete went upriver to visit James but no one was there. They returned home, and on the 20th Shepp went back to the Bemises. On the 21st he climbed Warren Ridge, where he saw eight deer; one was a buck with antlers. He also saw Polly and Charlie's horses. On Monday the 22nd Shepp had a chicken dinner at Polly and Charlie's, and Boston Brown was there, too.[384] The next couple of days Shepp and Brown were at Smith's, building a bridge for him, and on the 25th Shepp was back at the Bemises, where he "split boards for porch" and went "up to tree in afternoon"; he returned home the next day.[385]

On Wednesday March 10 Shepp spent the night at Polly and Charlie's place. He returned home the following day with lard, some onions, and about seven pounds of potatoes from them. On Sunday the 14th Bemis went up in the afternoon to visit Shepp. On the 17th Shepp crossed the Salmon River to stake out a placer mine. James visited too, and both men spent the night with Polly and Charlie. The next day Shepp went hunting up on the hill. Although he saw three deer, and shot five times, he didn't hit one. When he left on the 19th, James was still there. On Monday the 22nd Shepp went up to Del Rio

[the mine] and Concord, and then back to Del Rio the next day. At Del Rio, he got a screen of some sort for Charlie Bemis. On Friday the 26th he was back at the Bemises, and repaired their roof. On Saturday he "finished roof & fixed wire on chicken yard." He returned home on the 28th, with a can of eggs from Polly.[386]

In April Shepp stayed with the couple from the 9th through the 16th. Although he wrote little about what he did while he was there, perhaps he helped with the spring plowing and planting. On Tuesday the 13th Shepp went hunting up on the hill, and got a deer and a bear. The next day, he and Charlie went up and got the meat. On Thursday, Shepp fleshed the bear hide, and on Friday he returned home.[387]

May 1, 1909, saw Shepp at the Bemises' place again. James was also down, from upriver, for a visit. The Bemises' peach and pear trees were blooming and the apple trees had just begun to blossom, but their lilac bush wasn't yet in bloom. Neither the Salmon River nor Crooked Creek were high; the river was just over the island. Shepp came home on the 2nd, with eggs and pickles from Polly. On the 10th Shepp went down to the river again, and visited Polly and Charlie for several nights. While he was there he got $15 from Polly, but didn't say what it was for, and a watch from Charlie that probably needed repair. By then, their lilac bush was just about in bloom. On the 19th he went back across the river and was there until the 24th. He reported that "none of [the Bemises'] garden truck up but peas & beets." While he was there, it rained off and on. He made a meat safe for Polly, and reported that "she caught a big fish." There were "lots of deer" in the Bemises' corral. On Sunday they had a chicken dinner, and Shepp noticed that their corn was just coming up. Before leaving, he got $3.50 from Polly for Montgomery Ward and Company.[388]

When Shepp next went down to the river, in mid-June, it was too high to cross; the river was the highest it had been in years. He tried again on the 20th, and wrote that he "saw Bemis," but the river was still so high that he couldn't cross safely. Shepp left his dog Teddy at Smith's because he was about to leave for Seattle; he had probably hoped to leave Teddy with Polly.[389]

Shepp was away until early August. On the 8th, he and Pete went down to the Bemises' place and stayed until the 10th. Shepp reported that it was "hot as the devil." While there, he made out an order for Polly to Montgomery Ward and got some potatoes, berries, cabbage, and cucumbers from the couple. On the way home, he "saw Smith" and "got option on ranch," meaning that he had contracted to buy Smith and Williams's place.[390]

On the 13th he went back down and spent the night with Charlie and Polly. He had his camera with him, so the next day he "took picture of Sugar Loaf" [Sugarloaf Butte, north of Crooked Creek and northeast of the Shepp

Ranch] from the Bemis Ranch. Shepp took two more pictures, one looking upriver (Fig. 4.10) and another of Smith's ranch from the Bemises' place. Before leaving, he got a pound of Union Leader tobacco and two pounds of butter, as well as some potatoes, eggs, cabbage, and tomatoes from Polly and Charlie. On Saturday the 28th Shepp went down to the river. He came back with all the horses, one of which was named Polly. He was planning to take produce to town the following day, so got onions, cabbage, tomatoes, and potatoes from Charlie Bemis.[391]

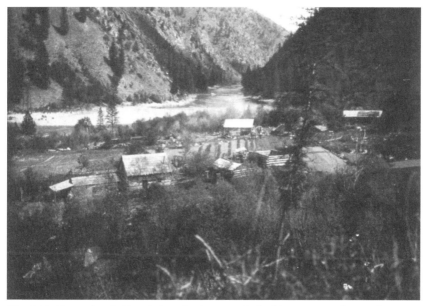

Fig. 4.10. Example of a Bemis Ranch photograph, looking upriver, date unknown (1914?). Courtesy Idaho State Archives, Boise, 79-98.109b.

In September Shepp didn't visit Polly and Charlie again until the 21st. When he did, he commented that "Yellow Bull [I]ndians" [a band of Nez Perce Indians, followers of Yellow Bull] were at Smith's. The next day he went back over the river and had Smith shoe the horses.[392] He also "made bargain with Smith on ranch. Pay him $100 down & [$]1000- as soon as we finish work on Star [North Star Mine] contract; ballance [*sic*] same time next summer."[393]

Although Shepp wrote that he also got 245 pounds of vegetables from Bemis, he doesn't list them under that date, but does so at the end of the 1909-1910 diary. On a page headed "1909" and "Bemis Vegetables" the following list appears, dated Sept. 22 (all amounts are in pounds): 40 apples, 44 tomatoes, 8 parsnips, 15 rutabagas, 17 onions, 90 spuds, 20 cabbage; these total 234 pounds, not 245, so perhaps he omitted one category. The next day

he brought them up to his house, first stopping off at Smith's to make his $100 down payment on the ranch. The Nez Perce were still there.[394]

On October 10, 1909, Shepp went up to Concord and on the 11th their winter freight came in, from Alexander and Freidenrich in Grangeville, by way of Adams Camp. Polly and Charlie's share weighed 959 pounds. Saturday the 16th Shepp went down with a load of goods for the couple. He reported that there were "engineers [surveyors] below Bemis." Shepp spent the next two nights there. Before leaving, he got 268 pounds of potatoes, 45 pounds of onions, and 90 pounds of cabbage. These totals are confirmed for October 17th in a listing of accounts at the end of the 1909-1910 diary. Bemis also paid $29.45 "by check from H. H. Martz No 19 on 1st Nat[ional] Bank, Harris[son] burg Va [Virginia]"; Shepp mailed this check to Alexander and Freidenrich. The Bemises' bill was $75.52, with freight charges on 874 pounds of $30.59.[395] On the 21st Shepp went up to Concord and got the last of the Bemises' freight down, and on the 22nd he took it over to the Bemises and spent the night. By then, the surveyors had "all gone down river." Shepp left there the 23rd, bringing with him a check from Bemis for $51.[396]

At the end of the 1909-1910 diary are some accounts. One page is headed "Oct 11 - 09." Under the name "Bemis" the following figures appear:

Freight 874# [pounds x] .3½ [cents per pound =] 30.59	
Oct 17 By check	29.45
To bill	75.52
Oct 23 By check #51	106.11
" 23	80.45
Oct 23 Ballance [sic]	25.66[397]

Shepp spent November 1909 mining, so didn't visit the Bemises at all that month. On the 4th he and Pete celebrated Pete's birthday - they "had clam chowder." On the 7th, Pete went to town, so Shepp sent Charlie Bemis's $51 to Alexander and Freidenrich. He also "sent films to Lewiston" for developing.[398]

At Christmas, Shepp went up to the Del Rio Mine, where he had a turkey dinner on Christmas Day. By the 27th he was back home, where he cut his hair and shaved, and then went down to the river the next day. He had dinner at Smith's, including "a couple drinks," and then went over to the Bemises' place by crossing on the ice at the upper boat landing. Shepp spent the next two nights with them, where it was 14 degrees above zero one morning. He returned home on the 30th, with some parsnips from the couple.[399]

Polly and Charlie must have greatly enjoyed Shepp's company to entertain him so often. While they visited, in the evenings, Polly would have worked, by lamplight, on various crocheting and needlework projects. Examples of these are in The Historical Museum at St. Gertrude in Cottonwood, Idaho (Fig. 4.11); at the Bicentennial Historical Museum in Grangeville, Idaho; and in her restored home on the Salmon River. Private individuals also own items of Polly's handiwork that she made and gave to her friends.[400]

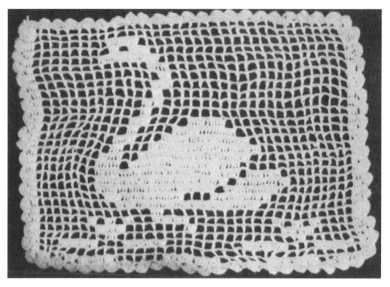

Fig. 4.11. This doily, an example of Polly's crochet work, depicts a swan, a bird that she sometimes saw on the Salmon River. Courtesy The Historical Museum at St. Gertrude, Cottonwood, Idaho, #964.5.3.

Also in 1909, the list of delinquent taxes for Warren included the name "Beamis [sic], Charles," for "Improvements in Warren," $150. It was probably an error, since his Warren properties had all burned in the 1904 fire, and the land they were on still belonged to the US Forest Service. Bemis also had "unpatented land" worth $150, probably the Bemis Ranch. His tax was $4.20 plus $.42 penalty, plus $.25 for advertising, for a total delinquency of $4.87, stamped "Paid."[401]

1910

Shepp came down to the Salmon River on Friday, January 7, crossed over on the ice, and stayed with Polly and Charlie for several days. He stopped at Tom's on the way and got a one-gallon "stone jar" [probably a stoneware ceramic canning jar] for Polly. The temperature "had been cold, down to 6

below." On Saturday he "done nothing," noting that it was a "fine day" and "warmer." On Sunday he went up on the hill hunting, but didn't see any tracks. Monday he made a keg of sauerkraut, Bemis cut wood, and Shepp noticed someone going upriver on the opposite side. The next day, the 11th, he returned home. On the 26th he and Pete went to the Bemises, crossing the river on the ice. They stayed for a couple of nights, and while they were there, Shepp fixed Polly's clock. When they came home, they crossed on the ice again. Shepp commented, "ice good."[402]

Saturday, February 5, Shepp came down to the river. He paid Smith $400 of the $1000 he still owed. He then crossed over on the ice and stayed with Polly and Charlie for two nights. Someone named, or nicknamed, "Boise" came over the next day and got onions. Shepp also took a couple of pictures. One was looking downriver and the other, on February 6, 1910, was of Polly Bemis with Nellie and Julie, two of the horses (Fig. 4.12). Shepp went home on the 7th, but returned to the Bemises on the 21st, once again crossing on the ice. He stayed there until the 26th. While there, he got a watch from Bemis, probably to either fix it or to take it out for repair.[403]

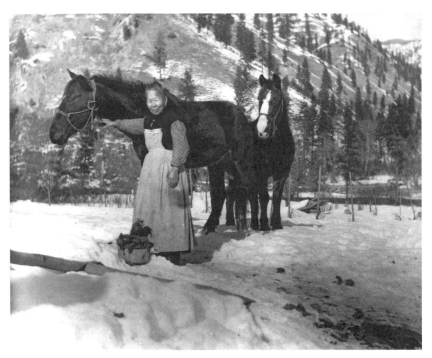

Fig. 4.12. Polly with Nellie and Julie; the kettle contains carrots for the horses, 1910. Photograph by Charlie Shepp, February 6, 1910. Courtesy Idaho State Archives, Boise, 62-44-7.

On March 11th Shepp went to town. There he received the sad news from his sister, Nellie, that his mother had died on February 15th. Three days later he went down to Polly and Charlie's place. Pete joined him there on the 17th, bringing $150 from the "Star people" [North Star Mine], which he gave to Smith on his way home the next day.[404]

The ranch became Shepp's on Thursday, March 24, 1910 (Fig. 4.13). That day, he "gave Smith & Williams 2 notes, one on demand for 450 & one 1 year for 400 with 6%. ... Started on garden, spaded up all the ground inside wire fence. Hitched up the horses. Baldy don't work at all. Polly [a horse] all right."[405]

Shepp began planting at his new place on Friday, and over the next few days he and Pete did other chores such as fixing a fence and hauling manure. On Saturday, March 26, Shepp went over to the Bemis Ranch for dinner. Before returning home, he "got parsnips & onions from Bemis." The following Thursday, the last day of the month, Shepp "was over river got pu[llets?] & rooster," and a "bucket [sauer]kraut from Polly." While Shepp was there, "Bemis wrote Roberts," probably so Shepp could mail the letter when he or Pete went up to town.[406]

Polly and Charlie Bemis were surely very pleased to have such good friends as their new neighbors. By then, the couple had been living on the Salmon River for sixteen years. With Polly in her mid-fifties and Charlie in his early sixties, it must have been reassuring to have the younger men so close at hand.

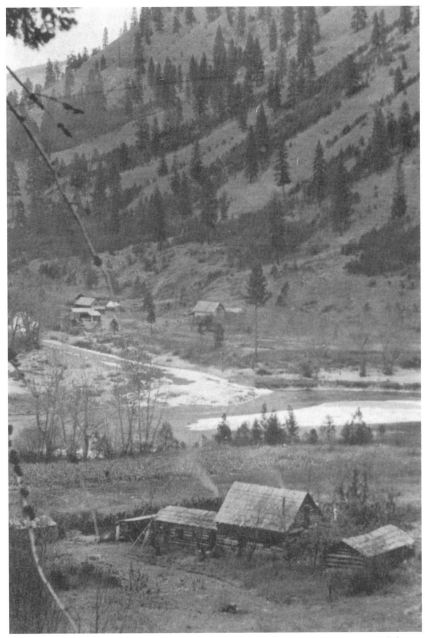

Fig. 4.13. Top, Shepp Ranch; bottom, Bemis Ranch, about 1914. Courtesy Idaho State Archives, Boise, 79-98.109a.

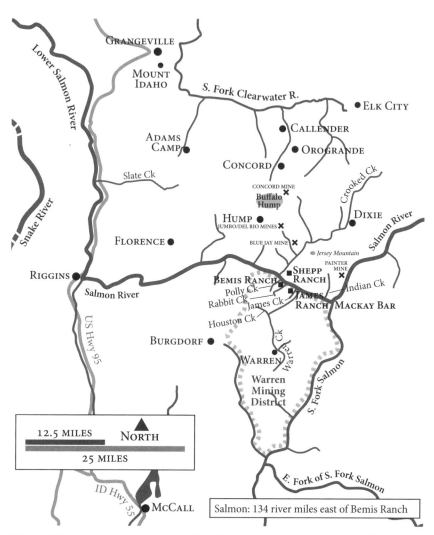

Map 5. Idaho place names mentioned in Chapter Five. Roads in gray did not then exist, but are included for context. Drawn by Melissa Rockwood.

CHAPTER FIVE:
Life on the Salmon River, Spring 1910 through 1914; Polly, age 56-61

On April 1, 1910, Charlie Shepp used two horses, Polly and Baldy, to move to his new home.[1] The property that became known as the Shepp Ranch is located where Crooked Creek flows into the Salmon River, across from the Bemis Ranch. The former co-owner, "Four-eyed" Smith, left and moved in with "Tom," possibly Tom Copenhaver.[2] Although Shepp had often spent time at the Bemises' place before moving down to the river, once he settled in, his visits to the couple increased, as did theirs to him. From then until Charlie Bemis died in 1922, and Polly's death in 1933, Shepp, and his mining and ranching partner, Pete Klinkhammer, were the most important people in Polly and Charlie Bemis's lives.

Early 1910 through 1914

In placing the Bemises' lives and times into the context of world, national, and local events, 1910 saw Japan's annexation of Korea; San Francisco Bay's Angel Island became the center for processing Asian immigrants; and Halley's Comet appeared for the first time in 76 years.[3] In 1911, explorer Roald Amundsen reached the South Pole and in New York, the Triangle Shirtwaist Company fire killed 145 people, mostly young immigrant women working in sweatshop conditions.[4] In 1912, the *Titanic* sank on her maiden voyage, New Mexico and Arizona became the 47th and 48th states, and Woodrow Wilson was elected the 18th US president.[5] 1913 saw increases in women demonstrating for the right to vote; the 16th amendment, establishing income tax, was adopted; and Henry Ford introduced the first moving assembly line.[6] World War I began in 1914, the Panama Canal was completed, and Charlie Chaplin gained fame as The Little Tramp.[7]

Of these and other events, Shepp mentioned only Halley's Comet and the sinking of the *Titanic* in his diaries, small notebooks with brief, often cryptic,

entries. For example, "went over" or "over river" means that he crossed the Salmon River to the Bemises' place. Before power boats, the Salmon River, which flows downstream in a westwardly direction, was called "The River of No Return," for obvious reasons. Because of the steep hillsides, foot or horse transport was mostly up or down. Places not on the Salmon River, like Concord and Dixie, on Shepp's side of the river, and Warren, on the Bemises' side, were "up," as in Shepp's brief notation, "up to town."

Shepp's diaries chronicle how his and the Bemises' lives became intertwined. As both friends and neighbors, they lent and borrowed food, tools, and equipment; participated together in the seasonal round of cultivating, planting, and harvesting; and welcomed, and often fed, travelers who crossed the Salmon River between the two ranches or who floated down it in boats.

1910

Several days after Shepp's April 1 move, his dog, Teddy, got caught in a trap at Tom's. The next day "Pete took Polly up to Teddy"; Teddy must have been injured badly enough to need her reputed nursing skills. In the margin Shepp wrote "Polly" and "Teddy." Two days later he got 18 pounds of [dried] beans and 17 pounds of potatoes from Polly and Charlie. Accounts at the end of the 1909-1910 diary confirm those amounts, and note that he also obtained 30 pounds of parsnips.[8] One Sunday Bemis brought his boat across the river, and at midweek Shepp went over and "got seed corn & 3 magazines." On the 15th Shepp planted red and white potatoes, from Bemis.[9]

April 15, 1910, was also "Census Day," the date for counting everyone who lived in a particular household on that exact day. The enumerator might visit the residence on a later date that month, but recorded the information as of April 15.[10] Probably because of their remote setting on the Salmon River, the census taker did not visit Polly and Charlie Bemis, or Charlie Shepp, so they are absent from the 1910 census. Peter Klinkhammer was enumerated in Concord Precinct, as a 30-year-old gold miner, in a household with five other miners.[11] Whether this was for the Concord Mine, the Del Rio Mine, or the Jumbo Mine is not specified, however, it was most likely the Jumbo Mine since Klinkhammer was known to have worked there.[12]

Polly's friends, the Schultz family [see later in this chapter] also lived in Concord at the time of the 1910 census. August ["Gus"] was a 36-year-old gold miner and his wife, Nellie, was 31 years old. Although no occupation was listed for her, she would have been kept quite busy as a homemaker. The couple then had two children, daughter Helen, age nine, and son Charles, age five.[13]

Also, at that time, there were still six Chinese men living in Warren: Ah Kan, Lee Dick, Ah Hi, Ah Sam, Ah Soon, and Ah Tow [probably Ah Toy].

All were listed as laborers, doing odd jobs. Ah Hi worked for a Euroamerican farmer, and lived there; Lee Dick, Ah Soon, and Ah Sam shared a household; and Ah Tow and Ah Kan lived separately but near one another. They had all arrived in the US between 1870 and 1881.[14]

Returning to the Salmon River, on Sunday, April 17, someone named Cook came down with Pete and they spent the night at Shepp's new place.[15] The three men all went over to the Bemises' for Sunday dinner [dinner is always the noon meal]. That day, Shepp "got bucket kraut & pie from Polly" and "got our glasses from Bemis"; perhaps Charlie had repaired them.[16] On the 19th Shepp obtained a shovel, a plow, a deed, and "Borac" [*sic*, for boric] acid from Polly and Charlie. The next day Shepp "moved both boats down below rock," on the 21st and 22nd he planted the sweet corn seed that he had gotten from Charlie, and on the 28th he "saw Bemis plowing potato ground in alfalfa."[17]

In early May 1910 Shepp got some rhubarb from Polly and Charlie and also took some meat over to them. He planted 10, 150-foot rows of beans, with seed from Bemis. On the 17th Shepp, "Four-eyed" Smith, and possibly Pete visited Polly and Charlie and "got radish seed & sweet corn & rhubarb." The next day Shepp went back over the river. He took cucumber seed to the Bemises, and got some pickles from Polly. Intriguingly, the last line in that day's entry read, "Failed to see comet."[18] The reference is to Halley's Comet, which was visible in 1910 (Fig. 5.1). Perhaps it was a cloudy night, because according to an elderly informant, now deceased, it "lit up half the sky."[19] The 19th was definitely cloudy, and Shepp "didn't see any comet." Saturday the 21st Shepp took Smith across the river in the morning, noting that "Bemis 'yelled' this morning before I was up." Shepp went over there after breakfast, and got some meat. The next day, Shepp finally "saw the comet at 8:30." Tuesday

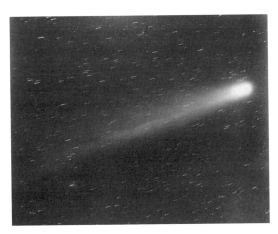

Fig. 5.1. Halley's Comet in 1910. Image taken at the Yerkes Observatory, gelatin silver print in the New York Times *Collection. Courtesy the Museum of Modern Art, New York, NY, U.S.A. Digital Image © The Museum of Modern Art/ Licensed by SCALA / Art Resource, NY.*

afternoon he went over the river noting only that he "cut hair," but it is not clear whether he did that over there or at home.[20] On May 31, Shepp wrote,

Took [Orson] James across river this am.[21] We stay'd over to B.- [Bemis's] for dinner. Tom Pritchard at house when we came home. He came down from Dixie. ... No Rail road this year. Bemis got letter from Roberts. 3 men went down river in boat about 3 or 4 days ago. James told us about them. They stopped at his place. River about on stand just below big tree at Bemis landing. Got some potatoes from Bemis.[22]

"Four-eyed" Smith came down on June 1 and took Tom Pritchard across the river. Shepp went over to the Bemises' in the afternoon. There he met Gus Cooper, who killed a rattlesnake at Polly and Charlie's, and H. E. Dickey. Shepp wrote "M. E." after Dickey's name, probably meaning that he was a mining engineer. Dickey was "gathering ore from all parts of the country," and talked with Shepp about Shepp's claims; Dickey may also have had a similar conversation with Charlie Bemis.[23] On the 4th a man named "Neskin" [probably Nethkin] crossed the river to Shepp's that evening.[24] The next day, Shepp took him back across the river, and "Neskin" offered $25 for a placer, nearly $668 in today's money.[25] Shepp did not indicate who owned the placer, or whether the offer was accepted. On the 8th Shepp and Smith, and possibly Pete, went over the river to dinner. Shepp took some wonderberries over and got 10 tomato plants "& peppers," probably pepper plants.[26] He visited Polly and Charlie again the following Sunday afternoon.[27]

In mid-June 1910, on a Wednesday, Shepp went to the Bemises' to cut hay, and "had cherry pie for dinner," which Polly would have prepared. Pete went over to finish the hay, returned home, and completed the job the following morning. On Sunday, Smith went over the river in the afternoon. Shepp went across on the 21st and got potatoes. He "met Hardy & Thorne camped at boat landing."[28] The two men were going to placer on Rabbit Creek. On the afternoon of the 26th Shepp went over again and borrowed a brush scythe from Bemis. On the 28th, Pete got currants, gooseberries, and raspberries from the couple. He took the fruit up to town [probably Concord] the next day, to sell, along with some produce from the Shepp Ranch.[29]

Monday, July 4, Shepp went over the river to dinner. Hardy and Thorne were there, too. The next day Shepp got his produce ready to go to town, and Pete crossed over and got berries, onions, and peas from Polly. On Wednesday Pete took everything up on two horses. Hardy and Thorne finished their placering and crossed over the river to Shepp's side on Thursday. The next day they sold him two shovels, two picks, two saws, and an axe for $5. Sunday evening Shepp visited the Bemises and got some string beans from Polly. He

may have seen them again on Wednesday, when he crossed over and went up to Warren, and also on Thursday when he returned home. On Friday he went to the Bemises' again and got some potatoes, peas, onions, and beans, for Pete to take up to town the following day, with "both horses packed."[30]

On July 19 Shepp went over the river in the afternoon and continued on upstream to Rabbit Creek. He visited Polly and Charlie again the evening of the 21st and picked four boxes of apples weighing a total of 187 pounds. He also killed a skunk at the boat landing. At the end of that day's entry is the note, "187 apples 60 spuds 16 cucumbers," meaning pounds of each. Pete went up to town the next day, the 22nd, so undoubtedly took the produce with him. When Pete returned on the 24th he reported that the cider mill they had ordered was on its way. On the 26th Shepp returned to the Bemises' place and got two, ten-pound buckets of blackberries. At home, he "put up 7 small jars." Sunday the 31st Shepp went over the river in the afternoon. He took the boat down to the lower crossing, and returned with 184 pounds of apples, 60 pounds of potatoes, 35 pounds of cucumbers, and one bucket of berries for Pete to take up to town the next day.[31]

On Wednesday, August 3, Shepp went to the Bemises' place for the mid-day meal, and Bemis and Polly crossed over to visit him that afternoon. Shepp reported that "Polly caught quite a nice lot of fish," and "Bemis got 2 grouse." The following Sunday afternoon Shepp went over to visit the Bemises. Bemis went "up to see horses," probably because Shepp "saw a bear on side hill above Bemis house." Although Shepp mentioned that Polly had lost 15 chickens, he didn't say what had happened to them. When Pete returned, he had only part of the cider press with him, as well as two sacks of flour for Polly. Still needing a cider press, and knowing that the Bemises had one, Shepp crossed the river on Thursday the 11th and borrowed it. Over the next couple of days he made 15 gallons of cider, using 270 pounds of apples. He turned five gallons into vinegar, kept ten gallons of cider, and gave Polly and Charlie a gallon of the latter, which Pete may have taken to them, because he went over the river on Saturday afternoon. On Sunday Shepp went over again and got 43 pounds of tomatoes and some cabbage for Pete to take up to town on Monday. Potatoes, beets, carrots, cucumbers, and apples also went up with Pete, but it was not clear whether Shepp or the Bemises provided these. It took three horses to get everything loaded up.[32]

On Wednesday, August 17, Shepp's diary entry includes several mentions of Polly and Charlie Bemis: "Polly & Bemis over to dinner. Polly caught 27 fish. Took picture of Teddy [Shepp's dog]. Smoky. Bear been eating Bemis' apples. Got a head for 10 gal[lon] keg from Polly. Had watermelon at B[emises]. Fine day."[33] In later years, Pete Klinkhammer commented, "Polly loved to fish

and was good at it. We'd see her [gardening] & she'd bend to the earth real quick, then shove something into the big pocket of her long dress. Come three o'clock every day Polly had her gardening done and her fish bait, ready and waiting in her pocket. We used to know what time it was by watching her"[34] (Fig. 5.2).

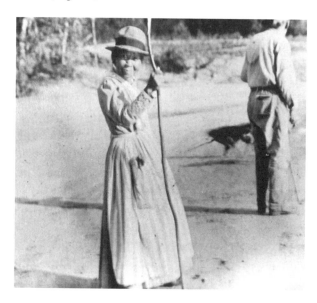

Fig. 5.2. Polly with her fishing pole, date unknown. Courtesy Idaho State Archives, Boise, 62-44.6.

On Thursday morning, August 18, Shepp "heard gun go off at 9:30. Over river this am. Bemis' gun hit a bear, knocked some of his teeth out. Over river again this afternoon. Bemis & his dog found bear on side hill above water hole on trail. Couldn't locate bear for thick brush. I took shot at bear by [illegible]. Run him out and lost him."[35]

Shepp's entry for Thursday, August 25, 1910, is intriguing. He wrote, "Polly gone out side [outside, i.e., off the ranch] Schultz took her out."[36] Was this Polly the person, or Polly the horse? If the person, there is no indication where they went, or exactly when Polly returned home. If the person, this could have been a visit to her friend Nellie Schultz, then living in Concord, about 18 miles away, mostly uphill. In later years, Polly did say that she had been to Slate Creek, so perhaps that was her destination. Other evidence, however, indicates that Polly Bemis never left the ranch after she moved there in 1894 (Chapter Seven; July 1922). If so, Gus Schultz may have borrowed Shepp's horse, Polly.[37]

Near the end of August Shepp went out to Grangeville. He returned with Harvey, his brother, and Harvey's friend, Jake, last name unknown. They had come out for nearly a month's vacation. "The boys" fished frequently, did

quite a bit of gallivanting around, and were visited by people such as Polly and Charlie, who crossed the river more often than usual while Shepp's visitors were there.[38]

On September 5, 1910, Shepp went over to the Bemis Ranch and got a box of tomatoes, two boxes of apples, and 30 pounds of onions. This, combined with the Shepp Ranch produce, meant that Pete needed four horses to take it all up to town the next day. On the 7th, Shepp went to the Bemis Ranch and on the 9th and 10th Bemis came over both days for a visit. On Sunday the 11th Shepp went over the river to dinner; presumably his guests went along too. Shepp got two boxes of apples from Bemis, and "made out order for grub for us & Bemis," which Pete took up to town the next day. Shepp's entry for Monday the 12th contains the cryptic note that ["Four-eyed"] Smith and [Charlie] Williams "will pay 75 for Bemis," without further explanation. The answer appears in some accounts at the end of the 1909-1910 diary. Under the heading "Smith & Williams," an entry for September 12 reads "To Bemis .75," i.e., 75 cents. On the 14th Bemis and Polly came over; this is the first direct mention of her since she (or Polly the horse) left on August 25; Polly the horse was back at the Shepp Ranch by August 31. Shepp's notation on September 14, "Got 10# lard" seems to mean that the Bemises brought it to him.[39]

On the 17th Shepp wrote, "Dug up [I]ndian over in field. Bones about all decayed." This prior use of Shepp's ranch should not be surprising—Native Americans would have used this land for centuries prior to the "white man's" arrival.[40]

Shepp visited Polly and Charlie again on Sunday, September 18. He took two cameras with him, and noted that he "took picture 7 x 5 of house & 2 in same place with little Kodak."[41] Shepp was a camera hobbyist. In a 1968 interview, Pete Klinkhammer recalled, "We used to have a setup of five cameras here"[42]

Shepp, Harvey, and Jake went up to town on the 22nd, and "the boys" left on the 23rd. While up there, Shepp got a letter from Alexander and Freidenrich in Grangeville notifying him that the winter supplies he had ordered would arrive about October 1. On Saturday the 24th Shepp visited Polly and Charlie and got a box of tomatoes, one and a half boxes of apples, 10 pounds of onions, and two sacks of potatoes. On Sunday, Pete took everything up to town to sell. On Monday Shepp went over the river and made 10 gallons of cider, implying that he made it at the Bemises' place, with their apples and their cider press. Pete returned from town on Tuesday, and brought a cat with him, for rodent control. On Wednesday, September 28, Charlie and Polly Bemis went over to Shepp's for dinner.[43]

Shepp visited Polly and Charlie the first Sunday in October 1910 and returned at midweek to get 417 pounds of potatoes, 50 pounds of cabbage, one and a half boxes of peaches, and a half-box of tomatoes. Some of the produce was for Shepp and Klinkhammer's own use, and the rest went up to town with Pete the next morning. On Sunday, October 9, Shepp went over to the Bemises' and "got yellow tomatoes." On Monday, he took the cat over to them. Pete was going to town on Wednesday, so on Tuesday Shepp got two boxes of tomatoes and 120 pounds of potatoes from Polly and Charlie. Saturday the 15th Shepp took a squash over to the couple; Charlie was out hunting. When Pete got back from town he had some of their winter food supplies. The Bemises' bill was $66.74, and the freight cost $22.86.[44]

The next day Shepp went over in the afternoon. He got 100 pounds of onions and took over Polly and Charlie's bacon, sugar, butter, and salt; the couple reciprocated by giving Shepp nearly six pounds of the bacon. On Monday the 17th Shepp went over the river in the evening, taking a cookbook.[45] Polly may have wanted a particular recipe, but since she was not literate, Shepp or Bemis would have read it to her.

On Thursday, October 20, Shepp took three squashes over to Polly and Charlie and got some tomatoes, and on Saturday he returned for 123 pounds of onions. Bemis crossed over to visit Shepp that evening, and Shepp gave him a pumpkin. The Bemises went over together Sunday afternoon. When Shepp dug his potatoes and put them in the cellar, he set aside 30 pounds of Long seed for Bemis.[46] The rest of the Bemises' winter supplies had arrived, so Shepp took everything over to them the morning of Wednesday, October 26. He returned home, and Art Hillyer [sic, later Hillyard] and George Yarhaus came down just at suppertime.[47] On Saturday, Shepp, Art, and George went over to Polly and Charlie's for dinner and Shepp went back there again on Monday afternoon.[48]

On November 1 Shepp borrowed a harness from the Bemises and started plowing his new garden. He finished on Thursday and visited the couple that afternoon. On Friday and Saturday Shepp and Pete went hunting. Pete got a fawn the first day and a fawn and a doe the second day. On Sunday, November 6, Bemis came over twice and Shepp gave him some venison; Polly and Charlie must have enjoyed eating this fresh meat.

Shepp and Klinkhammer always exercised their right to vote, sometimes overcoming great difficulties to do so. In November 1910, for example, they left on Monday the 7th, trudging though the snow up to Concord in order to vote the next day. Shepp returned home on Wednesday, experiencing "about the hardest snow shoeing I ever had."[49] At Concord he also collected a package from Harvey, his brother, including a "pipe for Bemis & Polly"[50]

(Fig. 5.3). Shepp and the Bemises grew tobacco, and also bought chewing and smoking tobacco from time to time. Here, the "pipe for Bemis and Polly," is direct evidence that Polly smoked a pipe.[51] As discussed in Chapter One, Polly may have been a Daur, a Chinese minority nationality. Daurs, both

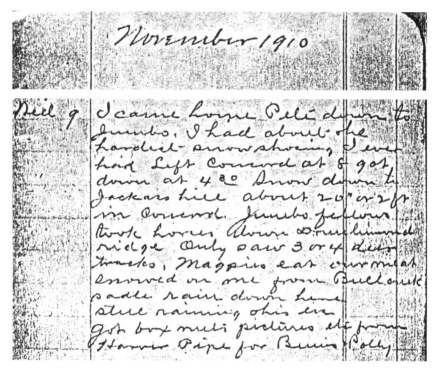

Fig. 5.3. Entry in Charlie Shepp's diary mentioning "pipe for Bemis & Polly," 1910, last line. From Charles Shepp, [Diary], August 4, 1909, through December 4, 1910, photocopy, University of Idaho Library Special Collections, MG 155, November 9, 1910. Used with permission.

men and women, smoked tobacco in pipes.[52] Further confirmation for this practice among Chinese women in general comes from Mrs. Will Shoup [first name unknown] who reported that "many" of the Chinese women in Salmon, Idaho, "smoked tobacco in American pipes."[53] Euroamerican women were also known to smoke pipes.[54]

Thursday, November 10, Shepp visited the couple and got a thermometer from Charlie. For the rest of the month, Shepp visited Polly and Charlie every Sunday afternoon and also went over at other times to get a kraut cutter and to take them some olive oil. On Wednesday the 23rd Shepp "killed Julius, he weighed 5# [pounds]"[55]; Julius was probably a rooster. On Thursday the 24th, Thanksgiving, Shepp had Bemis and Polly over for dinner; no doubt

Julius was the main course. Polly brought some eggs, and Shepp gave her a jar of blackberries and a pumpkin. He reported that there was "snow all day, the first of the season."[56] Shepp went over again the morning of Wednesday the 30th, and commented, "Bemis lost Fanny [his dog]. She left yesterday afternoon."[57]

Thursday, December 1, Shepp wrote, "Fannie [sic] must have came [sic] home. I saw her over river this evening."[58] Sunday afternoon Shepp visited Polly and Charlie,[59] and on Monday the 5th, "Bemis came over river to look after chickens," because Shepp and Pete were going up to town.[60] They went to Concord on the 6th and then to Callender on the 7th, where storekeeper Bill, also Billie, Allen gave Shepp the diary he would use for the rest of 1910 and all of 1911.[61] When Shepp got back down to his ranch on Thursday, Bemis was there. Bemis came back the next day, and Shepp "gave him Limberger [sic, for Limburger cheese] from [Billie] Allen."[62] Sunday the 11th Shepp and Pete went hunting across the river. Pete was up on Bemis Ridge and Shepp was up on Warren Ridge, high points between the Bemis Ranch and Warren. Pete got a deer, but Shepp got nothing. While he was over there, Shepp borrowed the Bemises' kraut cutter again. He visited them on Saturday the 17th, and on the 18th he and Pete went hunting and they each got a deer. On Monday Shepp took some meat over to the couple. On Saturday the 24th Shepp wrote, "put on my new pants," and on Sunday the 25th he and Pete had Christmas dinner with Polly and Charlie; perhaps Polly cooked some of the venison Shepp had provided. The two men crossed in the boat because there was "hardly any ice in river." Shepp took a rooster and a black pullet over to Polly, perhaps as a Christmas gift for her. From the couple, Shepp "got pair suspenders for Xmas," and "Pete the same."[63]

1911

Shepp subscribed to several magazines and occasionally shared them with Polly and Charlie, just as they shared theirs with him. In early January he mentioned receiving the *Youth's Companion* and the *Saturday Evening Post*. On Thursday the 5th he visited the couple for dinner, and gave Charlie the receipt for the Bemises' winter supplies from the Alexander and Freidenrich store in Grangeville. This time, the Salmon River was frozen over, so Shepp crossed on the ice. Bemis went over to Shepp's the afternoon of the 14th and "got his drawing tools."[64] The next day he and Pete went over to Polly and Charlie's for Sunday dinner. Pete set an otter trap under the bluff on the Bemis side of the river, and Shepp "got emery grinder from Bemis."[65] The following Sunday Bemis went over to Shepp's, perhaps to invite him to dinner, because Shepp wrote that he "washed and went over river to dinner." A week later,

Shepp returned the emery wheel, and reported that it was a "fine day, warm" and that "Bemis saw [r]obins yesterday." Shepp had grown tobacco, and on the 31st he "put tobacco in box to sweat" [to ferment and cure it]. He also wrote to *Popular Mechanics* for a book on mission furniture.[66]

In February 1911 Shepp visited Polly and Charlie several times. Once Shepp borrowed their tomcat "for Mariah," meaning, so Mariah would get pregnant; mouse control seems to have been a continuing problem. On Wednesday the 22nd, Shepp went over for dinner, and toward the end of the month he got a whipsaw from Bemis. Pete also went over once, and Bemis visited Shepp and Klinkhammer by crossing at the lower eddy, most likely on the ice. On the 17th Shepp reported that "Pete got a buttercup on hill across creek this afternoon."[67]

On March 1, Shepp wrote, "Tom, Bemis' cat, died this AM. Found him in chicken house."[68] While we would like to think that Tom died of natural causes, Tom could have died at Shepp's hands for killing chickens.

The following Sunday afternoon, Bemis visited Shepp and Klinkhammer. He brought over a dozen eggs and Shepp gave him some fish. On the 10th, Pete crossed the river on the ice, and on Sunday the 12th Shepp, and maybe Pete, crossed by boat. Because Pete was going up to town the following afternoon, Bemis gave Shepp an order to mail to Montgomery Ward. Although some of Shepp's writing is illegible, Bemis's order did include pencils, a paintbrush, shoestrings, and "rubbers," probably rubber overshoes. Pete returned Wednesday afternoon, and Shepp took Bemis's mail over to him. On Thursday Pete went up to town again. Before he left, Shepp went over and got mail from Bemis and went over again Sunday afternoon. On Tuesday Bemis and Polly went to Shepp's for dinner. While over there, Polly caught a fish in Crooked Creek. Shepp also got some tree grafts from Charlie Bemis's "red fall apple." Shepp visited Polly and Charlie on Friday the 24th. On the 25th he went again, and saw four swans in the river that morning.[69]

In early April 1911, Shepp noticed Bemis plowing one afternoon. On the 6th he went over and got 10 pounds of lard from Polly, and on the 7th he got tobacco seed from Bemis and also took him some; these must have been different varieties. During the rest of the month, Shepp went over to dinner once, and Charlie and Polly paid a return visit, also for dinner. One day, Shepp went over and took Bemis's boat down to the lower landing. He visited them several more times that month, not always for a specified reason. Once he heard Bemis shoot, and went over, but Bemis had gotten nothing. On Saturday the 22nd he took the horse, Mary, across the river and another time, after Pete had shot a deer, Shepp took Polly and Charlie a front quarter of it.[70]

In May, Shepp got a harness, a piece of meat, and a froe from Bemis, while from Polly he obtained 22 pounds of sugar and six wonderberry plants.[71] Shepp also planted 14, 75-foot rows of beans, using seed from Bemis. Bemis only went over to Shepp's once, but Shepp and Pete visited Polly and Charlie several times.[72] On May 6, a "boat with 7 men went down river this a.m. They stayed at Bemis' last night. ... Took picture of boat going over ripple but too early 7:30. Pete & I over river this am,"[73] surely to get all the details about the visitors.

In later years, Pete Klinkhammer commented,

The 7 men were Captain [Harry Guleke] and crew who had started out at Salmon with three wooden scows powered by sweeps, one at front and one at back of boat. The three scows were loaded with machinery and other equipment for the J. R. Painter mine five miles above Mackay Bar on South side of River. One of the boats and its in-animate contents was overturned and lost to swift water before it got to its destiny. Painter had a diver come in but he was helpless in that particular current. Some of the stuff was retrieved after high water subsided. The other scow was left at Painter[']s and used for lumber. [Guleke] & his men continued in the remaining boat. Stayed overnight at Polly's and went on to Lewiston. J. R. Painter was a … Wyoming cowboy (Fig. 5.4). Used to talk big. Tried to make everyone think—and some did— that he owned thousands of Wyoming acres & cattle. Even claimed that the big trains halted to let [him] & his cattle through. He used to do some promoting at Elk City [Idaho]. Then he got some New York sucker on the line and bought out Aiken.[74] The New York fellow gave Aiken a check for 8 thousand dollars and of course Painter gave him one too. Only Painter's wasn't any good.

Fig. 5.4. John R. Painter before 1936. From Johnny Carrey and Cort Conley, River of No Return (Cambridge, ID: Backeddy Books, 1978), 174. Used with permission.

Well, the New York fellow found out about it and pressed the matter. Painter landed in jail. but Painter had a woman who was a Western story writer on the string and she [Caroline Lockhart] bailed him out. She spent one summer at the mine and wrote a story named 'Man of the Bitter[r]oots' and something called 'The Wrangler,' I think. 'Man of the Bitter[r]oots' was Painter[,] of course. Somebody went to Wyoming and found he [Painter] just owned a few scrubby acres there with eight or ten cows. The Painter mine had a washing plant and water power. Lots of electrical equipment. He started about 1910 & in 1918 he was broke. Sold some of the machinery, wire etc. to some Jew[ish man] in Portland. Aiken said he'd boat it out for him. Started out in a scow and beached it above Mackay Bar. [Guleke] came by & said he'd get the stuff out. So the following spring [Guleke] came down & loaded 3 tons or more on a wooden scow. He took the stuff clear to Portland & tied up at the wharf. Come to find out this Jew[ish man] who'd bought the stuff had a second hand store about 4 blocks away. So you might say [Guleke] same as put it right in the fellow's back yard. The Jew[ish man] was so tickled that he took [Guleke] to his brother, who owned a clothing store, and said, 'Outfit this man from head to foot.' [Guleke] was tickled about that. He loved the river. Said it was [great] getting paid for something he dearly loved to do.[75]

On May 11, 1911, Shepp went over to Polly and Charlie's home again. He met Ira McGary there, and took two pictures, one of the Bemises' house (Fig. 5.5) and one of the Bemis Ranch "from point of hill across creek."[76] On Tuesday, May 16, another boat came downriver, at noon. Perhaps it stopped at Polly and Charlie's place, because Shepp and Pete went across in the afternoon, and Shepp "took 2 snapshots of boat on riffle." He also reported that Bemis and Polly caught three big fish. On the 20th, Shepp's cat, Mariah, had kittens in the morning, but "she [Mariah] killed them."[77]

On Friday, June 2, Shepp wrote, "Bemis cut tree for wood on river. He worked long & faithfully yesterday & today."[78] This comment indicates that Charlie Bemis could work hard when the occasion demanded it, and when he felt physically up to the challenge. On the 12th, Pete, who had gone up to town the day before, returned with the Gus Schultz family, who by then lived at the Del Rio Mine on the way to Hump.[79] Nellie Schultz and the two children stayed at Shepp's for nearly two weeks, while Gus did various things with Pete. They did not visit the Bemises at all; the river was too high just then. June 21 was daughter Helen's birthday, and Shepp took her picture; she was 10 or 11 years old. The Schultzes left on the 25th, and Shepp visited Polly and Charlie the next day. He reported that the river was down to just below

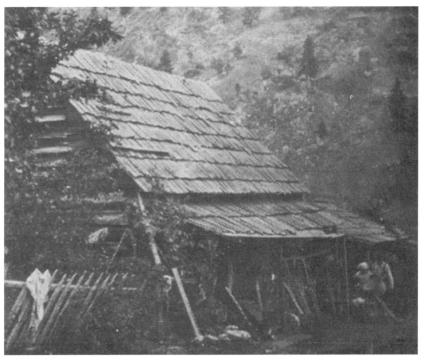

Fig. 5.5. *Possible Charlie Shepp photograph of the Bemises' home on the Salmon River, before 1922. From Johnny Carrey, "Moccasin Tracks of the Sheepeaters," in* Sheepeater Indian Campaign (Chamberlain Basin Country), (*Grang[e]ville, ID:* Idaho County Free Press, *1968), 43. Used with permission. Of the two figures in the lower right corner, Polly is on the left. The man on the right is unknown, but it isn't Charlie Bemis.*

the big stump at the Bemis boat landing, and that their cherries were just getting ripe. On Wednesday the 28th Shepp went over the river to dinner. He came home with about 30 pounds of strawberries and the next day made four gallons of strawberry preserves, using 21 pounds of sugar. Two days later he went back and got five 10-pound buckets of cherries as well as a bucket of strawberries.[80]

On the Fourth of July 1911 Charlie and Polly Bemis came over to Shepp's for a special dinner, at noon. He fixed fish, peas, and new potatoes, with both cherry pie and strawberry shortcake for dessert. Two days later Shepp visited them and "got lines for horses."[81] The following Monday he returned for four 10-pound buckets of cherries, which he put up for his own use. On the 14th he got raspberries, currants, and peas for Pete to take up to town to sell. On the 16th he wrote, "Bemis beans coming in bloom,"[82] referring to the bean seed he had earlier obtained from Charlie Bemis. Pete returned on

the 18th, with mail from Shepp's brother, Harvey, enclosing some pictures. Pete also brought down a cat for Polly to replace the late Tom. The next day, Shepp went over the river to dinner, perhaps taking the cat with him. He "gave Bemis pictures of his house." The morning of the 20th, Shepp went back across the river, because there was a "gov[ernment] survey [crew] down in 2 boats."[83] In later years, Pete Klinkhammer commented, "We recommended the name for Polly Creek. Thought maybe Polly would be remembered a lot longer than Bemis."[84] The government survey, published in 1914, did give the name Polly Creek to the creek on the Bemis Ranch that runs into the Salmon River[85] (Fig. 5.6).

On Friday July 21 Shepp reported that "Goddard & Jackson from Dayton [Washington], here this eve."[86] They stayed for a long weekend. On Sunday, the two guests "caught [a] mess [of] fish for Bemis." Shepp went over the river that afternoon, surely to deliver the fish; while there, he got a 10-pound bucket of raspberries. On Monday, his visitors gone, Shepp went over to the Bemises' for berries, potatoes, beans, peas, and onions. The next day, Pete took three horses and went up to town with the produce. On the 31st of July Shepp got a five-pound bucket of raspberries. He also "killed rattler on trail across river."[87]

The raspberries were for his own use, since the next day, he made some of them into a pie. On August 2 he went over and fixed a door for Polly and Charlie. Gus Schultz came down after his horse, Bob, and that evening, Gus and Pete visited the couple. Pete was going up to town in the morning, so Shepp went over early, with Gus, and got 100 pounds of potatoes, 30 pounds of cabbage, 20 pounds of beans, 12 pounds of rhubarb, and some onions from Charlie Bemis. On Saturday the 5th Shepp had dinner at Polly and Charlie's place, and made a hoe for Charlie. The next day, the couple came over to Shepp's for the noon meal. The following Thursday George Yarhaus, Art Hillyard, and a man named Laurie were at Shepp's for supper, and the next day they and Shepp went over the river.[88] On Saturday Shepp and Pete had dinner there, and Shepp got at least five pounds of blackberries.[89]

In mid-August Shepp went over and sharpened Bemis's scythe. He then returned a couple of evenings later and "made out order for Bemis' and our grub," because Pete was "going outside" in the morning, taking three horses, Bob, Baldy, and Polly.[90] On Friday the 18th Charlie and Polly came over to dinner, and on Sunday they reciprocated. The remainder of the month, Shepp crossed over twice and Pete went once to get cabbage and tomatoes.[91]

On September 1, 1911, Shepp invited Bemis and Polly over for dinner. Shepp's muskmelons were ripe so they enjoyed that treat. A couple of days later he crossed to get some sugar from them. Pete had gone to Grangeville

PLAN AND PROFILE OF
SALMON RIVER,
SALMON, IDAHO, TO RIGGINS, IDAHO
LITTLE SALMON RIVER,
RIGGINS, IDAHO, TO MEADOWS, IDAHO

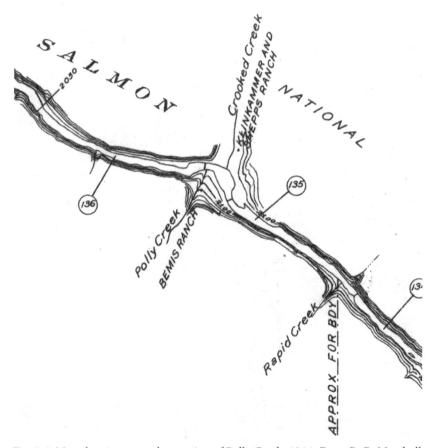

Fig. 5.6. Map showing an early mention of Polly Creek, 1914. From R. B. Marshall,
Profile Surveys in Snake River Basin, Idaho, US Geological Survey, Water-Supply
Paper 347 (Washington, DC: Government Printing Office, 1914), Map 26. "Rapid
Creek" should be Rabbit Creek.

again at the end of August. He returned September 6th with sugar and
Economy canning jars, among other things. Shepp went to Polly and Charlie's
for dinner on the 7th, and "fixed shoes for Julie," one of Bemis's or Shepp's
horses. The next day Pete shod Julie's front hooves. On Sunday the 10th Pete
crossed the river and continued up to Rabbit Creek. He "got Bemis' horses.

Brought Mary across river & shod her." On the 11th Shepp went over the river for dinner, noting "Becker down." This was surely John Becker, the owner of the Buck placer mine on Houston Creek in the Warren Mining District.[92] Pete was going up to town the next day, so Shepp got two boxes each of apples and tomatoes, 35 pounds of onions, and three dozen ears of corn. On the 13th Shepp visited the couple, and wrote that "Ryley [the stallion, Riley] served old Nellie." On the 17th, when Charlie and Polly visited Shepp's for dinner, they brought two buckets of tomatoes. Shepp saw them at their place at least seven more times that month. Several of those visits involved taking a horse across and once he got tomatoes to make catsup and preserves. The last time, on the 30th, he took Bill Boyce with him.[93] They went over after dinner. Boyce got tomatoes and "ground cherries" [strawberry tomatoes (*Physalis* sp.), also called husk tomatoes].[94]

During October 1911 there was frequent traffic back and forth across the river. On the 3rd Shepp went over in the morning, and wrote, "[John] McKay down river in boat."[95] Shepp crossed over again on the 5th, and "Bemis took boat over." On the 9th Bemis came over in the morning, and when he returned, Shepp and Pete went back with him and stayed to dinner. Shepp got 15 pounds of onions from Polly and Charlie on the 13th. On the 17th, Shepp went over in the morning, and in the evening, late, Pete returned from having been up to town. He brought the Bemises' winter supplies down with him. The next day they "took Bemis' stuff over river. All over but 8 sacks flour." In the afternoon, Shepp took the horses back across the river.[96] On Thursday the 19th "Pete & Bemis went up trail about 8-. I went over river after dinner & fed horses. Came home ... & went back over river at 5. Andy Henry & Mascam [unknown] at Bemis when I got there. ... Pete came back about 8 p.m. with Nelly [*sic*], Polly, & Julie [three horses]. Bemis took Bob & Baldy [horses] to Warren."[97] This passage indicates that Charlie Bemis and Pete Klinkhammer went to Warren for winter supplies, and that Shepp and the other men helped Polly with chores in Bemis's absence.

They may all have spent the night, since the following day, Shepp wrote that "Henry, Mascam & I came over this am. ... Pete H & M went over river this eve." Shepp took the horses across the next morning; Pete had spent the night at the Bemises' with their other visitors. Shepp went back again for Sunday dinner. On Monday Bill Boyce came down at noon. He went over the river and got some more "ground cherries." Bemis came over to Shepp's and got six pounds of nails. Shepp went over twice more that month, once for Sunday dinner and again on the 31st, with no reason given.[98]

On November 4, 1911, a Saturday, it was Pete's 31st birthday, so Shepp invited Bemis and Polly over to dinner. On Monday Pete shot a deer; he and

Shepp went up and got it the next day. That afternoon, Shepp took a quarter of it over to Polly and Charlie. Not until Sunday the 12th did Shepp take the Bemises' flour over to them. The eight sacks probably weighed 100 pounds each; Polly would have used her sourdough starter to make bread several times a week. The following Thursday Shepp went over in the morning and took them another quarter of meat, some eggs, and some pears. Bemis also visited Shepp and got the kraut cutter, some cabbage, and three magazines. Shepp had Sunday dinner with Polly and Charlie, and then did not see them for nearly a week because he was "under the weather." On Saturday the 25th "5 men went down river in boat. They camped at boat landing." Shepp went across in the afternoon, and Bemis came over and got some more magazines. On Monday the 27th Bemis came over again, and Shepp went to their place for dinner. The eddy was full of ice, so he "pulled boat out of water."[99]

On Saturday, December 9, Charlie Bemis went over to Shepp's at noon. To get there, he crossed on the ice, above the upper boat landing. He probably came to invite Shepp for Sunday dinner. Shepp went over the next day, crossing in his boat. He got a "saw gummer" [sharpener] from Bemis, and observed, "river froze over as far up as you can see." The following Sunday Shepp "washed & went over river" again. He took the Bemises three rolls of butter and a sack of buckwheat. That day, Pete went hunting and got two deer; the next day, Shepp took one of them over to Polly and Charlie. On Christmas Day, Bill Boyce came down, and they all went over the river for Christmas dinner with Polly and Charlie. They crossed in a boat, but "had quite a time with ice on this [Shepp's] side" of the river. Shepp also reported that his "cider started working," meaning that he was making hard cider rather than apple juice.[100]

1912

The year started out "cold as the devil." On Thursday, January 4, it was two degrees above zero at 8:00 a.m. Shepp and Klinkhammer started to go over to the Bemises' place, but met Charlie Bemis just above the Shepp Ranch gate, so the two men, and Bemis, returned to the house. Bemis "brought magazines over & took some back, also a few apples." Three days later, Pete visited the couple. Shepp was going to order seed for spring planting, and Bemis wanted some Queen onion seed.[101]

Occasionally there is unintended humor in the diaries. One sequence starts on Sunday, January 7, 1912: "Put George in chicken house." The following day, when it was 10 below zero at 7:00 a.m., Shepp "killed George, he weighed 4#." Then, on Sunday, January 21, Shepp wrote, "Bemis & Polly

over to dinner. Cooked George with noodles."[102] Shepp had kept "George" in Mother Nature's freezer for over a week.

Meanwhile, on January 12 it rained all night, and all day on the 13th. At 5:00 p.m. there was a big slide on the Bemises' side of the river. On Monday the 15th Shepp went to the upper boat landing, where he observed that the slide went nearly halfway across the river, noting, "Bemis started over but turned back." On Tuesday Bemis made it across, and Shepp gave him some apples. Two days later Bemis came over again, and "brought his saw set," a tool used to slightly bend saw teeth to keep the saw blade from binding as it cuts. On Friday, January 19, Shepp went across for dinner with Polly and Charlie, and visited them again Saturday afternoon.[103]

On Sunday, January 21, Shepp mentioned six horses by name: Jimmie, Polly, Bob, Mary, Julie, and Baldy. Apparently, he and the couple kept all their horses together, on one side of the river or the other, so it is difficult to determine who owned which ones. Another of the Bemises' animals was Fannie [sometimes Fanny], a dog that Shepp had mentioned earlier. Toward the end of the month Shepp wrote, "Fannie over here at noon. I chased her over the river after dinner."[104]

On Friday, February 2, Pete took a dozen eggs over to Polly and Charlie, and Shepp shot two deer on his side of the river. That Sunday Pete took half a deer and a jar of peaches over to Polly and Charlie, and they crossed over to Shepp's after dinner. Shepp didn't see the couple again until Wednesday the 14th. That day, his friend Hillyard came down for dinner with him, and they crossed the river in Shepp's boat that afternoon. Shepp wrote, "Ice all gone out of river." On Saturday Shepp took Polly and Charlie a dozen eggs and a jar of pears, and the next day he returned to have Sunday dinner with them. Shepp's friend Bill Boyce, possibly Hillyard's partner, came down to the river; he and Shepp crossed over for dinner with the Bemises.[105]

As the weather got better in March 1912, their mutual visits increased, mostly because Polly and Charlie often got milk. Shepp does not mention whether it was fresh or canned, but since he wrote about milking a cow, and about someone else getting a gallon of milk, the Bemises may have gotten fresh milk too, rather than canned; after 1897 they no longer seem to have had a cow. Apparently Shepp and Pete had more fresh milk than they could use, but we don't know whether the Bemises were simply getting some of the surplus, or whether they had underestimated the amount of canned milk they would need to get them through the winter.

The first Sunday in March Shepp went over there to dinner. He got some apple grafts and also took over a dozen eggs and some milk. Shepp took milk over on two more days that month, one time taking some seed, too, but

mainly it was Charlie Bemis who crossed the river to get milk, coming over for it six times that month. Once Bemis also got a dozen eggs from Shepp. He came over another time, to get a dozen eggs, but no milk, and also brought Shepp some meat. Charlie and Polly visited Shepp for Sunday dinner on the 10th. They also came over together for milk on the 20th. This was at noon, so they may have stayed to dinner then, too. Toward the end of the month, when Bemis came over for milk again, he brought a half-inch drill bit for Shepp, and told him that Polly had a toothache. On the 29th Shepp took Polly and Charlie's boat up to the upper landing.[106]

In April 1912 Shepp began to graft his trees, using some of the scions he had obtained from Polly and Charlie.[107] These included "Bemis wine sap, [Winesap]," "Bemis red fall," "Bemis red & one yellow," all apples. Shepp also mentioned that "Bemis took boat on his side," implying that they shared a boat. Early in the month, Shepp took milk and one and a half dozen eggs over.[108] A couple of days later, Bemis came over for some more milk and said that "his" [Polly's] chickens were beginning to lay eggs. On the 7th, Bemis and Polly had Sunday dinner at Shepp's, and went home with more milk. During the rest of the month, Charlie Bemis came over for milk seven more times. He also got some Burbank seed potatoes on one of those visits and brought over some meat another time. That month, Shepp and Pete planted onions, peas, lettuce, beets, spinach, radishes, early cabbage, tobacco, peppers, tomatoes, parsnips, two kinds of carrots, parsley, and 725 hills of early potatoes. Presumably the Bemises planted many of the same things.[109]

One evening, toward mid-April, Shepp noticed a "big flock of swans or geese flying round the river." On Tuesday the 23rd Shepp "sharpened drills" for Bemis. Then he, Pete, and Boyce all went over to Polly and Charlie's for the noon meal. Polly had caught a four-pound fish and cooked it for all of them. Later in the month Shepp also transplanted some strawberry plants from the couple—"1 row Bemis hulless & 1 row Bemis Corsican." On Friday the 26th he visited the Bemises and also went over the following Sunday for dinner. Orson James had come down the night before, and had spent the night at Polly and Charlie's place. James "cut Riley [illegible] for Bemis" while he was there, meaning that he gelded Charlie's horse. That day, Charlie also "came over & got boat." On the 29th, Bill Boyce came back from town in the morning. Either he, or a letter from Shepp's sister Nellie, had some big news; Shepp "first heard of the loss of the *Titanic* by hitting an iceberg."[110]

Charlie Bemis visited Shepp on May 1 and Shepp "gave him tools … to fix gun." Bemis got milk on the 4th, and he and Polly came for Sunday dinner on the 5th. Bemis obtained more milk on the 7th and brought some meat and fish to Shepp and Klinkhammer; Pete crossed over "to see old Nellie," one of

the horses. On the 9th Shepp went to the Bemis place, Bill Boyce took the boat over on the 12th, and on the 15th, Pete crossed. That same day, Shepp transplanted 17 Winningstadt and 12 Wakefield cabbage plants that he had gotten from Bemis.[111]

On Friday the 24th Shepp went over to Polly and Charlie's' place for dinner. At home, he planted 92 hills of watermelons, as well as some muskmelons, cucumbers, and string beans. On Sunday the 26th, he crossed over the river in the afternoon to get some cabbage plants. He "met some one coming down river, at boat landing," and observed that the river was "coming up fast." While Shepp was out planting squash and pumpkins on the 28th, he could see that "some man" was over at the Bemises' place, cutting wood. On Thursday, May 30, he wrote, "some one wanted to cross river this am, too high, I wouldn't cross.[112]

The river was still high during most of June 1912, so Shepp did not cross until the end of the month. By the 14th, his strawberries had begun bearing, so he "had strawberry short cake;" by then, Polly and Charlie may also have been enjoying this delicacy. The morning of the 14th there was "snow at head of Bemis [C]reek" [now Polly Creek], but just over a week later the temperature reached 80 degrees. That day, the 22nd, Shepp observed "some one over at Bemis," and on the 25th he noticed that "Bemis got some one cutting hay." Shepp was finally able to cross the river on Sunday the 30th. He got two 10-pound buckets of cherries and learned that "Wagner" was the person who was over there.[113]

A man named Ed had arrived at Shepp and Pete's on June 4th, and stayed with them for more than a year, until early August 1913.[114] On Monday, July 1, 1912, Shepp and Ed went over to visit Polly and Charlie. Wagner had intended to go to Hump, but it rained. Shepp got a Montgomery Ward order from Polly; back home, he "put up" [canned] the cherries he had already gotten from the couple. The next day, Wagner left for Hump, probably taking Polly's order with him, and Ed went over and picked two more 10-pound buckets of cherries, yielding six quarts when he canned them on the 3rd. On Independence Day, July 4, Polly and Charlie went over for dinner; Shepp served them new potatoes and peas. That morning, a Mr. Coulter had crossed the river from the Bemises' side on his way to Hump.[115] The following day, "Bemis took in part of his hay." On the 8th Shepp and Ed went over in the morning and got one 10-pound bucket of cherries and one 10-pound bucket of gooseberries for their own use. Because Pete was going up to town the next morning, Polly sent up onions, currants, and blackcap raspberries for sale. That evening, Charlie Bemis rowed over to Shepp's.[116]

Late on Thursday, July 11, Pete and Ed went over for more berries, and on Saturday the 13th Shepp crossed over in the afternoon and got raspberries. Although Charlie Bemis was ill, he must have improved by the following day, since he and Polly were at Shepp's for Sunday dinner. Shepp had killed a rooster the day before, and wrote that they "had rooster for dinner." On Monday the 15th Pete went to the Jumbo Mine with four packs of produce to sell.[117] Some of it may have been from Polly and Charlie, although that is not stated explicitly. That day, Shepp and Ed went over for two 10-pound buckets of raspberries; they also stayed to dinner. On Wednesday the 17th Pete came back to the Shepp Ranch with the Schultz family. "Allen from Grangeville," probably Bill Allen, formerly of Callender, was also with them; he was on his way to Warren. Shepp took Allen's horse over the river that evening and also "got a clock" that day, either in the mail or from the Bemises. The next day, Gus and Pete went up to the Blue Jay Mine to work for a week, while Mrs. Schultz and the children stayed at Shepp's. With the river low enough to cross, there was some visiting visit back and forth. On Friday the 19th Shepp and the Schultz family all had the noon meal at Polly and Charlie's. Shepp got another bucket of raspberries, and reported, "Blake down from Warren." The next morning Shepp went over, got Blake, and took him across the Salmon River.[118]

On Monday, July 22, Shepp got more raspberries from the couple. On the 24th Polly and Charlie came over to dinner and Polly brought two dozen eggs. On Friday Shepp took Mrs. Schultz and the children over to the Bemises' in the afternoon. He killed a rattler at the "mud hole," and reported that Polly was ill. An entry on Saturday the 27th is ambiguous. It reads, "Gus & family over after dinner." Perhaps they had spent the night at the Bemises' place, even with Polly sick. However, Pete and Gus had come back from the Blue Jay the evening before, and there is no mention of Gus going across the river. Charlie Bemis took the boat over the river. On Sunday the 28th the Schultzes and Pete went to the Del Rio Mine. Shepp stayed home and wrote that he "found a crazy Swede, took him across river."[119]

During August 1912, Shepp and Pete frequently crossed the river. On several occasions Shepp got produce from Polly and Charlie, sometimes for himself and sometimes for Pete to take up to town to sell. In all, that month he got five 10-pound buckets of blackberries plus one 5-pound bucket of blackberries for his own use. To sell, he got cabbage four times: once 15 pounds of it, twice an unstated amount, and another time 30 pounds. He also got 10 pounds of beets, 44 pounds of string beans, and some onions. Besides getting produce, Shepp and Klinkhammer went over the river for other reasons, not always stated. On the 8th, Pete watered the Bemises' beans

and beets. Shepp mentions taking a few pictures, one at the Blue Jay Mine and another of a load of hay at the Bemises' place. While there, Shepp also killed a rattlesnake on the trail and Pete killed one in the garden.[120]

In mid-August Shepp went across and upriver to Orson James's place. He found a big boat and a raft below Rabbit Creek, so brought them down to his upper boat landing. On the 16th, Pete visited Polly and Charlie, "took hat & HHH over," and reported that the weather was "Cloudy & cool."[121] HHH was probably Horseman's Hope Horse Medicine, patented in 1867, and known for short as H.H.H. Horse Medicine (Fig. 5.7). It contained "52% alcohol, [plus]

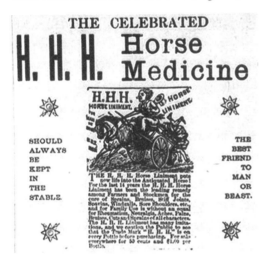

Fig. 5.7. Advertisement for H. H. H. Horse Medicine, "The Best Friend to Man or Beast," 1895. In The Daily Bulletin (*Honolulu [Hawaii]*), *February 22, 1895, from Chronicling America: Historic American Newspapers, Library of Congress, available at https://chroniclingamerica.loc. gov/lccn/sn82016412/1895-02-22/ed-1/seq-4 (accessed October 15, 2019).*

camphor oil, wintergreen, cedarwood, camphor soap[,] and ammonia," and was advertised as "The Best Friend to Man or Beast."[122] Whether the Bemises gave it to their animals and/or used it on themselves is not known.

The following day Shepp got some cabbage and onions from the couple; Pete would take that produce up to town the next morning. Shepp visited the Bemises again on the 20th and wrote, "Polly got rheumatism again." On the 22nd he took a cider mill over to them. On the 25th Polly and Charlie had a visitor, Alex McDonnald [sic].[123] He probably spent the night of the 24th with them, because Shepp went to get him in the morning, entertained him for dinner and supper, and took him back in the evening. Since McDonald intended to go up to Orson James's the next morning. he probably spent the night of the 25th with Polly and Charlie.[124]

An unusual event occurred on Tuesday, August 27. Polly came over to Shepp's for the noon meal without Charlie, who remained at home; we cannot tell from the diary if she rowed the boat herself, or if Shepp came over to get her. Shepp must have taken her back home, because he wrote that he had a

piece of watermelon at the Bemises' place. On Saturday the 31st Shepp went across and got a store order from Charlie Bemis.[125]

Shepp returned there again on Sunday, September 1, 1912, and got 22 pounds of onions, 22 pounds of beets, 30 pounds of cabbage, 14 pounds of tomatoes, and 170 pounds of Burbank potatoes for Pete to take up to town the next day. He also commented, "Polly our horse dead." Two days later Shepp got a piece of chicken wire from Bemis to put around his pear tree. When Pete came back on Wednesday, he had "some fellow with him" who was on his way to Warren. The man spent the night, and the next day Pete took him over the river.[126] There are no diary entries from September 6th through September 30th. If Shepp went "outside," to Grangeville or beyond, he did not mention it in his diary, and the entries that start in October give no indication that he had been away.

On October 2, 1912, a Wednesday, Shepp had Polly and Charlie over for dinner. That Saturday, Pete and Ed got apples from the couple. On Sunday Shepp went over the river in the afternoon. That day he also wrote a few letters for Pete to take up to town the next day; one was an order for shoes for Charlie Bemis from Montgomery Ward. Polly and Charlie had some overnight company on Wednesday the 9th or Thursday the 10th; the date is uncertain because the people arrived while Shepp was helping Bill Boyce bring down a deer that he had shot. On October 9, a surveyor, R. Moses, and his helper, Denny, other name unknown, had come downriver to survey the Shepp Ranch. They spent the night at the Bemises and started the survey on the 10th. That day, Pete and Boyce took all the horses but one across the river because Pete, Boyce, and Charlie Bemis were going to Warren the next morning. Shepp helped the surveyors on the 11th, and they finished in the afternoon, putting in nine corners in all. That evening, Shepp and Moses took part of the deer and a box of candles over to Polly. Pete returned from Warren that same night, and Charlie Bemis got home on the 13th.[127]

Pete spent the night of the 11th at Polly's and went home the next day, taking 20 pounds of lard and a sack of sugar over to the Shepp Ranch; Shepp crossed the river on Sunday afternoon to get more of their supplies.[128] On the 14th, Shepp, Pete, and/or Bemis brought the horses back across the river as well as eight boxes of apples. Pete went up to town [Concord, Dixie, or Grangeville] on the 15th and returned on the 17th. He "brought all our stuff down," i.e., purchases he had made in town. Pete went over the river on the 18th and Bemis crossed on the 19th. Pete went up to town again on the 20th, and on the 21st Bemis came over again and "took all his stuff over." Shepp visited Polly and Charlie on the 24th. Pete was in town until the 26th, but

their winter freight, from Grangeville, did not come in while he was there. The next day Pete took one of the horses, Billie, across the river.[129]

November 1912 began with Pete hunting, unsuccessfully, on Bemis Ridge. Shepp had ordered a mower and heard that it had reached Concord. Sunday the 3rd, Bemis, Polly, and Boyce were at Shepp's for dinner. He served them "the 2 young roosters." On the 4th, Shepp, Pete, and Boyce went up to Concord, because Tuesday the 5th was Election Day. Altogether, fifteen people voted there. Shepp and Boyce came home on the 6th and "brought down rubbers & shoes for Polly" as well as a "plow share for Bemis." Bemis crossed over on the 7th, and on the 10th, he and Shepp exchanged visits. Shepp took some raspberries over, and got half a sack of coal, probably for blacksmithing purposes. Although Shepp did not say that their freight had arrived, a notation at the bottom of this page of the diary reads, "Bemis bill [$]58.61" and "Freight 968 [pounds] = [$]21.78."[130]

In mid-November Shepp went over and got two boxes of Bismarck apples.[131] On Sunday the 17th, Bemis, Polly, and Bill Boyce were at Shepp's for dinner. That day, Shepp's "bull served cow"; having a calf would help ensure that the cow continued to give milk. Monday, Shepp went over and "gummed saw for Bemis."[132] On Thursday Alec [Alex] McDonald was at Polly and Charlie's again. Friday, Shepp and Ed went over there, and McDonald returned with them. On the 27th Pete returned to the Bemis Ranch after having been gone since Election Day. He brought mail, including a letter from W. F. Bemis, Charlie Bemis's brother.[133] Thursday the 28th was Thanksgiving. "All of us" [i.e., Shepp, Pete, Boyce, and Ed] went to the Bemises for a chicken dinner. Although there was "quite a little ice in eddy," they were able to cross by boat above the eddy.[134]

In December, Shepp visited the couple on the 14th. He could cross the river by boat, but "had to cut ice on the other side." On Christmas Day, Boyce came down again, and the four men celebrated by having dinner with Polly and Charlie. Shepp reported that they crossed in the boat, and that there was "hardly any ice." The year ended with the "hardest wind [Shepp] ever saw on Salmon [R]iver this eve."[135]

1913

Charlie Bemis went over to Shepp's in early January, crossing on the ice above the boat landing. On the 12th, Shepp returned the visit. He had probably suggested that Charlie should make out his seed order, because on Monday the 13th Bemis came over for the noon meal, Pete went up to town afterward, and Shepp wrote, "Sent for seed." He visited the couple again on the 21st, and observed that they had about 18 inches of snow. On Wednesday

the 29th, Ed crossed over to the Bemises' place to enjoy the noon meal with Polly and Charlie.[136]

In February, Polly, Charlie, and Bill Boyce had dinner at Shepp's on the 10th. That was the only time the couple crossed the river together that month, although Charlie Bemis, by himself, visited Shepp on the 27th. Shepp, however, visited the Bemises numerous times. Usually, he provided a reason for coming over. For example, on the 1st, he "took 10 eggs to Polly." On the 7th he "cut wood for Bemis." On the 8th he and Ed went over for dinner, but cut wood first; Ed became ill afterward, so returned home before eating. On the 12th, Shepp got a sack from the Bemises. By the 18th, Ed must have been better, since he went over to Polly and Charlie's in the afternoon. On Saturday the 22nd, Shepp and Ed went over to dinner again. Bemis was sick, so they cut wood for him. The next day, Bill Boyce came down to the river. He and Shepp went over to the Bemises' place for dinner and cut wood. Bemis, who was "still sick," must have thought he might die; he wrote a will and Boyce witnessed it.[137] Bemis, then about 65, would actually live for another nine and a half years.

Pete finally returned on the 24th, and on the 25th Shepp, Pete, Ed, and Boyce all went over and cut wood for the Bemises, and on the 27th Pete and Ed went over and "turned cattle on hill," meaning that they turned the cattle out to forage for themselves.[138] By then, there would be grass growing where the snow had melted.

On Saturday, March 1, 1913, Shepp visited the Bemises in the morning, perhaps to invite them to Sunday dinner, since they came across for that the next day. A week later, Shepp went over there in the morning, and took Polly and Charlie a dozen eggs; Bemis's illness continued. On Sunday, March 9, Shepp, Boyce, and Ed all went over the river and cut firewood for the couple, because Bemis still hadn't recovered. Shepp intended to return there on Monday, and started out, but the ice "looked too rotten" so he turned back. On Tuesday he was able to cross in the boat, and took the couple one and a half dozen eggs. The next day Shepp "saw a big cougar track up on bench," on his side of the river. By Friday, when Shepp crossed over again, Bemis was better. Shepp went hunting over there on the 15th, and got nothing, but it would have given him a chance to see if Bemis was improving. He was over there again both Wednesday and Thursday, and on Thursday, Bemis had recovered sufficiently that he could go hunting up on the hill. Although he "got a shot," he "didn't get anything." Finally, on Sunday the 23rd, Bemis was well enough that he and Polly could go over to Shepp's for dinner. When Shepp visited them on the 25th, Polly had a sore back, which may be why Orson James came and stayed with them from the 26th to the 27th. Shepp went over

on the 27th, and on the 29th he saw Bemis and Polly both fishing. That day, he reported some bad news—he heard that in February, Alex McDonald had left Warren for James's, but never reached there, and was presumed lost. On Sunday the 30th Shepp went over to the Bemises' for dinner; Polly probably served the two fish that she had caught the day before. Shepp also "cut down tree on river for Bemis."[139]

On April 3 Shepp cut some firewood for Polly and Charlie, but after that, Bemis was apparently fit enough to do his own woodcutting. On the 6th Shepp got a fish from him, and on the 9th he took some eggs over, got another fish, and got "Blue stone" from Bemis.[140] On Friday the 11th, when he went over again, Polly gave him a fish. He also moved the boat up to the upper landing. On the 13th Shepp, Boyce, and Ed went up to James's, and perhaps visited with the Bemises on the way. They "met Otterson & young Shafer [Shiefer] up there," at James's.[141] Shepp took another one and a half dozen eggs over to the couple on the 17th, visited them again on the 19th, and returned a week later, when he took Polly and Charlie some more eggs.[142] The implication from the diary is that these eggs were not for eating, but were for hatching under a broody hen. Chicken eggs hatch in about 21 days, and sure enough, Polly would have some chicks by then.[143]

On May 1, 1913, in honor of spring, Shepp put on his new overalls and visited the Bemises. On Tuesday the 6th Bill Boyce went over there and "blasted rocks in potato ground"; Shepp "took powder fuse over." Boyce stayed there until the 8th and then went home about noon. On Sunday the 11th Shepp wrote that he "Made beer," underlining those words for emphasis. A week later, he bottled it. Meanwhile, he had begun to plant his garden, and on the 14th he went over and "got some cabbage plants from Bemis." Toward the end of the month, when he planted 54 of them in his "old tobacco ground," Shepp identified them as early cabbage. When he visited the Bemises on the 19th, he learned that "Polly got 2 chicks, 1 white;"[144] probably from the eggs he had given her earlier.[145] Pete shot a deer that afternoon,[146] and the next day Pete and Ed went up and got the rest of it. Shepp took half of it over to Polly and Charlie, and "got some grape cuttings from Bemis." On May 22, Shepp, Pete, and Ed went over, but had dinner at James's on their way up to Frank Jordan's place; he lived three and a half hours away.[147] On their return the following day, the three men found Bemis at the boat when they got down to the river. Five days later, Shepp planted another 20 cabbage plants from Bemis; these were all late cabbage.[148]

Shepp and the Bemises spent little time together in June, probably because the river was too high to cross safely. At mid-month, Shepp heard Bemis shoot his rifle twice one evening, and also saw a deer across the river. Not until the

24th did Shepp cross. That afternoon, he got some cherries and a 10-pound bucket of strawberries, but noted that the cherries were "hardly ripe." On the 29th he went over again for some more cherries and strawberries, and also "cut part of brush on trail."[149]

In early July Shepp and Pete went up to Concord for their mower. On July 4th, Shepp celebrated with Polly and Charlie, and also got eleven 10-pound buckets of cherries. The next day, Saturday, he put up the cherries in 12 half-gallon jars, without sugar. He also "put the mower together." On Sunday, Bemis and Polly came over to dinner; they were probably invited to see the new mower in operation, because that afternoon, in the 100-degree heat, Shepp cut part of a meadow with it. Two horses, Bob and Mary, pulled the mower. Rowing the couple back, Shepp broke an oar, but fixed it on Monday. On the 8th, Bill Boyce came down, had dinner with Shepp, and then went "over river to cut hay for Bemis." When the hay was ready to be hauled, Shepp took Ed across to help Boyce. After being at Polly and Charlie's for nearly a week, Boyce returned that afternoon and went home. On Sunday the 13th, Ed continued hauling hay for Bemis. On Monday, Shepp went over in the afternoon and brought Ed back. He got two 10-pound buckets of raspberries, one 10-pound bucket of currants, and some gooseberries and rhubarb. These were for his own use; he canned them the next day. On the 16th Ed returned to Polly and Charlie's to help put up the rest of the hay. The next day, Shepp and Pete crossed over for some raspberries and string beans, and Ed came back with them. Shepp canned the raspberries, but Pete likely took the string beans up to town to sell. On Saturday the 18th, Shepp was at the Bemises' all day, and on the 23rd Polly and Charlie both visited him for dinner. On the 26th Shepp got a piece of meat from the Bemises, and the next day he got some berries from them.[150]

Orson James and Boston Brown visited Shepp the night of July 31, and the next morning Shepp took them across the river.[151] On August 4, Shepp and Ed went over for some blackberries, and on the 9th Shepp got two 10-pound buckets of them, and canned them the next day. On Monday the 11th, Shepp, Ed, and Pete all went across to the Bemises' place. It gave Ed a chance to say good-bye to them, since he was "going outside" the next day, after living at Shepp's place for more than a year. On the 17th Shepp crossed to get tomatoes from the Bemises. On the 19th he got some more of them, and also took over two pounds of butter and 10 pounds of lard. He visited them again on the 21st, perhaps to tell them that he had seen a bear. The following Sunday, another 100-degree day, Bemis and Polly came over to dinner. On Tuesday, Pete and Boyce visited the couple, and that afternoon, after coming home, Pete killed a bear. He came down and got Shepp, and they went up and brought the bear

down in a wheelbarrow. Wednesday morning, Shepp took half of it over to Polly and Charlie, and saw two more bears. The next day, Boyce went over to cut hay for the Bemises. Shepp rendered nearly 15 pounds of bear grease, as the Bemises may have done with their share.[152]

On September 1, 1913, Shepp crossed the river and subsequently commented that Bemis was "taking in his hay," probably meaning that he was putting it in his barn. Two days later Shepp returned over there for 10 pounds of sugar and nearly 25 pounds of bacon. He also got some tomatoes to can, and went back on Saturday as well. On Sunday, Bill Boyce came down. He, too, had shot a bear, and brought part of it down for Polly. That day, Shepp took a grindstone over to Charlie Bemis. Thursday the 11th a man came down the river in a boat. He spent the night at the Shepp Ranch, and camped in the garden. Shepp, Pete, and the traveler, Moore, all went over the river to dinner; Shepp wrote that Polly was ill.[153] When Moore left the next day, Shepp sold him two dozen eggs for 50 cents. That afternoon, Shepp went over to see Polly and Charlie. On Sunday the 14th, Pete left for Grangeville, and the Bemises visited Shepp for Sunday dinner. On Tuesday Bill Boyce came down and went over the river and got a box of apples. Two days later, Shepp made three gallons of catsup and on Sunday afternoon he took a bottle of it over to the Bemises. In exchange, Shepp got two pullets from Polly; he also learned that Bemis was ill. Shepp visited them again on the 23rd and the 24th, and had dinner with them on the 26th; that day, John Becker was there, too.[154] Shepp also went over on the 28th. One day he saw an otter, and another time he saw a little brown bear, but it isn't clear what side of the river they were on. Shepp apparently had trouble with coyotes stealing his melons; he wrote, "coyotes took melons I put cyanide in."[155]

Meanwhile, from September 18 to October 8, two Government Land Office surveyors made a detailed map of that area from their earlier survey. It included Orson James's place as well as a cabin at the mouth of Warren Creek. Two trails are the most intriguing features on this map. One is the straighter "Warren to Salmon River Trail," following Warren Creek, and the other is the "Warren to Salmon River Winter Trail," with numerous switchbacks[156] (Fig. 5.8).

Although not mentioned in Shepp's diary for September 1913, the B. A. Baerlocher party inspected mining prospects in the region, visiting the Jumbo Mine. It was

> located on the Salmon River divide about thirteen miles from the river. From here, the trail led down to where Peter Klinkhammer and Charles Shepp had their homestead—across from where the Chinese girl, Polly Bemis, lived with her white husband until his death, and

Fig. 5.8. *Warren to Salmon River trails (arrows), 1914. From Government Land Office plat of T24N R7E, surveyed by Albert Smith, Jr., and Ray D. Armstrong, 1914. Available at https://glorecords.blm.gov/details/survey/default.aspx?dm_ id=40256&sid=pqtobjkh.chl#surveyDetailsTabIndex=1 (accessed October 15, 2019).*

afterwards, alone. At the time, 1913, she had a beautiful garden there.[157]

In October 1913 Shepp went to Polly and Charlie's on numerous occasions, but not for the noon meal, for which they only visited him once. From the couple, during that month, Shepp got two and a half gallons of pear preserves,

as well as onions, beets, and cabbage; 50 pounds of beans for the Jumbo Mine; 50 pounds of onions; and some apples, peaches, and ground cherries. He also got some eggs from Polly. In the diaries, Shepp often kept a tally in the margin showing the number of eggs his hens produced each day; it had been "0" for several days. Sometimes Shepp took things over to the couple, including a quarter of meat, a package for Polly from Ed, all the Bemises' winter supplies from Grangeville, and some eightpenny nails. Other chores Shepp did with and for the Bemises included putting up a stove; moving the boat up for the winter; and bringing the horses, Bob, Mary, and Julie, across the river, with Bemis's help. Shepp also stretched a bear skin, perhaps for Polly and Charlie. Pete, too, was over at the Bemises' place several times. When Pete killed a deer and a bear toward the end of the month, and Shepp got another bear the next day, Pete took the front half of one bear over to Polly. Bill Boyce also visited them once, and got some peaches. On the 15th, Shepp recalled that a boat with two women, two children, and three men had gone down the river the previous Saturday, the 11th.[158] Apparently, they did not stop at either ranch.

Shepp had been raising cattle to sell for meat, and on November 1st he killed a red heifer. Since Bemis and Polly came over for dinner on the 5th, Shepp perhaps cooked some of it for them. After Shepp reported that he killed a steer on the 9th, he also mentioned that Bemis got 18 pounds of meat, but it is not clear whether Charlie bought it or if Shepp gave it to him. Two young fellows from the South Fork stayed at Shepp's for a night, went downriver, returned a few days later, and crossed over the river. On Tuesday the 11th Shepp "killed old rooster," and then served it to Charlie and Polly when they came over for dinner two days later. Shepp also sent for something [illegible] for Polly, perhaps glasses. He crossed over on the 17th for no stated reason. On the 18th, however, he took Charlie "Trawl" [Troll?] over.[159] Two days later, Shepp crossed to get some wire from the Bemises; and on the 23rd he visited them again. Thursday the 27th, Shepp had Thanksgiving dinner with Polly and Charlie, and on the 29th, he brought back his dog, Teddy, who had crossed over the night before. On the 30th, Charlie and Polly Bemis came over to Shepp's for Sunday dinner.[160]

On December 6th Shepp wrote, "Bemis called across river this afternoon." Bemis probably invited Shepp for Sunday dinner, since Shepp went over there then. He visited them again the following day, too. On the 10th, Pete killed a deer, so Shepp took Polly and Charlie some meat. Tuesday the 16th, Bemis came over to Shepp's; he crossed on the ice. Shepp did the same when he went over there the following Sunday. Bemis returned to Shepp's on the 24th, undoubtedly to invite Shepp over for Christmas dinner the next day. Shepp went, and had Charlie and Polly over on Sunday the 28th. Orson James had

been there, but it wasn't clear if he was still there that day, or had gone back upriver to his home.[161]

1914

In January 1914 Shepp and Bemis each crossed the river once. We know that Pete was not living at the Shepp Ranch at this time, since he and a man named Kelly came down at mid-month and crossed over to the Bemises' place.[162]

In February, Bemis came over just once, crossing on the ice. Shepp shoveled snow out of the boat and cleaned it up. After the river thawed, he crossed over in the boat several times. Sunday the 22nd Shepp wrote that he "started to save pullets' eggs," meaning that he was saving them for hatching, rather than for eating.[163] On the 23rd Shepp shot a fawn, and the next day he took some of the meat over to Polly and Charlie. Pete and Kelly may have visited them when they crossed to go upriver to James's on the 26th, and Shepp also crossed over that same day. On the 27th Pete and Kelly came back with some mutton from James. Shepp took Polly and Charlie a tire for their wheelbarrow, as well as a bucket of eggs.[164]

That March, Shepp went over on the 3rd, perhaps to invite the Bemises to Sunday dinner, since they and Boyce were there for it on the 8th. At midweek, Shepp "took setting eggs over to Polly. 6 [from his hen named] Maud & 7 [from his hen named] Polly: She [Polly Bemis] put them under hen this a.m." He shot another fawn the following day and took some meat to the couple on Saturday. Bemis, Polly, and Bill Boyce had Sunday dinner with Shepp again, on the 22nd, and on Monday he reported "snow on top of hill back of Bemis." Shepp visited them on the 26th for the noon meal, and on the last day of the month he went over in the morning and brought them a sack of flour.[165]

In early April 1914 Shepp took Polly and Charlie "some late pear scions," probably for them to graft onto their pear trees. The following Saturday Shepp "killed flop comb, she had been sick for a week"; "flop comb" was one of his hens. On Sunday he wrote, "Bemis & Polly over to dinner," so perhaps he served "flop comb" to them. The next day he observed "Bemis plowing." Shepp went over on the afternoon of Sunday the 12th. Polly gave him a fish, and he noticed that their sweet cherry trees were in bloom. On Friday the 17th he commented, "2 fellows down river in boat. One of them was down last summer." Shepp also went over the river that afternoon. By then, Pete had come back to live at the Shepp Ranch. On Saturday, Gus Schultz came down to visit Shepp and Pete, and the next day Gus and Pete went over the river and got 12 dozen eggs from Polly. Schultz left later that morning so he may have

taken the eggs up to town to sell for her. Late that month, Shepp visited the couple again and took "took 50# [pounds] sugar over.[166]

During the first week in May two men came down the river in a boat. From them, Pete and Shepp bought a boat, three sacks of flour, two shovels, six picks, and "some other junk" for $20, and Shepp "gave the boatmen 3# [pounds] of coffee." On Sunday the 10th Shepp visited Polly and Charlie and took them a scythe and some fruit preserves. He had dinner with them the next day, and visited them the following Monday also. That time, he took the couple three pounds of coffee, and mentioned that the Bemises had some visitors, "2 fellows from James down to Bemis." While he was there, he learned that Bemis had killed a deer the previous Saturday. By Friday the 22nd Shepp noticed that the snow was "all gone at head of Bemis [Polly] Creek." He went over on Tuesday the 26th, and learned that Bemis had gotten another deer that morning. The last day of the month Shepp and Pete crossed over. Shepp stayed at the Bemises' all day, while Pete went up to James's place.[167]

Snow was back at the head of Polly Creek in early June. Shepp went over a couple of times in mid-month, once to visit James. By the 21st the couple's cherries were becoming ripe, so Shepp went over and got four 10-pound buckets of them. He went over again on the 26th and 27th, and Polly and Charlie visited him for Sunday dinner the following day; Shepp served new potatoes.[168]

Charlie Shepp visited the couple on July 1, 1914. Two days later, Bill Boyce came down in the morning, and Shepp took him over the river by boat so he could cut hay for Charlie Bemis. The next day, the 4th, Shepp went over there for dinner to celebrate Independence Day, and Boyce went home afterward. On the 7th, Shepp's dog Teddy, here spelled Teddie, crossed the river, and Shepp went over to get him. Two days later, Pete and Boyce went over to Polly and Charlie's and got some black raspberries; once home, Shepp "wrote for Victor [record] catalog." That month, it was "hot as the devil," and Shepp went over to the Bemises' place six more times. Once, he killed a rattlesnake over there, another time he got beans and eggs, and toward the end of the month he "tryed [sic] new gun. Got 2 grouse." Meanwhile, some phonograph records arrived that he had ordered. Toward the end of the month, "2 forest men" named Knighton and Carter, probably Forest Service employees, spent a night at the Shepp Ranch, and may have visited Polly and Charlie with him.[169]

August was a busy month for all of them. The main event was the arrival of Shepp's new phonograph, and some more records, on the 14th. Before that, Bemis and Polly had been over for Sunday dinner on the 2nd, and on the 4th Shepp visited them and got a 10-pound bucket of blackberries. He went back on Monday the 10th, and on the 11th reported that he "saw a bear in Bemis'

alfalfa this afternoon." On the previous two days, on his side of the river, he had seen a "big bear on hill above house," and a "little black bear" across Crooked Creek. Shepp shot a porcupine in the doorway of his chicken house on the 12th, and on the 13th he went over to the Bemises' in the afternoon. He reported that it was a "fine day" but "awful smoky," and "hot as the devil."[170]

On Friday, August 14, 1914, Pete came back from town with the phonograph and records. Shepp wrote, "the phonograph not the one we ordered, but a cheaper one."[171] The next day, he went over to Polly and Charlie's in the morning, presumably to tell them it had arrived, since they came over to his place that afternoon. They returned for Sunday dinner on the 16th, and Shepp wrote that he "recorded some records on Bemis' machine."[172] In later years, Pete Klinkhammer recalled that Shepp

> built his own radio sets. These delighted Polly, but completely mystified her. Even more to her delight was the old phonograph. Tho [sic] how the voice could come out of that big horn amplifier was ever a marvel to her. One record concerned a Chinese laundryman[,] and Uncle Josh's troubles invariably made Polly chuckle[173] (Fig. 5.9).

Shepp visited the Bemises again the next day, perhaps to see if they needed anything from town, since Pete was going up there. Shepp sent $4.50 with Pete for more Victor records. Beginning on the 22nd he began reporting on a big fire on his side of the river, and saw a black bear in his orchard that evening. From the 23rd through the 26th he and Pete helped fight the fire. Another man, name unknown, assisted them; he was hired by John S. Bigley of Robinette, Oregon.[174] The fire must have been out by the 28th, because Shepp went over to Polly and Charlie's and learned that a bear had been eating their apples. Three days later, "Bemis got a bear." Bigley spent the night of the 30th at the Shepp Ranch because he was going to Warren the next day. In the morning, Shepp took him across the river, and in the afternoon Shepp and Pete went to Concord.[175]

At Concord, on Tuesday, September 1, Shepp and Klinkhammer voted in the primary election, and then Shepp returned home. He visited Polly and Charlie the next afternoon, and a couple of days later he took them a sack of flour. On Saturday he could see that there was "some one with mules over to Bemis," and on Sunday he crossed over to find out that it was Sid Robbins.[176] Pete Klinkhammer and Gus Schultz came down that evening. They brought all but one of the records Shepp had ordered from Victor. The next day, Bemis, Polly, and Sid Robbins were at Shepp's for dinner; everyone surely listened to the new records. A couple of days later, Shepp went to the Bemises' and filled two flour sacks with apples; Sid Robbins was still there. Friday, Shepp went over for dinner and learned that Sid had left the day before. He also got

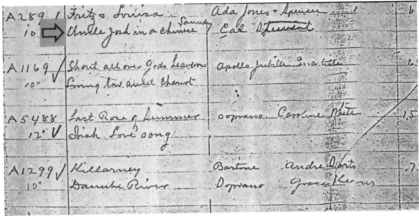

Fig. 5.9a. Charlie Shepp's record list, compiled between 1914 and 1917, showing "Uncle Josh in a Chinese Laundry" by Cal Stewart. Charles Shepp, [Diary], June 1 through December 31, 1917, photocopy, University of Idaho Library Special Collections, MG 155, ledger page number 158. Used with permission.

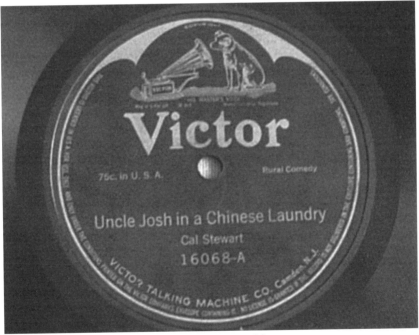

Fig. 5.9b. The record's label. Courtesy www.45worlds.com.

"Polly's bill for grub," meaning that Polly gave him a list of what the couple needed in the way of winter supplies.[177]

By mid-September, winter was on its way. On Saturday the 12th, Shepp saw "snow on hill above Bemis." He visited them on the 16th, but didn't mention

any reason for going. On Saturday the 19th he got a box of apples from them and two days later he got another box of apples and some Bartlett pears. On the 24th he got more apples and some onions from Bemis and the next day he got two more boxes of apples. Sunday the 27th Bemis and Polly visited Shepp for Sunday dinner; however, they "left before Charley [Charlie] had finished his dinner." Although Shepp gave no reason for Polly and Charlie's sudden departure, he did write, "James & man & wife & 2 kids over river at noon," so the Bemises may have returned home to see what the visitors wanted.[178] The group probably spent Sunday night at the Bemises' place, since on Monday they crossed the river for the noon meal with Shepp, who learned that the man's name was Blackwell. Shepp went back over on both the 29th and the 30th, and got a box of peaches on the second visit.[179]

In October 1914, Shepp had Sunday dinner with Polly and Charlie on the 4th. The next evening, Pete returned from town with part of their winter food supplies. Shepp and Klinkhammer also got their "fire money," $57, for helping fight fire in August. On the 6th, Shepp got 155 pounds of onions from the couple, for Pete. Pete "went up to stay at cabin on creek, but got 2 deer & came home after dark." In the meantime, Shepp "took some of Bemis' grub over, 1 can oil, case milk & box groceries." The following day he took them a piece of meat from the deer Pete had shot, and got some tomatoes from them. Pete went up to town with apples and onions to sell and Shepp sent $24.50 with him for more records. Bemis and Polly visited Shepp for dinner on Thursday the 8th. They must have told him that eight men in a boat had come down the river, because Shepp reported that he "didn't see them." On Saturday the 10th Shepp "took Bemis' glasses over"; perhaps he had been fixing them. Shepp returned on Wednesday and "got papers," probably newspapers.[180]

During the second half of October Shepp reported that a man named Bayless, from upriver, spent the night of the 17th with him.[181] On Sunday the 18th, Bill Boyce came down for dinner. Shepp, Boyce, and Bayless all went over the river that afternoon; Pete was still away. Shepp took some more of the Bemises' "stuff" over to them on Wednesday morning. On Saturday, Boyce was down again. He went across to visit Polly and Charlie, and took some bacon to them. Shepp was over there for Sunday dinner on the 25th, and Pete came back that evening, with more records, but just part of what Shepp had ordered. On Monday Shepp took more of the Bemises' supplies over to them; on Tuesday they visited him for dinner and undoubtedly listened to the new records. The last day of the month, Shepp went over and got 120 pounds of cabbage for Pete to take up to town the next day.[182]

In November, Shepp visited Polly and Charlie on the 2nd. The following Friday Shepp shot a buck on his side of the river. On Saturday he took the

couple a piece of it, and Sunday afternoon he took them some more meat. He also got eggs from Polly; Shepp's daily tally of his own chickens' eggs had been zero or one for some time. On the 10th he took three sacks of flour across, and reported, "all Bemis' stuff over." On Saturday he got a rooster from Polly. He may have cooked it for Sunday dinner, since Bemis, Polly, and Bill Boyce were there for that meal, as well as Pete, together with a visitor, Jim Reaves.[183] On Monday, Shepp crossed the river and got 128 pounds of potatoes, onions, and beans for Boyce to take with him when he left. Boyce came back on the 18th, and either he or Shepp took a piece of bear meat over to Polly and Charlie. On Saturday Shepp went over the river and turned the horses out. The next day he went there again, "put back in stove,"[184] and noticed that the eddy was full of ice. He returned on the 23rd, and again for Thanksgiving dinner on the 26th.[185] Apparently some railroad surveyors had come through. Although Shepp didn't mention them specifically, he did note, on the 30th, "Railroad stake at survey tree …" and also mentioned another stake at the "fir tree on Bemis trail to boat landing."[186]

In December Shepp went over on the 2nd, and again on the 17th, when he crossed on the ice. Polly and Charlie had dinner with him on Saturday the 5th, and on the 16th he "saw Bemis this a.m.," probably meaning that they were both outside at the same time. By the 20th the "river froze over from island to Bemis side." Bemis visited him the next day, probably to invite him to Christmas dinner, because on the 25th Shepp wrote, "Boyce & I over river to dinner. Had chicken," and on the 29th Polly and Charlie visited him in return.[187]

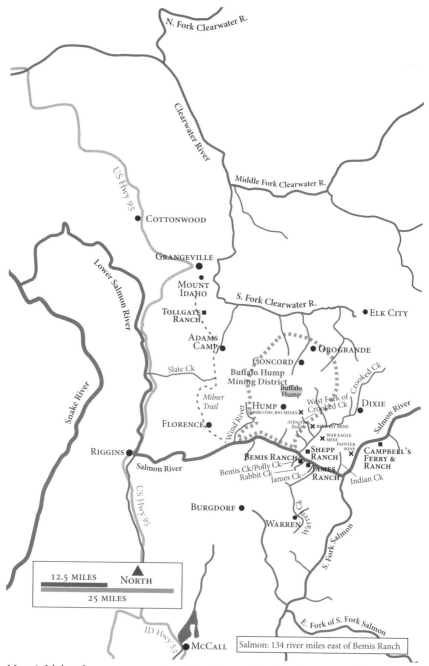

Map 6. Idaho place names mentioned in Chapter Six. Roads in gray did not then exist, but are included for context. Drawn by Melissa Rockwood.

CHAPTER SIX:
Life on the Salmon River, 1915 to November 1919; Polly, age 62-66

During these five years, Charlie Shepp's diaries reveal that Polly and Charlie Bemis are beginning to rely more and more on the help of neighbors and friends to do the heavy ranch work for them, such as chopping wood, plowing and planting their garden, harvesting their hay, and ordering and delivering their winter food supplies. Although the couple suffered various unstated illnesses from time to time, Polly, especially, seems remarkably healthy despite, or perhaps because of, their remote living conditions. Raising their own fruits, vegetables, eggs, and chickens, and obtaining freshly-killed game, meant that their food was primarily organic. As the Bemises aged, however, Charlie was seen outside less and less, and by the close of 1919 he had become almost bedridden.

1915 to Fall 1919

In placing the Bemises' lives and times into the context of world, national, and local events, in 1915 a German submarine sank the British liner *Lusitania* with more than 1,000 lives lost, and the one millionth Ford automobile was manufactured.[1] Events of 1916 included Montana's election of Jeanette Rankin, the first woman to serve in the US Congress; the creation of the US National Park Service; and Margaret Sanger's opening of the first birth control clinic, in Brooklyn, NY.[2] In 1917 the US entered World War I and a disastrous flu epidemic struck worldwide; by 1920, half a million people had died from it in the US alone.[3] The year 1918 saw the introduction of Daylight Savings Time, unemployment was just 1.4%, and World War I ended.[4] In 1919 the US adopted the 18th Amendment, prohibiting sales of alcoholic beverages, and the American Telephone and Telegraph Company introduced rotary dial telephones.[5] Shepp mentioned none of these events in his diaries. He did install a telephone, but it lacked a rotary dial.

1915

Shepp celebrated New Year's Day with dinner at Polly and Charlie's place. Bill Boyce also came down, and Orson James, Boston Brown, and George Otterson were there too.[6] James and Otterson spent the night at the Bemis Ranch, and Brown went home with Shepp. The next day, Brown crossed back over the river in the morning, and James and Otterson stayed with Shepp that night. On Wednesday Shepp went across the river, and on Thursday Charlie Bemis crossed over to the Shepp Ranch. Shepp baked bread on Saturday, and Boyce, Bemis, and Polly were at Shepp's for Sunday dinner. Shepp visited the couple on Sunday the 17th, and the following Wednesday he took them six eggs. On the 22nd, Boyce visited Shepp, and brought him "4 records from home," probably ones that Shepp's sister Nellie or brother Harvey had sent him for Christmas. On Saturday the 23rd, Boyce went over to see the Bemises, probably to invite them to Sunday dinner at Shepp's so they could listen to the new records. They did come over for dinner on the 24th, and Shepp visited them the following Tuesday.[7]

On February 4, Charlie Bemis crossed the river, and Shepp reported that he saw three deer on the Bemises' side. He crossed over himself on the following Sunday, and on Monday noticed that there were some buttercups in bloom on the hill on his side of the river. Bemis and Polly came over to Shepp's for dinner on Wednesday the 10th, and on Thursday the 11th Bill Boyce came down and went over to cut wood for the couple. He spent the night there and returned home the next day. Shepp took a rooster to them on Saturday, and on Sunday he got some tobacco from the Bemises. From home, he saw five deer at their place on Tuesday. Friday the 19th, Bemis came over to Shepp's with George Green and Frank Jordan.[8] On Sunday, Shepp "found Jensen's old horse dead this morning."[9] Monday the 22nd, Boyce was down. The two men crossed the river on the ice and had dinner at Polly and Charlie's. On Tuesday, Bemis came over, and "got 2 old [metal] files." The men "put old horse in river," the disposal method, in 1915, for large, dead animals. In the afternoon Shepp saw that there were three men at the Bemises' place. They were the two "Shafer [Shiefer] boys & another boy from Warren"; the three of them visited Shepp for dinner on Wednesday the 24th.[10]

In July 1987 Fred Shiefer, then 89 years old, recalled that visit. The young men "came down in February on the ice from the South Fork[,] hunting [mountain] sheep. They stayed at Shepp Ranch with Shepp and Klinkhammer and enjoyed dinner one night with Polly and Charlie …. Fred recall[ed] helping Polly with the dinner and the dishes and especially enjoyed Polly's carrot pie"[11] (Fig. 6.1).

CARROT PIE

2 medium sized carrots	½ teaspoon ginger
½ cup sugar	½ teaspoon cinnamon
2 eggs	Speck salt
1½ cups milk	Pastry

Cook carrots until tender and transparent. Mash. Add sugar, beaten eggs, milk, spices, and salt. Mix and pour into raw pastry shell. Bake in a moderately hot oven.
Time in oven, 40 minutes. Temperature, 400° 5 minutes and 360° 35 minutes. Servings, 6.

Fig. 6.1. Carrot pie recipe, 1924. From Modern Priscilla Cookbook: One Thousand Recipes Tested and Proved at the Priscilla Proving Plant (*Boston, Priscilla Publishing Company, 1924*), *252. Book in public domain, Google digitized, available at https://babel.hathitrust.org/cgi/pt?id=coo.31924086713264 &view=1up&seq=5 (accessed November 18, 2019).*

Bill Boyce came down the 24th and brought five more records that had come from Spokane for Shepp. Paddy [sometimes Paddie], Boyce's dog, swam across the river that evening, and "Boyce went over & got him." In the margin Shepp noted, "last crossing on ice."[12]

That was true for him, but on March 1 Charlie Bemis and George Green crossed on the ice above the upper boat landing. Shepp gave Bemis some eggs to take home to Polly. On the 5th, Shepp rowed across in the boat. He took a dozen eggs and got two sacks of coal. When he went over the following Monday, he found that Green had left. On Thursday, Bemis and Polly had dinner at Shepp's; Polly had caught eight fish. Shepp took Polly and Charlie a dozen eggs on the 16th and visited them again on the 24th. He went over for dinner on Friday the 26th and reported, "Bemis sick." Jack Howard spent the night of the 27th with Shepp.[13] They crossed the river and found that Bemis was "still sick." Shepp visited them again the 28th and the 29th, and again on the 31st.[14]

There are no diary entries from April 1, 1915, through July 31, 1915. Since the diaries both before and after this period are complete, the missing dates may have been in a separate diary, now lost.

In July sometime, men named Miller, Ballerson, and Dysert visited Shepp. Miller was the Dayton, Washington, judge who was one of the three owners of Shepp's Blue Jay claim, together with men surnamed Goddard and Jackson, also from Dayton; Ballerson and Dysert are unknown. They left early on August 1, and Shepp visited the Bemises that afternoon. Three days later, he went over again and "took boat down," probably to the lower

boat landing. On Saturday the 7th, Pete came down and brought two more phonograph records. The next day Shepp went over to Polly and Charlie's. He got a 10-pound bucket of eggs; "put 5 loads hay in barn for Bemis"; and brought one of the horses, Juno, back across the river. On Monday Shepp visited again and got some berries. Two days later, on the 11th, Shepp had Charlie and Polly Bemis over for dinner; he wrote, "Polly caught 19 fish." That day, the temperature was 98 degrees. Shepp went over to see them on the 17th, the 22nd, the 25th, and the 26th, without giving any reasons. Some of these visits might have concerned the telephone that he was working on, since on Saturday the 21st, he wrote, "Made board & box for telephone." On Tuesday the 24th, Charlie and Polly had dinner with Shepp again. George Green had come "down from Warrens," but it isn't clear whether he was with them. On the last day of August, Shepp visited the Bemises in the afternoon, and "had ripe watermelon."[15]

During September 1915 Shepp continued working on the telephone he was installing between the Shepp and Bemis ranches. On the 2nd, he "made reel for wire." On the 3rd, he was "over river on wire for telephone." Saturday the 4th, he went over for dinner; Green was down from Warren again, and Shepp reported that the "telephone won't work," but didn't mention the telephone any more that month. Meanwhile, he wrote about other interactions with Polly and Charlie. He took them a sack of flour and a piece of bacon, "sent to Mont[gomery] Ward for shoes for Polly & got her order for grub," and noted that he "got about 2 box[es] apples from tree with Bemis graft."[16]

September 1915 was a good month for visitors. On the 9th Shepp visited the couple, because "Gulike [Guleke] & Smith down river in boat;" the boat was named *Peg o' My Heart*. The boatmen stayed at Shepp's place that night and left the next morning.[17] From 1896 to 1939, Harry Guleke worked on, or piloted, freight and passenger scows [homemade wooden boats] down the Salmon River, the River of No Return, from Salmon to Riggins and even beyond. Described as "the most magnetic and knowledgeable boatman on the river,"[18] he had many interactions with Polly and Charlie Bemis during his long career.

Shepp visited the Bemises again for dinner on September 11, and although this was the date on which Polly traditionally celebrated her birthday, he didn't mention it. Several days later "Green & young Smeed" [Smead] were visiting the Bemises,[19] and came over to spend the night at Shepp's. Jim McCafferty visited Shepp from the 17th to the 19th, and from there he went to Warren, so probably stopped a bit to chat with Polly and Charlie.[20] Pete came back from town on the 21st, bringing a "pair glasses from Omaha," sent by his brother, Harvey. These must have been intended for Polly, because the next morning

Shepp took them over to her, but reported "glasses no good for Polly." On the 25th there was a "prospector with 3 horses down from above;" he wanted to go to Warren. The next day, however, there was "rain about all day," so Stock, the prospector, didn't cross until Monday morning. Shepp stopped in for a visit with Polly and Charlie, and "heard McGarry [Ira McGary] was dead."[21] Shepp visited the couple again on the 29th, and they had dinner with him on the 30th.[22]

Pete had gone up to town [Dixie, Concord, or Hump], and on October 1 he returned with the news that "[Gene] Churchill was drowned."[23] Shepp went over to Polly and Charlie's the next day; he no doubt told them the sad news about Churchill. He also got 20 pounds of spikes from Bemis, for $1.60. On the 6th he "crossed man & horse" in the morning. Because Pete was going up to town on the 9th, Shepp visited the couple to get two boxes of apples and a sack of cabbage for Pete to take up to sell for them. Shepp also wrote his brother Harvey, in Omaha, and sent back Polly's glasses. "Green & boy," who may have been at the Bemises, came across to Shepp's for the noon meal. He also went over the river and got a "milk box" full of peaches; probably meaning that the box he used had once contained a case of canned milk.[24]

On the 12th, Bill Boyce was down. Shepp wrote, "over river to dinner"; perhaps Boyce went with him. Shepp returned there the afternoon of the 14th, and wrote that "the boys from Indian [C]reek [probably Fred and Ed Matzke] & kid from Grangeville stopped this afternoon," implying that they were at Polly and Charlie's place. On Sunday the 17th, Charlie Bemis visited Shepp, as did Boyce; later that day. Shepp crossed the river for some apples. He returned there on the 19th, and again on the 21st, when he got a piece of meat. On Saturday the 23rd, Shepp visited the Bemises again. Pete went hunting on the 24th and shot a deer. When he went up to get the meat, he got another deer. Boyce was down again; he and/or Shepp went over the river. On Tuesday the 26th, Shepp took a deer quarter over to Polly and Charlie. Two days later, he went back again. George Green was there, and Shepp learned that some of their goods had arrived at Warren. On Sunday the 31st, he "done nothing," and visited the couple in the afternoon[25] (Fig. 6.2).

On Monday November 1, Bemis and Polly had their noon meal at Shepp's; he learned that "Curtis & Willie at Bemis' last night. Hunting."[26] On the afternoon of the 3rd, Pete and Russell came down to Shepp's.[27] Russell went to Warren the next morning, the 4th, and Pete went across too, to visit with Polly and Charlie. Shepp wrote, "Had pork roast," probably in honor of Pete's 35th birthday, although Shepp didn't mention it. On November 5, Shepp "took 9 sacks hay & pack saddles over river at lower landing this am. Took 5 horses over this afternoon." This was apparently in preparation for Pete to go

Fig. 6.2. Polly and Charlie Bemis at their Salmon River home, date unknown. Photo from Roscoe LeGresley Collection, courtesy Jacqulyn LeGresley Haight.

up to Warren for their supplies, since on the 7th Shepp wrote that Pete was back that evening. Meanwhile, Shepp had seen a boat go down the river at 4:00 p.m. On Monday the 8th, Shepp started bringing some of their goods over. On the 9th he and Bemis "took boat up," probably meaning that they moved it to the upper landing.[28] On Wednesday, November 10, Shepp wrote, "Got all our stuff across. Horses crossed below creek, all but Juno & Mary. Brought them over this am. Bemis short 100# sugar. No milk ordered. Gave Bemis 50# of our sugar & case milk."[29]

From then until the end of the month Shepp went over six more times, but he doesn't always state his reason. Once he got a tree faller's wedge, and another time Green was there. On the 18th, Shepp sawed wood for the couple, and on the 24th, Bill Boyce cut wood for them. Thursday the 25th would have been Thanksgiving; Shepp had dinner with Polly and Charlie that day, and Boyce may have been there as well.[30]

In December 1915 Shepp concentrated on making cider. He scalded out the cider kegs, ground 19 boxes of apples, and pressed them. After filtering the juice, he obtained 36 gallons of it. Meanwhile, he visited the Bemises on the 5th, and Boyce cut wood for them on the 9th and 10th. Shepp went back on the 12th and took them some sauerkraut, and returned again on the 16th. On the 20th, Boyce's dog, Paddie [sometimes Paddy], visited the Shepp Ranch without his owner and crossed the river to the Bemises' place.[31] Boyce came

down the next morning; he and Shepp went over to the Bemises' for dinner and presumably retrieved Paddie. On Christmas Day, the two men returned to Polly and Charlie's for dinner. Pete came down the next day, bringing Shepp mail from his sister, Nellie, and brother, Harvey, and two more records. Shepp visited the couple again on the 27th, and Pete may have gone with him.[32]

1916

By the end of the first week in January the Salmon River had frozen over, and the river dwellers could cross on the ice, which Shepp did on the 9th. On Sunday the 16th Bill Boyce came down, and he and/or Shepp visited Polly and Charlie. The next day, the temperature was eight degrees below zero in the morning. Shepp lit a lamp and put it in his cellar to keep his stored produce from freezing. On the 26th, the Bemises' dogs crossed over to Shepp's side, and on the 30th and 31st, Shepp visited Polly and Charlie.[33]

It warmed up in early February. Shepp ordered garden seed on the 1st, both for himself and for the Bemises. On the 9th, it was 50 degrees in the afternoon, and Shepp saw some robins. On the 12th, Charlie Bemis came over to invite Shepp for dinner the next day. Shepp went, and reported that he also stretched the telephone wire across the river. Bemis came over on the 14th, and again on the 17th, for some pills. Meanwhile, Shepp went over for dinner on the 16th. Bemis's dog crossed over to Shepp's on the 18th, and Shepp had dinner with the couple again on the 22nd.[34]

In March 1916, Shepp went over on the 7th and the 9th. The second time he took a saw with him and "got match plane from Bemis."[35] On the 10th he set two fishing poles, and on the 11th he "drawed off cider." Pete came down and "cut limbs off tree for wire across river." Monday the 13th Shepp got his boat to the upper landing, and took the Bemises' seed over to them. That Friday he put up the telephone wire, and went back again the next Thursday.[36]

Toward the end of the March entries there is some unintentional humor: "Sat 25 Killed Shorty. Awful fat. Sun 26 Bemis & Polly over to dinner. Had Shorty,"[37] probably a rooster.

More seed must have arrived, because on the 29th Shepp took some over to Polly and Charlie. He also got three heads of cabbage that day.[38]

Shepp went across again on April 2 and 9. Pete came down on the 12th to stay for a while. He visited Polly and Charlie on the 13th and again on the 21st. Shepp went over for dinner on the 17th, and spent the 21st fiddling with the telephone but "couldn't make it work." Shepp took some seed corn over on the 23rd, and on the 26th, he wrote that a boat came down the river right after dinner. Shepp commented, on the 27th, that he saw Bemis plowing. Shepp went over on the 29th, and "got wood," perhaps cutting some for Polly and Charlie. That evening there was an earthquake at 7:30 p.m. On Sunday the

30th Shepp went over to help the couple with their garden, and reported that Polly caught a six-pound fish.[39]

In May, Shepp first crossed the river on the 3rd. He wrote that he "hauled manure & plowed potato ground," implying that he did it for Polly and Charlie. George Green was down as well. On the 7th, Shepp finally got the telephone to work, and on the 8th he wrote, "Over river. Got telephone up. Works all right." Bill Boyce came down on the 11th, and he, Shepp, and Pete all went across to the Bemises' place. On Friday at 6:45 p.m. there was another earthquake; this one was "harder than the one on the 29th of last month."[40] Charlie and Polly came over to dinner on Sunday the 14th, and on Monday the 15th, Polly planted beans. That Thursday Shepp "planted part of Bemis' corn," despite the rain, and wrote that Polly was "catching big fish." The next day he put a switch on the telephone. On Sunday afternoon, the 21st, Captain Harry Guleke came down the river in a boat and stopped for a while. The next day Shepp went over and fixed the switch on the Bemises' telephone, and got 14 tomato plants from them. The following Saturday he took them 50 cabbage plants and on the 31st he went over in the morning and "got grinding machine & a big fish, about 2 or 3# [pounds]." He observed that he could still see some snow at the head of Bemis Creek [now Polly Creek].[41]

As usual in June, the swiftly rising river soon put a temporary halt to visits back and forth. Shepp went across to dinner on the 2nd, and returned to the Bemises' place again on the morning of the 6th. As the snow melted in the mountains, the Salmon River rose between six inches and a foot or more daily. Shepp watched certain markers that told him the rise. On the 5th, for example, it was at the two-foot mark and by the 7th it was at the seven-foot mark. For the next few days it fell back to about five feet above the mark, and then began to rise again. On the 15th it was at eight and a half feet, and by the 17th it was at twelve feet and carried lots of driftwood. It crested at fifteen and a half feet on the 19th, causing Shepp to write in the margin, "River high." He also "saw Green's boat go down" that morning, without mentioning if Green was in control of it or if the boat had come loose from its moorings. From the 19th to the 22nd the river fell 10 feet, but then came back up to 9 feet toward the end of the month, before beginning to fall again. Meanwhile, on the 21st, Shepp noticed that the snow was gone at the head of Bemis [Polly] Creek.[42]

On Sunday, July 2, 1916, Shepp wrote that he "gave Bemis some music" that evening. If this was sheet music, there is no indication that Polly and Charlie had a musical instrument. Perhaps Shepp meant that he played a record over the telephone for them. For some reason, maybe because the river was still too high, they all skipped their usual Fourth of July celebration. Shepp didn't cross the river until July 13th, and reported that the water was

still "pretty high." While at Polly and Charlie's, he got two 10-pound buckets of cherries. Pete, who had been up to town for several days, came back that night, and the next day he was over the river "making hay." On the 18th Shepp had an overnight guest, "a Swede named Nolan." The next morning, Nolan was leaving for Warren, so Shepp took him over. While there, he "put 11 loads hay in barn for Bemis." He and Pete had supper there and then came home, bringing a dozen eggs and three cans of milk from Polly. On Wednesday the 26th Shepp had dinner with the Bemises and got a 10-pound bucket of raspberries. That evening, two Forest Service men, Brown and Clark, spent the night at Shepp's and were there all day the 27th.[43] The same day, Guleke was down with a boat, and Shepp sold him a cowhide, for which Guleke paid him $5. Afterward, Shepp went over to Polly and Charlie's, probably to tell them all about it. When Shepp visited them again on Sunday afternoon he noticed that there was a "new island in river between upper end of big island & this side."[44]

August was a busy month, with people coming and going between the north and south sides of the river. In early August, Polly and Charlie had an overnight guest from Warren named Taylor.[45] He and Charlie Bemis had their noon meal with Shepp the next day. After they went back, Taylor left. On Sunday the 6th, both Bemis and Polly were at Shepp's for dinner. On Monday the 7th, the couple had another overnight guest from Warren. He went to Hump the next morning, but Shepp didn't get his name. On the 9th, Shepp had dinner at Polly and Charlie's and got a 10-pound bucket of blackberries. Shepp reported seeing a flock of ducks on the 12th, and was across the river the following afternoon. Another Forest Service man, Sword or Seward, spent the night at Shepp's on the 14th.[46] That day, Shepp got cabbage, beets, rutabagas, beans, onions, carrots, and apples from Polly and Charlie. Probably because he had a guest, he played his phonograph until midnight. Sword [Seward?] left the next morning, and Bob Pugh from Elk City was there that night.[47] Since Pugh was going to Warren, Shepp took him across the next morning. On Thursday the 17th, it rained all day. Shepp had two more overnight guests, "2 fellows on horses." On Friday he took them across the river by boat and charged them $2; the horses swam. George Green and two other men were down from Warren to visit Polly and Charlie. Green, and perhaps the others, spent the night, and Green went back to Warren Saturday morning. Shepp went across the river Sunday afternoon and reported that Guleke came downriver in a boat again, with a boatman and a Dr. Johnson.[48] Guleke gave Shepp another dollar for the cowhide Shepp had sold him earlier. When Shepp went over to the Bemises' on the

22nd he learned that Polly was ill. He returned on Thursday the 24th and took them some tobacco.[49]

September 1, 1916, saw Shepp crossing the river. George Green had come down from Warren with two horses, bringing "our" 100 pounds of sugar, meaning, for Shepp and Klinkhammer. Shepp moved the boat down to the lower landing. The following day, Polly and Green came over for dinner, and Bemis watered his corn. On Monday the 4th, Shepp went up to Concord because the next day was Election Day. It took him seven hours to walk the 18 miles. On Tuesday, eight people cast their ballots. Four voted Democratic and four, Republican. Shepp came home the next day and visited Polly and Charlie the following afternoon. He wrote, "got 18 old chickens, 12 young ones" but it isn't clear whether he actually obtained them from the couple or owned them himself. By the 9th, winter was approaching; Shepp saw snow at the head of Bemis [Polly] Creek. He went over on the 10th and got a sack of flour, and was back the next day, the 11th, for dinner on Polly's 63rd birthday. She and Charlie visited Shepp on the 13th for dinner, the noon meal, and he had dinner with them the next day. They all made out their orders for their winter "grub" for Pete to take up to town on Friday. On Saturday the 16th, Shepp got cabbage and green tomatoes from Polly and Charlie. He ground them up, together with some onions, and made 12 jars of piccalilli relish the next day. On Tuesday he complained that coyotes were eating his muskmelons, and on Wednesday the 20th he went over to the Bemises' and took them a jar of piccalilli. Sunday the 24th, he crossed again and took them a dozen candles. The next day Bill Boyce was down, and one or both of them crossed the river. On the 26th, Shepp visited the Bemises in the morning and got some green tomatoes, which he used to make two and a half gallons of preserves.[50]

Pete returned the afternoon of September 28 with some of the winter supplies for both ranches. Shepp reported that there was mail from W. F. Bemis, Charlie's younger brother. On Friday afternoon, Shepp took two sacks of flour to Polly and Charlie. Gus Schultz was down at Shepp's that night, and the next day Gus, Shepp, and Pete went over to Polly and Charlie's and got four boxes of apples.[51]

On Sunday, October 1, Shepp visited the couple again and filled an oil box [coal oil, i.e., kerosene for lamps] two-thirds full of tomatoes. The next day it rained all day, so he made two gallons of catsup. On Wednesday the 4th, Shepp visited Polly and Charlie and took them four bottles of catsup and four quarts of the piccalilli that he had made in September. On Friday the 6th, Boyce came down, and went over to Polly and Charlie's. That evening, Pete Klinkhammer and Andy Henry came down too, with part of Shepp's winter supplies—flour, milk, coffee, and sugar.[52] On Sunday Shepp went across the

river in the morning, and reported that Polly was sick. The following day, he took them their flour, sugar, and one case of canned milk, and Boyce went over too. Saturday the 14th, Pete came back down with the rest of their winter food supplies, and Shepp went over and got 200 pounds of potatoes for Humptown. On Monday afternoon, Shepp took the Bemises' goods over to them. Boyce came down again on the 19th and went over to the Bemises' for dinner. On Friday the 20th, Andy Henry came down again, and on Saturday he got some apples from Polly and Charlie. While Henry and Boyce were still there, Shepp had Bemis and Polly over for Sunday dinner. The next day, he went over in the afternoon and cut wood for them, and on Sunday the 29th he took them some more candles. Andy Henry, who had gone home, returned on the 29th. The next day he and Shepp crossed the river, and Henry got some vegetables from Bemis.[53]

In early November Andy Henry came down again and shot a deer. Shepp took Polly and Charlie some of the venison, and visited them again the following day. On the 6th, Shepp, Klinkhammer, Boyce, and Henry all went up to Concord for the general election on Tuesday the 7th. Voters cast six ballots: five Democratic and one Republican. After he returned home, Shepp took Polly and Charlie some bear meat; he didn't mention the successful hunter's name. On Friday the 10th, he returned and got some cabbage, and two days later he took them their salt, oil, and "mush," cornmeal or oatmeal, from their winter supplies order.[54] On Tuesday the 21st, he wrote, "Gus Sints [Sindt] at Bemis."[55] The next day Shepp went across by boat, perhaps while Sindt was still there. On Thursday, Shepp returned, this time to fix Polly's clock. Two days later, he and Henry went up to the cabin on the West Fork (of Crooked Creek) and got some meat, and the next day he and Henry took some of it over to Polly and Charlie. Shepp implied that he also took them copies of the *Saturday Evening Post* from April, May, and June. Shepp's mention of ordering 10 sacks of flour, probably holding 100 pounds each, gives us an idea of their food consumption in winter. On November 28, he opened the first sack. He, Boyce, and Henry had dinner with Polly and Charlie on Thursday the 30th, crossing by boat. As yet, there was no snow on the ground.[56]

In December, Shepp didn't visit Polly and Charlie until the 7th. On Friday the 22nd, he noticed that Charlie Bemis was up at Shepp's boat landing. He had crossed on the ice but, surprisingly, didn't come to Shepp's house. On Sunday the 24th, Andy Henry and Bill Boyce arrived at Shepp's, and Ed Matzke and another man came downriver to borrow a whipsaw from Shepp. Using snowshoes, they crossed the river on the ice, and no doubt stopped to visit with Polly and Charlie, at least briefly.[57] On Monday, Christmas Day,

Boyce, Henry, and Shepp all crossed on the ice for dinner with the Bemises. In order to cut wood for them, Boyce stayed with the couple until Thursday.[58]

1917

Bill Boyce came down to Shepp's on Thursday, January 4. He also visited the Bemises, but went home in the afternoon. Boyce, or Bemis on the telephone, must have told Shepp that the Bemises' dogs were missing, because on Thursday the 11th, Shepp wrote, "Bemis dogs came home." Shepp had dinner with Polly and Charlie on Saturday the 13th, and on Thursday the 18th Bemis came over to the Shepp Ranch. On Monday, Shepp cut wood for the couple. The next day, he went back, and wrote that the horse, "Old Nellie," was "about all in"; she died on Thursday.[59] On the 26th and 27th, Pete was across the river sawing wood for Polly and Charlie. Pete left the next day (Fig. 6.3), and on the 30th Shepp went across the river, where he "got wood" again, probably meaning that he helped somehow with the Bemises' winter wood supply.[60]

On February 6, Bemis came over; he found a deer on the river that coyotes had killed. Andy Henry's dog Paddie [also Paddy] visited Polly and Charlie on the 7th, and on the 12th Shepp had dinner with them. Pete visited Orson James on the 16th and came back the following day, no doubt spending time with Polly and Charlie both going and returning. Bemis and Polly had Sunday dinner with Shepp on the 18th, who was, in turn, invited to them on the 22nd. On the 26th, the Bemises' barn collapsed, likely from snow load on the roof. Shepp cut wood for them both that day and the next. At the end of the month he reported there was about 30 inches of snow on the ground.[61]

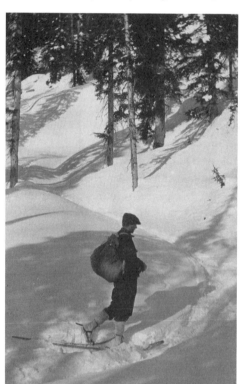

Fig. 6.3. Pete Klinkhammer on snowshoes, 1917. Courtesy Heidi Barth.

March 1917 was an exceptionally slow month for socializing. Charlie Bemis and Andy Henry both visited Shepp on the 5th, but Shepp

didn't cross the river himself, by boat, until the 25th. He wrote, "Snow all of 2 feet at Bemis."[62]

In April, Shepp and Henry visited Polly and Charlie on Sunday the 8th, and then Shepp and Klinkhammer went there together the next day. The following Sunday, Shepp crossed in the afternoon. On the 17th, a boat came down the river about 7:30 a.m., but it didn't stop. However, the next day, when Bemis and Polly were at Shepp's for dinner, and Pete was back, another boat came down. This time it was Harry Guleke, John Painter, and six other men.[63] They stopped to visit for about an hour and got some apples.[64] On Saturday April 21, Shepp wrote, "[George] Bancroft & [Charles] Curtis down from Warren to look at mine."[65]

"Bancroft" was George Jarvis Bancroft (1873-1945), a mining engineer from Colorado. In a later reminiscence, "The Way to War Eagle," he recounted his adventures in visiting that mine:

> During the winter of 1916 [i.e., 1916-1917], I was making my head-quarters in Boise, Idaho.
>
> … While in Boise, I met a man that told me of a wonderful gold discovery on Crooked Creek, 3 miles North of the Salmon River. This great river runs, roughly, west through Central Idaho cutting the state in two with its deep can[y]on. Boise is 150 miles south of the can[y]on.
>
> I wired my client and he said to examine this new gold discovery, called the War Eagle.[66]
>
> I hunted up my informant, who was a newspaper man, and quite a conversationalist, and asked him how I was to reach War Eagle. He said, 'Well, I will tell you:—You take the train as far as you can, then you take the stage as far as you can, then you take the horse sled as far as you can, then you take the dog sled as far as you can, then you snow-shoe as far as you can, then you take a canoe as far as you can, then you ride horse-back as far as you can and then you climb up a rope.' These unusual directions were literally true. I took the train to McCall. There I took the stage going around Payette Lakes. By this time I was getting into the deep snow country. At a stage station we switched to a horse-drawn sled, that took us to Burgdorf. Here I spent a comfortable night at the commodious road-ranch run by an old Cripple Creek [Colorado] harlot. [The word "harlot" is crossed out, probably by Bancroft's daughter, Caroline, and replaced with "acquaintance."] Next day I went to Warren's by dog-sled. The snow at Warren's was about 8 feet deep on the level. Here I hired a guide and bought a pair of web snow-shoes.[67]

161

Bancroft and Curtis started out for the Salmon River, but the snow had obliterated not only the trail, but also the blazes on the trees. Fortuitously, they saw smoke from a miner's cabin and were able to stay there for the night. Bancroft continued,

> In the morning he [the miner] put on his snow-shoes and guided us to a certain ridge. He told us to follow the ridge down into the can[y] on and we would come to Judge Bemis' orchard. ... Judge Bemis had married a [C]hinese dance girl, named Polly, and they lived in seclusion in this orchard hide-a-way. Across the river a man named Shepp had another little orchard. ... He was also a recluse.[68]

> Shepp had strung a wire across the river and put in phones, so I called Shepp and he came over in his canoe. There was a placid pool in the river between the two orchards. I stayed with Shepp all night. Billy Boyce, the discoverer of War Eagle, was also there. In the morning Shepp saddled a horse for me, but Billy Boyce preferred to walk. We went up Crooked Creek and soon got into snow again, but the horse made it to the foot of the cliff. Billy Boyce had a rope hanging down the cliff, and we climbed up this to the mine.

> It turned out to be a good mine and we bought it and made some money.[69]

Meanwhile, on Monday, April 23, Shepp took Bancroft and Curtis up to his mine, the Blue Jay, and he and Bancroft stayed at the cabin there. The next day they started for the Shepp Ranch, but Bancroft spent the night at Boyce's leaving Shepp to return home alone. Bancroft returned to Shepp's on Wednesday; he and Curtis left on Friday. Previously, on Thursday the 26th, Shepp took the horses across the river because Pete was plowing over there. Curtis went over for dinner, and Shepp and Bancroft went across in the afternoon.[70]

April 1917 appears to be the beginning of George Bancroft's friendship with Polly and Charlie Bemis, an association that lasted at least into the early 1920s. According to Bancroft's daughter, Caroline (1900-1985), her father bought her a "brooch with gold pan, pick & shovel fashioned by 'China Polly' Bemis" in 1917[71] (Fig. 6.4). Perhaps Polly did make this trinket, or its components; George Bancroft's "China Polly—A Reminiscence," states that Polly "had been taught the art of goldsmithing and she used to beg nuggets from her fr[ie]nds and fashion them into hammers and picks and other trinkets which in turn she sold for goodly sums."[72] Indeed, similar statements elsewhere are accompanied by a photograph of Caroline Bancroft's brooch, with a somewhat different description of the finished product. A 1957 newspaper article by M. Alfreda Elsensohn states, "In 1917 Polly made a gold pan,

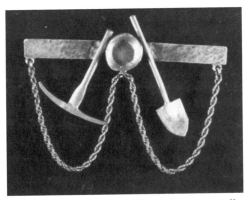

Fig. 6.4. Caroline Bancroft's jewelry, reportedly made by Polly Bemis, date unknown. Courtesy Idaho State Archives, Boise, 75-228.43/k.

gold pick[,] and gold shovel for Mr. Bancroft, which his daughter had mounted on a hand-made silver brooch".[73] This sounds as if Polly crafted the individual pieces, sold them as such to George Bancroft, and then Caroline Bancroft later had them made into a brooch. Charlie Bemis is most likely the person who taught goldsmithing to Polly; one account states that he had been a jeweler in Connecticut.[74]

In late April 1917, from Saturday until Monday, Pete was at the Bemises' place, doing the plowing. Orson James and a man named Mosberg [sometimes written Mousberg] came down and brought the horses back across the river.[75]

During early May 1917, James and Mosberg stayed in the area, visiting back and forth with Shepp and the Bemises. Shepp noted that he had planted beets, lettuce, radishes, turnips, and late cabbage, with tomatoes and peppers going into a "hot bed." Polly and Charlie Bemis were likely planting the same produce at their ranch.[76] Shepp also pruned and grafted fruit trees, chores that Polly and Charlie would have done too, unless their neighbors pitched in to perform those tasks for them.[77]

On Monday the 7th, Shepp spent almost all day with Mary, his sick horse. In the morning, she was "down in barn." After trying nearly all day to get her to stand up, he pulled her up with the help of Juno and Bob, two other horses, and wrote that she was "all OK." Afterward, he crossed the river after supper, and "got fish & Boston beans," probably Boston baked beans that Polly had cooked, or perhaps canned beans.[78]

The next day he wrote, "Polly & Charlie caught 5 fish." By Wednesday the horse, Mary, had had a relapse, so he "Put Mary out of misery & took her down to river," meaning that he shot her and dragged her to the river for disposal. That evening, he got a plow wheel from Bemis.[79]

On Friday May 11, 1917, Shepp noticed that a boat went down about 10 a.m. but it didn't stop. Later, he crossed the river for dinner with Polly and Charlie, and wrote that he cut 900 eyes out of potatoes, for planting, but the diary isn't clear whether this work was for himself, for Polly and Charlie, or for both gardens. Bill Boyce came down to Shepp's on Saturday, and contin-

ued across the river to get some chewing tobacco. The following Friday Shepp took Polly and Charlie some tomato and tobacco plants.[80]

Shepp next washed his windows, another chore that Polly and Charlie would likely have done as well. Over the subsequent few days Shepp crossed the river, made a hoe for Polly, and got three dozen "Express" cabbage plants, a small, red, early variety. At the end of the month his dog, Teddy, tangled with a porcupine, an event that Polly and Charlie must also have experienced with their pets.[81]

In early June, Shepp ventured to Orogrande, Concord, and Del Rio [the mine], all in the Buffalo Hump Mining District.[82] At one of those places, probably Orogrande, he heard that high water had taken out all the bridges on the North Fork of the Clearwater River.[83] Back home, he killed a buck deer and on June 4 he took some venison over to Polly and Charlie and got some eggs from them. Two days later he took them 90 tobacco plants. Although he hadn't been across the river since then, on the 13th he learned, probably by observation or by telephone, that "Bemis got one," meaning Charlie had shot a deer. By the 20th he noticed that the snow was gone at the head of Bemis [Polly] Creek.[84]

On July 1, 1917, Shepp saw a coyote swimming across the river, and by July 8 the temperature was 105 degrees. On Monday the 9th, Shepp crossed the river in the afternoon. He killed a rattlesnake and got a 10-pound bucket of eggs from Polly. That Friday, he went to Orogrande to meet his brother, Harvey, who arrived by stage. On Saturday, they went to Concord, left there the following morning at 5 a.m., and reached the Shepp Ranch after a nine-hour hike. At Polly and Charlie's for supper, they had new potatoes.[85]

The next day Shepp noticed that Polly and Charlie had company – "[George] Green and some other fellow … from Warren."[86] Always curious about the couple's visitors (some would say nosy), Shepp went over there the following afternoon. Besides Green, the other man may have been Wells; Shepp's writing isn't always clear.[87] While there, he got six 10-pound buckets of cherries and a 10-pound bucket of eggs; he also killed another rattlesnake. On Wednesday, July 18, the Bemises' visitors returned to Warren, and Pete Klinkhammer went over that day, perhaps to start cutting hay. Meanwhile, back at the Shepp Ranch, Charlie Shepp canned the 60 pounds of cherries into nine, half-gallon jars. That day he observed, "Mosquitoes awful bad."[88]

Polly and Charlie needed help cutting their hay; that activity began in earnest on Thursday, July 19. Shepp went over in the morning to do it, and presumably stayed for the noon meal. He likewise returned Friday morning, and also took Polly and Charlie three jars of cherries;[89] it is easy to imagine Polly making cherry pies as a fall or winter treat. On Saturday the 21st, Pete

crossed over and finished cutting the Bemises' hay. Two men, Fred Wade and George Y[arhaus] came down from Warren, crossed the Salmon River, and spent the night at Shepp and Klinkhammer's place;[90] Polly surely wouldn't have let them leave without a visit.

On Sunday, July 22, Shepp took Bob, one of the horses, over to the Bemises' place, began stacking their hay, and finished the next day. Once back at the Shepp Ranch, Pete shod Bob in preparation for a trip up to town in the morning, presumably with produce from both ranches, although nothing is mentioned specifically. Taylor Smith, a child when the Bemises lived in Warren, and then a man in his early 30s, was at Polly and Charlie's place.[91] Shepp crossed on Friday the 27th, and two days later he took a cut of meat over to them. Harvey, who was still visiting his brother, caught 12 trout.[92]

On Thursday, August 2, Harvey caught another 15 fish; Shepp took some of them over to Polly and Charlie. The following Sunday, Shepp wrote, "Claud Flint and pard over at Bemis tonight," and "W. R. Flint."[93] On Monday, Flint and presumably his partner, left for Warren in the morning.[94] The next day, August 7, Shepp crossed the river. He had had a note from George Bancroft to share with Charlie Bemis; Bancroft "[w]ants to find out about claims."[95]

Just over a week later, on August 16, Shepp had a visitor, name unknown, who crossed the river the next day, probably in Shepp's boat, on his way to Warren; Shepp took that opportunity to get some eggs from Polly. On Saturday the 18th, Shepp went across the river and "brought boat down," implying that he moved Charlie Bemis's boat to the other landing. He learned that Frank Jordan was at Polly and Charlie's; Frank had lost his horse. Earlier that day Shepp had "killed old hen," and undoubtedly shared it with the couple when they came over for Sunday dinner. Afterward, Harvey took a picture of Polly, and the next afternoon he developed and printed it, together with other photos he had taken.[96]

Shepp didn't visit Polly and Charlie again until Friday, when he went across the river, perhaps taking the photos to show them. Back home, up Crooked Creek, Shepp picked five pounds of huckleberries. He again visited Polly and Charlie on Sunday the 26th; on Thursday the 30th he got two gallons of cucumber pickles from Polly.[97]

Shepp took the couple a gallon of vinegar on September 5 and on Sunday the 9th he went across the river to dinner. Harvey probably went with him for a farewell meal, since he was leaving the next day for home. Shepp and Harvey took two horses up to Concord, where they spent the night. The next day they traveled to Adams Camp; Shepp "sent orders for grub" from there. On Thursday the 13th "Gus Schultz came in with rig for Harvey," which Harvey used to get to Grangeville; from there he could catch a train to

Lewiston. Shepp got back to his ranch on Saturday and had dinner with Polly and Charlie on Sunday, no doubt recounting his adventures in getting Harvey headed home.[98]

An artifact associated with this trip is a grocery store invoice printed on bright pink paper. (Fig. 6.5). Dated September 15, 1917, it is from Alexander and Freidenrich in Grangeville, and is made out to C. A. Bemis, Hump, and signed by the clerk, Wilber Fuller.[99]

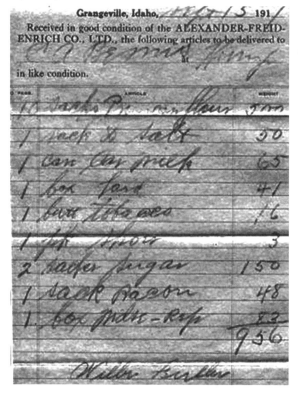

Fig. 6.5. Invoice for Charlie Bemis's order from Alexander and Freidenrich, Grangeville, Idaho, September 15, 1917. Courtesy Heidi Barth.

Although some of the entries are abbreviated, it reads:[100]

10 sacks Princess flour	5.00
1 sack D. [dairy] salt	.50
1 case Car [Carnation; canned] milk	.65
1 box lard	.41
1 bott[le] tobasco [Tabasco] (Fig. 6.6)	.16[101]
1 pk [pack] shoes [shoelaces]	.03[102]
2 sacks sugar	1.50
1 sack bacon	.48
1 box mdse- [either "Refs" or "Reps"]	.83[103]
[Total]	$9.56

A shopping list for "Klinkhammer and Shepp 1917" contains some similar items, plus ones that Polly and Charlie may have ordered for themselves at other times. Since the quantities aren't identical, it is for a different order of unknown date. The men needed six sacks of Princess flour, 150 pounds of sugar, three cases of Carnation [canned, probably evaporated] milk, 30 pounds of Peaberry coffee,[104] (Fig. 6.7), three pounds of tea, 50 pounds of dairy salt, 200 pounds of stock salt, two cartons of wheat flakes [breakfast cereal], 20 packages Carnation [cigars?],[105] 40 pounds of bacon, 30 pounds of lard, one small cheese, 10 pounds of rice, 10 packages of [baking] soda, two and a half pounds of baking powder, three small bottles Mapleine [maple flavoring], two dozen self-sealing Mason jar caps [screw bands], two dozen lids for Mason jars, three dozen Economy jar caps, 25 [boxes?] of toothpicks, and one tin of matches.[106]

A receipt from Alexander and Freidenrich dated 9 [September], 25, 1917, probably corresponds to the shopping list described just above.[107] Although the amounts and items listed in the receipt aren't quite identical to the list, they may represent what A & F had on hand at the time they filled the order. Again, Polly and Charlie may have purchased similar items at other times.

The receipt is made out to "Klinkhammer & Shepp, Hump." It lists the following goods:

3 case[s] milk	1.95
1 sk [sack] D[airy] salt	.50
4 sks [sacks] H. G. [unknown] salt [stock salt?]	2.00
2 sacks Sugar	2.00

Pepper Sauce

One 4-ounce bottle, 10c

McIlhenny's Tabasco Brand. Made from fresh peppers in water and distilled vinegar. Red or Green, in bell-shaped bottles. Contents, 4 fluid ounces

Red Pepper Sauce
99A5162—1 bottle$0.10
Green Pepper Sauce
99A5156—1 bottle.........$0.10
Shipping weight, per bottle, ¾ pound.

Tabasco Sauce

One 2-ounce bottle, 33c

McIlhenny's. Regular Size. Squirt-top bottle. Contents, 2 fluid ounces. A "Hot" Pepper Seasoning. We quote the genuine McIlhenny's Tabasco Sauce which is incomparable for use with fish and oysters. For those who prefer a milder sauce, we recommend either green or red pepper sauce, which is made from fresh peppers, cured with pure vinegars.
99A5161—1 bottle$0.33
Shipping weight, ½ pound.

Fig. 6.6. Tabasco in a Montgomery Ward & Co. catalogue, 1918. From Pure Food Groceries May June 1918: Price List No. 571 (Chicago, IL: Montgomery Ward & Co., 1918), 25. Catalogue in author's possession.

6 " [ditto, for sacks] Princess flour	3.00
1 " [ditto, for sack] bacon	.40
2 cartons Wheat flakes [breakfast cereal]	.90
1 box mdse- [either "Refs" or "Reps"]	.76[108]
1 tin matches	.15
1 box Lard	.50
[Total]	$12.16

[signed] Wilber Fuller

During Shepp's visit across the river on September 16, 1917, he saw a bear above the Bemises' place. On Tuesday the 18th, he went back and picked a box of tomatoes which he canned two days later, making 16 quarts. Meanwhile, he "drawed off cider." John Becker came down to Polly and Charlie's and crossed over to Shepp's place. On the 20th, Pete arrived with part of the "grub" that both households had ordered, and on Friday the 21st Shepp took some of it across the river. On the 30th, Polly and Charlie visited Shepp for Sunday dinner.[109]

Pete came down again with "most of Bemis' stuff" on October 2, and Shepp ferried part of it over to them the next day. A boat with 10 men came down the river that afternoon, but they mustn't have stopped because there is no more information about them. On the 4th Shepp went up to Bill Boyce's cabin on the West Fork of Crooked Creek. He met Pete there, who had packed down Boyce's grub. Pete also brought some shoes for Polly from Harvey, who was in Seattle. On Friday the 5th, Shepp crossed the river, no doubt to give Polly her new shoes. He also got some tomatoes, which he turned into catsup on the 8th. Meanwhile, he had gotten 13 tobacco plants from Charlie

Fancy Santos Peaberry Coffee

Ten pounds,

$2.30

We buy the very best old Golden Santos Peaberry, selecting those coffees only that are uniformly round and stylish. Fancy Peaberry makes a mild sweet delicate cup of coffee, having a flavor like fancy Santos.

Whole (Unground) Beans

99A11336—5-pound bag..$	1.18
99A11344—10-pound bag.	2.30
99A11319—2-pound canister	.52
99A11136—5-pound canister	1.26
199A1151—25-pound drum	5.95
199A1150—50-pound drum	11.65

Steel Cut

99A11268—2-pound canister	$0.52
99A11324—5-pound canister	1.26

Fig. 6.7. Peaberry coffee in a Montgomery Ward & Co. catalogue, 1918. From Pure Food Groceries May June 1918: Price List No. 571 (Chicago, IL: Montgomery Ward & Co., 1918), 5. Catalogue in author's possession.

Bemis. Shepp had dinner with Polly and Charlie on the 9th and on Sunday the 14th he went over there again, probably because Jack Howard was down from Warren and needed Shepp to take him across the river. On the 15th Shepp went back to the Bemises' to get "tobacco for Jack," and on the 16th he took Jack back there for his return to Warren.[110]

Shepp was still getting Polly and Charlie's provisions across the river. On Wednesday, October 17, he hauled their lard and a hundred pounds of sugar, and got a box of apples from them for Pete to take up to town to sell. When Pete returned on the 23rd, he brought two beer kegs; these were dismantled, since Shepp talked about working on them, including putting the hoops on them. He would use them for the cider that he was making from his and the Bemises' apples. He paid a couple more visits to Polly and Charlie that month, and Bill Boyce and Jack Howard also spent time with the couple on their way up to Warren where Boyce bought winter supplies. On the 30th, Shepp "got Boyce's stuff over river,"[111] so that Boyce could pack it up to his place on the West Fork of Crooked Creek.

When Shepp went across on November 3, 1917, he learned that Polly was ill; he also got a sack of cabbage. Over there again the next day, he shot a small deer and a coyote "on ridge back of Bemis." Boyce came down to Shepp's on Monday the 5th and brought Charlie Bemis's saddlebags with him.[112] Shepp crossed the river on the 8th, perhaps to return the saddlebags; he also got twenty pounds of beans "for Joe."[113]

On Sunday, Shepp went over to Polly and Charlie's and wrote that a boat with two men was headed down the river. They stopped for the night and Shepp learned that the boatmen were "Patterson & son from Salmon for Riggans [Riggins].[114] The next day Shepp crossed the river, probably to invite Bemis and Polly to dinner on Saturday the 17th. The following day, Sunday, Shepp shot a "buck sheep" and Pete took some of the meat over to the Bemises on Tuesday. On the 23rd, Shepp took a bundle of *Saturday Evening Post* magazines, dated from January to September 1917, to Polly and Charlie.[115]

Shepp continued with his cider-making tasks, which lasted into late December. From various entries in the 1917 diary, it appears that he was making apple cider, hard cider, apple syrup, and apple cider vinegar, and even distilling apple brandy. For example, on Wednesday, November 21, he ground up eight and a half boxes of "Bemis sheep nose apples."[116] The following day he made 26 gallons of cider. Over the next several days he borrowed a wash boiler from Polly, scalded two beer kegs, and put the cider into the kegs. He had one 15-gallon beer keg full and one 10-gallon "open keg Bemis apples."[117] On Monday, December 3, Shepp made 20 gallons of vinegar. Two days later he fixed the wash boiler, and on Thursday the 6th he wrote, "Bemis cider

beginning to work." On Friday the 14th, Shepp boiled down some of his cider into apple syrup, adding one pound sugar per gallon, and canned three and a half gallons of it. On December 18, Shepp "drawed off cider"; it yielded one 16-gallon container and two 10-gallon containers.[118]

The distilling process began on or before December 21, 1917, when Shepp wrote, "Distilled 3 qts got 1 qt good," meaning that from three quarts of cider he obtained one quart of liquor. Other entries are more cryptic, and may refer to two different products, cider from apples and liquor from cider: "Used 4 gal [of pressed apples] got nearly 3 qts cider," and "Got 24 oz [distilled] from 4 gal = 6 oz to gal."[119] This pastime continued into 1918.

Some of Shepp's other activities that December involved Polly and Charlie more directly. When he visited the couple on the 1st, he noted that it had rained most of the day, and that water nearly covered the island in the Salmon River. Other visits, such as on the 7th, 10th, 14th, 17th, and 22nd, were un-eventful. Earlier, however, Harry Guleke had come downriver with his boat and stayed the night of December 12 with the Bemises. The next day he went across to Shepp's with a petition for improving the river, and Shepp signed for himself, Pete, and Bill Boyce; Charlie Bemis probably had signed it also. On the 13th, Shepp hung tobacco in his house to dry. It included several types, namely "Big H" and Comstock, as well as a mixed batch from Charlie Bemis, likely from the plants he had gotten from Bemis that fall.[120] Additional chores that Shepp did in December, surely ones that Polly and Charlie did also from time to time, included fixing his teakettle and rubber boots and half-soling his shoes.[121]

In anticipation of Christmas, Pete Klinkhammer and Gus Schultz came down to the Shepp Ranch on Christmas Eve. Boyce arrived on Christmas morning and they all went over to Polly and Charlie's for Christmas Day dinner.[122] Although alcoholic beverages aren't mentioned, Shepp may well have contributed some to the festivities.

1918

Shepp shot a deer in early January and the next day he took some of the venison over to Polly and Charlie. After that, he crossed over only about once a week, one time for dinner and another time to take some traps to them, but doesn't specify whether the traps were for varmints or for larger animals. On most days he recorded temperatures from near zero to just above freezing. Although distilling isn't actually mentioned as such, his descriptions leave no doubt about his activities: "Run off 8 gal got 5 qts" and "Got 46 oz from 8 gal."[123]

In February Shepp made a few more trips to Polly and Charlie's place than he had done the previous month, but none were for dinner. Once he got a cat, probably to alleviate a mouse problem, and another time he took the couple

some venison. On the 27th George Bancroft came down to Shepp's and the next day the two men crossed over to visit the Bemises. Shepp continued distilling: "Used 10 gal got 1½ gal not strong didn't double work it. This cider was made on Nov. 2nd." The next day Shepp "made 60 oz from what I made yesterday - pretty strong."[124]

On Friday, March 1, Charlie and Polly crossed the river for dinner at Shepp's; he went over to their place in the afternoon of the 5th. Bill Boyce came down on the 13th, and the two men went over to the Bemises' home for dinner. The next day Shepp made more cider, or liquor, "from Bemis' sheep nosed [apples]" and went over the river again. Pete brought the mail down on Friday the 15th; it included some pictures from Harvey. Since Shepp visited Polly and Charlie the next day, he probably took the pictures to show them. He also reported, "Polly caught big fish, gave it to us." Later in the month, Charlie Bemis burned a stack of hay; perhaps it was old or had molded. Toward the end of March, Shepp and Klinkhammer helped Polly and Charlie out by doing their plowing. On the 29th Shepp "took Bob & Juno [horses] over river plowing all day." On the 30th Pete plowed for them, and the next day Shepp finished the plowing and brought the horses home; Polly gave him 10 pounds of lard.[125]

Besides going to Warren for supplies, or ordering them from Grangeville, it was also possible to get them from Salmon, Idaho. On Sunday, March 10, George Bancroft left for Salmon to place his and Shepp's order. By the 30th, Shepp had learned that Harry Guleke would bring the goods in his boat on April 2; Guleke actually arrived on April 3 with 5,500 pounds of supplies. Pope, otherwise unknown, and Orson James accompanied him. Bill Boyce came down to the river as well, and the men "got all stuff put away." Guleke left the next morning and Pete took four packs of provisions up to Boyce's camp. Guleke brought more supplies on the 21st, including three barrels and five sacks of flour; Shepp paid Guleke $38.15 in freighting charges.[126] Although none of the supplies were for Polly and Charlie, they could well have benefited later from the generosity of their neighbors.

In early April 1918, Shepp crossed over to get some beans for George Bancroft, and on the 17th he returned for dinner. A week later he took Bob and Juno over to the Bemises' place and finished plowing for their garden, and on the 28th he took the couple some potatoes.[127]

In May, Shepp crossed over to Polly and Charlie's several times. While there, he got "horseradishes" and "pieplant" [rhubarb] from Polly. He also took them some cabbage, [canned?] tomatoes, and a few tomato and pepper plants. Guleke came down in his boat on the 13th; his passenger was a Captain Hollewirth [or Hollenwirth; the name isn't entirely legible] who had

killed four bears so far that trip. On the 14th Gus Schultz came down to the Shepp Ranch, and the two men "got jag on," meaning, they got drunk. Shepp underlined the words in his diary, emphasizing their importance. George Bancroft stayed with Shepp on the 27th, and both men went over to Polly and Charlie's the next day.[128]

Nearly every year, in June, melting snow in the mountains turned the Salmon River into a swift, high, and debris-laden torrent, making it too dangerous for boats to cross. Shepp recorded the rising river almost daily, to a maximum of over 14 feet at mid-month. Although he took Jack Howard across on the 4th, he was unable to go over again until the 25th, when he took some potatoes to Charlie and Polly. Meanwhile, when Jack was back at the Bemises' on the 8th, Shepp wrote, "River too high, I won't cross." The telephone between the two ranches must have been operational, since Shepp wrote, on the 10th, "Bemis saw some wreckage going down river, a sweep [steering device for a scow] & some cans." Jack Howard was again, or still, at the Bemises on the 20th. He "started to cross on a raft but gave it up." Bob "Highland" [sic, for Hilands], a placer miner near Riggins and later the owner of Campbell's Ferry Ranch,[129] was also at Polly and Charlie's then. On the 21st the two men crossed at Orson James's place, upriver from the Bemises, and hiked to the Shepp Ranch.[130]

Shepp had a visitor named Kline in early July. On the 3rd he wrote, in handwriting that is sprawling and nearly illegible, "Over river. Kline here. Fine day. Drunk." Kline left on the 4th, and Shepp's writing returned to normal.[131] Shepp went to the Bemises' place on the 5th. Harry Cone and a man named Lytler spent the night at Shepp's place and crossed over the next evening.[132] Shepp and Gus Schultz visited the couple on the 11th, Jack Howard went over the following day, and Pete Klinkhammer spent the 13th through the 16th cutting the Bemises' hay. On the 18th Shepp went over in the morning and began cocking the hay [stacking it so it would dry out], and in the afternoon he took a horse over the river to help with hauling the hay. Shepp turned 58 the next day, July 19. Charlie and Polly's other visitors that month were Shepp again on the 24th, Jack Howard on the 29th, and Pete Klinkhammer and Gus Schultz on the 31st.[133]

In August 1918 Polly and Charlie had dinner at Shepp's on Sunday the 4th and again on Thursday the 22nd. In between those dates there was a lot of activity on the Bemises' side of the river. On the 5th the "Salmon Kid" stayed with Shepp and the next day both men crossed the river for "The Kid" to get "spuds."[134] Shepp went over the next day with Paul Seifert, and on the 9th Shepp and Gus took over some supplies for Polly and Charlie.[135] Jack Howard crossed over on the 10th, and Shepp went there on the 14th. Captain

Harry Guleke came downriver and stayed with Shepp on the 16th. The next day both men went across and got a chicken from Polly. George Green and John Becker spent the night of Sunday August 18 at Polly and Charlie's. The following day Shepp went over to see Green and Becker, who were still there on the 20th.[136]

Although Polly surely enjoyed her male visitors, she must have been especially thrilled with the rare event when a young woman came to stay with her. On Monday the 26th Shepp came over for dinner, perhaps to tell Polly that he expected a visit that evening from Gus Schultz together with his two older children, Helen and Charlie, then aged about 17 and 13, respectively. The following day, they all went over to dinner at the Bemises' and Shepp wrote, "Helen with Polly tonight." Helen stayed there until the evening of the 28th. That day, Green and Becker began building a barn for the Bemises to replace the one that had collapsed in February 1917. The next day, Shepp crossed for a bucket of apples. He must have had Polly tell him what supplies she and Charlie would need for the coming fall and winter, because on the 30th Shepp "made out order for Polly."[137]

He saw Polly and Charlie again on September 1 before heading up to Concord to vote. From Concord, Shepp went to Grangeville via Tollgate, where he caught a ride in an automobile. In Grangeville, Shepp ordered their winter supplies and visited the dentist, Dr. Green. He also bought some eyeglasses for Polly, for $6.00. Shepp returned home on the 11th and the next day he crossed the river, no doubt to report on his trip and to deliver Polly's new glasses. That day, either from the Bemises or by telephone, Shepp learned that their friend Jack Howard had cut his throat the previous Thursday.[138]

On Sunday the 15th, Polly and Charlie Bemis had dinner at Shepp's; on Saturday, Shepp had caught four fish. Later on Sunday, Bert Wolf came to the Bemises' place unknowingly looking for Jack Howard, who was last seen on September 6 when he left another friend's "with 2 big cuts on his neck."[139] Sadly, on the 22nd, Howard's body was found in the Salmon River, below where the Wind River enters it.[140]

On September 16, Shepp took 24 pounds of Polly's beans "up" to sell, apparently to one of the mines or towns on his side of the river. On Thursday the 19th, Shepp and Paul Seifert crossed over to Polly and Charlie's place and Shepp returned there the next day. John Becker and George Green were there, probably still working on the barn, because Shepp took over some nails; Becker and Green left on the 21st. Bob Hilands stayed with Shepp on the 19th, and on the 21st he crossed over to go to Warren. Shepp visited the Bemises the morning of the 24th. On the 28th he "took some of Bemis' stuff over," and on the 30th he probably took more of it over and also got two traps.[141]

In early October 1918, Jack Stone visited Shepp and the two went across to Polly and Charlie's place for dinner on the 7th.[142] Shepp returned there on the 10th and the 11th, and got $50 from them, probably to help pay for their provisions. He was also getting ready to go "outside," place unspecified, the following day and didn't return until the 21st. On the 22nd he crossed over for dinner with Polly and Charlie, took a case of milk over, and surely related his adventures to them. On the 23rd, the neighbors saw their first freeze of the season. Shepp went over that day and again on Sunday the 27th, and on Monday the 28th, he got four boxes of apples from the Bemises.[143]

In late October, Shepp, Pete Klinkhammer, and Paul Seifert "killed little cow." They packed most of the meat up to George Bancroft and to Hump to sell, kept some, and took the tripe [stomach] over to Polly and Charlie.[144]

Sunday afternoon, November 3, Shepp went across the river and got four sacks of little yellow apples for making cider. The next day three packers came down for some "rails" – Shepp had broken up one of Guleke's boats for the lumber. They stayed several days, and before they left Shepp got 300 pounds of potatoes, five boxes of apples, and some cabbage from Polly and Charlie. At least some of the produce was for the packers, but "they left 100# [pounds] potatoes & squash from Bemis." Boyce came down on the 18th, and both men crossed over the river in the afternoon. On Thursday, November 28, Charlie Shepp, Pete Klinkhammer, Bill Boyce, and George Bancroft all had Thanksgiving dinner at Polly and Charlie's home.[145]

On Friday, December 6, Shepp and Pete went over the river for dinner, and the next day Shepp and Boyce got 50 pounds of [dried] beans from Polly and Charlie. Boatman Harry Guleke came down again; he had left his boat upriver at Orson James's place. The two men went to Polly and Charlie's where they spent the night of the 19th. Guleke may have brought some sort of equipment for them, because after he and James left, Shepp and Boyce crossed over and, intriguingly, "Tried machine. Works all ok." They, and Pete, went back on the 25th to celebrate Christmas Day with Polly and Charlie.[146]

Meanwhile, Shepp and his guests busied themselves making liquor. They "heated malt" and were "on boiler" several times. Toward the end of the year, two of his horses died within a month of one another. Juno "rolled on Dixie hill," meaning, the hill going up to Dixie, and Bob "rolled ... on hill above old strawberry bed." This time, instead of disposing of the remains in the river, Pete Klinkhammer set three traps at Juno and Bill Boyce set one at Bob; the men hoped to catch wild animals when they came to feed on the carcasses.[147] Later, they would sell the pelts.

1919

From early to mid-January 1919, Charlie Shepp and Bill Boyce helped Polly and Charlie Bemis by cutting wood for them and getting it in to where the couple could access it. On the 3rd, only Boyce was over there, and Shepp, who stayed home, "caught a coyote at horse," one of the dead horses where they had set traps. Shepp went over again on the 8th. He still had some of the couple's winter supplies and took them some flour on the 11th. On the 13th Jack Cameron spent the night at Shepp's and the next day he went over to Polly and Charlie's. Cameron probably stayed there for several days, to help them out, since he visited Shepp again for Sunday dinner on the 19th, and Shepp cut his hair.[148]

Toward the end of January, Shepp began working on his liquor again. On the 26th, he made three gallons of it, but said it was "no good." He didn't finish until 2 a.m., so must have slept in, since "Bemis rang me up at 1 p.m., thought I was sick." Shepp finished the "run" later that day but "got only 2½ qts." On the 29th, Charlie Bemis visited Shepp in the afternoon, perhaps to sample the finished product. Shepp went to Polly and Charlie's for dinner the next day, and they ate with him on Friday the 31st; that day, Pete was back, and Julius Hicks was down.[149]

On the 5th of February, Shepp wrote that he made four ounces of starch from five pounds of potatoes. A week later he used it in another of his liquor experiments; that one yielded five and a half quarts in the first run, but just one quart in the second run. On the 17th, Pete and "McMeekin & wife" stayed the night with Shepp. The next day, Pete and "Mc" crossed over to the Bemises' place. Although it isn't clearly stated, the group likely included McMeekin's wife, whom Polly would have enjoyed meeting. By the 22nd, the Salmon River had frozen over, so when Shepp visited Polly and Charlie for dinner that day he "crossed on ice." On the 26th, Bill Boyce visited Polly and Charlie, perhaps to see how they were doing and if they had enough wood; two days later he was "over river cutting wood" but returned to Shepp's that afternoon.[150]

In March 1919, no one from Shepp's side of the river visited the Bemises until the 20th, when Shepp rowed Bill Boyce over. Boyce stayed until Saturday the 22nd, probably helping with chores. That day, Pete Klinkhammer and George Bancroft came down to Shepp's and they all went over to have dinner with Polly and Charlie, taking Boyce back with them when they left. The following day Shepp "wrote Guleke order for Bemis," meaning that Polly and Charlie needed some supplies that Guleke would bring on his next trip. Orson James visited Shepp on the 26th, and the next day Shepp took him across the river. Bancroft came down again on the 30th and spent the night with Polly and Charlie.[151]

That April, on the 7th, a man named McGregor came down to the Shepp Ranch. He and Shepp went over to the Bemises' that afternoon. They took the couple 50 pounds of potatoes and got some seed from Charlie Bemis.[152] On Thursday the 10th, Shepp "took Boyce over river to spade garden for Polly,"[153] indicating that Charlie Bemis was no longer physically able to do it himself. On Sunday the 13th, Shepp learned that Guleke had left Salmon on April 9.[154] Bancroft came down again on the 14th. He and Shepp visited Polly and Charlie on the 16th. Guleke's boat, with eight men, arrived on Thursday, April 17. The boat left the next morning, with Bancroft on it. Shepp wrote, "Our stuff wet, mush [cornmeal or oatmeal] spoiled. Got nearly all up to house. Boyce down. Got all Bemis stuff over but coal oil," which he took to them the next morning. Shepp paid Guleke for Polly and Charlie's bill, $85.44, and collected from Bemis on the 25th.[155]

On the 19th, Shepp made 20 gallons of raisin wine, using 20 pounds of brown sugar, and put it in kegs on the 21st. That day, Polly caught four fish. On the 23rd, Shepp took Red, one of the horses, and a plow across the river. He also put new batteries in the telephone. He returned on the 24th to plow, and finished on the 25th. On the 29th, Shepp "put wine in keg & jugs": one five-gallon keg, three one-gallon jugs, and three quarts in bottles.[156]

May 1919 saw little interaction among Charlie Shepp and his neighbors across the river. On the 3rd he got a piece of wire and went again on the 10th. Sunday, April 18, Pete, Boyce, and Gus all went over the river to plant corn and beans for Polly and Charlie.[157] At home, among other chores such as spring planting, Shepp kept busy demolishing one of Guleke's boats for the lumber, and drawing off the wine from the five-gallon keg. He also had a friend shear his sheep; nine of them yielded 93 pounds of wool.[158]

On June 2, Harry Guleke came down the river again, with John Painter, Percy Anderson, and Hollewirth [or Hollenworth] (Fig. 6.8). Shepp got a box of prunes from Guleke and gave him 73 pounds of wool.[159] The next day, Shepp, Bill Boyce, and Bob Highland crossed the river, and Boyce worked on Polly and Charlie's garden that day and the next. On Friday, June 6, "Lytler & boy" spent the night at Shepp's and on the 8th they left for Warren. Since they had to cross the river to do that, Polly undoubtedly enjoyed visiting with them before they headed up to town. On the 11th Shepp went over to the Bemises' and found that Charlie had shot a deer; he gave Shepp a quarter of it. Boyce came down that night, and the next day he crossed over for the day, probably to help the couple with their garden again.[160]

At mid-month Shepp learned that the telephone wire on the Bemises' side was broken. The next day Bob Hilands and Bill Boyce came down and got some cherries and strawberries from Polly and Charlie. On June 19 and 20

Fig. 6.8. Harry ("Cap") Guleke, right, and Percy Anderson on a river trip, 1917. From Johnny Carrey and Cort Conley, River of No Return (*Cambridge, ID: Backeddy Books, 1978), 24. Used with permission.*

Boyce and Pete Klinkhammer were "over river" and Pete went back by himself on the 21st. That day, Shepp wrote, "Boat down this eve, 6 men. Got wire chicken fence. 150 feet. [$]6.60. [G]ot [$]30- for wool. After all expense paid wire fence & freight rec'd $19 from Guleke."[161] That trip left Salmon City on June 16, "with a load of supplies for ranchers and mining men residing along the river." The boat also carried an unnamed "artist" who was taking "motion pictures of scenes in central Idaho, especially along Salmon [R]iver."[162]

On the 22nd Ed Matzke and his brothers, Fred and Charlie, were at Shepp's. The next day Fred and Charlie crossed over to visit with Polly and Charlie, and Pete went across too, to finish getting in the couple's hay. Shepp went over in the afternoon of the 27th and on the 29th he "made 4 gal[lons of] cherry & prune mash," for wine.[163]

Pete and Bob visited Polly and Charlie on July 4, and Shepp went over on the 8th, no doubt to tell Polly and Charlie all about the two men who had come down the river in a boat and who had spent the previous night at the Shepp Ranch. On the 14th Shepp finally began to fix the telephone, when he, Pete, and Bob "stretched wire across river." The next day he, Pete, and Boyce crossed over; Shepp reported, "Hot. 106 [degrees]. In the afternoon of July 17, Shepp took four joints of stovepipe over to the Bemises; Matzke had brought it "from camp," meaning, their mining camp in the hills above the Shepp Ranch. Shepp visited again on the 20th, after dinner, and crossed in the

177

morning of the 21st and again in the evening when he realized that Polly and Charlie had company. The visitors were John Becker; his sister, Bessie, visiting from New York (Fig. 6.9); and "Mrs. Rhodin" [*sic*, for Ethel Roden, wife of Warren Hotel owner Ed Roden]. The next day the visitors, together with Polly, crossed the river to have the noon meal at Shepp's, and he commented, "Becker & sister caught [a] mess [of] fish." On the 23rd, "Becker & folks went home am [a.m.]."[164]

Toward the end of July 1919, Shepp crossed over on the 25th and again, with Pete, on the 26th. Pete got beans and peas and took them up to town to sell the next day. Shepp must have been coping with another mouse infestation, because on Monday the 28th he "took Polly's cat home." On the 31st, Shepp went over again, to get string beans and two dozen eggs from Polly.[165]

Fig. 6.9. Bessie Becker and her brother, John Becker, about 1921. From Cheryl Helmers, Warren Times: A Collection of News about Warren, Idaho (Odessa, TX: The Author, 1988), October 1921. Used with permission.

During August, Shepp visited Polly and Charlie on the 4th; the 5th, when he took them some apples; and the 6th. Fire season had begun on his side of the river, and Pete helped fight it. On the 10th the telephone stopped working, so Shepp crossed over the next day and fixed it. The following Tuesday, August 12, Shepp wrote, "Boat down at noon, party [of] hunters from Idaho Falls. [Harry] Guleke & [Percy] Anderson over river," to visit with Polly and Charlie. He also observed that it was "awful smoky" that day and the next, when the "fire looked bright tonight."[166]

On Thursday, August 14, 1919, Polly and Charlie crossed over for dinner with Shepp. This wouldn't be an unusual event, except that it was evidently the last time Charlie Bemis crossed the river, another indication that his health was failing. After lunch, Pete Klinkhammer and a man named Porter arrived at the Shepp Ranch, bringing sugar, coffee, macaroni, and canning jars.[167] The next morning Shepp took Porter across the river, and commented, "So smoky can't see across river."[168]

The fire intensified during the second half of August, and Shepp became very involved in feeding the fire crew. On the 16th he "killed little black bull with horns," for a meat weight of 364 pounds. The next day he crossed over to the Bemises' place because "telephone out of commission." On the 18th

Shepp wrote, "Fire spreading all over basin"; it burned his mining claim cabin on Arlington Ridge. On the 20th he could no longer see any fire. That day Shepp got more string beans from Polly. The following evening Shepp cooked supper for a fire crew of 23 men, and fed "the gang" breakfast the next morning. On Saturday, August 23, Shepp killed two sheep, yielding 75 pounds of meat each. Pete "packed them up to both [fire] camps" and brought back a telephone receiver from George Bancroft. Again, it was too smoky to see across the river. The next day a cook and a packer came down from the fire crews; they got some milk. On Monday, Shepp killed another young bull, gaining 390 pounds of meat; smoke from the forest fire still prevented him from seeing across the river. Two days later he took the beef tongue over to Polly and Charlie and crossed the river again on Saturday the 30th.[169]

During September 1919 the river dwellers remained concerned about the fire threat, had another visit from Captain Guleke, and celebrated Polly's 66th birthday. By September 1 there was fire on the Bemises' side of the Salmon River. Shepp went to look in on Polly and Charlie, and the next day he returned to dig a trench, for a firebreak, on the upper part of the Bemis Ranch. Boyce and the fire crew's cook came over, too, but not necessarily to help with the trench. On the 3rd, Shepp observed that fire was coming down Warren Ridge, south toward the Bemis Ranch. Shepp and two unnamed men went over to work on the trench, and Shepp finished it the next day.[170]

Saturday, September 6th, was busy; Shepp, Pete, and Boyce went up to check on George Bancroft's camp and found "everything there all OK." Harry Guleke's boat came down with nine men. They all stayed at the Shepp Ranch, and some of them slept in the barn. The passengers were William and George Shoup, "Mr. Hanson …, Mr. Campbell & boy, [the] Cook, [Harry] Guleke & [Percy] Anderson & Mr. Bates."[171]

Although Shepp doesn't mention a visit to Polly and Charlie by the boat passengers, that is indeed what happened, at least for Will Shoup. Guleke and Anderson likely crossed over too, and perhaps some of the other passengers also met the Bemises. In an account of the trip, Shoup said,

> Another interesting character we met was Charles [A.] Bemis, who has lived with a Chinese wife on a little 4-acre patch of land on Polly [C]reek opposite the mouth of Crooked river [*sic*, for Creek] for the past twenty-five years [i.e., since 1894]. He is getting too old to work and Polly, the wife, 69 [almost 66] years old, does it all.[172]

In a later interview, Will Shoup provided additional information about the Bemises' life on the Salmon River:

> They raised their own food and bought only a few necessities they could not raise. Produce from their garden — 'Polly's garden' — was

taken into Warrens ten [actually, 18] miles away and sold or traded for their necessities, which were packed out to the farm by pack animals. However, some articles could not be purchased at Warrens and so word would be sent up the river by some person going to Salmon that Charlie and Polly needed coal oil especially. One summer when … Shoup was at the Bemis ranch on a hunting expedition Polly ordered a pair of overshoes, size four, to be sent down on the next boat of travelers or hunters.[173]

No money was ever taken for board and lodging, although the Bemis [R]anch really substituted for a hotel in that region …. When the guest left he was loaded with all the fruit and vegetables he could carry, and his last memory would be of Charlie and Polly Bemis standing on the trail waving goodbye.[174]

After the boat left on the 7th, Shepp crossed over to the Bemises' place that day and the next. On both the 9th and 10th he observed that the fire was still burning in Bemis Gulch. On September 11, 1919, he, and probably Pete also, since he was visiting Shepp, went over for dinner, and wrote, "Polly's birthday, 66," thus reconfirming that she was born in 1853.[175]

On the 12th Shepp returned, probably to get Polly and Charlie's order for winter supplies, since Pete took their shopping list up to town two days later. The night of the 13th Shepp hosted a man named Sayer who was on his way to Warren; Shepp took him across the following day.[176] By mid-month the fire had spread to the west side of Bemis [Polly] Creek and was still there on the 18th. Shepp had several visitors the night of the 16th, and the next day he and Jack Stone crossed the river to have dinner with Polly and Charlie. Shepp went back on Sunday morning and on Monday he again had the noon meal there, together with Bill Boyce. On Thursday Shepp got some grapes from Polly. The next day, Boyce went over to cut wood for them, and Shepp observed that there was still fire on Bemis [Polly] Creek.[177]

That Sunday, Shepp made seven gallons of grape wine using three and a half gallons each of grape juice and water and eight pounds of sugar. On Monday he took Polly and Charlie a sack of flour, got his boiler ready, and made three and a half gallons of liquor, which took him until 3 a.m.[178]

During early October 1919, the arrival of autumn rain and snow solved the fire problem. On the 3rd, Shepp got some tomatoes from Polly. That evening, he, Pete Klinkhammer, Bob Hilands, and perhaps Bill Boyce, "got a jag on" [got drunk]. Pete and Bob must have brought the Bemises' winter supplies with them, because on the 4th, Bob, Boyce, and Shepp "took grub over;" Pete was sick, perhaps hung over, so didn't go with them. He had recovered by Sunday the 5th since he and Shepp visited Polly and Charlie. Shepp went to

Warren on the 7th and returned on the 11th. In the meantime, Bob had gotten a deer, so on Sunday Shepp took Polly and Charlie some of the meat, as well as four sacks of flour, noting that he still owed them one sack. The following Thursday, Shepp took the Bemises' salt and macaroni over, and on the 21st he got two sacks of cabbage from them. He last visited them on Sunday the 26th, when he went "over river after dinner."[179]

As Polly and Charlie aged, they depended more and more upon the kindness of their neighbors. During November 1919, for example, Shepp and his friends, Bob Hilands, Pete Klinkhammer, and Bill Boyce, shared venison with Polly and Charlie and cut wood for them.[180] Shepp also crossed the river numerous times that month, perhaps just to check on the couple. On Sunday the 16th, Shepp wrote that he heard Bemis shoot four or five times.[181]

Charlie Bemis was close to becoming bedridden from illness, and that mention of him shooting is the last indication in the Shepp diaries that Bemis was outdoors. In 1966 Marybelle Filer, who then owned the Shepp Ranch with her husband, Paul, commented, "Diary entries by Shepp at that time [1919] indicate that Bemis was then an invalid."[182] By mid-1921, Polly Bemis told an interviewer, "He [Charlie Bemis] bin abed 'most two year now."[183]

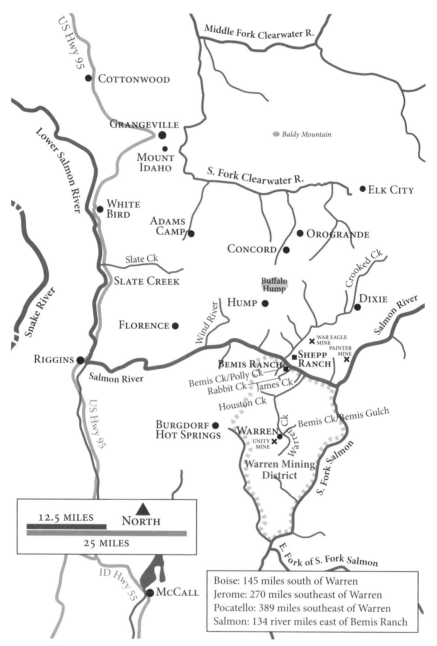

Map 7. Idaho place names mentioned in Chapter Seven. Roads in gray did not then exist, but are included for context. Drawn by Melissa Rockwood.

CHAPTER SEVEN:
On the Salmon River and in Warren, November 1919 to October 1924; Polly, age 66-71

Once Charlie Bemis was bedridden, a new chapter began in Polly's life. For some time, as Charlie gradually became more feeble, their friends and neighbors kindly stepped up to help with the heavy ranch work, thus enabling the couple to continue living on the Bemis Ranch. This dependence only increased over the next few years. Charlie Shepp provided the most assistance, aided, when possible, by Pete Klinkhammer when he wasn't working elsewhere, away from the Shepp Ranch. Following Charlie's death, in late 1922, Polly moved back to Warren. She lived there for the next two years while her friends rebuilt her Salmon River home.

Major Events from November 1919 to October 1924

In establishing context for Polly Bemis's life from late 1919 to late 1924, a number of significant events occurred during that period. For example, in 1920, the United States ratified the 19th Amendment, giving women the right to vote, and Republican Warren G. Harding was elected the 29th president of the US.[1] The following year, Mao Zedong founded the Communist Party in China,[2] and Arlington National Cemetery received its first burial in the Tomb of the Unknown Soldier.[3] Noteworthy international and national events of 1922 included Mussolini's march on Rome and his formation of a Fascist government; the opening of King Tutankhamen's tomb; and the dedication of the Lincoln Memorial in Washington, DC.[4] During 1923, a powerful earthquake destroyed nearly half of Tokyo, killing more than 150,000 people; President Warren G. Harding died, Vice-President Calvin Coolidge succeeded him, and Rin Tin Tin became the first canine movie star.[5] Internationally, in 1924, Lenin died and Stalin took over as dictator. Nationally, Nathan Leopold and Richard Loeb's wanton murder of 14-year-old Bobby Franks shocked

the entire country.[6] Harding's death was the only one of these events to be mentioned in Charlie Shepp's diaries.[7]

1919

In early November 1919, one of Polly's Chinese friends from Warren returned to China. McCall's *Payette Lake Star* had this to say about his departure:

> Lee Dick, a resident of Warren for the past 18 years, is returning to his home in China. Dr. Dick, as we called him, saved many lives in this section owing to his knowledge of Chinese medicine. He spent many days and nights on the trail to relieve the suffering, never expecting pay. He was far above the average Chinese in this country, and left here with a good fortune from placer mining. Hardly a person in this section has not come under his care for illness, and it is with regret that we must announce the departure of Dr. Dick, the highest type of his class we have ever met.[8]

On November 17, Shepp went over to the Bemis Ranch in the morning. He took the couple a lamp chimney and some copies of the *Saturday Evening Post*; he also brought a saw over and sharpened it. Since Thursday, November 27, was Thanksgiving, Charlie Shepp, Bob Hilands, and Bill Boyce went over to Polly and Charlie's for dinner; again, always the noon meal.[9] They crossed by boat, but because the eddy was full of ice, Shepp pulled the boat out of the water when they returned home.[10]

December was exceedingly cold; on Friday the 12th the temperature was 22 degrees below zero at 3:00 a.m. Shepp kept a fire burning in his root cellar all night to keep his canned goods and stored produce from freezing. Over the next two days Hilands and Boyce crossed the river to cut wood for the Bemises. Shepp continued to make wine and distill alcohol, and on Friday the 19th he took Polly and Charlie a bottle of his wine and a half-pint of his homemade brandy. Pete came down on the 22nd, and the next day he and Shepp visited the Bemises, crossing on the ice. The two men, plus probably Bill Boyce and Bob Hilands as well, returned to Polly and Charlie's on Christmas Eve, and Shepp came again on the 28th.[11]

1920

In late December Shepp killed his bull, and on January 2 he took some meat over to Polly and Charlie. Frank Jordan was at the Bemises' place that night, and on the 5th and 6th, Shepp and Bob went over there to cut wood. Shepp took a saw over on the 8th and returned there on the 10th and 13th. Meanwhile, on the 11th, Bob cut wood for them again. Shepp visited with

the Bemises on the 21st and took them some beef ribs from the bull he had killed. Two days later Bob went over to cut wood for them. On the 28th Shepp canned 12 quarts of meat and on the 30th he and Bob went over in the morning. Shepp wrote, "Cooked 7 jars meat over," implying that he canned that meat at the Bemises.[12]

On February 1, 1920, Shepp "took part of bull neck over river for chickens." He also "got rubbers from Bemis."[13] If Charlie Bemis were bedridden by then, as evidence indicates, he would have had no further use for his boots or rubber overshoes. Shepp crossed again on Thursday the 5th and Saturday the 14th, and on the 16th, Bob was "over river on wood." Both men went over for Sunday dinner, crossing on the ice, and on the 25th Bob returned to cut wood for Polly and Charlie.[14]

On February 27 Shepp noted that he had "6 head horses 10 cattle" and that he had "sent grazing permit." Cryptically, he wrote, "& deed for Bemis," implying that he had mailed it off as well. Meanwhile, Shepp continued with his distilling and on the 29th [it was Leap Year], he took Polly and Charlie another pint of his homemade brandy.[15]

Warmer weather arrived in March. On the 4th, Shepp and Boyce crossed the Salmon River, but on the 6th Shepp wrote, "Ice going out. Tried to cross, looked too bad." The following Saturday, Shepp had company; Bob Hilands and Billie Allen came down. Shepp wrote, "Opened bottle. They settled all IWW troubles & got man for President."[16]

Although Shepp didn't mention being away, from the 14th through the 25th there were no entries in his diary. On the 26th he killed a calf. He and Bob crossed the river, so they probably took Polly and Charlie some of the meat. Bob returned on the 29th to cut wood for them, and perhaps brought the census taker back with him, since Shepp noted, "Davis cencus [*sic*, for US Census] man here tonight."[17]

The US Census for 1920 listed Polly and Charlie Bemis as living in Warren Precinct (Fig. 7.1); as indicated above, enumerator George L. Davis actually made his way down to the Salmon River to count them. The Bemis household then consisted of Charles A. "Bemiss," age 71, and his wife Polly, age 67. Bemis owned his home, free of any mortgage, and both had "None" in the column for occupation. Polly's year of immigration to the United States was "Un," unknown, and she was unable to read or write. The census taker believed she was a naturalized citizen, "Na," although no year was given.[18] However, because Polly had been born in China, she was thus ineligible for naturalization.

Fig. 7.1. *1920 US Census of Warren, Idaho, showing Charles A. "Bemiss"* [sic] *and Polly. US Census,* Fourteenth Census of the United States, 1920, *Idaho, Warren Precinct, Idaho County, Idaho (National Archives Microfilm Publication T-625, roll 292, Enumeration District 105, Sheet 1B, lines 79-80); Records of the Bureau of the Census, Record Group 29.*

Across the river, in Idaho County's Concord Precinct, Charles W. Shepp, Head (of household), and Peter Klinkhammer, Partner, are listed in the 1920 US Census (Fig. 7.2). Shepp was a 59-year-old farmer, and Klinkhammer was a 39-year-old fur trapper.[19]

Fig. 7.2. *1920 US Census showing Charles W. Shepp and Peter Klinkhammer. Their friend Bob Hilands is also listed, in his own (separate) household. US Census,* Fourteenth Census of the United States, 1920, *Idaho, Concord Precinct, Idaho County, Idaho (National Archives Microfilm Publication T-625, roll 292, Enumeration District 88, Sheet 1B, lines 51-53); Records of the Bureau of the Census, Record Group 29.*

April was the plowing season and the beginning of planting; fortunately for Polly and Charlie, their neighbors willingly did those chores for them. On Friday the 2nd Shepp went over to their place and on Sunday the 4th

he, Boyce, and Bob went over. On the 6th he crossed again and fixed their sled; Polly may have needed it to bring things from the outbuildings to the house. On the 7th Shepp got a plow and a cultivator from the Bemises, and on the 13th he "got our plow" from them. Meanwhile, John Becker and a man named Mosberg stayed at the Bemises from the 8th until Sunday the 10th when they crossed over to have dinner with Shepp.[20]

On Wednesday morning, April 14, Polly caught a fish that weighed four and a half pounds. She may have conveyed that information by telephone because no one was over there until a week later when Pete and Bob visited the Bemises that evening. On the 23rd Ed Matzke spent the night at the Shepp Ranch and went over to the Bemises' place the next morning, perhaps to report on the boat that had come down the river earlier that day.[21] From the 26th to the 27th, Shepp, Bob, and Pete were across the river plowing. The next day Boyce went with them; he pruned trees, spent the night, and went back to Shepp's at noon on the 28th. The others finished the plowing on the 27th and brought the horses back across the river. They also planted onions and carrots for Polly.[22]

More planting took place in May. On Thursday May 6, Bob and Boyce put in Polly's garden, and on the 7th they planted corn and potatoes for her. Shepp crossed over himself on Sunday the 9th, and took the couple six boards. On the 13th he took the Bemises some "corned meat"; this was from the bull that he had killed in late December and had put into brine to preserve it. He also got a bucket of eggs from Polly. Gus Schultz came down to Shepp's on Sunday the 16th and after dinner the two men visited the Bemises. Two days later Boyce and Pete crossed over, and on the 25th, with Gus back again, he and Shepp went across.[23]

From Wednesday May 26 through Saturday June 12 there are no entries; Shepp was away from his ranch. Wherever he went, perhaps to Seattle, he reported that it took him four days to get home. While he was gone, Pete and/or Boyce surely looked after Polly and Charlie, and Shepp visited them the day after he returned. He didn't go over again until June 24, when he got some strawberries. Boyce was there from Friday the 25th until Sunday afternoon the 27th, and went "outside" the next morning. On his way to, or through, Grangeville, he called in at Alexander and Freidenrich's, with orders for goods from both Polly and Shepp, and mailed an order from Shepp for another truss, this time to the Cluthe Truss Company.[24]

Haying season at the Bemis Ranch began on July 1, 1920. Pete went over that day to begin cutting the hay and continued on the 2nd. Bob came down the next day and went across to help Pete. They may have taken Sunday off, since Pete didn't return there until Monday the 5th. On the 7th, Shepp

learned that George Green had died.[25] Shepp took Boyce over to the Bemises' place during the morning of the 9th and Bob crossed over that afternoon. A week later, Boyce was back and crossed again. He, Pete, and Charlie Schultz, Gus and Nellie's son, visited Polly and Charlie on Monday the 19th. On the 21st, Boyce spent all day there "on corn," probably watering and weeding it; the water came from Bemis Creek [Polly Creek], diverted via a ditch to Polly's garden. Shepp went over himself on the 22nd and again on the 29th when he "got spuds."[26]

Shepp took Polly a sack of flour on Monday, August 2, 1920. On the 5th, he returned to water their corn and potatoes. On Friday the 6th, Pete came down to the Shepp Ranch with a pressure cooker and groceries. The next day, Shepp took the Bemises some of the groceries and 10 pounds of lard and visited them again the following afternoon or evening. On the 10th he cooked some meat in his new pressure cooker; when he crossed over to visit the Bemises the next day, he surely told Polly how well it worked. Sunday the 15th, for the second time that month, Shepp watered the Bemises' corn and potatoes. He went over again in the afternoon on the 19th and the 23rd, and had dinner with them on the 27th.[27] The next day, Saturday, Shepp took some fish over, and on Sunday he and Boyce visited the couple for dinner; perhaps Polly cooked the fish for them. Shepp also commented, "Boat down at noon. 3 men & 3 women. W. R. Thurston Salt Lake."[28] Shepp implies that the boat stopped on the Bemises' side of the river while he and Boyce were over there. As we'll see, Polly relished chatting with the three women; they in turn would have enjoyed meeting her.

In March 1922 Lee Charles Miller, a member of the Thurston boating and hunting party, published an article about the excursion in *Outing* magazine.[29] Captain Harry Guleke and Percy Anderson were the boatmen and according to Miller, Guleke "no longer insisted upon the members of the party wearing life preservers. In fact ... we did not have a single life preserver on board the boat."[30] Guleke manned the front sweep [oar], Anderson controlled the rear sweep, and Charlie Dodge was the cook. Although Miller, coyly, doesn't provide full names for the six adventurers, from Shepp's information combined with other sources we know that they included mining engineer W. R. Thurston and his wife [Miller's "Walter and Althea"]; Miller's "a couple of adventurous youngsters from South Orange, N. J., ... Henry and Harty" Munger; and Miller himself, "The Bishop," together with his wife, "My Lady Brown Eyes"[31] [Minnie W. Miller, Miller's wife].[32]

Miller mentioned Polly:

Next in interest ... comes Polly Bemis, the quaint little Chinese woman who came to Warren, Idaho in [18]'72, married a miner who

was a saloon keeper, and when Warren died as a mining camp, moved to the Salmon River, where they have mined and farmed for twenty-seven years, and where Polly (and her now invalid husband) still lives, her intrepid spirit undaunted by her lonely life.[33]

…

At the point opposite where Polly Bemis and her husband live are two old-timers by the name of Schepp [Charlie Shepp] and [Bill] Boyce. They, too, have a little farm or ranch, and they, too, mine for gold.[34]

They have built a little telephone line from Polly Bemis' log cabin across the river to their cabin, and every evening at a certain hour they talk to each other; this keeps them all from being too lonely. With the exception of one or two months in the spring, when the high waters come, they can cross the river back and forth in a boat.[35]

This group had a movie camera with them.[36] Although no film of their trip has been located, an earlier narrative by Miller, about the same adventure, includes four, virtually identical, motion picture stills from it[37] (Fig. 7.3). In this article, Miller had even more to say about Polly, although somewhat inaccurately [corrections in brackets]:

When we told Polly we were going to put her on a moving-picture film she clapped her hands in glee

Fig. 7.3. Polly Bemis in motion picture stills, 1920. From Lee Charles Miller, "Adventures of a Motion Picture Amateur," Outing 79:1 (October 1921), 18.

One of the interesting characters of the river and one of whom we heard from the time we entered the canyon near Salmon City was little Polly Bemis. She is a Chinese woman who as a girl (and the old timers describe her as very beautiful in those days) came to Warren, a mining camp on the head-waters of some streams pouring in the Salmon River in 1870 [1872], coming from Hankow, China.[38] In 1872 [1890] she nursed Bemis back to life, after he had been shot in … some frontier brawl. In 1874 [1894] Bemis married Polly and for years she helped him run a saloon in Warren.

She naïvely told us, 'I never drink any whiskey. When the miners come and ask me to drink, I have a bottle of ginger ale, I pour that out in a little glass – I drink it, but I make them pay for it like whiskey,' and with this her eyes would dance with laughter.[39]

…

In 1892 [1894], Bemis and his Chinese wife went down over the difficult trail and established a home on the banks of the Salmon River and at the mouth of the stream which has been named Polly Creek. Here he ran a placer mine and at the same time built up a little farm or ranch. Irrigation water from Polly Creek made it possible to irrigate the little delta that had been formed at the mouth of this creek. Eventually he established a fine orchard and a fine little farm from which potatoes, vegetables, and all crops of the temperate zone can be raised. Here, he and Polly had lived ever since.

The pay dirt ran out and then the two settled to make their living on their farm. Of course it cost little to live there and fresh meat is always available in the big game found in that remote section.

But as years have gone on, Bemis, who is getting on the shady side of the hill of life, has been unable to do much and the devotion of the old timers to little Polly Bemis is a pleasing thing to recount. They come in the summer time long distances, some of them a hundred miles, to help Polly plant her patch of potatoes or harvest it, to help her gather the fruit or to bring her a half of venison or some furs for primitive clothing. All this we had heard in many tales around the camp fire as we drifted down the Salmon River.[40] So we were eager to see Polly.

We found Polly all that we had pictured her, bright, active, of keen mind. Hers was one of the most interesting personalities with whom we have ever come in contact.

We designed to make a moving picture of Polly. We thought we would have to explain to her what it was. We knew Polly had not been out of the canyon for eighteen years.[41]

Bless me! Polly knew all about moving pictures, though she had never seen one. And when we told her that we were going to put her picture on a moving picture film, she clapped her hands in glee.

And the way she arched her eyes and waved her hand and talked and marched around in her little yard while I ground away at the crank of the moving picture camera would have made many a moving picture actress green with envy. And I am proud to report that we got a very interesting film of Polly.

She was excited at meeting our ladies; they were the first women she had seen in eighteen years.[42]

For ten years after they moved into the canyon, she was able to go out once a year as far as the old mining camp of Warren; and so had some touch with the outside world. [Miller believed that the Bemises moved to the Salmon River in 1892, but it was actually 1894. Subtracting ten years from 1892 leaves 1902 as the last year Polly went up to Warren.]

But for eighteen years [i.e., since 1902] on account of a touch of rheumatism [today's arthritis] she has been unable to make the strenuous trip out of the canyon. And she is afraid of the boat.[43] In fact if she went out by the boat, she could only go back by going clear around from Spokane [Washington] to Butte [Montana], Butte to Armstead [Montana], and Armstead to Salmon City [Idaho], and floating down the river in the next boat trip.[44]

The hunting party moved on, no doubt leaving Polly with warm feelings from her meeting with the Millers, Thurstons, and Mungers, and from sharing her past life with them. The next encounter she had with visitors was on August 31, when Orson James and Oscar "Weller" [Waller] spent the night at the Bemises' place.[45] Polly surely regaled them with her filming exploits.

During September 1920, Polly and Charlie seldom lacked for company. On the 1st, Shepp went over with Bob Hilands, and James and Waller went home. Shepp visited the couple again on the 2nd and 4th, and on the 5th he and Boyce crossed over together. Shepp also returned on the 7th, the 9th, and the 10th.[46] On Saturday, September 11, he wrote, "Over river to dinner. Polly 67 years old. ... China Sam at Bemis tonight."[47] "China Sam," or "Ah Sam," as the Euroamericans called him, was really named Jung Chew (1863-1933). He ran a bathhouse in Warren and was one of Polly's friends from when she lived there between 1872 and 1894 (Fig. 7.4).

The next day, the 12th, Shepp came over with Boyce. He also fixed the telephone at his house, and went back to the Bemises' on the 13th to try it out. Boyce was down again on the 16th and visited the Bemises; Shepp was

busy making wild cherry wine that day. Pete had also come down, bringing Shepp's new truss. On the 17th, Shepp took Polly her flour and a case of milk, and Pete and Billie Allen visited the couple on Sunday the 19th. The next day, Pete and Shepp returned and "got all their [the Bemises'] corn in." Shepp went back to Polly and Charlie's after dark because the telephone wasn't working, and he returned there again on the 21st.[48]

That evening a boat came down the river; it isn't clear whether they stopped for the night at Shepp's place or at the Bemises since Shepp just wrote, "I was over to see them after supper." This could mean that he crossed the Salmon River, or just went over Crooked Creek, on his side, to where they were camped. He continued, "9 on boat besides the 3 boatmen. All Doctors. Had several drinks." They left the next morning.[49]

Fig. 7.4. "Ah Sam"/"China Sam"/Jung Chew, date unknown. From Jeffrey M. Fee, "Idaho's Chinese Mountain Gardens," in Hidden Heritage: Historical Archaeology of the Overseas Chinese, ed. Priscilla Wegars, 65-96 (Amityville, NY: Baywood, 1993), 74. Photo in collection of Payette National Forest, McCall, Idaho, donated by Herb McDowell.

The Salmon, Idaho, newspaper had reported on this boating party before the group set off in early September:

Members of the Portland medical and surgical party making up the voyagers down the Salmon [R]iver on Tuesday were joined here by Drs. Hammer, Putnam, Adams[,] and P. J. Dempsey. The visitors were entertained at dinner by Mrs. Hammer and Mrs. Dempsey on Sunday and Monday evenings.[50]

The telephone between the Shepp and Bemis ranches continued to cause problems, so Pete went up to town to get another one. On the 23rd, after Shepp had visited the Bemises that day, Pete came down in the evening with the new telephone. The next day, Shepp took it over and installed it. He went

back on Saturday and Sunday, the 25th and 26th. On Sunday he got a box of apples and borrowed a corn sheller from Polly. The next day he used the sheller and "made mash with red corn," another of his liquor experiments. On Tuesday the 28th Pete and Bob crossed over and got two boxes of apples from Polly. Shepp's "mash started working" on the 30th.[51]

Over two days in early October 1920, Shepp dug the Bemises' potatoes, totaling 1,500 pounds. Their winter supplies began to arrive; Shepp received the sugar, lard, and oats on the 5th, and the next day he, Bob, and Pete crossed the river, taking 30 pounds of lard and 50 pounds of sugar with them. When Shepp returned there on the 10th, he may have noticed that Polly was getting low on wood, because on the 14th, Pete went over to cut some for her. Shepp crossed over on the 17th.[52] On the 20th, a boat came down at noon, but it probably didn't stop because Shepp gave no details about its occupants. Later, he went over to the Bemises and picked two boxes of Ben Davis apples and one box of culls; he also "cut cabbage," i.e., harvested it.[53]

Pete arrived at Shepp's place the next afternoon. He had come via Orogrande hoping to pick up some of their winter supplies that would have been freighted there from Grangeville, but there was "no stuff at Orogrande."[54] He also brought the news that John Long had died in mid-October. Long was well-known to Polly Bemis as the husband of Bertha Long, Polly's friend from when the Longs lived in Warren from April 1889 to November 1890. It is easy to imagine that Polly would have grieved Long's death as she mourned her friend's loss.[55]

Shepp, who was still involved with George Bancroft's mining ventures, noted his contributions to them in his diaries. On October 22 he "got 3 [wooden] rails & 2 bars [of] drill steel ready for Pete to take up to [Bancroft's] camp. The wood came from one of Guleke's boats that Shepp had previously bought and dismantled. The next day Shepp crossed the river to cut grass out of the Bemises' water ditch. On the 27th Gus Schultz came down with two horses and "brought our grub down." Pete visited the Bemises that afternoon, and the next day he and Shepp cut wood for them. They returned on the 29th, perhaps to cut more wood, although it isn't mentioned. On the 31st Shepp and Gus swam six horses across the river. The men took four of them upriver so they could forage at Rabbit Creek, three-quarters of a mile away, and used Nellie and Major to haul wood.[56]

The next day, November 1, Shepp "got all wood in across river" and brought the two horses home. Polly gave Pete $25, probably to help pay for the winter supplies that she had ordered. On the 4th Shepp crossed again and "brought wood tools home"; this was a bit premature because he was over there again cutting wood on the 9th and 10th, from the 23rd through the 25th, and again

on the 27th. Although the 25th was Thanksgiving, Shepp didn't mention having dinner with the Bemises, but since he was already there, he probably did eat with them. He also crossed on the 12th and 14th, but didn't specify what he did on those days; perhaps he was just checking on Polly and Charlie to be sure they didn't need help with anything. On the 24th the horses had wandered down to the Bemis Ranch from where they had been grazing, and on the 30th the horse Nellie crossed the river to join them.[57]

In early December Shepp put a fence around the Bemises' barn and went over again a couple of days later. On the 8th, looking across the river, he could no longer see the horses, so the next day he went over to hunt for them but found them all back at Rabbit Creek. He also took Polly seven pounds of bacon and got a dozen eggs from her. Shepp crossed again on the 19th, and Pete visited the Bemises the next day. Fred Matzke spent the night at Shepp's on the 22nd and the two men crossed over on the 23rd. The Bemises had no company for the last week of the year; on the 31st Shepp wrote, "Done nothing all day."[58]

1921

During January 1921 Shepp only visited the Bemises once, when he got two dozen eggs from Polly on the 20th. Otherwise, Polly and Charlie's only known visitor was Orson James, who spent the night of the 31st with them.[59]

On February 1 James crossed over to Shepp's place, and on the 3rd, James, Bob Hilands, and Shepp visited the Bemises. James spent the night there and headed home on the 4th. On Thursday the 10th Shepp and Bob crossed over and "shoveled snow off sheds." On the 14th Shepp visited again, and on the 21st he was there all day, cutting wood.[60]

In March the visits across the river increased somewhat. Although they weren't primarily to see the Bemises, Shepp and Pete surely stopped to pass the time of day on the 2nd, when they took the horses up to Rabbit Creek, through snow up to their knees on the trail, and again on the 15th, when Pete took salt up to the horses. The boat needed attention, so Shepp caulked it on the 23rd. That day, Bob came down with their seed and "part of stuff from Montgomery Ward." On the 24th, Shepp and Bob crossed the river in the afternoon. Bob came down again on the 29th. He had shot a deer, so the next day he and Shepp took some meat over to the Bemises.[61]

In April no one visited Polly and Charlie until Sunday the 10th, when Bob and Shepp went over in the afternoon. Shepp and Pete returned a week later and cut wood; Shepp wrote, "Polly sick." The next day Shepp, Pete, and Bob all went over to help out. This time, they spaded the onion ground, cut wood, and Pete cleaned out the water ditch. On Saturday, April 23, Shepp took some

horses over to the Bemises; he also worked on their plowing, which he finished a couple of days later. Afterward, he brought all the horses back to the Shepp Ranch. Also on the 23rd Shepp reported that a boat had come down that evening. It tied up for the night at his place. The people aboard were "Cunningham, Forest [Service] man[,] & Mooney down from [John (J. R.)] Painter's" place.[62] That month, Shepp last visited the Bemises on April 28.[63]

On Sunday, May 1, Shepp planted his garden with onions, carrots, parsnips, turnips, lettuce, radishes, cabbage, tobacco, tomatoes, and peppers. He surely planted most or all of the same things for Polly and Charlie, since the following day he wrote, "Over river on garden," which he finished on the 3rd. On Friday the 6th a boat came down at noon. Shepp received 300 pounds of salt, probably for the animals, for which he paid $12.00. That afternoon he visited the Bemises and on Monday the 9th, he, Pete, and Bob planted the couple's corn and potatoes. That Friday Shepp and Pete crossed over in the afternoon. While there, they measured Polly for a dress[64] (Fig. 7.5). In earlier years, Charlie Bemis would have performed this intimate task for her; the fact that Polly's neighbors had to do it demonstrates just how ill he was. Still, according to Pete Klinkhammer, "Polly was not in any way shy. She had a keen sense of humor and was mentally quick. She was helping harvest walnuts one day and after a lengthy retrieving session of stooping to the ground

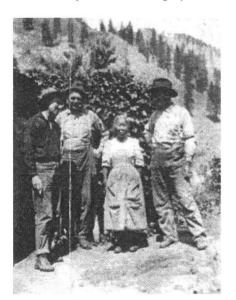

exclaimed, 'When you get so you pick up horse nuts instead, it's time to quit,' and quit."[65]

For the rest of May, the Bemises had no more visits from Shepp and his cronies. The snow was melting, turning the Salmon River into a raging torrent. Crossing was too dangerous, and Shepp, who noted the river's height each day, wouldn't risk it.

In early June 1921 the river was still high; crossing it continued to be impossible. The telephone must still have been working, though, because on the 13th Shepp learned that Polly was

Fig. 7.5. Polly at her home on the Salmon River, 1921. Left, unknown; second left, Harry ("Cap") Guleke; right, Percy Anderson. Courtesy Cort Conley.

sick. He finally got over there on the 20th, with Pete and Boyce; the three men cultivated Polly's

garden. Over the next three days Shepp was at the Bemis Ranch daily, cutting grass, hauling and cocking hay, and putting the hay in their barn. He returned on the 29th and 30th with Pete; the first day, Shepp was "on spuds," perhaps watering and weeding them, while Pete cut more hay. The second day, Pete continued with the hay and Shepp was "on corn & tomatoes," again, probably doing the watering and weeding.[66]

During the first week of July Shepp went over to the Bemises' place where he turned the hay, so it would dry, and picked 40 pounds of cherries. These he combined with another 10 pounds of his own fruit, and canned eight, one-half gallon jars. He returned to Polly and Charlie's on the 5th, 6th, and 8th, to work with their hay and to weed and water their corn. On the 11th, he and Boyce got another 20 pounds of the Bemises' cherries; Shepp canned them the following day. Earlier, Bob Hilands had cut himself with an axe, perhaps badly enough to need a doctor, because on the 12th "Bob & his doctor [came] down this eve[ning]." This implies that Polly's supposed "nursing skills," not borne out by the Shepp diaries, were insufficient for treating Bob's bad cut.[67] The next day Shepp took Boyce and "Doc" over the river, perhaps to examine Charlie Bemis. Not until the 15th do we learn that the doctor's last name is Kenyon.[68]

On Sunday, July 17, Shepp crossed over in the afternoon, and found that "[Frank] Mitchell from Rabbit Creek" was visiting; Mitchell, who had lost the trail, had been out all night.[69] At the Bemises, Shepp took care of a "little fire in Bemis [C]reek" [Polly Creek]. Two days later he was back there "on corn."[70]

On Thursday and Friday, July 21 and 22, 1921, Shepp briefly noted, "Boat down this eve.," and "Over river. Boat left this am [a.m.]."[71] On this trip, again captained by Harry Guleke, one of the passengers was Cissy Patterson, also known as Countess Eleanor Gizycka. The boating party left from Salmon, Idaho, where the local newspaper reported, "Countess E. Gyzicka [sic] of Chicago and a woman companion with a guide and cook were passengers on Capt. Guleke's first trip down the river for this season, leaving on their interesting and strenuous trip on Sunday morning last."[72]

The actual composition of the boat party has been difficult to determine. In her published articles about the trip, Gizycka refers to herself as "E. G." and to her so-far-unknown woman companion as "R. E.," but there were three females, besides Polly Bemis, in the group photo taken at the Bemis Ranch (Fig. 7.6). Of the men on the trip, "Ben" was Cal Carrington, Gizycka's lover at the time; "Arthur" is otherwise unknown; and Percy Anderson was "the slant-eyed mate."[73] Ben Ludwig, age 73, was the cook and guide.[74]

In 1923 an account of Gizycka's visit with Polly Bemis appeared in the magazine *Field and Stream*; it is the first known interview with Polly.[75] The

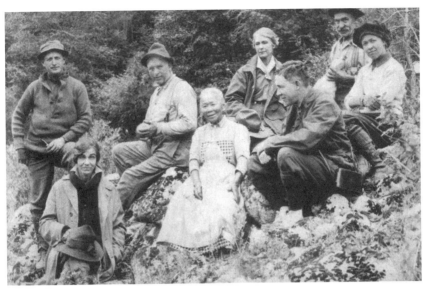

Fig. 7.6. Polly Bemis with some of the crew and passengers from the Countess Eleanor Gizycka river trip, 1921. From left to right they are "Ben" (Cal Carrington, Gizycka's then-lover); unknown; Harry ("Cap") Guleke (boat captain); Polly Bemis; "R. E." (otherwise unknown; possibly Gizycka's friend, Rose Crabtree); "Arthur" (otherwise unknown); Ben Ludwig (cook and guide); and "E. G.," (Eleanor [Cissy] Patterson, a.k.a. Countess Eleanor Gizycka). Percy Anderson (first mate) may have taken the photograph. Courtesy The Historical Museum at St. Gertrude, Cottonwood, Idaho.

countess wrote, "[Polly] stands not much over four feet, neat as a pin, wrinkled as a walnut, and at sixty-seven she is full of dash and charm" (Fig. 7.7). Gizycka reported that Polly's folks had sold her because they had no food, and that an old woman smuggled her into Portland. Polly told the countess, "I cost $2,500. Don't looka it now, hmm?," and chuckled, saying, "Old Chineeman he took me along to Warrens in a pack train. I never seen a railroad." The countess "asked Polly where Mr. Bemis was, and she said, 'Abed. He bin abed most two year now.'" When Polly indicated that Charlie was pretty cross, and implied that she had to wait on him a lot, the countess suggested that maybe Polly should get another husband. "Hee! hee!," she laughed, "Yas, I t[h]ink so, too."[76] Gizycka wrote, "The captain [Guleke] told me Polly always went hunting with her husband in the old days, for she could see game when he couldn't; and she used to run up and down and whisk around the hills like a squirrel in a pine tree."[77] Gizycka also commented,

> Polly warned us against rattlesnakes after our beds had been unrolled in the field between her cabin and the river. We slept with ropes

laid in a loop around our blankets, for a rattlesnake would die of starvation rather than cross a circle of hair rope. We haven't any real hair ropes, but used what hemp rope we had and let it go at that.[78]

The boating party left the next day, but not before Shepp went across the river himself. On Monday, July 25, he made five gallons of currant/gooseberry wine; perhaps he later shared some with Polly and Charlie. He visited them again on the 27th, and watered their potatoes and corn. Saturday the 30th Shepp reported, "The folks from Warren down to Bemis about noon. 5 of them." Of course, being ever-curious about the Bemises' company, he went over there that afternoon. Shepp's diary for the next day, Sunday, provides the guests' names, because they all

Polly Bemis and the Author

Fig. 7.7. Countess Eleanor Gizycka (Eleanor [Cissy] Patterson) with Polly Bemis, 1921. From Eleanor Gizycka, "Diary on the Salmon River," Part II, Field and Stream, 28, no. 2 (June 1923):188.

came over to the Shepp Ranch for the day. They were "Mrs. Rhoden [sic, for Ethel Roden, wife of Warren Hotel owner Ed Roden] her 2 kids & neice [sic] Miss Nelson & Oscar Waller"[79] Polly would have greatly enjoyed their visit the previous day.

In late July 1921, the Salmon, Idaho, newspaper reported that a geological survey was headed down the Salmon River; "W. B. Fowler completed a boat on Monday for a party of the geological survey for a trip down the Salmon. The party is headed by W. G. Hoyt."[80] Curiously, Shepp didn't write about them, unless this was the boat party that he mentioned on August 13: "Boat down about 2 p.m. I didn't see them."[81]

During August 1921 Shepp crossed the river to the Bemis Ranch on numerous occasions. On the 2nd he didn't say why he went, but on the 3rd he got four 10-pound buckets of blackberries; on the 5th he got potatoes and string beans from Polly; and on the 6th and 7th he was "on corn."[82] On the 4th, "[Anson] Holmes and wife" [Jennie] visited Shepp, and the next day Shepp took the Holmeses across the river.[83] They must have brought mail

for Shepp and the Bemises, because Shepp wrote, "Polly got 2 dresses from Nellie," his sister.[84] This would have been an exciting day for Polly – not only a package for her, but also, and even better, a visit from a female friend.

Shepp crossed again on the 8th and picked 25 pounds of blackberries. He didn't visit the Bemises again until the 13th. On the 14th Boyce came down to the Shepp Ranch and the next day he and Shepp went over the river and back. On the 17th Shepp returned to the Bemises' place and picked six boxes of windfall Astrakhan apples.[85] Over the next couple of days he ground them up and made them into 15 gallons of cider.[86]

Meanwhile, "Ah Can" from Warren visited the Bemises the afternoon of August 18, and Shepp went over there that evening.[87] "Can" was surely Ah Kan, Chinese name unknown, also called "Sleepy" Kan (Fig. 7.8). Kan was "Warren's legendary Chinese packer, [who] made countless trips to and from other settlements, freighting thousands of tons of cargo on the backs of up to 150 pack mules, over hundreds of miles of treacherous trails winding through the Salmon River Mountains."[88] Ah Kan was the packer who had brought Polly to Warren in July 1872.[89]

Fig. 7.8. Chinese pack train operator Ah Kan, about 1912. From Cheryl Helmers, Warren Times: A Collection of News about Warren, Idaho (*Odessa, TX: The Author, 1988*), August to October, 1912. Used with permission.

During the third week in August Shepp saw the Bemises several times. On Sunday the 21st he went over and "Got corn & spuds for [Anson] Holmes." Shepp paid Polly a dollar, and he went back the next evening for more pota-

toes and corn for Holmes. On the 23rd Pete was going "up to camp" [a mining camp above the Shepp Ranch]. He took two horses loaded with produce to sell, including 40 pounds of potatoes from Polly, and probably some of her corn as well. That day, Shepp went over to water Polly's potatoes, and on the 25th he got three cans of milk from her.[90]

The following Sunday, the 28th, Shepp got three and a half dozen ears of corn from Polly. He also "Made out our & Bemis' orders. $25 from Bemis."[91] This would have been for their winter supplies. The next day, Pete went up to Concord with three horses. Part of what he took up there included Polly's corn, to sell for her. Shepp closed out August by crossing over to the Bemises again, but didn't mention the purpose of his visit.

In early September 1921 Shepp visited the Bemises several times, for no stated reason, except that on the 7th he got ten pounds of cabbage for Holmes. On the 11th he crossed over for Sunday dinner and returned home with 10 pounds of onions and 88 pounds of potatoes. The next day Pete took it "up to camp" along with some other produce and two chickens.[92]

Shepp crossed over to the Bemises on the 13th, no reason stated, and returned the next day to retrieve two of his horses that had swum over. On the 18th he "Took 4 ft. iron over"; this is otherwise unexplained, but it may have had something to do with his work on a roof over there on the 24th and 25th. Shepp returned on Monday the 26th and "dug all their spuds." On the 28th Shepp left for Grangeville via Concord and Adams Camp. There are no diary entries until he returned, but Pete Klinkhammer had come down on the 27th to take care of things during Shepp's absence.[93]

Shepp arrived home from Grangeville on October 8 and crossed the river the next day. The diary implies that he was making wine over there, since on the same line and the next he wrote, "Drawed off 5 gal keg wine." Shepp returned to the Bemises' on the 12th and got a piece of meat and picked a sack of beans.[94] What sort of meat it was, and where the Bemises had gotten it, is unknown. Charlie was bedridden, so couldn't hunt, but perhaps Pete had killed a deer while Shepp was away.

Shepp visited the Bemises on each of the next three days, mentioning what he did on two of them. On October 14th he replaced the battery in their telephone and on the 15th he took over their winter order, except for two sacks of flour. He also got 16 pounds of onions, 105 pounds of potatoes, and 25 pounds of cabbage from Polly. Then, Sunday, Pete took the produce "to camp." Shepp took a break from the Bemises that day, but was over there the 17th and again on the 18th, "on cellar," a root cellar dug into the hillside to keep produce cool and for storage of winter squash, root vegetables, and filled

canning jars. The next few days he continued work on the Bemises' root cellar and finished it on the 22nd.[95]

Back home that day, Shepp encountered a man named Litchfield that afternoon.[96] He had come down the river, and had had nothing to eat for three days. Shepp "gave him some grub & sent him to Holmes on way to Hump."[97] Litchfield returned to the Shepp Ranch on the 29th, this time on his way to Warren, and Shepp took him across the river the next day.[98] Doubtless he had a nice visit with Polly before heading up the trail, suitably well-provisioned.

Meanwhile, the arrival of autumn meant that the Bemises needed plenty of wood. Shepp went over to cut some for them on October 28. On the 31st he made 58 gallons of cider, and took the Bemises a gallon of it, keeping most of his for distilling. That night, Ed Matzke and one of his brothers were at the Shepp Ranch; they "Brought 2 cats over,"[99] probably on loan for mouse control.

During November 1921 Shepp crossed the river numerous times to help the Bemises with chores such as snow shoveling, woodcutting, and for other reasons, sometimes not stated. For example, he fixed their roof on the 9th, took Polly's clock over on the 12th (he must have repaired it for her), "shoveled trails & got in some wood" on the 20th, "shoveled kitchen woodshed & barn" and "turned water off ditch" on the 21st, cut wood for them on the 24th, and went back the afternoon of the 28th.[100]

December turned colder, necessitating more woodcutting for the Bemises, which Shepp did on the 3rd, the 5th, and the 17th and 18th. On the 5th he also got a 20-gallon barrel from Polly for his distilling project. It snowed on the morning of the 19th, and the temperature that day ranged from 14 to 18 degrees above zero. Shepp put a lamp in his root cellar to keep things from freezing; presumably Polly did the same. Charlie Bemis's bedridden condition probably precluded festive Christmas dinners there; instead, Shepp "killed old rooster" on the 24th and "had chicken dinner" with Pete on the 25th. Nearly closing out the year, he went over to the Bemises on the 27th and spent some time "getting in wood." He reported that he crossed by boat, but that there was "Quite a little ice in river."[101]

1922

During January 1922 Shepp continued to cut wood for the Bemises, on the 2nd, the 20th, the 26th, and the 31st, and Pete did likewise for them on the 17th. Pete had crossed on the ice for the first time on the 9th, and all subsequent crossings were made that way, even on the 11th when Shepp took all nine head of horses over there; he had put up a fence around the Bemises' barn on the 10th. Shepp visited the couple again on the 13th, and on the 15th

he reported, "Polly's stove pipe afire this afternoon"; Pete responded, putting it out before it could burn down the Bemises' house. On Monday, January 23, Shepp visited the couple, got Polly's order for garden seed, and went over again on each of the next two days.[102]

In early February 1922 Shepp made a "sawbuck" [sawhorse] for Polly. He and Pete traded off cutting wood for her, on the 7th, 16th, 17th, 19th, and the 20th. On the 18th, Pete, Orson James, and Ed Matzke visited the Bemises, and on the 22nd Shepp was "over river to dinner." On Tuesday the 28th Pete went up to Dixie via the War Eagle Mine, taking a number of letters to mail, including one from Charlie Bemis to his brother, W. F. Bemis.[103] A diary entry from several years later states that it was 17.5 miles to Dixie from the Shepp Ranch.[104]

March 1922 saw very little activity between the two households. Shepp brought the horses back home on the 8th, crossing on the ice again. He visited on the 12th, cut wood on the 13th, and went over again on the 26th. Otherwise, he spent much of the month distilling.[105]

Although Shepp's diary contains no entries from April 1 through April 12, he didn't indicate that he was away from the Shepp Ranch. It is tempting to suggest that he may have been testing his distillery results … to excess. On the 13th the female cat had five kittens; this would help with future control of the mouse population. Four days later Shepp was at the Bemises' place to dig up their onion patch. On the 22nd he planted onions in it, and on the 24th he "took horses over river. Planted barley in old sweet corn patch [indicating knowledge of crop rotation] & plowed old garden patch."[106] The next day he plowed some more and finished on the 26th; he also burned brush and grass and brought the horses home. On the 27th he raked Polly's garden, planted it the next day, and had dinner with them on Sunday the 30th.[107]

In early May 1922 Shepp wrote that two "forest men," named Dyer and Dwin, were down from Ed Matzke's, along with a man named "Nefkin" [probably Nethkin];[108] Shepp, Dyer, and "Nefkin" visited the Bemises the next morning.[109] May was rather meager for other known visitors, except for Charlie Shepp and Pete Klinkhammer, who separately and together spent many hours at the Bemis Ranch, helping with the heavy work. On the 11th Shepp planted potatoes and part of the corn, and Pete finished planting corn the next day. Pete shot a deer on the 14th and the next day Shepp took some of the meat to the Bemises. Pete was there the following afternoon, and on the 24th Shepp cultivated Polly's garden.[110]

In early June the Salmon River was too high to cross safely, and in mid-June Shepp went "out side" for a week. Therefore, he wasn't able to visit the Bemises until the 24th. He went over with Pete, and while Pete cut hay, Shepp

watered the corn and killed a rattlesnake. Shepp was back there the next day, "on corn," and both men went over on the 26th, with Pete "on hay" for that day and the next four. On Friday the 30th, Shepp reported, "Polly's dog bit by snake," but he didn't say if it died or survived.[111]

During the first part of July, despite the temperature peaking at 104 degrees, Shepp spent several days across the river "on corn." On the 6th he wrote, "… finished corn" but on the 18th he was "on corn" again.[112] Although we know Polly picked ears of corn for sale, this corn may have been intended as animal feed. Meanwhile, on the 7th, two men spent the night at the Shepp Ranch. One was named Beck; they were on their way to Warren.[113] Beck and his friend crossed the next day, were back at Shepp's for the night of Sunday the 9th, and left for Hump the following morning.[114] They would surely have visited with Polly, at least briefly, when they were on her side of the river. Shepp next went over in the afternoon of the 17th, and when he was there on the 18th he killed another rattlesnake.[115]

On the 19th a boat overnighted at the Shepp Ranch.[116] Although Shepp didn't record the names of the people aboard it, this group was the R. E. Shepherd party from Jerome, Idaho, with Harry Guleke piloting the boat. In June, Shepherd had written his youngest daughter, Irene, in Los Angeles, inviting her to join the proposed trip. The other members of the boating party were five men from Minneapolis plus F. B. Shepherd from Oswego, New York; he was R. E.'s brother and Irene's uncle. Besides Captain Guleke, the "mate guide" was Jack [John Cunningham] and "Curly" was the cook.[117] Trip member F. J. Mulcahy kept a diary, and his entry for Wednesday, July 19, 1922, reads,

> About 5 p.m. we stopped at Polly Bemis' place (Fig. 7.9a, Fig. 7.9b, Fig. 7.10). Bemis is an old timer here, probably 75 years old and confined to his bed. His wife, Polly, is a Chinese woman. She looks after him and tends to the garden, orchard[,] and farming operations. Polly has been in the Salmon River country for more than 40 years and has never been off the ranch for 28 years [i.e., since 1894, when they moved there]. Mr. Bemis has been i[n] the Salmon River country since 1865 …. Just across the river from the Bemis Place is Sheep's [*sic*, for Shepp's] Place.
>
> We pitched our sleeping bags in the sand, had a good swim[,] and enjoyed a fine supper at 7 P.M.
>
> Mr. "Sheep" is a man about 60 years of age, who has lived here for 40 years; has a good ranch. For years he has never been anywhere except to his post-office at Dixie [incorrect, according to evidence from the Shepp diaries], an inland town 16 miles distant.

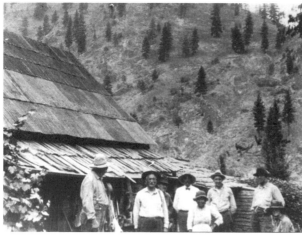

Fig. 7.9a. The R. E. Shepherd boating party from Jerome, Idaho, with Polly Bemis, 1922. Front row, left, Harry ("Cap") Guleke; second from left, R. E. Shepherd; right, Irene Shepherd, second from right in front, Polly Bemis. The four men in the background are not individually known; see July 19, 1922, and Note 117 for possible names. Fig. 7.9b. Closeup of Polly Bemis from 7.9a. Courtesy Philinda Parry Robinson.

This spot is one of the most beautiful on the whole river.[118]

Mulcahy also observed, "All along[,] as we have come in contact with the few inhabitants[,] we have been impressed with the fear with which they regard the Salmon. Each year it takes its toll of human life." Irene Shepherd also noted, "Each family offered stories, moonshine[,] and fresh food from their gardens."[119]

Fig. 7.10. 1922, another image from the R. E. Shepherd party, Jerome, Idaho. Courtesy Philinda Parry Robinson.

The evening of July 20, 1922, a party from Warren, "3 fellows [one named Davis] & a woman & 5 horses" camped up Crooked Creek. On Friday, July 21, Shepp crossed the river and took the Bemises some bacon and cheese, perhaps from the boat people or the campers. On the 27th he picked some of Polly's yellow beans and canned them the next day, along with some of his own. Gus Schultz was down, and on Saturday the 29th he and Shepp went over to Polly's in the morning and "Got 50# [pounds] vegetables onions carrotts [sic] spuds & rutabagas for [George] Bancroft. [$]2.50 for Polly. Pete took 4 packs up to War Eagle camp."[120] Shepp ended July by being "On corn over river."

Despite starting innocuously, August 1922 would be a significant, and catastrophic, month in Polly Bemis's life. On the evening of August 3, Pete Klinkhammer and Oscar Waller came down to the Shepp Ranch; Shepp "took Waller over river." Two days later Shepp "Took clock etc over to Polly." He visited her again on the 8th and the 13th, and in the meantime, at home, he made 26 bottles of beer.[121] Then, on Wednesday, August 16, with Pete away taking produce to Dixie, catastrophe struck Polly and Charlie. Shepp wrote [clarification in brackets],

> Bemis house burned at 12 [noon]. Had a hell of a time [-] got the old man [the bedridden Charlie Bemis] out by the skin of my teeth. Lost Teddy [Polly's dog] he got burned (Fig. 7.11). Polly & I got the old man over [the Salmon River to the Shepp Ranch] about 4 [p.m.], had hard time. Didn't save a single thing. The whole place was on fire when I got over.[122]

In fact, Polly rescued two vital documents; both of these are now in The Historical Museum at St. Gertrude, in Cottonwood, Idaho. One was her marriage certificate, dated 1894, and the other was her Certificate of Residence, dated 1896. Perhaps she kept them in a box near the front door, to be snatched up in case of fire. She may even have carried them on her person at all times, in a pocket of her dress or apron, just not in the same pocket where she would put her fishing worms.

The fire likely started in the stovepipe, as had happened in January, when Pete put it out. This time, help arrived too late to save the house. The loss of her home and her dog must have devastated Polly, but at least she and Charlie were rescued. One can only imagine her frantic, but ineffectual, efforts to save her helpless husband, but thanks to Charlie Shepp, Bemis was still alive.

The next day Shepp crossed the river. Besides surveying the ruins, he got some sweet corn to take back. Once home, he made a bed for Charlie Bemis, and commented, "Every body feets burn [sic]." Pete came back on the 18th. Shepp, and perhaps Pete as well, went over and got all 30 of Polly's chickens.

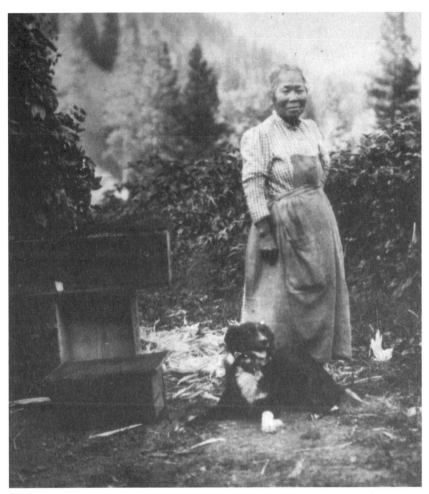

Fig. 7.11. Polly and Teddy, her dog, before mid-August 1922. Courtesy The Historical Museum at St. Gertrude, Cottonwood, Idaho.

Until the end of August, Shepp, sometimes with Polly, crossed the river several times to get things or to take care of the growing crops. On the 19th he got corn and cabbage, on the 21st he was "on corn," and on the 27th he "Watered cabbage & got vegetables for Holmes," noting, "Fine day. Hot. 104." Polly went over with him on the 25th and again on the 31st.[123] On one of those days she must have sifted through the ruins, since she did recover the gold buttons from "one of [her] most cherished possessions … a blue silk dress about 35 years old, with rows of buttons made by her husband from $2.50 and $5 gold pieces." The silk came from San Francisco, likely sent by Charlie Bemis's brother, William, and was lined with flour sacks from Grangeville.[124]

206

In the meantime, on the 30th, Pete came down to the Shepp Ranch and Shepp "Wrote A & F [Alexander and Freidenrich, in Grangeville] for stuff for Polly; Pete mailed Shepp's letter in Dixie when he went up there the next day.[125]

During September 1922 Polly must have been busy caring for Charlie. Shepp crossed the river several times, but she only went with him once. On the 11th he caught a porcupine over there. That afternoon, Charlie Schultz, son of Gus and Nellie Schultz, came down to the Shepp Ranch and the next day he and Shepp got some grapes from the Bemises' place. Pete came back that evening with the A & F order for Polly and a $10 credit to her from them. On the 15th Shepp and Polly went over in the morning and on the 21st Shepp got all the grapes and onions from the Bemis Ranch.[126]

October saw Shepp gathering more of the Bemises' crops. On the 2nd he dug 250 pounds of their potatoes and left 50 pounds of them over there "for seed." In addition, he got one and a half boxes of apples and three squash. The next day he dug another 420 pounds of potatoes, leaving another 50 pounds of them for seed. He also reported, "Polly sick with tooth ache." On October 4 "Pete went to Dixie with 5 horses," probably taking some of Polly's potatoes to sell. That day, Shepp "Finished digging spuds over river," put the seed potatoes in the root cellar, and got 110 pounds of carrots. When Pete came back on Thursday, Dr. Kenyon was with him. Besides examining Charlie, which could have been one reason for his visit, on Friday he also "pulled Polly'[s] teeth & cut [castrated] Julie's colt.[127] Pete and Kenyon went to Dixie on Saturday, and on Sunday the 8th Pete returned with "all our stuff." A week later, Polly and Shepp went over to the Bemis Ranch in the afternoon. Shepp got five sacks of Bismarck apples, and Polly "gathered sweet corn." Polly's cast iron stove top had survived the fire, and they brought it back with them. On the 20th, Shepp went over for cabbage and 90 pounds of rutabagas. The following Sunday he wrote Charlie Bemis's brother, likely telling William Bemis that Charlie was near death. Pete was leaving for Dixie the next day and could mail Shepp's letter.[128]

On October 29, 1922, Charlie Bemis died. Shepp wrote, in the margin, Bemis Dead, underlining it for emphasis (Fig. 7.12). "Bemis passed in [died] at 3 am [a.m.]. Up to camp [a mining camp in the mountains]. Left at 5 am [a.m.]. Gus [Schultz] & [Anson] Holmes down. We buried the old man right after dinner [the noon meal, which Polly surely prepared while they were digging Charlie Bemis's grave]. … Fine day.[129] Shepp's account doesn't mention building a coffin for Bemis, but perhaps the men did so. That they did was certainly assumed; a later newspaper story stated, "Mining men in the wilds gathered, built a box for him[,] and buried him on the river bank."[130]

207

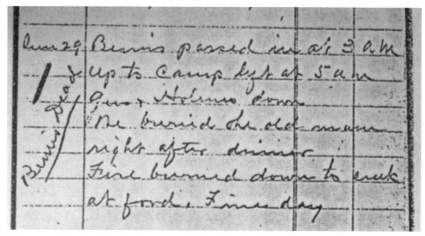

Fig. 7.12. Charlie Shepp's diary entry mentioning Charlie Bemis's death, 1922. From Charles Shepp, [Diary], November 1, 1921, through December 31, 1923, photocopy, University of Idaho Library Special Collections, MG 155, October 29, 1922. Used with permission.

However, since Bemis wasn't actually "buried … on the river bank," perhaps there was also no coffin.

While we cannot be sure of the immediate cause of Charlie Bemis's death, which was surely hastened by smoke inhalation from the house fire, his father, Alfred, died in 1876 of "consumption," an earlier name for tuberculosis (TB).[131] Charlie may have become infected from Alfred, but if he did, the disease lay dormant within him until years later, when his immune system became weak from some other cause.[132] In a later conversation with M. Alfreda Elsensohn, Frank McGrane Sr. "stated that Bemis had a cough for several years before his death."[133] Although a persistent cough is one of the symptoms of tuberculosis, it can also indicate a number of other diseases. Charlie may also have suffered "from a depression bordering on paranoia," another "characteristic of advanced TB."[134]

Charlie Bemis's grave can still be visited today (Fig. 7.13), at the Shepp Ranch. Since Polly surely helped choose his final resting place, it isn't surprising to find that it is in a nearly perfect setting with respect to the Chinese principles of *fengshui*.[135] In that belief system, "the ideal location [for a grave] is in the center of a south-facing slope overlooking a body of water, preferably a meandering stream or river. The south face brings warmth from the summer sun."[136] A curving, south-facing hillside embraces Charlie Bemis's grave, which would still face Crooked Creek and the Salmon River, if modern buildings didn't intervene.

Fig. 7.13. Charlie Bemis's grave, at the Shepp Ranch. Photo by author.

With Charlie Bemis dead, the men, and Polly, must have discussed her future. She couldn't continue to live at the Shepp Ranch, because it wouldn't "look right." Charlie Shepp was often the only man there; gossip could easily damage, or even destroy, Polly's fine reputation. Also, there may not have been room for her on a long-term basis. On October 30, Pete returned to the Shepp Ranch, and on the 31st Shepp wrote, "Polly going to Warren."[137] That day, Shepp took four horses across the river, plus Polly's belongings, and some food—onions, squash, and 100 pounds of potatoes.

The next day, November 1, Pete took her up to town.[138] She would live there for the next two years.

Exactly where she lived in Warren can only be surmised. The earliest known map of Warren, surveyed in October 1917, shows several small houses lined up in Bemis Gulch along Warren's Bemis Creek, near the northwest corner of the town, not far from where Bemis Creek flows into Warren Creek.[139] The house Polly lived in doesn't show on that map; it was across the creek. Pete Klinkhammer would have rented it for her, but whether he used Shepp's money, or even Polly's, is unknown. A photograph of Warren, taken in 1922 (Fig. 7.14), shows much of the town, but the house where Polly is believed to have lived would be off to the left, out of the image.

With Polly gone from the Salmon River, there are naturally fewer mentions of her in Shepp's diaries. Nevertheless, occasional entries are relevant. While Pete was away getting Polly settled in Warren, Shepp spent some time at her place cutting logs and poles and dragging them, with the help of his horses, to the site for Polly's "barn."[140] Although a later survey called it just a "log hay shed," at 16 by 26 feet it was larger than the house, which was 14 by 20 feet, so the "shed" probably served as an animal barn also.[141]

Pete returned from Warren on November 3. The following day, Shepp did more work on Polly's barn and brought the horses back over to his side of the

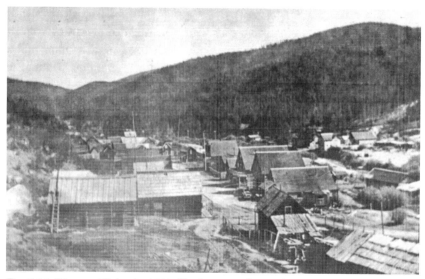

Fig. 7.14. Warren, Idaho, in 1922, "looking east from Chinatown." Courtesy Idaho State Archives, Boise, 71-185.19.

river. The next day he was back working on the barn again; he also dismantled a wire fence.[142]

On November 6 Pete went up the mountain to Dixie; on November 8 he returned with "dresses for Polly & pay from Forest dept. for vegetables from Polly."[143] No later diary entries indicate how or when Shepp or Pete got the dresses and money to Polly in Warren.

1923

Charlie Shepp's diary for January 1923 had no relevant entries, but in mid-February he crossed the river one morning, on the ice, because "Some one down river on other side yesterday."[144] From this, we can infer that he was keeping an eye on Polly's place for her. On February 22, Shepp "Wrote Polly," perhaps to tell her how her property was faring in her absence.[145] Although Polly couldn't read or write, one of her friends in Warren could have read the letter to her and then written a reply that Polly dictated.[146] Pete Klinkhammer later said, "Bemis started to teach her to read once but she got along too well & he quit. It wouldn't have taken her very long if he'd been willing to put out the effort."[147]

The next entry related to Polly wasn't until mid-April, when Pete went over to her place and "pruned berry bushes on chicken wire."[148] These were Polly's numerous raspberry and/or blackberry plants. From the 19th through the 21st, Pete was at Polly's place "on wire fence" and possibly doing other

chores.[149] On April 24, Shepp "Put wire fence round CAB" [Charles A. Bemis's grave];[150] that fence is no longer there.

During May 1923, Shepp and Klinkhammer increased their visits to, and work at, Polly's place. On the 9th, Shepp was over there in the afternoon, per- haps because Harry Guleke and a man named "Neskin" [Freeman Nethkin?] came down in a boat and camped at Shepp's for the night.[151] Beginning on the 11th, Pete was "over river on house logs," and was there again for all or part of the 12th, 14th, 15th, and 18th.[152] On Sunday, May 20, Shepp wrote Polly again, and on the 25th Pete was back there "on logs."[153] Winter lingered; at month's end there was still "A little snow ... at head of Bemis [C]reek."[154]

Polly, in Warren, may have interacted with some of the local children late that month. One reminiscence states, "Polly has been seen out flying kites with the children."[155] Herb McDowell, who arrived in Warren in 1922 or 1923,[156] and was in Warren at the same time as Polly until she left there in October 1924, had no recollection of any kite flying.[157] Johnny Carrey, who also knew Polly when he was a child, first replied "yes" to the kite flying, but later changed his answer to "no."[158] Perhaps he observed the activity but didn't participate in it.

Back on the Salmon River, in early June 1923 Shepp wrote to his brother, Harvey, and to Polly again.[159] This correspondence was probably related to an impending visit from Harvey, together with Shepp's sister, Nellie. On the 6th Shepp crossed the river, possibly to plant cabbage.[160] On the 23rd he wrote, "Am going out tomorrow";[161] there are no entries from June 24 through July 8.

Grangeville was one of the places Shepp visited while he was "out." On June 28, 1923, at the Idaho County Courthouse in Grangeville, Charles W. Shepp filed the patent (i.e., the document, similar to a deed, that granted him title to the ranch) for his homestead claim. At the same time, he recorded the sale of a one-half interest in the property to Peter Klinkhammer, for $2,500.[162]

On July 9, 1923, Shepp "Left Warren & came to ranch. ... Nell & Harvey & I pretty tired."[163] This wasn't surprising, since it was about an 18-mile hike from Warren to the Salmon River [about 14 miles "as the crow flies"]. While in Warren, the group would surely have had a nice visit with Polly. Once at the Shepp Ranch, Harvey mostly fished; he caught so many that Shepp made a smoke house and smoked them, and the following day Harvey and Pete caught 93 more fish.[164] Nellie picked currants for jelly, aired the beds, and also fished occasionally. Pete cut hay at Polly's place, and Shepp and Nellie picked some of her raspberries. The next day Shepp and Nellie went "up to Rabbit [C]reek. Some one building a house there."[165] The builder was Ellis Winchester. According to Salmon River historians Johnny Carrey and Cort Conley, Winchester "built a house, barn, and outbuildings by the mouth of

the creek, and grew flowers, fruit, and vegetables. There was a sawmill on the place, as well."[166]

In the meantime, Polly kept busy in Warren. She renewed old acquaintances there, and made many new friends. She was especially fond of children. One, Johnny Carrey, was a very special young friend. He grew up to write several books, one of which was *River of No Return*, with Cort Conley, about life for the hardy folks, including Polly and Charlie Bemis, who lived along the Salmon River.[167]

In the late 1990s, Johnny Carrey shared his reminiscences of Polly. Born in June 1914, he was eight years old when Polly arrived in Warren, and ten years old when she left. His memories of her date mostly from the fall of 1923, when he and his next-youngest sister, Gay, lived in Warren to attend school.

At that time, he, his parents, Thomas and Jeannie, and his two sisters, Gay (b. November 1915) and Mary (b. February 1920), lived on the South Fork of the Salmon River[168] (Fig. 7.15), 12 miles from Warren.[169] That area had no school, and there were no school buses then, so the children had to live in Warren, away from home. Their uncles had the mail route, so brought them in for the school year.[170] If there was heavy snow, they used a toboggan, if not, they rode horseback with the mail carrier. They couldn't ride a horse to Warren by themselves because there was no place where they could stable the horse for free.[171] Given the transportation difficulties, with no proper roads or

Fig. 7.15. Johnny Carrey and his family, 1925. Left, Johnny; sisters Mary, center, and Gay, right; behind, parents Tom and Jeannie. Courtesy Johnny and Pearl Carrey.

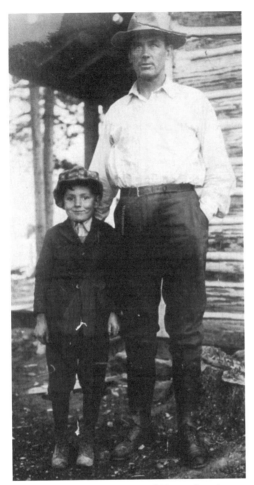

Fig. 7.16. Johnny Carrey and Forest Service district ranger Charley Gray, early 1920s. Courtesy Johnny and Pearl Carrey.

modern vehicles, they weren't even able to return home for weekends or holidays, such as Thanksgiving and Christmas.[172] It seems heartbreaking to us now, but that was just how it was then, and they made the best of it.

Although Johnny originally started first grade in the fall of 1922[173] (Fig. 7.16), and remembered Polly's return to Warren,[174] he soon became too homesick to remain in Warren by himself so returned to his family.[175] There also may have been some unhappiness with the then-teacher, Mrs. Lucy Tibbs. In 1997 Johnny described her as "a big woman—like a grizzly," but Johnny's wife, Pearl, suggested, "She just seemed that way"[176] to a young boy.

Johnny's parents held him back a year until his sister Gay was ready to start school in the fall of 1923, and they entered first grade together.[177] Johnny stayed at the Murphy Hotel and Gay lived with Polly that fall.[178] First, though, Gay spent one night with Mrs. Tibbs, the one-room school's former teacher;[179] the other children who boarded with Mrs. Tibbs were "rough miners' kids," probably why it was best that Gay didn't stay there.[180]

After Polly offered to have Gay live with her, Gay moved to Polly's place on Bemis Gulch.[181] The children's parents gave Polly vegetables and some money, and paid the Murphy Hotel for Johnny's room and board.[182] Johnny helped Polly with chores, such as bringing wood inside for her wood-burning stove.[183] Although other children lived with Polly at various times, Gay was the only one that fall.[184] She walked to school from Polly's place.[185]

Johnny also recalled that Polly had a garden when Gay lived with her. She grew "nearly everything." Johnny, who sometimes ate with them, liked Polly's cooking, which was American-style, but with more rice than potatoes or noodles.[186] Polly cooked breakfast and supper for Gay, and Johnny ate at the hotel. Both children took lunches ["dinner"] to school.[187] Polly was affectionate with the children, but not demonstrative; she sometimes hugged them, but not often.[188] Although we know that Polly smoked a pipe, Johnny never saw her doing that.[189]

The novel about Polly Bemis, *Thousand Pieces of Gold*, has a poignant story about how Polly met Gay Carrey by finding her crying behind the woodpile at the Warren School because she was homesick.[190] Since Gay never cried, according to Johnny,[191] certain other events may have been invented for the sake of the novel. Nevertheless, Polly and the children did participate in some of the pastimes reported in the book. For example, Gay pretended to be a horse, Johnny borrowed a fiddle and played tunes for Polly and Gay, and he inflated a chicken's crop and tossed it like a balloon [Polly said, "Get rid of it!"]. They also had picnics and went for walks together.[192] Polly often took Johnny and Gay to the dredge pond to fish for trout. When the children caught fish, Polly cooked the fish for them. In the winter, they still fished there through a hole cut into the ice.[193]

Every evening, Johnny would measure Polly with a yardstick and make a mark on the wall. He couldn't understand why he kept growing, but Polly was always four feet, nine inches tall. Despite all the times that Johnny measured Polly, she never measured him.[194]

Johnny reported that Polly was easy to understand when she spoke English, and he never heard her speak Chinese to anyone.[195] Oddly, Polly never talked about Charlie.[196] Polly told the children stories, sometimes about when she left China and first came to Warren;[197] she also told them things about China that Johnny didn't quite understand.[198] Johnny particularly remembered Polly's saying, "Be on time."[199]

When asked about Polly's house, Johnny recalled that it was up Warren's Bemis Creek and that they had to cross the creek to reach it.[200] It was up the bank, near Granny Hanthorn's house.[201] Johnny remembered that Polly's house was built of logs,[202] and had two rooms, a kitchen/living room in front and a bedroom in back.[203] There was no indoor plumbing; the toilet, called an outhouse or privy, was outside.[204] Johnny couldn't live there too because Polly's house was too small.[205] The bedroom held just one bed, so Gay slept with Polly.[206]

Johnny remembered that Polly had a restaurant at her house,[207] presumably in the front room of her home. However, she didn't run the restaurant when

Gay stayed with her. She ran it earlier,[208] and definitely afterward, according to Herb McDowell's information.[209]

Gay liked living with Polly, who was usually cheerful and happy, and never got angry, so Gay was sad to leave her when the school term finished.[210] As a parting gift, Polly gave Gay two photographs. One was of Polly in the dress she wore at her wedding, and the other was of her husband, Charlie Bemis.[211] In later years, Gay Carrey described receiving the photos from Polly:

> I knew her in Warren when I was a little girl. I used to visit her, and she was my friend. I have her wedding picture. She gave it to me, one day. She brought this picture, and one of a man [Charlie Bemis]. Told me that with Bemis gone, she had no one, and these were their wedding pictures. And she told me to keep them. I still have them.[212]

By the fall of 1924, Polly had moved back to her ranch,[213] and the Carrey children never saw her again.[214]

Herb McDowell recalled other details about Polly's life in Warren during 1924. Various children lived with her from time to time. They included

> the Hawthorn girl, the Smith boy, the Adams kids, and Gay Carrey. The Hawthorn girl was the daughter of a 'lady of the night' who was married several times …. She had a drinking problem, so Polly took care of the girl 3-4 times. … The Smith boy lived on the river. Polly took him in and fed him.

Polly used to 'treat' all the kids. Otis Morris said she was a 'good old soul' because she was so kind.[215]

Herb recalled that Polly had a restaurant, which was the front half of her house up Bemis Gulch. Polly was friendly with the other Chinese in Warren, and spoke Chinese with them and English with other people. [216]

Herb's aunt, Mary Turner, started a Sunday School, and Polly went there.[217] Turner taught Polly about the Bible. Polly tried to Christianize some of the Chinese. She had a picture of Christ ["Clist"] in the restaurant, and told them that "he runs the world." The Chinese would say, "she gone nutty" or "she crazy."[218] Curiously, Johnny Carrey didn't remember any of this.[219] However, it rings true, so it must have happened after he and Gay had returned to their home on the South Fork.

The Chinese man called "Ah Sam" ("China Sam," or Jung Chew, his real name), mentioned earlier (September 1920), has been described as the "honorary mayor of Warren."[220] Herb McDowell, who moved to Warren in 1923, aged almost eight, remembered other details about him. McDowell recalled,

> The old Chinese [in Warren] liked children and used to tell us stories of their past. They seemed to be happy when the [US] government outlawed opium in 1900 [1909] in the United States. ….[221]

Ah Sam told about his struggle to quit [smoking] opium. He had one can of it left and the other Chinese tried to buy it but he wouldn't sell. Then he was offered hundreds of dollars for his last smoke but refused the offer. For a week after his supply was gone he was sure he would die. He had cramps in his stomach and said he felt like he was being stuck by millions of needles.

It was [more than] a month before he got over being shaky. When the horrible torture was over he was happy to be rid of the habit. When he had been taking opium he had worked 10 hours a day, seven days a week just to support his habit.[222]

Books on the agonies of opium withdrawal echo Ah Sam's torment in even more chilling detail.[223]

Following Ah Sam's success in ending his opium smoking, he became a successful business owner in Warren. He operated a bakery, a laundry, and a bathhouse.[224]

In those days, people often didn't have a bathroom in their homes – an outhouse contained a pit toilet, and they bathed in a portable metal bathtub in the kitchen or living room. This was inconvenient, so people who could afford it went to Ah Sam's bathhouse. There, Ah Sam chopped wood for the fire that heated the water. He provided hot water, soap, and a towel, and charged 25 cents per bath. This was expensive, so people usually only bathed once a week. Ah Sam let Polly Bemis and Johnny and Gay Carrey bathe for free on weekends, because when Ah Sam was away, Polly ran the bathhouse for him. Johnny helped Polly split wood to keep the fire burning.[225]

When Herb McDowell interviewed long-time Warren resident Otis Morris (ca. 1963), more details about Ah Sam's bathhouse emerged. Ah Sam had "the only bathtub in town. He charged 50 cents. Ah Sam heated the water in five-gallon cans on a stove." Once, when Herb and his three brothers all took a bath at once, for the bargain rate of $1.00, they had a water fight. Herb recalled Ah Sam's complaint to their mother: "Gee Clis [Jesus Christ] come up get crazy damn kids!" Ah Sam kept the boys out of his bathhouse for a year and after that he would only let them in one at a time.[226]

In the 1920s and early 1930s, as historical archaeologist Jeffrey M. Fee later wrote,

Sam ... was greatly respected and loved by all Warren residents. Hours before dawn, on cold winter nights, Sam would go from one end of the sleepy Warren town to the other[,] kindling dying embers in each stove so that the residents would have warm homes when they awakened. In return, the residents put out pastries, cold cuts, and other

tasty foods. As the late Otis Morris described it, 'Sam was just chuck full of breakfast by the time he opened the stove of that last house.'[227]

Returning to Salmon River life, on August 1, 1923, Shepp "got some red raspberries" at Polly's, and wrote, "Bear got about all the black ones."[228] On the 5th, Pete returned to the Shepp Ranch with the news that President Warren G. Harding had died.[229] By August 9 Harvey had caught 250 fish.[230] On the 10th they all went over to Polly's and picked three, 10-pound buckets of blackberries. Shepp also took three horses over there, since everyone was going to Warren the next day.[231] Shepp doesn't explain why he took only three horses, since he, Harvey, Nellie, and Pete all went up to Warren. Perhaps Pete walked while the others rode.

The party left for Warren on Saturday, August 11. Shepp wrote that they "Stopped at Becker's for dinner," i.e., the noon meal; John Becker was the owner of the Buck placer mine on Houston Creek in the Warren Mining District,[232] about halfway between the Bemis Ranch and Warren. They arrived in Warren about 5:00 p.m. and spent the night "At Mrs. Rodin's" [sic, for Ethel Roden]; she and her husband Ed owned the Warren Hotel.

Shepp left for home the next morning. Then, or at some other time, he, or another person, took a picture of Polly sitting on the steps in front of Fred Shiefer's cabin; this building is still standing in Warren (Frontispiece). In later years, Shiefer commented that he "lived next to her in Warren from [late] 1922 to 1924. She wore a [size] #10 boy's shoe. She had trouble walking but you had a hard time keeping up with her."[233]

After lunch, Nellie, Harvey, and Pete, together with Polly, left Warren by car and spent Sunday night in the hotel at Burgdorf Hot Springs,[234] about 14 difficult miles from Warren. Their destination was Grangeville, where Nellie and Harvey could begin their train journey home. On the way to Grangeville the following day, Harvey took a couple of photographs of the group on the highway next to the Salmon River (Fig. 7.17, 7.18).[235] On the back of one photo is the notation, "Polly Bemis' first car ride," and on the other is "On the road between Riggins and Whitebird [sic, for White Bird]." Pete's great-niece, Heidi Barth, commented, "I know for certain that Pete wasn't the driver. He never learned how to drive a vehicle or a motor boat. He either rode horseback, rowed a boat, walked, or took a bus or train to travel."[236] Further along, another photo depicts Nellie and Polly on what may well be the old White Bird grade or the Burgdorf to Salmon River road (Fig. 7.19).[237]

Polly's visit to Grangeville was front-page news in the *Idaho County Free Press*. The reporter marveled that Polly had been "isolated in the rugged mountains of Idaho [C]ounty for fifty-one years [confirming that she arrived in 1872], during which she had been only three places, at Warren, at her home

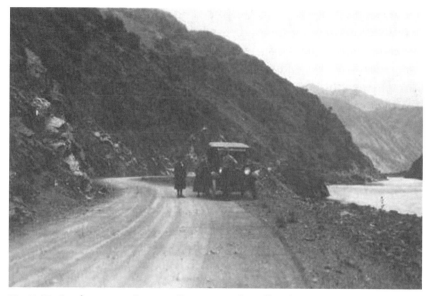

Fig. 7.17. On the way to Grangeville, 1923. Left, Nellie Shupp; center, Polly Bemis; right, Pete Klinkhammer. Photo by Harvey Shupp, courtesy Heidi Barth.

Fig. 7.18. Another photo from the same journey, 1923. Left, Polly Bemis; center, Nellie Shupp; right, Pete Klinkhammer. Photo by Harvey Shupp, courtesy Heidi Barth.

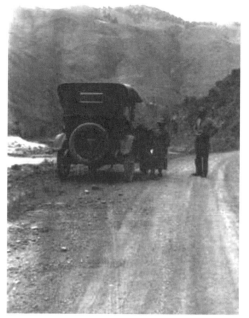

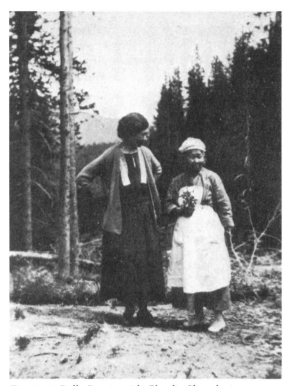

Fig. 7.19. Polly Bemis with Charlie Shepp's sister Nellie Shupp on the way to Grangeville, 1923. Photo probably by Harvey Shupp. Courtesy Idaho State Archives, Boise, 75-228.43/F.

for twenty-eight years on Salmon [R]iver [since the fall of 1894], and once to Slate Creek.[238] Described as a "little, old, gray-haired woman, weighing less than a hundred pounds," Polly wore "[boys'] shoes on her tiny feet, bound in childhood … and [wore] a plain cotton dress. Polly had many callers during the week at the home of Mrs. Anson [Jennie] Holmes, where she is a guest. She came here from Warren by automobile - her first automobile ride - in order to be fitted with glasses;"[239] she also had some dental work done.[240] "Had her eyes not troubled her, her visit to Grangeville, one of the most notable events in her lifetime, wouldn't have been made."[241]

A photograph from Polly's visit to Grangeville in 1923 shows Polly with another woman (Fig. 7.20).[242] Denis Long, grandson of Polly's friend Bertha Long, stated that the other woman wasn't his grandmother, but that the photo was definitely taken on the Long Ranch.[243] Perhaps the two women came to visit his grandmother, and she took the photo. The woman with Polly has been identified as Margaret Josephine Shearer Dysard (1879-1964), Eldene Wasem's "Aunt Maggie." Margaret was a waitress at Grangeville's Imperial Hotel; in this photo she may be wearing her hotel uniform. She moved away from Grangeville in the late 1920s,[244] so would have been there in 1923 during Polly's visit.

In Grangeville, Polly told a newspaper reporter, "When school come to Warren, I can't go to school.[245] I got to make money. God gave me that much,"

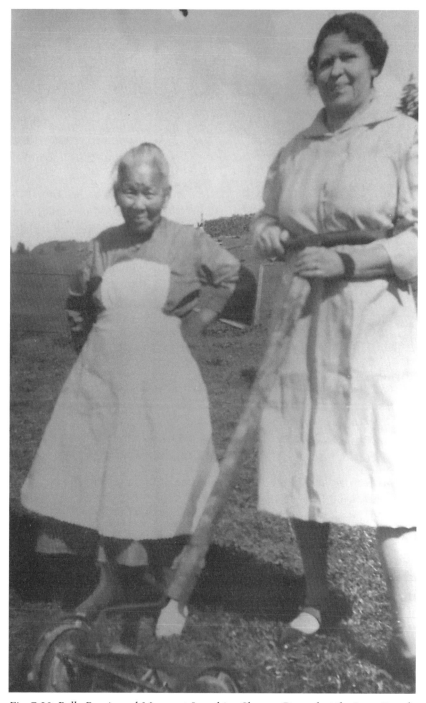

Fig. 7.20. Polly Bemis and Margaret Josephine Shearer Dysard at the Long Ranch, near Grangeville, 1923. Photographer unknown. Courtesy Denis Long.

she said, pointing to her head. "I learn right along." The reporter commented, "Polly knows the name of every child born in Warren and the date of its birth. She also remembers every death and when it occurred. She has a most remarkable memory, and when asked of any particular event with which she is familiar, she describes it in detail and gives the exact date it occurred."[246]

During her visit to Grangeville, Polly was

> ... delighted beyond her ability to tell. ... [She] sits with a hand-kerchief held tightly against her face and chuckles, and then bursts into a laughter of tears, as she attempts to describe what she has seen. Wonderful beyond her power of expression, is it all. And she laughs and cries, and [as the reporter put it, unkindly] endeavors in the gibberish characteristic of those of her race who try to speak English, to describe it all. Again she bursts into tears and gives up the job, in vain.[247]

An additional story, on an inside page, bore the headline, "Polly Awakened." In flowery, sometimes condescending, prose, the reporter described Polly Bemis herself, as well as Grangeville's impact on her:

> There is in Grangeville this week [mid-August 1923] a Chinese woman who is a most unusual character. She is remarkable in that for fifty-one long years she has continuously resided in the roughest mountain country of Idaho [C]ounty – the most rugged mountain region in the [W]est, and in all these years, more than half a century, she has not left her mountain homes, first at Warren, once a lively gold-mining camp, and then for twenty-eight years in the deep canyon of the Salmon [R]iver, where for weeks and months, sometimes, she saw not a living soul save her husband, a white man, who passed away last November [actually, October 29, 1922], and left her alone in the world.

> This Chinese woman today is having 'the time of her life' in Grangeville, which to her is a veritable metropolis. She has lived the primitive life of a frontierswoman. Hidden in the mountain fastness-es, the march of progress has surpassed her greatest expectations. She is unable to comprehend the world, or any particular part of it, save the isolated mountain region, with its peaks and its canyons, its deep snows of winter and dancing brooks in the summer time.

> This woman, until she came to Grangeville, had never seen a locomotive.[248] Until a few days ago, she knew not the sound of an automobile engine. The method of locomotion employed by Eve in the Garden of Eden was hers, by her own feet, and not in twenty years had she even ridden horseback, the necessarily favorite means of transportation in the mountains.[249]

Grangeville, with its 1600 people, its picture show, its brick business blocks, its hundreds of speeding automobiles, and far more wonderful than that[,] the steaming steel locomotive that nightly pulls the passenger train into this metropolis—as Polly views a typical western town that in many parts of the country would be termed nothing more than a village—it's all marvelous, so marvelous.

Polly is a modern Rip Van Winkle, but instead of sleeping twenty years in the Catskills, she is awaking from a half[-]century of slumber under the shadow of the majestic Buffalo Hump [the mountain].

She cannot explain her delight, her utter astonishment at what she has seen. She stands aghast. She chuckles for joy. She walks in the street[s] of Grangeville grasping the arm of her companion, for fear she may become lost – that she may be engulfed in the maelstrom of the mad throng. The wonders of it all – they are to her a great, great puzzle, as much of a mystery as is life itself, and death. She cannot solve it.

But what would Polly say if she were suddenly transported from Grangeville to San Francisco, to New York or to London? Ah, the contrast would be too great. She would drop dead, this plucky, good[-] natured Chinese woman. She is overjoyed in Grangeville, but already she has expressed a desire to return to the mountains, to her humble cabin. She has seen enough. 'It's home,' she said, 'and I want to go back.' Polly has seen the world.

She is satisfied to go back to the mountains and spend the rest of her days amid the scenes she has known so long.[250]

J. C. Safley, who edited, owned, and published the *Idaho County Free Press* from 1917 to 1924, was the person who interviewed Polly for the story, above, that ran in his newspaper. He later wrote Idaho County historian M. Alfreda Elsensohn with additional details from his conversation with Polly, items that didn't appear in his 1923 article about her. Elsensohn subsequently used his information in a newspaper article:

[Bemis] once captured a cougar and kept it as a pet for some time, evidently in the Salmon [R]iver home. The cat ate at the table with them from a tin plate nailed to the table. Concerning this Polly remarked, 'Charlie he pet um big cat but when stranger come he [the cougar] hump um up and spit um.' Eventually the cougar had to be put away.[251]

An interview with Johnny Carrey corroborated the pet cougar story. Salmon River boatman Joe Powell also confirmed that he saw the big cat on the Bemises' roof, that it growled at him, and that he saw its tin plate nailed to the Bemises' table. He also reported, "Polly pulled the cougar around."[252]

It is evident that Polly thoroughly appreciated her first visit to the "metropolis" of Grangeville. Not only did she take her first automobile ride, to get there, but once there, she also saw her first train, and was even able to board the engine. Friends took her "to the railroad station to witness the arrival of the evening train. When the trainmen were advised that she had never before seen a locomotive or cars, they lifted her into the engine cab, opened the firebox, and allowed her to peer at the seething, roaring furnace," which frightened her. The reporter seemed surprised that cameras didn't bother Polly at all, but of course she was often photographed, whether by Charlie Shepp or by people who came down the river with Captain Guleke.[253]

In Grangeville, Polly also saw a "motion picture show." It "was the most fascinating to her of all the wonderful things she saw."[254] Polly would have seen the film at the Lyric Theatre, in operation since at least 1909.[255]

A later account of Polly's 1923 visit to Grangeville, "her first trip out to civilization to see an oculist," stated that she "stayed with … Mrs. Bertha Long, whose acquaintance she had made long ago in the mining town of Warrens."[256] However, Long herself later indicated that Polly didn't actually stay overnight with her. Instead, as she related,

> When she [Polly] came to the [Camas] Prairie in 1923 I brought her out to my home for a visit (Fig. 7.21) and she did enjoy herself. I asked about the picture show. She didn't go much on them. She said, 'they make me shamed, I cover up my face' I guess these love scenes on the screen didn't appeal to her.[257]

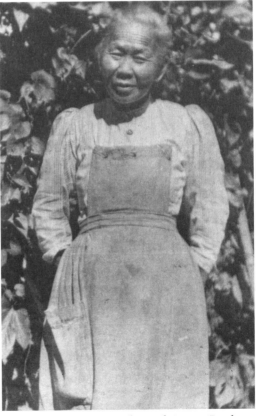

Fig. 7.21. Polly Bemis in front of vines at Bertha Long's house, near Grangeville, 1923. Courtesy David Rauzi, Idaho County Free Press.

Polly's visit to Bertha Long involved an amusing tale about Polly's interaction with the Long family's parrot:

While Mrs. Long was preparing the breakfast the parrot began to chatter, 'What does Polly want for breakfast? Polly wants something for breakfast.' The Chinese woman was puzzled and wanted to know how the bird knew her name. Mrs. Long explained that the bird's name was Polly, too.

The parrot was a large green bird with gold and green wings and Polly called it a 'talkee bird.' She said, 'This is the first talkee bird me see um since I leave um Shanghai. Most birds in Shanghai talkee hi-yu [very] bad; this talkee bird talkee nice.'[258]

A Long family anecdote relates that the parrot was squawking while Polly was making stew, and Polly Bemis said, "Polly better shut up or we have parrot stew."[259]

Another purpose to Polly's Grangeville visit in 1923 might have been to formalize an agreement with Charlie Shepp and Pete Klinkhammer that they would get the Bemis Ranch when she died, in exchange for them rebuilding her home and taking care of her in the years to come. This is hinted at in a newspaper article dated some eleven years later: "Charles Shep [Shepp] and Pete Klenkenheimer [Klinkhammer] … have agreed to furnish Polly her groceries and saw her wood in return for which she is to give them her place when she dies. It was while at Grangeville drawing up papers to that effect that Polly saw her first train and automobile,"[260] but no such agreement has been located.[261]

Polly's departure from Grangeville on Monday, August 20, 1923, was front-page news again, complete with a photograph of her. After a week there, "during which she was feted by many pioneer residents of Idaho [C]ounty who knew her in the early mining days at Warren," Polly returned to Warren on the Salmon River stage. "I have best time in fifty year," she exclaimed. "'Maybe I come back next year,' Polly declared. 'It take hi you [lots of] money, but maybe I come back,' she laughed." "Bedecked in a new dress, a gay hat and white shoes, and with a grip [suitcase] filled with new clothing, all gifts of friends, the 70-year-old Chinese woman … was as happy as a child after the annual visit of Santa Claus." She was "particularly proud" … of her "new gold-rimmed spectacles" (Fig. 7.22).[262]

Since newspapers exchanged issues in those days, it isn't surprising that accounts of Polly's visit to Grangeville ran in Idaho's *Pocatello Tribune* and in the *Salmon Herald* and perhaps in other newspapers as well.[263] Because the stories were retyped, errors crept in, such as the substitution of "thirty-one" years for Polly's actual 51 years in Idaho.[264]

Meanwhile, Shepp visited Polly's place occasionally. On August 13 he picked two 10-pound buckets of blackberries, got three more buckets of them on the 21st, and another 10 pounds two days later.[265] He had some Polly-related interactions with US Forest Service personnel, namely, a ranger and a packer came "down from Dixie with 7 pack mules with wire for telephone"; Shepp also met with one of the men who was improving the "Bemis trail."[266]

On September 8 Shepp went over to Polly's and on the 9th Ellis Winchester came down from Rabbit Creek. Winchester "got bellows, anvil, and a lot of junk at Bemis' & some spuds & tomatoes."[267] Shepp, who was looking after Polly's place for her, would have known what equipment she would no longer need; presumably Winchester paid him for it and for the produce, and Shepp could get the money to Polly eventually. On Monday, September 10, there was a total solar eclipse, which Shepp observed at 12:20 p.m.;[268]

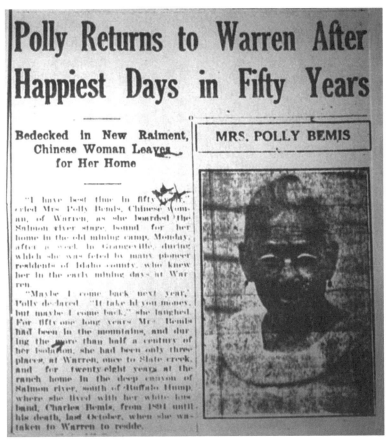

Polly Returns to Warren After Happiest Days in Fifty Years

Bedecked in New Raiment, Chinese Woman Leaves for Her Home

MRS. POLLY BEMIS

"I have best time in fifty years," cried Mrs. Polly Bemis, Chinese woman, of Warren, as she boarded the Salmon river stage, bound for her home in the old mining camp, Monday, after a week in Grangeville, during which she was feted by many pioneer residents of Idaho county, who knew her in the early mining days at Warren.

"Maybe I come back next year," Polly declared. "It take all your money, but maybe I come back," she laughed. For fifty-one long years Mrs. Bemis had been in the mountains, and during the more than half a century of her isolation, she had been only three places, at Warren, once to Slate creek, and for twenty-eight years at the ranch home in the deep canyon of Salmon river, south of Buffalo Hump, where she lived with her white husband, Charles Bemis, from 1894 until his death, last October, when she was taken to Warren to reside.

Fig. 7.22. Polly Bemis wearing her new glasses, 1923. From Idaho County Free Press, *August 23, 1923.*

Polly, in Warren, may also have seen it. On the 22nd Shepp was back at Polly's; he "Got about all the Concord grapes."[269]

Toward the end of September 1923 Ruby McDowell and her four sons, Charles, George, Herbert (Herb), and Harold ("Tuffy"), arrived in Warren to join husband and father Wallace McDowell who was employed at the Unity Mine.[270] In later years, Herb McDowell told an anecdote about Polly Bemis to Arnie and Sue Johnson.[271] Herb recalled that Polly visited his mother and admired Ruby's yellow curtains. When Polly said she thought they would make a pretty dress, Ruby took the hint and kindly gave Polly the curtains.[272]

During October 1923 Shepp began spending more time constructing Polly's new house, sometimes with help from Pete Klinkhammer and other men. He was over there on the 4th and the 10th, and on the 13th Pete and a man named Jake were there also.[273] Near the end of the month Shepp spent a couple of days "on house logs," and on the 31st he "Took 2 box[es] apples up on trail for Polly" because Ellis Winchester was going to Warren the next day and could take them to her.[274]

November 1 saw "Pete and Jake on logs" for Polly's house. They, and/or Shepp, "cleaned off old cans for house."[275] This sounds as if Shepp decided to erect Polly's new house in a different place, perhaps where an old can dump had been. On the following two days Shepp, and maybe the others as well, were "Over river on logs," then "Finished logs & brought horses home."[276]

House building began on Monday, November 5, 1923, when Shepp wrote, "Over river, put up 2 rounds log[s]." He spent that whole week working on it, and by Friday the 9th he had gotten "logs up to 1st story."[277] On the 10th he installed the stair joists, on the 15th he "got logs up to roof," and on the 16th he "Got roof started." The next day Shepp cut a big fir tree to use for roof shakes.[278]

That Sunday, the 18th, Shepp wrote, "Pete & Jake up round Polly [C]reek."[279] This seems to be the first mention in the Shepp diaries of the new name for Bemis Creek, the one at the Bemis Ranch,[280] although it was already known as Polly Creek in 1914.[281] During the next several days Shepp was "Over river on shakes," and on the 20th Jake wheeled them to the house.[282] Several days later, on Friday, Shepp "Put up top roof log." He took a few days off, but by Tuesday he was back working on the house, putting shakes on the roof. On the 30th, however, it was "To[o] cold to shake," but he did manage to "Cut ends off roof."[283] Meanwhile, Ellis Winchester went up to Warren again and surely saw Polly while he was there.[284]

The cold weather continued on December 1, so Shepp couldn't work on the roof shakes. Instead, he dug a trench around the house, probably for drainage. The weather warmed up enough for him to finish shaking the roof on the 3rd, but by the 8th he was finished for the winter; that day, he went

over and got his tools.[285] On Sunday, December 23, Pete went up to Warren.[286] He undoubtedly visited with Polly, who would have been delighted to learn about the progress on her new home.

Shepp's 1921-1923 diary concludes at the end of December 1923. Of interest, at the end, is a note providing prices for a few types of produce during 1923. That year, potatoes were three and a half cents a pound, and apples, carrots, and onions were all five cents a pound.[287]

1924

The only relevant entry for January 1924 in Shepp's diary was on Wednesday the 9th. It read, "Pete & Jake over river, got traps."[288] These would have been for trapping fur-bearing animals, to skin them and sell the fur; as mentioned previously, the 1920 US Census for Idaho County's Concord Precinct listed Klinkhammer as a fur trapper.[289] There were no pertinent entries in February, but in March the men resumed work on Polly's new home. For example, on the 4th, Pete and Jake began sawing the floorboards. They finished on Friday the 7th, and Shepp took a photo of the saw pit, noting that it measured "25 ft 7-7" [25 feet long by 7 feet wide and 7 feet deep] and was a "good big pit."[290] The form nominating Polly Bemis's house for listing on the National Register of Historic Places states that it is Idaho's "only inventoried instance of the use of whipsawn lumber."[291]

During March, besides working at his own ranch, Shepp did a few chores at Polly's place. On the 10th he pruned her grapes, on the 30th he took horses across the river in the afternoon, and the next day he began plowing over there.[292] Meanwhile, on the 29th, he saw three swans in the Salmon River.[293]

In early April 1924 Shepp went over to Polly's and cleaned up around the house. He also took cuttings from one of her apple trees and, on the 9th, grafted them onto a couple of his own trees. On the 19th, "Pete planted garden stuff over river," and on the 21st Shepp "Got roof on porch" of Polly's house, and worked on it the next two days as well.[294] Pete and Jake were over there the morning of the 24th, perhaps to work in Polly's garden, and Shepp was at Polly's the next two mornings but didn't say why he went.[295]

During March and April 1924 Shepp received the materials to build a radio receiver.[296] After fiddling with it at various times, and getting another tube for it, he finally got it to work in early May: "Got radio all set & heard just a little music so faint couldn't tell any thing about it."[297] Later, when Polly was back, and the radio was working well, she also enjoyed listening to it.

While Polly was living in Warren before first moving to the Salmon River in 1894, and when she lived there again from late 1922 to late 1924, her Chinese acquaintances might have included the man named Goon Dick, a "veteran

Idaho [C]ounty miner," age 70.[298] If he and Polly did know one another they probably would have spoken in English, because her native language wasn't the same dialect of Chinese that was spoken by the Cantonese/Taishanese miners.

Goon Dick, also called "China Dick," was a different person from Warren's Dr. Lee Dick. Goon Dick was a miner in the Elk City, Florence, and Warren areas from the early 1880s.[299] Unusually, by March 1917, Goon Dick was a partner with a Euroamerican man: "On Summit Flat, Al Nurse and China Dick are developing a very promising prospect. They have about 100 tons of ore on the dump which is said to assay close to $65 per ton."[300] By May 1918, described as "aged and frail of body," he had a young Chinese companion, probably Boon Ning, to help with his mining efforts.[301] That July, Dick and a different non-Chinese partner sold their Woods-Dick placer mine on War Eagle Mountain to Boston Brown.[302] In March 1919

> Goon Dick and Boon Ning, two Chinamen of this place [Warren], left Saturday for Burgdorf, intending to go by skiis [sic] from there to Grangeville. They spent three days wandering near Baldy [M]ountain trying to get through the breaks down to Salmon [R]iver and finally circled back. Before reaching Burgdorf they became exhausted, but the younger man succedded [sic] in reaching the station on his hands and knees and rescuers went out and hauled in Goon Dick, who is past 60 years of age. … Goon Dick reached McCall on Sunday's stage and left Monday for Grangeville. From there he will go to Seattle. His partner had "muchee plentee hell," and finished his trip at Burgdorf.[303]

Goon Dick spent the next year in Seattle, returning to Warren in April 1920; that year, beginning in December, he wintered in Grangeville.[304] He must have gone back to the Warren country in 1921, because a newspaper story from early 1922 reported that Goon Dick "has arrived in Grangeville from Warren … [and] will leave shortly for Seattle. For forty years he has been mining in Idaho [C]ounty, and is one of the few Chinese left in the county of the early-day [O]riental hordes which swarmed the mining camps."[305] In November 1922 the *Idaho County Free Press* commented, "Goon Dick has re-turned to Grangeville from the Warren country, where he spent the summer mining."[306] In 1923 Goon Dick reached Warren in June and left in October.[307]

In April 1924 Grangeville's *Idaho County Free Press* interviewed Goon Dick when he arrived in Grangeville "enroute from Seattle on his annual pilgrimage to the placer mines near Warren." Described as "[w]rinkled and bent with age, but with the enthusiasm of youth," Goon Dick

> … is one of the remaining Chinese of the thousands who in the early days swarmed the placer diggings of Idaho [C]ounty. He has spent forty years searching for the precious yellow metal in Elk City,

Florence[,] and Warren foll[o]wing boom after boom in the glorious mining days of yesteryear. In his declining years he has centered his activities in [the] Warren country, where he comes every spring with pick and pan and grubstake to spend the summer sifting the sands for nuggets and dust.

'Ketch 'em hi-you [get lots],' he says, 'but spend 'em all,' he sadly relates. Me ketchem hi[-y]ou, pretty soon, Hi-you big gold. Me lich [rich] man, by and bye.'

Dick says he is 70 years old and expects to live to be a hundred. He is afraid of the devil and says old Satan won't catch him.[308]

During the winters, Goon Dick stayed with friends in Seattle. The reporter asked him if he smoked opium there. With opium smoking being illegal, Goon Dick wisely didn't answer the question, but did volunteer "the information that four draughts on the opium pipe cost a dollar in Seattle's Chinatown."[309]

Back on the Salmon River, in early May 1924, Pete crossed over to Polly's place and saw a cougar track. The next day Shepp installed her telephone and Ellis Winchester planted some corn. Pete was there again from the 7th through the 10th, and Jake was over for several days also, "on boards for floor" and "on flooring," which he finished on the 13th. Meanwhile, on the 12th, Shepp "got joist in" and the next day he helped Jake complete the floor.[310]

That must have been the upstairs flooring, because on the 14th Shepp wrote, "Over river am. Got lower floor in. ... Pete over river all day. Jake finished lumber." The next day Shepp was "Over river on house" while Jake "dressed doors." On Friday the 16th Shepp installed a window in Polly's house, and Pete and Jake were over there on the 17th.[311]

On Sunday May 18th Ellis Winchester was at the Bemis Ranch. He used Polly's new telephone and called Shepp, saying that he was going up to Warren the next day.[312] While there he surely reported to Polly about the progress on her house. Shepp's last visit to Polly's place in May was on the 20th when he and Jake "Got windows in."[313]

Shepp's radio finally began to work well in June. On the 1st he got "Church service in California. Good music but couldn't hear good" so on the 10th he "Put in new ground for radio & heard the first good music from 9 to 1 am [a.m.]. Hotel St. Francis, San Francisco."[314] Meanwhile, Pete was at Polly's place on the 5th. Shepp didn't return there until the 26th, when he was "on garden."[315]

In early July 1924 Shepp went up to Warren for several days. On the 3rd he left home at 4:00 a.m., probably because it had been so hot – it was 108 degrees the day before. He got to town about 11:00 a.m. on Thursday, stayed Friday and Saturday, and returned home on Sunday.[316] He and Polly undoubtedly had several good visits, with lots to talk about, especially her house and his radio.

Back home, Shepp picked 10 pounds of Polly's black raspberries on the 9th, watered her garden on the 10th, and irrigated her potatoes on the 12th.[317] On the 17th he entertained "Guleke & 5 other fellows" who arrived that evening in a boat; the next morning Shepp fed them breakfast before they left.[318]

From the 23rd through the 28th Shepp was at Polly's four more times. Once he was "on garden" and picked a half-bucket of blackberries; another day he picked two 10-pound buckets of them. Shepp also noted that "Winchester watered his corn;" he had planted it at Polly's place in May.[319]

During August 1924 Shepp was often over at Polly's. On the 1st he picked two 10-pound buckets of blackberries. Two days later, on Sunday, he watered her potatoes and her garden.[320] That date, August 3, 1924, was a big day for Polly Bemis. Her friends Jay Czizek, Idaho's first inspector of mines, and his wife took Polly to Boise. In late September 1933 Boise's *Idaho Sunday Statesman* interviewed Czizek, who commented on that trip:

> Several years ago … my wife and I brought Polly to Boise. She was grieving over the death of her husband and we thought it would cheer her up to get out of the camp [Warren]. But the rush of gay little Boise, the many bright lights and the general confusion, to a woman used to life on a far away Salmon [R]iver ranch, was too much for her and she begged to go back at once.[321]

In Boise, the three stayed at the Idanha Hotel (Fig. 7.23). On Monday, August 4, 1924, the "Hotel Arrivals" section of Boise's *Evening Capital News*, under "IDANHA," listed J. A. Szizic [*sic*] and wife, and Mrs. Polly Benns [*sic*], all of Warren.[322] A story in Boise's *Idaho Daily Statesman* reported that Polly

> … went to bed at the Idanha Sunday evening with a badly strained neck and tired eyes. She had seen her first street car, her first high building, her second movie show, and ridden in her first elevator, all in one day. Last summer, needing dental work badly, she went over to Grangeville for a few days ….
>
> This year, needing more dental work, she accompanied Mr. and Mrs. Jay Czizek down from Warren.
>
> 'Czizek eat in my boarding house 32 years ago. I know him long time,' she said.
>
> The reporter who went to interview Polly Bemis at the Idanha found a tiny woman with iron gray hair, the brightest of eyes, dressed in a blue cotton dress, her whole appearance scrupulously neat.
>
> Her speech is excellent, with just enough of the 'pidgin English' to make it fascinating. Her memory is remarkable, particularly for dates, and her eyes twinkle as she tells jokes on herself, as when she spoke of the miners not liking the coffee she made in camp, and the way she

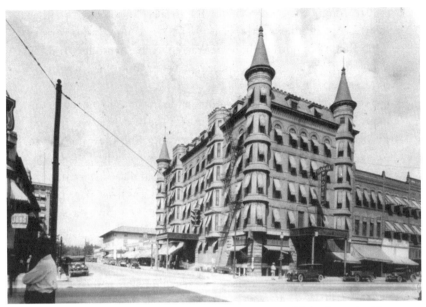

Fig. 7.23. Idanha Hotel, Boise, Idaho, ca. 1930. Courtesy Idaho State Archives, Boise, 75-177.6.

silenced them by appearing with a butcher knife and the question, 'Who no like my coffee?'

...

'My husband say, "We will never see railroad, I guess," and he die, then I come out to get dentist to see my teeth and I see railroad at Grangeville last summer. Now I see Boise, big city, stores five, six stories high, street cars run middle of street.[323] Lots of people, I like it, but it makes me tired to look so much.'

Asked what she thought of the 'flapper' of today with her rouge and paint [makeup], she said:

'I paint like that, too, all the time, till I go to my man [Charlie Bemis]. Then I not have to paint any more. American girl today paint till she gets man too.'

Bobbed hair is not to Polly's liking, however. She recalls the long glossy tresses of the Chinese maidens, dressed in hugh [*sic*, for high or huge] pagodas, atop the head, and shakes her head at shorn locks. Of modern dress she quite approves.[324]

Asked how she liked the movies, she said, 'some very nice – ships and big sea – and some very bad, shut eyes'[325] (Fig. 7.24).

Polly has not seen a Chinese woman for 35 years [since] the other Chinese wom[a]n of the Warren camp died.[326] She is going to pay

a visit to some of the members of the local colony today. Another person she would like to meet is 'Bob No. 2,' a Chinese who worked for Bob Katon [*sic*, for Keathon] of Warren, who, she understands, is now living in Boise [i.e., the Chinese man called 'Bob No. 2' was living there; Keathon died in 1902].[327]

For years Polly has run [this venture ended when she moved to the Salmon River in 1894] a boarding house for the miners at Warren and she is beloved by all the old timers of the camp. She knew nothing of cooking, she said, and as no one was willing to teach her, she simply watched two American women who did cook, and then started in.[328]

The Boise paper ran its story on page two, but it was front-page news when it was reprinted in Grangeville's *Idaho County Free Press* three days later. That article recapped Polly's visit to Grangeville the previous summer, embellishing it with a couple of opening paragraphs. On her Boise visit, Polly "had her first peep at a modern city, with paved streets, tall buildings[,] and street cars" After arriving home from her visit to Grangeville Polly "had seen much that was new. In a way, she realized that what she had seen on her memorable trip

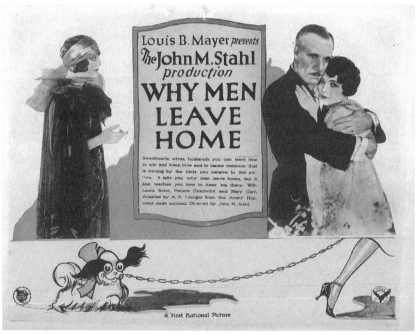

Fig. 7.24. Lobby card for the film, "Why Men Leave Home." Courtesy Heritage Auctions, HA.com. Available at https://movieposters.ha.com/itm/drama/whymen-leave-home-first-national-1924-title-lobby-card-11-x-14-drama/a/58074-54448.s?ic4=GalleryView-Thumbnail-071515# (accessed June 18, 2019).

to Grangeville, was a mere glimpse of the outside world. She desired to enlarge her sphere, so she went to Boise."[329]

Following her Boise visit, Polly returned to Warren on Tuesday, August 5.[330] Also on that day, Shepp went to Ellis Winchester's place on Rabbit Creek and got three quilts that Polly had sent down.[331] As it was summer, she wouldn't have needed the quilts, but by returning them to the Salmon River she must have realized that she would be moving back home before winter.

Shepp was over at Polly's place on August 6, and again on the 9th, when Winchester was also there, watering the corn.[332] This is additional confirmation that Winchester was growing corn for himself at Polly's. Also, later that month, Shepp, who was over there, wrote, "Shot 2 crows in Winchester's corn." He also observed that it was "Hot. 108 [degrees]."[333]

On a couple of days Shepp picked a total of three and a half boxes of apples at Polly's.[334] He was there again from the 11th through the 14th, twice just in the morning. One day he watered the garden and worked on the house floor and another day he watered the potatoes.[335] Meanwhile, Ellis Winchester went to Warren on the 11th and the 23rd. There he would have visited with Polly and learned about her trip to Boise earlier that month.[336]

In late August 1924 Shepp spent several mornings at Polly's, "on floor." He also "Changed wire on telephone & fixed pole for aerial."[337] On the 28th Shepp went up to Winchester's in the morning. Winchester came down with him and that afternoon they took the boat up there "& got Polly's stuff down, 4 boxes [and] 1 sack."[338]

Shepp took a few days off but by Wednesday, September 3, he was back at Polly's again. He was "on windows" for two days, "on house" that Friday, and back again Saturday morning without mentioning what he did that day.[339]

Shepp stayed away from Polly's for the next couple of days—he probably had plenty of his own work to do. Some of it involved improving his radio reception. For example, on the 8th, probably in the evening, he noted, "Radio worked good. Got Seattle, Vancouver [probably BC], & Hastings, Nebr[aska]."[340]

With only a month left before Polly would return to her rebuilt home, Shepp was over there almost daily, working on it for part or even all of the day. From September 9 through 12 he "Got 1 window in," "Chinked south side upstairs," and "Got window frame in & chinking about done."[341] Chinking, or caulking, filled in the spaces between logs so that air couldn't enter; Shepp didn't mention what substance he used.

Pete Klinkhammer was back to help on Saturday the 13th. The two men "Finished chinking & upstair[s] floor." They also went "Up to Rabbit

[C]reek with boat" and got "2 box[es] for Polly";[342] Ellis Winchester must have brought them down from a visit to Warren.

On September 15 Shepp "Finished in side [inside] of house."[343] He was back there again on the 18th and 19th, in the morning, but didn't mention what he accomplished on those days.[344] On Saturday the 20th Shepp worked on the downstairs floor, and on Sunday the 21st he was there all day; he "Got floor done & door & upper windows cased."[345] On Monday, September 22, Shepp began building the staircase between the first and second floors of Polly's house. The following day he "Got stairs done."[346]

Just as Shepp had chinked between the logs inside Polly's house, he also needed to do the same to the spaces between the logs on the outside of her new home. Because "mud" [clay] was often used for this, the procedure was called "mudding." On Wednesday the 24th Shepp "Started to mud. Got 1 side as high as I can reach." He continued this for several days and on Saturday he wrote, "Finished mudding house."[347]

Shepp spent the next couple of weeks putting the finishing touches on Polly's house and preparing for her imminent arrival, but didn't always mention his specific tasks. He "Got door hung" [the front door?] on the 29th, was "on shelves" on October 6, "Cleaned [root] cellar and house" on the 7th, and "Graded & filled shed floor" on the 8th.[348]

Meanwhile, during the afternoon of Thursday, October 2, Shepp took four horses across the river. The next day, Pete took them up to Warren. On the 4th he came back "with some of Polly's grub," i.e., her fall and winter food supplies.[349] Pete returned to Warren on the 8th, and on Thursday, October 9, 1924, he came back with Polly. Shepp noted, "Got all her stuff down."[350] That day, he also wrote "Polly" in the margin of his diary, emphasizing the importance of this event.[351]

Shepp's diary entries completely contradict fanciful accounts, such as this one, of Polly's return to the Salmon River: "Shepp and Peter looked after Polly's place, until the morning they saw smoke over there, and found Polly in one of the outbuildings. She had walked over the mountain from Warren. "This my home. I stay. I not bother anybody."[352]

Again, entirely repudiated by Shepp's diary describing his months of laborious work building Polly's home:

> There was not a lot of talk that first morning. But Shepp and Peter sharpened saw and axe, gathered those tools needed to raise a house, and crossed to Polly's side of the river. Shepp [R]anch chores got short shift [sic, for shrift] until they had Polly installed in a neat, tight, small but comfortable new log cabin … smaller than the house which had burned, for Polly would be alone.[353]

Although Polly was back on the Salmon River, her home still wasn't quite ready for occupancy, so she stayed with Shepp and Klinkhammer for a few days. On Friday the 10th Shepp "Took stove over river" and on the 13th he "… got stove up";[354] this stove would have been for cooking. Meanwhile, on the 11th, Pete was at Polly's place where he "Dug part of spuds over there."[355] Three days later, Pete and Polly "… got spuds & carrotts [*sic*] in," and Ellis Winchester came down and built a fence.[356]

On October 15 Shepp made a bed for Polly, and the next day he "Got telephone fixed up."[357] Finally, on Friday, October 17, 1924, Shepp reported, "Polly moved in her house. She is over there tonight."[358]

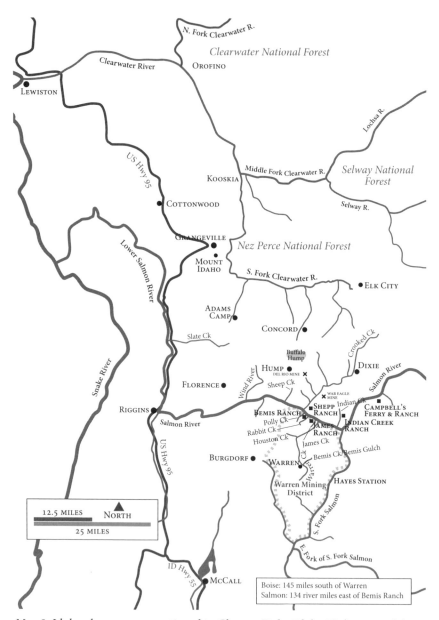

Map 8. Idaho place names mentioned in Chapter Eight. Idaho Highway 55 did not then exist but is included for context. Drawn by Melissa Rockwood.

CHAPTER EIGHT:
Polly Bemis's Last Years, October 1924 to November 1933; Polly, age 71-80

O nce Polly's neighbor, Charlie Shepp, had built her a new house with some help from his ranch partner, Pete Klinkhammer, and other friends, Polly moved back down to the Salmon River in the fall of 1924. Life went on, much as before, until early August 1933. Then, Polly had an apparent stroke, was taken to the county hospital in Grangeville, recovered somewhat over several months, but died there in early November.

Major Events during Polly's Later Life

World and national news impinged little if at all on Polly Bemis's life on the Salmon River. During 1925, national news of importance included the installation of Nellie Tayloe Ross as governor of Wyoming, the first female governor in US history.[1] In 1926, after the death of Sun Yat-sen in 1925, Chiang Kai-shek became the leader of China's revolutionary party.[2] World news for 1927 saw solo aviator Charles Lindbergh make the first-ever, non-stop, transatlantic flight.[3]

Noteworthy events of 1928 included Herbert Hoover's election as United States president, replacing Calvin Coolidge.[4] In 1929, the stock market crash ushered in the Great Depression.[5] During 1930, the Nazis began their rise in Germany.[6] In United States news during 1931, the "Star Spangled Banner" became the national anthem.[7] In 1932, aviatrix Amelia Earhart became the first woman to fly solo over the Atlantic Ocean.[8] In 1933, unemployment in the United States reached a whopping 25.2%, the worst of the Great Depression; Franklin D. Roosevelt became president, replacing Hoover; and Prohibition was repealed.[9]

1924

After Polly moved into her rebuilt home (Fig. 8.1), on Friday, October 17, 1924, Shepp gave her a day to settle in, then visited her on Sunday morning.[10] He left for Grangeville the next day and didn't return home until the 30th.[11] In early November Shepp visited Polly frequently, sometimes in the morning and sometimes in the afternoon. Usually he didn't mention what he did over there, but on the 7th he "Fixed Polly's chairs."[12] Perhaps he built some for her, since hers would have burned in the 1922 fire.

Fig. 8.1. *Polly's second home on the Salmon River, under construction, 1924. Courtesy Cort Conley.*

Tuesday, November 4, was Election Day. Surprisingly, because it was a presidential election year, Shepp didn't go up to town to vote, although Pete did go to Dixie on the 3rd. Instead, Shepp stayed home and canned a hindquarter of a buck that Pete had shot a few days earlier. That night he listened to the election returns on his radio until 1 a.m.,[13] without commenting on them—Calvin Coolidge was elected president.

From November 10 through 13, 1924, Pete helped out at Polly's every day. He cut wood for her and "Got both doors hung & locks on."[14] Neither Shepp nor Klinkhammer visited Polly until Saturday, November 22, when Pete was over there, but Shepp didn't mention anything specific about that visit. The next day, however, Shepp entertained Polly Bemis and Ellis Winchester for Sunday dinner; as always, this would have been the noon meal.[15] It may have been in lieu of Thanksgiving dinner; the holiday was the following Thursday,

November 27, but Shepp's diary doesn't mention a special meal that day. Instead, at his own place, he finished making a table for Polly and took it over to her the next day. If she had had it sooner, she surely would have entertained her friends on Thanksgiving, as she had done so often in the past.[16] Earlier that week Shepp had "Put iron on south side of house."[17] The "iron" may have been corrugated iron placed about three feet up the side of the house that received the most snow and weathering in winter.[18] He also "Fixed place for Polly's chickens."[19]

As part of his house-building efforts, Shepp had repaired Polly's telephone (Fig. 8.2). Apparently, she and Shepp arranged for her to call him every evening. One account of their calls states,

> The half mile of thin wire fascinated Polly and the day was not complete unless she used it at least once. If Shepp did not call her she would call him.
>
> 'How many eggs you get today? Six! I get 10.' Then there was a peal of merry girlish laughter from a throat old enough to know nothing but a cackle. 'How many fish you catch? None! You no good! You fella come over Sunday. I cook one great big one I catch today.'[20]

It was thus an unusual event if Shepp didn't hear from Polly; on Saturday, November 29, he wrote, "Polly didn't ring up tonight."[21] The next day she must have alleviated his concerns because he didn't mention it again.

Shepp and Pete visited Polly a few times in December. On the 11th "Polly'[s] stove broke down," problem not specified, but Shepp fixed it for her, and Pete helped out by cutting wood. Pete also shot a fawn and took a quarter of it over to Polly.[22] On December 24 Shepp wrote, "[Norman?] Church & Boston [Brown] down [a.m.]. Pete & Church over river afternoon."[23]

Convenient Wall Telephone

For use on any bridging or private line of any length. Oak cabinet, finely varnished and polished. Easily installed, with the complete directions in- cluded free. Equipped with solid back transmit- ter, bi-polar receiver, lightning arrester, adjust- able ringer movement with 2½-inch gongs, powerful generator with laminated magnets, each bar con- sisting of three distinct magnets tempered and magnetized separately. Every 5-bar generator has 15 magnets and every 6- bar generator has 18 mag- nets. Length 20 inches, width, 9 inches. Shipping weights, 32 to 38 pounds.

Prices include two dry batteries

Article Number	Each	Six For	Size Gener.	Ringer Movement
263 C 1001	$14.75	$87.50	5-bar	1000 ohm
263 C 1003	14.85	88.10	5-bar	1600 ohm
263 C 1005	14.90	88.40	5-bar	2000 ohm
263 C 1007	14.95	88.70	5-bar	2500 ohm
263 C 1009	14.90	88.40	6-bar	1000 ohm
263 C 1011	15.00	89.00	6-bar	1600 ohm
263 C 1013	15.05	89.30	6-bar	2000 ohm
263 C 1015	15.10	89.60	6-bar	2500 ohm

ctory in Northern Indiana

Fig. 8.2. Telephone, possibly similar to Charlie Shepp's, 1922. From Montgomery Ward & Co., Catalogue No. 97, Fall & Winter 1922-1923 (Portland, OR: Montgomery Ward & Co., 1922), 545, from Wayback Machine, "Internet Archive," available at https://archive.org/details/ montgomerywardca1922mont (accessed November 20, 2019).

Christmas Day at Polly's was busy – Boston Brown visited her in the morning, and Ellis Winchester was her guest for Christmas dinner. We don't know what she served him, but Shepp cooked a rooster for his guests, Pete, Church, and Boston.[24] At year's end Shepp reported that there was "About a foot of snow on ground." That night he "Heard Denver good" on the radio (Fig. 8.3); a couple of weeks previously he had received Walla Walla, Washington.[25]

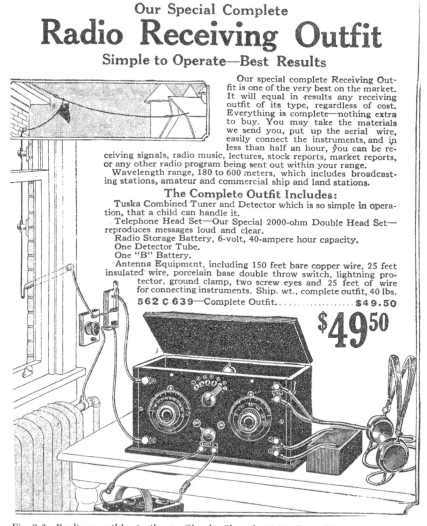

Fig. 8.3. Radio, possibly similar to Charlie Shepp's, 1922. From Montgomery Ward & Co., Catalogue No. 97, Fall & Winter 1922-1923 (Portland, OR: Montgomery Ward & Co., 1922), 540, from Wayback Machine, "Internet Archive," available at https://archive.org/details/montgomerywardca1922mont (accessed November 20, 2019).

1925

In early January 1925 Shepp reported that he "Had Los Angeles [on the radio] tonight."[26] Pete visited Polly that day and helped her several times that month by cutting wood.[27] On the 18th Shepp and Charlie Matzke went over there; Shepp wrote, "Something got the 3 pullets [young hens] of Polly's;[28] unfortunately, the "place" he had earlier "fixed … for Polly's chickens" wasn't secure against varmints. A week later her "barn" [hay shed] roof fell in, so Pete, Shepp, and Ellis Winchester worked on it, and got her hay covered.[29]

At month's end Shepp commented that the river ice was "getting bad," although there was still nearly a foot of snow on the ground.[30] Typically for him, he wouldn't cross the Salmon River when he felt it was too dangerous; consequently, he only visited Polly once in February, on the 24th.[31] Pete, 20 years younger and more fearless, cut wood for Polly on seven different days that month, and once in early March.[32]

On March 18 Pete dug up Polly's parsnips. Ellis Winchester was there the morning of the 22nd, and Shepp took five days between the 26th and the 31st to put shakes on Polly's chicken house.[33] He also chinked it, finishing in early April.[34] Shepp and Polly fished one afternoon; he got "nit" [nothing], but "Polly caught big one."[35]

On April 10, 1925, Shepp reported that he and Pete were "under weather, done nothing all day," and that "Polly [was] sick like the rest of us"; their ailments, perhaps bad colds, aren't specified. Harry Guleke and an unnamed person came down the river in a boat, but "stopped only a little while."[36] At mid-month Shepp took four "old hen[s]" over to Polly and went back there again the next day. On Friday the 17th there was "Snow at head Polly [C]reek."[37] Pete visited Polly on the 18th but neither man went back there until Saturday, April 25, when Shepp went over and "Raked on garden." He returned on Sunday to see Ellis Winchester who was going to Warren in the morning.[38] Shepp was back at Polly's from the 27th through the 29th. While there, he "… raked garden," "Planted onions & got garden ready to plant," "… got garden planted & part of corn ground raked," and "Caught a Porcupine."[39] Porcupines were nuisance animals to ranchers, particularly for their destructive habit of chewing on wooden tool handles to obtain salt from sweaty hands, and also because they ate plants and gnawed on small trees.

The first week of May Shepp was at Polly's almost every day. He "Got ground all ready to plant," "Planted 1000 hills spuds [using 36 pounds of potatoes] & sweet corn," "… finished planting corn," "Put fence round onions & fixed corn mill," and caught two more porcupines. On Sunday, when he wasn't over there, he noticed that Ellis Winchester was visiting Polly.[40] On Friday the 8th there was snow at the head of Polly Creek.[41] Shepp only went to

Polly's one more time that month, to plant two rows of onions.[42] Otherwise, he avoided crossing the Salmon River because it was rising due to melting snow. Although he stayed home the rest of May, and concentrated on planting his own garden, he did notice that Ellis Winchester visited Polly on Sunday, May 17.[43]

On June 1, Pete went to see Polly in the afternoon. Shepp was there himself on the 3rd and 4th, "on corn"; he also took some tomato plants over. On the 6th he "finished corn" and "Polly hoed spuds."[44] From the 11th to the 13th Pete, and then Shepp, were "over river on old chicken house roof."[45] Next, from the 15th to the 20th, they began working on Polly's hay barn. Shepp also cultivated her corn, Pete burned brush, and one day Pete was "on hay" while Shepp was "on spuds."[46] On Saturday the 20th, Gus Schultz and Joe Bryce came down to Shepp's. They spent the night there and visited Polly the next morning.[47] On the 22nd and 23rd Shepp cut Polly's alfalfa and put it in the new hay barn, and on the 26th and 27th he watered her corn.[48]

July 1925 was extremely hot; Shepp recorded temperatures of 106 degrees twice and even 108 once. On the hottest day there was "Hard thunder & lightning this eve about 8"; the lightning ignited a fire at the head of the West Fork of Polly Creek.[49] Throughout the first half of July Shepp spent time at Polly's "on spuds" once, "on corn" several times, and "finished corn" on the 18th.[50]

Shepp also reported that Polly had several visitors in July. First, John Becker and his sister, probably Bessie, whom Polly had met previously, were at her place on the 11th, then all three of them had the noon meal with Shepp on Sunday the 12th, after which he accompanied them back across to Polly's.[51] On the 16th Ed Matzke visited Shepp for the night. The next day he crossed the Salmon River to go up to Warren, so surely visited with Polly before starting out.[52]

Pete came down to Shepp's on the 19th and spent the day rounding up all the remaining "old spuds" from Ellis Winchester, at Rabbit Creek, and from Polly; they added up to 120 pounds, of which 50 pounds went to Anson Holmes and 70 pounds to "Forest" [Service]. By then the air was "getting smoky" from forest fires in the region.[53] At month's end, Shepp and Polly went "up to Winchester's with boat" where they "Changed the water."[54] This suggests that Winchester was away, and that they needed to redirect the water to his garden.

In early August 1925 Shepp wrote, "Wed 5 … Boat down this eve about dark." The following day he commented, "Thur 6 Boat left afternoon."[55]

This trip set off from Salmon City, Idaho, on August 1, 1925. Captain Guleke piloted the scow, assisted by J. W. Bowman; John Brown of Ogden,

Utah, was the cook. The passengers were J. Will Johnson and Jerry D. Griffin of Chicago, and A. C. Hinkley, Lyman Fargo, and W. J. Ingling from Pocatello.[56]

An article by Ingling reported,

On the fifth night we camped at Crooked Creek, and the next morning crossed the river to visit China Mollie [*sic*], an old woman of seventy-two, who was brought from China as a slave some fifty years ago. During the gold rush at Idaho City [actually Warren], she married a white man, and together they have developed a beautiful garden spot in this wilderness. Since his death, two years ago [actually October 1922], she has lived here alone. She took us about her garden, more active and erect standing in her walking than any of us, and showed us her watermelon patch, where deer had feasted the night before on melons they had broken and devoured to the rind.[57]

August 1925 was a busy month for Polly, filled with harvesting and visitors. Besides the boating party's visit, on the 6th, Shepp was "Over river on corn" twice and on the 15th he harvested a dozen ears of it.[58] Friday morning the 7th Shepp crossed over to Polly's and on Saturday he learned that "Cook on boat quit his job at Sheep [C]reek [seven miles downriver] Thursday."[59]

On August 9 Shepp "Done nothing all day. Had too much company," one of whom was Bill Hart, who came down with a new telephone.[60] Over the next two days Shepp put it up, went over to Polly's to test it, and reported, "Telephone works all right."[61] On the 12th Shepp crossed the river to find that Oscar Waller from Warren was there; Waller spent the night at Polly's.[62]

Saturday, August 15, Shepp crossed over to Polly's with "Bob." Although Shepp didn't provide Bob's last name, he was apparently the cook for a Forest Service trail-building crew. Shepp furnished the group with potatoes and cabbage, and that evening he entertained them with phonograph music.[63]

In the afternoon of August 20 Bill Hart came down to Shepp's and spent the night; Charlie Matzke was there also. The three men visited Polly the next day, and got two dozen ears of corn.[64] On Sunday the 23rd Pete came down to Shepp's and he and a man named Pat, possibly from the Forest Service crew, visited Polly. They may have picked some watermelon and corn there because Shepp wrote, on the 24th, "Forest water melon .50 corn .35 from Polly."[65]

Wild huckleberries, on the hillsides, were also available to the various riverside households. On August 25 Shepp "Canned 11 qts" of them;[66] it is easy to imagine Polly also picking and canning huckleberries. As Polly's produce continued to ripen, Shepp helped her with picking and selling it. For example, on Friday the 28th he went over in the morning and got melons and corn, some of which went to the Forest Service, and on Saturday he picked muskmelons.

Bill Hart came down to Shepp's on the 29th, bringing a couple of packages from Montgomery Ward. The next day, Hart went over to Polly's where he "got 3 w[ater]melons & muskm[elons] & 3 doz[en] ears of corn from Polly. He paid for melons 2.50, charged corn to Forest [Service]."[67]

Shepp occasionally helped people cross the Salmon River, and these individuals surely interacted with Polly before going on their way. On Sunday, August 30, Shepp wrote, "Rip's old pard [mining or ranching partner] down from Dixie with 3 horses going to McCall. Took pack outfit across river today."[68] The following morning Shepp took a man named Maples and his three horses across the river.[69] The men and equipment would cross in the boat, whereas the horses would swim.

Although Shepp hadn't mentioned ordering Polly's winter supplies for her, he must have done so, since on September 2, for a cost of $15 in freight, "Vernon & wife brought Polly's stuff from Warren."[70] Vernon was probably Roy C. Vernon; in 1921 he was a US Forest Ranger based in Warren who was acquitted of killing a deer out of season.[71] Polly would have been delighted to see his wife, whom she surely knew from when she recently lived in Warren, and the couple doubtless spent the night before heading back the next day.

On the 5th Shepp "got m[usk]melons from Polly," some of which went to the Forest Service.[72] On Tuesday the 8th, "Bob," last name unknown but perhaps the Forest Service cook, came down to Shepp's in the afternoon and the next day he and Shepp went over to Polly's for dinner.[73] Shepp was back there the next day, Thursday; he "shot a porcupine" and on Friday he "picked 2 rows corn."[74] That date, September 11, 1925, was also Polly's 72nd birthday, but Shepp didn't mention it.

Two unusual events occurred on Monday and Tuesday, September 14 and 15. On both days Shepp wrote, "Saw Flying machine," i.e., an airplane;[75] perhaps Polly also saw or heard it. Several days later Grangeville's weekly newspaper, the *Idaho County Free Press*, confirmed what Shepp had seen:

FOREST AIR PATROL IN GRANGEVILLE
Airmen To Look Over Idaho County Forests

The forest air patrol spent Monday and Tuesday taking up Forest Officers of the Selway and Nezperce Forests for their maiden flight. Both these forests have been successful in handling fires the past season and local forestry officials with the exception of Supervisor Hurtt, who made two flights in August, have had no opportunity to get air experience.

[Gives names of officials who flew, and where they went.]

The pilots, machines[,] and mechanics for the air patrol are loaned to the Forest Service by the Army for two and a half months this year

for a thorough try out. Forest offiicals [sic] who have had experience in observing from the air, feel that the air patrol has decided pos-[s]ibilities in the case of forest fires and possibly in mapping inaccessible territory. … The flights of the past few days have been for the purpose of training forest offiicals [sic] to observe accurately while in the air. If the air patrol is continued next year there will be several observers for each forest who have had some experience.[76]

On the 18th Shepp and Bill Hart got more melons from Polly and on the 22nd Shepp "got box mush" from her, probably cornmeal mush, a breakfast staple.[77] Saturday the 26th Shepp picked some watermelons and muskmelons at Polly's, and the next day Bill Hart was back with a check for $1.50 for melons previously obtained from her.[78] On September 28 Shepp took Polly fifty pounds of sugar and two packages of mush. Winter was coming; on the last day of the month, in the morning, there was "Snow on hill below Polly's."[79]

October 1925 saw Shepp and Pete heavily involved in harvesting Polly's crops. Pete husked all her corn, nine sacks of it, and took it to their side of the river. They also picked her peppers and squash and dug over 1,000 pounds of her potatoes.[80] Ellis Winchester visited Polly on Sunday the 18th and on the 24th Shepp took a piece of deer meat to Polly, from a big buck brought down by his visitors a couple of days earlier.[81] On Monday the 26th Monroe Hancock came downriver in a boat; Shepp and Bob [Forest Service cook?] visited Polly, probably to tell her about it. Hancock spent the night at Shepp's and left the next day.[82] With winter looming, Shepp and Pete closed out October by cutting and hauling wood for Polly.[83]

Shepp went over to Polly's place on November 1 and got some Winesap apples; the next day he noticed that there was snow on Polly Creek.[84] He and Shepp spent much of November helping Polly prepare for winter. Pete cut wood and wheelbarrowed it in, while Shepp fixed her root cellar, her chicken house, the stairway, and their telephones. On the 16th he "Put up heating stove for Polly," and a couple of days later he "Put board under stove." Shepp also "shut off ditch and put wire on stove pipe."[85] Thursday, November 26, was Thanksgiving. Polly fixed dinner, but Shepp was her only guest—Pete was away, in Concord.[86]

During December 1925 Shepp was at Polly's several times but didn't give a reason for his visits. On the 7th [Norman?] Church was down from Warren. He may have stayed at Polly's that night, because the next day he was at Shepp's.[87] Meanwhile, Shepp wrote that Pete "went up to see Rippleman"; he returned the next day, and on the 8th Shepp wrote, "Pete bought ranch."[88] Polly had no more visitors until Christmas Day, when Shepp, Pete, and "Chester" [Ellis Winchester] were there for dinner.[89]

Four pages at the end of Shepp's 1925 diary have accounts of produce and other items sold to Anson Holmes and to the Forest Service. Apples were four and five cents per pound; potatoes, carrots, beets, turnips, cabbage, tomatoes, cucumbers, and pears sold for four cents a pound; corn was two and a half cents per ear; melons were 50 cents apiece, and vinegar cost 30 cents per bottle. Three of the sales, for corn and for melons, have Polly's name next to them[90] (Fig. 8.4).

1926

During January 1926 Shepp recorded very little information about Polly. One unusual mention was on the 15th when he wrote, "Polly talked to Pete [Klinkhammer] in Concord & Gus [Schultz] at Moore's."[91] This would have been on the telephone, which was working then although by the 19th he commented, "Telephone won't ring but can hear good."[92] Shepp only visited Polly once that month, on the 27th, but it was risky for him because "ice not too good," i.e., the river's ice was breaking up, making crossing too dangerous.[93] Earlier, he wanted to go over on the 16th, because Ellis Winchester was there, but the ice was "too soft to cross."[94]

Polly had several visitors in February. One was Winchester, on the 3rd, and the others were Roy Vernon and his wife, on the afternoon of the 9th;[95] as mentioned, Polly was always happy to spend time with another woman, a rare occurrence in her life. Shepp finally went over himself on Sunday the 21st, and Pete visited Polly on the following Tuesday afternoon.[96]

On March 2, 25, and 26 Pete went over to Polly's with no reasons given.[97] Twice, on the 4th and the 8th, Shepp sawed and cut wood for her, and was there again on the 19th.[98]

During April 1926 Shepp and Pete increased their time with Polly. The weather was improving and the Salmon River could be crossed easily by boat. On the 2nd, Shepp "fixed Polly's stove pipe," with four sections of pipe that he had somehow obtained from the Forest Service.[99] On the 7th Polly caught a 16-inch fish;[100] it must have been a great treat to again have that variety in her meals. Over the next few days Shepp and Klinkhammer were at Polly's where they burned brush, corn stalks, and grass. They "got [Polly's] onion ground ready to plant," began plowing, put a fence around the onion patch, harrowed the garden, staked and plowed ditches in alfalfa, and "Planted Polly'[s] onions" and "carrotts [sic]."[101] At mid-month Shepp noted, "Northern lights bright tonight";[102] Polly, too, would have enjoyed seeing them.

On April 17 Pete was "over river." Shepp visited Polly the next day, and Ellis Winchester was down from his place. While there, Shepp learned that "Polly killed a Porcupine last night."[103] We'll just have to imagine how she

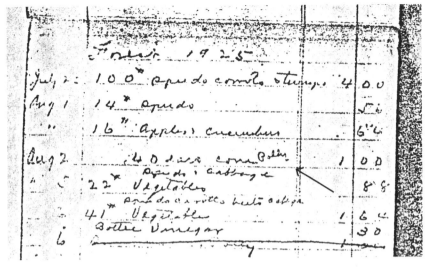

Fig. 8.4. Three amounts owing to Polly (arrows) from produce sold on her behalf, 1925. From Charles Shepp, [Diary], January 1, 1925, through December 31, 1925, photocopy, University of Idaho Library Special Collections, MG 155, last several pages. Used with permission.

accomplished that, since the diary doesn't mention her method; perhaps she whacked it with an axe.

Although Shepp's diary doesn't state what Polly might have done with the dead porcupine, she could have cooked it in several different ways. One

Chinese American woman suggested that she could have made soup from it.[104] Porcupines can also be stewed, baked, and fried.[105]

On Monday the 19th Shepp and Klinkhammer went "Up to Pete['s] ranch." Once back, Pete was over at Polly's daily from the 22nd through the 24th, reasons unknown.[106] Shepp visited Polly himself on the 28th and reported that "Polly['s] dog got her nose full of quills." This must have unleashed an anti-porcupine vendetta in Polly; that night, she killed two more porcupines, and in early May she got one more, at 10 p.m.[107] Meanwhile, on April 29, Shepp raked Polly's "corn ground" and noted that she "got 13 little chickens" whereas the Shepp Ranch's hens had only hatched two so far.[108]

In early May Shepp planted 940 hills of potatoes for Polly, as well as "Sweet corn in upper patch & part of field corn"; the corn planting was about the same as the previous year.[109] On the 8th he began building a meat safe for Polly. He continued on the 12th, finished on the 13th, and then "put meat safe up in shed."[110] We can tell the weather was getting warmer, because the next day, while Pete was at Polly's, Shepp washed two blankets; presumably Polly did the same on another fine day. On the 15th Pete was back at Polly's. There, he "Sprouted spuds, got 210#,[111] meaning that after he had sorted through their shared potatoes and rubbed off the sprouts, the potatoes weighed 210 pounds.

During the afternoon of May 17, Shepp went over to Polly's. There he "marked Polly['s] melons," meaning that he marked out the ground where they would be planted, while Polly planted beans. No one visited her until the 27th, when Shepp went over to cultivate her corn and potatoes, i.e., using a hoe to loosen the soil around the sprouting plants.[112]

During June 1926 Shepp was often over at Polly's, the first time on June 2nd. On June 3 he wrote, "Space down afternoon," probably Ralph Space.[113] The two men crossed the river the following morning and got 120 pounds of potatoes from Polly. Space also bought 65 pounds of potatoes and 30 pounds of apples from Shepp; the quantities strongly suggest that he was procuring food for a work force, likely a trail crew. The 215 pounds of produce cost four cents per pound, for a total of $8.60, of which $4.80 was for Polly's share of the potatoes.[114]

On June 8 Shepp was "Over river on corn," during which he "Watered sweet corn & all of upper patch." The following day he finished watering the corn and got the potatoes irrigated. He also observed, "2 horses been in garden over river." On the 10th Shepp "cultivated all corn & spuds."[115] June 11, according to Shepp, there was a "Trail crew down about noon."[116] This must have been Space's group; they were working and camping in the vicinity. "Boys over this eve," wrote Shepp, the next day, Saturday; [They] "Got log

across creek [Crooked Creek] at island." On Sunday the 13th Shepp went "Over creek to dinner" with the trail crew.[117]

At mid-month Shepp and Bob, no last name given, but probably the trail crew's cook, visited Polly the evening of the 15th and "took fish over." On the 18th, Shepp got a bucket of Polly's cherries, 50 cents' worth, for the Forest Service crew.[118] During the latter part of June both Pete and Shepp often helped Polly with her garden. Both men visited her on the afternoon of the 20th, Shepp was there "on spuds" on the 22nd and 23rd, and Pete went back on the 26th and was "on hay" the next day. Shepp was "on spuds" that Monday and watered all of them on Tuesday. He also "Got in part of hay."[119] On the 28th Oscar Waller was down from Warren. Although he would have visited with Polly, he stayed the night at Shepp's because he was en route to Dixie.[120]

Waller returned to Shepp's on the 30th. On July 1 Shepp swam Waller's horse over to Polly's and would have taken Waller across in the boat. Waller returned to Warren the next day and no doubt visited with Polly again before heading up the trail. Both Shepp and Pete were at Polly's, where Pete was "on hay." They were both there the next day, too; Pete "got all alfalfa cut," and Shepp was "On corn."[121]

Monday, July 5, 1926, would have been an exciting day for Polly. Shepp wrote, "Polly, Pete[,] & I over [Crooked C]reek to dinner [the noon meal, at the trail crew's camp]. Gave them red rooster & old hen. ... Pete took boat down below creek to take Polly across."[122] Two days later Shepp went to Polly's to hoe her corn. That day, there was "Hard rain & thunder"; "Polly [C]reek [was] up high & muddy."[123]

Polly had no visitors until the 16th when Shepp was there again. He wrote, "Over river on corn, got upper patch done," and the next day he "got corn & spuds done." That evening, Polly killed a rattlesnake.[124] On the 21st and 22nd, Shepp and Bob got a total of four 10-pound buckets of blackberries from Polly's place. Shepp canned some, and two buckets of them went to the Forest Service. "The boys" were still camped nearby; on Sunday afternoon, all of them came to Shepp's for some music.[125]

During the last week of July, Shepp was at Polly's three more times. First, he was "on spuds & corn," and then he "finished corn"; this probably means that he was hoeing and/or watering it. He also got 12 dozen eggs from Polly for the Forest Service crew; those sold for 40 cents per dozen, or $4.80 to Polly.[126]

On August 2 Shepp was back at Polly's "on spuds & corn" and finished the next day. He was over there again the afternoon of the 7th, and was "on spuds" again on the 12th, "on corn" the 13th, and "got spuds & corn done"

on the 14th. Meanwhile, on the 8th, he "Heard some fellow drowned …"; the body wasn't found until the 16th.[127]

Shepp's diary entry for Wednesday, August 18, includes a brief, puzzling, note: "Over river. 8 pups in river."[128] We know, from an April 1926 diary entry, cited earlier, that Polly then had a female dog. Shepp's cryptic entry suggests that the dog had puppies, and that Shepp drowned them.[129] If so, that wouldn't have been an unusual event. The few scraps from Polly's table would scarcely have fed even one adult dog, let alone eight puppies, once weaned.

By mid-August Polly's melons and sweet corn were becoming ripe. On the 19th, Shepp got 30 ears of corn from her. Four days later he got two watermelons from Polly, and charged the Forest Service 50 cents each for them.[130] Other produce that Shepp obtained from Polly that month included corn, twice, and three melons.[131] Meanwhile, on the 25th, Shepp wrote that "Polly lost her cat."[132] This implies that it died somehow, and didn't just disappear.

During September 1926 the harvest continued at Polly's. Birds were attacking the corn, so Shepp "put scarecrow in corn" on the 3rd.[133] On the 5th Shepp wrote, "Alex, Johnnie[,] & I over river am [a.m.]";[134] the three men got seven watermelons from Polly for the Forest Service, and Johnnie went back with Shepp the next day to get corn and apples. Shepp noted that the apples weighed 15 pounds, but didn't mention how much corn Johnnie took.[135]

Between the 10th and the 17th Shepp got seven watermelons from Polly, as well as some apples. Notations in his diary indicate that he sold the melons to the Forest Service for 50 cents each.[136] On Sunday the 19th he sent out an order for Polly, totaling $9.40. This may have been for some of her winter food supplies; a week later, an ambiguous entry in Shepp's diary, "I home, over river. Made out order for grub," may also have referred to Polly. Meanwhile, Shepp was over there on the 20th, and on the 23rd he noticed "Snow on hill below Polly [C]reek." Shepp visited Polly one more time in September, during the afternoon of the 28th.[137]

Fall chores took Shepp, and sometimes Pete and others, over to Polly's in October. On two days, Shepp husked a total of 11 sacks of field corn, for livestock feed, and brought it across the river to his place.[138] Gus Schultz had been down at Shepp's for several days; he and Pete visited Polly the evening of October 7. The two men returned there the 10th, and Gus got two boxes of apples.[139] On the 13th Shepp wrote, "Got part of our order & nearly all of Polly['s].[140]

Digging their shared potatoes came next. In two days Shepp dug 1,150 pounds of them and brought home six 50-pound sacks. Shepp saved 250 pounds as seed potatoes to plant in spring, putting 100 pounds in Polly's root cellar.[141] That Sunday Roy Vernon's horses appeared "on Polly's ranch,

came down last night. I [Shepp] drove them up trail, met Vernon & wife, they camped at 3rd saddle."[142]

October 18 saw both Shepp and Klinkhammer across the river. Pete was "on wood," meaning that he was cutting firewood for Polly. Shepp busied himself digging more potatoes. He put 50 pounds in Polly's cellar and brought 400 pounds of them over to his place. Both men returned there the next day. Pete continued cutting wood, and Shepp "Finished spuds." In all, there were 1,500 pounds of eating potatoes and 150 pounds of seed potatoes in Polly's cellar, and 900 pounds' worth in Shepp and Klinkhammer's root cellar.[143] That day, October 19, 1926, Shepp also wrote, "Boat down. Handcock [boatman Monroe Hancock] & [boatman John] Cunningham, Mr. Wedner [Weidner] & son."[144] On the 20th, Shepp "took horses over river & got in some wood [in the] afternoon." The next day Pete was "over river on wood," and on the 22nd Shepp put up a chicken fence for Polly; he also brought the horses back to his place.[145]

Beginning the 24th of October, and lasting a few days, Shepp had several guests, a couple of whom also visited Polly. Alex [Alec Blaine?], [Bob] Parsons, and Rice, first name unknown, arrived first; Rice left, but on the 28th Alex [Alec?] and Shepp were at Polly's that afternoon.[146] Meanwhile, on the 25th, George Maurtz went to Warren, no doubt visiting with Polly first.[147] Finally, on the 29th, Shepp filed Polly's saw and took it over to her on Sunday afternoon.[148]

During November 1926 Shepp and Klinkhammer helped Polly prepare for winter; snow at the head of Polly Creek on the 7th added urgency to their tasks. They were there, for parts of the day, on ten different occasions. Both men cut wood for Polly, and Shepp "patched daubing" on her cabin and put up a new stovepipe on her heating stove. Although Thanksgiving was Thursday the 25th, Shepp was over at Polly's but didn't mention eating there.[149]

On December 8 Pete shot a deer and the next day he took Polly some of the meat. No one visited her until the 25th, Christmas Day, when Pete went over there for dinner. Because Shepp wrote, "Had canned Duck for our dinner," Pete may have enjoyed two holiday meals that day.[150]

The Salmon River was beginning to freeze over, but not entirely. On the 27th, "Polly'[s] dog got in river off ice, got out all right." Shepp wouldn't risk going across, but Pete visited Polly on the 28th. On the 29th Pete shot a buck, and on the 30th he went over to see Polly in the afternoon. He may have taken her some more meat, although that's not mentioned. On New Year's Eve Shepp wrote, "Fine day. Stayed up till 12, had some radio but not good. Polly rang up at 12. … About 4 or 5" [inches of] snow on ground. … River froze

over but not safe." The temperature that day was 22 degrees in the morning and 20 that night.[151]

1927

During January 1927 Pete only crossed the Salmon River twice, and Shepp didn't go over at all. On Friday the 7th Pete went to Dixie, mainly to get the mail. He returned with it on Sunday, and on Monday he went to Polly's, taking her "Xm[a]s [Christmas gifts] from [illegible name], Mrs. [Nellie] S[chultz,] & Oscar [Waller] over" (Fig. 8.5).[152] Pete went again on the 12th and took Polly "a piece of buck," i.e., part of the deer that he had shot in late December.[153]

Fig. 8.5. *Wrapping paper addressed to Polly Bemis from her friend, Nellie Schultz, date unknown, but before August 1933. Photo in Asian American Comparative Collection, University of Idaho, Moscow, PB slide 94.*

One of Pete's main pursuits that January was trapping and killing coyotes. He caught one on the 2nd, across Crooked Creek, but the main bounty came after their horse, Jimmie, died. On the 25th, Pete set some traps at the carcass, and caught two more coyotes that month and another one in early February. From a hint in Shepp's diary, there was apparently a dead deer near the river; Pete set a trap there, too, and caught "a wild cat" [Canada lynx or bobcat] in mid-February and another one in a different trap in early March.[154]

It was nearly the end of February before Shepp crossed the Salmon River again. On the 26th he put his boat back in the water. On the 27th he went over and surely visited with Polly before continuing up to Ellis Winchester's place on Rabbit Creek.[155]

In early March Ted Carpenter and another man [Shepp left a blank space to fill in his name later, but never did] came down to Shepp's the morning of the 4th. The next day "all of us" – Shepp, Pete, Ted, and the other man – went over to Polly's in the afternoon and "Burned off alfalfa,"[156] meaning that they

cleared the field of weeds and debris. On Friday the 11th there was a "Boat down at noon." Shepp wrote "Boat" in the margin of his diary, but didn't provide any information on its occupants.[157]

In mid-March 1927 there was another mention of "Pete's ranch," the one he bought in December 1925. On the 15th, "Pete went up river. [Roy] Vernon at Pete's ranch so he came home this eve." That day, "A regular March day, wind cold & spit snow," Shepp went over to Polly's. On March 17 he "Heard China Dick [Goon Dick, Chapter Seven] was dead";[158] how he got that news isn't clear.

Earlier, in April 1924, Grangeville's *Idaho County Free Press* newspaper had interviewed Goon Dick as he prepared to leave for Warren.[159] That October Goon Dick finished mining for the season. Instead of going to Grangeville as usual, he went to San Francisco.[160] There was no word on his adventures for 1925, but in the August 1926 primary elections he received one vote for Idaho County treasurer.[161] Finally, on March 2, 1927, Goon Dick died:

China Dick Dies

One of the picturesque figures of Idaho [C]ounty died at the county hospital [in Grangeville] yesterday. China Dick had been a prospector in this county for a long, long time, and was known in every section. No one knows what part of China he came from.

There is a story connected with him of a 'lost mine,' but as usual with such stories, little credence is placed in its veracity.

The funeral was held from the Hancock parlors to-day and he was buried in the cemetery by the county. Probably, as is the custom, his bones will finally be taken back to China.[162]

Toward the end of March, Polly might have had a visitor. "Johnnie" [John] Becker was at Shepp's for supper on the 25th. He stayed that night and the next, and on Sunday, March 27, he "went up to [Ellis] Winchester's [in the] afternoon on his way home."[163]

During April 1927 Pete was frequently over at Polly's; Shepp, less often. On the 5th Shepp pruned her blackberries. On the 6th and 7th, the 9th, and from the 11th through the 15th, Pete was there every day.[164] Shepp didn't say what Pete did, but he was probably preparing her various plots of ground for planting. On Sunday the 17th Shepp took two horses over to Polly's and for the next three days Pete plowed with them. Thursday the 21st Pete was "on corn & garden over river," and on Friday he and Shepp took the horses back home.[165]

Since Shepp's rowboat needed attention, on the 24th he fixed the oarlock and the seat. He also "Put on summer undercloth[e]s";[166] his winter longjohns must have become too warm. Polly would have done the same.

On the 26th Shepp visited Polly and reported that she got her garden planted. Two days later he went back and learned that she "lost 12 little chickens"; some unnamed varmint likely devoured them. Pete was there the 29th and 30th, "on spud ground."[167]

Spring hadn't quite arrived by early May; on the 1st, Shepp observed "Snow on Polly [C]reek." The next day, Pete went over to Polly's; Ellis Winchester was there, too. On the 3rd Shepp and Klinkhammer went up to Winchester's place where "Pete cut [castrated] his [Winchester's] horse." Pete was back at Polly's the next day.[168]

On Friday, May 6, 1927, Shepp went to Polly's. There he "planted sweet corn in old patch & got spud ground ready to plant." The next day he "planted corn & spuds 1188 hills." For most of the next week Shepp, and sometimes Pete, washed blankets; by Friday, when they finished, they had washed 17 double and 45 single wool blankets and 22 double cotton ones.[169] This is an overly large number of blankets for their own use; later we learn that the blankets belonged to the Forest Service, used by their trail and/or fire crews. Meanwhile, a boat came downriver on the 9th but mustn't have stopped; Shepp subsequently learned that it was Monroe Hancock and a man named "Widner" [filmmaker Henry Weidner again, this chapter, October 1926].[170]

Pete visited Polly on Saturday afternoon, the 14th. He then went up to his own ranch the next morning and again on the 21st. Shepp cultivated Polly's corn on the 20th and also on the 31st.[171]

The last entry in Charlie Shepp's 1926-1927 diary is June 23, 1927. During June neither Shepp nor even Pete visited Polly; often, the Salmon River was running so high that crossing it would be too dangerous.[172] Any diary for the rest of 1927 is missing.[173] When/if found, it might mention one of Captain Harry Guleke's hunting and fishing trips down the Salmon River in October 1927. The party included three men from Butte, Montana, one of whom, Andy Davis, "was official movie photographer." The other two Butte passengers were Dr. H. D. Kistler and Howard Pierce. The party also included Dr. William Kroger of Los Angeles and Dr. L. F. Sonntag of Great Falls, Montana. Sonntag was "the chronicler for the party." Guleke had hired Jay Farnsworth as the cook and Jack Bowman as the boatman.[174] Although Davis's film hasn't been located, a diary from that trip exists. On October 24, Sonntag wrote,

We have passed Crooked Creek and are now getting back to civil[i]-zation again as we are at the Old Chinese lady's cabin. She is the only Chinese in this part of the country. Polly, as she is called, and her sister, whom she has never seen since, were brought to this country with a boatload of Chinese girls 61 years ago. They were bought in China for 30 cents each, U. S. money[,] and sold in the U. S. for differ-

ent purposes. Polly was 13 years old at this time and was bought by an American couple for a house girl. She served as such until the death of her mistress, 10 years later. For two years she served as a housekeeper for her master and then they were married and came to this lonely place where they lived happily for 45 years, until her husband's death four years ago. He is buried across the river where his grave can be seen from the cabin. She is known and respected by all up and down the river. Here we saw the first corn being grown, all kinds of fruits and vegetables, also tobacco – as Polly smokes a pipe – melons and anything one might want.[175]

Much of the above account contradicts what we know about Polly. This is the first time a possible sister has been mentioned; if true, how sad for both them! The idea that she was "bought by an American couple as a house girl" is also a new, and fanciful, concept. Sixty-one years ago, from 1927, is 1866, and Polly, born in 1853, would have been 13 that year, but by her own account she arrived in Warren in July 1872 after having been purchased in Portland, Oregon, on behalf of her Warren Chinese owner. Polly and Charlie married in 1894 and moved down to the Salmon River that year. They had only been married for 28 years when he died in 1922, although they had been together since at least 1880.

1928

Shepp and Pete crossed the Salmon River by boat on Sunday, January 8. They intended to bring back some hay from Polly's place, but there was so much ice in the eddy that they couldn't accomplish this task. Nevertheless, Pete returned the next day and was "on hay" and Shepp was there Thursday the 12th. Friday and Saturday Shepp got four loads of hay across in the boat. It got colder on Sunday so he got more hay across, but on the ice. He was back on Monday, obtained more hay on Tuesday, and Pete did likewise on Wednesday.[176] On the 21st Shepp "took some sausage over to Polly"; he may have made it from the deer that Pete shot on the 11th.[177] Shepp brought back four more loads of hay from the 22nd to the 24th, and on the 28th and 31st Pete cut wood for Polly.[178]

Meanwhile, in Warren, Polly's friend Ah Kan was in dire financial straits. The Idaho County Commissioners, meeting in Grangeville in early January, noted that he was "in indigent circumstances and will suffer" if not assisted by the county. The commissioners directed "that an allowance be made to said Ah Kan in the sum of $10.00 per month, to begin January 1st, 1928."[179]

During early February Pete cut wood for Polly on the 1st and the 3rd, and Shepp did the same on the 6th. On the 5th he reported that Charlie's old horse

rolled [died];"[180] this was a horse that had belonged to Charlie Bemis. Pete went over again on the 7th, and Shepp filed Polly's saw that day. He crossed the next afternoon, probably to take the saw; he also "Put Tent over hay." By mid-month there was ice in the river, but with holes in it, so Shepp crossed by boat.[181]

Polly had no visitors during the rest of February, so she must have been happy to see Pete when he came over to feed the horses on March 1, and Shepp when he came to get them and the mule on the 15th. On Sunday March 18, Ellis Winchester was "down to Polly's"; she likely fixed dinner for him at noon.[182]

With the weather improving as spring arrived, April 1928 saw lots more activity at Polly's. Someone named Parsons from Riggins stayed at Shepp's for several days and the two men visited Polly on Thursday the 12th in the afternoon.[183] Pete went over there the next Wednesday morning, and on the following day, the 19th, he got seven sacks of potatoes from Polly.[184] That Sunday Shepp "Took horses over river"; Pete used them to plow Polly's "spud ground" on Monday the 23rd and perhaps on the following two days when he was there again. He may have raked Polly's garden also but that isn't clear. On Thursday Shepp was at Polly's "on garden"; that day, he also took the horses back.[185]

Ellis Winchester visited Polly on May 6; since this was a Sunday she may well have cooked dinner for him. Shepp and Pete only visited her once each that month; Shepp went on the 7th and Pete went over on the 8th. During the rest of May the river was rising, making it too dangerous to cross. Shepp spent much of his time washing the Forest Service's blankets; on June 1, a packer came for them and "took all the bedding up[.] 180 blankets[.]"[186]

Shepp was at Polly's nearly every other day in June, and sometimes Pete joined him or went alone. The men were "on corn," "on alfalfa," "on hay" [probably the alfalfa again], and "on spuds." In between these events, on Monday the 18th Charlie and Fred Schultz came down to Shepp's for a few days, and Wednesday afternoon Shepp took them over to Polly's where Fred picked some cherries.[187]

July 1928 was similarly busy at Polly's. Although Shepp was over there often, he usually didn't say what he did there.[188] On the 3rd Shepp picked two 10-pound buckets of cherries at Polly's, and on the 8th he "Got hay in." That day, Charlie and Fred Schultz were down again, and "Chas. [Charlie] got cherries." Wednesday the 11th Shepp "got water on corn"; Thursday the 12th he was "on corn" in the morning and finished watering it the following day.[189] On the 21st he "took clock over"; perhaps he had fixed it, again, for Polly. Shepp was back "on corn" on the 25th. There was some excitement

on the 30th; Shepp wrote, "Boat down. Guleke & quite a crowd." This was a party of four Grand Rapids, Michigan, businessmen, together with Harry Guleke as captain, Jack Bowman as boatman, and L. F. Farnsworth as cook. "The party wound up their 175 miles of dangerous river travel at Riggins and made the trip to Lewiston by stage."[190] Bowman apparently carried a camera with him; he "said that if his eastern companions hadn't been so nervous and shakey [sic] on the boat and could have held still long enough, he could have obtained some remarkable camera shots of the finest wild game in Idaho."[191] Although the group apparently didn't visit Polly, Shepp crossed the river, picked two 10-pound buckets of blackberries, and no doubt told Polly all about the visitors. The boating party left the next afternoon.[192]

During August 1928 Shepp got another 15 pounds of blackberries on the 3rd, and on Sunday the 5th he and Polly went up to Ellis Winchester's place on Rabbit Creek[193] (Fig. 8.6). Beginning on the 10th, Polly's side of the river was threatened by fire. It began downriver, and the next day there were "5 men down from War[r]en on fire." By Sunday the 12th the fire had "burned hard up to Polly [C]reek" and by that evening it was "on top of ridge at saddle." On the 13th Shepp wrote, "Fire nearly down to Polly'[s] ranch." There were four horses at Polly's; to keep them safe, Shepp brought them over to his place the next day. Thursday the 15th Shepp wrote, "The crowd down at Noon. 29 [fire]fighters & 3 pack strings. ... Got this end of fire correlled [sic] on this side Polly [C]reek.[194] Although the worst of the fire was out, at least around Polly's place, Shepp provided updates on it over the next few days – it continued burning downriver as well as up to the head of Polly Creek. Finally, on the

Fig. 8.6. Ellis Winchester and his sawmill, Rabbit Creek, mid-1920s? From Johnny Carrey and Cort Conley, River of No Return *(Cambridge, ID: Backeddy Books, 1978), 206. Used with permission.*

20th, Shepp and "Higgans" [probably Higgins] "brought pump & hose over on this side"; by then, there was "Not much fire today or tonight."[195] On the 22nd, however, it was apparent that the fire wasn't completely out yet. That day, Shepp was "Up to fire on Polly [C]reek just above where we got house logs. It is burning along [illegible]." By that night and the next day, it was about out, and by Saturday the 25th there was "No fire in sight."[196]

With the fire out, activities could return to normal. Shepp visited Polly on Sunday afternoon, and the following Tuesday he went back and "made order for Polly." It might have been for $4.00 but the amount isn't clear and the purpose isn't mentioned. Shepp was there again Thursday evening; something must have been eating Polly's corn because he "Set 3 traps" in it. Shepp went back to Polly's on the 31st. He also sent Montgomery Ward 50 cents for her.[197]

During September 1928, Shepp went over to Polly's a few times. Although his activities aren't always mentioned, he shot a crow and killed a skunk; fixed Polly's glasses at his home and took them back to her; got wood in and split it; and put out a fire, perhaps in her stovepipe, which he later fixed. Although Polly's birthday was on the 11th, he didn't mention it.[198] One day Shepp "got 4 sacks of corn from Polly's patch" and the next day he and someone else, not mentioned, got another 10 sacks of it, totaling about 450 pounds.[199] Toward the end of the month, Shepp wrote down Polly's order for her winter supplies.[200] Meanwhile, Ellis Winchester visited her on the 2nd, and on the 13th a boat came down the river with "3 fellows. One of them [was] the old Elk City man Arthur Rudd." Shepp went over to Polly's that afternoon and surely told her all about the boating party. The group spent the night at Shepp's, probably just sleeping on the boat or the river bank.[201]

In early October 1928 Polly's winter supplies began arriving and Shepp took them over to her. These included flour, rice, canned milk, and 50 pounds of sugar.[202] On the 7th Pete and Alex [Alec Blaine?] went over to Polly's, and Pete was back there on the 13th. On the 19th, a Friday, the three men dug all Polly's potatoes, 1,200 pounds of them, and brought half of them back to the Shepp Ranch, implying that they were using Polly's land to grow potatoes for themselves. Finally, toward the end of the month, Shepp was at Polly's a couple of mornings.[203]

On November 4 Shepp and Alex went over to Polly's. Shepp wrote, "Sent to M. W[.] [Montgomery Ward] for gloves for Polly." On the 9th Shepp visited her in the morning, but didn't go back there at all the rest of the month. Pete, however, was there for part of each day from the 13th through the 15th, and both he and Alex were there on the 17th and 19th. This year, Thanksgiving wasn't on the fourth Thursday, the 21st.[204] Instead, it was on the fifth Thursday, November 29. Several days before that, on Sunday evening, Shepp listened to

the radio and "Heard the President ["lame duck" Calvin Coolidge] give the Thanks," i.e., Coolidge's Thanksgiving Proclamation.[205] On the 29th, Shepp wrote, "Polly and [Ellis] Winchester over to dinner."[206] This is the last known time that Polly, then 75 years old, ventured over to the Shepp Ranch.

On December 2 Shepp took two horses across the river, without giving a reason. By the 4th, both Crooked Creek, on his side, and the Salmon River were beginning to freeze over, so he pulled his boat out of the water. On the 14th he reported that the river was "freezing more all the time."[207] Shepp commented that "Pete got a [illegible; some sort of animal]" on the 16th. Since Pete went to Dixie the next day, Shepp was left with the task of cutting up the meat and getting it into the house. He visited Polly on the 20th but didn't mention taking her any of the meat that day. Instead, he took some over on the 22nd and "got 2 pies & some doughnuts" from Polly; perhaps she served the meat on the 25th when Shepp and Winchester were there for Christmas Day dinner. Shepp went back the next day to take Polly some "coal oil" [kerosene, for her lamps] and some onions. On the 30th he wrote, "Pete's father dead 27th."[208]

<h2 style="text-align:center">1929</h2>

Polly's life for the first half of 1929 is a mystery, because that diary is missing from the photocopied materials at the University of Idaho Library Special Collections. We do know that on April 11, 1929, Peter Klinkhammer applied to have the Bemis Ranch surveyed as a Homestead Entry, listing himself as claimant.[209]

The first mention of Polly for that year is on July 13, 1929, when Shepp wrote, "Bill [Hart?] & I cocked last of hay over river. ... Picked & seeded 2 10# buckets cherries. 1 from Polly's."[210] Shepp visited her again on the 17th, and wrote, "Hot as the devil 107." That Saturday he got 13 dozen eggs from Polly; these may have been to help feed the fire crew that was in the area.[211] Some trail workers were on Polly's side of the river in July, and two of them had dinner with Shepp on the 24th.[212] Shepp visited Polly on Friday morning, July 26, and then on Monday he took one of his horses over there and got most of the hay stacked; he finished this chore the next day.[213]

On August 8, Thursday, Shepp got two 10-pound buckets of blackberries at Polly's. Pete may have taken some of them to sell when he went up to Dixie the next day, and Shepp canned part of them.[214] On the 15th, Harry Guleke, cook Monroe Hancock, and three passengers came downriver in a boat; they camped at Shepp's that night and left the next morning.[215] Ellis Winchester from Rabbit Creek, upriver, visited Polly for two Sundays in a row, and no doubt had Sunday dinner with her then. On the 26th Shepp crossed over again.[216]

During September 1929 both Shepp and Pete were often at Polly's. On Sunday the 1st, they went over together. Pete went up to Warren, and Shepp may have fixed the downed telephone line. A week later, before visiting Polly in the afternoon, Shepp "Put new oil cloth on table."[217] Oilcloth was cotton covered in boiled linseed oil, which made it waterproof; it was a common, everyday covering for kitchen and dining room tables because it was long-lasting and easy to clean.[218] Polly may also have used it on her table.

Shepp was back at Polly's for dinner on the 11th.[219] Although he doesn't mention it, that was Polly's 76th birthday. Pete was at her place on the 12th, and the next day he returned to husk Polly's corn. On the 18th Shepp got some tomatoes from Polly, and on the 19th he made two and a half gallons of tomato preserves from them.[220] Pete visited Polly during the afternoon of September 21, and on the 26th he set a trap for a bear at her place. The next morning, as Shepp later reported, "Pete got a small bear over river." Pete was back at Polly's on the 28th, presumably butchering the bear and giving Polly a share of it. After enjoying his Sunday dinner on September 29, Shepp wrote, "Had roast Bear for dinner."[221] On the 30th Shepp went to Polly's because Ellis Winchester's horses had apparently wandered down to her ranch.[222]

The horses were still at Polly's on October 1, so the next day Shepp "Drove Chester's horses up hill." This may have been to get them out of the way of the surveyors, who consisted of three men with 10 horses.[223] Forest Service Surveyor Charles J. Truscott carried out the survey, and recorded that the "Bemis Ranch" consisted of 27.29 acres.[224] At that time, the only improvements noted on the property were "Log house, 14 x 20 ft., Value $500.00; Log blacksmith shop [12 x 13 ft.], Value $50.00, and Log hay shed [16 x 26 ft.], Value $150.00."[225] The property description was as follows:

> Warren, Idaho, the most accessible postoffice, is southwest about 18 miles. McCall, Idaho, the nearest railroad point, lies southwest about 65 miles. This claim consists of a small bottom along the Salmon River, at the mouth of Polly Creek. The soil is a rich sandy loam, and well adapted to agricultural purposes. The elevation of this place above sea level is under 2000 ft. Parts of the place have been cultivated for many years, being irrigated with the water from Polly Creek. Fruit trees are growing on this claim which are about 15 years old. No timber having a commercial value is found on the claim.[226]

The group, helped by Pete Klinkhammer, surveyed the Bemis Ranch over the next three days, from the 3rd through the 5th. On Sunday the 6th Shepp wrote, "Surveyors Farrell, Trascott [sic, for Charles J. Truscott], & Packer Adams went to Warren am [a.m.]. ... Pete put up fence at Polly's."[227] Pete was back there the next two days; on his second visit, Fred Schultz went with him

and they picked two boxes of Polly's apples. That day, Shepp "Took a fellow & 4 horses across river"; often, he did that sort of thing for free, but this time they paid him $5.00. On October 12 Shepp was at Polly's where he dug their potatoes and then brought 700 pounds of them over to the Shepp Ranch, and two days later he picked a box of Polly's apples. On the 17th Pete got cabbage from Polly, the next day Shepp dug the remaining potatoes, and on the 19th Pete picked four boxes of Polly's apples.[228] The following Wednesday, October 23, a boat came down the river with seven men aboard; to Shepp's disappointment, it didn't stop.[229] Over the next two days, October 24 and 25, Shepp worked on Polly's root cellar and reported, "Got cellar fixed." He also obtained six heads of cabbage from her. He went back the next day because Ellis Winchester's horses were there; on the 31st, "Pete went to Warren with Chester's horses,"[230] probably for winter supplies.

Pete returned on Saturday, November 2. The next day, Winchester came down and took his horses home; meanwhile, Shepp got the pack saddles back across the river.[231] According to Shepp's diary, there was very little activity at Polly's for the rest of the month. Of course, Polly would have been busy as usual – cooking, cleaning, washing, tending animals, and doing all her other usual chores. On the 13th, Pete took her some kerosene lamp oil and Winchester visited her on Sunday the 17th. Shepp crossed over on Tuesday, November 26; there he "Got 4 chickens killed & cleaned them for War Eagle." Although the chickens were undoubtedly for the War Eagle Mine's Thanksgiving celebration, on Thursday the 28th, Shepp and Polly didn't celebrate that holiday together.[232]

On December 4 Shepp saw the northern lights again; perhaps Polly also saw them. Two weeks later Johnnie Steenhouse [sic, for Steinhaus] came down for a visit to Shepp. He and Bill [Hart?] had "their camp" nearby; they were in and out of Shepp's place until year's end. On Christmas Day Shepp and Johnnie went over to Polly's for dinner; Ellis Winchester was there also. Polly must have been "in her element" as she cooked for, and socialized with, these three friends.[233]

1930

During January 1930 Bill and Johnnie went back and forth between Shepp's place and their camp. On the 22nd Johnnie was at Shepp's and the two men went over the river to see Polly. Most likely, for that time of year, they crossed on the ice; Shepp reported that it was a "Fine day, cold, 14 below" [degrees below zero] in the morning. For some reason, maybe because there was more feed at Polly's, they took all of Bill's horses over there on the 26th and 27th. Shepp returned on the 30th to feed them.[234]

Ellis Winchester visited Polly on Sunday, February 2, and Shepp took two horses and a mule over to Polly's the next morning. A couple of days later he returned to feed the horses, and the following day Bill and Pete went over. Shepp described the day as "warm"; it was 34 degrees in the morning.[235] Shepp fed the horses again on the 13th, and on the 19th Pete brought them back to the Shepp Ranch.[236] Although Polly had no more visitors for the rest of the month, the telephone may have been working.

March 1930 saw activity increase a bit at Polly's. Ellis Winchester was there on two Sundays, the 2nd and the 16th, probably for dinner. On the latter date, Shepp and Pete visited Polly in the afternoon, and Pete returned there on the 17th. Shepp got word that Elk City had had a big fire; the next day he wrote, "Elk [City, Idaho] about all gone. Perry's store only building left."[237] On the 27th Shepp took a couple of horses across the river. Pete was there the 28th, and on the 29th he "got ditch cleaned out." On the 31st he "Fixed Hotbed [a primitive greenhouse, for starting seedlings] and raked on garden."[238]

During April Pete helped Polly a great deal. From the 1st through the 5th he was there for part of every day. Once he burned brush, and another day he "Brought horses over river" in the afternoon, but it isn't clear whether the horses went to Polly's or came back from there.[239] He also caught two fish on her side of the river; one weighed three and a half pounds. Meanwhile, Shepp spent many hours with his radio in the evenings, fussing with it to get ever-better reception. On the 5th he wrote, "Radio good. Stay[e]d up till 10:30. Best I ever heard late. Got about all long wave stations & Cleveland fine." Sunday the 6th Shepp and Pete went up to Ellis Winchester's place but he wasn't home. Pete then continued on to the old James Ranch at James Creek, a couple more miles upriver. On the 10th Pete was at Polly's. The next day Shepp was there, "on Polly's garden." He also reported that she caught a fish.[240]

April 1930 saw the unusual event of both a lunar and a solar eclipse in the same month. On Saturday April 12, Shepp wrote, "Saw eclipse, not much." This was a partial lunar eclipse that was more visible in other parts of North America. On the 28th he wrote, "Saw Eclipse, not good, cloudy." That was a total solar eclipse, but the clouds would have obscured his view of it.[241] Undoubtedly Polly, too, tried to see one or both of these eclipses. Meanwhile, on the 19th, Shepp, and perhaps Polly also, got a good view of the northern lights; that night they were "pretty bright."[242]

Ellis Winchester was at Polly's on Sunday April 13, and the rest of that month was quite busy for her. On Monday, Shepp caught a big fish at her place, and put up a fence around her garden. He was there again the next day, "on fence & hay barn." Wednesday April 16 saw Shepp over there again.

Winchester was down; "he & Pete put up fence & on Barn." On the 17th Shepp worked on her barn in the morning, and wrote that "Polly started her garden" that day. He came back for more barn work on the following two days, but took off enough time to catch a four-pound fish. By the end of the month Shepp had nearly finished building Polly's barn. Occasionally he mentioned his daily accomplishments: "put ties and one slate," "got rafters up," and "got braces all up in barn." On Tuesday the 22nd, there was a "Young fellow from War Eagle [Mine] down at Polly's for dinner."[243]

During April and May 1930 Idaho County residents received visits from enumerators taking the decennial US Census. Intriguingly, Polly Bemis appears in it twice. First, she was recorded for the Dixie Precinct, which extended from the town of Dixie south to the Salmon River, but not across it. On April 29 Charlie Shepp wrote, "Leslie Powelson down this eve," and the next day "Leslie took our count and went to War Eagle [the mine] afternoon."[244] Powelson, the census enumerator for the Dixie Precinct, recorded Charles W. Shepp and Peter Klinkhammer; then seven men at a "Gold and S[ilver] Mine"; and finally Polly Bemis, listing her as a 76-year-old Chinese woman with no occupation. She immigrated in 1872, rented her home, and could not speak English.[245]

The census-taker for the Warren Precinct was John M. Condon. A month later, near the end of May, this intrepid man ventured down to Polly's place on the Salmon River to record her in person, and more accurately. In his diary, Charlie Shepp commented, "John Condon at Polly's this afternoon."[246] Condon's information differed from Powelson's in several important instances. In the 1930 US Census for Warren Precinct, Polly is listed as a 77-year-old Chinese woman who was a "Farm operator." She arrived in the US in 1870 [actually 1872], owned her home, and could speak English.[247]

Curiously, one author states that "the 1930 census identifies Polly three times."[248] When investigated, the third supposed listing was for Valley County, South Fork Precinct. It was crossed out and re-entered, instead, on the sheet for Warren Precinct; the census enumerator, John M. Condon, was the same for both.[249]

Meanwhile, at home on the Shepp Ranch, Shepp spent early May washing blankets for the Forest Service, as he had done the previous two years. In all, he washed 81 double-width blankets and 84 single-width ones. Interspersed with this chore, he was over at Polly's a couple of times. First he "planted corn in old spud ground" and then he "Planted 1000 hills spuds on new ground." Finally, he "washed our blankets."[250] Polly probably washed hers, too, that month.

With the blankets finished, Shepp could spend more time at Polly's. On May 12 he was "on mower" in the afternoon. The next day he was over there "on barn" while Pete "painted [corrugated?] iron for roof."[251] On the 22nd Pete continued work on the barn. That evening, the Forest Service packers, "Harvey & 'Red,'" arrived with mules, and the next day they "went to Dixie with Blankets, 165."[252] Pete "put part of iron on roof" that day, and "got roof on barn" the next. Both men were at Polly's on the 26th. Shepp "got corn hoed" and "Pete put old hay in new barn."[253] On May 27 Shepp started to take some horses across the river, but it was too windy. Instead, he went alone and cultivated Polly's potatoes.[254] On May 30, Condon was "over from Polly's. Pete crossed him." Then, on the morning of May 31, Pete took Condon back across the river so he could return to Warren.[255]

During June 1930 Pete was gone for the first couple of weeks, so Shepp helped out at Polly's by himself. He cultivated her corn and potatoes, turned water from Polly Creek into the ditch, and watered the corn.[256] On the 16th, from home, Shepp observed "2 men over river on Warren trail"; they may have stopped to chat with Polly. Pete returned that evening; two days later Gus and Fred Schultz came down. Shepp wrote, "Pete & Gus took horses across river, water pretty high." On Thursday the 19th Shepp and Pete got Polly's alfalfa cut while she watered all the potatoes.[257] Saturday the 21st, a "Mr. Hockinstine & wife" spent the night at Shepp's. The next day they crossed over for a visit with Polly, who must have been delighted to see another woman for the first [known] time since February 9, 1926.[258] On Monday Shepp crossed over to Polly's. Since it was "too wet to do any thing with hay," he cultivated her corn instead. Pete was at Polly's on the 24th and 25th, and "got hay in." Shepp brought the horses back the following afternoon. Finally, on the 29th, he killed a raccoon at Polly's.[259]

During July 1930 Shepp was at Polly's occasionally. On the 3rd he watered her potatoes and found some potato bugs on them. On the Fourth of July he had dinner at Polly's and remarked that it was a "Fine day, hot, 96." He didn't get back there again until the 16th when he "Took horses across river & cut oats." He returned with Pete the next day; Pete cut alfalfa. On Friday Shepp was over there again, "on hay." The next day he "got oats & hay all in" and brought the horses back to his place. On the 24th he saw Polly again, probably to tell her the news that there was a forest fire on his side of the river and that Pete had gone to Grangeville.[260] The next day he went up to see the fire, and, no doubt, to hobnob with the fire crew; he could tell all that to Polly when he went over to get blackberries on the 26th.[261]

Boston Brown spent the night at Shepp's on the 31st. On August 1 he went up to the War Eagle Mine and back, and then crossed the river where he spent

the night at Polly's "to get early start for Warren in morning," 4:00 a.m.[262] Polly and Boston hadn't seen one another for a while so they must have had a good time "catching up." Polly had other visitors that month. On the 3rd, Paul Eimers and "Ollmstead" [*sic*, for Olmsted] had supper at Shepp's and spent the night. The next day Shepp, Paul, and "Jean" [*sic*, for Gene Olmsted] went over to Polly's where they picked two 10-pound buckets of blackberries.[263]

Since Polly's glasses needed fixing, Shepp got them from her on the evening of Tuesday, August 5. He didn't get them back to her until that Friday, perhaps because he was busy with guests – Paul and Gene were him visiting again.[264] At mid-month he mentioned fixing the telephone line on his side of the river, but presumably the line to Polly's was still working – he seldom mentions it unless it isn't working. On the 16th, Ellis Winchester's horses got into Polly's alfalfa; Shepp had to drive them out twice that day.[265]

On Tuesday the 19th, Shepp wrote, "Airplane went over & back up river."[266] As mentioned previously, sighting an airplane was an unusual event for the river people.

Shepp's comments are sometimes cryptic, in that it isn't easy to tell what happened. For example, on Friday, August 22, he wrote, "Had watermelon. Polly & [I] ate it. She had musk melon."[267] Whether Polly ate the muskmelon too, or grew it, unclear. Nevertheless, it is another indication of their bountiful crops.

Polly continued to have trouble with Winchester's horses getting into her alfalfa. On one occasion Shepp went over and drove them out. Three days later the horses were back so he and Pete crossed over and chased them up the hill. That Sunday, Winchester was at Polly's in the morning, perhaps to deal with his unruly stock.[268]

Polly had some company in September, but infrequently. Fred Schultz came down to Shepp's for the night on the 5th; he, with Pete, visited Polly the next afternoon. When Pete went to Winchester's on the 14th for five gallons of canned peaches, he probably crossed at Polly's and saw her on both parts of his journey. Meanwhile, by the 23rd, there was snow at the head of Polly Creek, and frost on the ground the next morning.[269] On the 24th one of Winchester's horses was back in Polly's alfalfa. Since Shepp doesn't mention going over there, perhaps she was able to shoo it out. John Becker may also have visited with Polly toward the end of the month. He was at Shepp's for one night and then went to Winchester's the next afternoon so he likely crossed over at Polly's. On the 29th, Becker, Shepp, Pete, and Polly probably all saw the "Bunch mt [mountain] sheep on river"[270] (Fig. 8.7).

During October 1930 Polly would have seen Winchester on the 5th when he crossed the river to go to Shepp's. Shepp himself was at Polly's on the 7th,

Fig. 8.7. Mountain sheep on the Salmon River, 1987. Photo by Lennard Chin.

but most of his time, and Pete's, was taken up building a root cellar at the Shepp Ranch.[271] The Forest Service packer, Harvey, lost a mule on the river on the 10th; the next day he and "Peewee went down on Polly side & got the pack saddle – about 3 miles."[272] On the 13th Shepp helped a man with five horses cross the Salmon River. The next day Pete went over to Polly's with Fred Schultz; Fred had come down to Shepp's the previous night. Pete and Fred got potatoes and apples at Polly's. From the 19th to the 20th, Shepp dug the rest of his and Polly's potatoes.[273]

That November Shepp and Pete each crossed the river with some of Polly's winter supplies. On the 11th Shepp took her two sacks of flour and some un-named "stuff in sack"; on the 14th, Pete took her some more flour, as well as some "Bacon etc." Shepp noted that he "put grub away" at his place, meaning that he stored his winter food supplies, a task that Polly would also have done. Pete was back at Polly's on the 15th and the 19th. Although Shepp doesn't say what Pete did there, he may have cut wood for her.[274] Finally, on the 29th, Roy Vernon was at Polly's in the afternoon.[275] There is no indication in the diary that any of the neighbors spent Thanksgiving together.

Although December 2 was a cold day, just above freezing, Shepp washed his windows. This is another chore that Polly probably did too, on occasion, but she would surely have chosen warmer weather for it. By the 18th there was "over a foot of snow on ground." Pete visited Polly on the 24th, perhaps to give her a little Christmas gift. For Christmas Day dinner, Shepp had killed a chicken for Pete and a guest, but Polly spent the day alone. On the 28th, Pete took her some meat from the deer that he had shot the day before, and Shepp put a lamp in his root cellar to keep things from freezing.[276] Polly would have had to do the same.

1931

During January 1931 someone was at Polly's nearly every day. Shepp was there on the 1st, and Pete probably visited her when he went to Ellis Winchester's place on the 6th. The next day Bill, probably Bill Hart, brought his horses up to Shepp's and took them over to Polly's along with a couple of Shepp's horses. On the 8th, Pete went down the trail on his side of the Salmon River, got Ralph Space's horses, and the next afternoon he took them over to Polly's and cut some wood for her.[277] Pete went back on five of the next six days, probably to cut more wood for Polly and see to the horses. Their friend "Alex" [Alec Blaine?] was at Shepp's for a while, beginning on the 16th. Alex and Pete were at Polly's for part of every day the next week. They must have been chopping wood for her, because on the 25th Shepp wrote, "Pete over river, got all Polly's wood in"; Alex had been there in the morning. Then, from the 26th through the 31st, Alex was over at Polly's every day. Although Shepp didn't give a reason for the visits, a later entry implies that he was cutting more wood for her. Occasionally, as he did on January 31, Shepp wrote that he "baked bread"; Polly would likely have baked bread regularly also; there was always flour included in her winter supplies, and we know that she used a sourdough starter (Chapter Ten).[278]

In early February Alex was at Polly's again for six consecutive days. On the 7th, Alex got wood all cut up at Polly's"; he was back there again on the 9th. On the 12th, Alex and Pete brought some of the horses back to Shepp's, crossing on the ice, and on the 19th, they took the remaining six horses across. On the 21st Pete went to Ellis Winchester's while Shepp and Alex "put a joint of pipe on Polly's heating stove." They also "Got 2 roosters from Polly."[279]

March 1931 was a lonely month for Polly. Since she had a good supply of wood, her neighbors didn't need to come over to cut more for her. Finally, on the 20th, Shepp went over in the morning to help Justin McCarty cross the river. McCarty had come down from Warren, and spent that night at Shepp's.[280] Shepp's diary reported no more activity at Polly's for the rest of the month.

On April 1 Shepp took two horses across to Polly's; over the next several days, Pete and Alex used them for plowing. They finished on Saturday the 4th, and brought the horses back. Alex was at Polly's the next two days; he and Pete were both there on the 9th.[281] On the 15th Shepp put up a chicken fence at Polly's and on the 18th he caught a small fish at her boat landing. For the next two afternoons Shepp raked Polly's garden and got it ready for planting. On the 20th he also "Put in ditches in oats next to spuds," and observed, "Polly sick today." By the next day, when Shepp was over there, Polly had

recovered enough to plant peas, carrots, and onions. She had no more visitors until Shepp returned on the last day of the month, in the afternoon.[282]

On May 1, 1931, Shepp reported, "Snow about gone on ... hill below Polly's. Took fish lines up across river River coming up." This passage implies that Shepp had a trot line [also trotline], a single line with baited hooks at intervals, possibly for sturgeon.[283] On Monday the 4th Pete went to Polly's; "he got spud ground ready." The next day Shepp "Planted Polly's spuds 1100 hills." In the afternoon of Monday the 10th Shepp "Turned water [from Polly Creek] on garden ditch for Polly." He also mentioned that Ellis Winchester was down in the afternoon. By mid-May the snow was all gone at the head of Polly Creek. On the 16th Polly had a visitor whom Shepp didn't know. He wrote, "Some fellow from Warren down to Polly's." The man continued on to Winchester's place. Pete visited Polly on the 24th, and the next day Shepp "Took Paul Shinkle across river" because Shinkle was going to Warren.[284] On Thursday the 28th Shepp went over to Polly's in the morning, where he "cultivated spuds."[285]

Shepp began June by going over to Polly's where he "Killed rattler on trail." That Friday, Pete went up to Winchester's, perhaps crossing at Polly's; he returned with rhubarb. On Monday he was back at Polly's, cutting her alfalfa, which he continued doing the following day. Shepp crossed over, too, and "hilled up spuds." That evening, there was a good rain; when Pete returned to Polly's the next day, he found that the hay was wet.[286] On the 11th there were "2 trail men over river tonight." When Shepp next went to Polly's on the 14th, he found Winchester there. Shepp watered Polly's potatoes on the 15th, and was at her place again on the 17th and 19th. Meanwhile, he reported that the telephone was "out of commission" but didn't specify if it was the line to Polly's place or the line over the hill into town. He also mentioned that he washed, meaning washed clothes, and made some doughnuts;[287] both were things that Polly would have done also. That Saturday, the 20th, Shepp "put water on last row alfalfa." He returned on the 22nd and 23rd, without saying what he did there, but on the 24th he picked one and a half 10-pound buckets of cherries at Polly's. Finally, on the 27th, he "cut out ditch to spuds,"[288] for watering purposes.

Although Shepp didn't mention it in his diary, on June 30, 1931, the US Forest Service sold the Warren townsite at auction for a total of $900. Described as a former "million dollar gold mining camp," it was by then filled with "scores of dilapidated old buildings," that were "vacant, strung with cobwebs and swaybacked from burdens of many winters' snow." Thirty-five residents bid, unopposed, for the lots on which they lived, obtaining them for the minimum bids required, all between $15 and $42.[289]

On Wednesday, July 1, Shepp did more ditch work at Polly's and that night Charlie and Fred Schultz were down at his place. The next day the three men crossed the river; Fred and Charlie picked two buckets of cherries. Shepp visited Polly again on Friday evening and she gave him two pies and a cake.[290]

For some time Shepp had been working on his radio set, often commenting "Radio not good," but sometimes "Radio pretty good." On the evening of Friday, July 3, despite writing "Radio not very good," Shepp "Heard the big fight. Stalling [sic, for Max Schmeling] won in 14th." The next day he corrected that to "Smalling" [sic] and noted that Schmeling's opponent was "Stribbling" [sic, for William Stribling] and that Schmeling won in the 15th round.[291]

In mid-July Shepp was over at Polly's several times. One Sunday he "Took fellow over river am [a.m.]. Took Bacon Sugar & Tobacco over to Polly[292] (Fig. 8.8). Since Charlie Bemis died in 1922, this entry cannot be ambiguous; the tobacco was definitely for Polly and provides additional evidence that she smoked a pipe. If Polly did belong to China's Daur minority group (Chapter One), pipe-smoking wouldn't have been unusual for her; Daur women, as well as men, smoked tobacco and shared pipes with visitors.[293]

Fig. 8.8. Charlie Shepp's diary provides confirmation that Polly Bemis smoked a pipe. From Charles Shepp, [Diary], October 11, 1930, through October 1, 1931, photocopy, University of Idaho Library Special Collections, MG 155, July 19, 1931. Used with permission.

On July 25, 1931, Shepp picked three 10-pound buckets of blackberries at Polly's. That day the temperature reached 108 degrees, but it had been even hotter on the 20th, 110 degrees.[294]

Forest fires were an ominous threat nearly every summer. Occasionally it was so smoky that Shepp couldn't see across the river, and in August 1931 fire came so close to Polly's home that Shepp and some others had to dig a trench around it. First, though, Shepp was over there on both the 2nd, when he first started mentioning fire on his side of the Salmon River, and on the 3rd, when he "got 6 little Roosters from Polly." By that date there were "2 big fires up river … both have crossed river." On August 4 the fire was nearly down to Warren Creek, and Shepp saw three airplanes that day. Ellis Winchester came down to Polly's on the 5th, perhaps to help out.[295]

Meanwhile, a couple of men, Lars Gjettrup and Harry Newton, camped across Crooked Creek from Shepp's, and on the 7th he took them over to Polly's.[296] On the 8th, with Pete back, the four men "cut trench [a firebreak] nearly round Polly's," and continued working on it the next day. That afternoon, Pete went up to Winchester's place on Rabbit Creek. He returned there the following day, while Shepp and the other two men finished a trench around Polly's alfalfa. On Thursday 10 men came down from Warren to fight the fire, and from Friday through Thursday "Pete & 2 boys over on fire." On Saturday evening, the 22nd, Shepp reported that "Fire burned up this eve below gulch next to Polly." By the 24th the fire was no longer so close to Polly's place, so on Wednesday the 26th Shepp went over there that afternoon and "got muskmelon & apples." On the 27th he wrote, "Fire not burning much, only 2 spots on hill below Polly's." The next day, Friday, Shepp went up to Winchester's. Winchester, who had gone up to Warren on Monday, returning on Tuesday, reported that there was "lots of fire on trail." On Sunday the 30th Shepp and Lars went over to Polly's in the morning and got muskmelons from her. That day, the fire was "not doing much on river."[297]

On September 1 Shepp wrote, "No fire in sight tonight but 1 small one at head Polly [C]reek, and by the 5th there was "No fire on hill below Polly [C]reek." However, there were still firefighting crews in the area, until, on the 7th, there was a "Good rain tonight. I guess every one of the fire crew got good and wet." Meanwhile, Shepp had gotten some muskmelons from Polly and had also gone up to Winchester's.[298]

On Friday, September 11, 1931, Polly celebrated her 78th birthday by inviting Shepp for the noon meal. He was her only guest; at that time, Pete was working away from home. Shepp went over there again on Monday afternoon and took 45 pounds of "some old corn" over to her. Polly's "old hen" had hatched "14 little chickens." Shepp also "Got 2 roosters from Polly. Killed one this eve." He was at Polly's again on Wednesday afternoon and the following Monday he noted that there was "Snow at head Polly [C]reek." On the 22nd and again on the 24th he took Polly a 50-pound sack of corn, and on the 25th he "Husked & took 50# sack corn over river," implying that he had also husked his earlier corn deliveries.[299]

On Saturday the 26th Shepp took another 50-pound sack of corn over to Polly. She must then have been very ill; Shepp wrote, "Polly pretty bad. Went over this eve & got old hen and the 14 little chicks,"[300] implying that Polly was so sick that she couldn't even care for her hen and its chickens. Shepp also killed a rooster that night, and the next day he shared it with Boston Brown, who came down that day and spent the night, and with Pete, who was back. Shepp took some of the cooked rooster to Polly, and reported, "The little

chickens all OK." Pete visited Polly on Monday morning, Shepp was there on Tuesday, and Pete surely visited her on Wednesday the 30th when he went to Winchester's for some cans of milk.[301]

On October 1 Pete looked in on Polly both in the morning and in the afternoon.[302] She must have continued to be very ill because two visits in one day were almost unprecedented. On Friday the 2nd "Pete set bear trap in [Shepp's] orchard"; the trap caught a bear on Sunday the 4th and Shepp canned and cooked it over the next few days.[303] Although he doesn't mention giving any of it to Polly, he surely did so, if she liked it. Meanwhile, on Saturday, Shepp and Pete went together to see Polly that evening. On Sunday, Shepp visited her again and reported, "Polly better." He went back there the following afternoon and the next; during the latter visit he got some salt, which he probably needed to preserve the bear meat. He also noticed that there was snow at the head of Polly Creek again.[304] After spending most of Thursday cooking and canning some more of the bear meat, Shepp went over to Polly's that afternoon.[305]

On Sunday October 11 Shepp visited Polly in the morning. Winchester was there also; he and possibly Shepp, harvested Polly's squash and got it into storage. "Alex" [probably Alec Blaine] had arrived at Shepp's on the 10th. On Monday he and Shepp began digging Polly's potatoes. By the end of the day on Tuesday they had dug 1,620 pounds of them. They finished the potatoes on Wednesday, with a total of 1,800 pounds in Polly's root cellar, and another 240 pounds that they brought over to Shepp's, as well as 100 pounds for seed potatoes.[306]

Thursday the 15th Shepp wrote, "Nixon down. Crossed his horses. He b[r]ought jar caps. Camped at Polly's."[307] Both Shepp and Pete went over to Polly's on Tuesday morning. They picked a lot of apples that day but it isn't clear if they were Polly's apples or their own. Shepp visited Polly again on Friday afternoon. On Monday the 26th "some fellow" who had spent the night at Shepp's crossed the river on his way to Warren. Pete must have taken him because Pete also got some of Polly's potatoes. The next day, Pete delivered four sacks of potatoes and eight boxes of apples to the War Eagle Mine; later, Shepp and Klinkhammer would get paid for this produce. On Wednesday morning Shepp went to Polly's in the afternoon. He picked over some potatoes, perhaps for Pete to deliver to the Del Rio Mine when he went there the next day. On Thursday Shepp took Polly some bacon in the afternoon. Then, on the 31st, Pete visited Polly to get more potatoes for the War Eagle Mine.[308]

During November 1931 Shepp first visited Polly on Thursday the 5th, when he "got Polly's cabbage all in." That Saturday he began preparing her place for winter when he "took wire on chicken fence down," and on Monday

he got her garden fence down. He returned on the 12th, 14th, 18th, and 20th, but without specifying any reason. The temperature was getting down into the 20s and on the 20th there was six inches of snow on the ground.[309] On the 21st Shepp had a visitor for several days, Johnnie Steinhaus,[310] and on the 24th Shepp, Steinhaus, and Pete all went over to Polly's. There, they "got Polly's chickens 11 [of them]. We got 22 chickens now." On Thursday the 26th Ellis Winchester had Thanksgiving dinner at Polly's. Shepp's final visit to Polly's that month was during the afternoon of Sunday the 29th, when he crossed the river in his boat.[311]

By December 1 the Salmon River had frozen up enough for Pete to cross on the ice when he visited Polly that morning. He went back there on the 9th, and on the 11th Pete took Polly 50 pounds of sugar and some flashlight batteries. Shepp finally visited Polly on the 16th, in the afternoon.[312] He probably waited till he was sure the thickness of the ice met his requirements; Pete, 20 years younger, was less cautious.

Pete shot a deer on December 20 and on the 21st Shepp took a quarter of it to Polly, as well as four cans of milk. With Pete away, at the Del Rio Mine, Polly likely served the deer meat to Shepp and Ellis Winchester when they visited her for Christmas dinner on the 25th. Polly's final visitor of the year was on December 31 when Pete crossed over that afternoon, no doubt to wish her a Happy New Year.[313]

1932

On January 1, 1932, Shepp took two of his horses, two of Gus Schultz's, and "Homer's mule & horse 6 in all over river,"[314] probably because there was more feed for them at Polly's. That day, Shepp also "got the latter part big foot ball game in Passadina [sic, for Pasadena] Cal.," but reported, "Radio not very good."[315] That was the 1932 Rose Bowl game between the University of Southern California, Los Angeles, and Tulane University, New Orleans; USC won, 21 to 12.[316]

Pete visited Polly on the 2nd. The next day nine of Bill [Hart?]'s horses and mules were at Shepp's in the morning; Pete took them all over to Polly's. He was there again on the 4th and 5th, perhaps to check on them. Meanwhile, Shepp canned five quarts of meat and three quarts of soup from one of the hindquarters of the deer that Pete had shot in December;[317] "Mother Nature's freezer" would have preserved it until he had time to process it. On the 6th Shepp visited Polly but didn't record taking her any more of the meat.[318]

With so many horses and mules at Polly's it was a big responsibility to keep them fed. That chore fell to Pete, who was over there for part of every day from the 7th through the 9th, and again daily from the 11th through the 16th.

The next day, Sunday, Shepp wrote, "Low[e] cougar hunter here from down river."[319] This was George Lowe, "for years Idaho's veteran cougar hunter."[320] The next morning Pete took Lowe across the river to Polly's.[321]

The following May, Lowe reported on his visit to Polly, unfortunately embellishing his account with misinformation acquired from other sources:

It was while I was on the Salmon that I met and had a pleasant visit with Polly Bemis, a Chinese woman, whose past reads like a page from the history of romance and tragedy. *It seems as though* [emphasis added] Polly ... was brought from China to San Francisco as a slave girl She passed from one tong to another and finally fell into the hands of a rich Chinese gambler. About this time gold was discovered at Warren and Florence and thereabouts, and the Chinaman took his slave girl and started for the new El Dorado.

... *The story goes* ... [emphasis added; it is followed by an account of the poker game legend in which Charlie Bemis supposedly "won" Polly.]

Mrs. Bemis lives alone with her dog on the south side of the main Salmon. She is 18 miles from Dixie and 20 mil[e]s from Warren, by the mountain trails, opposite the mouth of Crooked Creek. ... Across the Salmon from her home live two sourdough miners – Charles Shep [*sic*, for Shepp] and Pete Klenkenheimer [*sic*, for Klinkhammer] – and they have agreed to furnish Polly her groceries and saw her wood in return for which she is to give them her place when she dies. It was while at Grangeville drawing up paper to that effect that Polly saw her first train and automobile. [As mentioned, Chapter Seven, this would have been in August 1923; no such legal "paper" was located at the Idaho County Courthouse in Grangeville.]

Shep and Klenkenheimer have constructed telephone line connecting the two cabins and each evening they call Polly to find out if she is all right. Last winter she saw and heard her first radio. Shep and Klenkenheimer have one and they had her over one evening. In explaining it, they said it was neither a telephone or a phonograph but the sound came from waves through the air, whereupon Polly said she did not believe it. Occasionally she sees an airship [airplane] passing over.[322]

On January 19 and 20 Pete fed the horses at Polly's. On the 21st, he took the Shepp Ranch mail up to the War Eagle Mine to be sent out, so Shepp fed the horses that day.[323] From the 22nd through the 28th the two men took turns going over to Polly's to feed the horses. She would have been glad of their visits, since she usually didn't have much company in January.[324]

The horse feeding continued during February 1932. When Shepp went to Polly's on the 1st, he found that "Chester" [Ellis Winchester] was already there. On Friday the 5th Boston Brown came down to Shepp's. He stayed for several days, and helped both Shepp and Pete feed the horses at Polly's; she would have enjoyed seeing Boston again.[325] On Wednesday the 10th Pete fed the horses and cut wood for Polly. He was over there again every day through the 19th and cut more wood for her that day. On the 20th Pete fed the horses at Polly's for the last time; the next day he and Shepp brought them all back to their side of the river.[326]

The men may have been crossing on the ice to do these chores because on Saturday, March 12, Shepp made a point of writing that Pete had crossed the river in their boat.[327] On March 21 a man named Charles Hinkle [for Hinkler] came down to the Shepp Ranch and spent the night. He was on his way to Warren so Shepp took him across the Salmon River and also took Polly some eggs. Lacking any known company for the past month, she would have been delighted to visit with the two men. A week later, Pete visited her on Sunday afternoon.[328]

With the arrival of spring, and thus plowing and planting season, Shepp and Klinkhammer increased their visits to Polly's place. On Friday April 8 Pete went over there and brought back four sacks of "spuds." The next day Shepp "Took horses over river," and Pete began plowing on Monday the 11th. He might have seen Polly the previous afternoon when he went up to Winchester's place, since the best place to cross was at the Bemis Ranch.[329] Pete must have used her plow, but found it unsatisfactory, because on Tuesday he took over a plow from the Shepp Ranch. He finished the plowing on Wednesday and brought the horses back home. Meanwhile, Shepp reported seeing a meatior [sic, for meteor] one evening.[330] From the 19th through the 21st Pete was back at Polly's, working on her garden. In the afternoon of Friday April 22, Shepp put a fence around Polly's garden.[331]

During May 1932 Polly's neighbors only visited her a couple of times. On the 4th, Shepp went over there and planted her potatoes, and on the 17th Pete visited her in the afternoon. Meanwhile, on the 9th, Shepp "Put on light underware" [sic]; the day before, the temperature was above 80 degrees.[332]

June saw some sporadic activity on Polly's potatoes. On the 4th, Pete cultivated them, but it wasn't until the 29th that Shepp was over there; he "Got spuds about hilled & watered." The next day he "Cut out ditches," meaning that he straightened the ditches' sides and bottoms for more efficient water flow.[333] During June Polly had some other visitors, but their names aren't known; Shepp must have just observed them from his side of the river. On the 12th there were "2 fellows camped at Polly's on Warren trail" and on the

23rd there was "Some fellow at Polly's" in the morning. The next day Shepp wrote, "That fellow still over river."[334]

On Friday July 1 Shepp visited Polly and on the 2nd he went back to pick two 10-pound buckets of cherries. When he canned them the next day, they yielded six quarts. That afternoon, Pete visited Polly. On Monday the 4th Shepp was over there "on hay" in the morning and cultivated her garden in the afternoon. He was back on the 5th; on the 6th he cocked Polly's hay and on the 7th he picked another two 10-pound buckets of cherries. The next morning "Pete took a fellow & 3 horses across river" in the morning, while Shepp canned another six quarts of cherries. On Saturday the 9th Shepp "Took Pete across river" in the morning [this Pete was a horse], and "got alfalfa in." Charlie, one of Gus Schultz's sons, came down to Shepp's that evening. The next day Charlie Schultz picked two buckets of cherries at Polly's place. She must have been happy to see him, because his mother was one of her closest friends.[335] On the 17th Pete cut oats at Polly's. On July 19 Shepp wrote "My birthday," but didn't seem to celebrate it; he would have been 72 years old in 1932. Pete visited Polly on Thursday the 21st and two days later Shepp watered her potatoes. The next afternoon he got some peaches and rhubarb there and a few days later he "Fixed stove pipe in kitchen."[336] Toward the end of the month Shepp reported that four men came down from Dixie and camped in his barn. The next day he took two of them across the river, where they surely met Polly and chatted with her, while the other two stayed behind and "caught good mess of fish." At least two of the men were from Walla Walla, Washington; Shepp recorded their names and addresses in his diary.[337]

In the evening of Tuesday, August 2, Captain Harry Guleke arrived with a boat carrying six passengers, five men and one woman. They spent the night at the Shepp Ranch, probably camping near their boat, but left the next day without crossing over to visit with Polly.

The six people included Guleke's then-partner, Elmer Keith; "Miss Florence Schultz, former school teacher at Gifford [Idaho]"; "D. R. Hogue, Payette; D. W. Powers, Ontario, Ore; Casper Beimsohr, Evanston, Ill., student at the University of Idaho, who is spending a vacation at Salmon City; and J. H. Pelton, Salmon City."[338]

Although the party didn't visit Polly, Shepp doubtless told her all about it when he was there on the 4th to water the potatoes. He also noted that there was "Some fellow down at Polly's" in the afternoon. The man was camping "at Mitchel's [Mitchell's] on Rabbit [C]reek."[339] Polly had plenty of visitors the rest of the month. Pete shod two horses there on the 9th, Shepp took her some eggs on the 12th, Ellis Winchester came for Sunday dinner on the 14th, Shepp

watered her potatoes on the 15th, "Chester" visited her again on the 19th, and Shepp was back there on Saturday morning, August 20.[340] On Monday the 22nd Pete began cutting Polly's alfalfa, which he continued doing for the next two days. Shepp went over to water Polly's potatoes, and took over the hay cutting on the 25th, probably because "Pete shot his finger with the .22" the previous evening. The next day Shepp fixed dinner, the noon meal, for "some fellow," name unknown, who went to Warren that afternoon.[341] If Shepp crossed him in his boat, the two men probably had at least a brief visit with Polly. Shepp was back at Polly's the morning of the 30th, and on the night of the 31st he "Saw part of eclipse about 10:30 to 11."[342] Perhaps Polly saw it too, if she stayed up that late.

During September 1932 Polly seldom lacked for visitors. On Thursday the 1st, in the afternoon, Shepp "Took coal oil [kerosene] & watermelon over," and on Sunday the 4th he took two muskmelons to Polly.[343] On the 6th, two men, one woman, and four horses came down from Warren. Presumably they visited with Polly before Shepp came over in his boat to take the people across the Salmon River while the horses swam. The travelers paid him $2.00 and camped on the other side of Crooked Creek. The next day he took Polly some melons. In the afternoon of Friday the 9th Shepp visited Ellis Winchester,[344] surely spending some time with Polly before heading upriver. As he often did on Sundays, Winchester was at Polly's on Sunday, September 11, probably to have Sunday dinner with her; this was also Polly's 79th birthday. The next day Shepp took Polly one and a half dozen eggs and three muskmelons. The following Saturday, the 17th, Winchester came down to Polly's in the morning and "got the pup."[345] For there to be a puppy available, Polly, or Shepp, must have had a female dog at that time.

On the 18th, Shepp went to Winchester's and got one and a half five-gallon containers of peaches, which he canned on Tuesday the 20th. That day, Shepp also reported that there were "2 fellows at Polly's" in the afternoon, and that they went up to Winchester's place. The next day Shepp visited Polly in the afternoon. A Forest Service pack train had come down the trail [from Dixie?] with "wire for cable across river at Sheep [C]reek," a few miles downstream from the Shepp Ranch.[346] On Friday the 23rd, Shepp took "the boys" over to Polly's in the afternoon; he also took her mail over, and would have read it to her. Despite being unable to read or write, as indicated, Polly sometimes did get mail. It waited at the nearest post office for Pete Klinkhammer to collect when he took produce into town to sell, or, as here, when people from town came down to the Shepp Ranch. The following Sunday, the 25th, Shepp got more peaches at Winchester's, and the next afternoon he went over to Polly's for 16 pounds of sugar; he needed it to can the peaches on Wednesday.[347]

Meanwhile, on Monday evening, Alex [Alec Blaine?] came down to the Shepp Ranch. He and Shepp visited Polly the next afternoon.[348]

During October 1932 Shepp took Polly some eggs on Sunday the 2nd. On the 4th he helped a man named Nixon, probably Bert, cross the river with five big horses; Nixon gave Shepp $5.00. The diary doesn't indicate which direction Nixon crossed, but surely he and Shepp visited with Polly when they were on her side of the river.[349] Winter was on the way, with snow at the head of Polly Creek on the 9th. Toward mid-month Shepp took Polly six cans of milk and a slab of bacon, and the next day he got all of Polly's carrots into her root cellar. On Wednesday the 19th he dug 320 pounds of Polly's potatoes, and put them in the root cellar also.[350]

The last entry in that diary is October 19, 1932. The next diary, written on ledger paper, doesn't begin until July 18, 1933.[351] If there were a diary for the intervening months, it is missing.

1933

On Wednesday July 19 Shepp wrote, "Over river am. On our spuds & garden. Not so hot today. Polly's birthday Sept. 11, she will be 80. My birthday 73."[352] Shepp's birthday was that very day, July 19. His mentioning his age, 73, confirms that he was born in 1860. It is unusual that he would mention Polly's birthday, since it was two months away, but perhaps they had been talking about her becoming 80 years old. This provides additional confirmation that Polly was born in 1853.

During the remainder of July Shepp was over there six times. Mostly he watered Polly's potatoes, but he also worked on her garden and split wood for her. It was "awful hot" on the 23rd, and on the 25th the temperature reached 107 degrees. Pete only visited Polly once, on the 31st.[353]

August 1933 was "the beginning of the end" for Polly. Early that month Shepp watered her potatoes and cultivated her garden,[354] but on Friday the 4th he wrote, "Over river am [a.m.], found Polly laying out side. She is bug house [insane] and nearly helpless." Although he didn't mention doing so, Shepp must have carried Polly into her house, put her to bed, and cared for her as best he could. He also watered her potatoes thoroughly. Fortuitously, because his help with Polly would be needed, Anderson, first name unknown, arrived at Shepp's from the old Harbison Ranch. On Saturday morning the 5th, Shepp called Frank McGrane in Grangeville. Anderson and Pete Klinkhammer went over to Polly's that day, and Pete spent the night there. On Sunday morning the two men got Polly across the river and then "took her with a horse up to half way house" [Adams Camp]. There they met an ambulance that was sent from Grangeville to get her.[355] The ambulance driver

was Glenn Ailor, owner of the Ailor Mortuary in Grangeville.[356] The entire trip, from the Shepp Ranch to Grangeville, some 87 miles, reportedly took 9 or 11 hours;[357] Pete spent the night at the War Eagle Mine and returned to the Shepp Ranch the next morning.[358]

On August 8 the Lewiston, Idaho, newspaper reported that Polly was

… ill at the Idaho [C]ounty [H]ospital at Grangeville and citizens of that country and elsewhere are eagerly awaiting news from her bedside, hoping her condition will take a turn for the better and that she will be able to return to her ranch on the Salmon [R]iver ….[359]

Another newspaper account of Polly's transfer to the hospital provided some different information, but since it reports that Pete Klinkhammer and Charles "Shep" [sic], not Anderson, brought her out, other details also may be incorrect. For example, according to the story, the group was met at the War Eagle Mine, not the "half way house," "by Deputy Sheriff Gus Hoene and Miss [Bernice] Naser, a nurse, who brought her to Grangeville." The account continued, "Polly's many friends wish her [a] speedy recovery, and she will be glad to see visitors at the county hospital."[360] "County hospital" implies that she was taken directly to the poor farm for indigents.

Yet another story relates that "it was Peter who put an ailing Polly on his packboard, then climbed out of the canyon" via the trail up Crooked Creek.[361] This account implies that he carried Polly out on his back, but Shepp's mention of their using a horse contradicts that account.

Polly's illness and hospitalization were newsworthy much farther afield, picked up by other newspapers from copy sent out by the Associated Press. For example, the *Hartford Courant*, of Hartford, Connecticut, ran a four-paragraph story, headlined, "Chinese Woman Who Wed Conn. Yankee Is Ill" (Fig. 8.9). The *Courant* perpetuated several errors, including "John" Bemis for Charlie Bemis, "Shep" for Shepp, and "Kleinkenheimer" for Klinkhammer.[362] Both Shepp's name and Klinkhammer's name were misspelled in the original *Lewiston Morning Tribune* story dated August 8, but where the *Courant* got "John" Bemis is a mystery. Even the *Evening Independent* of St. Petersburg, Florida, ran a version of the story as front-page news, with "John" Bemis; Shepp and Klinkhammer were unmentioned.[363]

On Friday, August 11, Frank McGrane called Shepp to say that Polly was "getting along fine."[364] She probably had had a stroke.

Shepp doubtless expected that Polly would return, since on August 12 and 19 he split some wood for her. He continued to water her potatoes and corn, and learned that he owed $1.70 for telephone calls, probably relating to Polly's illness. On Monday the 21st Pete crossed over in the morning. He might have checked to see if the alfalfa was ready to cut, since the next day

Chinese Woman Who Wed Conn. Yankee Is Ill

Polly Bemis, Now 81, Was Once Slave Pawn in Poker Game

Grangeville, Idaho, Aug. 9.—(AP.) —Polly Bemis is ill. She is 81 years old and near death now, but at 18 she was a beautiful Chinese slave, and a white man risked a fortune in a poker game to win her from the oriental who smuggled her into the Idaho mining camps.

John Bemis, a Connecticut Yankee had come West to make his fortune. In the wild mining camp of Warren, saloons and gambling houses ran night and day. Bemis was a good poker player.

Polly's master, a leader among the hundreds of Chinese engaged in scooping gold from the sands thought he was a good gambler until he met Bemis. He lost all he had, then offered to play for the ivory-skinned girl. A tense crowd watched.

Bemis won her, married her, and lived happily until he died in 1922. For 65 years she lived on their ranch. Then she willed it to Charles Shep and Pete Kleinkenhelmer on condition they care for her until she dies. They have done so. When she became ill, they brought her on horseback over dangerous mountain trails to the hospital here for treatment.

Fig. 8.9. Polly Bemis's illness was news even on the East Coast. From Hartford Courant, *August 10, 1933, 4.*

Shepp "Took horses over river PM & Pete cut all the alfalfa." For the next few days Pete was over there "on hay"; he got it into the barn on Friday and brought the horses back. On Tuesday the 29th Shepp returned to Polly's place but didn't give a reason.[365]

Historian M. Alfreda Elsensohn reported,

In August 1933, when the press first announced the illness of Polly, Lamont Johnson, living in Twin Falls at the time, wrote to Polly in Grangeville. A letter soon came back from Mrs. Eva Weaver [later Mrs. Clark Lyda] of the Weaver Nursing Home [the county hospital for indigents, also called the poor farm] who was nursing Polly. Mrs. Weaver wrote Mr. Johnson that she would write the story of Polly as she told it;[366] see November 1933, below.

Sunday, September 3, Shepp visited Polly's again, and on Friday the 8th he went over to do some fishing, but caught nothing. He also wrote, "Muggins had 3 kittens[;] put them in creek."[367] We can't tell from the diary entry if Muggins was Polly's cat, or Shepp's cat; nevertheless, he drowned the unwanted kittens, either in Polly Creek or, on his side of the river, in Crooked Creek. That month, he only went over to Polly's place twice more, and at mid-month he observed "Snow at head Polly [C]reek."[368]

While she was hospitalized in Grangeville, Polly had occasional visitors. Frank McGrane, accompanied by his wife, reported that Polly told

them, "Charlie wouldn't have died [so soon] if he hadn't been lazy. He just sat around till he was [of] no account."[369] Bertha Long also visited Polly. Reportedly, Bertha said, "You'll soon get well," and Polly replied, "No, me too old to get well, me have to go to other world to get [um] well."[370] Since Bertha was a good friend of Polly's when the two women lived in Warren in the early 1890s, it is likely that she visited Polly multiple times. One account indicates that she took her eight-year-old granddaughter, Marion Eisenhauer, with her.[371] In 1966, Bertha recalled, "When Polly was brought out to Grangeville [in 1933] I went to see her and took my little grandson [Denis Long], then a baby only a few months old. She was so pleased she cried. She didn't live long after coming. She told me she was "too old, too tired.""[372]

Another of Polly's callers was a 10-year-old boy, Bob Bunting (Fig. 8.10). [Bob later married Marion Eisenhauer.] On his first visit, his friend and neighbor, Gloria Dyer, accompanied him. As Bob reminisced 60 years later,

Warm summer days, after school has been dismissed for the year, are precious times to a boy of ten. … It is a time to look for snakes, build a dam in the creek, ride the bike up to the foothills, or some other valuable endeavor. A boy's time should not be interrupted by sound[s] like, "Mow the lawn," "Come and help clean out the barn," or other such nonsense.

It was just that sort of summer morning in 1933 in Grangeville, Idaho, when Mother summoned me to run an errand. Naturally, I had other plans and her task was not a part of them. She had picked a bouquet of sweet peas and wanted me to take them to the County Hospital. She carefully explained to me that they were for an important Chinese lady, Polly Bemis, who

Fig. 8.10. Robert (Bob) Bunting, about 1933. Courtesy Robert Bunting.

was very ill. After some protesting and pleading, I reluctantly agreed and set forth to complete the task as quickly as possible, so I could return to far more important matters.

There were still a few elderly Chinese left over from the gold rush days, but the Chinese settlement at the foot of China Hill [in Grangeville] was no longer there. I had seen Chinese, but they had been men and I couldn't remember seeing a Chinese woman.

I had been playing with a neighborhood friend, Gloria Dyer, and she agreed to accompany me to the hospital. … The hospital was

located just north of the cemetery. It was an old farm house that the county had taken over for the purpose.

Mrs. Lyda [formerly Eva Weaver] operated the hospital. ... [She] was a friendly woman, who knew us and she insisted that we take the flowers upstairs to Polly. Polly was in a room that was only partly finished and resembled an attic room. It was terribly warm in the room although the one small window in the room was open. Polly was on a leather pad, much like a doctor's examining table, dressed and covered by a heavy blanket. I remember wondering how she could stand it in all the heat of the room. On the other side of the room was an elderly Chinese gentleman. Mrs. Lyda told us that he was a very close friend of Polly and was near death. She told us his name, but I have long forgotten who he was.[373]

Polly was awake and Mrs. Lyda called her attention to us and pointed out the flowers to her. Mrs. Lyda excused herself and left us alone with this strange woman. Polly was trying to tell us something. She was flat on her back, very ill, and had difficulty speaking. Polly spoke in very broken English and we could not understand what she was trying to tell us. After a few minutes, Mrs. Lyda returned and explained to us that Polly was thanking us for the flowers and wanted us to see her feet.

Mrs. Lyda removed the blanket and showed us a sight that I shall never forget. They were just tiny little feet, almost stubs. I couldn't believe that a person could walk on them. Polly's feet were tightly bound when she was a child, in the old Chinese custom, and Mrs. Lyda explained that this was a beauty mark for Chinese women. By the side of the bed was a pair of tiny shoes that I couldn't imagine anyone could wear.

Polly wanted to talk and tell us much more, but after a time Mrs. Lyda gave her a drink of water and said we should leave and not excite her further. I shall not soon forget the longing look in Polly's face as we left the room. She had so much to tell us and wanted someone to listen to her.

...

During that summer and fall, I took flowers to Polly on several occasions and even though she was terribly ill, she always had a big smile for me and tried to express her appreciation. She longed to talk and would hold my hand until Mrs. Lyda would release her hand from mine. Polly had so many stories to tell and most of them will never be

told. As time went on, she could only smile and extend her hand to me. She never wanted me to leave.[374]

In late September 1933 the *Idaho Sunday Statesman* had a lengthy article about Polly Bemis's life, subtitled, "Czizek Explodes Myth of Chinese Poker Bride."[375] Although the implications of this statement will be discussed in Chapter Nine, the article is relevant because it included a seldom-seen image of Polly Bemis. She is sitting on a blanket, on the ground, and is wearing a crocheted or knitted cap (Fig. 8.11). Versions of that article subsequently appeared in the Lewiston, Idaho, newspaper and in the Grangeville, Idaho, newspaper, but without the photograph.[376]

During October 1933 Shepp was at Polly's place more often. Mostly he dug and stored potatoes, but he also picked corn and "daubed chicken house," i.e., chinked it with something, perhaps mud. While there on the 1st, he looked for Polly's cats, but didn't see them.[377] However, on Saturday the 7th Pete "...went to Dixie with 2 horses. Took blk [black] cat up to W. E. [War Eagle Mine]; whether this was Shepp's cat or Polly's is unknown, but the War Eagle was probably in need of a mouser.[378] Toward the end of the month Shepp shut the water off to Polly's ditches, and "fed Johnnie," Polly's remaining cat.[379]

On October 19, 1933, Grangeville's *Idaho County Free Press* had the following item. "From Dixie—Peter Klinkhammer, from near Dixie, visited a short time in the city [Grangeville] last week, on his way to Spokane."[380]

While in Grangeville, Pete undoubtedly visited Polly Bemis in the County Hospital. Shepp's diary for this time period only mentions that Pete went to Hump the morning of October 9; he isn't mentioned again until the 25th, when Shepp wrote, "Pete in Hump,"[381] evidently on his way home from Spokane. From Spokane, Pete could have taken the train to Minnesota and back, to visit relatives.

Because Polly Bemis was destitute, Idaho County accepted the responsibility of caring for her. In early October 1933 the county commissioners ordered two bills to be paid for her care, charged to "The Indigent Fund of the County." Eva Weaver received $150.08 for "Board and nursing Polly Bemis, indigent," and Bernice Naser received $10.00 for "Nursing Polly Bemis, indigent."[382] From the amounts paid to the two women, it seems likely that Naser filled in for Weaver on the latter's day(s) off. Other bills paid that might have involved Polly included ones from The Owl Drug for "Medicines to indigents" and from the mercantile firm of Alexander and Freidenrich for "Merchandise for various county indigents."[383]

In early November 1933 Shepp twice observed an airplane, once going upriver and the next day going downriver. On the 5th he crossed over to Polly's but didn't comment on his reason for going there.[384]

CHINESE-AMERICAN PIONEER DIES

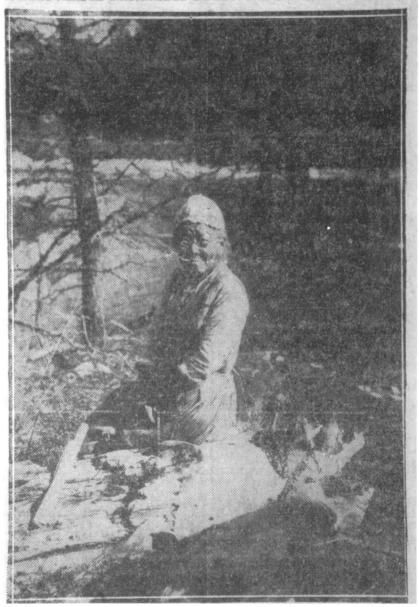

Fig. 8.11. Polly on blanket with cap, 1930s? From Lewiston Morning Tribune, *November 7, 1933, p. 1. Used with permission.*

On November 5, 1933, reporter Lamont Johnson, writing for the *Sunday Oregonian*, published a lengthy article with sensational headlines: "Old China Woman of Idaho Famous. Polly Bemis Seriously Ill in Grangeville Hospital. Career Nearly Ended. Patient Denies that She Was Won in Poker Game by Man Who Later Married Her."[385]

This information came to Johnson in a letter from Eva Weaver, Polly's nurse. Weaver

> … related personal traits to show the old lady as a most likable character. She has been a friend to all unfortunates, and [was] particularly fond of children, although she never had any of her own. Her wrinkled face lights up with a lovely smile when she hears the little folk, or of them. She had a keen interest in an expectant mother at the hospital and was anxious to see the baby when it was born. Polly has been an expert angler and loved to fish in Salmon River, but she was so frail and small - 'only as tall as a broom,' she said - about 4 1/2 feet high, and was always afraid the fish would pull her into the river. She made pets of any kind of bird or animal she could find. Once she took a nest of baby robins and raised them, letting them come and go as they pleased. When they found fresh meat at a nearby market in Warrens they spent so much time there that a French clerk killed them. This made Polly very angry, Mrs. Weaver said.[386]

In December 1958, Lamont Johnson wrote M. Alfreda Elsensohn,

> If and when I locate that letter of 1933 from Polly's nurse, I will send you a photostatic copy The real poker bride was an Indian girl named Molly, and I can't help but think what a story it would make, to know about that card game: Where was it? Who was the man who bet her, as the last thing he owned on earth? What became of him? Who was the man who won her, and where did they go? Was Molly there to watch that game, and see herself lost and won? … Polly didn't tell me these details, but she told me all the rest of it. It seems to me that the letter covered several pages, and I know I never destroyed it; I think it is still stowed away among other r[e]search stuff in a garage I have hired.[387]

Johnson later wrote Sr. Alfreda that he had visited the garage, but didn't find the letter.[388]

Sadly, on Monday, November 6, 1933, Polly Bemis died in the Grangeville Hospital; she was just over 80 years old. Her death certificate lists cause of death as "chronic myocarditis," (Fig. 8.12), which a dictionary defines as "inflammation of the muscular part [myocardium] of the heart wall." Shepp

noted Polly's death in his diary, "<u>Polly</u> <u>passed</u> <u>away</u> <u>this</u> <u>afternoon</u>," underlining each word for emphasis.[389]

Bob Bunting, age 10 when he had visited Polly in the hospital "every week before she died,"[390] later recalled,

In the early part of November 1933, my father came home to announce that Polly had died. The City Council had decided to attend the funeral and they were very concerned because they could not find a minister to conduct the service. Polly was a 'heathen' and none of the local ministers would have anything to do with the funeral. My

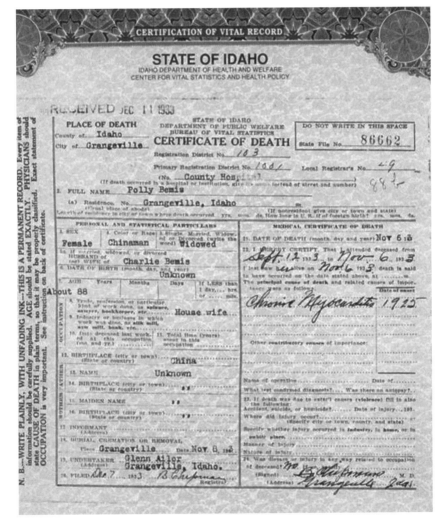

Fig. 8.12. Polly Bemis's death certificate, 1933. Idaho Department of Health and Welfare, Bureau of Vital Records and Health Statistics, Boise.

father was Mayor and he was afraid he would have to read the service. He was also disturbed because the local paper had given only a brief notice of her death, while her death was front page news in New York and San Francisco.[391]

Shepp's diary entry for November 7 read, in part, "Polly to be buried 10 am [a.m.] tomorrow," and on Wednesday, November 8, he wrote, "Polly buried am [a.m.] at 10. Got 1 [deer] to day[,] pretty big."[392]

Grangeville's Ailor Mortuary handled Polly's burial. One author, knowing that Polly wished to be buried at her home on the Salmon River, asked Ailor why Polly's wishes weren't carried out. Ailor replied "that the county felt it could not pay transportation costs farther than the [Grangeville] cemetery."[393]

Because Polly was indigent, the mortuary billed Idaho County $27.00 for their costs, on a form probably provided by the county. The "Record and Bill of Items for the Funeral of Polly Bemis," describes her as a "Chinaman" and notes that she died in the County Hospital. Her Date of Birth was given as "1846 or 1851," rather than the date that she herself used, 1853[394] (Fig. 8.13). The Certifying Physician was Dr. Chipman, the Date of Interment was November 8, 1933, and the Officiating Clergyman was "Jameson"; this was R. F. Jameson, denomination unknown.[395] From what Bob Bunting recalled, about the difficulty in finding a clergyman to perform this ceremony for someone they thought was a "heathen," Jameson may not actually have been a minister. However, Bunting also mentioned a Reverend Walker who might possibly have conducted Polly's service.[396] Polly's pallbearers were reportedly members of the City Council [County Commissioners?], but this couldn't be verified in their minutes.[397]

According to the "Record and Bill of Items," Polly's funeral service was at the Ailor Mortuary at 2:00 p.m., contrary to the 10:00 a.m. time that Shepp reported. The mortician, Glenn Ailor, ticked various boxes indicating that the following items were provided: Casket or Coffin, Burial Suit, Services, Hearse, and Newspaper Notices. Polly didn't receive Lining and Pillow Set [for coffin], Handles [for coffin], Plate [nameplate for coffin], Outside Box or Vault, Slippers, Embalming, Washing and Dressing, and Shaving. Polly also wasn't provided with a number of other possible options, including Use of Chairs, Church Charges, Cemetery Charges, Music, Flowers, Candles, Gloves, Bearers or Porters, and Automobiles.[398] Sixty years later, Bob Bunting recalled, "The day Polly was buried was a cold, blustery day in November and only a handful of people, other than the Council members, were in attendance at the graveside service."[399]

RECORD AND BILL OF ITEMS

Yearly No. *46*

FOR THE FUNERAL OF

Total to date..............

Polly Bemis

Residence... *Grangeville*

Place of Death... *County Hospital* Wife or Widow of..............

Date of Birth... *1846 or 1851* *Sept* *11* — 87 *82* ..Years Sex.............. Color or Race *Chinaman*

Date of Death... 1933 *Nov* *6* — *1* Age *1* ..Months Single..............

Maiden Name.............. *25* *25* ..Days Married..............

Birth-place.............. Occupation..............

Name of Father.............. His Birth-place..............

Maiden Name of Mother.............. Her Birth-place..............

Cause of Death—Primary.............. Secondary..............

Certifying Physician... *Dr. Chipman* Residence..............

Place of Burial... *Grangeville* Cemetery..............

Funeral Service at... *Ailor Mortuary* Lot No...............

Time of Service... *2 P.M.* Grave No...............

Date of Interment... *Nov 8 1933* Section..............

Put in the Diagram one mark like this I for every Grave in it. And mark *this* Burial with double dagger thus : ‡

Designate site of monument thus : ☐

Casket or Coffin No.	✓		Candles		
Size............ Made by			Gloves		(
Lining and Pillow Set No.			Bearers or Porters		
Handles			Hearse to	✓	
Plate			Removal		
Outside Box or Vault			Automobiles		
Burial Suit	✓				
Slippers			Newspaper Notices	✓	
Embalming					
Washing and Dressing					
Shaving					
Services	✓				
Use of Chairs			Transportation Charges		
Church Charges			Officiating Clergyman *Jameson*		
Cemetery Charges			Amount of Bill	27	00
Music			Goods Ordered by		
Flowers			Bill Charged to		

DR. *County* CR.

Nov 6 *complete* 27 00 *Jan 13* *Warrant* 27 00

Paid in full

1/13/34

Fig. 8.13. "Record and Bill of Items for the Funeral of Polly Bemis," 1934. Note that Polly's date of birth is given as "1846 or 1851," rather than the date of 1853 that she herself used. Photocopy courtesy Carol Sue Hauntz, daughter of mortician Glenn Ailor.

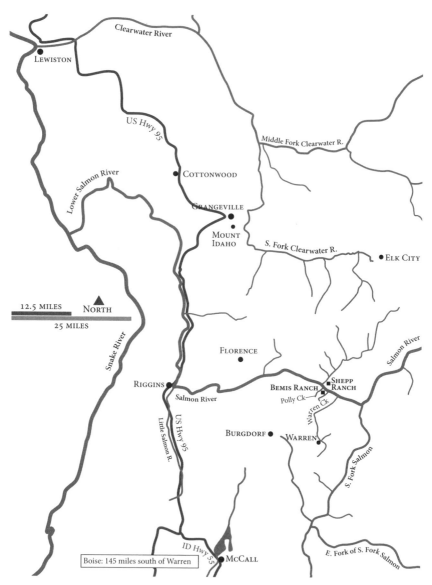

Map 9. Idaho place names mentioned in Chapter Nine. Drawn by Melissa Rockwood.

CHAPTER NINE:
Exposing Myths and Inaccuracies about Polly Bemis

During the course of Polly Bemis's long life in the West, from her arrival in 1872 until her death in 1933, and even beyond, a number of myths and inaccuracies about her became established. Even today, these falsehoods are very difficult to dispel. One rumor is that she was a prostitute. Another myth is that her Chinese owner's name was "Hong King." A third belief is that Polly's Chinese name was "Lalu Nathoy." The most pervasive inaccuracy is that Polly's husband, Charlie Bemis, won her in a poker game. Despite abundant evidence to the contrary, misinformed authors continue to enlarge on these topics, thus sensationalizing Polly and her life. We'll examine the origin and development of these individual myths and inaccuracies as well as the evidence that refutes them.

Polly Bemis Wasn't a Prostitute

During the 61 years that Polly Bemis lived in Idaho, no contemporary accounts indicate that she was once a prostitute; i.e., there is no evidence that she ever engaged in promiscuous sexual relations, or received money for doing so. However, because of the circumstances that brought her from China to the United States (Chapter One), she was undoubtedly raped repeatedly over time. Only after her death, when she was no longer alive to defend herself, have misguided writers sullied her reputation by calling her a prostitute.[1] One writer, for example, ventures far beyond his self-imposed geographical limits of San Francisco to include Polly Bemis as "[o]ne of the Chinese prostitutes who worked in a mining camp during the 1870s," with no evidence, while admitting that he relied on "popular authors" for his information.[2]

In a 1924 newspaper interview (Chapter One), Polly seems to hint at being forced to engage in sexual relations. She describes being taken, along

with two other young Chinese girls, "almost directly to Florence, Idaho[,] and Polly tells the tragic story of their disillusionment."[3]

In 1933, just before Polly died, a newspaper reporter relayed questions to her through her nurse, and wrote about her replies. Polly

… said that Chinese girls were often bought or stolen in China and smuggled into the United States. She was born September 11, 1853, on the Chinese frontier near one of the upper rivers of China, …. Her parents were poor and suffered from drouth [drought] to their crops and from the ravages of brigands. One year these outlaws raided the country and took all the crops. To prevent starvation to the rest of the family in that year of famine[,] Polly's father sold her to one of the leaders of the plundering band in exchange for enough seed to plant another crop.

The bandit leader took Polly down the river to one of the big seaport cities, whence he sailed to San Francisco. [Polly was sold in Portland.] Soon afterwards the gold rush around Idaho City lured him to Warrens, where he either died or deserted Polly, who operated a restaurant [boarding house] for several years.[4]

The first official document to confirm that Polly lived in Warren, Idaho, is the 1880 US Census.[5] That year, she and Charlie Bemis appear together, apparently inhabiting the same household in the town of "Washington," as Warren was then named. Charlie's first name, Charles, was abbreviated to "Chas.," and Polly has no last name given. Besides their names, and a listing by household, the information that was gathered at that time included race, sex, age, marital status, occupation, and place of birth[6] (Chapter Two, Fig. 2.1).

Charlie's listing shows that he was a white male, age 32. Polly was a Chinese female, age 27. The occupational column states that Charlie ran a saloon, and that Polly was housekeeping—probably just keeping house for him, and not yet running a boarding house, as she is known to have done later. The last columns show that Charlie was born in Connecticut, as were his parents, while Polly was born in, or near, "Pekin[g]," in northern China. Diagonal marks in other columns are used for marital status. The mark for Charlie indicates that he was single, while the mark for Polly indicates that she was a widow.[7]

Polly's surprising identification as a widow requires an explanation, one that is rooted in Chinese cultural practices. Some background to this is available from contemporary Chinese customs and from a 1921 interview with Polly, published in 1923.[8]

Polly arrived in Warren in 1872, at a time when, both in China and in the US, Chinese females were considered to be the property of men; women and

girls could be bought and sold like any other commodity. Despite the fact that slavery had already been abolished in the US, the Chinese custom of men owning women prevailed. In the late nineteenth century the numbers of Chinese men in the West vastly exceeded the numbers of available Chinese women, so a man who wanted a woman, for whatever purpose he had in mind—as a servant, a prostitute, a wife, or a concubine—had to pay a great deal of money for her.

In China, wealthy Chinese men often had more than one wife as well as one or more concubines. Although a man's parents selected his primary wife, he could choose to buy minor wives and concubines. A concubine, usually purchased for sexual gratification,[9] was much more than a mistress; she was a legally-recognized household member, and all her children were legitimate.[10] Because most married Chinese men who came to the United States in the late nineteenth century did so with the intention of making their fortune and then returning home, their wives usually remained in China, living with their husband's family and caring for their children and their parents-in-law.

The few Chinese women who immigrated legally to the West during the last half of the nineteenth century were primarily wives of Chinese merchants. Although immigration was forbidden to wives of Chinese laborers under US law, merchants were usually exempt from this prohibition.

Since Chinese custom required that a man's parents arrange his marriage, Chinese men seldom married in the United States. When a married Chinese man ventured here for entrepreneurial reasons, leaving his family members behind in China, he undoubtedly missed female companionship. Once established and financially secure, he might consider obtaining a woman for his home away from home. In that case, he could buy one to be his concubine and would thus have exclusive use of her services.

That is apparently what happened to Polly. In the 1921 interview, she stated that her parents in China sold her because they had no food. Indeed, she could have been sold again, more than once, before she arrived in Portland in 1872. There, a Chinese man bought her and took her to Warren in a pack train.[11] Although Polly might have been purchased as a servant, her price, $2,500, is too high to justify that assumption. Prostitution is also unlikely. Polly's Warren owner would have been a wealthy Chinese businessman, perhaps the proprietor of a local saloon/dance hall. A Chinese merchant or any other Chinese man of status found it distasteful to share a woman with other men, particularly lower-ranking ones, such as laborers.[12] Therefore, the most likely explanation is that Polly was purchased to be the Chinese man's concubine. A woman in that kind of relationship, while not a wife, was "like a wife." Consequently, based on the fact that Polly called herself a widow in

the 1880 census, she was undoubtedly purchased as a concubine. If her owner then died or returned to China, as implied in an account of her life that she corroborated in 1933,[13] she would have considered herself a widow. One writer succinctly summed up Polly's tragic situation, writing, "Though she [Polly] may have experienced sexual exploitation at his [her owner's] hands, she was probably not intended to service the community."[14]

One reason for people having the mistaken impression that Polly Bemis was a prostitute comes from an illustration in the book, *Thousand Pieces of Gold*. An uncaptioned photo introduces "Part Two—1872" and shows a young Chinese woman behind a screened window, one that seems to be part of a door.[15] Photo credits on a separate page, easily missed, identify the image as "Chinese slave girl in a Chinatown bagnio. ... Courtesy of the Caxton Printers and the San Francisco History Room, San Francisco Public Library." Because the book is called "a biographical novel" on the title page, and since some images in it do depict Polly, it isn't surprising that readers might conclude that all the photographs are of her.

Polly may well have been molested, even raped, by her various captors and owners, but there is no evidence to support the statement that she was once a prostitute. Writers conducting inadequate research and possessing overactive imaginations have portrayed Polly in this unflattering and inaccurate light.

The Name of Polly Bemis's Chinese Owner Wasn't "Hong King"

Although numerous accounts of Polly's life, written after her death, often state that her Chinese owner's name was "Hong King and that he owned a saloon,"[16] there is no evidence showing that either statement is true. No Chinese man with that name, or that exact occupation, appears in any of the documentary sources so far located. Although two Warren Chinese dealt in "retail liquor" in 1870 and 1871, their names were My Yick Chung and Ye Yick.[17] In a brief sketch of Polly Bemis's life, historian M. Alfreda Elsensohn used the name "Hong King" for the Chinese man who owned Polly; however, Elsensohn herself questioned its existence. In a 1943 letter to a local "old-timer" she asked, "Do you know whether there was a Chinaman by that name at Warrens in the early days?"[18] There is no record of any response, and where Elsensohn learned that name isn't yet known. Her earliest use of "Hong King," in 1947, mentions that she found it in "several printed accounts,"[19] that she doesn't identify.

Since Polly cost $2,500 in 1872,[20] the 1870 US Census might indicate if any Chinese man then in Warren could have afforded to pay that much money for her two years later. In 1870, the only Chinese man in Warren with sufficient net worth was a 30-year-old placer miner named Ah Yung.[21] The word "Ah"

was often used before Chinese first names, so Ah Yung simply meant "that person is called Yung," with no indication of any last name.[22] He had wealth valued at $3,500. The next wealthiest Chinese man, Ah Hon, a 35-year-old merchant, had a building and possessions worth only $1,900 in 1870[23] (Fig. 9.1). With "Hon" being his first name, and no last name given, he <u>might</u> be the "Hong King" referred to, but that coincidence isn't enough to say that his name <u>was</u> Hong King, or that anyone in Warren actually had that name. The person who bought Polly in 1872 may not even be in the 1870 Warren census. He may have arrived after the census was taken, or wasn't counted. For example, Charlie Bemis, who later became Polly's husband, lived in Warren by 1870, but for some reason he isn't listed in that year's census. Perhaps he was out-of-town, or mining in a remote area.

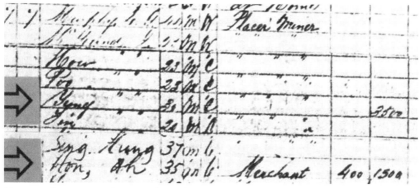

Fig. 9.1 Composite of entries from the 1870 US Census showing Ah Yung and Ah Hon and the amount of wealth each man reported. US Census, Ninth Census of the United States, 1870, Idaho County, Washington [Warren] Precinct, Idaho (National Archives Microfilm Publication M-593, roll 48, sheet 195, pages 7 [Ah Hon], 9 [Ah Yung]); Records of the Bureau of the Census, Record Group 29.

During the author's extensive research at the Idaho County Courthouse in Grangeville, Idaho, the name "Hong King" wasn't found. Similarly, Warren researcher Gayle Dixon commented, "I have never come across the name Hong King anywhere in all of the documents that I have looked at, and I have looked at many primary documents."[24] It may instead have come from recollections of Warren mining companies or property owners with similar names. For example, an "Ah King" and an "Ah Hong" conducted property transactions in Warren in 1875 and 1876.[25] Ten years later, in an 1886 Idaho County report on assessed valuations for tax purposes, two names were Hong Sing Hong, with property valued at $3,405, and Hong Hing, whose property was worth $6,660.[26] A similar report for 1887 included Hong Hing Hong Co., $6,600, and Hong Fook Hong, $1,250.[27] The name "Ah King" appears in

what may be the index to the incomplete "Patterson Store Ledger," 22 pages of which are housed at the Payette National Forest in McCall, Idaho. The index suggests that his name will be on page 2, and indeed, on the second page of the unpaginated document, under Nov. 6, 1894, is the notation, "Paid Ah King $9.00."[28] With several personal and company names having elements of "Hong" and "King," local memory may have combined them into "Hong King."

In a further search for the name of Polly's owner, there is a possibility that he was called "Big Jim" by his non-Chinese acquaintances. In late September 1933, shortly before Polly died, her friend and former boarder, Jay Czizek, stated,

> 'Big Jim'[,] an exceedingly tall[,] handsome Chinaman, was the leader of the Chinese colony, he might be designated the mayor. He managed all their affairs. He always dressed in elegant brocaded silk robes and wore a mandarin cap with a scarlet botton [button] on the top. He brought a half dozen Chinese women to the camp [Warren].[29]

However, if 'Big Jim' were Polly's owner, Czizek couldn't have known him personally; Czizek didn't meet Polly until about 1888. Polly had been living with Charlie Bemis since at least 1880, which implies that "Big Jim" was either dead or had departed Warren by then.

Who was "Big Jim?" That nickname isn't substantiated by Idaho County records. A Chinese American family, however, who resided in Idaho for many years, recognizes a man called "Big Jim" as an ancestor. His Chinese name, in transliteration, was Chin Tan Sun, and by 1900 he was a millionaire businessman in San Francisco.[30]

Other accounts of Polly's life have used different names for her Chinese owner, calling him "Wing Toy";[31] "Ah Sung";[32] "Hong Kong";[33] "Hog King,"[34] and "Hong King Hum"[35] as well as suggesting that she had four joint owners, "Wing Lee," "Hang Ki," "Ah Lin," and "Shun Wo."[36] The need for authors to invent a name for Polly's owner, whether "Hong King" or something else, indicates that his actual name is probably lost to history.

Polly's Chinese Name Wasn't "Lalu Nathoy"

Over time, people have speculated about Polly Bemis's Chinese name, most often believing that it was "Lalu Nathoy." However, that name doesn't appear in any of the early newspaper accounts, in the interviews with Polly, or in the Shepp diaries. Its earliest occurrence seems to be in 1947, in Volume 1 of M. Alfreda Elsensohn's *Pioneer Days in Idaho County*.[37] There she states, "As previously indicated, in the Certificate of Marriage (Chapter Three, Fig. 3.4), her Chinese name was Lalu Nathoy." This statement is very curious,

because the name Lalu isn't mentioned in the Certificate; her first name is given as Polly.

In examining the document itself, there is some ambiguity in the spelling of Polly's surname, which has often been deciphered as "Nathoy," but it could well be "Hathoy." Compounding the difficulty of interpretation, there is no other capital H or capital N in the document. However, it is clear that it should be Hathoy because, in the marriage record ledger book at the Idaho County Courthouse in Grangeville, Polly's surname appears as Hathoy in both the index and the marriage record itself[38] (Fig. 9.2). The transcription of Polly's surname, in both the index and the entry, could be interpreted as Hathay, Hathey, or Hathoy, but in the original certificate it is definitely Hathoy. The "H" is unquestionably an "H" when compared with that letter written by various clerks, for example, the index entry for Walter Hovey Hill in the same volume.[39] The Bemises' marriage was evidently not recorded until late September since their entry in the marriage record book follows one that was filed on September 24, 1894, for another couple.[40]

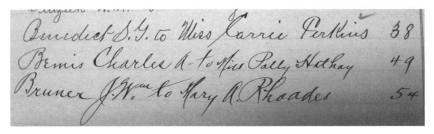

Fig. 9.2a. Marriage of Polly and Charlie Bemis as officially recorded, 1894, showing their names in the index.

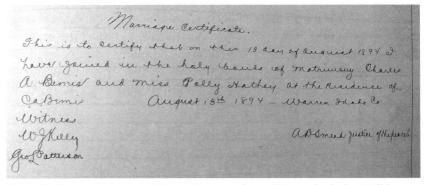

Fig. 9.2b. The Bemises' recorded marriage certificate. Note in both that Polly's surname is spelled with an H, not an N, Idaho County, Marriages, "Marriage Record, Probate Court" [1890-1911] (Idaho County Courthouse, Grangeville, ID), index under B and p. 49. Both courtesy Sam Couch.

Since neither Nathoy nor Hathoy is a Chinese name, this word may be an approximation of the Chinese name, Ah Toy, "a common given name for women."[41] Curiously, or coincidentally, one author of a fictional account does use the name Ah Toy for Polly.[42]

As mentioned, Elsensohn first used the name "Lalu" for Polly in 1947, but how she learned it, or believed it was accurate, is unclear. Polly died in 1933, before Elsensohn began her research into Idaho County history, and there is no record that the two women ever met.

Polly's national origin might give a clue as to whether the name "Lalu" could be accurate. As indicated in the 1880 US Census, she came from the "Pekin" [Beijing] area, in northern China, and is possibly of the Daur ethnic minority whose language is related to Mongolian (Chapter One). A query to the Institute of Nationality Studies in Beijing provided the following response from Wu Anqi, a research fellow there and vice-chief editor of the journal *Minzu Yuwan* ("Minority Language"): "In Mongolian, the sound "L" cannot appear in the beginning of the words as other consonants so much, and Lalu is meaningless both in Mongolian and Manchu."[43]

In addition, Wu Chizhe, a professor at Inner Mongolia University, wrote, "I made some inquiries here with colleagues of Mongolian and a few other ethnic origins concerning Lalu Nathoy (or Hathoy). They pondered and pondered over such a strange name and then told me that it makes no sense in their languages."[44]

During the late nineteenth century, as Chinese women arrived in Western communities, local residents often gave them Western names, such as "Annie," "Fannie," "Mary," and "Jennie," rationalizing that their Chinese names were too hard to remember or pronounce. If Polly's actual name <u>had</u> been "Lalu," in itself not exactly difficult, then why would the Euroamericans in Warren call her "Polly" and not "Lulu," "Lula," or "Lou"? Although never very common names in the United States, those three names reached the height of their popularity in the early 1880s,[45] so would have been well-known names to Warren residents even in 1872. In 1880, the earliest date for which name popularity figures are obtainable, Polly ranked number 240, well after Lula (#39), Lulu (#86), and Lou (#122).[46]

Origin of the "Lalu Nathoy" Name

The handwritten name "Lalu Nathoy" appears on one of two versions of an undated (but see below), typed manuscript about Polly Bemis ["China Polly—A Reminiscence"] written by George J. Bancroft (Fig. 9.3), a mining engineer who knew Polly and Charlie Bemis, but not until 1917.[47] Several repositories hold one or both copies of this manuscript; each bears different, handwritten annotations by his daughter, Caroline Bancroft. One of them

(call it Manuscript A) is in both the Denver Public Library and The Historical Museum at St. Gertrude in Cottonwood, Idaho. The other one (Manuscript B) is in both the Denver Public Library and the Idaho State Historical Society in Boise (Fig. 9.4).[48] Manuscript B is a photocopy of Manuscript A, but on larger paper (11"x 17"), probably to give Caroline Bancroft more room for writing her notes.

Fig. 9.3. George J. Bancroft, about 1910. Courtesy Denver Public Library, Western History Collection.

Fig. 9.4. Composite illustration of Manuscripts A and B. Manuscript A, top, is from the George J. Bancroft papers in the Caroline Bancroft Collection, L29, Box 4, FF 56, in the Western History Collection at the Denver Public Library with a copy at The Historical Museum at St. Gertrude, Cottonwood, Idaho. Manuscript B, below, is from the George J. Bancroft papers in the Caroline Bancroft Collection, L29, Box 21, FF 110, in the Western History Collection at the Denver Public Library with a copy at the Idaho State Archives, Boise, MS 2/13.

The five-page, typed, Manuscript A has a handwritten title, "China Polly —A Reminiscence by George J. Bancroft." The handwriting is identical to that of Caroline Bancroft, who made additional notes on page five. Each page is initialed G. J. B. in printed Gothic lettering in the upper right-hand corner. Because the writing is different from that of his daughter, a few handwritten corrections to the text of the manuscript were probably made by Bancroft himself.

The date of George J. Bancroft's "China Polly" manuscript can be deduced from some information on page five. He noted that Charlie Bemis died in 1922 and that Polly "is now living in Elk City."[49] Since Polly actually lived in Warren from late 1922 until the fall of 1924, while her second house on the Salmon River was being built after the first one burned, Bancroft's manuscript can most likely be dated to that time period, and certainly to before Polly's death in 1933 because he implies that she is still alive at the time of his writing about her.

Manuscript A, containing Caroline Bancroft's additions to her father's essay, is signed "Caroline Bancroft, Dec. 30, 1952" (page five). Page one of Manuscript B bears a note that Polly died in November 1933, and page five has a reference to M. "Elfreda" [sic, for Alfreda] Elsensohn's book, *Pioneer Days in Idaho County*, Volume 1 [1947]. Although Caroline Bancroft wrote that it contained, "an excellent discussion of China Polly" (page five), Elsensohn didn't actually use the name "China Polly" at all.[50]

When Caroline Bancroft photocopied Manuscript A on larger paper to create Manuscript B, she must have photocopied her father's original manuscript because her additions to page five of Manuscript B aren't identical to the notations that she made to page five of Manuscript A. Using the oversize paper, she made additional notes on Manuscript B. The most intriguing of these appears on page one next to the title, and reads:

(Lalu Nathoy)

1862 [sic, for 1853]-1933[51]

Curiously, the name "Lalu" isn't in George Bancroft's manuscript at all. Presumably, Caroline Bancroft obtained that name from Elsensohn's *Pioneer Days in Idaho County*, volume 1, page 97, where it is reportedly in Polly Bemis's Certificate of Marriage ... but it isn't (Chapter Three, Fig. 3.4). Where Elsensohn obtained the name "Lalu Nathoy" is unknown.

Other additions to Manuscript B, in Caroline Bancroft's handwriting, include some history of Polly and Charlie Bemis on the bottom of pages one and two, and an undated rewrite, "Addendum by Caroline Bancroft," of the information contained on page five of Manuscript A. This includes correcting "Elfreda" to "Alfreda," thus indicating that the corrections to Manuscript B

were made after those to Manuscript A. Both manuscripts have wording (page five) stating that photographs in Elsensohn's book, on unnumbered pages between pages 90 and 91, were taken by George J. Bancroft and given to Pete Klinkhammer; Manuscript B states that Klinkhammer gave the images "to Sister Alfreda" [M. Alfreda Elsensohn].[52] However, if any of the images depicting the Bemises and the Bemis Ranch were taken by George Bancroft, that information didn't accompany the images to the various repositories where they are housed; instead, Charlie Shepp most likely took all of them.

Caroline Bancroft later relied on her father's written work as the basis for a published article about Polly Bemis. She first produced a typed manuscript titled, "China Polly: From Dancing Girl to Western Idol."[53] Dated to the "1950s," but certainly by late 1953, it is a precursor to her November 1953 *Empire* magazine article, "The Romance of China Polly,"[54] which in turn owes much to her father's manuscript, "China Polly: A Reminiscence."[55] None of these works mention the poker game in which Bemis supposedly won Polly.

Another possible origin for the "Lalu" name comes from the Chinese practice of addressing one's elders, even brothers and sisters, according to a name hierarchy in which siblings are addressed by birth order, i.e., "number one," "number two," and so on.[56] Lalu may thus be a corruption of *lao nu*, sixth daughter or sixth female.[57]

Polly's Written Name

Fig. 9.5. Chinese characters from Polly's court case, 1896. National Archives at Seattle, "Judgment: The United States vs. Polly Bemiss" [sic], Judgment Roll 181, Record Group 21, National Archives at Seattle, Seattle, Washington, 1896, 2.

In 1896, Polly had to apply for a Certificate of Residence, required for all US Chinese residents, to avoid deportation (Chapter Three). The document from her court case (she didn't appear in person) is in the National Archives at Seattle, Washington.[58] Two blurred Chinese characters appear on one page of it (Fig. 9.5). At first, several people literate in the Chinese language who looked at them said that the characters don't read "Lalu Nathoy," and, also, that they are apparently meaningless. They suggested that since Polly couldn't read or write, she may have learned these marks, from a literate Chinese person in Warren, and used them to symbolize her signature.[59]

More recently, several scholars perceive the two characters as reading, "Gong Heng" or "Gung Heung" and have various arguments to support this

interpretation.[60] Strangely, however, that name appears nowhere else in all the documentation about Polly Bemis.

Instead, Emma Woo Louie, an authority on Chinese names,[61] provides a much more common-sense approach. Louie's explanation invokes the principle of "Occam's razor," in which the simplest explanation is usually the correct one.[62] Louie suggests,

> The Chinese characters on her Certificate of Registration [i.e., the court case document that entitled Polly to receive a Certificate of Registration] don't look like regular words. My first guess is she was trying to use the characters to phoneticize Polly [in Cantonese]: P'o [pronounced Poh], the word for 'universal' and Li [pronounced Lee], the word 'plum' (Fig. 9.6). But [in the signature on the document] some strokes are missing at the top of the first character and a little extra left side stroke was added. The top of the 2nd character is missing two strokes.[63]

Polly could neither read nor write the Chinese language. Although the written characters convey the same meaning throughout China, their pronunciation is different in different regions of the country. Most, if not all, of her Chinese-speaking contemporaries in Warren would have been from southern China; their spoken language was Cantonese or Taishanese. A literate Chinese person must have taught her the characters that, in Cantonese or Taishanese, would approach the pronunciation of her name,

Fig. 9.6. The characters in Fig. 9.5, properly written, phoneticize Polly [in Cantonese] as P'o [pronounced Poh], the word for 'universal,' and Li [pronounced Lee], the word 'plum.' Thanks to Emma Woo Louie for this interpretation.

P'oh Lee. As she was unaccustomed to writing them on a daily basis, it isn't surprising that she misremembered some of the necessary components, nor is it surprising that they look like other words.

Louie commented,

> It is so easy to leave out a stroke or two, add a stroke or two when one doesn't write in Chinese regularly. Also thought the characters could have represented the sound of Polly because I had seen certificates of residence in which the Chinese characters represented the sound of the name that was written in English and they did not always consist

of a family name and given name. For example, a couple of men named Charlie wrote their names in Chinese by using a character that had the sound close to "Cha" (each chose a different character) and the plum lee character for the "lee" sound.[64]

Both Charlie ("C. A.") Bemis and Polly, with no surname given, have individual entries in the 1893 Idaho County Assessment Roll, the year before their marriage (Chapter Three, 1893). Polly was listed separately, under the letter "P" as "Polly" [in quotes] with information provided "by C. A. Bemis," indicating that even her future husband didn't know her Chinese name (Fig. 9.7).

Fig. 9.7. This 1893 Assessment Roll, created the year before the Bemises were married, lists "Polly," in quotes, under "P"; the notation, "by C. A. Bemis," indicates that even her future husband didn't know her Chinese name. From Idaho County, Assessments, "Assessment Roll and Delinquent Tax List, 1893" (Idaho County Courthouse, Assessor, Grangeville, ID), 130.

Polly may have been guarding her Chinese name for reasons of propriety. Difficult events in her life, while not her fault, might have shamed the family name, so it was better to conceal it. As an example, Chinese characters on four wooden "donor boards," dating to 1888 and part of the Beuk Aie Temple exhibit at the Lewis-Clark Center for Arts & History in Lewiston, Idaho, list the names of, and amounts given by, over 500 Chinese individuals and businesses to rebuild the temple. Six of the donors were women. Because no surnames appear for them, these women were probably prostitutes.[65]

Polly Bemis Wasn't Called "China Polly"

Although later writers such as Caroline Bancroft have sometimes called her "China Polly," there is no evidence that Polly Bemis's contemporaries used that name for her. An 1881 newspaper account refers to her as "Mrs. Chas. Bemis,"[66] even though Polly and Charlie weren't yet married, just living in the

same household. According to Johnny Carrey, who knew Polly in 1923 when both of them were in Warren, no one there called her "China Polly."[67]

Polly is briefly mentioned in a 1960 *Saturday Evening Post* article by Hal Evarts, where she is called "China Polly" and a "poker bride."[68] In one paragraph of just 19 lines nearly every "fact" about her is incorrect, i.e., "she was smuggled into this country in the 1860's" [1872], "she saved Bemis's life when he was wounded by a revolver shot by fishing the bullet out of his eye socket" [Bemis was wounded under his eye], and "she died at the age of eighty-four" [eighty].[69]

Polly Bemis Wasn't "Won in a Poker Game"

Just before her death, Polly stated that she wasn't "won in a poker game,"[70] and others who knew her also believed that the alleged poker game never occurred.[71] So, since Polly herself denied the "won in a poker game" legend, how did the story get started?

A University of Idaho history student, Georganne Slifer, may have discovered the answer. In 1988 I helped her find information on the Chinese in Idaho for her term paper in history.[72] The finished essay included the text of an interview Slifer had with her uncle, Herb McDowell, regarding the origins of "'the Poker Game Bride' story." McDowell, who grew up in Warren from late 1923 on, and who knew Polly through the fall of 1924, during his eighth year, stated emphatically, "Polly wasn't won in no poker game." He told how Polly and Lee Dick, a Chinese physician, nursed Charlie back to health after he was shot, and commented, "They got pretty close[,] her and Charlie during this time and when he got better they got married just like any other normal people." When Slifer asked how her uncle knew this was accurate, he said that Otis Morris had told him, implying that Otis Morris ought to know because he was the stepson of W. J. Kelly, a witness at the Bemis wedding.[73]

Earlier, about 1964, Herb McDowell had interviewed Otis Morris, a longtime Warren resident.[74] Morris stated, "My stepdad died in 1911 and up to that time I had never heard a thing about it but sometime after that in the next five or six years they got the story out that she was won in the poker game."[75] Therefore, Otis Morris first heard the story about 1916 or 1917. Morris also thought he knew where it originated, saying, "I'm satisfied in my own mind that Jay Czizek started that."[76]

Under further questioning from his niece about how the "poker game" story originated, McDowell elaborated:

> Oh, well, that story, well ole [old] Fred Shaffer [Shiefer] and Jay Cizik [Czizek] got that story going -- those two guys liked to joke and tell big stories so they just started tellen [*sic*] her that crape [*sic*]. "Telling

who, Herb?," asked the interviewer. [Y]ou know[,] that Catholic lady Sister Alfredo something from Grangeville [M. Alfreda Elsensohn, from Cottonwood]—well[,] they were just story telen [*sic*], you know how they are there in Warren, and that poor lady, she didn't know. She was lookin[g] to write for history.[77]

McDowell added, "It makes a good story though[;] someday maybe they'll make a movie out of it, but I think it'd be good for history if the truth were known"[78] Subsequently, McDowell augmented his earlier explanation:

... In later years, after Polly died, Fred Shiefer,[79] ... [Jay] Czizek, and Herb's father [Wallace McDowell], wanted to promote Polly, get her [story] in the movies, and make her famous. They would tell "windy" stories to [Hollywood movie producer] Sam Goldwyn[80] ["Sam Goldwyn had heard the story about Polly being 'won in a poker game' but he was not too interested in things that were made up."[81]] Goldwyn owned a mine in the [Warren area] back country, about 1927 or 1928,[82] specifically the Big Creek area.[83] He had a Franklin [touring car] and would drive up from California with his wife, early enough for steelhead fishing. Everybody liked Sam. Herb [McDowell] called him "the fishin'est old guy I've ever seen. He came up for the fishing from 1927.[84]

In her writings, M. Alfreda Elsensohn accepted the story that Polly Bemis was "won in a poker game," but that she "wasn't a poker bride." In other words, Bemis won her, but didn't marry her until later. The Historical Museum at St. Gertrude in Cottonwood has a two-page manuscript written by pioneer Taylor Smith about how Charlie won Polly in a gambling game. He names five men who reportedly saw the game and told him about it.[85]

Interestingly, one of the five was W. J. Kelly. Kelly was Otis Morris's stepfather, but Otis Morris said he had never heard the story until after his stepfather had been dead for five or six years. Therefore, there are unresolved contradictions here. However, given the anti-Chinese attitudes prevalent in early Idaho, it is difficult to believe that a lone Chinese man would sit across the table from a Euroamerican man, in a roomful of other Euroamerican men, staking his entire fortune playing a "white man's" card game.

Other people are just as convinced that the "poker game" story is true. A Spokane woman stated that her parents knew Charlie and Polly Bemis, and that the two couples talked about how Charlie won Polly in a gambling game.[86] Perhaps the Bemises played along with the story, got some good laughs out of it, and entertained their friends with it. Finally, nearing death, Polly denied that it had ever happened. In a more recent example, a newspaper article

about the 50th anniversary of an eastern Washington couple stated, "Howard teases that 'he won Sybl in a poker game.'"[87]

During her lifetime, Polly Bemis was interviewed in person several times, once in July 1921 (published in June 1923),[88] twice in August 1923,[89] and once in August 1924.[90] As with Polly's supposed Chinese name, neither the stories based on the interviews nor Charlie Shepp's diaries mention the "won in a poker game" story, so if the legend even existed then, it wasn't widely known. Apparently, the first published account of it was a May 1932 article about cougar hunter George Lowe (Chapter Eight);[91] he had met Polly in mid-January 1932 when Charlie Shepp took him across the river to visit her.[92] Several months later, he embellished his written account of meeting Polly with stories that he had heard about her.[93]

Lowe wrote,

In those days gambling was the favorite past time [*sic*] of the miners and stakes were often high. *The story goes* [emphasis added] that the Chinaman met a man named Bemis, who was then in Warren, and they indulged in a friendly game of poker. In the game[,] luck smiled on Bemis and frowned on the Chinaman and in the end Bemis had all the man's wealth. The last wager was a fabulous sum put up by Bemis against Polly. Again Bemis won. The Chinaman, broke, left the country. Bemis married the girl and they lived happily together until his death several [actually, nearly ten] years ago.[94]

The next published mention of Polly in connection with the supposed poker game appeared in the *Lewiston Morning Tribune* in August 1933, when Polly was ill and in the Idaho County hospital at Grangeville:

Idaho County has boasted many interesting characters but none more so than Polly Bemis, a Chinese, who, when a comely miss of 18 years, was won by a white man from a Chinese in a poker game, being staked against a stack of gold.

...

The greatest romance in Polly's life – possbly the only one – centered around a gaming table. Fiction often tells of women and girls being used as stakes in a poker game, but hardly ever has that been known a fact. But in Polly's case it was.

Old-timers at Warren and in other mining camps tell of the game in which Polly was staked against a pile of gold. Her owner, a Chinese, lost her[,] and Charles Bemis, a white man, won. R. G. Bailey, writing of the early history of this part of Idaho, gathered material related to the poker game for unusual stakes for his book, "The River of No Return."[95]

Curiously, R. G. Bailey's book, *River of No Return (The Great Salmon River of Idaho)*, with its accompanying unwieldy subtitle, *A Century of Central Idaho and Eastern Washington History and Development, Together with the Wars, Customs, Myths, and Legends of the Nez Perce Indians*, wasn't published until 1935, two years later than the newspaper story that mentioned the legend.[96] Although the article implied ["Bailey writes"] that Bailey's book was already in print, it wasn't, but Bailey must have begun sharing information from it, perhaps in response to an inquiry from the *Lewiston Morning Tribune*.[97] In any case, whether in 1933 or in 1935, Bailey should be credited, if that is the appropriate term, with an early exaggeration of the "won in a poker game" legend. In his *River of No Return*, unnamed "old timers" told

> ... of one evening long to be remembered when every game in a big gambling house stopped dead still and the players and dealers alike gathered around Bemis to watch his poker play with a Chinaman.[98] ... The Chinaman was a leader among his race in the camp, and he and Bemis had met in many a friendly game. Sometimes luck was with one and then with the other. On this particular evening the Chinaman was decidedly out of luck. He had lost everything he possessed in the way of money. But he was a good sport and was willing to go the limit. He had but one possession left. This was a beautiful Chinese slave girl, who was 18 years of age[99]

Bailey provides no name for the Chinese gambler, nor for his "last and most cherished possession," which he wagered during this "tense and dramatic moment." The "old timers" told Bailey that "a pin could have been heard to hit the floor had it fallen," and "the intake of breath by the two men in the intense silence sounded like the exhaust from a steam engine." Although the poker hands "were nearly equal," Bemis emerged the winner.[100]

Bailey concluded, "The camp settled down to its humdrum existence, but 50 years later the dramatic story of Bemis and the Chinese slave girl were [sic] still favorite topics [sic] of conversation among the old timers."[101] If the supposed poker game took place in 1872, as inferred from Polly's age at the time, then "50 years later" would have been in 1922, when the "old timers" told Bailey this tale.

Much of the other lore that has been handed down about Polly Bemis can be traced to Colorado's George J. Bancroft (1873-1945).[102] He wrote a reminiscence about her, "China Polly," mentioned earlier. Although it is undated, internal evidence suggests that it was apparently composed about 1923 or 1924,[103] and was probably known only to his daughter, Caroline, during his lifetime. His precise account, with its wealth of detail, seems plausible, until we realize that Bancroft was never in Warren while Polly and Charlie

were living there. He met them about 1917 when he came out to the Salmon River country as a mining engineer for the War Eagle Mine; the first mention of him in Charlie Shepp's diaries is in April 1917.[104] Interestingly, Bancroft's reminiscences don't include the "poker game" story, so he may not have heard of it by then:

It is obvious that none but the boldest and most persevering gold seekers would ever find their way through the dense woods and the rough mountains to the Eldorado of Central Idaho; nevertheless Polly, the pretty, sweet[,] little Chinese dancing girl, found her way there. [This account ignores Polly's Chinese owner arranging to purchase her in Portland in 1872, and her transport to Warren over well-established trails.]

...

By and by he [Bemis] bought a place of his own [in Warren]. There was a small bar in front and a bed room in the rear, but the place was mostly given over to roulette wheels and card tables.

...

Next door to Charles Bemis' gambling emporium was a large dance hall, and, in spite of the hardships [of mining], there were a number of dancing girls. The [Chinese] proprietor was shrewd and progressive. Chinamen won't buy much whiskey [true] but they are liberal with their women folks [unproven], so he sent to San Francisco [Polly actually came through Portland] for a bevy of Chinese dancing girls [unproven]. Among them [one or two were left in Florence] came Polly [brought alone, by a Chinese pack train operator], —Polly with the pink cheeks and the shy, modest ways. The [C]hinese girls were a great hit. [Polly was then the only Chinese woman in Warren.] Not only did the [C]hinamen loosen up and spend much money with the girls, but some of the white miners took a great fancy to the little [O] rientals. This situation naturally led to race feeling and occassional [sic] "rough houses" and the girls themselves were often roughly handled.

Polly was always industrious and noting the untidiness of her neighbor's (Bemis') bedroom she used to slip over during the early afternoon and tidy up Bemis' room. This of course pleased Bemis and he took a personal interest in the little dancing girl. Also she had been taught the art of goldsmithing and she used to beg nuggets from her freinds [sic] and fashion them into hammers and picks and other trinkets which in turn she sold for goodly sums. So what with the goldsmithing, the tips she got from Bemis and the money she got from

women's time-honored methods [slanderous; implies prostitution], she prospered greatly.[105]

When things got too rough in the dance hall she used to fly out the back door and into Bemis' back door or if unable to do this she used to call Bemis [how?] and he never failed her. His quiet, sober, stern personality together with his reputation for being able to keep a can rolling with his six[-]shooter saved Polly from several very threatening situations.[106]

As discussed earlier, Bancroft first met the Bemises at their home on the Salmon River in the spring of 1917.[107] He apparently didn't know that the 1880 US Census for Warren, then called Washington, shows Polly and Charlie Bemis, unmarried, listed as living together in the same household. Ten years later, in September 1890, Bemis was shot in the face by a part-Indian man who felt that Bemis owed him some money; Bancroft, who wasn't present for the event and didn't know its date, just called it "One day …."[108] His description of it is completely fanciful compared with contemporary witness and newspaper accounts.[109] For example, "Polly heard the shot and came running over." [They were living together in 1890.] She "aroused the town marshall [sic] and got the doctor" [the doctor actually came from Grangeville, over 100 miles away.] After two weeks, "Polly found the bullet inbedded [sic] in the flesh at the back of the neck. Bemis was so cross at the doctor for refusing to do anything to try to save his life that he would not have him come near the room [the doctor had long since returned to Grangeville], so Polly, the dancing girl, got a razor and cut out the bullet."[110]

Two newspaper stories that appeared during Polly's lifetime both contradicted the "won in a poker game" story. In September 1933, a newspaper article reported that "Czizek explodes myth of Chinese poker bride," suggesting instead that an Indian girl named Molly was the "real poker bride."[111] Jay Czizek was Polly's friend as well as her former boarder from when she ran a boardinghouse in Warren in the early 1890s. As mentioned, Otis Morris believed that Jay Czizek had helped promote the story that Polly Bemis was won in a poker game. If true, that would explain Czizek's denial of it in September 1933.[112] Another mention, Polly's own denial, expressed through her nurse, is Lamont Johnson's November 1933 article, just before Polly's death.[113]

Chinese American writer Walter Mih has recently proposed an alternative explanation for Polly's association with Charlie Bemis. Mih speculates that since Polly's sale price in 1872 was $2,500, "it is inconceivable that her Chinese owner would just give her up for free."[114] He suggests, instead, that over several years, Polly's Chinese owner "owed a large sum of gambling debts to Bemis. … If Polly's owner had returned to China with her as his concu-

bine, it would have caused much discontent within his family at his ancestral home, so it was better for him to return home alone." Mih suggests, therefore, that "when [Polly's owner] was ready to return to China, he offered Polly to Charlie in exchange for his large gambling debts."[115]

Chinese custom supports this interpretation. Scholar Maria Jaschok has noted, "A change in the status of a female was conditional on intervention of a member of the male dominant structure."[116]

Other Legends about Polly Bemis

Since Polly Bemis's death in 1933, in addition to the more common inaccuracies about her, discussed above, others have surfaced. She supposedly was smuggled into San Francisco in a padded crate, came in 1872 as a cook, worked on the railroads, used a crochet hook to extract a bullet from Charlie Bemis's head, settled on a "homestead" on the Salmon River, nursed others as "The Angel of the Salmon River," and became a US citizen.

The "Padded Crate" or "Cage" Legend

One author has written, "separating the real Polly Bemis from the legend has been next to impossible."[117] True, but that doesn't entitle anyone to perpetuate myths about Polly, one of which seems to have originated in Christopher Corbett's *Poker Bride*, namely, that Polly "was smuggled into the port of San Francisco, probably in a padded crate."[118] In fact, Polly herself told how she was smuggled into Portland, not San Francisco.[119] Although no evidence is provided for the "padded crate" assertion, other authors have eagerly added it to Polly's "story." Elsewhere, Corbett's "probably" becomes fact, as in, Polly was "smuggled into San Francisco in a padded crate."[120] In another book, the authors transform the "crate" into a "cage."[121] There is no evidence for either version.

The "Cook" Legend

In a one-paragraph biography of Polly and Charlie Bemis, one author states that Polly "came to the West [C]oast as a slave at age 18 and to Warrens as a cook in 1872."[122] Perhaps the "cook" myth, seen nowhere else, came from the fact that Polly did run a boarding house in the early 1890s.

The "Railroad Worker" Legend

Perhaps the most outlandish myth about Polly is that she "was a Chinese lady imported at an early age to work on the railroads." Subsequently, she "was sold as a prostitute to work in the mining camps of Northern Idaho."[123] That author may have seen, and misinterpreted, Charles Kelly's 1970 article where he states, incorrectly, "Polly had been admitted to the United States

under a work permit such as was issued to laborers on the Central Pacific Railroad. When her permit expired[,] Bemis married her to prevent her return to China"[124]

The "Crochet Hook" Legend

According to one romanticized account, Polly "removed the bullet from [Charlie's] neck with the help of a razor, [and] cleaned out the festered wound with her crochet hook sterilized no doubt with whiskey"[125] Realistically, however, no interviews with Polly, or any other primary sources, support the popular notion that she supposedly extracted the remainder of the bullet with a crochet hook.[126] Although Polly may have extracted the remainder of the bullet, as is widely believed, nowhere does it explicitly state that she actually did so, or with what implements. Surely tweezers would have been more effective.

Attached to this legend is the one about Polly being the daughter of a Chinese labor contractor. After Bemis was shot,

He needed a nurse badly, but there was none available in Warrens. In that camp was a Chinese contractor of Chinese labor who had a young, beautiful daughter of about eighteen years. She was hired to nurse Charles and they fell in love and were married. Rumor has it that the fathers of the couple disowned them.[127]

The "Homestead" Legend

In May 1894 or a bit earlier, Charlie Bemis purchased the ranch on the Salmon River where he and Polly would live out their lives.[128] Although it has often been called a "homestead," that designation is inaccurate because they didn't "homestead" their land in the sense of legally filing on a piece of public land. It was actually the Bemis Ranch Claim, a mining claim. Bemis didn't officially locate it until November 1898, and he finally recorded it in February 1899.[129]

A magazine article published in 1960 accurately stated that after Polly and Charlie Bemis married, they "moved down to his placer claim on the river."[130] If more future writers had read it, they would have been less likely to call it a "homestead."

The "Angel of the Salmon River" Legend

In a 1970 article for *The Pony Express: Stories of Pioneers and Old Trails*, under a photograph of Polly Bemis in a long, light-colored dress, described as "nursing garb," author Charles Kelly ("Rocky Mountain's Top Historian") called Polly the "Angel of the Salmon River," stating that she was the "official nurse for anyone who became ill or injured. Whether they could pay or not,

the 'Angel of the Salmon' nursed the patients."[131] The photograph Kelly used actually came from R. G. Bailey's book, *River of No Return*, where it is captioned, "Polly Bemis, the Chinese slave girl, as she appeared in 1927 [*sic*, for 1923], when visiting Grangeville"[132] (Fig. 9.8). The 1923 date is confirmed by the use of a portrait from the same photo in an *Idaho County Free Press* article dated August 23, 1923[133] (Chapter Seven, Fig. 7.22).

Although Polly Bemis was in Grangeville for only one week of her long life, author Benson Tong perpetuates the nursing legend in his book about Chinese prostitutes. About Polly he writes, "Throughout her life, she provided succor to the sick and ailing in the community of Grangeville City."[134] In support of this statement, Tong cites M. Alfreda Elsensohn's *Idaho Chinese Lore*, but nowhere does Elsensohn provide that information.[135]

In 1968 an interviewer asked Pete Klinkhammer, Polly's neighbor, "What would you do when you got sick when you were in here?" Pete replied, "[M]y goodness, you just tended to doctor yourself." Then the interviewer asked, "Did Polly Bemis ever have to do some doctoring for you?," and Pete replied, "No, nope. None."[136] Although the diaries of Pete's mining and ranching partner, Charlie Shepp,

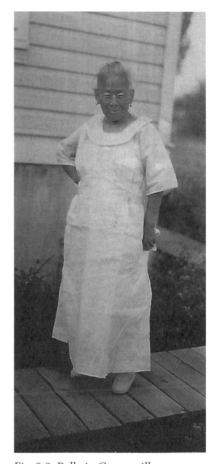

Fig. 9.8. Polly in Grangeville, Idaho, 1923. She is wearing the misinterpreted "nursing garb" mentioned in Charles Kelly, "He Won His Wife in a Poker Game," The Pony Express 36:9 (No. 429, February 1970), 4. Courtesy Nez Perce County Historical Society, Lewiston, Idaho, Robert G. Bailey Collection, photo number 75-53-634.

contain many references to Polly Bemis, none of them mention instances where she nursed her Salmon River neighbors, just their pets (e.g. Chapter Five, April 1910).

The "US Citizen" Legend

In 1966 the *Idaho County Free Press* published a couple of articles that referred to Polly Bemis's citizenship status, or lack of it. One stated, "it is known, after Chas. A. Bemis took the Chinese lady as his wedded wife, he started action to see that she was legally entitled to remain in this country."[137] A different story, on the same page of the same issue, reported, "Although Polly wasn't a citizen, Bemis' having married her, saved Polly from having to return to China."[138]

For many years, from the early 1950s into the mid-1980s, readers of the *Idaho County Free Press* enjoyed beloved columnist Frances Zaunmiller Wisner's regular articles about life on the Salmon River. Many of them were later collected into the book, *My Mountains: Where the River Still Runs Downhill.*[139] One column, which appeared on June 30, 1976, expanded on the citizenship topic but seems to have misinterpreted it by stating, "Bemis had the paper work done, so Polly could, and did, become a citizen of these United States. No danger of her being deported, should she be widowed."[140]

Because Polly Bemis had emigrated from China to the United States, she was, in quasi-legal jargon, "an alien ineligible to [or for] citizenship" because she was born in an Asian country.[141] Sadly, the 1882 Chinese Exclusion Act, a racist US law forbidding Polly or any other Chinese immigrants from becoming naturalized citizens, wasn't repealed until the Magnuson Act of 1943, ten years after Polly's death.[142] Even marriage to Charlie Bemis, an American citizen, did not allow Polly Bemis to apply for citizenship.

Conclusions

Because Polly Bemis was an unusual person, about whom facts are few and hard to find, most people who have written about Polly since her death in 1933 have chosen to believe myths and inaccuracies about her, or have even contributed to them. Disbelief in the romanticized versions of her life is overdue. Polly Bemis wasn't a prostitute, her Chinese owner's name wasn't "Hong King," Polly's Chinese name wasn't "Lalu Nathoy," and Charlie Bemis didn't win her in a poker game. Polly Bemis's own history is genuinely fascinating; she was a remarkable person whose life doesn't need embellishment.

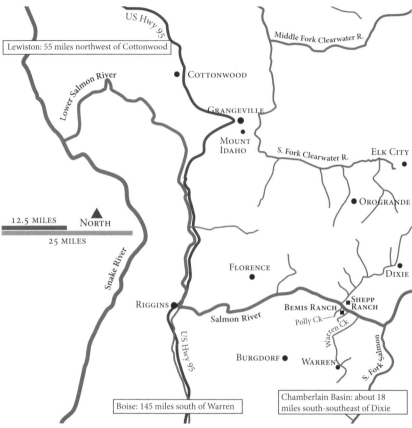

Map 10. Idaho place names mentioned in Chapter Ten. Drawn by Melissa Rockwood.

CHAPTER TEN:
Epilogue, Polly Bemis's Legacy

During the rest of November 1933, after Polly's death, Charlie Shepp crossed the river several times to get things from her home, including staples such as sugar and flour. In addition, he retrieved Polly's bed, presumably the one he had made for her in 1924 before she moved back down to the Salmon River from Warren. He also fed her cat, Johnnie.[1]

December saw Shepp at Polly's place several times. He usually didn't provide a reason for his visits, but on the 14th he and "Alex," probably Alec Blaine, went over in the afternoon. They "got fence at barn up & took stove pipe down."[2]

On December 15, age 70, Polly's good friend Ah Sam [Jung Chew], Warren, Idaho's, "beloved Chinaman," died there "at the home of Mr. and Mrs. G. T. Eyman [usually Eyeman], who had been his devoted friends for years."[3] His obituary was front-page news in both Boise's *Idaho Daily Statesman* and Grangeville's *Idaho County Free Press*. "China Sam died … of an attack of influenza which struck him at his shack a few miles from town and brought death soon after he had made his way to the home of a neighbor."[4] Ah Sam "was a familiar figure about the town, welcomed in every home, beloved by old and young. He always had a cheery laugh and a kind word for everyone and no child was ever neglected with a treat. He was a life time [*sic*] friend of Polly Bemis, the Chinese woman who died recently in Grangeville."[5] The community's regard for Ah Sam resulted in his burial in Warren's Euroamerican cemetery, not in the Chinese cemetery, and in the erection of a gravestone for him (Fig. 10.1).

In January 1934 Shepp again went over to Polly's place a few times. On the 11th, he "didn't see Johnnie," Polly's cat, and on the 16th he wrote, "Johnnie gone."[6] Finally, on February 1, 1934, Shepp made what would be his last related trip across the river to Polly's place. That day he wrote, "Over river PM. I guess Johnnie is gone."[7] In hindsight, given Shepp's concern about feeding

Polly's cat, it seems odd that Shepp didn't try to capture Johnnie and take him over to the Shepp Ranch.

Early March 1934 marked the death of Ah Kan, another of Polly's Chinese friends (Fig. 10.2). Kan was a well-known Warren pack train owner, almost certainly the man who had brought Polly to Warren from Portland. "Can" [sic] came to Warrens when he was 16 and packed for many years," finally selling his pack string about

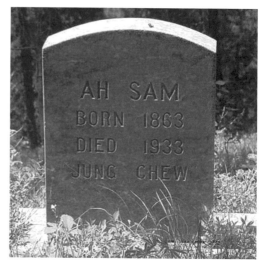

Fig. 10.1. Gravestone of "Ah Sam" (Jung Chew) in the Warren, Idaho, cemetery. Photo by author.

1908.[8] In the winter of 1931-1932 he reportedly put ashes over the snow to discourage children from skiing near his cabin.[9] In February 1934, Kan, now the last Chinese person in Warren, had been ill for several days and was taken by plane from Warren to the Grangeville hospital.[10] Ironically, Kan apparently "hated airplanes and hit them with his walking stick saying 'son of a bitchy—pretty soon you fall down.'"[11] At the hospital "attendants undressed the Chinese, took his filthy clothes and burned them despite his desperate fight with them and unintelligible complaints"; Kan later conveyed "that he had his money sewn under the patches."[12] On March 10, 1934, Kan died in Grangeville.[13] Although Kan's burial took place in Grangeville's Prairie View Cemetery, his grave hasn't been located.

If deceased indigents were found to possess any money, Idaho County appropriated it. In mid-May 1934 the Idaho County Commissioners accepted and approved the "Report of the Probate Judge on money paid in to the county treasury, which has come in to his hands from the effects taken from the deceased persons, who have been county charges, and applied on the expense that the county has been to in the care of said persons during their last sickness, and before."[14] For example, "Polly Bemis, a chinawoman" [sic] had $5.00 which was "paid in to the county treasurer and credited to the Indigent Fund of the County." Similarly, the County recovered $27.50 from "Sleepy Kahn, Chinaman of Warran" [sic], deceased.[15]

After faithfully recording the Bemises' lives, and his own, for so many years, Charlie Shepp died. His date of death is uncertain; a marker at his grave

Fig. 10.2. Pack train operator Ah Kan, Warren, Idaho, 1928. From Jeffrey M. Fee, "Idaho's Chinese Mountain Gardens," in Hidden Heritage: Historical Archaeology of the Overseas Chinese, *ed. Priscilla Wegars, 65-96 (Amityville, NY: Baywood, 1993), 70. Photo in collection of Payette National Forest, McCall, Idaho, donated by Herb McDowell.*

gives it as 1936, when he would have been 76 years old. However, the last date he wrote something in his diary was November 20, 1937; that October he had been very ill. Although his grave appears to be to the left of Charlie Bemis's grave (Fig. 10.3), his coffin was reportedly buried on top of Bemis's.[16]

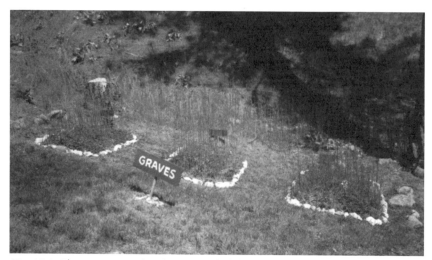

Fig. 10.3. Three graves at the Shepp Ranch; left, Charlie Shepp; center, Charlie Bemis; right, Alec Blaine. Photo in Asian American Comparative Collection, University of Idaho, Moscow, PB 2000.4.

On December 8, 1936, Polly's ranch was awarded to Pete Klinkhammer as his homestead but it wasn't until October 18, 1962, that he filed and recorded it at the Idaho County Courthouse in Grangeville.[17] Pete Klinkhammer also inherited the Shepp Ranch and continued to live there. During World War II, he left to work at the Portland, Oregon, shipyards. While he was gone, Alec Blaine and "Shorty" Fleming stayed at the Shepp Ranch.[18] When Blaine died in 1940, he was buried to the right of Bemis.

In 1943, because China was our ally during World War II, Congress finally repealed the Chinese Exclusion Act, first implemented in 1882 and subsequently renewed in 1892, extended in 1902, and made indefinite in 1904.[19] With repeal came the right of naturalization for people born in China,[20] too late for Polly Bemis, who died in 1933.

In 1950 Pete Klinkhammer agreed to sell the Shepp Ranch to Paul and Marybelle Filer for $10,000 on the condition that he be allowed to live there for the rest of his life. The Filers had owned stores in Elk City and Orogrande, but sold them and moved to the Salmon River;[21] they owned the Shepp Ranch until 1969.[22]

During the 1950s Vern Wisner lived at Polly's place at various times.[23] He was there in December 1955 and was expected to join the Filers and Klinkhammer at the Shepp Ranch for Christmas dinner.[24] In 1956, writer and local character Frances Zaunmiller, later Vern Wisner's wife, described how Marybelle Filer's cat "moved over to live with Vern." When Vern went to Elk City for the winter, the cat stayed behind at Polly's place. Pete

Klinkhammer, who rowed over every day to feed it, tried to catch it, without any luck. Somehow, the cat swam the Salmon, back to the Shepp Ranch, where Marybelle found it in the yard one October day, just as the weather was turning cold.[25]

Pete Klinkhammer, 20 years younger than Charlie Shepp, lived until 1970. He was 89 when he died and is buried in the Grangeville, Idaho, cemetery (Fig. 10.4).

Fig. 10.4. Pete Klinkhammer's grave at Prairie View Cemetery, Grangeville, Idaho. Photo by author.

The Popularization, Commercialization, and Exploitation of Polly Bemis

In the years since Polly's death, numerous manuscripts;[26] newspaper, magazine, and journal articles;[27] book chapters, sections, and collected biographies;[28] and several individual books have been written about her;[29] one of the books was even made into a film.[30] Various masters' theses and dissertations also incorporate Polly's "story" into larger discussions of the Chinese in the West.[31] In addition, Polly Bemis can now be found in art,[32] music,[33] drama,[34] film critiques,[35] encyclopedias,[36] and a multitude of Internet resources.[37] Almost all of these productions provide embellished versions of Polly's life, and perpetuate the legends about her; their citation in the endnotes is for information only and doesn't necessarily endorse them.

The Book *Thousand Pieces of Gold*

Much of Polly Bemis's subsequent fame derives from Ruthanne Lum McCunn's fictional biography, *Thousand Pieces of Gold* (1981),[38] as well as from the even-more-fictionalized film, *Thousand Pieces of Gold* (1991),[39] loosely based on the book. On the book's title page, McCunn describes it as

"a biographical novel" that "tells the story of … Polly Bemis. A few fictitious characters have been added and certain events transposed for the sake of the narrative, but the essential story of Polly's life remains accurate."[40] The title, *Thousand Pieces of Gold*, is the English translation of a term of endearment, *qiānjīn*, used by Chinese fathers to refer to their daughters.[41]

The film premiered in Lewiston, Idaho, on April 18, 1981, and was heavily advertised in the *Lewiston Morning Tribune*.[42] Reporter John McCarthy interviewed McCunn prior to the premiere,[43] interviewed some of the film's stars,[44] and wrote a review of the movie.[45] In her interview with McCarthy, McCunn stated that she was "not associated with it [the film] … and didn't work on the development [of it]."[46] Those comments were very gracious. In fact, when the film was in development in 1986, McCunn expressed apprehension about the producers' plans to portray Polly Bemis as a prostitute "for dramatic purposes," and tried, unsuccessfully, to buy back the film rights.[47]

Elements of the Poker Game Myth

The earliest published mentions of the "poker game story" provide just a simple account of its occurrence. Only in later retellings do the details develop over time, such as the exact cards allegedly held in the winning and losing hands. Not surprisingly, these differ wildly. Sometimes, mention is also made of the participants' physical descriptions and/or the clothes they were surmised to be wearing; these also vary in the individual accounts. The fact that these aspects aren't identical strongly suggests that the poker game didn't actually happen; if it were true, surely there would be more correlation among its details.

The Various Poker Hands

For example, the first "poker game" report so far located was a May 1932 newspaper interview with cougar hunter George Lowe who met Polly in February of that year. Although Lowe described the supposed game in some detail, he didn't include any information on the winning hand. Bemis was lucky and the Chinese man was not; "in the end Bemis had all the man's wealth," including Polly.[48] In August 1933, reporting on Polly Bemis's illness, the *Lewiston Morning Tribune* repeated the "poker game story," crediting it to R. G. Bailey, who had collected it for his forthcoming book, *River of No Return*. Here, too, the reporter doesn't mention the poker hands, merely saying, "Bemis' luck stayed with him and he won the girl."[49] Bailey's book, which appeared in 1935, says only, "The hands were nearly equal, but the luck of Bemis was with him."[50]

Over time, many enhancements have crept in to the "poker game story," including descriptions of the winning and losing hands. In an undated typescript, Roscoe LeGresley retold the story of the legendary poker game.[51]

Despite not believing that it had happened, LeGresley wrote about it anyway. In his version, "Bemis had a pair of Jacks showing, his opponent a pair of Queens, the call was made and Bemis flipped over a third Jack. The [Chinese man's] hole card was a d[eu]ce."[52]

An early magazine article, "How Mr. Bemis Won the Chinese Slave Girl," by Ladd Hamilton, appeared in a 1954 issue of *Saga: True Adventures for Men.*[53] The youthful author described it as a story that "has been handed down by old men who knew how the cards fell; old men who had long memories and who were there."[54] With a full house consisting of three Queens and two threes, "Charley" Bemis bested his unnamed Chinese opponent, thus winning Polly.[55]

In the 1960s, Western writer Lee Ryland published two articles about Charlie and Polly Bemis. The first, in 1962, was "Redemption of Charley Bemis" in *Real West: True Tales of the American Frontier*,[56] and the second, in 1967, was "The Strange Winnings of Charlie Bemis" in *Big West: True Stories of the Western Frontier.*[57] In the five years between the two articles, Ryland made several changes in, and enhancements to, the story line. For example, the spelling of Charley (1962) became Charlie (1967), and Charlie won Polly with a hand of four aces (1962) and four "bullets" (1967).[58] Ryland's 1962 story, apparently the first to describe the winning hand as containing four aces, may well have influenced Ethel Kimball's 1963 *True West* article, "River Rat Pioneer."[59] Although it is mainly about famed Salmon River boatman Harry "Cap" Guleke, it briefly mentions Polly Bemis who was "won by Charley [*sic*] Bemis when he held four aces in a poker game."[60]

Charlie had other winning hands, detailed in various sources. For example, in James Horan's *Desperate Women* (1952),[61] "Johnny" Bemis won Polly with five clubs, which beat "the elderly Chinaman's" three aces.[62] An undated (1950s?) typed manuscript by J. Loyal Adkison, entitled "The Charles and Polly Bemis Story as Told to Me by Taylor Smith,"[63] relates how Bemis supposedly won Polly with three Queens; his opponent had only aces and deuces.[64] Bemis's winning hand in Fritz Timmen's story (1969) was "Aces over," meaning a full house with three aces and an unspecified pair; this beat the unnamed "Chinaman's" ace-high straight.[65] In Charles Kelly's 1970 article, "He Won His Wife In a Poker Game," Charlie Bemis had four of a kind, while his opponent held only three aces.[66] By naming specific winning hands, writers hope to bring more credibility to the unsubstantiated "won in a poker game" story. However, if the story were credible, there should be more agreement.

For the chapter, "China Polly," in his 1974 book, "Days of the Tong Wars,"[67] C. Y. Lee credits James Horan's *Desperate Women* (1952) with the "ring of authenticity" regarding the life of "China Polly,"[68] while unaware that Horan's names for "Johnny" Bemis and "China Polly" were both incorrect. Despite

expressing adulation for Horan's work, Lee changed Horan's winning poker hand from five clubs to four kings and a queen.[69] Ruthanne Lum McCunn's *Thousand Pieces of Gold* (1981) had Charlie's full house beating Hong King's straight.[70] In Peggy Robbins's article, "China Polly: Poker Bride," (1991), "Big Jim's" three aces were no match for Charlie's "five clubs, a flush!"[71]

A 1961 article, "Charlie Bemis' Highest Prize," by Grace Roffey Pratt, doesn't state the winning hand, only that it "was close, but Bemis won," either due to "pure luck" or to "more than his usual cleverness."[72] Indeed, Pratt offers "another explanation, one that has never been suggested." She declares that "maybe Hong King *wanted* young Charlie Bemis to win," stating,

> It is not implausible that old Hong King had become fond of her [Polly] as a guardian often becomes fond of his charge and that he felt responsible for her permanent welfare. He knew the New Englander would never deliberately choose an Oriental for his wife, and would not be bribed or bullied into it. But he was sure to live up to a responsibility that was rightly his, and winning Polly at poker made her his responsibility.[73]

Then, to account for them living together, thus adding an aura of respectability to Polly and Charlie's relationship, the author speculates that "many a marriage went unrecorded. The couple may have had a Chinese ceremony. Whatever it was, it was satisfactory to them and was respected by the townsfolk."[74] Oddly, Pratt was unaware of the Bemises' 1894 wedding.

Descriptions of Polly and Her Clothing

To enhance the "realism" of their tales, some authors resorted to embroidering the details, complete with sexual innuendo. Ladd Hamilton's 1954 article, "How Mr. Bemis Won the Chinese Slave Girl," described Polly as a "sloe-eyed slave girl with the skin like whipping cream, the velvet hair[,] and the smooth[,] warm thighs."[75] Lee Ryland's first description of Polly, "Lalu Nathoy looking as pretty as a filly in a field of buttercups" (1962), became Lalu Nathoy, "a Chinese girl [who] was delicately lovely, her round, young body seductively sheathed in red brocade satin" (1967).[76]

C. Y. Lee's book, *Days of the Tong Wars* (1974) calls his "China Polly" a "nameless Chinese girl" in "a loose, old, blue cotton blouse and pantaloons, her hair disheveled." On the day of the big poker game, however, Polly dressed up in a "yellow silk blouse and pantaloons."[77]

In the poker game portrayed by M. Alfreda Elsensohn in her *Idaho County's Most Romantic Character: Polly Bemis* (1978), "Polly appeared dressed in yellow." After Bemis won Polly, he moved her "to one of the twin cabins,"[78] thus protecting Polly's reputation, since the two weren't yet married. McCunn, in *Thousand Pieces of Gold* (1981), even implied that "Lalu Nathoy"

was a virgin; after "Hong King" raped Polly, there was a "stain of blood that proved his victory."[79]

Peggy Robbins, in her "China Polly: Poker Bride" (1991), contrasts Polly with the "yellow" Chinese men who populated Warren, Polly was "olive-skinned," as well as being "graceful" and "pretty." On the day of the supposed poker game, she "wore a sheathlike yellow dress that was slit to her knees on both sides."[80] Fritz Timmen's fictional Polly wore a "high-necked Chinese dress [that] was plainly cut, but it fitted her figure well enough so [Charlie] could see she was a sure enough woman. She wasn't bold or brassy either, but kept her eyes cast down."[81]

Descriptions of the Other Participants

C. Y. Lee, in his *Days of the Tong Wars* (1974), refers to Polly's Chinese owner as "Wing Toy, the roly-poly tong leader with the sallow round face."[82] This description contrasts sharply with Ruthanne Lum McCunn's description of "Hong King" in *Thousand Pieces of Gold* (1981); there, Polly's owner had "bony hands" and "a Chinese face as cracked and creased as parchment," with "thin, white lips," "black stumps of teeth and sour breath," and "hairs sprouting from the wart on his chin."[83] In Peggy Robbins's "China Polly: Poker Bride" (1991), the Chinese man called "Big Jim," Polly's owner, was "quite large for a Chinese. He had very yellow skin, slant eyes that were beady and black, and he was pig-tailed."[84] The variety of names and descriptions, some quite stereotypical in "evil Fu Manchu" fashion,[85] reveal that none of the authors ever saw Polly's owner, or knew his name.

In contrast, the Chinese man's opponent, "John" [also "Johnny"] Bemis, was "a young, tall cowboy-miner with a good-natured face."[86] Another description of "Charley" notes that he "was tall and thin; his face was weather-beaten, bronzed by the sun, but he was good looking."[87]

Exaggerated Retellings of Polly's Life

In more recent years, a number of authors have repeated the "won in a poker game" story, or continue to print that Polly Bemis was a prostitute. For example, one wonders what she is doing in Benson Tong's 1994 book on Chinese prostitutes in nineteenth-century San Francisco.[88] Although correctly stating that she was born in late 1853, and arrived in Warren in mid-1872, Polly was then supposedly just "at the age of thirteen." Another misconception states,

> Later she nursed a regular customer of the saloon who had sustained a serious gunshot wound. The grateful white man, Charlie Bemis, offered to marry her, and she accepted. ... [H]er husband was burned to death in a fire that razed her property.[89]

The Chinese American Family Album (1994),[90] states that Polly "saved [Charlie's] life a second time by dragging him unconscious from their burning cabin"; Charlie Shepp's major assistance isn't mentioned. Also, Grangeville, Idaho, residents supposedly "named the stream running through her property Polly Creek in her memory."[91] Actually, in 1914, on the recommendation of Charlie Shepp and Pete Klinkhammer, government surveyors renamed the former Bemis Creek, earlier Powell Creek, in Polly's honor.[92]

Probably the most distressing assault on Polly Bemis's true history was the publication of Christopher Corbett's *The Poker Bride: The First Chinese in the Wild West* in 2010.[93] Although earlier articles had called Polly a "poker bride,"[94] none had the national impact of Corbett's controversial book, which uninformed readers praised,[95] and knowledgeable reviewers savaged.[96]

Preservation of Polly's Home on the Salmon River

In 1972, Jim Campbell and Hank Miller founded Wilderness Encounters/ Wild Rivers Idaho to guide people on float trips into the Idaho backcountry. The partnership dissolved after a year and the business continued under Campbell. He purchased the Shepp Ranch, across the Salmon River, in 1973, sold it after several years, and with three partners, purchased Polly's place from its then-owners.[97] Campbell lived there and developed the property into a time-share resort.[98] By 1983 Campbell had become affiliated with entertainer Wayne Newton or his accountant,[99] and the Wayne Newton Flying Eagle Resorts restored Polly's cabin in 1987.[100] On June 5 that year, Campbell's Salmon River Resort Club, then-owner of the Polly Bemis Ranch, dedicated her restored log cabin as a museum. The 80 attendees included Idaho Governor Cecil Andrus and other dignitaries.[101]

Exhumation of Polly Bemis

Just before the dedication event, Jim Campbell had Polly's remains exhumed from Grangeville's Prairie View Cemetery. He reburied her adjacent to her restored home,[102] so she is <u>across</u> the river from her husband, who is still buried at the Shepp Ranch. Polly's gravestone was also moved. Some evidence indicates that Polly's own wish was to be buried beside the Salmon River. In July 1959 a rafting trip stopped at the Shepp Ranch for the night. The party met ranch owners Paul and Marybelle Filer, and former owner Pete Klinkhammer, who continued to live there. According to a journal entry by trip member Leona Brown, who likely heard it from Pete Klinkhammer or one of the Filers, Polly Bemis "died ... in Grangeville where she was buried against her wishes as she wanted to be back where she could hear the river"[103] Klinkhammer's estate paid for Polly's gravestone there.[104]

In Idaho, exhumation requires a disinterment permit. Campbell obtained one, but it cannot now be located. Although the state of Idaho has a copy, state law prevents the agency from supplying a copy of the disinterment permit. No copy exists at the cemetery district in Grangeville, at the local funeral home, or at the Polly Bemis Ranch.[105]

Fred Noland represented Grangeville's Noland Funeral Home at Polly's exhumation. Around 1999, I interviewed him concerning that experience, asking, "What was the condition of her remains?" Noland replied, "We really can't reveal those conditions when we exhume someone."[106] Marvin Ackerman, the cemetery sexton who assisted with the exhumation, was more responsive. He stated that the body was in a casket inside a concrete liner. The men removed Polly's remains and put them into another box that they had made; it measured two feet on all sides. Ackerman described Polly as a very small person, whose skeleton consisted of her skull, "back bones" [vertebrae], and "big leg bones." Ackerman didn't notice anything unusual about the remains, and remarked that they "looked pretty natural." He also observed that Polly had false teeth and no jewelry, and that "her clothing was rotted." She had some hair left but they "couldn't tell much about its color because of the dirt." The men exhumed her in the morning and "a guy came with a truck and took her upriver."[107]

The man with the truck was Jim Campbell, then-owner of the Polly Bemis Ranch. He was also present at the exhumation, which was probably conducted with a backhoe. Campbell confirmed that Polly had false teeth.[108] He took Polly's remains to her home on the Salmon River and reburied her there prior to the dedication ceremony that celebrated her cabin becoming a museum. In the Salmon River Resort Club's newsletter for July 1987, Campbell commented, "With some great support from Idaho historians, Grangeville morticians, and state of Idaho personnel, I returned Polly to the river via truck and jetboat on June 3rd. She was placed in the ground just above her river home with a few tears and joyous hearts."[109]

Because non-Chinese people selected her grave site, it lacks the *fengshui* characteristics of her husband's burial place, which Polly helped choose (Chapter Seven, October 1922). Ironically, therefore, Charlie Bemis's grave site is more typically Chinese than Polly's is.[110] In addition, although such a secondary burial was common in China,[111] it was highly unusual for it to happen in the United States in 1987.[112]

By 1992, Newton had filed for Chapter 11 bankruptcy.[113] Sometime after 2000, Campbell left the area for other pursuits.[114] Today,

The Polly Bemis Ranch is a not-for-profit corporation formed for the exclusive purpose of providing recreational and social facilities for

its members. Each member becomes an owner and receives a share of stock in the property and all of its improvements, and consequently can sell his or her equity-interest in the property or pass it on to heirs or assigns. The number of memberships [is] capped at 100.[115]

Visiting Polly Bemis's Home on the Salmon River

For several years in the 1990s and 2000s, I taught "The World of Polly Bemis," a brief summer school class for the University of Idaho Community Enrichment Program.[116] During a visit to Polly Bemis's restored cabin, now easily accessible only by jet boat from Riggins, Idaho, participants compared both the book and the movie with what is known about Polly Bemis's actual life.[117] Currently, visitors arrive during rafting trips down the Salmon River, or via jet boat from the Shepp Ranch across the river, or by jet boat from Riggins. Some of this visitation may have resulted from a 2009 North Central Idaho Travel Association tour that brought over 70 participants from regional travel-related enterprises on a "Salmon River Sampler," encouraging them to "sell" the Polly Bemis Ranch and Museum as a destination worth a visit.[118]

Honors for Polly Bemis

Polly's house is on the National Register of Historic Places, and Polly herself is in the Idaho Hall of Fame. She appears in a book about Idaho's one hundred most famous residents, and has also been lauded for her gardening abilities. A book about Polly Bemis represented Idaho at the National Book Festival, she was one of 150 components of an "Essential Idaho" exhibit, and she was one of only eight persons mentioned in a recent newspaper account of famous people in northcentral Idaho and southeastern Washington. Two eminent United States government officials have even suggested posthumous citizenship for Polly Bemis.

National Register of Historic Places

Polly's house, at the Polly Bemis Ranch, was nominated to the National Register of Historic Places in 1987,[119] and listed there on March 4, 1988.[120] Information from the Polly Bemis Ranch website states:

The Ranch is a 26-acre estate located on the main branch of the Salmon River, 44 miles east of Riggins, Idaho. It lies in an area protected by the Wild and Scenic Rivers Act and is surrounded by 2.2 million acres of the Frank Church-River of No Return Wilderness Area - the largest protected wilderness area in the continental United States.[121]

The Polly Bemis House, as described in the National Register of Historic Places Registration Form, "is significant under criterion A

for its association with the social history of Chinese women in Idaho. The house is significant under criterion C as an excellent example of log construction and of the gable-front single-pen [one-room] dwelling as they were employed in the central Idaho mountains." In addition, the building is "the only inventoried instance of the use of whipsawn lumber" in the state[122] (Fig. 10.5).

Fig. 10.5. Polly Bemis's restored home on the Salmon River, Idaho. Photo by author.

Idaho Hall of Fame

Polly Bemis was inducted into the Idaho Hall of Fame in 1996 in the History category.[123] A brief biography on the Idaho's Hall of Fame website states, "With her wit and spirit, Bemis overcame all struggles and secured for herself the legacy of being the Pacific Northwest's most famous Asian pioneer."[124]

Other Recognition for Polly Bemis

Polly appears in Richard Beck's 1989 compilation, *Famous Idahoans*, as one of 100 Idaho residents worth remembering.[125] In 2008, gardening expert Mary Ann Newcomer called Polly "Idaho's most famous gardener."[126] Five years later, the Idaho Commission for Libraries chose *Polly Bemis: A Chinese American Pioneer* to represent Idaho at the 2013 National Book Festival in Washington, DC.[127] That same year, to commemorate the 150th anniversary of Idaho statehood, Polly Bemis and a few of her possessions appeared in Panel 42 of the Idaho State Historical Society's exhibit, "Essential Idaho: 150 Things That Make the Gem State Unique."[128] A 2016 newspaper article

listed her as one of just eight "famous folks who have/had ties to this region," meaning northcentral Idaho and southeastern Washington. Polly Bemis represented Idaho County.[129]

Suggestion of Posthumous Citizenship for Polly Bemis

In July 1989, James C. (Jim) Miller III, former director of the Office of Budget and Management under President Ronald Reagan, and Donald H. (Don) Rumsfeld, former Secretary of Defense under President Gerald Ford, visited Polly Bemis's home and grave on the Salmon River during a guided river trip.[130] After hearing about Polly from historian and river guide Cort Conley, the two men were so touched by her story that they talked about the possibility of getting posthumous citizenship for her.[131] Posthumous citizenship is possible, but generally only for "an alien or noncitizen national whose death resulted from injury or disease incurred on active duty with the United States armed services during specified periods of military hostilities."[132] Although Miller stated, "I think we can get that done,"[133] it would have taken an Act of Congress to obtain posthumous citizenship for someone like Polly. Despite their considerable influence in Washington, DC, after returning home they apparently didn't follow up on their kind thought.

Polly Bemis in China and Elsewhere

In June 2010 Idaho Governor C. L. "Butch" Otter headed a trade mission to China. There, he "plugged Idaho potato products, encouraged Chinese investors to visit Idaho[,] and sang cowboy songs."[134] Otter also recounted Polly Bemis's story to Huang Hua Hua, governor of Guangdong province, and even stated that she was born "in Taishan County,"[135] part of Guangdong province, rather than her actual birthplace, somewhere in northern China.

Some of the Chinese whom Otter encountered may already have been familiar with Polly Bemis's story. Ruthanne Lum McCunn's novel about Polly, *Thousand Pieces of Gold*, was previously translated into Chinese, as well as into Danish, French, Greek, Mongolian, Portuguese, and Romanian.[136]

In 2015 a production team from New York's Partisan Pictures visited Idaho to film Polly Bemis's home on the Salmon River as part of their three-part series for China's CCTV 9, *Gold Mountain: Chinese in the Old West*. Information about Polly Bemis appeared in Part 3, "Pioneers and Provocateurs"; the series aired in China in late 2016.[137]

Polly Bemis's Character and Personality

During 1918 and 1919, Lucille Moss's parents, Fred and Anna Biggerstaff, lived in the Chamberlain Basin and subsequently in Warren. Anna later told

her daughter that Polly "was very clean. She scrubbed the floor every day. It was so clean you could eat off it."[138] The Biggerstaffs were at Polly's once for dinner, probably the noon meal, but surely ate at the table.

Others commented on Polly's cleanliness. Her friend, Bertha Long, who knew Polly in Warren during 1889 and 1890, later wrote that Polly's home "was always immaculate," and "never did I see Polly look dirty."[139] As mentioned, a newspaper reporter who interviewed Polly in 1924 commented that "her whole appearance [was] scrupulously neat."[140]

Polly Bemis was also known for being direct and outspoken, even feisty (Fig. 10.6). She reportedly had sharp words for Charlie on more than one occasion, and responded to newspaper reporters with wit and humor. M. Alfreda Elsensohn reported that one day, as Polly's husband attentively watched a nest of ants, he called Polly over to look. "Bemis," she said, "if you'd work um like these ants we wouldn't be poor folks."[141] Elsensohn also recounted that an unidentified acquaintance of the Bemises recalled that after their marriage, "Polly would find Bemis playing cribbage with friends. She would approach him and count 1, 2, 3, up to 15 and then say, 'You go home and put wood in the woodbox. Yes um, there's no wood in my woodbox,' and Bemis would go."[142]

In July 1921 newspaperwoman Cissy Patterson, also known as Countess Eleanor Gizycka, interviewed Polly when Gizycka stopped at the Bemis Ranch during her boat trip down the Salmon River (Chapter Seven).[143] According to Gizycka, Polly was "full of dash and charm." As mentioned, Polly told the countess, "I cost $2,500 [in Portland]. Don't looka it now, hmm?," and chuckled.[144] With Charlie bedridden by then, and cranky, Polly had become his caregiver. The countess jokingly suggested that Polly should get another husband; "Hee! hee!," she laughed, "Yas, I t[h]ink so, too."[145]

When Polly visited Boise in August 1924, as mentioned (Chapter Seven), the newspaper reporter who interviewed her wrote that Polly's "eyes twinkle as she tells jokes on herself, as when she spoke of the miners not liking the coffee she made in camp, and they way she silenced them by appearing with a butcher knife and the question, 'Who no like my coffee?'" The reporter asked Polly what she thought of the 1920s "flapper [a trendy young woman] … with her rouge and paint" [makeup]. Polly replied, "I paint like that, too, all the time, till I go to my man [Charlie Bemis]. Then I not have to paint any more. American girl today paint till she gets man too."[146]

Another anecdote about Polly dates to about 1911. In the late 1950s a friend of Pete Klinkhammer asked him if Polly could read. Pete replied,

Could Polly read? Money and fifteen-two! She was a sharp gambler in a crib[bage] game & used to pit her wits against the best of 'em.

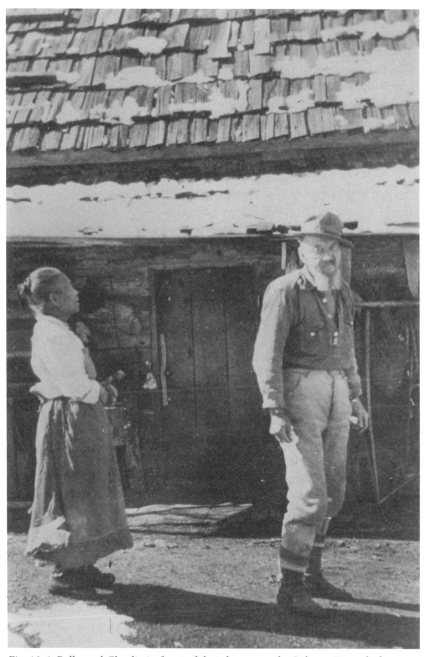

Fig. 10.6. Polly and Charlie in front of their house on the Salmon River, before 1922. Courtesy The Historical Museum at St. Gertrude, Cottonwood, Idaho.

Two fellows [once] came & camped across Crooked Creek & did some placer mining over there. One of them liked to make a big show. He used to get vegetables and a few little things from Polly. She never charged for the stuff. But he kept flashing this one hundred dollar bill—to show off, I think. Well, Polly let it pass a few times. Then one day she got tired of this and she surprised him. Two things Polly could do good—count money and fifteen two. She changed it for him. After that he didn't flash no more money.[147]

Author Judy Smith, reporting information obtained from Gene Olmstead of the *Idaho County Free Press*, stated, "Polly had lots of cats and would fish for them and talk to them as if they were human and treated them as such. She was also quite a good hunter and had very good vision. She could spot animals that most people could not begin to distinguish."[148]

In a 1980 interview, Idaho teacher, rancher, and hunting guide Gertrude Maxwell, born in 1908, reported knowing Polly Bemis personally "from the Shepp Ranch," and called her "a grand little lady" and "the only real Chinese woman I've ever known." When asked if she had chatted extensively with Polly, Maxwell replied,

Yes. She was a real, real person. She had a lot of personality. she was a little different than most of them [Chinese women] would be, I think. Yes, she was interested in the country and the beauty of the country. She was a person who appreciated beauty more than one would suppose, having lived like she did under the conditions that she lived. I knew her quite well.[149]

Maxwell also recalled that Polly Bemis loved her surroundings, and remembered her saying, "Look, look, oh how beautiful," about the surrounding timber and woods. According to Maxwell, Polly "spoke English quite fluently."[150] Maxwell described Polly as "a smiling, little gnome-like creature, very short, a little chubby, but she was very happy. Her stance as a rule was a very happy one. She viewed life in a cheerful way."[151]

In writing about Polly Bemis some time in the 1950s or early 1960s, supplementing the account told to him by Taylor Smith, J. Loyal Adkison [d. 1965] interviewed Nellie Schultz [d. 1966], Polly's friend from her Salmon River days.[152] Schultz "visited many times with Polly, in her home, on the banks of the Salmon, across from the mouth of Crooked [Creek]. Mrs. Schultz proclaims, without end, as to [Polly's] character and nobility"[153]

Polly Bemis and Her Chinese Zodiac Sign

For those who believe in astrology, another clue to Polly's character and personality might come from her sign in the Chinese Zodiac. If indeed she

was born on September 11, 1853, as seems likely, her Zodiac animal is the Ox. More specifically, 1853 was the year of the Water Ox,[154] with water being one of the five elements besides metal, wood, fire, and earth. These paragraphs could easily describe Polly Bemis:

The Ox works hard, patiently, and methodically, with original intelligence and reflective thought. These people enjoy helping others. Behind this tenacious, laboring, and self-sacrificing exterior lies an active mind. While their balance and strength inspire confidence, Oxen can seem rigid, obstinate, and slow. They impress others as leaders, fearing neither responsibility nor risk. However, sometimes they must labor long hours to accomplish little.

...

People born under the influence of the Ox are kind, caring souls, logical, positive, filled with common sense and with their feet firmly planted on the ground. Security is their main preoccupation in life, and they are prepared to toil long and hard in order to provide a warm, comfortable[,] and stable nest for themselves and their families. Strong-minded, stubborn, individualistic, the majority are highly intelligent individuals who don't take kindly to being told what to do.[155]

In associating the Water element with the Ox sign, the following paragraphs also suggest Polly's character and personality, and may help explain why she was so happy to live adjacent to the Salmon River for nearly 40 years, almost half her life:

Water lends the solid Ox a sense of much needed flexibility and the Water Ox is the most easy-going of all the Oxen. If you explain things logically to the Water Ox, [she] is willing to change [her] mind and incorporate changes in order to achieve [her] goals.

The Water Ox may not be too open to anything too avant-garde though, so present alternatives in as conventional a manner as possible. The determined Water Ox's systematic and logical approach combined with a willingness to listen to others will stand [her] in good stead to rise to great heights. Like the steady flow of water, the Water Ox also has a strong propensity for hard work and will be reliable, diligent[,] and responsible in [her] tasks.

Socially, the Water Ox is also more popular as [she] is more amenable to people's different points of views. Since the native sign of the Ox is already that of water, the double water element will bestow on [her a] great amount of patience which will see through many things – both at work and in relationships. With this resilience, [she] is very

capable of managing both the commitments of [her] own life as well as to tackle obstacles that arise in a calm and unobtrusive way.[156]

Charlie Bemis's Character and Personality

Charlie Bemis's acquaintances described him as both hard-working and lazy, and both friendly and friendless. These assessments seem to have varied over time; in his later years he was most often described as being lazy and unfriendly, perhaps because of age and failing health.

Charlie's young friend, Taylor Smith, arrived in Warren about 1882, when he was 12 years old. His parents had separated, so his mother moved to Warren to run a hotel.

There, Charlie Bemis, the saloon keeper, and Taylor soon became warm friends. Bemis, the idol, became father councilor [*sic*] to the fatherless boy. As Taylor said, 'Charlie and Polly Bemis were like father and mother to me, but Charlie would never let me come into the saloon.'[157]

According to mail carrier Will Warden, in recollections of the mid- to late 1880s, Bemis was "a proud and haughty gambler, like most of the leading characters of those days," as well as being "as honest as they made 'em."[158]

Some Warren acquaintances did see another side to Bemis even while he still lived in Warren. In 1890, when Johnny Cox shot him, Bemis was reportedly "without friends because of his general demeanor in the camp,"[159] and "had developed a bad reputation."[160]

However, Robert G. Bailey first encountered Polly and Charlie Bemis in 1901, when Charlie refused payment for assisting Bailey, his companion, and their horses across the Salmon River. Bailey commented, "Later I visited several times with this couple, and never have I been more courteously entertained. They were hospitality itself, and would take no remuneration for their troubles."[161] Bailey noted that after Polly and Charlie's marriage, Charlie "proved to be a kindly, gentle, and appreciative husband,"[162] observing,

> Bemis was ambitious, thrifty, a hard worker[,] and ever on the alert to better his condition. ... Bemis took his pleasures as did his friends. He was no better nor worse than the average adventurous miner of the early days. His one great passion was gambling, and his friends say he was ready and willing to wager everything he owed when the fever of the game was upon him. Sometimes he had a good stake, and at other times it was a struggle for existence."[163]

In their book, *River of No Return*, Johnny Carrey and Cort Conley commented, "Hard work and Bemis were antonyms."[164] Since neither man knew Charlie Bemis personally, their appraisal surely came from comments made

by others during Bemis's later life. For example, "Bemis was a silent and unfriendly man. He often guarded his house with a gun to keep strangers away, as many of the travelers down 'the river of no return' would stop at the occasional ranches and try to see these people who spent their lives alone in the tremendous Salmon-river canyon."[165]

In 1970 the *Pony Express* magazine printed a photograph of Charlie Bemis and his dog (Fig. 10.7). The caption for it read, in part, "Note hatched-faced Charley's pointed nose. His black beard turned white in later years. The pipe-smoking wizard of the Salmon, who knew how to shuffle and cut cards, looks mighty sure of himself, and so does his dog"[166]

Over the years, as hinted earlier, Charlie acquired a reputation for being lazy. It is hard to tell if it is truly deserved, or if his industriousness simply couldn't compare with that of the three people who knew him best: Polly Bemis, Charlie Shepp, and Pete Klinkhammer. All three were prodigious workers; in comparison, Charlie Bemis's efforts do appear puny. Although Shepp's diaries often mention Bemis doing different kinds of work, Bemis notably accomplished much less when compared with them. Although those three had occasional ailments that lowered their productivity, Bemis differed in that he eventually became bedridden from illness, likely tuberculosis.

About Bemis's being lazy, Will Shoup, who met Polly and Charlie Bemis when Shoup was on a river trip in 1919, later told historian Fern Coble Trull that "Charlie was confounded lazy and let Polly do all the work. He fiddled all day long while Polly hoed in the garden."[167] In Charlie's defense, he may have been too ill to do much; by the summer of 1921 he had been bedridden for about two years. Another time, Frank McGrane, Sr. and his wife told M. Alfreda Elsensohn that they visited Polly in 1933 when she was ill in Grangeville. Polly reportedly said to them, "Charlie wouldn't have died if he hadn't been lazy. He just sat around"[168] In fact, he could well have suffered from depression.[169]

Marybelle Filer, a later co-owner of the Shepp Ranch, stated that once Shepp and Klinkhammer had purchased their 137-acre ranch from Smith and Williams, both places [including the Bemis Ranch] "were worked as one, the men crossing the river at all stages of water and on the ice in winter, to work and help Polly care for their inactive neighbor Bemis. It fell to the industrious and ever-cheerful Polly to wear out the three saw bucks [sawhorses] made for her by Shepp."[170]

As a boy, Herb McDowell, age six, moved to Warren with his mother and three brothers in September 1922 or 1923.[171] In a later reminiscence, he recalled,

Fig. 10.7. Charlie Bemis and his dog, before 1922. Courtesy The Historical Museum at St. Gertrude, Cottonwood, Idaho.

Every summer they [the Bemises] would come to Warren to visit everyone and sell things they had raised on the ranch. Polly would visit everyone to get all the news. She used to give us kids fruit she had brought up from the ranch. Her husband would get in a poker game and would generally win some money because he was a good card player.[172]

This is a wonderful story, but it doesn't fit the facts. Since Charlie Bemis was bedridden for the two years before the McDowells' arrival in Warren, Herb couldn't have met Bemis there and witnessed the poker games that McDowell described. Still, there may be a grain of truth in his story, such as the fruit from her ranch that she gave to children. When Polly was living in Warren from 1922 into 1924, Pete Klinkhammer would come up from the

Salmon River, bringing produce from her garden to give Polly as well as to sell on her behalf.

In the late 1950s, an interviewer asked Pete Klinkhammer why Polly would marry someone as lazy as Bemis. In Klinkhammer's opinion, "I gather that it was more a marriage of convenience on the part of both. They had known each other well for many years in Warrens where both were connected with the gaming houses. Polly would work and had a little money saved up"; also, she "was ever faced with the threat of being sent back to China."[173] According to Klinkhammer, "Bemis sold a cabin or two that he had in Warrens and they moved to the river where Polly could work and Bemis could laze."[174]

Questions Frequently Asked about Polly and Charlie Bemis

During the author's presentations about Polly and Charlie Bemis, people often ask if they had children, wonder how they could survive in such a remote place when they were old, and are surprised that they aren't buried together. Replies to other questions, posed by fourth-graders, appear on a website for the book, *Polly Bemis: A Chinese American Pioneer.*[175]

Why Didn't Polly and Charlie Bemis Have Children?

People often wonder why Polly and Charlie never had children, particularly since they lived together (1880) and then married (1894) during what would have been some of Polly's prime childbearing years, ages about 27 to 40. Possibly, one or the other of them was unable to have children. More likely, the couple, especially Polly, wouldn't have wanted to bear children who were half Chinese and half Euroamerican. During the latter part of the 19th century, extreme prejudice was directed at Chinese people and other "non-whites." Individuals who were half one race and half another were derogatorily termed "half-breeds" and neither group accepted them. Polly, who loved children, wouldn't have wanted to expose her own child to rejection.

Until actually becoming pregnant, a woman couldn't know if she and her partner were capable of having children together. Therefore, if Polly didn't want to have children, she would need to use some form of birth control.[176] Male withdrawal; the "rhythm method"; female douching; early diaphragms; spermicides; drugs for inducing abortion; and intrauterine pessaries, sponges, and other devices were notoriously unreliable. More effective methods, such as "the pill," didn't then exist.

In 1873, the year after Polly's arrival in the United States, Congress passed the Comstock Act, which, among other provisions, prohibited contraceptives in "an extraordinarily long list of 'obscenities.'"[177] Despite this law, "legal leniency, entrepreneurial savvy, and cross-class consumer support enabled

334

the black market in birth control to survive." Although "not openly endorsed, contraceptives were nonetheless accepted as Americans of all backgrounds created a zone of tolerance in which birth control was routinely made, sold, bought, and used."[178]

Despite prohibitions against them, condoms were obtainable, even on the Idaho frontier. Archaeologist David Valentine has "a high level of confidence that they [condoms] were available in 1880," even "in Idaho with the first merchants if not before."[179] Referring to a published article to corroborate his statement, Valentine noted that, nearly 30 years earlier, California rancher Cave Couts kept account books containing meticulous records of items that he bought for his house and ranch. Couts' entry for December 5, 1853, includes "1/2 dz skins," which were "condoms made from sheep or pig bladders," or, more likely, made using intestinal pouches from these animals.[180]

In 1878, author, illustrator, expectant mother, and later Idaho resident Mary Hallock Foote consulted a friend about contraceptive methods. In a letter, she told another friend what she had learned: "Mrs. H. said Arthur [Mary's husband] must go to a physician and get shields of some kind. They are to be had also at some druggists. It sounds perfectly revolting, but one must face anything rather than the inevitable result of Nature's methods. … These things are called 'cundums' and are made either of rubber or skin …."[181]

Although expensive, one to two dollars a dozen in 1872, manufacturers advertised condoms' durability and thinness, and implied that they were reusable.[182] One advice book even "provided detailed instructions for making condoms from the caecum [intestinal pouch] of a sheep."[183]

Since Polly was from China, she may have known about Chinese methods of preventing pregnancy. There, several types of condoms, *yin-chia*, were available, made out of "oiled silk, paper, and lamb intestines"; usually, however, they were just for the wealthy.[184] Most Chinese women would have prevented pregnancy "after the fact," i.e., using various herbs to expel the fetus and restore menstrual flow. In Chinese traditional medicine, there has long been an indistinct boundary between drugs that caused abortion and those that were used to "regulate the menses."[185] Often, in treating the latter ailment, any fetus present would be "collateral damage," whether inadvertent or not. For restoring menstrual flow, Chinese traditional medicine relied on "musk, cinnamon, Tibetan crocus, [and] peach-kernels."[186] In the US as well, certain botanicals could reportedly be used to "bring on a woman's courses,"[187] but whether they were available in China is unknown. Some US women even believed that a tea made from beaver testicles could prevent pregnancy.[188]

If an unwanted pregnancy did occur, Victorian women had recourse to abortifacients, instruments of abortion, or even to "female physicians," i.e.,

professional abortionists. Pills, fluid extracts, and medicinal oils were popular; many were "botanicals long associated in folk medicine with inducing menstruation and causing abortion," and bore names such as "Hardy's Woman's Friend" and "Belcher's Female Cure." Although they could be effective, these medicines were risky, even dangerous.[189] Abortions could also be self-induced with instruments bought for the purpose or fashioned from common household items including bent spoon handles, long-handled spoons, wires, and catheters.[190]

How Could Polly and Charlie Survive on the Remote Salmon River?

Because Polly and Charlie Bemis lived so remotely on the Salmon River, miles from any community, people often wonder how they could survive. According to Pete Klinkhammer, "Bemis did not have an income. Polly had a little money saved up from her days in Warrens."[191] Klinkhammer's interviewer commented, "Some years after Pete & Shepp came [to live on the Salmon River], Polly's money ran out. Peter paid a four-hundred-dollar grocery bill at Warrens [for her]."[192] The Bemises survived because of the kindness of their neighbors. For more than a decade, particularly after Charlie Bemis became bedridden, Charlie Shepp and Pete Klinkhammer plowed, planted, watered, and harvested the Bemises' garden and orchard; bought and delivered their winter food supplies; and cut and split wood for heating and cooking. Had Shepp and Klinkhammer not taken such good care of them, the Bemises likely would have died much sooner.

Why Aren't Polly and Charlie Bemis Buried Together?

It surprises people to learn that Polly and Charlie Bemis aren't buried together. Charlie is buried where he died, which was at the Shepp Ranch. Although Polly was originally buried in Grangeville, Idaho, where she died, she was subsequently exhumed and reburied near her house on the Salmon River, so she and Charlie are across the river from one another. Polly wouldn't have found that unusual; in China, husbands and wives are often buried in separate places.[193] There, a burial site is chosen because it is auspicious; the good luck it provides the person's descendants might not be the same for the other partner in the marriage. Surely neither the Shepp Ranch owners nor the Polly Bemis Resort/Ranch owners would consent to moving Polly or Charlie's remains; their graves, especially Polly's, have become tourist attractions in their own right.

Although the couple may have wished to be buried together, there is no convincing evidence that they expressed that wish—usually, others have wished it for them. In a brief account of the Bemises' life, Vardis Fisher and Opal Laurel Holmes end with, "In her last illness [Polly] asked to be taken

to the canyon home and buried at the side of her husband."[194] However, as mentioned earlier, in July 1959 Pete Klinkhammer told some visitors to the Shepp Ranch about Polly's desire to be buried where she could hear the river, with no mention of wanting to be buried alongside her husband.[195]

In 1987 Jim Campbell, then owner of the Polly Bemis Resort, wrote, "Over the last 15 years many of us who have lived and worked on the river all have had a great desire to see Polly's wish to be buried on her beloved Salmon River granted." Campbell believed that the reason Polly was buried in Grangeville rather than on the river was because "neither Shepp nor Klinkhammer could be reached in order to transport her body to the river as was her wish."[196] In fact, Shepp's diary for that time period records that he was notified, presumably by telephone, of Polly's death and subsequent burial in Grangeville,[197] but, as previously noted, it would have been too expensive to move her body to the Salmon River.

Contradictions about Polly Bemis

As mentioned, Polly and Charlie moved from Warren down to the Salmon River following their marriage in 1894. There is some debate about when, or if, Polly subsequently left the Bemis Ranch to visit friends in other towns. For example, Bob Bunting, grandson-in-law of John and Bertha Long, believed that Polly was staying at the Long Ranch near Grangeville when the first train reached that town in 1908.[198] The main problem with this scenario is that the first train arrived in Grangeville on December 9 of that year,[199] making it extremely unlikely that Polly would have left home in the winter. Charlie Shepp's diary for that time period places her at home on November 26, Thanksgiving, and doesn't indicate that she was away in December. Polly did visit Grangeville in 1923, however, and according to a newspaper interview at that time, she "saw her first train."[200] Clearly, Bunting combined two different events: the train's arrival in 1908 and Polly's first sight of it in 1923.

In two sources, Polly confirmed that she hadn't seen a train before her first known visit to Grangeville in 1923. In their conversation at the Bemis Ranch in 1921, Polly told newspaperwoman Cissy Patterson, "I never seen a railroad."[201] When Polly visited Boise in 1924, after Charlie's death in 1922, she told another interviewer, "My husband say, 'We will never see railroad, I guess,' and he die, then I come out to get dentist to see my teeth and I see railroad at Grangeville last summer [1923]."[202]

Other sources disagree on whether Polly ever left the Bemis Ranch between 1894 and mid-1922. On July 19, 1922, the R. E. Shepherd boating party from Jerome, Idaho, with Harry Guleke as captain, camped at Polly's place. Trip member F. J. Mulcahy kept a diary, and his entry for that date

reads, in part, "Polly has been in the Salmon River country for more than 40 years and has never been off the ranch for 28 years [i.e., since 1894].[203] That makes sense, because when Charlie Bemis went to town to sell produce or to purchase supplies, someone, Polly, had to stay behind to feed the animals. Still, filmmaker Lee Charles Miller believed that Polly did make a yearly visit to Warren until about 1902.[204]

In 1923, a newspaper story about Polly stated that she had been in Idaho County for 51 years [since 1872], and during that time "she had been only three places[:] at Warren [1872-1894 and 1922-1923], at her home for twenty-eight years on Salmon [R]iver [1894-1922], and once to Slate [C]reek [date unknown, but the other information would indicate that it was before 1894]."[205]

However, a curious entry in Charlie Shepp's diary for August 1910 says, "Polly gone out side [outside] Shultz [sic, for Gus Schultz] took her out."[206] Because several sources state that Polly Bemis didn't leave the ranch between 1894 when she moved there, and 1922, when she went up to Warren to live, Shepp's diary entry suggests that the Polly who left in 1910 was Shepp's horse, Polly, which Schultz had borrowed.

Other information comes from Long family reminiscences. After Bertha Swarts married John Long near Grangeville on December 12, 1888,[207] the newlyweds moved to Warren in the spring of 1889, and Bertha and Polly became friends.[208] The Longs moved back to the Grangeville area in late 1890.[209] According to their relative, Bob Bunting, their daughter, Mary [Long] Eisenhauer, born in Grangeville in 1893, "had many stories to tell of Polly. Polly was in the Long home several times when Mary was growing up."[210] Bunting also stated, "Denis Long, Bertha's grandson who now operates the Long [R]anch, confirmed what I have said. He said Polly made several trips to stay with Bertha and would usually stay a couple of weeks."[211] When that could have happened is unclear, but it had to have been before 1894, when Polly moved down to the Salmon River, or in 1923, during her first known visit to Grangeville.

In 1966, Bertha Long wrote a reminiscence about Polly Bemis for Grangeville's *Idaho County Free Press*.[212] In it, she related that Polly was a "great friend" of hers and that the two women, who lived a mile apart in Warren for the year and a half that Bertha was there, often visited one another in the afternoon. Bertha commented, "When she [Polly] came out to the Prairie [Camas Prairie; the Grangeville area] in 1923 I brought her out to my home for a visit and she did enjoy herself." If Polly had visited Bertha at other times, it is odd that Bertha didn't mention it. Polly didn't return to Grangeville for ten years. Bertha Long commented, "When Polly was brought

out to Grangeville [when she was ill, from August into November 1933], I went to see her and took my little grandson, then a baby only a few months old [Denis Long]."[213]

Polly and Charlie Bemis's Personal Possessions

Several repositories in Idaho now own a few of the Bemises' belongings. They include the Bicentennial Historical Museum in Grangeville, the Idaho State Museum in Boise, and The Historical Museum at St. Gertrude in Cottonwood. Other examples of their former possessions are individually owned, including some artifacts in Polly's cabin at the Polly Bemis Ranch on the main Salmon River. Polly was known to present samples of her handiwork, such as crocheting, as gifts to her friends, and a few of these may remain in private hands.

Polly Bemis's Belongings

Bicentennial Historical Museum, Grangeville

Grangeville's Bicentennial Historical Museum houses two items that once belonged to Polly Bemis. One is her plain gold wedding ring and the other is a white apron decorated with lace that Polly crocheted (Fig. 10.8).[214]

Idaho State Museum, Boise

The Idaho State Museum owns several items that formerly belonged to Polly Bemis: a sewing machine head, a pair of tennis shoes, a crocheted cap, and a cast-iron kettle. The Museum acquired the sewing machine head in 1970 from Mrs. M. Dale Stilwell of Boise, Idaho[215] (Chapter Four, Fig. 4.9). It came from Polly's first cabin, which burned in 1922. Because Polly didn't have electricity, her sewing machine would have been a foot-treadle type in which the sewing machine head was set into an oak or walnut cabinet that was fitted with a cast iron frame and treadle.

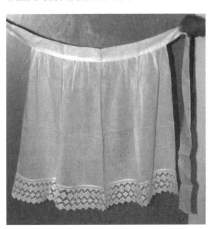

Fig. 10.8. Apron, with border crocheted by Polly Bemis. Photo by author. Asian American Comparative Collection (AACC), University of Idaho, Moscow, PB slide 240. Artifact in Bicentennial Historical Museum, Grangeville, Idaho.

On its upright arm below the spool pin, this brand of sewing machine head has an arm shield attached with a single screw at the top, likely allowing it to swing aside revealing a hole through which the machine can be oiled. On Polly's machine, the arm shield has a logo consisting of the intertwined initials HSM (Fig. 10.9). The initials stand for Household Sewing Machine, a brand first manufactured from 1873 to 1884 in Providence, Rhode Island, by the Providence Tool Company. In 1885 the company moved to Dayton, Ohio, changed its name to the Household Sewing Machine Company, and was in business until 1906. One reference says that

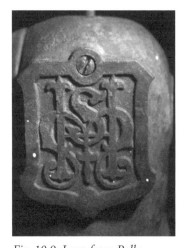

Fig. 10.9. Logo from Polly Bemis's sewing machine. This artifact is at the Idaho State Museum, Boise, object number 1970.051.0000. Image used with permission.

Household appears to have only manufactured a single model …. Having never introduced any original designs nor apparently winning any contracts with a retailer of significance (such as Sears Roebuck or Montgomery Ward), Household was in the sewing machine business for a little over thirty years and disappeared unnoticed.[216]

According to pictures and descriptions of the Household sewing machine found on the Internet, the horizontal arm of the sewing head would have had a decal reading "HOUSEHOLD," but because Polly's machine was in a fire, there is no trace of the decal now. Cabinets for the Household sewing machines were walnut and the base, or bed plate, is described as "fiddle-shaped." The cast-iron frame and treadle, which weren't donated to the Museum, might also have names incorporated into them; perhaps they still remain at the site of Polly's first cabin, the one that burned down in 1922.

Polly and Charlie Bemis moved down to the Salmon River in 1894, after their marriage that August. Whether Polly had the sewing machine then, or bought it later, is unknown. She had to have purchased it before 1906, the year that the company went out of business. She definitely had it in 1908, because on February 22 of that year Charlie Shepp wrote in his diary, "At B[emis's]. Fixed sewing machine."[217] After Polly's first cabin burned in 1922, destroying her sewing machine, there is no record that she bought another one to use in her new cabin, where she lived from late 1924 until the summer of 1933.

The Idaho State Museum also owns a pair of Polly's shoes that were found in her cabin after she died (Fig. 10.10).[218] Because Polly's feet had been bound in childhood, and later unbound, they were still small, but misshapen. A 1923 interview with her confirmed that she wore "boys' shoes on her tiny feet."[219] In his diaries, Charlie Shepp mentions how he helped Polly with shoe purchases occasionally. On November 6, 1912, he wrote, "... I came home. ... Brought down ... shoes for Polly."[220] Then, on September 6, 1915, Shepp was "Over river this eve[ning]. Sent to Mont[gomery] Ward for shoes for Polly"[221] Since the shoes from Polly's cabin bear a remarkable resemblance to ones that were available in a 1927 Sears, Roebuck catalogue, they may have been a later purchase from that company (Fig. 10.11).[222]

A crocheted cap that Polly Bemis made is also in the Museum's collection (Fig. 10.12). Catherine Irwin of Portland, Oregon, donated it in 1986, stating

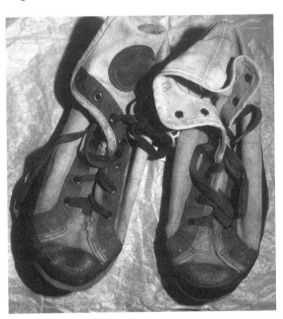

Fig. 10.10. Polly's shoes. These artifacts are at the Idaho State Museum, Boise, object number 1937.020.0000. Image used with permission.

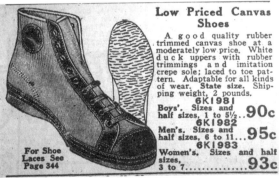

Low Priced Canvas Shoes

A good quality rubber trimmed canvas shoe at a moderately low price. White duck uppers with rubber trimmings and imitation crepe sole; laced to toe pattern. Adaptable for all kinds of wear. State size. Shipping weight, 2 pounds.

6K1981
Boys'. Sizes and half sizes, 1 to 5½ .. 90c
6K1982
Men's. Sizes and half sizes, 6 to 11 ... 95c
6K1983
Women's. Sizes and half sizes, 3 to 7 93c

For Shoe Laces See Page 344

Fig. 10.11. Advertisement for shoes similar to Polly's, 1927. From Sears, Roebuck and Co., 1927 Edition of the Sears, Roebuck Catalogue, ed. Alan Mirken ([New York]: Bounty Books/Crown, 1970), 524.

that "The cap made by Polly Bemis was given to my mother-in-law as a gift when she & Mrs. Jay [Czizek] visited her in the early 1920s while on a trip by Horse Back on the Main Salmon River."[223] The cap is white, with a small area dyed purple; perhaps a floral motif. A photograph of Polly from an unknown date shows her wearing the same cap, or a similar one (Chapter Eight, Fig. 8.11).

Cort Conley, author of *Idaho for the Curious* and co-author, with Johnny Carrey, of *River of No Return*,[224] donated Polly's cast-iron tea kettle to the Idaho State Museum in 2016[225] (Fig. 10.13). Conley obtained it from Jim Campbell in the late 1990s, before Campbell went to live in Costa Rica.[226] This kettle is quite unusual; rather than the flat base seen on modern kettles, Polly's tea kettle has a circular base that is smaller in diameter from the main body of the kettle, perhaps as a way to concentrate the heat so that water would boil faster. According to the 1895 Montgomery Ward catalogue, this type of vessel is called a "pit bottom" kettle.[227] An illustration for "iron tea kettles" shows one that is similar to Polly's. These came in Nos. 7, 8, and 9, weighing 8, 9, and 11 pounds respectively.[228]

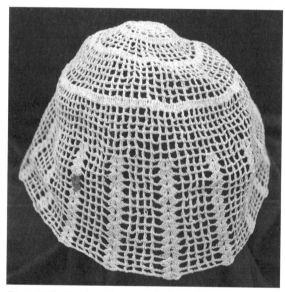

Fig. 10.12. Crocheted cap made by Polly Bemis. This artifact is at the Idaho State Museum, Boise, object number 1986.065.0001. Image used with permission.

Polly's kettle was apparently the No. 7 version, because it has a raised "7" on its lid; it would have cost 28 cents in 1895.[229] There is also a raised "3" on the base, but its meaning is unknown. The Montgomery Ward picture of the kettle that is similar to Polly's shows it with a wood hand-hold over a heavy-gauge wire handle (Fig. 10.14). Polly's kettle has a similar wire handle, except it is bent in places and lacks the wood, which suggests that her kettle might have survived the 1922 house fire, but that the handle burned. Ever frugal, Polly could have reused it. Whether the wire handle is original, or is a replacement, is unknown. This type of kettle has a "bird's mouth" opening on the pouring spout; on Polly's kettle the top of it is broken off.[230]

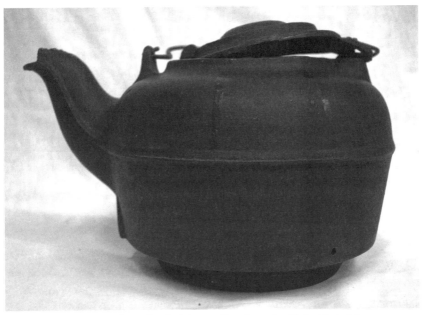

Fig. 10.13. Polly Bemis's tea kettle. This artifact is at the Idaho State Museum, Boise, object number 2016.024.0000. Image used with permission.

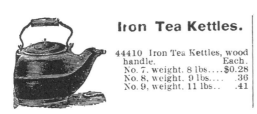

Iron Tea Kettles.

44410 Iron Tea Kettles, wood
handle. Each.
No. 7. weight. 8 lbs....$0.28
No. 8, weight. 9 lbs.... .36
No. 9, weight. 11 lbs.. .41

Fig. 10.14. Advertisement for a tea kettle similar to Polly's, 1895. From Montgomery Ward & Co., Catalogue and Buyers' Guide: No. 57, Spring and Summer 1895, *ed. Boris Emmet (New York: Dover, 1969), 428. Used with permission.*

The Historical Museum at St. Gertrude, Cottonwood

Over the years, until his death in 1970, Pete Klinkhammer gave many of Polly's personal belongings to The Historical Museum at St. Gertrude in Cottonwood, Idaho, in care of M. Alfreda Elsensohn (Fig. 10.15). More recently, other donors have contributed additional items. For example, Jim Campbell, previous owner of the Shepp Ranch and the Polly Bemis Resort, acquired some of the Bemises' possessions when he bought the ranches. In a few cases, people who had "rescued" certain items from those places returned them to him. In a 1997 telephone conversation with the author, he mentioned Polly's rocking chair and earrings, and noted his intention of eventually donating them to The Historical Museum at St. Gertrude.[231]

In June 2000, with the help of Cort Conley, Campbell gave the above items, plus one more, Polly's sourdough crock, to the Museum. A newspaper

Fig. 10.15. Pete Klinkhammer donating some of Polly Bemis's possessions to M. Alfreda Elsensohn, director of The Historical Museum at St. Gertrude, 1964. Courtesy The Historical Museum at St. Gertrude, Cottonwood, Idaho.

account of the donation noted that the gift included "(3) a rocking chair belonging to Polly Bemis; (4) a brown, glazed, wide-mouthed [Chinese] jar that was used by Polly Bemis for her sourdough starter; [and] (5) a set of un-finished earrings belonging to Polly Bemis."[232] A sixth item, not mentioned, was a remnant of manufactured lace.

In total, the Museum's artifacts from Polly and Charlie Bemis include clothing, crocheted items and other handiwork, household goods, and jewelry. The Museum is the only repository known to house any of Charlie Bemis's personal possessions,[233] including his saddle, dice, a balance scale, a ring, jeweler's wire, a watch chain, and a watch charm. Information about the Museum's holdings of the Bemises' possessions was obtained from docu-ments kindly provided by Museum personnel.[234]

Clothing

One bonnet, two shawls, and four dresses are included among the artifact assemblage. The bonnet, made of cotton, is described as a "sunbonnet," and is "blue with white stripe woven in [and a] fabric ruffle at brim."[235]

Of the shawls, one is "brown—blanket-like—[and has] stripes with border design and 4 in. tassels." The other is "striped soft mohair in shades of white, brown, and blue with 4 in. tassels at each end."[236]

The first dress is described as "black crepe with black lace collar and cuffs decorated with handmade pale blue and pink French knots. It has long

sleeves, [and] a gathered skirt with hand stitched hems on the belt."[237] The second dress is a "Brown wool winter dress with two hand-stitched pleats from shoulder to hem at front. A silver grey braid design decorates the top front."[238] The third dress is a "Tan linen summer dress decorated in white rick-rack. Seam at hems indicates the dress was shortened for Polly."[239]

The Museum received the fourth dress from Ann Smothers Copp in 1978. On its accession worksheet, a notation for the dress's date states, "1800's (at least 100 years old)." That date is impossible, because, except for what she was wearing, all of Polly's clothing burned in the 1922 fire, but this dress wasn't given to Copp until about 1932. If it is that old, and someone gave it to Polly after the 1922 fire, then Polly didn't make it, as is stated below. Its description reads, "brown [gold-toned] velvet dress lined with black dotted material with black & grey buttons down front of waist." A comment on the dress's history states, "made by hand by Polly Bemis, skirt made over once. Given to Ann Smothers when she was five y[e]ars old by Polly Bemis. It is evident that the hem has been adjusted a number of times."[240]

Ann Smothers Copp (1927-2009), was the daughter of Austin and Florence Smothers.[241] Her father was a placer miner, river guide, and jet boat designer. In 1932 the Smothers family moved to the Salmon River. They lived in a cabin at Lucky Creek, 57 river miles above Polly's place; Ann remembered that word came up the river when Polly died. Since Ann didn't recall actually meeting Polly, Polly must have given the dress to Austin Smothers for his daughter. Ann remembered that she didn't wear the dress, although she tried it on. She said the hem was taken up for Polly. Ann recalled that she also got a pair of shoes from Polly and "wore them out."[242]

There is no question that the dresses were once owned by Polly, and seem small enough to have been worn by her, but there is some dispute as to whether she actually did wear them. No photographs show her wearing any of them and, living and working on the river, with trips out only for a few days in the summers of 1923 and 1924, to Grangeville and Boise, respectively, she would have had very few occasions to wear anything other than her daily work clothing of cotton dress and apron. In fact, even in those cities her clothing was unpretentious. A reporter who interviewed Polly in Grangeville wrote that she wore "a plain cotton dress" and in Boise she wore "a blue cotton dress."[243]

Existing photographs of Polly, except for one, show her wearing what look like cotton dresses, usually with cotton aprons over them. Her "best" dress, in which she was photographed in 1894 for immigration documents, and which she probably wore when she married Charlie later that same year, burned in her house fire on August 16, 1922, as did all her other clothing except what she was wearing at the time.[244] As mentioned earlier, Charlie Shepp, who

helped the Bemises escape, noted in his diary, "Didn't save a single thing. The whole place was on fire when I got over."[245]

Bemis died on October 29, 1922.[246] Several days later, Shepp's mining partner, Pete Klinkhammer, took Polly up to Warren where she would live for the next two years. On November 6, Pete went to Dixie and on November 8, 1922, Shepp wrote, " Pete back. Got dresses for Polly …."[247] No diary entries exist from November 9, 1922, through December 23, 1922, so we don't know when Pete took the dresses to Warren.

In July 1923 Charlie Shepp's sister Nellie and brother Harvey came via Warren for a long visit.[248] When they left, in August, they went back through Warren. A car took them, and Polly, to Grangeville. Polly stayed there for a week. A newspaper report on her departure noted that she was "Bedecked in a new dress, a gay hat[,] and white shoes," and had a suitcase "filled with new clothing, all gifts of friends."[249] The "new dress" Polly is wearing in the accompanying photograph is distinctive enough that it cannot be confused with one of the dresses now at the Museum.

Handiwork

The Museum also owns some of Polly's handiwork. A white, tubular, pillow cover has "various overall designs in red outline stitch. The ends have diamond design filet crochet insert and edging with tucks between."[250] Four "small, rectangular doilies" measure from seven to nine inches on a side. Three of them, depicting a Scotty-type dog, a swan (Chapter Four, Fig. 4.11), and a pelican, are made of "white hand-crochet filet with pink edging." The final doily shows a geometric cross and is in "old rose with narrow edge."[251]

One fragment of lace in "white filet crochet" has a design "original to Polly" depicting "daffodils, a ship, butterflies, bird, chicken, cat, etc."[252] A piece of lace that Polly made is "crocheted filet" in "ecru color with wide pointed edge."[253] A table mat is "pink lace—crocheted filet with overall design including animals, birds, flowers pointing in different directions. It has a narrow 'old rose' color edging." A note accompanying this piece states, "Polly was creative; she didn't follow someone's pattern."[254]

The assemblage includes two table covers that Polly crafted. One is "red chain stitch embroidery on white linen, scalloped with pair of peacocks and floral design."[255] The other is "filet crochet in ecru edged in pink. [It has a] tulip border [with] swan, dog, cat, bird, & 2 butterflies."[256]

Tablewares

Some cutlery belonging to Polly Bemis is housed at the Museum. Because most of it is silver plate, or even sterling silver, it could well have been wedding gifts when Polly and Charlie married in 1894. Six table knives, possibly with silver blades, have "mother-of-pearl handles and sterling silver bands

[and are] richly decorated with [an] engraved ['Old English'] 'B.'"[257] Six silver table forks are similarly decorated and engraved.[258] Six "commemorative, sterling silver teaspoons" have an "1849 gold miner on three and George Washington on three with 'Polly' engraved on the back [of] each bowl." The three teaspoons with the gold miner have "'Sutter's Mill' picture and caption on back of handle. Rising sun and seascape in front bowl. 'Eldorado' label with picture of miner and bag of gold." The other three teaspoons have "Nov. 23, 1783, with Geo. Washington on horseback [on the] front handle" and "New Amsterdam 1656" on the back of the handle.[259] The interior of the spoons' bowls are embossed with a scene showing British soldiers, officers, and a boat with rowers, and the backs of the bowls bear an 1891 mark of the Towle Silversmiths. On November 23, 1783, "Evacuation Day," the last British troops left New York City following the end of the Revolutionary War (American War of Independence, 1776-1783), and George Washington triumphantly led his victorious army into the city.[260]

Other tableware includes eight sterling silver tablespoons. Two are in Rogers Bros. "Lily" and/or "Lily of the Valley" pattern, both inscribed "Polly."[261] Six others, with a "tipped pattern," are engraved, "Mrs. C. A. Beamis [sic]" on the front, and "STERLING" on the back. They are in their "original cloth-covered case" which has a "gold tone clasp." The outer cover of the case is silk brocade with an abstract pattern in gold, green, and black. The white, padded, inner lining is marked "E. V. RODDIN & CO. CHICAGO."[262] Founded in 1876 by Eugene V. Roddin, this business, described as "manufacturing jewelers and diamond importers," lasted until at least 1924.[263]

A silverplated gravy ladle also belonged to Polly Bemis. It is "ornately decorated with a curved handle. The design is a combination [of] scrolls and shell patterns." It, too, is in an "original box from E. V. Rod[d]in & Co., Manufacturing Jewelers, Chicago."[264] The ladle is marked "[impressed eagle] Wm. Rogers Jr. [impressed star]." This company was only in business from 1862 to about 1865 after Rogers Sr. retired in 1861.[265]

Other Household Goods

In 2000 the Museum received Polly's sourdough crock, her rocking chair, and a lace remnant. These objects joined some of Polly's curtains that the Museum already owned.

Like many, or even most, frontier housewives, Polly probably made bread every day or every other day. She would have begun with some saved sourdough starter, made from a fermented mixture of flour and water. The crock that Polly used for her sourdough starter is a traditional, wide-mouthed, brown-glazed stoneware, Chinese food jar[266] (Fig. 10.16). Identical jars once contained preserved or pickled vegetables, and pieces of them are fairly com-

mon on Chinese archaeological sites in the US. Made and filled in China, they were imported into the US by Chinese merchants and were sold in Chinese stores. Polly doubtless used this product in her cooking, so would have had access to an empty jar for reuse as a sourdough crock. To make bread, she would have begun with about two cups of starter from her crock, and then added more flour and liquid to it, making a dough. Before putting the crock away, Polly would have added more flour and water to the remaining starter, which would keep fermenting until her next baking day.

Polly's rocking chair has a seat measuring about 16 in. square, and it sits about the same distance from the floor. It has an incised, scrolled decoration on the back and is described as "Well used" (Fig. 10.17). Although it supposedly was "one of the few belongings left from cabin fire in 1922,"[267] that information is contradicted once again by Charlie Shepp's diary entry for the date of the fire; "Didn't save a single thing."[268] The rocker's carved back panel more likely dates to the 1895-1910 era, based on examples in Montgomery Ward and Sears, Roebuck catalogues; later rocking chairs, from about 1922 on, didn't have carved back panels. This type of rocking chair has also been called a bedroom or sewing rocker, and occasionally, a "nursing rocker," used by mothers for nursing their babies. Most likely, Polly bought it used, or was given it, when she lived in Warren from late 1922 on, or after she moved back down to the Salmon River in the fall of 1924.

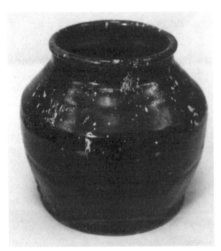

Fig. 10.16. Polly's sourdough crock. Photo by Mike Venso, in Asian American Comparative Collection, University of Idaho, Moscow, PBMV 2000.20. Artifact at The Historical Museum at St. Gertrude, Cottonwood, Idaho, object number 2001.1.1.

A remnant of manufactured lace that "belonged to Polly Bemis" came to the Museum with the donation of other objects in 2000. The Worksheet for this item describes it as "open work [H]ardanger embroidery."[269] Hardanger embroidery involves counted, drawn, and pulled threads, creating an open-work effect.

One single curtain and a pair of window curtains belonged to Polly, but there is no indication that she crafted them. The Museum has described them

348

as "white lace curtains – filet on a triangular net background." The single curtain is "lace … with doves and [a] flower basket design – split in center to the flounce." The pair of curtains is "two panels with 2 in. scallop edging – stylized leaf/flower design."[270]

Jewelry and Personal Items

The Historical Museum at St. Gertrude also owns some of Polly Bemis's jewelry, One item is a necklace, described as

> double strand, double link chain with bars every 9 links. Two have Chinese characters, not yet translated; others are decorated with geometric shapes. The necklace also has a locket and stone charm. Locket has scene of cabin by a river, holds 2 pictures.[271]

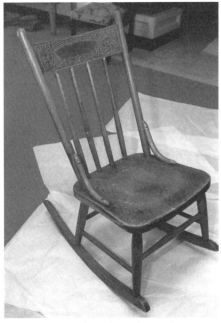

Fig. 10.17. Polly's rocking chair. Photo by Mike Venso, in Asian American Comparative Collection, University of Idaho, Moscow, PBMV 2000.21. Artifact at The Historical Museum at St. Gertrude, Cottonwood, Idaho, object number 2001.1.6.

Polly's two brooches are both bar pins. One has "3 charms; 2 are flowers with pearl centers [and the] center charm is [a] 6-pointed flower or star with pearls and a red stone center." This pin can be seen in the photograph that was taken for Polly's Certificate of Residence (Chapter Three, Fig. 3.9). The other bar pin has a "beveled edge." It "may have had something attached to [the] front."[272]

Six rings reportedly belonged to Polly. All but one are ¾ in. in diameter, corresponding to a size nine ring.[273] The assemblage includes an unmarked gold band, ¹/₁₆ in. wide; a gold band with a design resembling gathered fabric, also ¹/₁₆ in. wide; a gold band, ¼ in. wide, with a cross-hatched design; a gold ring, ¼ in. wide, set with eight square and seven round turquoise stones; a gold "insignia-type" [signet?] ring, ⅝ in. wide, with a worn central design, possibly of clasped hands, and flower motifs on the sides; and a wire ring with "blue and silver seed beads woven with 1 red tube bead, 1 in. in diameter and ⅜ in wide."[274] The plain gold band wasn't Polly's wedding ring; hers is

at the Bicentennial Historical Museum in Grangeville, Idaho. Perhaps it was Charlie Bemis's wedding ring.

A donation in 2000 included a pair of "unfinished earrings." They are ivory-colored ceramic, ¾ square, with "four gold drawings on each one." Apparently, the "drawings represent brands used by ranchers."[275]

The Museum owns one of Polly Bemis's hairpins and three of her hatpins. The hairpin's origin is given as China; it has Chinese characters on it that haven't yet been translated. It is "Oriental style" with a "gold, fan-shaped end. Very ornately tooled of flowers and leaves [with] a geometric border design."[276] Of the hatpins, one has a black glass head in a teardrop shape. Another has an ornate, silver-tone, filigree head. The third hatpin has a red-and-white-striped, faceted head.[277]

Another intriguing artifact that belonged to Polly is a gold spoon for removing earwax. It is described as "gold with diamond pattern handle and small 'spoon' on one end. Other end has a blunt point." It is stamped with "faint" Chinese characters, not yet translated.[278]

Polly's handbag or small suitcase is also at the Museum. It is made of "soft-sided leather with metal center frame and a handle painted to look like leather. 4 metal 'feet' on bottom. Inside lined with cotton fabric. 1 inner pocket." Accompanying it is a "small light-colored rawhide pouch possibly for coins."[279]

The Museum once had a number of buttons that Charlie Bemis made for his wife from $2.50 and $5.00 gold coins, but these have disappeared. As mentioned (Chapter Seven), after Polly's house burned in August 1922, she recovered her gold buttons from the ruins. In May 1949, Pete Klinkhammer donated them to the Museum,[280] which was then housed in the basement of the high school building at the Monastery of St. Gertrude. The Museum displayed Polly's gold buttons in a cabinet with many of her other possessions. One day, the gold buttons vanished, and they have never been recovered despite written appeals for their return.[281] Museum curator and Benedictine nun M. Alfreda Elsensohn always blamed herself for their disappearance, since she had inadvertently left their cabinet unlocked when some young boys were in the Museum unattended.[282]

The theft took place sometime between 1957 and probably 1960.[283] The gold buttons were still at the Museum in May 1957, when visitors to the school's Fourth Academy Day would be able to view them.[284] An undated Deaccession Record lists them as stolen; an earlier Accession Worksheet notes that the buttons were deaccessioned on February 21 but the year is illegible.

In addition to the many artifacts in the Polly Bemis Collection at The Historical Museum at St. Gertrude, the Museum also owns Polly's marriage

certificate (Chapter Three, Fig. 3.4) and her Certificate of Residence (Chapter Three, Fig. 3.9).[285] There are also two dozen photographs in the Polly Bemis Collection;[286] most appear elsewhere in this book.

Polly Bemis Ranch, Main Salmon River

In the summer of 1939 a boating party from Utah made a 15-day trip, beginning on the Middle Fork of the Salmon River, all the way to Riggins. On July 8 they stopped at Polly's place. One member of the party, Hack Miller, later recalled, "Saw the shack, it had eyeglasses, needlework, magazines[,] and papers."[287]

In June 1987, at the dedication of Polly's dwelling as a museum, the house featured certain exhibits that had formerly belonged to Polly and Charlie. These included "Polly's rocker [rocking chair] (courtesy of Paul Filer), tea kettle, sourdough crock (courtesy of Roberta Rice Tice), [eye]glasses, mirror, [embroidered] sampler, gold medallions and dice from the Bemis saloon in Warren (courtesy of Johnny Carrey), spurs, bottles, containers, skis, saddle, bed[,] and much more."[288] Some of these were later given to The Historical Museum at St. Gertrude, in Cottonwood, Idaho, and others remain in Polly's home or have disappeared. Polly's glasses, mirror, embroidered sampler, and bed are still inside the building; other items, such as the skis, may be outside or are now missing.

Charlie Bemis's Belongings

In 2000, Jim Campbell, who once owned the Shepp Ranch and the Polly Bemis Resort, donated some of Charlie Bemis's possessions to The Historical Museum at St. Gertrude, Cottonwood, Idaho, with the assistance of Cort Conley. A newspaper account of the donation noted that it included "(1) a saddle belonging to Charlie Bemis that was made by the O. Owenhouse Company in Bozeman, Montana Territory in the 1880s, and (2) a carved ivory dice set that was a possession of Charlie Bemis.[289]

The saddle is described as a "riding saddle – all leather with sheepskin lining. Both cinches are missing," and some repairs have been made to the saddle.[290] It was reportedly Bemis's "favorite saddle." He gave it to Charlie Shepp when he, Bemis, "became too ill to ride; Shepp passed it to Johnny Car[r]ey."[291]

The pair of dice are made of ivory and measure less than ½ in. on a side. They were said to have been "handmade by Charlie Bemis."[292]

The Museum already owned some of Charlie Bemis's belongings, ones that Pete Klinkhammer gave them with his earlier donations of Polly's possessions. These include a balance scale with two pans, for weighing gold, complete with marked and unmarked weights, as well as small, reused, metal

containers for housing the weights;[293] a small bottle containing 105 gold flakes and a "large" gold nugget, presumably placer-mined by Bemis from the Salmon River;[294] a fire-damaged gold ring, ornamented with leaves and set with an opal, that "Polly had … fixed for Mr. Klinkhammer," who never wore it;[295] three lengths of "gold and silver wire" that were "probably drawn out by Bemis";[296] a "Rope"-style watch chain;[297] and a watch charm in the shape of opera glasses,[298] "with picture of Spain and Italy in it."[299] These pictures are no longer visible.

The Museum also owns another saddle said to have belonged to Charlie Bemis.[300] An accompanying letter from the donor, Gertrude Maxwell, states that the saddle was

> used by Charley [*sic*] Bemis on the Chisom [Chisholm] Trail before the turn of the century. … [Bemis] gave this saddle to Wm. [William] Boyce who was on the Shepp [R]anch a great deal when he discovered the War Eagle Mine. Boyce lived here [on Gertrude Maxwell's ranch in Elk City, Idaho] most of the time after he sold the War Eagle and he used this saddle as long as he had any use for it then gave it to me [Gertrude Maxwell] sometime in the [19]20s.[301]

It is entirely possible that Bemis could have given Boyce the saddle. Boyce was a frequent visitor to the Shepp Ranch and is often mentioned in Charlie Shepp's diaries. Boyce knew the Bemises well and assisted Shepp and Klinkhammer in helping them with the heavier work at the Bemis Ranch.

Assuming that Bemis did own the saddle, it is very unlikely that he ever used it "on the Chisholm Trail." The Chisholm Trail, which ran from southern Texas up through Oklahoma to central Kansas, began circa 1864, when James Mead established a trading post in Oklahoma Territory at the site of what became Wichita, Kansas. His partner was Jesse Chisholm, a half-Cherokee trader. Chisholm established the route that was later named for him.[302] He used it on his trading expeditions and freshly marked it, in 1865, "while guiding a military expedition that was removing about 3,000 Wichita Indians from Kansas to a new location along the Red River."[303] The Chisholm Trail remained in use until about 1876.[304]

If our information about Charlie Bemis is correct, he arrived in San Francisco by ship prior to 1864. He was in Warren by that date, before Chisholm's trail was named for its founder. While Bemis doesn't appear in the 1870 census for Warren, there is enough other evidence for his presence in the vicinity to make it highly doubtful that he was ever anywhere near the Chisholm Trail.

Archaeological Research Related to Polly and Charlie Bemis[305]

In 1993 archaeologist Mark Smith, under contract to the Midvale Telephone Exchange, Inc., investigated cultural deposits in Warren near the northeast corner of East Main Street and Bemis Gulch.[306] The work took the form of 16 power auger holes, some of which were placed into the street in front of Lots 20, 19, and 18.[307]

Prior to the 1904 fire, the latter three lots housed Charlie Bemis's home and saloon (Lot 20), Comer's Barber Shop (Lot 19), and the Warren Hotel (Lot 18). (Chapter Two). The recovery of a concentration of cultural materials, including Chinese artifacts, from Auger Hole #4 led to its being expanded into a 3' x 3' excavation unit.[308] Chinese artifacts from the test unit and from the auger holes included a coin from the reign of Emperor Daoguang (Tao Kuang, 1820-1850); a Chinese single-dose medicine vial; fragments of brown glazed stoneware, form(s) unidentified; a rim fragment from a "Bamboo"-pattern rice bowl; six sherds of celadon/"Winter Green" porcelain tablewares; three body fragments and one spoon fragment in the "Four Seasons Flowers" pattern; and four pieces from an opium pipe bowl.[309] Two parallel logs were identified as "possibly floor joists from the pre-1904 Warren Hotel."[310]

Although the excavators refer to Lot 19 as "the probable location of Hong King's saloon,"[311] they provide no evidence for the historical existence of that person or that business. While we know, from photographs, that Bemis owned the building on Lot 20, no evidence associates a Chinese saloon owner with Lot 19.

In the 1880 census, taken in June of that year, Charlie Bemis is listed as a saloon owner. As indicated earlier, although Charlie didn't get the deed to the Ripson Saloon until August 1880, six months after he purchased it (Chapter Two), he might actually have begun running it as early as December 1879. Where he and Polly actually lived is uncertain. Usually, when taking the census, the enumerator went from house to house, consecutively. If that was the case for Warren in early June of 1880, Polly and Charlie lived between two households of Chinese men, four miners and one gardener.[312]

No archaeological excavations have yet been conducted at Polly Bemis's home on the Salmon River. They would undoubtedly be productive; many of the recovered artifacts are likely to be examples of ones mentioned in Charlie Shepp's diaries and on the Bemises' shopping lists.[313] For example, the person who donated Polly's sewing machine head to the Idaho State Museum included a postcard of the Shepp Ranch with her gift.[314] The card also depicts a portion of the Polly Bemis Ranch, including Polly's second cabin. The location of Polly's first cabin, the one that burned, is marked as "X 1," slightly southeast of the second dwelling, and the find spot for the sewing machine

head is marked "X 2" in an area of trees to the west and slightly north of the second cabin.[315] The "X 1" area is currently believed to be the Bemises' blacksmith shop, so it could be rewarding to examine both these areas in greater detail, from an archaeological perspective, to establish their previous uses. The sewing machine's cast-iron frame and treadle, which weren't donated to the Museum, may yet be found by archaeologists, should any excavations ever take place at the Polly Bemis Ranch.

Of potential archaeological interest is a comment that Charlie Shepp wrote in his diary on November 1, 1923, that Pete, Jake, and/or Shepp, "cleaned off old cans for house."[316] This helps confirm that Shepp decided to erect Polly's new house in a different place from her first home, perhaps in the location of an old can dump.

Archaeologists would also be keen to locate any outhouses (privies, toilets) associated with the Bemises' two homes, as well as any other outbuildings that no longer remain. Because Polly was Chinese, it is tempting to speculate that her homesite and associated dumping areas might contain fragments of broken Chinese artifacts. Since Polly's sourdough crock was a Chinese brown-glazed, wide-mouthed, food jar, it is certainly possible that she had access to other Chinese goods.

Remembering Charlie and Polly Bemis

Today, in Warren, Charlie Bemis's memory is kept alive through Bemis Creek, which flows through Bemis Gulch, and by neighboring Bemis Point, elevation 7,611 feet,[317] although the latter was actually named for his father, Alfred Bemis.[318] One source confused the mountain, Bemis Point, with the Bemises' Salmon River home, calling Bemis Point "a favorite stopping place for rivermen."[319] Although Bemis Point has also been known as Bemis Lookout and Bemis Mountain,[320] none of the places named for Charlie and Alfred Bemis can be found in the standard dictionary of Idaho place names.[321] Polly Bemis is remembered by the Polly Bemis Ranch, which is still on the Salmon River across from the Shepp Ranch, and by Polly Creek, the stream flowing through the property. *Idaho Place Names* lists the creek as having indeed been named for Polly Bemis.[322]

Polly Bemis has even been remembered on the menus of Idaho restaurants, although with creative spellings of her name. From at least 2002, the White Water Pizza and Pasta in Boise, later in Meridian, offered a "Polly Beemis" [sic] dish. Under "Upper Fork Pizzas," the Polly Beemis, for $7.99, included "Creamy vinaigrette, marinated chicken, tomatoes, artichoke hearts, and bacon chunks."[323]

In Riggins, Idaho, the River Rock Café has offered the "Poly Beamis" [sic] Calzone, for $8.95, since at least 2010. It consists of "Roasted peppers and onion mix, mushrooms, sun dried tomatoes, artichokes, [and] our Mozzarella cheese blend with pesto sauce."[324] Because it is extremely unlikely that Polly Bemis ever tasted an artichoke (not to mention a pizza or a calzone), it is truly odd for menu items named after her to include that vegetable.

Dolls and Ephemera

Several dolls representing Polly Bemis are known. Two came from the shop at The Historical Museum at St. Gertrude in Cottonwood, Idaho, and were made by Benedictine nuns to benefit the Museum. An artist made the third doll, which most closely resembles Polly. Ephemera include two bookmarks and a refrigerator magnet.

Nun-made Dolls

The first of these is just over 12 in. tall. She wears a black-and-white checked dress and a white apron, and has a painted cloth face (Fig. 10.18).[325] The second doll is 15 in. tall and wears a blue dress and a black-and-white checked apron; she also has a painted cloth face (Fig. 10.19).[326] Because the faces are so different, it is apparent that the dolls were made by different nuns.[327]

In late January 1997 the nun-made dolls were out of stock at the Museum. Director M. Catherine Manderfeld had asked one of the sisters to make more.[328] It is likely that it happened, because a later article (2003) pictured Sister Mercedes Martzen with "a Polly Bemis doll that she still makes for the museum."[329] Sr. Mercedes died in 2011 and as of this writing (2020), the Museum has no dolls for sale.

Artist-made Doll

A third, and more lifelike, doll, made by Sue Johnson, is 22 in. tall and "has an Alumilite [casting resin] head, cloth body, and jointed arms and legs" (Fig. 10.20). Her cotton dress has a small, non-floral print, and her apron is faded blue cotton. She has "a full suit of underwear" – her "long johns" were made "from grey wool socks."[330] Two copies of this doll exist. One is at The Historical Museum at St. Gertrude in Cottonwood, Idaho, and the second is in the artist's collection.[331]

Ephemera

The Idaho Humanities Council issued a bookmark featuring a photomontage of a mountain; a giant tree; two historic buildings; and eight notable Idahoans, including Polly Bemis. A portion of the bookmark, including Polly's photo, was also made into a refrigerator magnet. Another bookmark, with the same image, advertised Priscilla Wegars's book, *Polly Bemis: A Chinese American Pioneer* (Fig. 10.21).

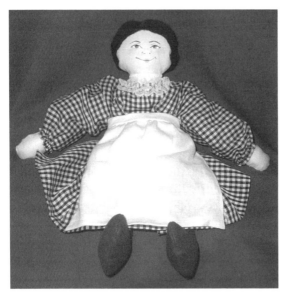

Fig. 10.18. Polly Bemis doll 1. Photo by author; doll in author's collection.

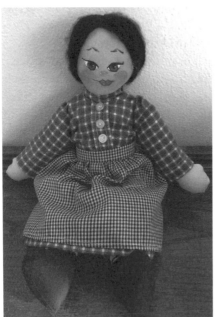

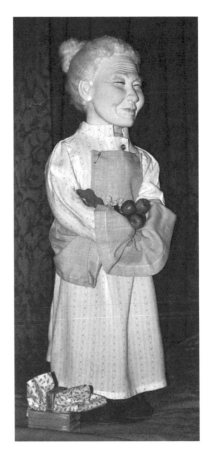

Fig. 10.19. Polly Bemis doll 2. Photo by Ron James; doll from collection of Marietta James. Used with permission.

Fig. 10.20. Polly Bemis doll 3. Photo by Sue Johnson; doll from collection of Sue Johnson. Used with permission.

Conclusions

In her master's thesis on Polly Bemis, Kathleen Whalen Fry suggests that Polly

must be taken out of the sensationalized and commodified arena in which she's been held for too long. She should not stand alone as an example of the Chinese experience either regionally or nationally. She must be read as a component of Chinese women's immigration history within the larger context of Chinese immigration history.

Fig. 10.21. Polly Bemis ephemera, including two bookmarks and a refrigerator magnet. Photo by author.

Resistance to a new interpretation of Polly's life is inevitable, but she must stand beside, not above, other aspects of Chinese history in America, regardless of how negative such experiences were.[332]

In writing about Polly Bemis some time in the 1950s or early 1960s, supplementing the account told to him by Taylor Smith, J. Loyal Adkison [d. 1965] presented another view of Polly. He observed that "in her own right, she stood out, challenging American womanhood for a place in Western civilization."[333]

People often ask, "What makes Polly Bemis so famous?" Certainly she represents all the forgotten Chinese women who came to the United States during the late 19th century, women who arrived often unwillingly, without knowing English, and with no prospect of ever returning home. While here, Chinese pioneer women faced racial prejudice from Euroamerican people and sexual discrimination from Chinese men. Polly Bemis lived in Idaho for more than 60 years. During that time, her strength of character enabled her to overcome adversity, winning respect and admiration from everyone who knew her.[334] Despite the ambiguities and contradictions about Polly's life that remain, there is one thread that joins all the sources. In one way or another, they have all said, "Polly was a wonderful person, and everybody loved her."

For several years I led a University of Idaho enrichment and summer school class up the Salmon River by jet boat to visit Polly's home and the two graves, where we tried to recapture the spirit of this remarkable pioneer woman. Perhaps one day you, too, can join me, going up the "River of No Return," back into the past.

Appendix:
Charlie Shepp's Diaries

Sometime after Polly and Charlie Bemis's marriage in August 1894 they moved down to the south side of the Salmon River; we know almost nothing about their lives for the next few years. However, in November 1902 the Bemises begin to be mentioned in what are known as the "Shepp diaries."

As noted (Chapter Four), Charles [Charlie] Shupp, later Shepp, was born in Iowa on July 19, 1860. He eventually settled in Seattle, and prospected from there for a few years, including in Alaska's Klondike. In 1900 Shepp came to Idaho's Buffalo Hump country following that area's gold mining boom. By 1902 he had a mining claim, the Blue Jay, on the West Fork of Crooked Creek, north of the Salmon River.

Briefly, the Mining Law of 1872 required claim holders to prove that they were working their mines in order to validate their ownership. For Charlie Shepp, this took the form of notations in small pocket diaries; these begin in November 1902.[1] In them, he names the claims that he located and the work he did on them. Shepp's diaries also record many of his other activities, such as coming down to the Salmon River to purchase produce from "Four-eyed" Smith[2] and Charlie Williams, owners of a ranch at the mouth of Crooked Creek, across the Salmon River from the Bemis Ranch.

In those days, there was much traffic back and forth across the Salmon, particularly by mining men and others on their way to mines and towns both north and south of the river. Even before Shepp purchased the Smith and Williams place in 1910, he often visited Polly and Charlie Bemis; once Shepp bought what became the Shepp Ranch, they visited him in return. From 1902 until Polly's death in 1933 Shepp regularly mentioned the couple in his diaries. The first such entry, on November 8, 1902, states, "Bemis and Egan over this am. Egan went to Hump. I was over river."[3]

Shepp's diaries were housed at the Shepp Ranch and remained there after Shepp died in 1937.[4] Shepp's mining and ranching partner, Peter (Pete) Klinkhammer, 20 years younger, inherited the Shepp Ranch. In 1950 Pete Klinkhammer, age 70, sold the Shepp Ranch to Paul and Marybelle Filer for

$10,000 on the condition that he be allowed to live there for the rest of his life; he died in 1970, age 89.[5] Marybelle Filer, and later owners, continued the diary tradition; the University of Idaho Library houses photocopies of many Shepp Ranch diaries through 1971.[6]

In 1981 Marian Sweeney prepared typed transcriptions of four of the earliest Shepp diaries.[7] In an introduction to her work, she recorded her observations on the diaries and their contents, stating,

For years, Shepp kept diaries in little notebooks he carried in his pocket. These notebooks appear now in several places. The four I've transcribed … were loaned to me by persons who choose to remain anonymous.[8]

It's interesting, though sometimes a bit boring, to transcribe the meager entries - 'Fine day, warm,' - over and over again. And yet, after days of typing, I began to feel a rhythm in the entries, the rhythm of a life on the river and the flow of its seasons.

In spring and late fall Shepp worked on his mineral holdings; in winter he cut wood, made sausage, went hunting. In summer he planted [a] garden and helped his neighbors, Charles and Polly Bemis, with the harvests.

Neighboring was common and hardly a day passed that Shepp didn't have company or visit someone or meet acquaintances on the trail.[9]

Years later, in reading the remaining, untranscribed, diaries for information about the Bemises, I noted some of the same things that had previously intrigued Marian Sweeney. For example, we both enjoyed getting into the rhythm of the seasons and yearned to know more about the many friends, acquaintances, and correspondents that Shepp mentions.[10]

Shepp's tendency to give his animals the same names as his friends or relatives provided some moments of confusion, as well as amusement. He named one of his horses after Nellie, his sister, and another after Polly Bemis, his friend and neighbor. A rooster, called George, was ultimately eaten for dinner. Although his eponym is uncertain, because Shepp, over time, had several friends named George, the rooster was probably named for George Yarhaus; he appears in the diaries at about the same time.

Catalogue of Transcribed and Photocopied Shepp Diaries

Photocopies of typescript transcriptions of four of the diaries covering portions of the years from 1902 through 1909 are in the University of Idaho Library Special Collections, Manuscript Group (henceforth MG) 5209.[11] Photocopies of original diaries for parts of 1903 through 1904 and most of

the years from 1909 through 1971 are also in the University of Idaho Library Special Collections, MG 155.[12] The Library does not hold any of the original diaries and their current location is unknown.

- Charles Shepp, [Diary], November 1, 1902, through June 12, 1903. [Sweeney's Book 1.] Spine title: "Shepp – Diaries 1902-09." Bound photocopy of typescript. Transcript prepared by Marian Sweeney, 1981. University of Idaho Library Special Collections, Moscow; MG 5209, call number Day-NW, F752, S35, S5.

- Missing: June 13, 1903, through July 13, 1903.

- Charles Shepp, [Diary], July 14, 1903, through June 8, 1904. Photocopy. University of Idaho Library Special Collections, Moscow; MG 155, Folder 2. [Folder 1 contains a few notes made by the Head of Special Collections and Archives at the time the photocopies were obtained.]

- Missing: June 9, 1904, through October 29, 1904.

- Charles Shepp, [Diary], October 30, 1904, through October 21, 1905. [Sweeney's Book 2.] Spine title: "Shepp – Diaries 1902-09." Bound photocopy of typescript. Transcript prepared by Marian Sweeney, 1981. University of Idaho Library Special Collections, Moscow; MG 5209, call number Day-NW, F752, S35, S5. [Sweeney's title page states that this diary begins May 9, 1904, but the first entry is not until October 30, 1904.]

- Charles Shepp, [Diary]. December 23, 1904, through December 31, 1904, and January 14, 1905, through February 6, 1905. Photocopy. University of Idaho Library Special Collections, Moscow; MG 155, Folder 3. [This is a small notebook provided by McKibben Hats; Shepp used it mostly for scratch paper. Of the few daily entries, many are crossed out and were copied into Sweeney's Book 2. Other pages have shopping lists, lists of names, and arithmetic calculations. One page reads, "Feb. 20 '06" above "Gone down to river" above "C. W. Shepp".]

- Missing: October 22, 1905, through November 12, 1905.

- Charles Shepp, [Diary], November 13, 1905, through April 30, 1908. [Sweeney's Book 3.] Spine title: "Shepp – Diaries 1902-09." Bound photocopy of typescript. Transcript prepared by Marian Sweeney, 1981. University of Idaho Library Special Collections, Moscow; MG 5209, call number Day-NW, F752, S35, S5.

- Charles Shepp, [Diary], May 1, 1908, through June 22, 1909. [Sweeney's Book 4.] Spine title: "Shepp – Diaries 1902-09." Bound photocopy of typescript. Transcript prepared by Marian Sweeney, 1981. University of Idaho Library Special Collections, Moscow; MG 5209, call number Day-NW, F752, S35, S5.

- Missing: June 23, 1909, through August 3, 1909.
- Charles Shepp, [Diary], August 4, 1909, through December 4, 1910. Photocopy. University of Idaho Library Special Collections, Moscow; MG 155, Folder 4.
- Charles Shepp, [Diary], December 1, 1910, through December 31, 1911. Photocopy. University of Idaho Library Special Collections, Moscow; MG 155, Folder 5.
- Peter Klinkhammer, "Year Book 1954 [1958]." Notes on 1910-1911 diary [as told to Marybelle Filer], written in diary dated 1954; first entry changed to 1958. Photocopy. University of Idaho Library Special Collections, Moscow, MG 155, Folder 6.
- Charles Shepp, [Diary], January 1, 1912, through October 31, 1913. [There are no entries from September 6, 1912, through September 30, 1912]. Photocopy. University of Idaho Library Special Collections, Moscow; MG 155, Folder 7.
- Charles Shepp, [Diary], November 1, 1913, through March 31, 1915. Photocopy. University of Idaho Library Special Collections, Moscow; MG 155, Folder 8.
- Missing: April 1, 1915, through July 31, 1915.
- Charles Shepp, [Diary], August 1, 1915, through June 30, 1916. Photocopy. University of Idaho Library Special Collections, Moscow; MG 155, Folder 9.
- Charles Shepp, [Diary], July 1, 1916, through June 3, 1917. Photocopy. University of Idaho Library Special Collections, Moscow; MG 155, Folder 10.
- Charles Shepp, [Diary], June 1, 1917, through December 31, 1917. Photocopy. University of Idaho Library Special Collections, Moscow; MG 155, Folder 11.
- Charles Shepp, [Diary], January 1, 1918, through June 30, 1919. Photocopy. University of Idaho Library Special Collections, Moscow; MG 155, Folder 12.
- Charles Shepp, [Diary], July 1, 1919, through November 1, 1921. Photocopy. University of Idaho Library Special Collections, Moscow; MG 155, Folder 13.
- Charles Shepp, [Diary], November 1, 1921, through December 31, 1923. Photocopy. University of Idaho Library Special Collections, Moscow; MG 155, Folder 14.

- Charles Shepp, [Diary], January 1, 1924, through December 31, 1924. Photocopy. University of Idaho Library Special Collections, Moscow; MG 155, Folder 15.
- Charles Shepp, [Diary], January 1, 1925, through December 31, 1925. Photocopy. University of Idaho Library Special Collections, Moscow; MG 155, Folder 16.
- Charles Shepp, [Diary], January 1, 1926, through June 23, 1927. Photocopy. University of Idaho Library Special Collections, Moscow; MG 155, Folder 17.
- Missing: June 24, 1927, through January 3, 1928.
- Charles Shepp, [Diary], January 4, 1928, through December 31, 1928. Photocopy. University of Idaho Library Special Collections, Moscow; MG 155, Folder 18.
- Missing: January 1, 1929, through July 12, 1929.
- Charles Shepp, [Diary], July 13, 1929, through August 31, 1929. Photocopy. University of Idaho Library Special Collections, Moscow; MG 155, Folder 19.
- Charles Shepp, [Diary], September 1, 1929, through October 10, 1930. Photocopy. University of Idaho Library Special Collections, Moscow; MG 155, Folder 20.
- Charles Shepp, [Diary], October 11, 1930, through October 1, 1931. Photocopy. University of Idaho Library Special Collections, Moscow; MG 155, Folder 21.
- Charles Shepp, [Diary], October 1, 1931, through October 19, 1932. Photocopy. University of Idaho Library Special Collections, Moscow; MG 155, Folder 22.
- Missing: October 20, 1932, through July 17, 1933.
- Charles Shepp, [Diary], July 18, 1933, through November 30, 1934. Photocopy. University of Idaho Library Special Collections, Moscow; MG 155, Folder 23.
- Missing: December 1, 1934, through February 14, 1936.
- Charles Shepp, [Diary], February 15, 1936, through April 12, 1937, and September 1, 1937, through November 20, 1937. Photocopy. University of Idaho Library Special Collections, Moscow; MG 155, Folder 24. [This was the last diary examined for this book, and the last one Shepp wrote.]
- Shepp Ranch Diary, 1948-1949 [actually into 1950]. Photocopy. University of Idaho Library Special Collections, Moscow; MG 155, Folder 25.

- Shepp Ranch Diary, 1950-1951. Photocopy. University of Idaho Library Special Collections, Moscow; MG 155, Folder 26.
- Shepp Ranch Diary, 1955-1956 [ends December 26, 1957]. Photocopy. University of Idaho Library Special Collections, Moscow; MG 155, Folder 27.
- Shepp Ranch Diary, 1954-1958. Photocopy. University of Idaho Library Special Collections, Moscow; MG 155, Folder 29. [Folder 28 contains a miscellaneous letter.]
- Shepp Ranch Diary, 1959-1963. Photocopy. University of Idaho Library Special Collections, Moscow; MG 155, Folder 30.
- Shepp Ranch Diary, 1964-1968. Photocopy. University of Idaho Library Special Collections, Moscow; MG 155, Folder 31.
- Shepp Ranch Diary, 1969. Photocopy. University of Idaho Library Special Collections, Moscow; MG 155, Folder 32.
- Shepp Ranch Diary, 1970. Photocopy. University of Idaho Library Special Collections, Moscow; MG 155, Folder 33.
- Shepp Ranch Diary, 1971. Photocopy. University of Idaho Library Special Collections, Moscow; MG 155, Folder 34.

ENDNOTES

Preface

1. Dorothy L. Sayers, with Robert Eustace, *The Documents in the Case* (New York: Harper & Row, 1930), reprinted (New York, Avon, 1968), 39. Citation is to the Avon edition.
2. Georganne Slifer, "Push-Pull-Push" (paper written for Dr. Carlos Schwantes's Idaho and the Pacific Northwest history class, fall semester 1988, photocopy of typescript in Asian American Comparative Collection, University of Idaho, Moscow), [9]-[10].
3. That PowerPoint presentation is titled "Polly Bemis: A Chinese American Pioneer," Idaho Humanities Council Speakers Bureau, Priscilla Wegars, https://www.idahohumanities. org/speaker-topic/polly-bemis-a-chinese-american-pioneer/ (accessed September 23, 2019).
4. Priscilla Wegars, "Charlie Bemis: Idaho's Most 'Significant Other,'" *Idaho Yesterdays* 44:3 (Fall 2000): 3-18.
5. Priscilla Wegars, *Polly Bemis: A Chinese American Pioneer* (Cambridge, ID: Backeddy Books, 2003); Priscilla Wegars, "Polly Bemis: Lurid Life or Literary Legend?," in *Wild Women of the Old West*, Glenda Riley and Richard W. Etulain, eds., 45-68, 200-203 (Golden, CO: Fulcrum, 2003).

Chapter One: Polly and Charlie Bemis through 1879

1. See Chapter Nine for an explanation of Polly's name and for a discussion of how she mistakenly became known as "Lalu Nathoy."
2. Warren used to be called "Warrens." Except for quotations, the name Warren will be used here. Following the 1862 gold discovery in the vicinity, two separate mining towns developed, called Washington and Richmond. Those names reflected the sympathies of the two sides then fighting in the Civil War: Richmond favored the South, and Washington, the North. The town of Richmond eventually died out. When Washington's first post office was established in 1868, the town's name was registered as Washington, Idaho Territory, but it was also known as "Washington at Warren's Diggin[g]s" and "Washington at Warren's Camp," after James Warren, the man who discovered gold there. It was later shortened, colloquially, to "Warrens." In 1885 the post office and town officially became Warren, Idaho Territory; however, "Warrens was commonly used in print for the next twenty years. Some still call it Warrens," Cheryl Helmers, *Warren Times: A Collection of News about Warren, Idaho* (Odessa, TX: The Author, 1988), preface. Today, Warren is a mountain community some fifty miles northeast of McCall, Idaho, ibid., [1].
3. Charles Alfred [for his father] Bemis was known variously as C. A., Chas., or Charlie. The latter nickname has sometimes been spelled "Charly" or "Charley." Because his preferred spelling is unknown, "Charlie" will be used here except for quotations from other sources. For example, one man who knew him uses the spellings "Charly" and "Charley," Taylor

Smith, letter to M. Alfreda Elsensohn, January 2, 1958, The Historical Museum at St. Gertrude, Cottonwood, ID, 1.

4. See Chapter Ten, Endnotes 27 through 29, for a listing of the most significant sources.

5. Bemis is profiled in Priscilla Wegars, "Charlie Bemis: Idaho's Most 'Significant Other,'" *Idaho Yesterdays* 44:3 (Fall 2000), 3-18.

6. US Bureau of the Census, *Tenth Census (1880)*, Idaho Schedules, Idaho County (Washington, DC: National Archives, 1880), Washington Precinct, 3. The 1880 US Census lists Polly (no surname given) as a Chinese female, age twenty-seven; subtracting twenty-seven from 1880 gives 1853 as the year of Polly's birth.

7. Asia Home, "Chinese New Year 1853," available at https://www.asia-home.com/china/nouvel-an-chinois/year/1853/lang/en.php (accessed October 31, 2017). The most recent Year of the Ox was in 2010 and the next one will be in 2022. In the US, the 1853 calendar year was notable for Franklin Pierce succeeding Millard Fillmore as US president, the creation of Washington Territory from Oregon Territory, and the invention of potato chips, Ken Polsson, "Chronology of United States of America," available at http://world-timeline.info/usa/usa1847.htm (accessed October 31, 2017). In addition, San Francisco's Levi Strauss and Company patented blue jeans with rivets in 1853, Levi Strauss & Co., "History," available at https://www.levistrauss.com/levis-history/ (accessed May 8, 2020).

8. Polly's Chinese name and her home village, both in Chinese characters, would need to be known before any attempt could be made to find a birth record for her. However, even if those facts were known, the Chinese government did not keep birth records for individuals at that time. Families and clans kept such records, particularly for males but seldom, if ever, for females because once women married, they became part of another family and clan. For more information on Chinese American genealogy, see Jean B. Ohai, "Family History for Chinese Americans," in *World Conference on Records: Preserving Our Heritage*, August 12-15, 1980, vol. 11: Asian and African Family and Local History (Salt Lake City: Family History Library, 1980), 1-13.

9. Charles (Charlie) Shepp was first an acquaintance and later became a neighbor when he bought the ranch across the Salmon River from Polly and Charlie Bemis's home.

10. US Bureau of the Census, *Tenth Census (1880), Idaho Schedules,* Idaho County, Washington Precinct, 3.

11. *Idaho Daily Statesman,* "Polly Bemis of Warren's Diggins Sees City's Sights for First Time," 61(8):2, August 4, 1924; *Idaho County Free Press,* "Polly Bemis Has Big Time on Visit to the State Capital," 40(13):1, 5, August 7, 1924.

12. Lamont Johnson, "Old China Woman of Idaho Famous," *Sunday Oregonian,* 52(45):sec. 5, pp. 1, 3, November 5, 1933.

13. E.g., Ruthanne Lum McCunn, "Reclaiming Polly Bemis: China's Daughter, Idaho's Legendary Pioneer," *Frontiers: A Journal of Women Studies,* 24:1 (2003), 93. I accept this characterization, so have not examined traits of other northern Chinese minority groups for comparison.

14. "Facts and Details," 'Daur Minority,' available at http://factsanddetails.com/china/cat5/sub88/entry-4351 (accessed September 20, 2017).

15. Yin Ma, ed., *China's Minority Nationalities* (Beijing: Foreign Languages Press, 1989), 76.

16. Ma, *China's Minority Nationalities,* 77. The types of vegetables are not specified; however, a website on the Daur ethnic minority lists maize [corn], sorghum [a grain], wheat, soybeans, and rice as their main crops, "Ethnic Groups—China.org.cn," 'The Daur ethnic minority,' available at http://www.china.org.cn/e-groups/shaoshu/shao-2-daur.htm (accessed November 28, 2019).

17. Although the first several chapters in Ruthanne Lum McCunn's beautifully written *Thousand Pieces of Gold* ([San Francisco]: Design Enterprises of San Francisco, 1981) describe "Lalu Nathoy's" family life in China; it is a "biographical novel," i.e., historical fiction, despite being based on "dozens of books, particularly those dealing with village

life, bandits, and the flora and fauna of nineteenth century Northern China," McCunn, "Reclaiming Polly Bemis," 77. To all of my former students who wondered "what happened to Polly's little brothers," *Thousand Pieces of Gold* depicts the fictional Lalu's household situation, not the real Polly's family circumstances.

18. Johnson, "Old China Woman of Idaho." McCunn, *Thousand Pieces of Gold*, 29-30, suggests that Polly's fictional family grew soybeans, sweet potatoes, peanuts, wheat, millet, turnips, cabbage, and "other vegetables."

19. E. g., *Idaho County Free Press*, "Woman of 70 Sees Railway First Time," 39(14):1, August 16, 1923, and Priscilla Wegars, *Polly Bemis: A Chinese American Pioneer* (Cambridge, ID: Backeddy Books, 2003), 23. No photographs exist of Polly's bound feet. McCunn's *Thousand Pieces of Gold*, [11], contains a picture of a young girl with bound feet; consequently, many people believe that it depicts Polly Bemis as a child, with bound feet. Although Polly did once have bound feet, that is not a picture of her then; the author got it from the Bancroft Library in Berkeley, California, ibid., [309]. The mistaken assumption later led to the photograph being redrawn and used as the cover for a booklet about Polly Bemis, Sheila D. Reddy, *The Color of Deep Water: The Story of Polly Bemis* (McCall, ID: Heritage Program, Payette National Forest, US Department of Agriculture, Intermountain Region, 1994), Cover.

20. There is a large bibliography of books on footbinding, including biography, e.g., Pang-Mei Natasha Chang, *Bound Feet and Western Dress* (New York, Doubleday, 1996); other nonfiction, e.g., Howard S. Levy, *Chinese Footbinding: The History of a Curious Erotic Custom* (New York: Bell, 1967); and fiction, e.g., Jicai Feng, *The Three-Inch Golden Lotus* (Honolulu, University of Hawai'i Press, 1986). Other writers concentrate on the special shoes for bound feet, particularly Beverley Jackson, *Splendid Slippers: A Thousand Years of an Erotic Tradition* (Berkeley: Ten Speed Press, 1997) and Dorothy Ko, *Every Step a Lotus, Shoes for Bound Feet* (Berkeley: University of California Press, 2001). The latter author also reexamined and reinterpreted the history of footbinding. In Dorothy Ko, *Cinderella's Sisters: A Revisionist History of Footbinding* (Berkeley: University of California Press, 2005), she postulates that "there is not one footbinding but many," meaning a diversity of "binding, rituals, and shoe styles" over the centuries and across China, 2. Ko's explanations for the custom include: "a symbol of the castration of women," where the foot and shoe are eroticized; "conspicuous consumption," in which the "feminine ideal ... demanded that women of the leisure class be made delicate" as well as "useless and expensive"; "mystification of female labor," meaning that although a footbound woman *appeared* [emphasis in original] incapable of labor, she still contributed to the household economy with other skills that involved the hands but not the feet; and, finally, the "marrying up" thesis where, matrimonially, prettiness of face was secondary to smallness of feet, Ko, *Cinderella's Sisters*, 2-3.

21. Levy, *Chinese Footbinding*, 17. As one scholar observes, "The emergence of footbinding as a widely practiced custom is the most vivid and the most material of the disabilities that increasingly constrained women; distance, familiarity, or exoticism should not disguise the horror of that custom nor the degree of psychic and physical violence it brought into the supposed security of home life," Hill Gates, "The Commoditization of Chinese Women," *Signs: Journal of Women in Culture and Society* 14:4 (Summer 1989), 821.

22. Ruthanne Lum McCunn, "Reclaiming Polly Bemis: China's Daughter, Idaho's Legendary Pioneer," in *Portraits of Women in the American West*, ed. Dee Garceau-Hagen, (New York: Routledge, 2005), 171.

23. Adele M. Fielde, *Pagoda Shadows: Studies from Life in China* (Boston, W. G. Corthell, 1884), 45; Ko, *Cinderella's Sisters*, 132.

24. Ko, *Cinderella's Sisters*, 228.

25. Ko, *Every Step a Lotus*, 58; Levy, *Chinese Footbinding*, 258.

26. Levy, *Chinese Footbinding*, 34, and Michel Beurdeley et al., *Chinese Erotic Art* ([Secaucus, NJ]: Chartwell Books, [1969?]), 206. Every effort has been made to obtain permission for

Fig. 1.5, but the original work could not be located. Beurdeley credits the Institute for Sex Research at Indiana University, now the Kinsey Institute, with providing the image but the Kinsey Institute has since moved their art collection off site and is currently unable to locate the artwork.

27. Levy, *Chinese Footbinding*, 34.

28. From the book's description, Hill Gates, *Footbinding and Women's Labor in Sichuan*, Routledge Contemporary China Series (New York, NY: Routledge, 2014), available at https://www.routledge.com/Footbinding-and-Womens-Labor-in-Sichuan/Gates/p/book/9781138104211 (accessed October 31, 2017).

29. Interviewed in Colleen Walsh, "Unraveling a Brutal Custom," *Harvard Gazette*, December 9, 2011, available at https:/news.harvard.edu/gazette/story/2011/12/unraveling-a-brutal-custom/ (accessed April 29, 2020).

30. Ibid. and C. Fred Blake, "Foot-Binding in Neo-Confucian China and the Appropriation of Female Labor," *Signs: Journal of Women in Culture and Society* 19:3 (Spring 1994), 700, 703.

31. Walsh, "Unraveling a Brutal Custom."

32. Jackson, *Splendid Slippers*, 38.

33. Ibid.

34. Ko, *Every Step a Lotus*, 60.

35. Ko, *Cinderella's Sisters*, 234, note 4, quoting from H. S. Y. Fang and F. Y. K. Yu, "Foot Binding in Chinese Women," *Canadian Journal of Surgery* 3 (April 1960), 199.

36. Eleanor Gizycka, "Diary on the Salmon River," part 2, *Field and Stream* (June 1923), 278. This unfortunate imagery suggests that Polly walked like an ape or a monkey.

37. E.g., the 1921/1923 interview is ibid. The 1923 interviews are *Idaho County Free Press*, "Woman of 70 Sees Railway"; ibid., "Polly Awakened," 39(14):3, August 16, 1923; and ibid., "Polly Returns to Warren after Happiest Days in Fifty Years," 39(15):1, August 23, 1923. The 1924 interview is *Idaho Daily Statesman*, "Polly Bemis of Warren's Diggins." There is also a 1933 "interview" consisting of Polly's reminiscences as told to her nurse, Johnson, "Old China Woman of Idaho."

38. *Idaho Daily Statesman*, "Polly Bemis of Warren's Diggins" and *Idaho County Free Press*, "Polly Bemis Has Big Time." No more details are available about the "American" woman; if she existed at all she surely spoke Chinese and could have been Euroamerican or Chinese American.

39. Gizycka, "Diary on the Salmon River," 278.

40. Johnson, "Old China Woman of Idaho."

41. Delia Davin, "Women in the Countryside of China," in *Women in Chinese Society*, ed. Margery Wolf and Roxane Witke (Stanford, CA: Stanford University Press, 1975), 244.

42. Joanna F. Handlin, "Lü K'un's New Audience: The Influence of Women's Literacy on Sixteenth-Century Thought," in *Women in Chinese Society*, ed. Margery Wolf and Roxane Witke (Stanford, CA: Stanford University Press, 1975), 13.

43. Maria Jaschok, *Concubines and Bondservants: A Social History* (Hong Kong: Oxford University Press, 1988), 10.

44. Maxine Hong Kingston, *The Woman Warrior: Memoirs of a Girlhood among Ghosts* (New York: Alfred A. Knopf, 1976), 43, 46; ibid., Vintage Books Edition (New York: Random House, 1977), 51, 54.

45. McCunn, *Thousand Pieces of Gold*, 20.

46. Mary Roberts Coolidge, *Chinese Immigration* (New York: Henry Holt, 1909), 18. Retired US Customs historian Harvey Steele observed that Portland, Oregon, had a Port of Entry in 1872 when Polly arrived there. At the time, Portland's US Collector of Customs (a federal official who oversaw collection of import duties on foreign merchandise shipped to the United States) was Harvey Scott (1838-1910), editor of Portland's *Oregonian* for

40 years and brother of Abigail Scott Duniway (1834-1915), herself the founding editor of *The New Northwest* newspaper and a fierce advocate for women's rights and suffrage, *The Oregon Encyclopedia*, "Harvey Scott (1838-1910)," by Lee Nash, available at https://oregonencyclopedia.org/articles/scott_harvey_1838_1910_/#.W2CF-aPQPA9 (accessed July 31, 2018). Steele speculated that it was "very likely" for Polly to have arrived on a ship that first called at Astoria and then landed in Portland. If she is on a passenger list at all, the entry of her name might not be directly interpretable. She might have been listed as a servant for the woman with whom she was traveling, or simply as a "Chinese woman," Harvey Steele, telephone conversations with author, notes in author's possession, April 1, 2001, and April 9, 2015.

47. Johnson, "Old China Woman of Idaho."

48. Gizycka, "Diary on the Salmon River," 278.

49. "The Inflation Calculator," https://westegg.com/inflation/infl.cgi (accessed July 30, 2018).

50. US Census, *Population Schedules of the Seventh Census of the United States 1850*, Connecticut, Hartford County (part), South Windsor (Washington, DC: National Archives, 1850), 140. Charlie Bemis's brother, William Bemiss [*sic*], was born on January 7, 1850, to Alfred and Marion Bemiss [*sic*]. William's parents were 32 and 24, respectively, at the time of his birth, they lived in South Windsor, and Alfred Bemis was a merchant, South Windsor, CT, Hartford County, "Vital Records: Birth, Death, Marriage. Acc[oun]t [of] Births from 1st Aug. 1849 to 1st Aug. 1850" (Salt Lake City: Genealogical Society, 1849-1850, microfilmed 1982), 10. That source does not provide Charlie Bemis's birth date. Alfred Bemis and Marion Amanda Foster were married September 30, 1846, "Hartford Vital Records," 27, citing vol. 1, p. 220, available at Ancestry.com—Connecticut Town Marriage Records, pre-1870 (Barbour Collection); thanks to Gayle Dixon, henceforth GD, for this and subsequent information about the Bemis family.

51. "The Inflation Calculator," https://westegg.com/inflation/infl.cgi (accessed July 30, 2018).

52. US Census, *Seventh Census, 1850*, Connecticut, South Windsor, 140. The census was taken on September 3, 1850; the information was to be accurate as of June 1, 1850. Dunn, from Ireland, had no occupation given, but may have been a household servant, while Filley [Finley] was listed as a clerk, probably in Alfred Bemis's store.

53. "Middletown Vital Records," p. 51, citing vol. 4, pp. 48-49, available at Ancestry.com—Connecticut Town Birth Records, pre-1870 (Barbour Collection), GD. The father, Alfred, age 29, was a manufacturer, and the mother, Marian, was 21; their surname was given as Bemiss [*sic*]. Thanks, too, to Leland Bibb for confirming this information, Leland Bibb, e-mail message to author, March 1, 2014. The year, 1848, appears in brackets in the original.

54. Peter Klinkhammer, letter [to M. Alfreda Elsensohn] regarding Charles A. Bemis, March 7, 1943, The Historical Museum at St. Gertrude, Cottonwood, ID.

55. Charlie Bemis's grave is between two others, that of Charlie Shepp (died in 1936) and Alec Blaine (died in 1940). The three markers are of identical construction: a copper rectangle with stenciled letters and numbers is fastened to a galvanized iron pipe driven into the ground at the head of each grave. The markers must have been placed sometime after 1940, the last burial there. A photograph of Charlie Bemis's metal grave marker is in Priscilla Wegars's *Polly Bemis: A Chinese American Pioneer* (Cambridge, ID: Backeddy Books. 2003), 11.

56. US Census, *Population Schedules of the Eighth Census of the United States 1860*, Connecticut, Hartford County (part), South Windsor (Washington, DC: National Archives, 1860), GD, Ancestry.com—1860 United States Federal Census, Connecticut, South Windsor, county of Hartford, 79.

57. *New York Herald*, "List of Letters," November 2, 1861, 3, GD.

58. Ancestry.com—1860 United States Federal Census, New York, 4th District of the 16th Ward, county of New York, p. 221. Monroe Finley was a salesman, and William Finley,

also listed, was a bookkeeper, Gayle Dixon in Kevin Gray, e-mail message to author, March 2, 2009, and Leland Bibb, e-mail message to author, February 27, 2014. Another source, not located by the author, states that Alfred Bemis and Marion Foster had a daughter, no name given, "born Aft. [after] 1849 in East Hartford, Hartford Co., CT; died Unknown," Gayle Dixon in Kevin Gray, e-mail message to author, November 23, 2007. Perhaps she died in infancy.

59. Ancestry.com—1860 United States Federal Census, California, township No. 7, county of Calaveras, p. 30, GD.

60. M. Alfreda Elsensohn, "Fourth Academy Day at St Gertrude's, Cottonwood, Renews … Memories of Polly Bemis," *Spokesman-Review*, May 12, 1957, 4.

61. Thomas Waln-Morgan Draper, *The Bemis History and Genealogy: Being an Account, in Greater Part, of the Descendants of Joseph Bemis of Watertown, Massachusetts* (San Francisco: Stanley-Taylor, 1900), 211, from "New York Public Library, Research Archive," 'The Bemis History and Genealogy,' available at http://www.archive.org/stream/bemishistorygene00drap/bemishistorygene00drap_djvu.txt (accessed August 30, 2017). The complete entry reads, "Alfred Bemis, of East Hartford, Ct. s. of Dr. Bemis, m. Mirriam (d. N. Y. City, Mar. 16, 1867, aged 40 yrs) dau. of D. J. Foster (d. Nov. 12, 1869, aged 90 yrs) and Amanda Fox of Hartford (d. June 7, 1869.) CHILDREN. I. Charles Bemis. II. William Foster Bemis."

62. David Bemis died in 1831. He and his wife, Almira, who died in 1864, are both buried in the Center Cemetery in East Hartford, CT, Gayle Dixon in Kevin Gray, e-mail message to author, March 2, 2009. Charlie's maternal family was at least important enough to appear in a genealogical handbook for Windsor, Connecticut, under the listing for Bemis's maternal grandfather, Daniel J. Foster. The complete entry [abbreviations are spelled out in brackets, for clarity] reads: "[FOSTER], D. J., came to So[uth] W[indsor] from E[ast] H[ar]tf[or]d; m[arried] Amanda Fox of H[ar]tf[or]d; kept store in So[uth] W[indsor]; he d[ied] 12 Nov., 1869 a[g]e[d] 70; she d[ied] 7 June, 1869. Ch[*ildren*]: (1) *Miriam*, m[arried] Alfred **Bemis** of E[ast] H[artford] (s[on] of Dr. B[emis]); had *Charles* and W[*illia*]*m F.*, who continued his g[ran]d-father's store in So[uth] W[indsor], and in spring of 1872 rem[oved] to Cal[ifornia]; Mrs. Miriam (Foster) Bemis d[ied] New York City, 16 M[ar]ch, 1867, a[g]e[d] 40," Henry R. Stiles, *The History and Genealogies of Ancient Windsor, Connecticut; Including East Windsor, South Windsor, Bloomfield[,] Windsor Locks, and Ellington, 1635-1891*, vol. 2, Genealogies and Biographies (Hartford, CT: Case, Lockwood, and Brainard, 1892), 35. The 1840 US Census named only the heads of households. Daniel Foster is listed as living in District No. 3, East Hartford, CT. He was between 40 and 50 years old, and was then engaged in agriculture. Also residing in his household were three females, one aged 5 to 10, one aged 10 to 15, and one aged 30 to 40, US Census, *Population Schedules of the Sixth Census of the United States 1840*, Connecticut, Hartford County, East Hartford (Washington D.C.: National Archives and Records Administration, 1840), 18. The oldest female, of course, was Daniel Foster's wife, Amanda. The eldest girl was "Miriam," who was probably about 14 then; she was 24 in the 1850 census. If the youngest female was a daughter, rather than someone who was just living with them, she may have died young, since the Fosters only had one child listed with their entry in Stiles, *History and Genealogies*, vol. 2, p. 35.

63. Stiles, *History and Genealogies*, vol. 2, p. 35. "Miriam" Bemis is buried in South Windsor, Connecticut's, Center Cemetery as Marian A. [Foster] Bemis, Find a Grave, available at http://www.findagrave.com/cgi-bin/fg.cgi?page=pv&GRid=16206029&PIpi=8513455 (accessed August 30, 2017). Although the death date of March 16, 1867 is correct, her husband's name is given as Andre [for Andrew?], not Alfred.

64. Ancestry.com—1870 United States Federal Census, South Windsor, Connecticut, county of Hartford, p. 4, GD.

65. William F. Bemis, age 31, is in the 1880 Walla Walla, Washington, census; curiously, his birthplace is given as New York, Ancestry.com—1870 United States Federal Census, Washington, Walla Walla City, county of Walla Walla, p. 17, GD.

66. Idaho County, Probate, "Probate Records" [1865-1880] (Boise: Idaho State Historical Society), microfilm 11/2, 247-250.

67. Helmers, *Warren Times*, November 1, 1873.

68. Gayle Dixon in Kevin Gray, e-mail message to author, February 25, 2009. A. Bemis, Charlie's father, Alfred, owed $22.00 and Chas. [Charlie] Bemis owed $17.00, Idaho County, "Probate Records," 250.

69. Robert J. Bailey, *River of No Return (The Great Salmon River of Idaho): A Century of Central Idaho and Eastern Washington History* and *Development, Together with the Wars, Customs, Myths, and Legends of the Nez Perce Indians* (Lewiston, ID: Bailey-Blake Printing, 1935), 476. Bailey's version was "pieced together" from "the stories told by the gentleman himself and information gathered from many sources ... on the Salmon River," ibid. The revised edition of his book, published in 1947 and reprinted in 1983, is more readily available. Although more material was added elsewhere, the section entitled "Polly Bemis, the Chinese Slave Girl" is identical. In the 1935 edition it appears on pages 474-479, while in the 1947 and 1983 editions it is on pages 675-680.

70. Ibid., 1935, 476.

71. Charles L. Kemp, "History of Idaho County: A History of Exploration[,] Adventure[,] and Discovery," *The Standard*, Industrial Edition, Grangeville, Idaho, December 1904, 3, courtesy Idaho County Courthouse, Office of the County Clerk. Florence was the first county seat, but it was replaced by Washington [Warren] in October 1868, Helmers, *Warren Times*, October 25, 1868. Mount Idaho became the county seat in 1875, followed by Grangeville in 1902, Pete T. Cenarrusa, compiler, *Idaho Blue Book: 1991-1992* (Boise: Pete T. Cenarrusa, Secretary of State, 1991), 245.

72. In the wake of the 1860 gold discoveries at Pierce, the town of Lewiston was illegally established on the Nez Perce Indian Reservation. It became the primary supply center for the Pierce, Oro Fino, Florence, Salmon River, Elk City, and Warren mining districts.

73. By water, Lewiston was 370 miles from Portland. A distance chart published in the mid-1860s described the following route [spelling and capitalization as in original]: Lower Cascades, Portage, [The] Dalles, Celilo, Five-Mile rapids, John Day, Indian rapids, Squally Hook, Rock creek, Chapman's woodyard, Big Bend, Willow creek, Castle Rock, Long island, Grand Ronde landing, Umatilla rapids, Windmill rock, Wallula, Snake river (mouth), Rapids, Fish Bend, Jim Fort's island, Pine Tree rapids, Pelouse crossing, Fort Taylor, Penana creek, Almota creek, Alpowa creek, Smith's ferry, Lewiston. Overland, the traveler went from Portland to The Dalles, and then via Deschutes, Mud Springs, John Day's river, Juniper spring, Willow creek, Well's spring, Butter creek, Umatilla river, Umatilla crossing, Wild Horse creek, Walla-Walla, Dry creek, Reed creek, Tucanon, Patapha, Alpowa, Smith's ranch, Craig's ferry, and Lewiston, a distance of 300 miles. Lewiston to Pierce City was 90 miles, to Elk City was 145 miles, and to Florence was 110 miles, US House of Representatives, *Letter from the Secretary of the Treasury, Transmitting a Report upon the Mineral Resources of the States and Territories West of the Rocky Mountains* (Report of J. Ross Browne, Special Commissioner, for 1866), 39th Congress, 2nd Session, House Executive Document No. 29, Serial Set No. 1289 (Washington, DC: Government Printing Office, 1867), 267.

74. Some years, such as in 1891, a Chinese pack train from Grangeville was the first one to arrive, *Idaho County Free Press*, "Our Weekly Round-Up: The China pack train ...," 5(51):1, May 29, 1891. It carried "5,000 pounds of supplies for the Andy McQuade contract on section 3 of the state wagon road"; the remaining freight went to Warren.

75. John Hailey, *The History of Idaho* (Boise: Syms-York, 1910), 30. Because of the deep snow, pack trains could not reach Warren until late May or early June.

76. James Warren has been described as "a shiftless individual, one-horse gambler, miner and prospector" by early Warren merchant Leo Hofen, "History of Idaho County" Idaho Ter[ritory] handwritten manuscript, Bancroft Library, University of California, Berkeley, 1879, 2, and microfilm, Idaho State Historical Society, Boise, MF109.

77. Helmers, *Warren, Idaho: Historical Sketches* (Odessa, TX: The author, 1986), [3].

78. Washington was at the lower end of the Warren Basin and Richmond was at the upper end of it, Herb Mcdowell, "From Our Past—Late 1800s—Idaho Mining," 'Town Brings Memories for Ex-Resident,' *Lewiston Morning Tribune*, May 17, 1987, E1. Although it is generally believed that Washington became Warren, some sources state that they were two separate communities, e.g., Everett A. Sandburg, "Partnership Born in Gold Rush," *The Pacific Northwesterner* 22:2 (Spring 1978), 22, while others believe that Washington, Richmond, and Warren were "all the same mining camp," e.g., Merle W. Wells, *An Atlas of Idaho Territory 1863-1890* ([Boise]: Idaho State Historical Society, [1978]), 16. Perhaps "same mining camp" means the Warren Mining District, since elsewhere, Wells agrees that Washington and Richmond were two separate communities, Merle W. Wells, "Rush to Idaho," *Bulletin No. 19* (Moscow, ID: Idaho Bureau of Mines and Geology, 1961), 15.

79. Wells, *Rush to Idaho*, 15.

80. Helmers, *Warren Times*, preface; *Lewiston Morning Tribune*, "Warrens is Wakening," 2(3):1, September 12, 1893; *Semi-Weekly Idaho World*, "Sketches of Travel in Idaho. Number III," 2(32):2, August 29, 1868; *The Standard*, "Warren," 1(10):5, May 31, 1899; Kemp, "History of Idaho County," 9.

81. Helmers, *Warren, Idaho*, [6].

82. Ibid., [10]. The Meadows post office was not established until 1883, Laila Boone, *Idaho Place Names: A Geographical Dictionary* (Moscow: University of Idaho Press, 1988), 250.

83. Hofen, "History of Idaho County," 2-3. Leo Hofen arrived in Lewiston in the spring of 1864. In 1865 he packed a load of merchandise into Warren and remained there as a merchant and assayer until 1874 when he sold out and returned to San Francisco, ibid., 1-2.

84. Ibid., 3-4. "Quartz" mining refers to lode or hardrock mining as opposed to placer mining (surface mining of loose gold). Quartz mining requires a mill, either a stamp mill or a grinding mill, to crush the rock so the gold can be released. One type of grinding mill was an arrastra, powered usually by animals or sometimes with water. Charlie Bemis had a couple of arrastras at one time, which he sold to his father, Alfred, in August 1873, and then inherited them when Alfred died in March 1876.

85. Gene F. Williams, transcriber, editor, and indexer, *Idaho Territorial Voters Poll Lists 1863*, Parts I, II (Boise: Williams Printing, 1996), part II, p. 4; "The 1863 Voters Poll Lists are the 'first census' of Idaho Territory" (ibid., part I, p. i). While this is called a census, and, indeed, it does include some women and children, neither could vote, so it is not clear how their total numbers came to be listed for some communities. The total for Warren, 660, includes no women, children, or non-voting men (ibid., part I, p. 6). Although M. Alfreda Elsensohn first gave the date of the Bemises' arrival as 1865 (Elsensohn, "Fourth Academy Day," 4), she later said that it could have been as early as 1863 or 1864, M. Alfreda Elsensohn, *Idaho Chinese Lore* (Cottonwood, ID: Idaho Corporation of Benedictine Sisters, 1970), 82.

86. Klinkhammer, letter, March 7, 1943. When Elsensohn commented on the discrepancy between the 1865 date provided by Klinkhammer and the 1864 date given on the music book, another of her informants commented, "One year does not make much difference," Taylor Smith, interview by M. Alfreda Elsensohn, August 2, 1958, transcript, The Historical Museum at St. Gertrude, Cottonwood, ID.

87. *Idaho Sunday Statesman*, "Romantic Figure of Warrens' Gold Camp Ill in Grangeville Hospital," 70(9):sec. 2, p. 4, September 24, 1933.

88. Bailey, *River of No Return*, 1935, 476.

89. Ibid. About 1910, historian John Hailey stated that Warren was "a small camp with a limited number of fairly good placer mining claims, but it never created much excitement

or caused a rush of people. Of late years [i.e., prior to 1910], some good quartz claims have been discovered at this place and worked successfully," Hailey, *History of Idaho*, 32.

90. Ladd Hamilton, "How Mr. Bemis Won the Chinese Slave Girl," *Saga* 8:5 (August 1954), 50-51.

91. Elsensohn, *Idaho Chinese Lore*, 82; "Since there was no dance music in the mining camp Bemis played the tunes he knew on the violin and Peter Bemer [*sic*] put down the notes," ibid. Bemer is also spelled Beamer, Helmers, *Warren Times*, December 9, 1866, or Beemer, Rob McIntyre, "A Survey of Musical Activity in the Mining Camps of Idaho through June of 1865" (master's thesis, University of Idaho, Moscow, 1993), 41. Helmers's undocumented account, written as a make-believe letter, states that "Beamer plays flute and conducts Charles Bemis and Rube Besse on violins, Nate Jenkins playing his hand made banjo[,] and Charles Brown playing an accordion. They practice during the evenings in the Bemis saloon. Our weekly dances are conducted in the Bemis saloon, at which time he closes the bar and covers it with a canvas, turns the pictures to the walls [presumably because they portrayed nude women], [and] stacks the tables and chairs out of the way, thus converting it to a dance hall so the ladies can be admitted. There is no smoking or drinking allowed in the 'dance hall' during the dances. Approximately 75 to 100 people attend, the ratio being about five men to one woman. There is music for schottis[c]hes, quadrilles, polkas, mazurkas, varsouverians, [varsoviennes], minuettes [minuets], and waltzes. Sometimes the dances last until daylight Sunday mornings. An intermission at midnight gives the musicians a break and the ladies serve supper buffet style," Helmers, *Warren Times*, December 9, 1866.

92. M. Alfreda Elsensohn, *Idaho County's Most Romantic Character: Polly Bemis* (Cottonwood, ID: Idaho Corporation of Benedictine Sisters. 1979), 13. Elsensohn also stated, "On the front page with pencil [Bemis] had written C. A. Bemis, Date 1864, also Camp Washington, Warren's diggins." To date this author has only seen scans of this book; if the writing is as stated on the first page, the letter "C" is too faint to be readable from the scan. Page 3 is a "Schottish" collected from a person at "Camp Washington, Idaho, Warrens Diggins," Peter Beemer Music Manuscript, Boise State University, Boise, Idaho, "MSS 268 Beemer Manuscript," p. 3, available at https://digital.boisestate.edu/digital/collection/beemer/id/152 (accessed March 20, 2019); I am grateful to Alex Meregaglia for sending me a link to it. This page is also an illustration in McIntyre, "Survey of Musical Activity," 46. Elsensohn obtained her information from Taylor Smith on a 1958 visit, Smith, interview, August 2, 1958. In a later letter to Elsensohn, Smith elaborated: "In Regard to the Music Book the Date on the Book Proves Bemis Was in Warren Before 1865. The Book[']s Date is 1864, in Bemis['s] own hand Writing. ... They had there [*sic*] Instruments and Musicians but no Music. Peter Bemer [*sic*] Pla[ye]d the Flute and Chas. Bemis the Violin. [T]he others I Don't [k]no[w]. So Peter Bemer [took] writing Paper Ruled it Like music. Then he would have people men and women that could sing or whistle a Piece right. He would write as they s[a]ng or whistled," Taylor Smith, letter to M. Alfreda Elsensohn, August 26, 1958, The Historical Museum at St. Gertrude, Cottonwood, ID, 1.

93. In his master's thesis on early Idaho music, Rob McIntyre partially described the music book, when it was then owned by Dale Walden of Boise, since deceased. McIntyre stated that "... the manuscript is eighty-six pages in length, printed upon legal size notebook paper with hand-drawn staves, with a canvas covered leather exterior, bound with string. It is accompanied by a document written by Taylor Smith, who was the second owner of the manuscript. According to Smith, it was composed in 1864 by Peter Beemer, an itinerant musician. Seeing the need for a dance band in Warren, Beemer approached the various musicians, miners, and other members of the community and asked them to whistle, sing, or hum their favorite melodies. Beemer then orchestrated these melodies for a six piece orchestra which consisted of two violins, one flute, one banjo, one accordion, and one other instrument which is unknown (probably another flute since the surviving manuscript contains pieces described as flute duets)," McIntyre, "Survey of Musical Activity," 41. The music manuscript itself "is a first violin part which originally belonged to Charles Bemis.

In later years, Bemis used it to teach a young Taylor Smith how to play the violin, and still later he gave the manuscript to Taylor," ibid. There is some question about how and when Taylor Smith obtained the book. "It was given to the late Taylor Smith of New Meadows by Charlie Bemis when Taylor was fourteen years old," Elsensohn, *Idaho Chinese Lore*, 82. That would have been about 1894, since Smith was 14 years old when he attended the Bemises' wedding that year, Smith, letter, August 26, 1958, 2. Typed notes from Elsensohn's interview with Taylor Smith corroborate that date, stating that "Mrs. [*sic*] Smith came to Warrens when he was 10 years old in 1890, Smith, interview, August 2, 1958. Elsensohn also states, "Mr. Smith knew Charlie Bemis very well though he did not receive the book directly from him but from a man named Charlie Brown," Elsensohn, *Polly Bemis*, 14; this may be the reported accordion player, Charles Brown, Helmers, *Warren Times*, December 9, 1866. Although Smith agrees with that statement in one place, Smith, interview, August 2, 1958, elsewhere, he states, "Chas. Bemis gave the Book to me m[a]ny years ago. Money would not B[u]y it," Taylor Smith, letter to Sister [M. Alfreda Elsensohn], September 2, 1958, The Historical Museum at St. Gertrude, Cottonwood, ID, 1. McIntyre analyzed the individual tunes and found that most were schottisches (15) and waltzes (14). Others were polkas (11), quadrilles and quicksteps (9 each), mazurkas (6), reels and operatic pieces (5 each), jigs and varsoviennes (4 each), wartime airs and plantation/minstrel songs (3 each), and hornpipes (2), McIntyre, "Survey of Musical Activity," 45. One of the tunes is headed, "Polka from Sanderson's Violin Instructor." This may be the same Sanderson who filed a mining claim location with Alfred Bemis in September 1866, Idaho County, Mining Claims, "Mining Locations," Book 1" [1866-1887] (Idaho County Courthouse, Auditor-Recorder, Grangeville, ID), 21.

94. H. J. Swinney, letter to [M.] Alfreda Elsensohn, November 17, 1958, The Historical Museum at St. Gertrude, Cottonwood, ID.

95. M. Alfreda Elsensohn, letter to H. J. Swinney, November 29, 1958, The Historical Museum at St. Gertrude, Cottonwood, ID.

96. Boise State University, "MSS 268 Beemer Manuscript."

97. Williams, *Idaho Territorial Voters Poll Lists 1863*, part II, p. 4.

98. Idaho County, Mining Claims, "Mining Locations, Book 1," 1.

99. Ibid., 15. Charlie's claim was number 13 [the numbers began with 10].

100. Ibid., 16. Charlie's claim was number 13, Alfred's was number 12, and their name was spelled "Bemiss."

101. Ibid., 22.

102. Ibid., 41. Charlie's claim was No. 9.

103. Idaho County, Mortgages, "Book I" [1862-1876] (Idaho County Courthouse, Assessor, Grangeville, ID,), 250-253.

104. Idaho County, Assesments, "Assessment Book for 1870" (Idaho County Courthouse, Assessor, Grangeville, ID), 16.

105. Idaho County, Bills of Sale, "Book 1" [1862-1893] (Idaho County Courthouse, Auditor-Recorder, Grangeville, ID), 180.

106. US House of Representatives, *Statistics of Mines and Mining in the States and Territories West of the Rocky Mountains; Being the 5th Annual Report of Rossiter W. Raymond, United States Commissioner of Mining Statistics*, 42nd Congress, 3rd Session, House Executive Document No. 210, Serial Set No. 1567 (Washington, DC: Government Printing Office, 1873), 201.

107. Klinkhammer, letter [to M. Alfreda Elsensohn], March 7, 1943.

108. Elsensohn, "Fourth Academy Day," 4.

109. Idaho County, Commisioners, "Commissioners Record, Book 2" [1869-1877] (Idaho County Courthouse, Auditor-Recorder, Grangeville, ID), 81.

110. Cenarrusa, *Idaho Blue Book*, 245.

111. *Semi-Weekly Idaho World*, "Sketches of Travel in Idaho. Number III."

112. Kemp, "History of Idaho County," 4; "Poor old Florence had seen its halcyon days. That camp was practically deserted and the hundred mile road from it to the new diggings was crowded with miners hailing with lusty delight this new El Dorado," ibid. Warren was closer to 45 miles from Florence, not 100. One estimate placed the "placer gold output of Warren camp from the year of discovery [1862] to 1884 at nearly $19,000,000," and probably more, ibid., 9. Walter Hovey Hill gave a figure of $14,000,000 for the same time period, M. Alfreda Elsensohn, *Pioneer Days in Idaho County*, vol. 1 (Cottonwood, ID: Idaho Corporation of Benedictine Sisters, 1965), 101. Former Warren resident Herb McDowell estimated that $9,000,000 worth of gold was taken out of "Warren's" between 1860 and 1969, McDowell, "From Our Past." The first meeting of the County Commissioners in the new county seat was in August 1869, Helmers, *Warren, Idaho*, [7].

113. *Semi-Weekly Idaho World*, "Sketches of Travel in Idaho. Number III." "Hurdy houses" were so named for the hurdy-gurdy girls who played the hurdy gurdy, a musical instrument, and who also danced with patrons for a fee. See Chapter Two and Elsensohn, *Polly Bemis*, 14-15, for more information about them.

114. *Semi-Weekly Idaho World*, "Sketches of Travel in Idaho. Number III."

115. Ibid. Lumber was available from sawmills at $80 per 1,000 feet, a vast improvement over the pre-sawmill, whipsawn price of $250 per 1,000 feet. Other supplies came from Grangeville, by way of Slate Creek and Florence, then down to the Salmon River and across it on Lloyd Carey's cable bridge, along to French Creek, up to the head of Fall Creek, then to Burgdorf and finally Warren, M. Alfreda Elsensohn, *Pioneer Days in Idaho County*, vol. 2 (Caldwell, ID: Caxton, 1951), 442.

116. *Idaho Tri-Weekly Statesman*, "Items from the Lewiston '*Signal*,'" "A correspondent ...," 8(153):2, July 13, 1872. It is not known if these particular gardens had Chinese owners.

117. Kemp, "History of Idaho County," 5. The county seat shifted to Grangeville in 1902, where it remains.

118. In the late 1870s, US mining commissioner Rossiter Raymond wrote that Warren's "placers are now nearly exhausted, except for the Chinese, who will continue to make from $1 to $3 per day per man for some years to come. Wages of white men in the mines during the past season have been from $4.50 to $5 per day, while Chinese labor has been $2.50 per day," *Payette Lake Star*, "Report of Rossiter W. Raymond on the Mining Condition of the Washington, Now Warren, District of Idaho, 1876-7," 2(24):5, June 13, 1919, 5.

119. Much has already been written about Chinese miners and mining in Warren. The most comprehensive accounts are probably Melvin D. Wikoff, "Chinese in the Idaho County Gold Fields: 1864-1933" (master's thesis, Texas A&I University, Kingsville, 1972); Jeffrey M. Fee, "A Dragon in the Eagle's Land: Chinese in an Idaho Wilderness, Warren Mining District, ca. 1870-1900" (master's thesis, University of Idaho, Moscow, 1991); Samuel L. Couch, "Topophilia and Chinese Miners: Place Attachment in North Central Idaho" (Ph.D. dissertation, University of Idaho, Moscow, 1996); and Cletus R. Edmunson, "A History of Warren, Idaho: Mining, Race, and Environment" (master's thesis, Boise State University, Boise, ID, 2012). More readily available information on the Chinese in Warren includes Elsensohn, *Idaho Chinese Lore*, 76-80, and Jeffrey M. Fee, "Idaho's Chinese Mountain Gardens," in *Hidden Heritage: Historical Archaeology of the Overseas Chinese*, ed. Priscilla Wegars, 65-96 (Amityville, NY: Baywood, 1993).

120. *Mining and Scientific Press*, "Idaho: Northern Idaho," 20(8):116, February 19, 1870.

121. The Chinese also mined nearby for cinnabar, the ore from which mercury is obtained. Gold miners use mercury in the gold recovery process.

122. *Mining and Scientific Press*, "Idaho: North Idaho," 19(26):404, December 25, 1869.

123. Helmers, *Warren Times*, December 9, 1869, from *Mining and Scientific Press*, and ibid., May 1870.

124. Helmers, *Warren Times*, May 1870. Curiously, this information supposedly came from Elsensohn, *Idaho Chinese Lore*, but it could not be found there.

125. Helmers, *Warren Times*, August 10, 1870. The Euroamericans comprised 213 men, 12 women, and 16 children in 9 families. There were also "3 Indians and 2 black men." Chinese women were vastly underrepresented in this population; historically, a Chinese woman traditionally lived with her parents-in-law, and if her husband went abroad to work for many years without returning, his wife became known as an "alive widow," Li-hua Yu, "Chinese Immigrants in Idaho" (Ph.D. dissertation, Bowling Green State University, Bowling Green, Ohio, 1991), 204. In 1870, for example, Idaho had only 126 Chinese women out of a total Chinese population of 4,274. Although this seems low, it "was the fourth largest Chinese female population in the US" at that time, Yu, "Chinese Immigrants," 202, citing Judy Yung, *Chinese Women of America* (Seattle: University of Washington Press, 1983), 119. Euroamerican women in Idaho numbered 2,815 but they, too, were underrepresented compared with the men, Yu, "Chinese Immigrants," 202-203; Idaho's total population in 1870 was 14,999.

126. US Census, *Ninth Census (1870), Idaho Schedules*, Idaho County, Washington [Warren], Washington, DC: National Archives, microfilm T-8, roll 48, University of Idaho Library, film no. 37, sheet 195, page 2, line 3.

127. The elevation on the South Fork of the Salmon River, at the South Fork steel bridge crossing, is some 3,027 feet, Helmers, *Warren, Idaho*, [3], more than 2,800 feet lower than Warren itself. In 1888 Charlie Bemis bought the China Jake Ranch on the South Fork of the Salmon River (Chapter Two).

128. Elsensohn, *Idaho Chinese Lore*, 77.

129. *Mining and Scientific Press*, "Idaho: Warren's," 21(22):365, November 26, 1870. This many people would need an incredible amount of foodstuffs to last the winter, since the first pack trains did not normally arrive until mid-June. In 1872, by the time the pack train arrived on June 15, "many articles had become extinct,—even whisky, that necessity of a miner, was scarce, and only by diluting to the most extreme limit had the fountain been kept up," *Idaho Tri-Weekly Statesman*, "Items from the Lewiston 'Signal': The first pack trains ...," 8(148):3, July 2, 1872.

130. Elsensohn, *Idaho Chinese Lore*, 77-78.

131. Ibid., 78.

132. Hiram T. French, *History of Idaho: A Narrative Account of Its Historical Progress, Its People and Its Principal Interests*, vol. 1 (Chicago: Lewis Publishing Company, 1914), 128.

133. Hofen, "History of Idaho County," 4.

134. One scholar has noted that for California, in 1870, 60% of Chinese immigrant women were prostitutes, in Cantonese, "*lougeui* ('always holding legs up') or *baak haak chai* ('hundred men's wife')," Marjorie King, "Nathoy, Lalu (Polly Bemis) (1853-1933)," in *Handbook of American Women's History*, 2nd ed., ed. Angela M. Howard and Frances M. Kavenik (Thousand Oaks, CA: Sage, 2000), 372-373. Sue Gronewold, in her fascinating "Beautiful Merchandise: Prostitution in China 1860-1936," *Women & History* 1 (Spring 1982) observes that prostitution was generally confined to public brothels that were "licensed by the state and organized into three classes, or levels, each with own recruitment, customs, and clientele," ibid. 4. "Courtesans, the elite of the profession, were not viewed as eternally fallen, sinful women ...; [they were] welcomed by the elite as a complement to the institution of marriage and were considered suitable candidates for secondary wives. Once married, they could lead respectable lives. Lower-class prostitutes, on the other hand, had a disreputable image—a function of their class more than of their occupation," ibid., 5. "Beautiful Merchandise" is a Chinese euphemism for prostitution, ibid., 3-4.

135. H. W. [Henry William] Brands, *The Man Who Saved the Union: Ulysses S. Grant in War and Peace* (New York: Doubleday, 2012), 499.

136. National Park Service, "Yellowstone National Park," 'History & Culture,' available at https://www.nps.gov/yell/learn/historyculture/index.htm (accessed September 19. 2017).

137. "Victoria C. Woodhull," in *Encyclopedia of World Biography*, vol. 16 (Detroit: Gale, 1998), 372; U.S. History in Context, available at http://link.galegroup.com/apps/doc/ K1631007058/UHIC?u=mosc00780&xid=27e316a5 (accessed September 19, 2017).

138. "Pinckney Benton Stewart Pinchback," in *Encyclopedia of World Biography*, vol. 12 (Detroit: Gale, 1998), 308; U.S. History in Context, available at http://link.galegroup.com/ apps/doc/K1631005220/UHIC?u=mosc00780&xid=4e78a422 (accessed July 25, 2018).

139. Thomas Edward La Fargue, *China's First Hundred: Educational Mission Students in the United States, 1872-1881* (Pullman, WA: Washington State University Press, 1987).

140. *Idaho County Free Press*, "Woman of 70 Sees Railway."

141. Ibid.

142. Although Helmers's *Warren Times* appears, at first glance, to be excerpts from a Warren newspaper, it is actually comprised of articles about Warren that appeared in a wide variety of other sources. In early 1890 the *Idaho County Free Press* stated that the Press had "a copy of the *Guerilla* [*sic*] *Corkscrew* published in Warrens on November 20 [or 30] 1889. The paper is quite a curiosity and will be put away in our cabinet and preserved," *Idaho County Free Press*, "Through the courtesy of Chas. Wood ...," 4(33):1, January 24, 1890. Although the *Idaho County Free Press* is still in business, they no longer have that paper, David Rauzi, telephone conversation with author, November 1997, nor does the Grangeville Bicentennial Museum have it, Carmelita Spencer, telephone conversation with author, January 1998. When Grangeville's *Idaho County Free Press* began, in 1886, it was described as "the first paper ever published in Idaho [C]ounty," *Idaho County Free Press*, "Our Warrens Letter," by N[orman] B. W[illey], 1(3):1, July 2, 1886.

143. Gizycka, "Diary on the Salmon River," 278. It is possible that Polly's owner sent the money to contacts in Hong Kong or China to obtain a woman for him. Alternatively, he could have given the money to the packer to purchase a woman in Portland. The packer would have received additional money for Polly's food and transportation on the way to Warren, Walter Mih, "The Life of Polly Bemis," *Asian American Comparative Collection Newsletter* 32:3 (September 2015), 6, and Walter Mih, "The Life of Polly Bemis (continued from September 2015," *Asian American Comparative Collection Newsletter* 32:3 (December 2015), 2.

144. Lamont Johnson, "Old China Woman of Idaho," 1. However, if 'Big Jim' was once Polly's owner, Czizek could not have known him personally, since Czizek did not meet Polly until about 1888, *Idaho Sunday Statesman*, "Romantic Figure," 4; Czizek stated that he first knew Polly "about 45 years ago," i.e., about 1888. Jay Czizek was Idaho's first State Inspector of Mines, appointed in 1899, Helmers, *Warren Times*, July 8, 1938.

145. The pack train operator was probably Ah Kan (Chapter Two). Reportedly, in Polly's own words, an "old Chinee-man he took me along to Warrens in a pack train," Gizycka, "Diary on the Salmon River," 278. People are often disappointed to learn that the handsome, young, Chinese man, Jim, the love interest in both the book and the movie, was one of Ruthanne Lum McCunn's "fictitious characters," McCunn, *Thousand Pieces of Gold*, preface, and Walter Hesford, "*Thousand Pieces of Gold*: Competing Fictions in the Representation of Chinese-American Experience," *Western American Literature* 31:1 (Spring 1996), 54-55.

146. Elsensohn, *Pioneer Days in Idaho County*, vol. 1, 94.

147. Helmers, *Warren Times*, July 8, 1872. One supposition, not seen elsewhere, but discussed in Chapter Eight for October 1927, suggested that one of the women might have been Polly's sister.

148. *Idaho Daily Statesman*, "Polly Bemis of Warren's Diggins," and *Idaho County Free Press*, "Polly Bemis Has Big Time."

149. The other two women's stay in Florence may have been brief. In 1870, two years before their supposed arrival, that year's census listed one Chinese woman in Florence. Her name was Shae[?] Sin, she was twenty-six years old, and her occupation was "Disreputable," Xu, "Chinese Women in Idaho," 123. The 1880 census did not list any Chinese women in Florence.

150. Polly may also have spoken English with other Chinese people, given that their native languages were mutually unintelligible, as discussed.

151. It is unlikely that Polly was a prostitute; see Chapter Nine for a discussion of this and other myths about her.

152. *Idaho Daily Statesman*, "Polly Bemis of Warren's Diggins" and *Idaho County Free Press*, "Polly Bemis Has Big Time." "Flapper," a slang term from the 1920s, referred to a bold, daring, young woman whose makeup, clothing, and conduct challenged society's stereotypes of women.

153. Idaho County, Commissioners, "Commissioners Record, Book 2," 135-136.

154. Ibid., 169.

155. Idaho County, Deeds, "Deed Record 3 & 4" [1870-1879] (Idaho County Courthouse, Auditor-Recorder, Grangeville, ID), 185-186. The deed was recorded the same day. These may be the two arrastras that Alfred Bemis owned in 1868, *Mining and Scientific Press*, "Idaho," 'Several arastras [*sic*]...,' 17(1):7, July 4, 1868, but no record was found to indicate that Alfred had previously sold them to Charlie. As mentioned earlier, lode or quartz mines, also called hardrock mines, were accessed by adits and tunnels and thus differed from placer, or surface, mines.

156. Idaho County, Commissioners, "Commissioners Record, Book 2," 214, 216.

157. *Idaho Tri-Weekly Statesman*, "Northern Idaho ... Death of an Old Pioneer Stock," 12(107):2, March 30, 1876. "Consumption," historically, was any disease in which the body wastes away; in Bemis's lifetime, consumption became equated with tuberculosis.

158. Although Alfred Bemis was buried in the Warren Cemetery, his name appears on a Bemis family marker in Sonora, California. This odd circumstance occurred because Alfred's older brother, Oliver, and two younger sisters, Almira and Mary, moved from Connecticut to Sonora, California, by 1880 when they are all listed in the US Census there, Gayle Dixon in Kevin Gray, e-mail message to author, February 25, 2009.

159. *Idaho Sunday Statesman*, "Romantic Figure."

160. Idaho County, Commissioners, "Commissioners Record, Book 2," 310-311.

161. Idaho County, Mining Claims, "Mining Locations, Book 1," 171-172.

162. *Lewiston Teller*, "Local Intelligence," 'In Town,' 2(26):3, April 13, 1878.

163. *Lewiston Teller*, "Local Intelligence," 'Personal,' 2(32):3, May 24, 1878. There is no explanation for why the editor thought Charlie was from the Camas Prairie, i.e., the Grangeville, Idaho, area.

164. L. M. McKenney, *Business Directory of the Pacific States and Territories, for 1878, ...* (San Francisco: L. M. McKenney, 1878), 277. The listing is under Washington, the previous name for Warren.

165. Idaho County, Deeds, "Book 5" [1878-1885] (Idaho County Courthouse, Auditor-Recorder, Grangeville, ID), 53-56. Although the sale was in November 1879, the deed was not recorded until late August 1880.

166. Elsensohn, *Idaho Chinese Lore*, 78.

167. Idaho County, Marriages, "Marriage Record 1" [1877-1929] (Idaho County Courthouse, Auditor-Recorder, Grangeville, ID), 8. This entry was "Transcribed April 24th[,] 1879 from Old Record." Thanks to Kathy Ackerman for locating the Ah Wan/Mary Ah You marriage record and providing additional information about it.

168. Idaho County, Deeds, "Deed Record 3 & 4" [1870-1879] (Idaho County Courthouse, Auditor-Recorder, Grangeville, ID), 250-251. Thanks to Herman Ronnenberg for providing a copy of this deed. On further investigation into "Deed Record 3 & 4," from page 250 through page 296 and possibly beyond, there are Chinese names on deeds to property in the Warren area and in the town of "Washington" [Warren]. The Chinese names are interspersed with Euroamerican names.

169. *Lewiston Teller*, "Trip to Warrens," 2(51):3, October 4, 1878.

170. *Idaho Tri-Weekly Statesman*, "Local Intelligence: Mr. Al Thompson …," 16(48):3, November 8, 1879.

171. *Lewiston Teller*, "Hanging," 4(6):2, November 21, 1879, and *Semi-Weekly Idaho World*, "Hanging" [from *Lewiston Teller*], 4(77):1. December 2, 1879.

172. Ibid.

Chapter Two: Polly and Charlie in Warren, 1880 through 1890

1. Idaho Timeline, "Chronological History of Idaho," available at http://www.3rd1000.com/history3/events/idaho_timeline.htm (accessed August 13, 2018).

2. Today, of course, people's "paper trail" usually starts with a birth certificate.

3. US Bureau of the Census, *Tenth Census (1880), Idaho Schedules*, Idaho County (Washington, DC: National Archives, 1880), Washington Precinct, 3. Charlie's first name, Charles, is abbreviated to "Chas." and Polly has no surname given. Each decennial census gathers slightly different information. For 1880, census enumerator Victor Hexter listed, besides the households and the names of their occupants, the race, sex, age, marital status, occupation, and place of birth of the individuals whom he recorded.

4. M. Alfreda Elsensohn, "Fourth Academy Day at St. Gertrude's, Cottonwood, Renews … Memories of Polly Bemis," *Spokesman-Review*, May 12, 1957, 4. "The saloon" could be any saloon; it does not necessarily mean that Charlie had his own saloon by then—that would have been "his saloon." Talkington later won Idaho County elections for sheriff, auditor, recorder, and clerk, Cheryl Helmers, *Warren Times: A Collection of News about Warren, Idaho* (Odessa, TX: The Author, 1988), March 6, 1941.

5. Helmers, *Warren Times*, March 6, 1941; Elsensohn, "Fourth Academy Day," 4. Talkington reportedly "said that Bemis did actually take Polly away from her Chinese owner" but gave no details.

6. Previously, M. Alfreda Elsensohn, in *Pioneer Days in Idaho County*, vol. 1 (Caldwell, ID: Caxton, 1947; Cottonwood, ID: Idaho Corporation of Benedictine Sisters, 1965), 96, stated, "The late A. W. Talkington said that he remembered when Polly first came to Warrens." Although Polly and Talkington knew one another, he could not have "remembered" her arrival if Polly arrived in Warren in 1872 and Talkington came in 1873.

7. Lamont Johnson, "Old China Woman of Idaho Famous," *Sunday Oregonian*, 52(45):sec. 5, p. 1, November 5, 1933.

8. According to the 1880 census, Charlie ran a saloon and Polly was "House Keeping"—probably just keeping house for him, and not yet running a boarding house.

9. US Bureau of the Census, *Tenth Census (1880), Idaho Schedules*, Idaho County, Washington Precinct, 3.

10. Idaho County, Deeds, "Book 5" [1878-1885] (Idaho County Courthouse, Auditor-Recorder, Grangeville, ID), 54. Bemis's $200 in 1879 would be worth more than $5,000 today, "The Inflation Calculator," available at http://www.westegg.com/inflation/ (accessed August 13, 2018).

11. Mount Idaho was Idaho County's county seat from 1875 until 1902, *Idaho Blue Book: 1997-1998*, fourteenth edition (Boise: State of Idaho, 1997-1998), 225.

12. Idaho County, Deeds, "Book 5," 53-56.

13. Ibid., 55.

14. *Plat of the Townsite of Warren* (Bureau of Land Management, Cottonwood, ID, and Idaho County Courthouse, Grangeville, ID, 1921).

15. In 1897, Bemis sold Lot No. 2 to James Comer, Idaho County, Deeds, "Deed Record 12" [1897-1899] (Idaho County Courthouse, Auditor-Recorder, Grangeville, ID), 136.

16. Helmers, *Warren Times*, July 1890. Labeled "Melvin photo," nothing indicates who provided the photograph or wrote its caption. Another building, between the Bemis Saloon and the hotel, isn't identified in the caption, but it is surely Lot 2.

17. Idaho County, Deeds, "Book 5," 178. Ball and Whitman owned an arrastra in the vicinity, *Mining and Scientific Press*, "Idaho: Lewiston Journal," 17(18):278, October 31, 1868; *Idaho Tri-Weekly Statesman*, "Items from the Lewiston 'Signal,'" 8(145):2, June 25, 1872. Their warehouse is mentioned in an Idaho County record dated 1873, Everett A. Sandburg, "Partnership Born in Gold Rush," *The Pacific Northwesterner*, 22:2 (Spring 1978), 23.

18. *Nez Perce News*, "On the Wing," 1(49):1, August 4, 1881. The other business establishments operated "by white men" included Grostein and Binnard's store and four warehouses, Benson & Hexter's store and three warehouses, the Washington Hotel, another saloon, a butcher shop, and a blacksmith shop. Why Bemis was called "Maj.," for Major, isn't known. Although undocumented rumors, but no authoritative sources, state that Bemis fought in the Civil War, he was about fifteen or sixteen when he came to Warren in 1863 or 1864 so was probably not a Civil War veteran and certainly not a major. A Google search located several men named Charles Bemis who did fight in the Civil War; one was from Massachusetts, another was from Michigan, and a third was from Wisconsin, but none were from Charlie Bemis's home state of Connecticut.

19. J. Loyal Adkison, "The Charles and Polly Bemis Story as Told to Me by Taylor Smith," typescript (Cottonwood, ID: The Historical Museum at St. Gertrude, n.d.), 2. One website defines a hurdy-gurdy as "a string[ed] instrument incorporating a wooden wheel rotated by a simple shaft connected to a hand crank. Sound is produced by the action of the rim of the rotating wheel rubbing across the string(s) as the wheel is turned, Oliver Seeler, "The Universe of Bagpipes," 'The Hurdy Gurdy Explained, I: Introduction,' available at http://www.hotpipes.com/hgdemo.html (accessed August 13, 2018). The hurdy-gurdy is also known as a wheel fiddle, Reverb, 'Hurdy Gurdy Wheel Fiddle," available at https://reverb.com/item/1122420-hurdy-gurdy-wheel-fiddle (accessed August 13, 2018).

20. Seeler, "The Universe of Bagpipes," 'The Hurdy-Gurdy Girls,' available at http://www.hotpipes.com/hggirls2.html (accessed August 13, 2018). To view and listen to the hurdy-gurdy in performance, visit Matthias Loibner, available at https://www.youtube.com/watch?v=QHmML7bu-iM (accessed August 13, 2018).

21. Chapter One, Note 84, explains the difference between placer and quartz mining, and the purpose of an arrastra and how it works.

22. *Nez Perce News*, "From Warrens and Florence," 1(50):1, August 11, 1881. A stamp mill is used to crush ore so that gold can be recovered from it. Each stamp is "a vertical steel stem with an iron foot or shoe that is lifted by a cam and dropped onto previously crushed ore. Five stamps in a row are usually included in one battery," Bruce J. Noble, Jr., and Robert Spude, "Guidelines for Identifying, Evaluating, and Registering Historic Mining Properties," *National Register Bulletin*, 42 (Washington, DC: US Department of the Interior, National Park Service, Interagency Resources Division, National Register of Historic Places, 1992), 30.

23. *Nez Perce News*, "From Warrens and Florence." The components of the ten-stamp mill were packed in on muleback from Lewiston in 1868. One mule carried an amazing 740 pounds, and others carried 500 to 600 pounds, over distances averaging twelve to fifteen miles per day. Ordinarily, freight rates were six cents per pound, but in this case, for such heavy machinery, the packer received fifteen cents per pound, *Semi-Weekly Idaho World*, "Sketches of Travel in Idaho, Number IV," 2(33):2, September 2, 1868. By 1899 freight rates were four cents a pound from Grangeville to Warren, *The Standard*, "Warren," 1(10):5, May 31, 1899.

24. Idaho County, Deeds, "Book 5," 178. Here, his surname is spelled "Beamis."

25. *Lewiston Teller*, "Suicide of Chas. Johnson," 7(3):3, October 26, 1882.

26. *Nez Perce News*, "From Warrens," 5(51):1, August 13, 1885. This issue is cited in *Warren Times*, where Bemis is described as "deputy sheriff," Helmers, *Warren Times*, August 13,

1885. No such designation appears in the original newspaper article. By mid-1889, however, Bemis did have this title, *Idaho County Free Press*, "Our Weekly Round-Up," 3(47):1, May 3, 1889; *Nez Perce News*, "Warrens," 5(52):4, August 20, 1885.

27. *Nez Perce News*, "Warrens." In the summer of 1887 an employee of the Euroamerican-owned butcher shop visited Grangeville in order to drive some hogs back to Warren, *Idaho County Free Press*, "Sidewalk Prattle," 'Nelson Miller,' 2(11):1, August 26, 1887.

28. *Idaho County Free Press*, "Warrens," 10(51):2, September 11, 1885.

29. Idaho County, Mining Claims, "Quartz Locations, Book 2" [1886-1890] (Idaho County Courthouse, Auditor-Recorder, Grangeville, ID), 35, located and filed for record October 1, 1885. The new location was "200 ft. in an easterly direction and 1,300 feet in a westerly direction from this notice, which is posted on a timber at the old shaft of said Keystone Mine the boundaries being marked by stakes."

30. *Idaho County Free Press*, "Our Solid Muldoons," 1(17):4, October 8, 1886. The term "solid Muldoon" is either a reference to the "Solid Muldoon," a prehistoric human body hoax perpetrated in Colorado in 1877, or to the 1880s wrestling champion, William "The Solid Man" Muldoon (1852-1933), Park City, UT, *ParkRecord*.com, Sally Elliott, "What Is a Solid Muldoon?," January 16, 2016, available at http://www.parkrecord.com/entertainment/what-is-a-solid-muldoon/ (accessed August 13, 2018).

31. Today, Bemis's property would be worth more than $31,000, "The Inflation Calculator," available at http://www.westegg.com/inflation/ (accessed August 13, 2018).

32. *Idaho County Free Press*, "Our Warrens Letter," 1(51):4, June 3, 1887. The letter writer was "N. B. W." [Norman B. Willey].

33. I am grateful to Terry Abraham for this suggestion. Today, the jewelry would be worth more than $54,000, "The Inflation Calculator," available at http://www.westegg.com/inflation/ (accessed August 13, 2018).

34. *Idaho County Free Press*, "Warrens Notes," 2(12):1, September 2, 1887.

35. Ibid., and "The Inflation Calculator," available at http://www.westegg.com/inflation/ (accessed August 13, 2018).

36. Leroy T. Weeks, "In the Mountains," *Idaho County Free Press*, 2(11):1, August 26, 1887.

37. Ibid. Weeks collected nearly $500 in today's dollars, "The Inflation Calculator," available at http://www.westegg.com/inflation/ (accessed August 13, 2018).

38. *Idaho County Free Press*, "Correspondence," by A. F. P[arker], 2(12):4, September 2, 1887.

39. *Idaho County Free Press*, "Sidewalk Prattle," by A. F. P[arker], 2(15):1, September 23, 1887.

40. *Idaho County Free Press*, "Our Solid Muldoons," 2(20):4, October 28, 1887. Valuations ranged from $1,000 to nearly $18,000. In today's dollars, Bemis's assessment of $1,025 would be worth more than $27,000, "The Inflation Calculator," available at http://www.westegg.com/inflation/ (accessed August 13, 2018).

41. Helmers, *Warren Times*, July 6, 1888; *Lewiston Morning Tribune*, "Warren Mail Carrier 55 Years Ago Goes Back over Old Golden Route and Finds Pioneer Glamour Gone," September 25, 1941, 12. Warden's horse stumbled; "he fell with me and I struck in such a manner that I was paralyzed from the hips down." Sensing trouble, Warden's dog went for help. Stretcher-bearers carried Warden to Grangeville. "After undergoing treatment two years in Portland [Warden] finally regained use of [his] limbs," *Lewiston Morning Tribune*, "Warren Mail Carrier."

42. Helmers, *Warren Times*, July 6, 1888; *Lewiston Morning Tribune*, "Warren Mail Carrier."

43. Idaho County, Deeds, "Book 7" [1888-1891] (Idaho County Courthouse, Auditor-Recorder, Grangeville, ID), 35-37.

44. Ibid.

45. J. D. McConkey, "A Trip to Warrens," *Idaho County Free Press*, 3(11):4, 1, August 24, 1888.

46. Ibid., 1.

47. *Idaho County Free Press*, "Our Weekly Round-Up," May 3, 1889. The "prairie" refers to the Camas Prairie, i.e., the Grangeville area.

48. Idaho County, Assessments, "Assessment Roll, Idaho County, Idaho, 1889" (Idaho County Courthouse, Assessor, Grangeville, ID), 7. The valuations don't seem to include land, only buildings and possessions, since the Salmon River property was undoubtedly the China Jake Ranch that Bemis bought in 1888 for $500. Most of the animals were probably kept there, since he obtained six horses with that purchase. The "stock in trade" was surely the value of the liquor he kept in his saloon, Idaho County, Deeds, "Book 7," 35-37.

49. "The Inflation Calculator," available at http://www.westegg.com/inflation/ (accessed August 13, 2018).

50. Idaho County, Deeds, "Book 7," 35-37.

51. R. L. Polk and Company, *Oregon, Washington and Idaho Gazetteer and Business Directory 1889-90* (Portland, OR, R. L. Polk and Company, 1889), 1042. Warren's population at that time was 475 people.

52. *Idaho County Free Press*, "How Warrens Celebrated," 4(5):1, July 12, 1889.

53. Mayflower Mining and Milling Company, Warren, Idaho County, Idaho, "Open Account Book," [1890-1894], copy at Payette National Forest, Warren, Idaho, [7]. Thanks to Gayle Dixon for scans of this ledger, Gayle Dixon, e-mail message to author, April 16, 2014.

54. Ibid., [7]. The 1890 date is inferred. Although the Bemis entry has no year given, "1890" is written two pages later in the book.

55. Idaho County, Bills of Sale, "Book 1" [1862-1893] (Idaho County Courthouse, Auditor-Recorder, Grangeville, ID), 340. Grostein and Binnard, and Benson and Hexter, had mercantile establishments in Warren and supplied their businesses with pack trains out of Lewiston. Chamberlain Creek and Chamberlain Basin were named for John Chamberlain, Johnny Carrey and Cort Conley, *River of No Return* (Cambridge, ID: Backeddy Books, 1978), 126.

56. Idaho County, Bills of Sale, "Book 1," 340.

57. Some additional information on the Chinese in the Warren area during this time period can be found in M. Alfreda Elsensohn, *Idaho Chinese Lore* (Cottonwood, ID: Idaho Corporation of Benedictine Sisters, 1971), 79-80.

58. US Bureau of the Census, *Tenth Census (1880), Idaho Schedules*, Idaho County, Washington Precinct. During both the 1870 and 1880 censuses, Warren was known as Washington. In the 1880 census, Warren had 62 "white" men, three "white" women, and eight Euroamerican children, as well as one Indian woman and three "half-breed" children, Helmers, *Warren Times*, after December 30, 1880. Lawrence A. Kingsbury, *Ah Toy: A Successful 19th Century Chinese Entrepreneur* ([McCall, ID]: Payette National Forest, 1994), 2, says the total was 393 Chinese, including two Chinese women.

59. Yixian Xu, "Chinese Women in Idaho during the Anti-Chinese Movement before 1900" (master's thesis, University of Idaho, Moscow, 1994), 130. Xu mistakenly interprets Polly's marital status as divorced.

60. Census enumerator and Warren resident Victor Hexter was a 21-year-old store clerk.

61. Others have written her name as Too Hay, Toc Hay, or TocHay. However, the second "o" or the "c" may be a misreading of the flourish on the capital "H" of Hay. See "To" [possibly "Toc"] Hay in Idaho County Deaths, "Mortality Schedule, 1880" (Idaho County Courthouse, Grangeville, ID, May 31), miscopied as "TocHay" in Genealogy Trails, Idaho Genealogy Trails, "1870 and 1880 Idaho County Mortality Schedules," '1880 Mortality Census,' 2012, available at http://genealogytrails.com/ida/idaho/census/mort.html (accessed August 13, 2018). I am grateful to Gayle Dixon for providing citations to relevant documents.

62. Sheila D. Reddy, *The Color of Deep Water: The Story of Polly Bemis* (McCall, ID: Heritage Program, Payette National Forest, US Department of Agriculture, Intermountain Region, 1994), 11. This source calls her "Too Hay."

63. US Bureau of the Census, *Tenth Census (1880), Idaho Schedules*, Idaho County, Washington Precinct, 4.

64. Peter D. Schulz, "Work Camps or Ethnic Villages? The Chinese Shrimp Camps of San Francisco Bay," *Society for California Archaeology* 9 (1996), 171.

65. Priscilla Wegars, "The Ah Hee Diggings near Granite, Oregon," in *Contributions to the Archaeology of Oregon*, ed. Lou Ann Speulda and Gary C. Bowyer, Association of Oregon Archaeologists, Occasional Papers No. 7 (Eugene, OR, State Museum of Anthropology, University of Oregon, 2002), 44.

66. US Bureau of the Census, *Tenth Census (1880), Idaho Schedules*, Idaho County, Washington Precinct.

67. *Nez Perce News*, "On the Wing."

68. *Idaho County Free Press*, "County Matters," 1(1):1, June 18, 1886.

69. Ibid. With "poll" having the meaning of "head," poll taxes were based on a "head count" of individuals, voters or not.

70. *Nez Perce News*, "Warrens," 5(52):4, August 20, 1885.

71. *Idaho County Free Press*, "Our Solid Muldoons," October 8, 1886.

72. *Idaho County Free Press*, "Our Solid Muldoons," October 28, 1887. As the list covers all of Idaho County, it is possible that some of those mentioned did not live in Warren.

73. *Idaho County Free Press*, "Our Solid Muldoons," 3(24):1, November 23, 1888. Lee Man (elsewhere spelled Mann), Elk City ($1,720), was also on the list.

74. *Idaho County Free Press*, "Warrens Notes," September 2, 1887. The occasion was Yulanpen, or the "Hungry Ghosts" festival, a time in mid-August when, in Daoist belief, "the dead return to earth in search of food and other necessities," Wendy L. Rouse, "'What We Didn't Understand': A History of Chinese Death Ritual in China and California," in *Chinese American Death Rituals: Respecting the Ancestors*, ed. Sue Fawn Chung and Priscilla Wegars (Lanham, MD: AltaMira/Rowman & Littlefield, 2005), 29, 40.

75. Cha[rle]s Clifford, "Warrens Notes," 'China new year …,' *Idaho County Free Press*, 2(40):1, March 16, 1888. February 1, 1888, was the beginning of the "Year of the Dragon."

76. *Idaho County Free Press*, "How Warrens Celebrated," 4(5):1, July 12, 1889.

77. Idaho County, Deeds, "Book 7" [1888-1891], 35-37. The deed was recorded on August 11, 1888. Ah Kan, a Chinese pack train operator, was also known as "Ah Can," "Ah Cain," "China Can," and "Sleepy" Kan, Helmers, *Warren Times*, index. Ah Ming and Ah Jake are both unknown, although Ah Jake may be the same person as Ah Jack from John Day Creek, who in 1894 went "clear to Portland to register" [for a Certificate of Residence] because he had "too many property interests to risk being sent back to China," Helmers, *Warren Times*, May 1894. Ah Kan, Ah Ming, and Ah Jake sold the China Jake Ranch to Charlie Bemis in 1888.

78. Helmers, *Warren Times*, June 5, 1883. During Ah Kan's career, he "packed incalculable tons of freight in and out of the [Warren Mining] District (as far as 170 miles one way) by means of pack trains (horses and mules) over the hazardous trails of the Salmon River Mountains. During that period, such trails were the only access that linked Warren with the civilized world," Jeffrey M. Fee, "Idaho's Chinese Mountain Gardens," in *Hidden Heritage: Historical Archaeology of the Overseas Chinese*, ed. Priscilla Wegars (Amityville, NY: Baywood, 1993), 70, parentheses in original.

79. McConkey, "A Trip to Warrens," 1.

80. *Idaho County Free Press*, "Our Weekly Round-Up," 'Several Chinese pack trains ….' 3(24):1, November 23, 1888.

81. Mayflower Mining and Milling Company, "Open Account Book," [2-3, 4, 6, 26 and 35, 38, 43]).

82. *Idaho County Free Press*, "Our Weekly Warrens Budget," 5(25):1, November 28, 1890. This portion of that column was dated "Nov. 23 90.—Observer," but whether that information was from a newspaper or from a correspondent is not known. Ah Toy was planning a trip to China that fall, ibid.

83. *Nez Perce News*, "From Warrens and Florence," August 11, 1881.

84. As such, the Bemises may have participated in Warren's social life. While a report of a local "grand dance" does not specifically name them as guests, "all the boys were in attendance." Owing to the shortage of women, the men had to dance with one another, ibid.

85. "Research suggests that crochet probably developed most directly from Chinese needle-work," Ruthie Marks, "History of Crochet," available at https://www.crochet.org/page/crochethistory (accessed August 13, 2018). Even so, Polly most likely learned to crochet from Euroamerican women in Warren.

86. Mrs. John D. (Bertha) Long, "Polly Bemis, My Friend," *Idaho County Free Press*, 80th Anniversary Edition, 79(49):sec. [8], p. 1, June 16, 1966. Bertha was not in Warren when Polly and Charlie began living together.

87. Adkison, "Charles and Polly Bemis Story," 3.

88. Robert L. Dorman, "The Creation and Destruction of the 1890 Federal Census," *American Archivist* 71:2 (Fall/Winter 2008), 350-351.

89. Idaho State Archives, "Reconstructed 1890 Idaho Census," available at https://docs.google.com/spreadsheets/d/1WlRwmFcbYtddrDZCmyvGvTbhHmZLM3W14BA3zJD7qO4/edit#gid=676905024 (accessed August 8, 2018).

90. *Idaho County Free Press*, "Warren Notes," 2(21):1, November 4, 1887.

91. US Bureau of the Census, *Tenth Census (1880), Idaho Schedules*, Idaho County, Washington Precinct, 3.

92. *Idaho Daily Statesman*, "Polly Bemis of Warren's Diggins Sees City's Sights for First Time," 61(8):2, August 4, 1924; *Idaho County Free Press*, "Polly Bemis Has Big Time in Visit to the State Capital," 40(13):1, 5, August 7, 1924.

93. *Idaho County Free Press*, "Shooting Affray in Warrens," 5(15):1, September 19, 1890.

94. Ibid. The "Palouse country" encompasses the nearby, mostly agriculture-based, counties of Latah, in Idaho, and Whitman, in Washington.

95. Ibid. Hutton isn't otherwise identified, although he is probably the same person as William Hutton who carried the mail on snowshoes in February 1890, Helmers, *Warren Times*, February 21, 1890. In 1940 the *Idaho County Free Press* included this article in their "Tempus Fugit" ["Time Flies"] column under the heading, "Fifty Years Ago." Interestingly, the item was not copied word-for-word from the 1890 issue, but instead was retyped inaccurately. It stated that Hutton brought Bemis to Grangeville, *Idaho County Free Press*, 55(19):8, September 19, 1940. In remote areas, before telephone and telegraph connections, it is likely that mail carriers were paid to deliver urgent messages to larger communities. This is inferred from fees that mail carriers received for other commissions, such as $1.50 for taking a watch to be fixed, and four percent for transporting gold dust, M. Alfreda Elsensohn, *Pioneer Days in Idaho County*, vol. 2 (Caldwell, ID: Caxton, 1951), 438.

96. *Idaho County Free Press*, "Dr. Bibby returned from Warrens ...," 5(16):1, September 26, 1890. Bibby was an ex-army surgeon who weighed 350 pounds, Adkison, "Charles and Polly Bemis Story," 4.

97. Adkison, "Charles and Polly Bemis Story," 4; Elsensohn, *Pioneer Days in Idaho County*, vol. 1, 98.

98. "The Inflation Calculator," available at http://www.westegg.com/inflation/ (accessed August 13, 2018).

99. Denis Long, telephone conversation with author, March 3, 2015.

100. *Lewiston Teller*, "Johnny Cox Captured," 15(1):1, October 2, 1890. Freeman is otherwise unknown.

101. *Idaho County Free Press*, "Woman of 70 Sees Railway First Time," 39(14):1, August 16, 1923. When used by Euroamericans, "half-breed" and "breed" are derogatory terms for people of Native American ancestry.

102. Johnson, "Old China Woman of Idaho," 1.

103. Adkison, "Charles and Polly Bemis Story," [1]. Taylor Smith's mother remarried in Warren on August 9, 1890, Helmers, *Warren Times*, August 22, 1890.

104. Adkison, "Charles and Polly Bemis Story," [1].

105. Ibid., 4.

106. Secondary sources provide wildly differing, inaccurate, details of Charlie's injury. Fern Coble Trull, "The History of the Chinese in Idaho from 1864 to 1910" (master's thesis, University of Oregon, Eugene, 1946), 102, states that he was "shot through the neck," whereas Rafe Gibbs, *Beckoning the Bold: Story of the Dawning of Idaho* (Moscow: University Press of Idaho, 1976), 103, says that Charlie "got into a fight with a white man over a poker game, and was badly beaten up, suffering the loss of one eye." A reminiscence published in 1965, citing long-time Warren resident Otis Morris, asserts that "Cox snapped out a derringer and shot Bemis in the left eye," *Idaho Daily Statesman*, "Golden Past of Warren Adds Spice of History to Fishermen's Jaunts," 10(362):4C, July 22, 1965.

107. Adkison, "Charles and Polly Bemis Story," 4. If Bemis's house was 150 yards away from the saloon, that would contradict the suggestion that they lived in, or next to, the saloon. However, they did live in different places at different times.

108. *Lewiston Teller*, "Johnny Cox Captured"; *Idaho County Free Press*, "Cox in Jail," 5(17):1, October 3, 1890.

109. *Idaho County Free Press*, "Cox in Jail."

110. Ibid.

111. Ibid.

112. "The Inflation Calculator," http://www.westegg.com/inflation/ (accessed August 13, 2018).

113. *Idaho County Free Press*, "Our Weekly Round-Up," 'The preliminary examination ...,' 5(20):1, October 24, 1890.

114. Ibid. According to one of Fern Coble Trull's informants, Bemis "was an invalid as a result of the shooting and Polly cared for him," Trull, "History of the Chinese in Idaho, 103, citing information obtained from P. T. Lomax. However, this was true only until Charlie recovered, which we know he did.

115. *Idaho County Free Press*, "Mountain Notes," 5(20):1, October 24, 1890. This account does not mention Polly.

116. *Idaho County Free Press*, "Our Weekly Round-Up," 'Harry Serrens and Dr. Troll ...,' 6(4):1, July 3, 1891.

117. M. Alfreda Elsensohn, *Idaho County's Most Romantic Character: Polly Bemis* (Cottonwood, ID: Idaho Corporation of Benedictine Sisters, 1978), 21-22.

118. *Idaho County Free Press*, "Woman of 70 Sees Railway," and Johnson, "Old China Woman of Idaho," 1.

119. Georganne Slifer, "Push-Pull-Push," (paper written for Dr. Carlos Schwantes's Idaho and the Pacific Northwest history class, fall semester 1988, photocopy of typescript in Asian American Comparative Collection, University of Idaho, Moscow), [9]. Slifer's informant may have been mistaken about Lee Dick's help for Bemis. According to a 1919 interview with Lee Dick, he was not in the Warren area until about 1901, *Payette Lake Star*, "Warren Notes," 'Lee Dick ...,' 2(45)1, November 7, 1919. Lee Dick should not be confused with Goon Dick, another Warren-area miner.

120. Fee, "Idaho's Chinese Mountain Gardens," 88. The donor of the photograph and its date are identified in its caption.

121. *Payette Lake Star*, "Warren Notes," 'Lee Dick'

122. *Idaho County Free Press*, "Mountain Notes," 'R. Besse is running ...,' 5(20):1, October 24, 1890, and ibid., "A Few Items from Warrens," 5(22):1, November 7, 1890.

123. *Idaho County Free Press*, "A Few Items from Warrens."

124. Ibid.

125. *Idaho County Free Press*, "Our Warrens Letter: December 29, '90," 5(30):1, January 2, 1891. The Little Giant was a hardrock (lode, quartz) gold mine.

126. *Idaho County Free Press*, "Our Warrens Letter," 5(31):1, January 9, 1891. For Rube Besse as a violin player, see Helmers, *Warren Times*, December 9, 1866.

Chapter Three: Life in Warren and on the Salmon River, 1891 through October 1902

1. Reference Desk, "Idaho History Timeline," available at http://www.ereferencedesk.com/resources/state-history-timeline/idaho.html (accessed August 20, 2018).

2. The People History, "1900 to 1909 Important News, Significant Events, Key Technology," available at http://www.thepeoplehistory.com/1900to1909.html (accessed August 20, 2018).

3. *Idaho County Free Press*, "Our Warrens Letter," 5(38):1, February 27, 1891. Cox's attorney was Judge Rand.

4. Ibid.

5. *Idaho County Free Press*, "Our Weekly Round-Up," 'The China pack train ...,' 5(51):1, May 29, 1891.

6. "Our Weekly Round-Up," 'Harry Serrens [*sic*, for Serren] and Dr. Troll ...,' *Idaho County Free Press*, 6(4):1, July 3, 1891. Serren would later testify on behalf of awarding Polly Bemis a Certificate of Residence.

7. *Idaho County Free Press*, "Our District Court. Clearing the Calendar," 6(4):1, July 3, 1891. Bail had already been reduced to $1,500; this discrepancy isn't explained.

8. *Idaho County Free Press*, "Town and Country News," 'Johnnie Cox ...,' 6(8):1, July 31, 1891.

9. *Idaho County Free Press*, "The Session of District Court," 6(20):1, October 23, 1891.

10. *Idaho County Free Press*, "District Court Adjourned," 6(21):1, October 30, 1891.

11. US Penitentiary, Boise City, Idaho, "Description of Convict," October 31, 1891. Thanks to Gayle Dixon for a copy of this document. Cox also has an entry in Idaho State Historical Society, "Old Idaho Penitentiary Inmates Catalog," Rachel S. Johnstone, compiler, 2008, 'Inmates of the Idaho Penitentiary 1864-1947: A Comprehensive Catalog,' available at https://history.idaho.gov/sites/default/files/uploads/inmates_1864-1947.pdf (accessed August 20, 2018), 25. The Territorial Penitentiary admitted its first inmates in 1872. After Idaho became a state in 1890, the first state legislature, meeting in 1891, renamed it the Idaho State Penitentiary, ibid., [v].

12. *Idaho County Free Press*, "Town and Country News," 'Johnnie Cox ...,' 6(33):1, January 22, 1892.

13. Ibid.

14. *Idaho County Free Press*, "Johnny Cox has been released ...," 7(33):1, January 20, 1893, and "John P. Cox was released ...," 7(34):1, January 27, 1893.

15. R. L. Polk and Company, *Idaho Gazetteer and Business Directory, for 1891-92* (Portland, OR, R. L. Polk and Company, 1891), 1382.

16. *Idaho County Free Press*, "Warrens is Coming to the Front," 6(2):1, June 19, 1891.

17. Idaho County, Assessments, "Assessment Roll and Delinquent [Tax] List, 1891" (Idaho County Courthouse, Assessor, Grangeville, ID), 9. I am grateful to Gayle Dixon for providing this reference.

18. Ibid., 127.

19. Ibid., 9. Today's dollar amounts are from "The Inflation Calculator," available at https://westegg.com/inflation/ (accessed August 20, 2018).

20. Idaho County, Mining Claims, "Record of Locations, Book 3" [1888-1892] (Idaho County Courthouse, Auditor-Recorder, Grangeville, ID), 420.

21. Idaho County, District Court Case Files, "Case No. 29" (Idaho County Courthouse, Grangeville, ID, 1891), 1.
22. Ibid. The costs totaled $52.20, and included a fee of $35.00 due the sheriff for serving a summons on N. W. Earle.
23. *Idaho County Free Press*, "Court Calendar," 6(2):4, June 19, 1891, and *Idaho County Free Press*, "Our District Court. Clearing the Calendar"; Idaho County, District Court Minutes, "Book 2" [1884-1896] (Idaho County Courthouse, Magistrate Court, Grangeville, ID), 191-192.
24. *Idaho County Free Press*, "Sheriff's Sale," 6(41):4, March 18, 1892.
25. "The Inflation Calculator."
26. Idaho County, Miscellaneous Records, "Book 12" [1881-1894] (Idaho County Courthouse, Auditor-Recorder, Grangeville, ID), 317-318.
27. Idaho County, Assessments, "Assessment Roll and Delinquent [Tax] List 1892" (Idaho County Courthouse, Assessor, Grangeville, ID), 8. Since Bemis still owned the arrastra, perhaps the contemplated sale of it in 1891 didn't take place. Today's values are from "The Inflation Calculator."
28. Idaho County, Deeds, "Book 10" [1894-1897] (Idaho County Courthouse, Auditor-Recorder, Grangeville, ID) 63. Thanks to Herman Ronnenberg for providing a copy of this document.
29. Idaho County, Mining Claims, "Record of Locations, Book 3," 403. The claim was located on January 27, 1892, and recorded on February 13, 1892.
30. Idaho County, Bills of Sale, "Book 1" [1862-1893] (Idaho County Courthouse, Auditor-Recorder, Grangeville, ID), 375. The document was filed on September 22, 1892.
31. "The Inflation Calculator."
32. Idaho County, Assessments, "Assessment Roll and Delinquent Tax List, 1893" (Idaho County Courthouse, Assessor, Grangeville, ID), 13, 130. I am grateful to Gayle Dixon for providing this reference.
33. *Lewiston Morning Tribune*, "Warrens is Wakening," 2(3):1, September 12, 1893. Today's travelers still reach Warren via the Warren Wagon Road from McCall. The road is now paved to the vicinity of Burgdorf Hot Springs.
34. As mentioned in the Preface, "Chinamen" is now considered a racist term.
35. *Lewiston Morning Tribune*, "Warrens is Wakening." Warren also had two general merchandise stores, a meat market, a livery stable, a hotel, and a blacksmith shop. The location of this boarding house is unknown.
36. *Idaho Daily Statesman*, "Polly Bemis of Warren's Diggins Sees City's Sights for First Time," 61(8):2, August 4, 1924; *Idaho County Free Press*, "Polly Bemis Has Big Time on Visit to the State Capital," 40(13):1, 5, August 7, 1924.
37. Idaho County, Mining Claims, "Record of Mining Claims Location Notices, Book 6" [1893-1896] (Idaho County Courthouse, Auditor-Recorder, Grangeville, ID), 51.
38. Ibid., 52. In October 1895, three of the owners, including Bemis, sold the Ellmore and Elmira placer claims, Idaho County, Mining Deeds, "Record of Mining Deeds, Book 1" [1895-1897] (Idaho County Courthouse, Auditor-Recorder, Grangeville, ID), 40.
39. *Lewiston Morning Tribune*, "Warrens is Wakening."
40. *Idaho County Free Press*, "Warrens Notes," 'Warrens is at present' 8(51):4, May 25, 1894. Warren's brief reputation for temperance didn't endure. In mid-1899, five years after the Bemises had moved away, Warren had three saloons, including one still owned by Charlie Bemis, *The Standard*, "Warren," 1(10):5, May 31, 1899.
41. Idaho County, Assessments, "Assessment Roll and Delinquent Tax List, 1894" (Idaho County Courthouse, Assessor, Grangeville, ID), 14.
42. "The Inflation Calculator."

43. *Idaho County Free Press*, "Record of the Week," 'Photographer Hanson, of the Elite [G]allery ….' 8(44):1, April 6, 1894. Hanson had already photographed 47 Chinese who lived in the Grangeville area.

44. *Idaho County Free Press*, "Record of the Week," 'Photographer Hanson is in Warrens ….' 8(48):1, May 4, 1894.

45. Associate Professor of Religious Studies Rudy V. Busto, University of California-Santa Barbara, has used this same image as the introduction to his class on Asian American Christianity. Because Polly's right hand rests on a book, certainly the photographer's prop, as Busto acknowledges, Busto elicits from his students the speculative interpretation that the book is a Bible, and that it is thus "a testimony to her affiliation [with] or conversion to Christianity, and, by association, her allegiance to the United States." Busto then asks his students, "Was Bemis in fact Christian? Did she mark her conversion by arranging this portrait at what must have been great expense?" He does suggest "… we do not know if Polly Bemis formally confessed Christianity," although for his students, "there is the expectation that the road to full citizenship for early Asian immigrants surely included Christianity," Rudy V. Busto, 'The Gospel According to Rice: The Next Asian American Christianity,' in "Asian American Religions in a Globalized World," ed. Sylvia Chan-Malik and Khyati Y. Joshi, *Amerasia Journal*, 40:1 (2014), 61-62. Thanks to Rudy Busto for a copy of this issue.

46. *Idaho County Free Press*, "Record of the Week," 'Photographer Hanson is back ….' 8(51):1, May 25, 1894.

47. *Idaho County Free Press*, "Record of the Week," 'This is the last day of grace ….' 8(48):1, May 4, 1894.

48. The first suggestion of this possibility was in 1933, when Polly's friend Jay Czizek stated, "When the Chinese deportation act passed and it was found that Polly was in danger of being deported with the other Chinese, Bemis immediately married her. I think it was just an oversight that he had not done it before. Apparently they had never thought it necessary," *Lewiston Morning Tribune*, "Indian Girl, Not Polly Bemis, Was Poker Bride, Warren Man Declares," October 1, 1933, sec. 2, p. 6.

49. Bemis's home had already been used for a wedding. On August 8, 1892, Crosby "Curley" Brewer married Georgia Ellen Smith there, Cheryl Helmers, *Warren Times: A Collection of News about Warren, Idaho* (Odessa, TX: The Author, 1988), August 12, 1892.

50. Bemis Marriage Certificate, "Marriage Certificate for Chas. A. Bemis and Polly Hathoy" (The Historical Museum at St. Gertrude, Cottonwood, ID, August 13, 1894). It was also recorded at the Idaho County Courthouse, Idaho County Marriages, "Marriage Record, Probate Court" [1890-1911] (Idaho County Courthouse, Auditor-Recorder, Grangeville, ID), 49; there Polly's name is given as Hathoy.

51. Lamont Johnson, "Old China Woman of Idaho Famous," *Sunday Oregonian*, 52(45):sec. 5, p. 1, November 5, 1933. The phrase, "having papers," wasn't correct at the time of Polly's marriage in 1894. On May 13, 1896, a judge ruled that she was entitled to a Certificate of Residence, which was awarded to her on August 10, 1896.

52. The revised law was still in effect in 1957, banning "marriages of white persons with Mongolians, Negroes or mulattoes" [*sic*], *Lewiston Morning Tribune*, "Negro-Indian Marriages Not Barred by Law," October 4, 1957, 4.

53. *Idaho County Free Press*, "Warrens Notes," 'C. A. Bemis …,' 8(51):4, May 25, 1894. "W. Helm" was George Warren Helm. In late 1897, Helm was the owner of the Silver King mine and one of Warren's "most highly esteemed young men," Helmers, *Warren Times*, December 16, 1887.

54. One source says 10 miles, Fern Coble Trull, "The History of the Chinese in Idaho from 1864 to 1910" (master's thesis, University of Oregon, Eugene, 1946), 103, but measured on a map it is at least 11 miles - even if one were able to go straight there. Charlie himself stated that his claim was "about 17 miles from the town of Warrens," Idaho County, Mining Claims, "Placer Locations, Book 9" [1896-1899] (Idaho County Courthouse, Auditor-

Recorder, Grangeville, ID), 522. Today, the ranch is "40 miles upriver from Riggins along the Salmon [River] and 12 miles upriver from the end of the nearest road," Bill Loftus, "Salmon River Museum Dedicated to Pioneer Polly Bemis," *Lewiston Morning Tribune*, June 6, 1987, 6A.

55. The claim wasn't officially located until November 1898; it was recorded in February 1899, Idaho County, Mining Claims, "Placer Locations, Book 9," 522.

56. Leo Hofen, "History of Idaho County Idaho Ter[ritory]," handwritten manuscript, Bancroft Library, University of California, Berkeley, 1879, 7.

57. Without providing evidence, one source states that "Polly and Charlie Bemis ... moved to the ranch two years after they were married in 1894," Bill Loftus, "Salmon River Museum Dedicated to Pioneer Polly Bemis."

58. G. Wayne Minshall, *Wilderness Brothers: Prospecting, Horse Packing, & Homesteading on the Western Frontier* ([Inkom, ID]: Streamside Scribe Press, 2012), 37. Bemis is described as "a local saloon keeper and gambler." This may be a quote from the 1895 to 1903 diaries of Luman G. Caswell on which *Wilderness Brothers* is based.

59. Johnny Carrey, "Moccasin Tracks of the Sheepeaters," in *Sheepeater Indian Campaign* (*Chamberlain Basin Country*) (Grang[e]ville, ID: *Idaho County Free Press*, 1968), 42.

60. M. Alfreda Elsensohn, *Pioneer Days in Idaho County*, vol. 1 (Caldwell, ID: Caxton, 1947; Cottonwood, ID: Idaho Corporation of Benedictine Sisters, 1965), 98. Hill was a miner, surveyor, and engineer, ibid., 100, and a "mining engineer," Helmers, *Warren Times*, August 14, 1896.

61. [Taylor Smith], letter [to M. Alfreda Elsensohn], [September 2, 1958?], The Historical Museum at St. Gertrude, Cottonwood, ID. Smith was present when Johnny Cox shot Charlie Bemis on the porch of this saloon.

62. Taylor Smith, letter to Sister Alfrida [*sic*, for M. Alfreda Elsensohn], October 9, 1958, The Historical Museum at St. Gertrude, Cottonwood, ID. According to unattributed notes in the author's possession, Priscilla Wegars, May 24, 1999, the three men on the sled were Mart Maynard, Royal Mathias, and Bill Borden ("Sheepherder" Bill). Borden was reputed to have "made and squandered two or three fortunes from the gold fields of central Idaho," Helmers, *Warren Times*, February 24, 1932; Maynard and Mathias are unknown.

63. M. Alfreda Elsensohn, *Idaho Chinese Lore* (Cottonwood, ID: Idaho Corporation of Benedictine Sisters, 1970), Plate X.

64. Ibid., 83.

65. Helmers, *Warren Times*, July 31, 1896. Earlier, in August 1894, W. J. Kelly and Geo[rge] L. Patterson signed the Bemises' marriage certificate as witnesses to their wedding. Although no date is given for Helmers's photograph, it must be prior to 1904, since most, if not all, of the buildings shown burned in the September 1904 fire (Chapter Four).

66. Helmers, *Warren Times*, July 31, 1896. Photographer John A. Hanson originally worked in Moscow, Idaho, but in 1893 he moved his studio and "Elite [G]allery" to Grangeville, Idaho, Helmers, *Warren Times*, January 5 and April 6, 1894. The photograph is identified as a "McCall Historical Society photo" but no such organization has yet been located in McCall, unless it is the Central Idaho Historical Museum.

67. Helmers, *Warren Times*, September 18, 1896; Hanson's "portfolio … of everything of interest in Warrens, Florence[,] and Dixie and contiguous country [is] on display in his gallery in Grangeville." The photo could instead date to the previous July, in 1895, when Hanson was "on a picture-taking trip through the Salmon [R]iver, Meadows, Payette Lakes[,] and Warrens countries. He is an artistic photografer [*sic*] in fact as well as name and comes highly recommended," Helmers, *Warren Times*, July 12, 1895.

68. When the Geary Act was passed in 1892, China's Qing dynasty government tried to get it repealed but was unsuccessful. The Chinese in the United States then resisted it, raised money to fight it through the Chinese Consolidated Benevolent Association [popularly known as the "Chinese Six Companies"], and hired lawyers to establish its unconstitu-

tionality. "The Supreme Court ruled, on 15 May 1893, that Congress had the right to exclude or expel aliens ... and that it had the right to provide a system of registration and identification of aliens within the country," Shih-shan Henry Tsai, *China and the Overseas Chinese in the United States, 1868-1911* (Fayetteville: University of Arkansas, 1983), 96-97. The US Chinese subsequently capitulated, and began to register.

69. National Archives at Seattle, "Judgment: The United States vs. Polly Bemiss" [*sic*], Judgment Roll 181, Record Group 21, National Archives at Seattle, Seattle, Washington, 1896.

70. Gayle Dixon, e-mail messages to author, April 12, 2004, and April 25, 2004. Two of the men were from Warren; the others were from the Salmon River, Elk City, Mount Idaho, and Florence, ibid., April 25, 2004. Dixon speculates that Charlie Bemis would have had to stay home with the animals, and that Polly might have traveled to Grangeville with Lee Ping and Ah Linn from Warren. However, because it wouldn't have "looked right" for Polly to go anywhere by herself or with men to whom she wasn't married, perhaps Charlie took her to Grangeville and got neighbors to take care of their place while they were away.

71. *Idaho County Free Press*, "The last of the Chinese certificates ...," 10(45):1, April 10, 1896. This information may have been copied from the *Lewiston Twice-a-Week Tribune*, "Chinamen Receive Certificates," 4(55):1, April 4, 1896.

72. M. Alfreda Elsensohn, *Idaho County's Most Romantic Character: Polly Bemis* (Cottonwood, ID: Idaho Corporation of Benedictine Sisters, 1979), 19-20. A photograph, p. 19, Plate V, is captioned "Courtesy Clifford Cyr" and "Jewelery [*sic*] brought from China by Polly, given to Mrs. Ada Cyr in 1896 in Florence." The main caption is a bit misleading since in 1896 "Mrs. Ada Cyr" was then Ada Smith, age about eight. The image clearly shows a pin flanked by two earrings but the text states that they were all "pins," 20. In the Chinese style, the earrings simply hook through holes in the ears rather than clipping, or screwing, on.

73. They all appear in the 1900 US Census for Florence; Ada is then 11 years old, US Bureau of the Census, *Twelfth Census of the United States 1900*, Idaho, Vol. 3, Idaho County, Florence (Washington, DC: National Archives), University of Idaho Library, microfilm reel no. 866-3.

74. Elsensohn, *Pioneer Days in Idaho County*, vol. 1, 41, 71.

75. Ibid., 71-72.

76. National Archives at Seattle, "Judgment: The United States vs. Polly Bemiss" [*sic*].

77. Harry Serren, a miner [sometimes spelled Serrin or Serrens], lived in the Warren area from at least September 1879 until at least April 1892, Helmers, *Warren Times*, September 1879, April 1892. By early April 1892 Harry Serren had bought a residence in Grangeville, *Idaho County Free Press*, "Town and Country News," 'Harry Serren has purchased ...,' 6[44]:1, April 8, 1892. Perhaps Polly Bemis did his laundry when he lived in Warren.

78. National Archives at Seattle, "Judgment: The United States vs. Polly Bemiss" [*sic*].

79. Ibid.

80. Ibid.

81. Elsensohn, *Idaho County's Most Romantic Character*, 27.

82. Johnny Carrey and Cort Conley, *River of No Return* (Cambridge, ID: Backeddy Books, 1978), 24-28.

83. Elsensohn, *Pioneer Days*, vol. 1, 98. Pete Mallick, a Nez Perce Indian, was part of the Mallick family who farmed in that area of the Salmon River before 1900, Carrey and Conley, *River of No Return*, 206. Mallick's property went through several owners before Charlie Shepp purchased it in 1910. It is still known as the Shepp Ranch.

84. Idaho County, Assessments, "Assessment Roll and Delinquent Tax List, 1897" (Idaho County Courthouse, Assessor, Grangeville, ID), 14. Today's values are from "The Inflation Calculator."

85. Idaho County, Deeds, "Deed Record 12" [1897-1899] (Idaho County Courthouse, Auditor-Recorder, Grangeville, ID), 136.

86. Idaho County, Assessments, "Assessment Roll and Delinquent Tax List, 1898" (Idaho County Courthouse, Assessor, Grangeville, ID), 14.

87. Ibid. Today's values are from "The Inflation Calculator."

88. Idaho County, Mining Claims, "Placer Locations, Book 9," 522. The 20.66 acre-area was based on infomal measurements. A later, professional, survey found that the Bemis Ranch actually comprised 27.29 acres, Homestead Entry Survey No. 817, for the Bemis Ranch, Charles J. Truscott, "U. S. Department of Agriculture, Forest Service, Field Notes of Homestead Entry Survey No. 817, Situated in the Idaho National Forest, Administrative District No. 4, in Section 12, Unsurveyed, Township 24 N., Range 6 E. of the Boise Base and Meridian, State of Idaho, Bemis Ranch, Warren Dist[rict]" (US Department of Agriculture, Forest Service, 1929), 5. Estimates of the amount of tillable land that it contained varied between 15 and 17 acres, M. Alfreda Elsensohn, "Fourth Academy Day at St. Gertrude's, Cottonwood, Renews … Memories of Polly Bemis," *Spokesman-Review*, May 12, 1957, 3-4, mentions 15 acres. Two other sources state that the Bemis ranch contained 17 acres, Marybelle Filer, "Historic Shepp Ranch Now Hunters' and Fishermen's Mecca," *Idaho County Free Press*, 80th Anniversary Edition, 79(49):sec. [8], p. 5, June 16, 1966; Carrey, "Moccasin Tracks of the Sheepeaters," 42. By the fall of 1919 just four acres were under cultivation, *Idaho County Free Press*, "Unique Mountain Folk Are Met in 200-Mile Voyage on Salmon River," 35(19):1, September 25, 1919.

89. Idaho County, Mining Claims, "Placer Locations, Book 9," 522.

90. *The Standard*, "Warren." In mid-1902 Warren still had three saloons together with the same number of general merchandise stores, two hotels, and one butcher shop, *The Standard*, "Warren Is a Lively Little Burg." 4(30):1, July 24, 1902.

91. *The Standard*, "Warren."

92. Idaho County, Assessments, "Assessment Roll and Delinquent Tax List, 1899" (Idaho County Courthouse, Assessor, Grangeville, ID, 1899), 6. Today's dollar amounts are from "The Inflation Calculator."

93. US Census, *Twelfth Census of the United States, 1900*, Idaho, Vol. 3, Idaho County, Warrens Precinct, 5. Edward Clark is otherwise unknown, although Helmers, *Warren Times*, May 12, 1899, mentions an Ed Clark, a miner. The fact that Charlie Bemis's last name is misspelled and his first name is given as "Peter" indicates that the census taker obtained his information from someone else and didn't actually make his way to the Bemises' remote home.

94. *Idaho County Free Press*, "County Fathers, [Ful]l Proceedings of the [Boar]d of County Commission[ers] July Term 1900, Tenth Term Day," 15(10):2, August 10, 1900.

95. Idaho County, Assessments, "Assessment Roll and Delinquent Tax List, 1900" (Idaho County Courthouse, Assessor, Grangeville, ID, 1900), 18. Today's dollar amounts are from "The Inflation Calculator."

96. Carrey and Conley, *River of No Return*, 139.

97. Robert J. Bailey, *River of No Return (The Great Salmon River of Idaho): A Century of Central Idaho and Eastern Washington History and Development, Together with the Wars, Customs, Myths, and Legends of the Nez Perce Indians* (Lewiston, ID: Bailey-Blake Printing, 1935). 474-476.

98. Ibid., 478.

99. Idaho County, Assessments, "Assessment Roll and Delinquent Tax List, 1901" (Idaho County Courthouse, Assessor, Grangeville, ID, 1901), 22. Today's dollar amounts are from "The Inflation Calculator."

100. Idaho County, Assessments, "Assessment Roll and Delinquent Tax List, 1902" (Idaho County Courthouse, Assessor, Grangeville, ID, 1902), 23. Today's dollar amounts are from "The Inflation Calculator."

Chapter Four: On the Salmon River, November 1902 through March 1910

1. Four of the Shepp diaries covering portions of the years from 1902 through 1909 have been transcribed. Photocopies of the typed transcriptions, but not of the original diaries, are in the University of Idaho Library Special Collections, Manuscript Group (henceforth MG) 5209. Photocopies of original diaries for parts of 1903 through 1904 and most of the years 1909 through 1934 are also in the University of Idaho Library Special Collections, MG 155. The Appendix has more information about the diaries.

2. Shepp's diary entry for July 19, 1908, notes, "48 years old today," Charles Shepp, [Diary], May 1, 1908, through June 22, 1909, photocopy of typescript, University of Idaho Library Special Collections, MG 5209, July 19, 1908. On July 19, 1933, Shepp wrote, "My birthday 73," Charles Shepp, [Diary], July 18, 1933, through November 30, 1934, photocopy, University of Idaho Library Special Collections, MG 155, July 19, 1933. Both entries thus confirm that he was born in 1860.

3. Johnny Carrey and Cort Conley, *River of No Return* (Cambridge, ID: Backeddy Books, 1978), 206; that account says that Shepp went to the Klondike "in '98 with Rex Beach, his partner." Pete Klinkhammer commented that Shepp "spent two years in the Klondike working as a miner for Rex Beach," Peter Klinkhammer, "Year Book 1954 [1958]," notes on 1910-1911 diary [as told to Marybelle Filer], written in diary dated 1954; first entry changed to 1958, photocopy, University of Idaho Library Special Collections, MG 155, January 14-15, 1954 [1958]. If they did know one another in 1898, who worked for whom is questionable; Shepp was born in 1860 and would have been 38 years old, and Beach, born in 1877, would have been just 21 years old. There is no definitive, first-hand confirmation of Shepp's association with Rex Beach, who later became an adventure novelist. When, where, if, and how Beach and Shepp knew one another is unknown, and probably unknowable. Charlie Shepp [birth name, Shupp] could not be found in the 1900 census, whereas Beach was living in Chicago then, Leland Bibb, e-mail to author, February 26, 2014. Beach initially went out to the Klondike in 1897 from Chicago, according to a biographical account of his life, Rollins College, Olin Library, "Rex Ellingwood Beach (1877-1949): Famous Rollins Alumni and Prolific Outdoor Novelist," available at http://lib.rollins.edu/olin/oldsite/archives/golden/Beach.htm (accessed August 21, 2018). Thanks to Wenxian Zhang, Professor and Head of Archives & Special Collections, Rollins College, for directing me to this biography of Rex Beach. An undated reminiscence from mining engineer George Bancroft states, "Shepp had been Rex Beach's partner in Alaska," [George Bancroft], "The Way to War Eagle," typescript (Caroline Bancroft Family Papers, WH1089, Western History Collection, The Denver Public Library, FF58n.d.), 1, but that statement is unconfirmed.

4. Carrey and Conley, *River of No Return*, 206. "Buffalo Hump is a bold, bare granite peak rising 8,926 feet above sea level on the divide between the Salmon River and the north fork of the Clearwater [River]," John R. Fahey, "The Buffalo Hump," *Pacific Northwesterner* 6:2 (Spring 1962), 17. The similarity between the mountain's shape and the shoulder hump of an American bison, often inaccurately called a "buffalo," inspired its name. In April 1899 Idaho's *Caldwell Tribune* reported that "[t]he old-time mining spirit pervades Buffalo Hump. Its very name suggests the wild and wooly [*sic*]. The camp is 'wide open'—the gambling den, the hurdy-gurdy, the dance hall and other characteristics of a rough-and-ready mining town, all being among Buffalo Hump's most striking features. Two stage coaches are running daily. As there is not room enough inside, the top of the stage is converted into a hurricane deck, and as many miners as can pile on do so and hang on to each other. ... Mr. Travis reports a depth of 16 feet of snow in some places at the camp. The locators are not deterred by the snow in the least, though. They start out on snow shoes and locate claims ... on the top of it. ... At present about 5,000 men are either in Grangeville or at the camp, or on the way," *Caldwell Tribune*, "Buffalo Hump," 17(23):3, April 29, 1899. An earlier report suggested that Buffalo Hump "will be the greatest camp in

the world within the present year," and that it "will justify a mining population of 100,000, *Caldwell Tribune*, "Buffalo Hump," 17(19):3, April 1, 1899, citing *Lewiston Teller*. The community near Buffalo Hump was also known as "Humptown," Carrey and Conley, *River of No Return*, 206, or simply "Hump," e.g., Charles Shepp, [Diary], November 1, 1902, through June 12, 1903, photocopy of typescript transcription, University of Idaho Library Special Collections, MG 5209, November 1, 1902.

5. Carrey and Conley, *River of No Return*, 206, 208, says the men met in 1902. In a 1963 interview, Pete Klinkhammer recalled that he "came from a Minnesota farm in 1904 looking for gold," Hugh A. Mulligan, "The Salmon: Lonely Splendor," *Lewiston Morning Tribune*, sec. 2, p. 1, October 6, 1963.

6. Carrey and Conley, *River of No Return*, 208. Klinkhammer's birthdate was confirmed by a notation on a 1955 calendar in a later diary, "Shepp Ranch Diary," 1955-1956, University of Idaho Library Special Collections, MG 155, last page. In the 1900 US Census, Peter Klinkhammer (shown as Klinkheimer), age 19 and a laborer, is listed as a hotel boarder in Superior, Douglas County, Wisconsin, Leland Bibb, e-mail message to author, February 27, 2014.

7. Carrey and Conley, *River of No Return*, 208. According to Johnny Carrey, "Moccasin Tracks of the Sheepeaters," in *Sheepeater Indian Campaign (Chamberlain Basin Country)* (Grang[e]ville, ID: *Idaho County Free Press*, 1968), 36, Shepp and Klinkhammer were in the Salmon River Canyon by 1899, but this date is too early for both men to have been there. Another source states that Charlie Shepp "gravitated from the Buffalo Hump to the Salmon River as early as 1899," and "his friendship with Charles Bemis and his Chinese wife, Polly, began at that time," Marybelle Filer, "Historic Shepp Ranch Now Hunters' and Fishermen's Mecca," *Idaho County Free Press*, 80th Anniversary Edition, 79(49):sec. [8], p. 5, June 16, 1966. However, the 1899 date is unlikely because Charles Shepp is listed in the 1902 Seattle City Directory, "address 25 Sullivan Bldg; rms [rooms] The Seneca"; his occupation was mining, Leland Bibb, e-mail message to author, February 26, 2014.

8. Carrey and Conley, *River of No Return*, 208.

9. Herman Ronnenberg, undated and unpublished notes in possession of author, "Joseph Pelikan," 3, citing R. G. Dun and Co., "Idaho Business List," 1904, p. 6, and Idaho County, Commissioners, "Commissioners' Minutes, Book 7," 1903-1906 (Idaho County Courthouse, Auditor-Recorder, Grangeville, ID), 124. Pelikan had previous brewing experience in Missoula, Montana, and in Grangeville, Idaho, Ronnenberg, "Joseph Pelikan," 1. Although "R. G. Dun and Co." could not be located as such for verification, it is probably (as cited elsewhere, but for a different date) *Mercantile Agency, Reference Book (and Key) Containing Ratings of Merchants, Manufacturers and Traders Generally throughout the United States and Canada* (New York: R. G. Dun & Co., 1904), "Idaho Business List," 6. A physical or scanned copy of this reference has not yet been located.

10. Idaho County, Commissioners, "Minutes, Book 7," 124.

11. "The Inflation Calculator," available at http://www.westegg.com/inflation/infl.cgi (accessed August 21, 2018).

12. Ronnenberg, "Joseph Pelikan," 3; *Idaho County Free Press*, "Fire Burns Hump," 24(8):1, July 27, 1905, and *Genesee News*, "Fire Burns Hump," 17(2):4, August 4, 1905. Curiously, Shepp doesn't mention the event in his diary, suggesting he was no longer a participant in the brewery.

13. Herman Ronnenberg, *Beer and Brewing in the Inland Northwest: 1850 to 1950* (Moscow: University of Idaho Press, 1993), 180-181.

14. Steven J. Koonce, *Idaho Beer: From Grain to Glass in the Gem State* (Charleston, SC: American Palate, 2014), 133.

15. *The Western Brewer: and Journal of the Barley, Malt[,] and Hop Trades*, "Breweries Closed," *Western Brewer* 31, no. 1 (January 1906):38, and *American Brewers' Review*, "Breweries Closed," 20:1 (January 1906), 75.

16. Ronnenberg, *Beer and Brewing*, 181.

17. The oldest diary begins on November 1, 1902. If there were earlier diaries, they have not been located. Shepp undoubtedly began writing them so that he would have a readily available record of his mining operations as part of his reporting requirements to the government.

18. Crooked Creek empties into the north side of the Salmon River, across from the Bemis Ranch, which is on the river's south side. Smith's first name is unknown.

19. Carrey, "Moccasin Tracks," 36; Tom Copenhaver was also a previous owner. According to Carrey, one of Smith and Williams's five dogs was named "Water," and the men's dishes "were as clean as 'Water' could make them," ibid.

20. Shepp, [Diary], 1902-1903, November 10, 1902.

21. Ibid., November 8, 1902.

22. Charles Shepp, [Diary], July 14, 1903, through June 8, 1904, photocopy, University of Idaho Library Special Collections, MG 155, November 18, 1903. The diary, if any, for June 13, 1903, through July 13, 1903, is missing.

23. E.g., ibid., December 21-22, 1903.

24. "Idaho Post Offices—Idaho County," available at http://www.mindspring.com/~metkin/idahopo_idaho.html (accessed August 21, 2018). Dixie is now a community post office supervised by Elk City. The Buffalo post office closed before the diaries begin.

25. Laila Boone, *Idaho Place Names: A Geographical Dictionary* (Moscow: University of Idaho Press, 1988), 113.

26. *Lewiston Tribune*, "Flashback," 'The Town of Dixie,' July 8, 2013, D1. Originally published March 16, 1901.

27. Fahey, "The Buffalo Hump," 20.

28. Boone, *Idaho Place Names*, 89.

29. Ibid., 61, where it is unaccountably spelled Calendar.

30. Ibid., 188.

31. Shepp, [Diary], 1902-1903, 1-2 November 1902.

32. Ibid., November 30 and December 4, 1902.

33. Even though Tom is mentioned frequently, there is no positive indication of his last name. He apparently was not Tom Copenhaver, who previously owned the Smith and Williams Ranch, because an entry in March 1903 reads, "Sun 29 Copenhaver at house last night. Tom up on Sugar Loaf this am," Shepp, [Diary], 1902-1903, March 29, 1903. Another sequence of entries in November 1903 reads, "Thur 5 Over to Bemis' this am. Bemis[,] Smith & Copenhaver[,] [Frank] "Schalkan" [Shalkan], with 8 horses went to Warren. Frid 6 Tom & I over the river. ... Bemis & Smith came home at 5.30," Charles Shepp, [Diary], 1903-1904, November 5-6, 1903. The diary, if any, for June 13, 1903, through July 13, 1903, is missing. If Tom Copenhaver went to Warren on November 5th, he could not also cross the river to the Bemises' side on the 6th. A Tom Beck is also mentioned in September 1903, Shepp, [Diary], 1903-1904, September 26, 1903. Finally, a Tom Gallagher died in late October 1907; Shepp underlined this information in his diary, to emphasize its importance, so perhaps Gallagher was his former mining partner, Charles Shepp, [Diary], November 13, 1905, through April 30, 1908, photocopy of typescript, University of Idaho Library Special Collections, MG 5209, October 27, 1907. The diary, if any, for October 22, 1905, through November 12, 1905, is missing; Shepp was in Seattle most of this time.

34. Klinkhammer, "Year Book 1954 [1958]," January 3, 1954 [1958].

35. Shepp, [Diary], 1902-1903, November 4, 1902. This diary gives Shepp's residence as Arlington Ridge, Hump, Idaho, Shepp, [Diary], 1904-1905, inside front cover.

36. Some of the workings were called Sunlight, Sunshine, Shepp, [Diary], 1902-1903, January 6, 1903; O. P. Reid, Marion Crawford, Shepp, [Diary], 1902-1903, March 9, 1903; ledge on Quo Vadis Ridge, Shepp, [Diary], 1902-1903, March 19, 1903; "Zeta old Ant," Shepp, [Diary], 1902-1903, April 6, 1903; Monitor, Merrimack, Shepp, [Diary], 1902-1903, April 8, 1903; Theta, Shepp, [Diary], 1902-1903, April 12, 1903; Ivanhoe, Shepp, [Diary], 1902-

1903, May 2, 1903; Alpha, Moon Shine, Shepp, [Diary], 1902-1903, May 13, 1903; Sigma, Shepp, [Diary], 1902-1903, May 21, 1903; Bighorn, Juno extension of Ivanhoe, Shepp, [Diary], 1902-1903, May 28, 1903; Wise Boy, Shepp, [Diary], 1903-1904, July 22, 1903; Sunrise, Shepp, [Diary], 1903-1904, July 29, 1903; Erin's Hope, Shepp, [Diary], 1903-1904, August 1, 1903; Crackerjack [also Cracker Jack], Shepp, [Diary], 1903-1904, August 7, 1903; Rob't Emmett, Montana, Shepp, [Diary], 1903-1904, August 9, 1903; Big Chief, Shepp, [Diary], 1903-1904, August 18, 1903; White Elephant, Shepp, [Diary], 1903-1904, August 31, 1903; Livingston, Shepp, [Diary], 1903-1904, September 4, 1903; and N. P., Shepp, [Diary], 1903-1904, September 21, 1903. With the exception of Erin's Hope, which Shepp recorded separately, in Concord, in September 1903, Shepp, [Diary], 1903-1904, September 17, 1903 ("Saw Yost. Recorded Erin's Hope"), the other workings may have been part of the Blue Jay.

37. Some of the other men who assisted with the mining in 1903 and 1904 were Ed, John, Webb, and Pat; Pat was Pat Malaby, from Hump, Shepp, [Diary], 1902-1903, March 19, 1903. Occasional notations indicate Shepp fed and paid some of them and others shared expenses and profits. For example, near the end of the 1903-1904 diary, Shepp entered "Grub for Blue Jay." The list included both food and mining supplies. Food comprised 50 pounds of sugar, for $6.25; 20 pounds of coffee, $8.00; 150 pounds of flour, $9.60; one-half case milk, $3.00; 22 pounds of butter, $9.00; 30 pounds of bacon, $6.00; 167 pounds of potatoes, $5.00; 100 pounds of apples, $5.00; 27 pounds of cabbage, $1.35; and 29 pounds of beans, $2.90. The men supplemented this with meat from hunting, particularly venison. Mining supplies included "200 powder," for $37.50, presumably 200 pounds of black powder, for blasting; 600 feet of fuse, $5.00; and "300 caps," probably blasting caps, $2.40. The "bill of all expenses on Blue Jay" totaled $121.25. This was divided three ways, with Tom and Pat each assessed $40.40, and each received $150.00, Shepp, [Diary], 1903-1904, fourth and third page from end.

38. Boone, *Idaho Place Names*, 89, 188. Fig. 4.4 is from the Idaho County GenWeb Project, available at http://idaho.idgenweb.org/PHOTOS/humptown.jpg. The image is likely in the public domain because of its creation date but its legal ownership could not be determined. The individual who posted the image could not recall its source.

39. Shepp, [Diary], 1903-1904, March 11, 1904.

40. Ibid., May 20, 1904.

41. Infoplease, "News and Events of 1903," available at http://www.infoplease.com/year/1903 (accessed August 21, 2018).

42. Infoplease, "News and Events of 1904," available at http://www.infoplease.com/year/1904 (accessed August 21, 2018).

43. Infoplease, "News and Events of 1905," available at http://www.infoplease.com/year/1905 (accessed August 21, 2018).

44. Infoplease, "News and Events of 1906," available at http://www.infoplease.com/year/1906 (accessed August 21, 2018).

45. Infoplease, "News and Events of 1907," available at http://www.infoplease.com/year/1907 (accessed August 21, 2018).

46. Infoplease, "News and Events of 1908," available at http://www.infoplease.com/year/1908 (accessed August 21, 2018; "The Inflation Calculator."

47. Infoplease, "News and Events of 1909," available at http://www.infoplease.com/year/1909 (accessed August 21, 2018).

48. Boy Scouts of America, "History," 'The Beginning of Scouting,' available at https://www.scouting.org/programs/cub-scouts/parents/about/history/ (accessed August 21, 2018).

49. M. Alfreda Elsensohn, "Fourth Academy Day at St Gertrude's, Cottonwood, Renews … Memories of Polly Bemis," *Spokesman-Review*, May 12, 1957, 4.

50. Frances Zaunmiller Wisner, *My Mountains: Where the River Still Runs Downhill* (Grangeville, ID: *Idaho County Free Press*, 1987), 208. Vern Wisner, whom Frances

Zaunmiller later married, lived at Polly's place on and off in the 1950s, Doug Tims, *Merciless Eden* (Boise, ID: Ferry Media, 2013), 305.

51. Charles Shepp, various diaries.

52. E.g., Elsensohn, "Fourth Academy Day," 4.

53. Several Idaho County Assessment Rolls mention that the Bemises owned cattle and milk cows. Since ducks and cows are not mentioned in the Shepp diaries, perhaps the Bemises no longer had those animals by the time they met Shepp.

54. A secondary source mentions that Charlie Bemis hunted elk successfully, Rafe Gibbs, *Beckoning the Bold: Story of the Dawning of Idaho* (Moscow: University Press of Idaho, 1976), 103, but the diaries do not. In addition, the same source declared that Charlie "in earlier days had been able to keep a can rolling with a six-shooter," ibid., but again there is no confirmation for that statement, although the Shepp diaries sometimes comment on his shooting prowess, e.g., Shepp, [Diary], 1905-1908, March 17-19, 1906. In later years, Bemis "had trouble seeing at long distance, so Polly spotted game for him, and crept with him near it, enabling him to bring it down with one shot. (Bullets were hard to come by)," Gibbs, *Beckoning the Bold*, 103. It isn't clear whether Gibbs means that bullets were expensive or just difficult to obtain. If they were actually "hard to come by," for whatever reason, it is surprising that Shepp and his cronies would use them for target shooting, e.g., Shepp, [Diary], 1905-1908, March 17-19, 1906. Shepp does mention buying a box each of 30-30 and 30-40 caliber bullets at Hump, Shepp, [Diary], 1903-1904, March 27, 1904.

55. Shepp, [Diary], 1902-1903, February 20, 1903.

56. Ibid., March 5, 1903.

57. Shepp, [Diary], November 1, 1921, through December 31, 1923, photocopy, University of Idaho Library Special Collections, MG 155, September 11, 1922.

58. Shepp, [Diary], 1902-1903, April 17, 23, 1903.

59. Ibid., April 17, 26, 1903.

60. Ibid., May 6, 1903.

61. Ibid., May 11, 1903.

62. Ibid., May 12, 1903.

63. Ibid., January 10, 1903.

64. Ibid., February 25, 1903.

65. Ibid., March 7, 1903.

66. Ibid., June 6, 1903.

67. Ibid., May 30, 1903.

68. Ibid., January 3, 1904.

69. Shepp, [Diary], 1908-1909, June 23, 1908.

70. Shepp, [Diary], 1902-1903, inside front cover.

71. Ibid., second page.

72. Ibid., fourth page.

73. Ibid., February 11, 1903.

74. Ibid., April 27, 1903.

75. Ibid., December 9, 1902.

76. Ibid., inside front cover.

77. Ibid., May 2, 1903.

78. Ibid., December 12, 1902.

79. Ibid., March 14, 1903.

80. Ibid., November 18, 1902.

81. Ibid., second page.

82. Ibid., November 9, 1902.

83. Ibid., February 14, 1903.

84. Ibid., December 16, 1902.

85. Ibid., April 27, 1903.

86. Ibid., February 17, 1903.

87. Ibid., May 2, 1903.

88. Ibid., November 1, 1902.

89. Ibid., inside front cover.

90. Ibid., December 14, 1902; "Bet Tom chew Dick left Hump today," meaning that Shepp bet his partner Tom some chewing tobacco that their friend Dick left Humptown that day, the 14th. Although Shepp does not say that he lost the bet, an entry for the 17th says, "Dick … came down from Hump yesterday."

91. Ibid., January 22, 1903.

92. Ibid., November 18, 1902.

93. Ibid., November 9, 1902.

94. Ibid., November 29, 1902.

95. Ibid., December 23, 1902.

96. Ibid., January 28, 1903.

97. Ibid., February 15, 1903.

98. Ibid., March 7, 1903.

99. Ibid., March 9, 1903.

100. Ibid., March 30, 1903.

101. Ibid., April 29, 1903.

102. Ibid., inside front cover.

103. Ibid., second page.

104. Ibid., November 6, 1902.

105. Ibid., April 2, 1903.

106. Ibid., April 16, 1903.

107. Ibid., April 16, 1903. The tackle is implied, since Shepp caught two fish.

108. Ibid., April 1, 1903.

109. Ibid., April 13, 1903. Later, horses replaced the mules.

110. Ibid., February 4, 1903.

111. Ibid., February 28, 1903.

112. Ibid., May 19, 1903.

113. Ibid., February 13, 1903.

114. Ibid., November 22, 1902; November 9, 1902; December 5, 1902.

115. Ibid., November 28, 1902.

116. Ibid., December 3, 1902.

117. Ibid., November 27, 1902.

118. Shepp, [Diary], 1903-1904, November 18, 1903. Polly could not read or write, so Charlie would have written any letters that she wanted to send.

119. Ibid., December 8, 1902

120. Ibid., December 12, 1902.

121. Ibid., March 14, 1903.

122. Shepp, [Diary], 1903-1904, March 15, 1904.

123. Ibid., July 11, 1905.

124. Shepp, [Diary], 1905-1908, March 20, 1906.

125. Ibid., April 11, 1906.

126. Ibid., December 5, 1907.

127. Ibid., December 6, 1907.

128. Ibid., January 16, 1908.
129. Ibid., January 23, 1908.
130. Ibid., January 29, 1908.
131. Ibid., February 5, 1908.
132. Shepp, [Diary], 1908-1909, May 27, 1908.
133. Ibid., January 28, 1909.
134. Shepp, [Diary], 1902-1903, March 26, 1903.
135. Ibid., April 19, 1903.
136. Ibid., December 9, 1902.
137. Ibid., December 10, 1902.
138. Ibid., December 18, 1902.
139. Ibid., February 17, 1903.
140. Charles Shepp, [Diary], October 30, 1904, through October 21, 1905, photocopy of typescript, University of Idaho Library Special Collections, MG 5209, October 31, 1904. The diary, if any, for June 9, 1904, through October 29, 1904, is missing.
141. Shepp, [Diary], 1908-1909, October 31, 1908.
142. Shepp, [Diary], 1902-1903, January 11, 1903.
143. Ibid., January 18, 1903.
144. Ibid., February 23, 1903.
145. Ibid., March 1, 1903.
146. Ibid., December 4, 1902.
147. Ibid., November 10, 1902.
148. Shepp, [Diary], 1908-1909, April 15, 1909.
149. Shepp, [Diary], 1905-1908, February 5, 1908.
150. Shepp, [Diary], 1902-1903, March 26, 1903.
151. Ibid., March 28, 1903.
152. Ibid., March 26, 1903.
153. Ibid., March 30, 1903. Later, on April 1, 1903, Shepp refers to it as a "crapping can."
154. Ibid., June 8, 1903.
155. Ibid., December 1, 1902.
156. Ibid., December 9, 1902.
157. Ibid., March 9, 1903.
158. Ibid., March 15, 1903.
159. Ibid., April 16, 1903.
160. Ibid., June 8, 1903.
161. Ibid., March 28, 1903.
162. Ibid., March 31, 1903.
163. Ibid., April 5, 1903.
164. Shepp, [Diary], 1908-1909, April 17, 1909.
165. Shepp, [Diary], 1902-1903, November 8, 1902; Egan's identity is not known. Bemis and Egan were actually visiting Smith and Williams, who owned the ranch at that time. The phrase, "I was over river," means that Shepp visited the Bemises; they lived directly opposite Smith and Williams.
166. Shepp, [Diary], 1905-1908, November 27, December 1, 25, 1905.
167. Shepp, [Diary], 1902-1903, November 20, 1902.
168. Ibid., December 1, 1902. He took something else, too, but it is only represented by _____ in the typescript, meaning that the word was illegible to the transcriber.

169. Ibid. "Dick B." may be Richard Beall, Cheryl Helmers, *Warren Times: A Collection of News about Warren, Idaho* (Odessa, TX: The Author, 1988), December 25, 1913 [newspaper dated January 8, 1914]. Later, Beall was superintendent of the Little Giant Mine, Helmers, *Warren Times*, August 10, 1916; August 9, 1917.

170. Shepp, [Diary], 1902-1903, November 27, 1902. Smith's nickname and Williams's first name were obtained from Carrey and Conley, *River of No Return*, 206. No sources have provided Smith's first name. The two men would have been living together at the time of the 1900 US Census, but they are not listed at all. The census taker must not have wanted to hike down to the Salmon River to get their information.

171. Ibid.

172. Ibid., December 25, 1902. Lawless is unknown. One of the James brothers was Orson; he lived at James Creek, three miles upriver from the Bemises, from 1901 to about 1921, Carrey and Conley, *River of No Return*, 203. When the diary says "James," Orson is presumed. "Before he [Orson James] arrived, Chinese miners had run a ditch up to Rugged Creek in order to have water to placer the bar. ... His friends downriver, Shepp and Klinkhammer, would loan him their cat to clean mice out of his cabin," Carrey and Conley, *River of No Return*, 203-204. In July 1910, Orson went up to Warren "with a load of vegetables on his six burros. He is a loud gruff fellow, the kind it takes to drive burros with a lot of yelling and rock throwing. ... James' place is just downriver from Warren [C]reek, on the main Salmon," Helmers, *Warren Times*, July 7, 1910. Milton James, Orson's brother, was a partner with Elton "Donely" on the Salmon River, Helmers, *Warren Times*, June 11, 1914; he is perhaps the same Donnelly, no first name given, who was Orson James's partner at their James Creek place, Carrey and Conley, *River of No Return*, 203.

173. Shepp, [Diary], 1902-1903, January 12, 1903.

174. Ibid., January 15, 1903.

175. Ibid.

176. Ibid., February 7, 1903.

177. Ibid., and February 22, 1903. His fellow guests on the 22nd were McNeal, Dick, Smith, and Tom.

178. Ibid., [4].

179. Ibid., February 26, 1903.

180. *The Standard*, "Thunder Mountain News," 5(10):1, March 5, 1903. The spring of 1902 saw a gold rush to Thunder Mountain which began to slow in 1905, Midas Gold, "Thunder Mountain Dedication," available at http://midasgoldidaho.com/community/thunder -mountain-dedication/# (accessed August 21, 2018). More information on Thunder Mountain can be found in the Idaho State Historical Society's Reference Series Number 20, "Thunder Mountain," January 1966, available at http://history.idaho.gov/sites/default/ files/uploads/reference-series/0020b.pdf (accessed August 21, 2018).

181. Shepp, [Diary], 1902-1903, March 22, 1903. Stone is otherwise unknown.

182. Ibid., March 30, 1903. Fish frequently caught locally were "'red sides'—which we now know as steelhead. But most of their set line catches were Dolly Vardens [trout]," Klinkhammer, "Year Book 1954 [1958]," January 4, 1954 [1958].

183. Shepp, [Diary], 1902-1903, April 2, 1903; Shepp, [Diary], 1902-1903, [4].] The latter page, headed "Bemis Cr[edit]," meaning that Shepp owed Bemis, lists the 30 candles, obtained on January 12, 1903; the 16# [pounds] sugar, 6# coffee, and 5# salt, obtained on February 22, 1903; and 100# flour, 15# sugar, 6# salt, and 1# [baking] soda, obtained on April 2, 1903. The individual diary entries do not always match the list. For example, the items obtained on February 22 are not mentioned in that day's entry, while the entry for April 2 correctly identifies the flour and salt, but has 16# of sugar and no soda.

184. Shepp, [Diary], 1902-1903, April 7, 1903.

185. Ibid., April 22-25, 1903.

186. Ibid., April 22, 1903.

187. Ibid., April 26, 1903.

188. Ibid., April 30, 1903. For Bert Goodpastor, see Helmers, *Warren Times*, April 27, 1901.

189. Ibid., June 7, 1903. Tom Ford was a miner in the Warren area, Helmers, *Warren Times*, November 12, 1897.

190. Shepp, [Diary], 1903-1904, October 31, 1903.

191. Carrey and Conley, *River of No Return*, 139.

192. Shepp, [Diary], 1903-1904, November 15, 18, 1903. The final four pages of the 1903-1904 diary have some accounts. One, headed November 18, indicates that Shepp owed Bemis $6.98. Part of that amount included $1.68 for 56 pounds of potatoes [3 cents per pound], $2.20 for 22 pounds of beans [10 cents per pound], and 60 cents for 12 pounds of onions [5 cents per pound].

193. Ibid., November 29, 1903.

194. Ibid., November 1, 1903.

195. Shepp, [Diary], 1904-1905, loose in original diary; described on page 62 of typed transcript.

196. Shepp, [Diary], 1903-1904, November 5, 1903. "Schalkan" is probably Franklin [Frank] Shalkan, a local miner who earlier sued successfully for unpaid wages and later sold some mining property for $1,000, Helmers, *Warren Times*, July 1, 1892; May 30, 1901; and August 5, 1909.

197. Shepp, [Diary], 1903-1904, November 6, 1903; Bemis returned with Smith.

198. Ibid., November 7, 1903.

199. Ibid., November 11, 1903.

200. Ibid., November 12-13, 1903.

201. E.g., ibid., November 8, 10, 1903.

202. Ibid., November 8, 1903.

203. Ibid., November 15, 1903.

204. Ibid., November 25-26, 1903; Boggs is unknown.

205. Ibid., November 28-30, 1903.

206. Ibid., December 2, 1903.

207. Ibid., December 9, 18, 1903.

208. E.g., ibid., December 29-31, 1903; January 2, 1904. The "house" was really a cabin.

209. Ibid., December 13-17, 1903.

210. Ibid., December 21-22, 1903.

211. Ibid., December 25, 1903. Warner and the Smiths are unknown.

212. Ibid., December 27, 1903.

213. Idaho County, Assessments, "Assessment Roll and Delinquent Tax List, 1903" (Idaho County Courthouse, Assessor, Grangeville, ID, 1903), 25.

214. Shepp, [Diary], 1903-1904, January 8, 1904.

215. Ibid., January 28, 1904. At the end of the 1903-1904 diary there are some accounts, one of which is $2.50 "for Yost." Yost was Frank Yost, Shepp, [Diary], 1904-1905, November 8, 1904, probably F. W. Yost, who, in March 1901, had been a blacksmith for the South Fork Hydraulic Company, Helmers, *Warren Times*, March 1, 1901. Yost must have had a meal, and/or the payment was for some or all of the potatoes the two men obtained then, Shepp, [Diary], 1903-1904, last page. On other occasions, it is not always clear just who owes whom. For example, the first page of the 1903-1904 diary bears the notation, "C. Bemis [$]12.85." It is crossed out, and marked "Paid," Shepp, [Diary], 1903-1904, [1].

216. Shepp, [Diary], 1903-1904, February 22-23, 1904.

217. Ibid., March 11, 1904.

218. Ibid., March 11, 14, 1904.

219. Ibid., March 26-27, 1904. In a 1968 interview, Pete Klinkhammer stated that Alec Blaine worked for the Forest Service in the summer and spent winters at the Shepp Ranch, Peter (Pete) Klinkhammer, interviewed by Jayne Brown, Shepp Ranch, 1968, transcribed by Bailey Cavender and checked by Priscilla Wegars, transcription in author's possession, 31-32. Blaine died in 1940 and is buried beside Charlie Bemis at the Shepp Ranch.

220. Shepp, [Diary], 1903-1904, March 29, 1904.

221. Ibid., April 8, 17, 1904.

222. Carrey and Conley, *River of No Return*, 206. The Blue Jay may have been named after, and have been on or near, "Blue J[ay R]idge," or vice versa, Shepp, [Diary], 1902-1903, April 17, 1903.

223. Shepp, [Diary], 1903-1904, April 7, 1904.

224. Helmers, *Warren Times*, October 13, 1904; March 1, 1917.

225. Shepp, [Diary], 1903-1904, April 9, 1904.

226. Ibid., last page.

227. *Idaho County Free Press*, "Disastrous Conflagration," 20(15):1, September 15, 1904.

228. Idaho County, Assessments, "Assessment Roll and Delinquent Tax List, 1904" (Idaho County Courthouse, Assessor, Grangeville, ID, 1904), 26. Bemis may also have lost money in bonds, perhaps during the "Panic of 1893." In 1942 Frank McGrane, Sr. told M. Alfreda Elsensohn that he thought "Bemis had considerable money at one time, but lost much of it in bonds," M. Alfreda Elsensohn, *Pioneer Days in Idaho County*, vol. 1 (Caldwell, ID: Caxton, 1947), 94.

229. Shepp, [Diary], 1904-1905, inside front cover.

230. Ibid., October 30, 1904.

231. Ibid., November 2, 1904.

232. Ibid., November 4, 1904. Frenchy is unknown.

233. Ibid., November 5, 1904.

234. Ibid., November 6-7, 1904.

235. Ibid., November 19, 1904.

236. Ibid., November 11, 19, 27-28, 1904. Ernest is unknown.

237. Ibid., November 16, 1904. Jordan was probably Frank Jordan, also spelled Jordon, who by 1910 had a place on the Salmon River, upriver from Orson James's place, Helmers, *Warren Times*, July 7, 1910; September 20, 1918. Guser is unknown.

238. Shepp, [Diary], 1904-1905, November 27, 1904.

239. Ibid., November 28, 1904.

240. Ibid., November 21, 27, 1904.

241. Ibid., December 4, 1904.

242. Ibid., December 6, 1904.

243. Ibid., December 8-15, 1904.

244. Ibid., December 23, 1904.

245. Ibid., January 15, 1905. Pat Lannan is unknown.

246. Ibid., January 28, 1905.

247. Ibid., January 29, 1905.

248. Ibid., January 31, 1905.

249. Ibid., February 1-3, 1905.

250. Ibid., February 22, 1905.

251. Ibid., February 22-March 4, 1905.

252. Ibid., March 17, 1905. Previous mentions of "Jerry" in the diaries leave no doubt that "Jerry" is a cat.

253. Ibid., March 16-24, 1905.

254. Ibid., March 25-31, 1905.
255. Ibid., April 1, 1905.
256. Ibid., April 6, 1905.
257. Ibid., April 14, 1905.
258. Ibid., April 27-29, 1905.
259. Carrey and Conley, *River of No Return*, 205-207.
260. Helmers, *Warren Times*, April 23 and 30, 1908; June 17, 1909; January 27 and September 15, 1910.
261. Shepp, [Diary], 1904-1905, May 25, 1905.
262. Ibid., May 31, 1905.
263. Ibid., May 5, 8, 12, 26, 30-31, 1905.
264. Ibid., June 1-2, 5-6, 9, 12-16, 1905.
265. Ibid., June 3, 1905. Wagner is unknown; he may be the same person as Wegner, also unknown, who appears in later diaries.
266. Ibid., June 1, 14-18, 21-23, 26-30, 1905. Cavanaugh and Aubrey are unknown.
267. Ibid., June 1, 19, 24, 1905.
268. Ibid., June 1, 10, 26, 28, 1905.
269. US Bureau of Immigration, "Chinese Census, District of Montana and Idaho, June 30, 1905," University of Idaho Library, Moscow. Hathoy, often misread as "Nathoy," is the surname on Polly's marriage certificate.
270. Shepp, [Diary], 1904-1905, July 10, 1905.
271. Ibid., July 12, 1905.
272. Ibid., July 13, 1905.
273. Ibid., July 21, 23, 1905.
274. Ibid., July 27, 1905.
275. Ibid., July 28, 1905.
276. Ibid., July 29, 1905.
277. Ibid., July 30, 1905.
278. Ibid., August 4, 1905.
279. Ibid., August 5, 1905.
280. Ibid., August 31, 1905. McCarty is unknown, although Helmers, *Warren Times*, February 7, 1918, mentions a Justin McCarty and, ibid., February 15, 1918, a Clarence McCarty, both of Warren.
281. Ibid., August 24, 29-31, 1905.
282. Ibid., September 2-3, 1905. Mallard is unknown.
283. Ibid., September 5-22, 1905.
284. Ibid., October 6, 1905.
285. Ibid., October 5, 1905.
286. Ibid., October 7, 1905.
287. Ibid., October 8 and 10, 1905.
288. Ibid., October 15, 1905. Shepp was on his way to Seattle, via Grangeville, so presumably would make the Bemises' purchases in one or both of those two places.
289. Ibid., last page [page 62 of transcript]. A few pages earlier, Shepp indicated that he paid Bemis in July 1905 for an "old bill" of $10.15 involving cash, $6.00; 45# [pounds] spuds, $1.35; 16# cab[bage], $.80; 17# beans, $1.70, and an additional 25 pounds potatoes and 6 pounds onions, for which no amounts were given, ibid., [page 61 of transcript].
290. Ibid., [page 62 of transcript]. A dictionary defines truss as "an appliance to support a weakened, injured, or deformed part, used especially in cases of hernia." The latter word is defined as "protrusion of an organ or part through some opening in the walls of its natural

cavity; a rupture." If "Nov. 28 06" is a date, it is not in the 1904-1905 diary. The 1906 diary does not mention a truss on November 28, 1906. Curiously, Bemis seems to have paid Shepp $2.21 for the truss, rather than $2.00.

291. Shepp, [Diary], 1905-1908, November 13, 1905.

292. Ibid., November 21, 1905.

293. E.g., Shepp, [Diary], 1904-1905, March 9, September 1-3, 1905.

294. Shepp, [Diary], 1905-1908, November 19, 1905. Pete's partner was probably Wagner, ibid., November 30, 1905; in early December, Shepp "went up to Wagners & Petes" and "stayd all night," ibid., December 1, 1905. Vance is unknown.

295. E.g., when Shepp returned from Seattle, he "met Ernest," ibid., November 18, 1905, im- plying that they traveled home together; later they stayed in Shepp's house together, ibid., December 15-22, 1905.

296. Ibid., December 2, 1905.

297. Ibid., December 10-11, 1905.

298. Ibid., December 12-15, 1905.

299. Ibid., December 24, 26, 1905.

300. Idaho County, Assessments, "Assessment Roll and Delinquent Tax List, 1905" (Idaho County Courthouse, Assessor, Grangeville, ID, 1905), 25.

301. Shepp, [Diary], 1905-1908, January 5, 20-23, 1906. Shepp probably suffered from painful arthritis rather than rheumatism; the latter word "is a colloquial term which is much less commonly used today by medical professionals and medical writers. There is no recognized disorder today called 'rheumatism,'" Capital Region Special Surgery, "What Is The Difference Between Arthritis And Rheumatism?," May 30, 2012, from *Medical News Today*, available at http://www.capitalregionspecialsurgery.com/pain-management/news/ what-is-the-difference-between-arthritis-and-rheumatism/ (accessed August 21, 2018).

302. Shepp, [Diary], 1905-1908, January 24-26, 1906. "Peters" is unknown.

303. Ibid., January 26-27, 1906.

304. Ibid., February 8-10, 19-24, 1906.

305. Ibid., March 11, 15-16, 1906.

306. Ibid., March 17-19, 1906.

307. Ibid., March 15-20, 1906.

308. Ibid., March 28-29, 1906.

309. Ibid., March 30-31, 1906. A scow is a flat-bottomed boat with square ends.

310. Ibid., April 9-10, 1906.

311. Ibid., April 21, 1906. Although Robinson is unknown, he is probably related to "Mrs. Robinson & 2 kids" of Rabbit Creek, ibid., August 13, 1907.

312. Ibid., April 23-26, 1906.

313. Ibid., May 10-14, 1906. The butter may be homemade or purchased.

314. Ibid., May 21, 1906.

315. Ibid., June 1, 11, 18-24, 1906.

316. Ibid., July 3, 1906. Frank Charcal is unknown.

317. Ibid., July 19-29, 1906. Wegner [Wagner?] is unknown; a Wagner, also unknown, appears in earler and later diaries.

318. Ibid., August 2, 1906. Tremain is unknown.

319. Ibid., August 3-6, 13, 19-27, 1906.

320. Ibid., September 10-14, 18-22, 28-30; October 1-4, 1906.

321. Ibid., October 9-10, 14-17, 20, 27, 1906.

322. Ibid., November 2-7, 1906.

323. Ibid., November 16-24, 1906.

324. Ibid., December 5-12, 1906. Paddy is unknown.
325. Ibid., December 13, 1906. Olie is unknown.
326. Ibid., December 25-28. 1906.
327. Ibid., January 7-8, 1907. Green is unknown.
328. Ibid., January 9-12, 1907.
329. Ibid., February 3-12, 1907. In drying tobacco, the worker tied a group of leaves together at the stem ends and hung the bundle over a horizontal stick with many other bundles. Each bundle was a "hand" and weighed about one pound, WholeLeafTobacco.net, "Yer Old Fashion Hand of Tobacco," formerly available at http://wholeleaftobacco.net/products/old-fashionhand-of-tobacco (accessed February 10, 2015, but gone by October 27, 2015). A video shows how the hands were tied and placed on sticks that were hung to cure, YouTube, "Tobacco Tying Machine, available at https://www.youtube.com/watch?v=hunbnvmCeTM (accessed August 21, 2018).
330. Shepp, [Diary], 1905-1908, March 5-9, 1907.
331. Ibid., April 6-8, 16-26, 1907. The colt's birth was noted in Shepp, [Diary], 1904-1905, April 14, 1905.
332. Shepp, [Diary], 1905-1908, May 7-10, 1907.
333. Helmers, *Warren Times*, May 1907.
334. Robert J. Bailey, *River of No Return (The Great Salmon River of Idaho): A Century of Central Idaho and Eastern Washington History and Development, Together with the Wars, Customs, Myths, and Legends of the Nez Perce Indians* (Lewiston, ID: Bailey-Blake Printing, 1935), 478.
335. Shepp, [Diary], 1905-1908, June 7-10, 25-30, 1907. In later years, Pete Klinkhammer commented that "Shepp was respectful of high water and would not cross under any circumstance when it reached a certain point," Klinkhammer, "Year Book 1954 [1958]," February 13, 1954 [1958].
336. Shepp, [Diary], 1905-1908, July 1-7, 13-15, 29-31, 1907.
337. Ibid., August 5-18, 1907.
338. Ibid., August 11-13, 1907.
339. Ibid., August 13, 1907.
340. Ibid., August 15, 1907.
341. Ibid., August 18, 1907.
342. Ibid., August 18-23, 28, 1907.
343. Ibid., August 24-25, 1907. Back home, two days later, he wrote the cryptic note, "Anvil at B," perhaps meaning that he needed his anvil, but it was at the Bemises, ibid., August 27, 1907.
344. Ibid., September 18-20, 1907.
345. Ibid., October 1-3, 1907.
346. Ibid., October 6, 1907. The exact date when Pete moved in is not specified.
347. Shepp did make three special notations. On the 19th, he "heard Tom Gallagher was worse, in hospital again," on the 27th he wrote, "Gallagher buried in Elk," underlining it for emphasis, and on November 5th he wrote, "Tom died Oct. 27," ibid., October 19, 27; November 5, 1907. "Elk" was Elk City. Tom Gallagher was a prospector who "had cabin about [a] mile up Crooked Creek on Jersey side," Klinkhammer, "Year Book 1954 [1958]," January 2, 1954 [1958]. Tom Gallagher may well have been Shepp's former mining partner.
348. Shepp, [Diary], 1905-1908, November 7, 20-26, 1907. Shepp also sent off to Montgomery Ward for a truss for his own hernia.
349. Ibid., November 26, 1907. The foodstuffs totaled 740 pounds.
350. Ibid., December 24-27, 1907.

351. Idaho County, Assessments, "Assessment Roll and Delinquent Tax List, 1907" (Idaho County Courthouse, Assessor, Grangeville, ID, 1907), page number unknown. Thanks to Abbie Hudson for copying and mailing this document to me. These records were not investigated for additional years because they are very difficult to access.

352. *Farm Conveniences: A Practical Hand-Book for the Farm* (New York, Orange Judd, 1884, reprinted 1907). Cort Conley now owns this book, e-mail message to author, May 21, 2017.

353. *Farm Conveniences*, 5-8. The author owns a copy of the 1906 printing. Curiously, the Table of Contents stops at page 239, but from pp. 241 to 256 there are nearly 20 additional, illustrated topics that are not listed in the Contents.

354. Shepp, [Diary], 1905-1908, January 11-15, 18, 21-22, 1908.

355. Ibid., February 8-10, 20-23, 1908.

356. Ibid., March 16-18, 1908.

357. Ibid., April 3-4, 12-16, 1908.

358. Ibid., May 1, 1908. Gans was probably Warren-area miner Andy Gam or Gambs, Helmers, *Warren Times*, March 4 and May 6, 1898.

359. Shepp, [Diary], 1908-1909, May 1-2, 6-7, 12-14, 30-31, 1908.

360. Ibid., June 1, 1908.

361. Ibid., June 7-10, 23-24, 28, 1908.

362. Ibid., June 29-30, 1908.

363. Ibid., July 1-8, 1908.

364. Ibid., [2].

365. Ibid., July 19-20, 1908.

366. Ibid., August 2-3, 11-15, 20-22, 1908.

367. Ibid., September 8-12, 1908. On the 8th he wrote that Williams was at Smith's, thus implying that Smith and Williams are no longer partners and probably haven't been for some time.

368. Ibid., October 1-6, 8, 1908.

369. Ibid., October 10, 1908.

370. Ibid., October 15, 1908. There is no explanation for the 20-cent discrepancy.

371. Ibid., October 21-26, 1908.

372. Ibid., November 1, 3-4, 10, 1908. William Howard Taft was the 27th US president.

373. Ibid., November 25-27, 1908.

374. Ibid., December 13, 1908.

375. Although miner "China Dick"/Goon Dick and physician Lee Dick were different people, they both mined and sometimes their individual mining interests were confused, e.g., Helmers, *Warren Times*, July 26, 1918; April 4, September 19, and October 30, 1919.

376. Ibid., March 1, 1917; May 9 and July 26, 1918; and September 19, 1919. These partnerships may actually, and more likely, have been between Lee Dick and the Euroamerican miners.

377. Ibid., March 21, 1919; April 15 and December 16, 1920; January 12 and November 9, 1922; June 21 and October 11, 1923; April 10 and October 23, 1924; and August 19, 1926. Goon Dick died March 2, 1927, in Grangeville, ibid., March 3, 1927.

378. Shepp, [Diary], 1908-1909, December 14, 1908.

379. Ibid., December 16, 1908.

380. Ibid., December 17, 1908.

381. Ibid., December 23-27, 1908.

382. Ibid., end. Shepp got these items at the Jumbo Mine, ibid., October 11, 1908. The lemon extract was a half-quart, i.e., one pint, and the "Maplene" was a "small bottle." According to his entry that day, the curry actually came in a bottle. The person who transcribed this diary mistakenly typed "Simon" for "Lemon" from the list at the end. For Mapleine,

see more at "Resurrected Recipes," available at http://resurrectedrecipes.com/2011/05/14/
oh-mapleine-1-of-3/ (accessed August 21, 2018). Invented by the Crescent Manufacturing
Company of Seattle in 1905, it was advertised at least as early as 1906.

383. Shepp, [Diary], 1908-1909, January 1-2, 15-23, 1909.

384. Ibid., February 8-10, 20-22, 1909. Boston Brown later helped with construction of the Forest
Service's road from Warren to Hayes Station. He also placer mined on War Eagle Mountain
with the assistance of Warren Chinese pioneer Lee Dick, Helmers, *Warren Times*, January
25 and July 26, 1918; April 11, 1919. The War Eagle Mine was on a tributary of Crooked
Creek. Bill Boyce discovered it in 1898, Carrey and Conley, *River of No Return*, 214.

385. Shepp, [Diary], 1908-1909, February 8-10, 20-26, 1909.

386. Ibid., March 10-11, 14, 17-19, 22-23, 26-28, 1909.

387. Ibid., April 9-16, 1909.

388. Ibid., May 1-2, 10-13, 19-24, 1909.

389. Ibid., June 13, 20, 22, 1909.

390. Charles Shepp, [Diary], August 4, 1909, through December 4, 1910, photocopy, University
of Idaho Library Special Collections, MG 155, August 8-10, 1909. The diary, if any, for
June 23, 1909, through August 3, 1909, is missing; Shepp was in Seattle during most of
that time.

391. Ibid., August 13-14, 28-30, 1909.

392. Ibid., September 21-22, 1909.

393. Ibid., September 22, 1909. The "Star contract" refers to some mining work Shepp was
doing on the North Star Mine, reportedly at Latitude 45.6385134 and Longitude
-115.6829089 in Idaho County, Idaho, ID HomeTownLocator, available at https://idaho.
hometownlocator.com/maps/feature-map,ftc,2,fid,387850,n,north%20star%20mine.cfm
(accessed September 9, 2019). Although two sources state that the men put in $500 apiece
to buy Smith and Williams's place, Carrey and Conley, *River of No Return*, 208; M. Alfreda
Elsensohn, *Idaho County's Most Romantic Character: Polly Bemis* (Cottonwood, ID, and
Idaho Corporation of Benedictine Sisters, 1979), 32, the diary entries imply that Shepp
was the sole purchaser.

394. Shepp, [Diary], 1909-1910, September 22-23, 1909, and third page from end.

395. Ibid., October 10-11, 16-18, 1909. On the 17th, Shepp "took 4 pictures on Smith's ranch."
H. H. Martz, whose check it was, is unknown.

396. Ibid., October 20-23, 1909. The $51 check was "no. 105 on Elk City Bank issued by
O. C. Lapp Co. Ltd. by E. L. Schnell [and] Geo[rge] Stonebreaker" [sic, for Stonebraker].
Stonebraker operated the Buckhorn group of mines in the region, Helmers, *Warren Times*,
July 7, 1910.

397. Shepp, [Diary], 1909-1910, fourth page from end.

398. Ibid., November 4, 17, 1909.

399. Ibid., December 25, 27-30, 1909.

400. Elsensohn, *Pioneer Days in Idaho County*, vol. 1, 97.

401. Idaho County, Delinquent Taxes, "Assessment Roll A-G," 'Taxes Delinquent List' (Idaho
County Courthouse, Assessor's Office, Grangeville, ID, 1909), 28. In late June 1931, Warren
residents were able to buy the town lots at auction, *Idaho Daily Statesman*, "Million-Dollar
Gold Camp Sold at Auction for $900," 67(292):1, July 1, 1931.

402. Shepp, [Diary], 1909-1910, January 7-11, 26-28, 1910.

403. Ibid., February 5-7, 21-26, 1910. The person "Boise" is unknown.

404. Ibid., March 11-18, 1910.

405. Ibid., March 24, 1910. In later years, Pete Klinkhammer commented that "their first
garden [was] across the creek. All the main water ditches had already been constructed by
former tenants of the ranch. 'Not Smith & Williams. They weren't ambitious enough. And

I don[']t t[h]ink it was Copenhaver. It might have been Mall[i]ck (Nez Perce). Some of the trees were fifty years old when I came here,"" Klinkhammer, "Year Book 1954 [1958]," February 9-10, 1954 [1958].

406. Shepp, [Diary], 1909-1910, March 25-26, 31, 1910. Roberts is unknown.

Chapter Five: Life on the Salmon River, Spring 1910 through 1914

1. Charles Shepp, [Diary], August 4, 1909, through December 4, 1910, photocopy, University of Idaho Library Special Collections, Manuscript Group [henceforth MG] 155, April 1, 1910. In the margin he wrote, "Moved." The horse, Polly, was named for Polly Bemis.

2. Ibid., April 1, 1910. Tom is unknown. He wasn't Tom Gallagher, Shepp's presumed former partner; Gallagher died in 1907. "Four-eyed" Smith's first name is unknown. He probably wore glasses, hence the nickname "Four-eyed."

3. Infoplease, "Top News Stories from 1910," available at http://www.infoplease.com/year/1910 (accessed January 18, 2018).

4. Infoplease, "Top News Stories from 1911," available at http://www.infoplease.com/year/1911 (accessed January 18, 2018).

5. Infoplease, "Top News Stories from 1912," available at http://www.infoplease.com/year/1912 (accessed January 22, 2018).

6. Infoplease, "Top News Stories from 1913," available at http://www.infoplease.com/year/1913 (accessed January 22, 2018).

7. Infoplease, "Top News Stories from 1914," available at http://www.infoplease.com/year/1914 (accessed January 22, 2018).

8. Shepp, [Diary], 1909-1910, April 5-6, 8, 1910, and third page from end. Mention of the exact weights implies that the Bemises had a scale.

9. Ibid., April 10, 13, 15, 1910.

10. Family Search, "United States Census, 1910 (FamilySearch Historical Records)," available at https://www.familysearch.org/wiki/en/United_States_Census,_1910_%28FamilySearch_Historical_Records%29 (accessed January 16, 2018).

11. US Census, *Thirteenth Census of the United States: 1910—Population, Idaho*, Idaho County, Concord Precinct, Concord Village (Washington, DC: Department of Commerce and Labor—Bureau of the Census), and "1910 Idaho County Census Images, Concord Precinct," available at http://idaho.idgenweb.org/Census/10ccrd.pdf, Sheet 1A (accessed January 24, 2018).

12. Johnny Carrey and Cort Conley, *River of No Return* (Cambridge, ID: Backeddy Books, 1978), 214.

13. US Census, *Thirteenth Census of the United States: 1910—Population, Idaho,* Idaho County, Concord Precinct, Concord Village, and "1910 Idaho County Census Images, Concord Precinct."

14. US Census, *Thirteenth Census of the United States: 1910—Population, Idaho,* Idaho County, Warren Precinct, and "1910 Idaho County Census Images, Warren Precinct," available at http://idaho.idgenweb.org/Census/10wrn.pdf, Sheets 5A, 7A, and 8B (accessed September 2, 2018). Ah Sam and Lee Dick were also doctors who treated both Chinese and Euroamerican patients, Fern Coble Trull, "The History of the Chinese in Idaho from 1864 to 1910" (master's thesis, University of Oregon, Eugene, 1946), 63, and Sam "doctored all the white people around with remarkable success," Lawrence A. Kingsbury, *Ah Toy: A Successful 19th Century Chinese Entrepreneur* ([McCall, ID]: Payette National Forest, 1994), 4, citing a 1969 interview with Walter G. Mann. Ah Kan had earlier been a packer (Chapter Two). More information on Ah Tow/Ah Toy and other Chinese in the Warren area as late as 1932 is available in Kingsbury, ibid.

15. Shepp, [Diary], 1909-1910, April 17, 1910. Cook is unknown.

16. Ibid.

17. Ibid., April 19-22, 28, 1910, and 3rd page from end. Pete Klinkhammer commented, "we got enough seed to last ten years the first year we were here. Planted stuff way too early — (last of March)—It would come up & just sit there, Peter Klinkhammer, "Year Book 1954 [1958]," notes on 1910-1911 diary [as told to Marybelle Filer], written in diary dated 1954; first entry changed to 1958, photocopy, University of Idaho Library Special Collections, MG 155, January 5, 1954 [1958].

18. Shepp, [Diary], 1909-1910, May 2, 4, 9, 10, 17-18, 1910.

19. Edgar Bryan, conversation with Priscilla Wegars, 1986. Eddie was five years old in 1910. His father set up chairs outside so Eddie and his brother could watch the comet.

20. Shepp, [Diary], 1909-1910, May 19, 21-22, 24, 1910.

21. Beginning in 1901, Orson James ran the James Ranch at James Creek, about three miles upstream from the Bemis Ranch, and on the same side of the river, Carrey and Conley, *River of No Return*, 203.

22. Shepp, [Diary], 1909-1910, May 31, 1910. Tom Pritchard is otherwise unknown, and Roberts is unknown. Dixie was "[f]ounded as a mining camp in 1867," Laila Boone, *Idaho Place Names: A Geographical Dictionary* (Moscow: University of Idaho Press, 1988), 113; it had a post office from 1896 to 1960, and currently has a Village Post Office. A list of accounts at the end of the 1909-1910 diary confirms that Shepp got 25 pounds of potatoes from Bemis on May 31, 1910, Shepp, [Diary], 1909-1910, 3rd page from end.

23. No additional information about Gus Cooper or H. E. Dickey could be located.

24. Shepp, [Diary], 1909-1910, June 1, 4, 1910. "Neskin" is unknown, but Freeman Nethkin was a local miner in 1914, Cheryl Helmers, *Warren Times: A Collection of News about Warren, Idaho* (Odessa, TX: The Author, 1988), April 30, 1914.

25. Shepp, [Diary], 1909-1910, June 5, 1910, and "The Inflation Calculator," available at http://www.westegg.com/inflation/infl.cgi (accessed January 16, 2018).

26. Shepp, [Diary], 1909-1910, June 8, 1910. "The Wonderberry is (probably) S[*olanum*] *retroflexum* or, perhaps more usefully, *S x burbankii*. The Wonderberry is one of the many plants bred by that great American garden pioneer, Luther Burbank. …. It is said that Luther Burbank raised this hybrid in 1909 and called it the Sunberry but he sold the seed and rights to one of his customers[,] John Lewis Childs[,] who renamed it Wonderberry. …The plants look almost exactly like black nightshade (*Solanum nigrum*) and anything with the name nightshade is treated with suspicion. The truly deadly deadly nightshade (*Atropa belladonna*) is distantly related (both are in Solanaceae) but looks nothing like these plants," "The Biking Gardener: Experience of Gardening in Ireland and Back in the UK," 'Wonderberries or Waste of Space?,' available at https://thebikinggardener.com/2014/10/31/wonderberries-or-waste-of-space/ (accessed January 15, 2018). If Shepp's wonderberry plants were indeed the Burbank hybrid, and not a parent of it, then to be cultivating it in 1910 shows that he was very current with modern plants.

27. Shepp, [Diary], 1909-1910, June 12, 1910.

28. Ibid., June 15-16, 19, 21, 1910. Hardy and Thorne are unknown.

29. Ibid., June 26-29, 1910.

30. Ibid., July 4-8, 10, 13-16, 1910.

31. Ibid., July 19, 21-22, 24, 26, 31, 1910. Pete Klinkhammer commented that he and Shepp "killed twenty skunks our first year here—1910," Klinkhammer, "Year Book 1954 [1958]," January 5, 1954 [1958].

32. Shepp, [Diary], 1909-1910, August 3, 7, 10-15, 1910.

33. Ibid., August 17, 1910.

34. Klinkhammer, "Year Book 1954 [1958]," January 11-13, 1954 [1958].

35. Shepp, [Diary], 1909-1910, August 18, 1910.

36. Ibid., August 25, 1910.

37. The W. R. Thurston boating party met Polly in late August 1920. A report of that trip published in 1922 implies that Polly might have gone "out" in 1902, but there is no independent confirmation for that belief (Chapter Seven, August 1920).
38. Shepp, [Diary], 1909-1910, August 26 to September 3, 1910. While in Grangeville Shepp also "filed homeste[a]d on claim from March 20."
39. Ibid., September 5-7, 9-12, 14, 1910, and second page from end.
40. Ibid., September 17, 1910.
41. Ibid., September 18, 1910. The location of these images is unknown.
42. Peter (Pete) Klinkhammer, interviewed by Jayne Brown, Shepp Ranch, 1968, transcribed by Bailey Cavender and checked by Priscilla Wegars, transcription in author's possession, 19.
43. Shepp, [Diary], 1909-1910, September 22-28, 1910.
44. Ibid., October 2, 5, 9-12, 15, 1910. Near the end of the 1909-1910 diary are some accounts. One page includes the following information: "Bemis goods 1910 Alexander & F[reidenrich] 66.74 Freight 23.76," ibid., fourth page from end; there is no explanation for the difference in freight cost between $22.86 in the daily entry and $23.76 in the accounts.
45. Ibid., October 16-17, 1910.
46. Ibid., October 20, 22-23, 25, 1910. If "Long" is a potato variety, it is unknown. Perhaps the original seed had come from someone surnamed Long.
47. Ibid., October 26, 1910. Hillyard and Yarhaus are otherwise unknown.
48. Ibid., October 29, 31, 1910.
49. Ibid., November 1, 3, 4-6, 9, 1910.
50. Ibid., November 9, 1910.
51. Further confirmation comes from a later entry in one of Shepp's diaries. In July 1931, Shepp took Polly some tobacco, Charles Shepp, [Diary], October 11, 1930, through October 1, 1931, photocopy, University of Idaho Library Special Collections, MG 155, July 19, 1931; since Charlie Bemis had been dead since 1922, the tobacco was definitely for Polly.
52. Yin Ma, ed., *China's Minority Nationalities* (Beijing: Foreign Languages Press, 1989), 76.
53. Trull, "History of the Chinese in Idaho," 100.
54. Idaho resident Ron James recalled hearing that his maternal great-great-grandmother, a Euroamerican woman, smoked a pipe. She lived in Arkansas and was married to a Baptist preacher. Ron's mother "remembers her … sitting by the woodstove [discreetly] smoking a corn cob pipe as her more pious husband disapproved. But she did smoke in front of [Ron's] mom and other children—everyone knew she did it," Ron James, e-mail message to author, November 20, 2015. A friend of Ron's reported that his grandmother, in Kansas, born in the late 1890s, "also smoked a corn cob pipe. He was just a small child but remembers that she enjoyed a pipe in the evening," ibid. For an example from China, when Ron and his wife LiLi were hiking in Yunnan province, they "stayed with a local Naaxi family. The elderly grandmother smoked a pipe—they grew their own tobacco plus some wild hemp," and LiLi recalled seeing "a few older Chinese women who smoked pipes in rural Fujian province," ibid.
55. Shepp, [Diary], 1909-1910, November 9, 10, 13, 18, 20, 23, 1910. Shepp often named his animals after friends, relatives, or acquaintances, but the eponym for the namesake "Julius" is uncertain. Julius was possibly named after Julius Hicks, mentioned later in Shepp's 1918-1919 diary.
56. Ibid., November 24, 1910.
57. Ibid., November 27, 29, 30, 1910.
58. Ibid., December 1, 1910. Entries from December 1 through 4 are duplicated in the 1910-1911 diary.
59. Ibid., December 4, 1910. This entry is duplicated in the 1910-1911 diary.
60. Charles Shepp, [Diary], December 1, 1910, through December 31, 1911, photocopy, University of Idaho Library Special Collections, MG 155, December 5, 1910.

61. Ibid., December 6-7, 1910. "Bill Allen owned small store & postoffice @ Cal[l]end[e]r," Klinkhammer, "Year Book 1954 [1958]," January 1, 1954 [1958].

62. Shepp, [Diary], 1910-1911, December 8-9, 1910.

63. Ibid., December 11, 17-19, 24-25, 1910.

64. Ibid., January 4-5, 14, 1911. Most likely, these were drawing knives for woodworking.

65. Ibid., January 15, 1911. The emery grinder may have been needed to sharpen the drawing tools.

66. Ibid., January 22, 29, 31, 1911.

67. Ibid., February 5, 7, 12, 17, 19, 22, 27, 1911.

68. Ibid., March 1, 1911.

69. Ibid., March 5, 10, 12-13, 15-16, 19, 21, 24-25, 1911. The 1910-1911 diary contains two lists of fruit trees. One, loose, is headed "Commencing on creek side." In the third row, the fourth tree is "5 winesap—Bemis." The other list is written in the diary. Headed, "Grafts on Trees 1911," it contains the same information.

70. Ibid., April 3, 6-7, 12, 15-17, 22, 26-27, 1911.

71. Ibid., May 2, 11, 16, 24, 1911. A froe was used to split shingles from a block of wood.

72. Ibid., May 4, 6, 11, 16-17, 24, 1911.

73. Ibid., May 6, 1911.

74. Aiken is otherwise unknown.

75. Klinkhammer, "Year Book 1954 [1958]," January 27-31, 1954 [1958] and February 1-8, 1954 [1958].

76. Shepp, [Diary], 1910-1911, May 11, 1911. McGary owned the White Monument Mine, near Warren, Helmers, *Warren Times*, June 2, 1910. A separate sheet of paper in the 1910-1911 diary is headed "Kodak Exposure Record." Under the date of May 11, Shepp noted that he took a picture of "Bemis house" at 10 a.m. and another of "Bemis Ranch" at 2 p.m.

77. Ibid., May 16, 20, 1911.

78. Ibid., June 2, 1911.

79. Ibid., June 11-12, 1911. "The Gus Schultz family—Mr. & Mrs., 2 boys, Fred & Chas. & one girl—lived at Del Rio mining claims on way to Hump. Peter & Shepp—mostly Peter —would go for mail & stop overnite there on way to & from. Peter would chop wood & take ranch produce to them in mountain hospitality exchange fashion," Klinkhammer, "Year Book 1954 [1958]," January 1, 1954 [1958]. Fred, age six, was not born until about 1914; he is listed in the 1920 census with his family, then living in Grangeville, Idaho, US Census, *Fourteenth Census of the United States: 1920—Population, Idaho*, Idaho County, Grangeville, Idaho, Precinct 4, Sheet 10A, "1920 Idaho County Census Images," available at http://idaho.idgenweb.org/Census/gv22.pdf (accessed November 7, 2019). Daughter Helen, 19 in 1920, is listed in Seattle, Washington, with her husband, Carlos Wiswell, Family Search, "United States Census 1920, Washington, King [County], Seattle," available at https://www.familysearch.org/ark:/61903/3:1:33SQ-GRXP-37X?i=11&cc= 1488411&personaUrl=%2Fark%3A%2F61903%2F1%3A1%3AMHNR-RXD (accessed November 7, 2019).

80. Shepp, [Diary], 1910-1911, June 13-25, 28-29, 30, 1911. For the buckets, he used pails that had once held 10 pounds of lard. Besides the photo of Helen on her birthday, he took two more of the Schultz family the day they left, one of Nellie and another of the family mounted on horses. Those photos have not been located.

81. Ibid., July 4, 6, 1911.

82. Ibid., July 10, 14, 16, 1911.

83. Ibid., July 18-20, 1911.

84. Klinkhammer, "Year Book 1954 [1958]," February 22-23, 1954 [1958]. Polly Creek, in Township 24 North, Range 6 East, Section 12, has been described as a "3.2-mi stream flowing N to Salmon River about 30 mi E of Riggins," Boone, *Idaho Place Names*, 300.

It was originally Powell Creek when Bemis located and recorded his placer claim there in 1898/1899, Idaho County, Mining Claims, "Placer Locations, Book 9" (Idaho County Courthouse, Auditor-Recorder, Grangeville, ID, [1896-1899]), 522. While Bemis was alive, it was often called Bemis Creek.

85. R. B. Marshall, *Profile Surveys in Snake River Basin, Idaho*, US Geological Survey, Water-Supply Paper 347, Washington, DC: Government Printing Office, 1914, map 26. A note on the bottom of the map states, "Surveyed in 1911."

86. Shepp, [Diary], 1910-1911, July 21, 1911. According to Pete Klinkhammer, Goddard and Jackson were two of the three owners of Shepp's Blue Jay claim. The other was Miller, a Dayton, Washington, district judge. The owners "used to get Charlie [Shepp] & Pete to do assessment work on claims. They came in once in a while just to get away from home. Had good time and fished and maybe got a little drunk too. Jackson big sheep man. Charlie [Shepp] said that was one thing [sheepherding] he never wanted to do for a living. Miller said, 'Well, it's how I got my start. Used to spend my summers herding sheep so I could go to college,'" Klinkhammer, "Year Book 1954 [1958]," February 19-21, 1954 [1958].

87. Shepp, [Diary], 1910-1911, July 21, 23-25, 31, 1911.

88. Ibid., August 1-3, 5-6, 10-11, 1911. Laurie is unknown.

89. Ibid., August 12, 1911.

90. Ibid., August 14, 16-17, 1911. "Going outside" meant going to Grangeville, or beyond. In later years, Pete told a bit about that trip, which he made when he was 27. "In his pocket was a list (of items for both ranches—things that could not be obtained at Humptown) for Shepp and Bemis ranches. He traveled 18 miles to Concord, where he had his own camp. The next day he traveled 25 miles of wagon road to Adams Camp. Adams was a way station—big boarding house, cabins, and saloon. It was the stopping place of miners with their pack strings and freighters with their four horse teams & wagons. The moderate Peter found exhilaration in a few drinks whilst watching the gaming tables. The following day he traveled the remaining 25 miles over the wagon road to Grangeville. His purchases were small as the income of those days warranted. Money was hard to come by," Klinkhammer, "Year Book 1954 [1958]," March 2-5, 1954 [1958].

91. Shepp, [Diary], 1910-1911, August 18, 20, 26-27, 30, 1911.

92. Ibid., September 1, 3, 6-7, 10-11, 1911. For John Becker, see Helmers, *Warren Times*, April 11, 1919, and March 22, 1934.

93. Shepp, [Diary], 1910-1911, September 12, 16-18, 20, 23, 25, 27, 29-30, 1911. Shepp never provides Boyce's first name , but he is undoubtedly the Bill Boyce who discovered the War Eagle Mine in 1898, Carrey and Conley, *River of No Return*, 214. According to Gertrude Maxwell, William Boyce "knew Charlie Bemis well," Gertrude Maxwell, interview by Patrick J. McCarthy, September 5, 1980, transcript, 20, Idaho County Historical Society, Grangeville, ID.

94. Shepp, [Diary], 1910-1911, September 30, 1911. "Ground cherries" or "strawberry toma-toes" (*Physalis* sp.), have an edible orange fruit in a papery husk.

95. Ibid., October 3, 1911. Pete Klinkhammer recalled that "McKay was an old river rat. That was ... the only time Peter ever saw him. McKay would build a wooden scow at Salmon, load it with what little he needed—probably a pair of overalls and a couple sacks of flour, a few beans. Then he'd placer his way down river, living mainly off the land as he went. If winter and ice befell during the year's trip, he'd simply fix a little dugout and hole up 'til the river broke. He worked along that way to Lewiston where he'd sell his boat, trade in his fine [*sic*, for fines, i.e., gold] and head for Salmon where he'd start again. He tried other rivers but the Salmon remained his first love ...," Klinkhammer, "Year Book 1954 [1958]," April 10-13, 1954 [1958]; Carrey and Conley, *River of No Return*, 5-10.

96. Shepp, [Diary], 1910-1911, October 5, 9, 13, 17-18, 1911.

97. Ibid., October 19, 1911. Andy Henry is otherwise unknown and Mascam is unknown.

98. Ibid., October 20-23, 29, 31, 1911.

99. Ibid., November 4, 6-7, 12, 16, 19, 25, 27, 1911.

100. Ibid., December 9-10, 17-18, 25, 1911.

101. Charles Shepp, [Diary], January 1, 1912, through October 31, 1913, photocopy, University of Idaho Library Special Collections, MG 155, January 2, 4, 7, 1912. If Queen is an onion variety, nothing more was learned about it.

102. Ibid., January 7, 8, 21, 1912.

103. Ibid., January 12-13, 15-16, 18-21, 1912.

104. Ibid., January 26, 1912.

105. Ibid., February 2, 4, 14, 17-18, 22, 1912.

106. Ibid., March 3, 9-10, 14, 17-18, 20, 23, 25-27, 29, 31, 1912.

107. A scion is part of a plant that is grafted onto another plant in order to propagate the original plant; "... scions are all as identical as identical twins," Marta McDowell, *The World of Laura Ingalls Wilder: The Frontier Landscapes That Inspired the Little House Books*, (Portland, OR: Timber Press, 2017), 233. Author Wegars's mother, born in 1909, learned grafting from her father. Growing up, Wegars enjoyed several different varieties of apples from the same apple tree, as well as different kinds of pears growing on just one pear tree.

108. Shepp, [Diary], 1912-1913, April 1-3, 1912. At the end of the month, Shepp noted that his chickens had produced 1,157 eggs from January 1 to May 1, ibid., April 30, 1912.

109. Ibid., April 5, 7, 9, 11, 13, 15, 16-18, 21-23, 1912.

110. Ibid., April 12, 23, 26, 28-29, 1912.

111. Ibid., May 1, 4-5, 7, 9, 12, 15, 1912. Winningstadt cabbage, a pointed-head variety, was traditionally used for sauerkraut. Wakefield, probably Early Jersey Wakefield, is, as its name implies, a type of cabbage that matures early.

112. Ibid., May 24, 26, 28, 30, 1912.

113. Ibid., June 14, 22, 25, 30, 1912. Wagner is unknown.

114. Ibid., June 4, 1912. Ed's last name is unknown.

115. Ibid., June 4, July 1-4, 1912. Coulter is unknown.

116. Ibid., July 5, 8-9, 1912.

117. The town of Jumbo "grew up around the Jumbo Mine in 1898," Boone, *Idaho Place Names*, 203; it had a post office from 1912 to 1913.

118. Shepp, [Diary], 1912-1913, July 11, 13-15, 17-20, 1912. "Blake" was perhaps Lew Blake, who had mining interests in the Warren area from at least 1897 to at least 1919, Helmers, *Warren Times*, February 12, 1897; January 31, 1919, or possibly Dr. Blake, a "physician who was interested in mining properties in the [Warren Mining] District," ibid., July 14, 1904.

119. Shepp, [Diary], 1912-1913, July 22, 24, 26-28, 1912. In later years, Pete Klinkhammer recalled the "crazy Swede," although he thought the event occurred a year earlier than it did. When he "accompanied the Gus Schultz family out," the party "passed a Swede who had come from Orogrande over the Hump trail. The fellow had a tiny pack sack, no gun, and only one shoe—the other foot being encased in a gunny sack. He had traveled over a foot of snow on the way through the Hump country. He tried to by-pass the ranch by cutting round it on [the] Jersey [Mountain] side. But Charlie Shepp saw him from the garden and cut up the hill to intercept him. Shepp offered breakfast and a hospitable rest at the ranch. 'Naw, I tank I be on my way.' 'Where to, man?' Well, he wanted to get to Long Valley between Boise and McCall. 'Oh hell,' Charlie said. 'Come on down to the ranch and I'll take you across the river in the boat.' 'Naw,' the Swede would make it on his own. Charlie inquired how he thought he'd get across the river. Swede replied he'd just keep on 'til he got to a bridge. 'Hell,' said Charlie, 'there isn't any bridge 'til you get clear to Salmon.' 'Then,' said the Swede, 'I'll schwim!' Shepp finally talked him into the concession of riding across the river. When they landed on the other side and started for Polly's they passed some wild 'timble' [thimble] berries. The Swede reached out and stripped a branch and

tossed the berries in his mouth. A real survivalist, that one. 'Polly gave him breakfast and I t[h]ink Bemis gave him an old pair of shoes,'" Klinkhammer, "Year Book 1954 [1958]," March 6-13, 1954 [1958]. Thimbleberries, *Rubus parviflorus*, are edible, thimble-shaped, red berries similar in appearance to raspberries.

120. Shepp, [Diary], 1912-1913, August 1-4, 6, 8-13, 1912.

121. Ibid., August 15-16, 1912.

122. Discover Underground: Bottle Digging, "H.H.H. Horse Medicine," available at http://www.discoverunderground.com/discoveries/hhh-horse-medicine/ (accessed February 18, 2019). One advertisement for it read, "'It quickly removes Wind Galls, Spavins, Calions [unknown], Lumps, Sweeny [Sweeney shoulder], and all blemishes of the horse, while the family finds it indespensible [*sic*] for Sprains, Bruises, Aches, Pains, and wherever a good liniment is required.' As the ad suggests, the medicine was not strictly for horses and was often advertised as an external liniment for man," ibid. Sweeney shoulder is the atrophy of shoulder muscles.

123. Shepp, [Diary], 1912-1913, August 17, 20, 22, 25, 1912. "Alex McDonnald" was surely Alexander McDonald, a Warren resident who was elected a county commissioner in October 1868 and reappointed in April 1873, and who read the Declaration of Independence in a "clear melodious tone" at the 1872 Fourth of July celebration, Helmers, *Warren Times*, October 25, 1868; July 20, 1872; April 19, 1873.

124. Shepp, [Diary], 1912-1913, August 25, 1912.

125. Ibid., August 27, 31, 1912.

126. Ibid., September 1-5, 1912.

127. Ibid., October 2, 5-6, 10-11, 13, 1912.

128. Ibid., October 11-14, 1912.

129. Ibid., October 14, 17-19, 21, 24, 26-27, 1912. Billie was likely named for their friend, Billie Allen.

130. Ibid., November 1, 3-7, 10, 1912.

131. Ibid., November 15, 1912. Bismarck apples are best for cooking.

132. Ibid., November 17-18, 1912. To "gum a saw" means to enlarge the spaces [gullets] between a saw's teeth.

133. Ibid., November 21-22, 27, 1912. The wording in the diary suggests that the letter was to Shepp, rather than to Charlie Bemis.

134. Ibid., November 28, 1912.

135. Ibid., December 14, 25, 31, 1912.

136. Ibid., January 2, 12-13, 21, 29, 1913.

137. Ibid., February 1, 5, 7-8, 10, 12, 18, 22-23, 1913. The Idaho County Courthouse could not find a copy of Bemis's will; many thanks to Nikki Sickels for her efforts in trying to locate it.

138. Ibid., February 24-25, 27, 1913.

139. Ibid., March 1-2, 8-12, 14-15, 19-20, 23, 25-27, 29-30, 1913.

140. Ibid., April 3, 6, 9, 1913. "Blue stone" [copper sulfate, CuSO4] is an antiseptic, antifungal agent used for treating humans, animals, and plants, Disabled World, "Copper Sulfate (Bluestone): Uses and Remedies," available at https://www.disabled-world.com/medical/alternative/homeremedies/bluestone.php (accessed January 31, 2018).

141. Shepp, [Diary], 1912-1913, April 11, 13, 1913. "Otterson" was probably George Otterson. In September 1919 he "lost his ranch improvements and belongings … in the big Nez Perce fires" that also threatened Warren, Helmers, *Warren Times*, September 5, 1919. "Young Shafer" was probably Fred Shiefer, who would have been about 15 in 1913. Although Fred had a brother, George, who was three years older, the boys' father had died in 1905, ibid., April 5, 1905, therefore, by 1913, George probably was known as "Shiefer," and Fred as "young Shiefer."

142. Shepp, [Diary], 1912-1913, April 17, 19, 26, 1913.

143. Ibid., May 19, 1913.

144. Ibid., May 1, 6, 8, 11, 14, 18-19, 1913.

145. Ibid., April 26, 1913.

146. Ibid., May 19, 1913.

147. Ibid., May 19-20, 1913. Jordan was probably Frank Jordan, also spelled Jordon, who by 1910 had a place on the Salmon River, upriver from Orson James's place, Helmers, *Warren Times*, July 7, 1910; September 20, 1918.

148. Shepp, [Diary], 1912-1913, May 23, 27-28, 1913.

149. Ibid., June 15, 24, 29, 1913.

150. Ibid., July 3-8, 12-18, 23, 26, 27, 1913.

151. Ibid., July 31 and August 1, 1913. Boston Brown later helped with construction of the Forest Service's road from Warren to Hayes Station. He also placer mined on War Eagle Mountain with the assistance of Warren Chinese pioneer Lee Dick, Helmers, *Warren Times*, January 25 and July 26, 1918 and April 11, 1919.

152. Shepp, [Diary], 1912-1913, August 1, 4, 9-11, 17, 19, 21, 24, 26-28, 1913.

153. Ibid., September, 1, 3, 6-7, 11, 1913.

154. Ibid., September, 12, 14, 16, 18, 21, 23-24, 26, 1913.

155. Ibid., September, 28, 30, 1913.

156. Government Land Office, plat of T24N R73, published 1914. The surveyors were Albert Smith, Jr., and Ray D. Armstrong. I am grateful to Gayle Dixon for providing this document. According to Dixon, in an undated note, the trail down Warren Creek ends "where Robert Keathon would have lived." Keathon, who died in 1902, "had a ranch down Warren [C]reek on the main Salmon which he had occupied for years and made a livelihood packing vegetables and fruit into Warren," Helmers, *Warren Times*, July 31, 1902. When Polly was in Boise in 1924, she hoped to visit "Bob No. 2," a Chinese man then living in Boise who had formerly worked for Keathon (Chapter Seven, August 1924).

157. M. Alfreda Elsensohn, *Pioneer Days in Idaho County*, vol. 1 (Caldwell, ID, Caxton, 1947, reprinted 1965), 216.

158. Shepp, [Diary], 1912-1913, October 1, 2, 5, 6, 8, 9, 15, 1913.

159. Charles Shepp, [Diary], November 1, 1913, through March 31, 1915, photocopy, University of Idaho Library Special Collections, MG 155, November 1-5, 8-11, 13, 17-18, 1913. Charlie "Trawl" was probably Charles Troll. He had mining interests in the Warren area in 1903, and died in 1917 aged 65, Helmers, *Warren Times*, April 2, 1903; March 1, 1917.

160. Shepp, [Diary], 1913-1915, November 20, 23, 27, 29-30, 1913.

161. Ibid., December 6-8, 10-11, 16, 21, 24-25, 28, 1913.

162. Ibid., January 12, 14, 18-19, 1914. There are no entries from January 20 through February 7. Kelly is unknown.

163. Ibid., February 10, 13, 15, 18, 22, 1914.

164. Ibid., February 23-24, 26-27, 1914.

165. Ibid., March 3, 8, 11-12, 14, 22-23, 26, 31, 1914.

166. Ibid., April 1, 4-6, 12, 16-19, 25, 28, 1914.

167. Ibid., May 7, 10-11, 18, 22, 26, 31, 1914.

168. Ibid., June 4, 13, 17, 21, 26-28, 1914.

169. Ibid., July 1, 3-4, 7, 9, 15, 19, 23-25, 28-30, 1914. Knighton and Carter are otherwise unknown.

170. Ibid., August 2, 4, 10-13, 1914.

171. Ibid., August 14, 1914. At the end of the 1916-1917 diary is the packing slip from the phonograph's manufacturer, Factory American Graphophone Company of Bridgeport, Conn., dated 6-22-12, Type: Favorite; Serial Number: 700570; Finish: Fume Oak; Inspector,

W. Fellows. The package contained a "reproducer" [the circular part holding the needle], a crank, a needle box, a tone arm, a turntable, and needles, Charles Shepp, [Diary], July 1, 1916, through June 3, 1917, photocopy, University of Idaho Library Special Collections, MG 155, end.

172. Shepp, [Diary], 1913-1915, August 15-16, 1914. The meaning of this is not clear.

173. Klinkhammer, "Year Book 1954 [1958]," March 16-17, 1954 [1958]. Shepp's list of the records he owned, written between July 1914 and June 1917 on pages from an old ledger, includes "Uncle Josh in a Chinese Laundry" (talking) by Cal Stewart, page 158, repeated on page 164. It was a 10 in. record, No. A289, and cost 65 cents. To hear a recording very similar to what Polly heard, visit UCSB Cylinder Audio Archive, "Uncle Josh in a Chinese Laundry," available at http://cylinders.library.ucsb.edu/detail.php?query_type=mms_id&query=990029921820203776&r=4&of=4 (accessed January 22, 2018), and "Uncle Josh in a Chinese Laundry," by Cal Stewart, on YouTube, available at https://www.youtube.com/watch?v=FkkM0Ocdv-c (accessed April 30, 2018). "Shepp & Klink[hammer] acquired many records thru the years—Caruso, all of Sir Harry Lauder's. When the call for records came over [the] radio for the war effort of 1943, Peter gathered up all the records which had found their precious way to isolation and backpacked them out to Dixie postoffice—18 miles uphill," Klinkhammer, "Year Book 1954 [1958]," March 17-19, 1954 [1958].

174. Shepp, [Diary], 1913-1915, August 17, 22-26, 1914. Bigley is otherwise unknown.

175. Ibid., August 28, 30-31, 1914.

176. Ibid., September 1-2, 4-6, 1914. Sidney W. Robbins had a saloon in Warren in 1905 and was Warren's Justice of the Peace from mid-1899 to at least the end of 1910, Helmers, *Warren Times*, June 14, 1899; July 27, 1905; and December 22, 1910.

177. Shepp, [Diary], 1913-1915, September 6-7, 9, 11, 1914.

178. Ibid., September 12, 16, 19, 21, 24-25, 27, 1914.

179. Ibid., September 28-30, 1914. "Blackwell" may have been C. W. Blackwell, who in 1904 and 1905 owned the "12-mile house" at Secesh Meadows, between Warren and Burgdorf, Helmers, *Warren Times*, November 17, 1904, March 23, 1905.

180. Shepp, [Diary], 1913-1915, October 4-8, 10, 14, 1914.

181. Ibid., October 17, 1914. Bayless is unknown.

182. Ibid., October 18, 21, 24-27, 31, 1914.

183. Ibid., November 2, 6-8, 10, 14-16, 18, 21-23, 26, 30, 1914. "Reaves" may be J. P. Reeves of "Oro Grande" [Orogrande], Helmers, *Warren Times*, August 9, 1917.

184. Although the meaning of this phrase is uncertain, it most likely refers to replacing the lining in the back of Polly's stove. The 1902 Sears, Roebuck & Co. catalogue lists "Acme Stove Lining Cement for lining stoves, ranges, etc., and repairing old brick linings. It never sets until it is burned. ... The 6-pound package will make a back. Full directions with each package so that no one can make a mistake," Sears, Roebuck and Co[mpany], *The 1902 Edition of The Sears Roebuck Catalogue,* with an introduction by Cleveland Amory (New York: Bounty Books/Crown, 1969), 582.

185. Shepp, [Diary], 1913-1915, November 2, 6-8, 10, 14-16, 18, 21-23, 26, 1914.

186. Ibid., November 30, 1914.

187. Ibid., December 2, 5, 16-17, 20-21, 25, 29, 1914.

Chapter Six: Life on the Salmon River, 1915 to November 1919

1. Infoplease, "Top News Stories from 1915," available at http://www.infoplease.com/year/1915 (accessed January 22, 2018).

2. Infoplease, "Top News Stories from 1916," available at http://www.infoplease.com/year/1916 (accessed January 22, 2018).

3. Infoplease, "Top News Stories from 1917," available at http://www.infoplease.com/year/1917 (accessed January 22, 2018).

4. Infoplease, "Top News Stories from 1918," available at http://www.infoplease.com/year/1918 (accessed January 22, 2018). Pete Klinkhammer registered for the draft on September 12, 1918, Leland Bibb, e-mail message to author, February 27, 2014.

5. Infoplease, "Top News Stories from 1919," available at http://www.infoplease.com/year/1919 (accessed January 22, 2018).

6. Charles Shepp, [Diary], November 1, 1913, through March 31, 1915, photocopy, University of Idaho Library Special Collections, Manuscript Group (henceforth MG) 155, Shepp, [Diary], January 1, 1915.

7. Ibid., January 2-3, 6-7, 9-10, 17, 20, 22-24, 26, 1915.

8. Ibid., February 4, 7-8, 10-11, 13-14, 16, 19, 1915. Green is likely to be the George Green who died in his Warren cabin on July 3, 1920, aged 73, Cheryl Helmers, *Warren Times: A Collection of News about Warren, Idaho* (Odessa, TX: The Author, 1988), July 15, 1920.

9. Shepp, [Diary], 1913-1915, February 21, 1915. Jensen is unknown.

10. Ibid., February 22-24, 1915.

11. Jim Campbell, 'Manager's Corner,' "June 5, 1987, Polly Bemis Dedication and Memorial," *Salmon River Resort Club* 5:5 (July 1987), [5]. Shiefer recalled the year as 1914 but the Shepp diary confirms that it was 1915.

12. Shepp, [Diary], 1913-1915, February 24, 1915. Elsewhere, Paddy is also spelled Paddie.

13. Ibid., March 1, 5, 8, 11, 16, 24, 26-27, 1915. Jack Howard owned the former Shearer Ranch and Shearer Ferry, on the Salmon River, M. Alfreda Elsensohn, *Pioneer Days in Idaho County*, vol. 2 (Caldwell, ID, Caxton, 1951), 84.

14. Shepp, [Diary], 1913-1915, March 27-29, 31, 1915.

15. Charles Shepp, [Diary], August 1, 1915, through June 30, 1916, photocopy, University of Idaho Library Special Collections, MG 155, August 1, 4, 7-9, 11, 17, 21-22, 24, 25-26, 31, 1915.

16. Ibid., September 1-4, 6-7, 1915.

17. Ibid., September 9-10, 1915. Smith is unknown, but may be the George Smith who "went with Cap [Captain Guleke] quite a few times on expeditions until Smith married, and his wife's fear of the river made him stop," Melanie Scoble, "Capt. Guleke: 'One of the West's Most Colorful Figures,'" *Patchwork: Pieces of Local History* (Salmon, ID: Salmon High School, 1989), 7.

18. Johnny Carrey and Cort Conley, *River of No Return* (Cambridge, ID: Backeddy Books, 1978), 23-24, 48. Guleke "charged a thousand dollars a trip at the turn of the century," ibid., 44. For more on Guleke's life, see ibid., 23-48. Scoble, "Capt. Guleke," 3-12, has additional information, especially on scow construction.

19. Shepp, [Diary], 1915-1916, September 11, 15, 1915. "Young Smeed" was probably one of the sons of "Pony" Smead, the Justice of the Peace who married the Bemises.

20. Ibid., September 15-19, 1915. McCafferty is otherwise unknown.

21. Ibid., September 21-22, 25-27, 1915. Ira McGary, a miner, also did assessment work for others, Helmers, *Warren Times*, May [date uncertain], 1913. In June 1912 McGary went "to Grangeville to enjoy the luxuries of city life for a spell," ibid., June 20, 1912.

22. Shepp, [Diary], 1915-1916, September 29-30, 1915.

23. Ibid., October 1, 1915. Gene Churchill lived with his wife about 25 miles upriver from the Shepp Ranch, at Little Mallard Creek. After a mining accident some years earlier, he had self-amputated his left hand and replaced it with a leather harness and hook. After wrecking his boat on a rock, his friends tried to haul him to shore. The leather harness

broke, and he drowned because he couldn't swim; his body surfaced 25 days later. "He was remembered with affection by the scores of people he fed and lodged without charge," Carrey and Conley, *River of No Return*, 157-158.

24. Shepp, [Diary], 1915-1916, October 2, 6, 8-9, 1915.

25. Ibid., October 12, 14, 17, 19, 21, 23-26, 28, 31, 1915.

26. Ibid., November 1, 1915. Curtis was miner Charles Curtis, Helmers, *Warren Times*, January 25 and July 12, 1918; April 18, 1919. In May 1919 he and two partners had a placer mine on Warren Meadows with "the latest hydraulic equipment," ibid., May 2, 1919. Willie is unknown; perhaps he was Curtis's son.

27. Shepp, [Diary], 1915-1916, November 3, 1915. Russell is unknown.

28. Ibid., November 3-6, 8-9, 1915.

29. Ibid., November 10, 1915.

30. Ibid., November 12, 14, 18, 21, 24-26, 30, 1915.

31. Ibid., December 1, 5-10, 12, 16, 20, 1915.

32. Ibid., December 21, 25-27, 1915.

33. Ibid., January 8-9, 16-17, 26, 30-31, 1916.

34. Ibid., February 1, 9, 12-14, 16-18, 22, 1916.

35. Ibid., March 7, 9, 1916. A match plane was a specialized tool for making tongues and grooves.

36. Ibid., March 10-13, 17, 23, 1916.

37. Ibid., March 25-26, 1916.

38. Ibid., March 29, 1916.

39. Ibid., April 2, 9, 12-13, 17, 21, 23, 26-27, 29-30, 1916.

40. Ibid., May 3, 7-8, 11-12, 1916.

41. Ibid., May 14-15, 18-19, 21-22, 27, 31, 1916.

42. Ibid., June 2, 5, 7, 15, 17, 19, 21-22, 29-30, 1916.

43. Charles Shepp, [Diary], July 1, 1916, through June 3, 1917, photocopy, University of Idaho Library Special Collections, MG 155, July 2, 13-14, 18-19, 26-27, 1916. Brown and Clark are otherwise unknown.

44. Ibid., July 27, 30, 1916.

45. Ibid., August 1-2, 1916. "Taylor" may be James (Jimmy) Taylor. In March 1917 he proved up on his homestead, "better known as the old 'Three Finger' Smith ranch, at the mouth of Elk Creek on the [S]outh Fork of [the] Salmon [River]," Helmers, *Warren Times*, March [?], 1917. "Three-fingered" Smith, Sylvester Smith, "lost the middle fingers off each of his hands" in an unusual accident: "He had his foot on a fence rail, his hands resting on the end of the barrel of his muzzle-loading shotgun. His foot slipped off the fence and hit the hammers of the gun, causing it to fire, and this cost him the loss of his fingers," Elsensohn, *Pioneer Days in Idaho County*, vol. 2, p. 90.

46. Shepp, [Diary], 1916-1917, August 2, 6-9, 12-14, 1916. Sword or Seward is otherwise unknown. Shepp called him a "ranger."

47. Ibid., August 14-15, 1916. Pugh is otherwise unknown.

48. Ibid., August 16-20, 1916. Dr. Johnson is unknown; he was probably a paying passenger on Guleke's trip.

49. Ibid., August 22, 24, 1916.

50. Ibid., September 1-2, 4-7, 9-11, 13-17, 19-20, 24-26, 1916.

51. Ibid., September 28-30, 1916.

52. Ibid., October 1-2, 4, 6, 1916. Andy Henry is otherwise unknown.

53. Ibid., October 8-9, 14, 16, 19-23, 29-30, 1916.

54. Ibid., November 4-7, 9-10, 12, 1916.

55. Ibid., November 21, 1916. In October 1914 Gus Sindt was a constable in Warren, Helmers, *Warren Times*, October 29, 1914, and in early 1918 was a mining man with "many valuable claims," ibid., February 15, 1918.

56. Shepp, [Diary], 1916-1917, November 22-23, 25-26, 28, 30, 1916. Because Shepp wrote that the Bemises had company for dinner on Thursday the 30th, they may have celebrated Thanksgiving that day rather than on the fourth Thursday in November, which that year fell on the 23rd.

57. Ibid., December 7, 22, 24, 1916. Matzke was either Fred or Ed. The brothers had "worked as entertainers in a circus," and in 1916 they settled on the Indian Creek Ranch, up the Salmon River from the Shepp Ranch and on the same side, Carrey and Conley, *River of No Return*, 201. The men may have wished to take a different route home.

58. Shepp, [Diary], 1916-1917, December 25, 28, 1916.

59. Ibid., January 4, 11, 13, 18, 22-23, 25, 1917. Whether Shepp or the Bemises owned Nellie is uncertain. The horses spent time on both sides of the river.

60. Ibid., January 26-28, 30, 1917.

61. Ibid., February 6-7, 12, 16-18, 22, 26-28, 1917.

62. Ibid., March 5, 25, 1917.

63. Ibid., April 8-9, 15, 17-18, 1917. "Painter" was John Painter. A "transplanted New Yorker," he "built the first hunting house-lodge on the river" and began the Painter Mine with Eastern capital, Carrey and Conley, *River of No Return*, 174-176.

64. Shepp, [Diary], 1916-1917, April 18, 1917.

65. Ibid., April 21, 1917. In later years, date uncertain, Bancroft wrote a short manuscript about Polly Bemis, George Jarvis Bancroft, "China Polly—A Reminiscence," [handwritten title], typescript; photocopy in Caroline Bancroft Family Papers, WH1089, Western History Collection, The Denver Public Library. Introduction, Series 1, Bancroft Family, Bancroft, George Jarvis—professional—engineering, inventions, memoirs, Box 2, FF41, circa 1930. A copy of the manuscript is also at The Historical Museum at St. Gertrude, Cottonwood, Idaho. Readers of it should keep in mind that Bancroft wasn't personally acquainted with the Bemises until 1917. His reminiscence was written after Charlie's death in 1922 and before Polly's in 1933. It may be dated as closely as 1923 or 1924 because at the time of writing, Polly was "now living in Elk City" [actually Warren], ibid., 5.

66. Bancroft's client was William H. Day, Jr., of Dubuque, Iowa, [George Jarvis Bancroft], "Central Idaho," typescript, 2, Caroline Bancroft Family Papers, WH1089, Western History Collection, The Denver Public Library, Introduction, Series 1, Bancroft Family, Bancroft, George Jarvis—professional—engineering, inventions, memoirs, Box 2, FF41, n.d. Bancroft refers to Day as Harry Day, [George Jarvis Bancroft], "Pioneering the Salmon," typescript, 1, Caroline Bancroft Family Papers, WH1089, Western History Collection, The Denver Public Library, Introduction, Series 1, Bancroft Family, Bancroft, George Jarvis—professional—engineering, inventions, memoirs, Box 2, FF51, n.d., but after 1936. The War Eagle was "3½ miles north of the [Salmon] River, on Crooked Creek"; the nearest railroad ... was Grangeville, 75 miles. N.W., all pack trail, or 110 miles by way of Oro Grande [Orogrande] and Elk City of which 30 miles was pack trail," ibid.

67. [George Jarvis Bancroft], "The Way to War Eagle," typescript, 1, Caroline Bancroft Family Papers, WH1089, Western History Collection, The Denver Public Library, Introduction, Series 1, Bancroft Family, Bancroft, George Jarvis—professional—engineering, inventions, memoirs, Box 2, FF58, n.d..

68. Ibid. So far as is known, Charlie Bemis was never a judge in Warren so this must have been a courtesy title.

69. Ibid., 2.

70. Shepp, [Diary], 1916-1917, April 23-27, 1917.

71. Photograph catalogue number AF 57, Denver Public Library. During that same trip, in 1917, Bancroft also bought, from a miner, "some unusual gold nuggets which I gave my daughter, Caroline, for a bracelet," [Bancroft], "The Way to War Eagle," 1.

72. Bancroft, "China Polly," 2.

73. M. Alfreda Elsensohn, "Fourth Academy Day at St. Gertrude's, Cottonwood, Renews … Memories of Polly Bemis," *Spokesman-Review*, May 12, 1957, 4. Here the photo of the brooch is credited to Fred Mazzulla of Denver. In M. Alfreda Elsensohn, *Idaho County's Most Romantic Character: Polly Bemis* (Cottonwood, ID: Idaho Corporation of Benedictine Sisters, 1979), 18, the same image is credited to Caroline Bancroft.

74. *Idaho Sunday Statesman*, "Romantic Figure of Warrens' Gold Camp Ill in Grangeville Hospital: Czizek Explodes Myth of Chinese Poker Bride," 70(9):sec. 2, p. 4, September 24, 1933.

75. Shepp, [Diary], 1916-1917, April 27-30, 1917. Mosberg is unknown.

76. Ibid., May 1-3, 1917.

77. Ibid., May 4-5, 1917.

78. Ibid., May 7, 1917.

79. Ibid., May 8-9, 1917.

80. Ibid., May 11-12, 18, 1917.

81. Ibid., May 19, 22-24, 31, 1917.

82. Charles Shepp, [Diary], June 1 through December 31, 1917, photocopy, University of Idaho Library Special Collections, MG 155, June 1, 1917. Unlike most of Shepp's small pocket diaries, this one is written on pages from an old ledger, numbered 156 through 188. Pages 156 and 157 list prices for various goods (produce, ham, vinegar, lard, oatmeal [for "mush"?]) plus freight. Pages 158 through 164 list [page 160], "Records we have July 1914" with prices for some. The record list includes "Uncle Josh in a Chinese Laundry" [talking] by Cal Stewart, page 158, repeated on page 164.

83. *Grangeville Globe*, "High Water Damages," 10(28):[4], June 7, 1917. The Harpster, Stites, and Kooskia, Idaho, bridges were all destroyed.

84. Shepp, [Diary], 1917, June 3-4, 6, 13, 20, 1917.

85. Ibid., July 1, 8-9, 13-15, 1917.

86. Ibid., July 16, 1917.

87. Ibid., July 17, 1917. Wells is unknown.

88. Ibid., July 17-18, 1917.

89. Ibid., July 19-20, 1917.

90. Ibid., July 21, 1917. Wade and Yarhaus are otherwise unknown.

91. Ibid., July 22-23, 1917. The Bemises knew Taylor Smith when they lived in Warren. Smith was just ten years old when they met in 1890, and 14 when the Bemises left Warren to live on the Salmon River.

92. Ibid., July 27, 29, 1917.

93. Ibid., August 2, 5, 1917. Claud Flint and his "pard," probably a mining partner, are unknown. William R. Flint was a miner in the Warren area, Helmer, *Warren Times*, June 14, 1918; perhaps Claud was his nickname.

94. Shepp, [Diary], 1917, August 6, 1917.

95. Ibid., August 7, 1917.

96. Ibid., August 16-20, 1917. These photos haven't been located.

97. Ibid., August 24-26, 30, 1917.

98. Ibid., September 5, 9-10, 12-14, 16, 1917.

99. Many thanks to Heidi Barth, great-niece of Peter Klinkhammer, for permission to reprint the receipt. Although the clerk abbreviated his first name as "Wilbr," it is clearly "Wilber" on a Klinkhammer and Shepp receipt, with the identical date, also owned by Heidi Barth.

100. Many thanks to Terry Abraham and Heidi Barth for assistance in deciphering the receipt.

101. This entry looks like it might have been for a butt of tobacco, but a listing in the 1922 Montgomery Ward catalogue shows that a butt of chewing tobacco contained six plugs, for a cost of $3.59, Hal L. Cohen, ed., 1922 *Montgomery Ward Catalogue: Reprinted in Its Original Form*, (n.p.: H. C. Publishers, 1969), 398. McIlhenny's hot Tabasco sauce and milder Tabasco brand pepper sauce are both listed in a 1918 grocery catalogue. The first product cost 33 cents for a two-ounce bottle and the second item cost 10 cents for a four-ounce bottle, Montgomery Ward & Co., *Pure Food Groceries May June 1918: Price List No. 571* (Chicago, IL: Montgomery Ward & Co., 1918), 25. In explaining the price differential between the receipt and the catalogue, the same product may have cost more at the Grangeville store, or the uncapitalized "tabasco" of the receipt could have been used as a generic term for a lower-priced hot sauce.

102. If this item were shoes or horseshoes, it would have been more expensive than three cents. Its price suggests shoelaces because these were available seven years later, in 1922, for just six cents for one pair, or just over three cents per pair if purchased in bulk, Cohen, ed., *1922 Montgomery Ward Catalogue*, 313.

103. This item is unknown. Perhaps it is a repeat order of unspecified items.

104. Peaberry coffee is a type of coffee bean, not a brand name. Normally, coffee beans grow in pairs, with one flat side. About five percent of the time, only one bean is formed, with rounded sides. Some people believe that coffee made with peaberry beans tastes sweeter and is more flavorful, Serious Eats/Coffee/Serious Coffee, "What Makes Peaberry Coffee So Special?," available at http://drinks.seriouseats.com/2011/01/wont-you-be-my-peaberry-what-are-peaberry-coffee-beans.html (accessed September 10, 2018).

105. This isn't powdered milk; Carnation didn't sell it until after World War II, Encyclopedia .com, "Carnation Company," available at https://www.encyclopedia.com/books/politics-and-business-magazines/carnation-company (accessed September 10, 2018). Carnation milk was named about 1899 for a brand of cigars with the same name, ibid.

106. Heidi Barth, great-niece of Pete Klinkhammer, kindly provided a scan of the order and permission to use it as an illustration.

107. I am grateful to Heidi Barth for providing a copy of the receipt and clarifying its date.

108. Again, this item is unknown. Perhaps it is a repeat order of unspecified items.

109. Shepp, [Diary], 1917, September 16, 18-21, 30, 1917.

110. Ibid., October 2-6, 8-9, 14-16, 1917.

111. Ibid., October 17-18, 21, 23-27, 30, 1917.

112. Ibid., November 3-5, 1917.

113. Ibid., November 8, 1917. Joe is unknown.

114. Ibid., November 11-12, 1917. Patterson is otherwise unknown. Because he was "from Salmon," he probably wasn't Elmer or George Patterson from Warren.

115. Ibid., November 13, 17-18, 20, 23, 1917. Mountain sheep still live in the Salmon River Canyon.

116. Ibid., November 21, 1917. Sheepnose apples are an heirloom variety that look a bit like a sheep's nose.

117. Ibid., November 22-23, 26, 1917.

118. Ibid., December 3, 5-6, 14-15, 18, 1917.

119. Ibid., December 21, 28-29, 1917.

120. Ibid., December 1, 7, 10, 12-14, 17, 22, 25, 1917. Shepp had received 13 tobacco plants from Bemis in October, ibid., October 6, 1917. In later years, a wooden cigarette-rolling apparatus was found at the Shepp Ranch. Besides rolling cigarettes, the residents would also have chewed tobacco, Cort Conley, personal communication to author, March 2018.

121. Shepp, [Diary], 1917, December 20-21, 1917.

122. Ibid., December 24-25, 1917.

123. Charles Shepp, [Diary], January 1, 1918, through June 30, 1919, photocopy, University of Idaho Library Special Collections. MG 155, January 1-4, 8, 18, 25, 1918. In later years, numerous shoe lasts were found at the Shepp Ranch, Cort Conley, personal communication to author, March 2018.

124. Shepp, [Diary], 1918-1919, February 2-3, 5, 8-9, 13-16, 23, 29-31, 1918.

125. Ibid., March 1, 5, 13-16, 20-21, 23, 27-31, 1918.

126. Ibid., April 3-4, 21, 1918. Guleke obtained supplies from Salmon's City Meat market, local dry goods stores, and Wright's flour mill, Scoble, "Capt. Guleke," 8.

127. Shepp, [Diary], 1918-1919, April 5, 17, 23, 28, 1918.

128. Ibid., May 11, 13-14, 22, 27-28, 1918.

129. Carrey and Conley, *River of No Return*, 160, 163.

130. Shepp, [Diary], 1918-1919, June 4-10, 14-22, 25, 1918.

131. Ibid., July 2-4, 1918. Kline is unknown, but he is probably the Bob Kline who visited again in November to get his horse, ibid., November 18-19, 1918.

132. Ibid., July 5-6, 1918. Harry Cone was in the Salmon River country as early as the spring of 1889, Elsensohn, *Pioneer Days*, vol. 2, p. 68. He was "a member of the Third Idaho Regiment during Territorial days," Helmers, *Warren Times*, April 12, 1918, and later had a lode mine three miles from Warren, ibid., July 19, 1918. Lytler is unknown.

133. Shepp, [Diary], 1918-1919, July 11-16, 18-19, 24-25, 29, 31, 1918. Shepp's birthdate was July 19, 1860. On the 25th he did some more distilling.

134. Ibid., August 4-6, 22, 1918. The "Salmon Kid" is unknown.

135. Ibid., August 6-9, 1918. Paul Seifert is otherwise unknown. On the 8th, Shepp did some more distilling.

136. Ibid., August 10, 14, 16-20, 1918.

137. Ibid., August 26-30, 1918.

138. Ibid., September 1-3, 5-8, 11-12, 1918. Tollgate, on the Milner Trail to the Florence mines, was where travelers paid a dollar apiece for each saddle or pack animal using the trail, Elsensohn, *Pioneer Days*, vol. 2, p. 433. Dr. Green is probably Dr. G. A. Green, Helmers, *Warren Times*, August 9, 1917.

139. Shepp, [Diary], 1918-1919, September 14-15, 1918. Bert Wolf is otherwise unknown.

140. Ibid., September 22, 1918.

141. Ibid., September 16, 19-21, 24, 28, 30, 1918.

142. Ibid., October 5, 7, 1918. Jack Stone is otherwise unknown. On the 3rd, Shepp prepared for more distilling by making a mash of rye, corn, and malted barley, ibid., October 3, 1918.

143. Ibid., October 10-12, 21-23, 27-28, 1918. There are no entries in the diary from October 13 through 20.

144. Ibid., October 29-30, 1918.

145. Ibid., November 3-4, 6, 8, 18-19, 28, 1918.

146. Ibid., December 6-7, 19, 21, 25, 1918. However, Guleke had left his boat at James's place. Therefore, any "machine" that he might have brought the Bemises would have had to be capable of being disassembled, or small enough and light enough to be packed by the two men, if they hiked, or carried on a pack animal, which isn't mentioned.

147. Ibid., November 30, December 1-6, 9, 18, 27-28, 1918.

148. Ibid., January 2-3, 11-14, 1919. Jack Cameron is otherwise unknown.

149. Ibid., January 24-27, 29-31, 1919. Julius Hicks is otherwise unknown.

150. Ibid., February 5, 13, 16-19, 22, 26, 28, 1919. McMeekin may have been Neal McMeekin, who lived on the Wind River (earlier, Meadow Creek), or perhaps his brother, Sam, although no wife is mentioned for either man, Carrey and Conley, *River of No Return*, 235-236.

151. Shepp, [Diary], 1918-1919, March 20-23, 27, 30, 1919.
152. Ibid., April 7, 1919. McGregor is unknown.
153. Ibid., April 10, 1919.
154. The previous line read, "Blackwell down from camp," meaning one of the mines above the Salmon River on Shepp's side. Blackwell may have heard via telephone, or Shepp heard by telephone, ibid., April 13, 1919.
155. Ibid., April 14, 16-19, 25, 1919.
156. Ibid., April 19, 21, 23-25, 29, 1919.
157. Ibid., May 3, 10, 18, 1919.
158. Ibid., May 7, 9, 17, 1919.
159. Ibid., June 2, 1919. Hollewirth [or Hollenworth], first name unknown, is probably the same person as Captain Hollewirth, who made a similar trip with Guleke the previous year, ibid., May 13, 1918.
160. Ibid., June 2-4, 6, 8, 11-12, 1919.
161. Ibid., June 16-17, 19-21, 1919.
162. *Idaho County Free Press*, "Central Idaho Scenes Filmed for Movies," 34(6):1, June 26, 1919.
163. Shepp, [Diary], 1918-1919, June 22, 27, 29, 1919.
164. Charles Shepp, [Diary], July 1, 1919, through November 1, 1921, photocopy, University of Idaho Library Special Collections, MG 155, July 4, 7-8, 14-15, 17, 20-23, 1919. Elizabeth (Bessie) Becker married Jay A. Czizek some time between 1920 and 1924; he was previously married to Mamie Dowd in 1900 but whether she died or they divorced isn't known, Helmers, *Warren Times*, June 8, 1900. Czizek was Idaho's first inspector of mines (1898), "Access Genealogy: A Free Genealogy Resource," http://www.accessgenealogy.com/idaho/biography-of-jay-a-czizek.htm (accessed September 10, 2018). More information on Ethel Roden is available in Helmers, *Warren Times*, index.
165. Shepp, [Diary], 1919-1921, July 25-31, August 1-2, 4, 1919. Three surveyors arrived at Shepp's on the 28th and surveyed his property over the next week; they enjoyed fishing when they weren't working, ibid., July 28-31, August 1-2, 4, 1919. The men paid Shepp $26 when they left, presumably for food and lodging.
166. Ibid., August 4-8, 10-13, 1919. The Grangeville newspaper published a lengthy description of the hunting and fishing party's adventures, including the names of all the participants, most of whom were from Idaho Falls, *Idaho County Free Press*, "Thrill after Thrill on Voyage in Boat down Salmon River," 34(14):1, August 21, 1919. The group left Salmon on August 5. Besides Guleke and Anderson, participants were Dr. H. H. Scarbrough, optician; Dr. J. J. Bybee, dentist; J. M. Adams, US internal revenue collector; B. W. Gillespie, hardware dealer; A. W. Quilliam, broker, John Beachy, shoe dealer; and Charles Dodge, cook.
167. Shepp, [Diary], 1919-1921, August 14, 1919. Porter is unknown.
168. Ibid., August 15, 1919.
169. Ibid., August 16-18, 20-25, 27, 30, 1919. In mid-September Shepp submitted a bill for $192.60 to the Forest Service in Grangeville, for supplying the fire crews, ibid., September 17, 1919.
170. Ibid., September 1-4, 1919.
171. Ibid., September 6, 1919. William and George Shoup were two sons of George L. Shoup (1836-1904), governor of Idaho (1889-1890) and US senator (1890-1901). Hanson, Campbell, and Bates are unknown.
172. *Idaho County Free Press*, "Unique Mountain Folk are Met in 200-Mile Voyage on Salmon River," 35(19):1, September 25, 1919. The story continues, with some errors, "... Bemis went to Warren mining camp in 1866, during the early day excitement. Four years later [*sic*, it was 1890] he was shot in a card game, and when the doctor gave him up Polly nursed him back to life. He then legally married her [in 1894]. She has lived in this country for fifty years" [47 years].

173. Fern Coble Trull, "The History of the Chinese in Idaho from 1864 to 1910" (master's thesis, University of Oregon, Eugene, 1946), 103-104. Additional supplies came from "A & F" in Grangeville, a mercantile firm founded in 1879 by Joseph Alexander and Aaron Freidenrich, Everett A. Sandburg, "Partnership Born in Gold Rush" *The Pacific Northwesterner,* 22(2):17-32 (Spring 1978), 17. A & F supplied many of the people who lived in Idaho County's most remote areas. Previously, Freidenrich had had a store in Warren from about 1873 to 1879, Sandburg, "Partnership," 22-24. The actual number of miles from Warren to the Bemis Ranch comes from Charlie Bemis's placer location in 1909 when he states that his mining claim is "about 18 miles north of Warren, Idaho County, Mining Claims, "Record of Mining Claims, Placer, Book 46" [1906-1911] (Idaho County Courthouse, Auditor-Recorder, Grangeville, ID), 504.

174. Trull, "History of the Chinese in Idaho," 104.

175. Shepp, [Diary], 1919-1921, September 7-11, 1919.

176. Ibid., September 12-14, 1919. Sayer was from the South Fork of the Salmon River, ibid., September 13, 1919, but is otherwise unknown.

177. Ibid., September 15-18, 21-22, 25-26, 1919.

178. Ibid., September 28-30, 1919.

179. Ibid., October 2-5, 7, 11-12, 16, 21, 26, 1919. Shepp's writing is slurred for part of the entry on the 3rd, and Pete may have been hung over on the 4th.

180. Ibid., November 5-6, 13-14, 21, 1919.

181. Ibid., November 10, 16, 19-20, 23, 26, 1919.

182. Marybelle Filer, "Historic Shepp Ranch Now Hunters' and Fishermen's Mecca," *Idaho County Free Press*, 80th Anniversary Edition, 79(49):sec. [8], p. 5, June 16, 1966.

183. Eleanor Gizycka, "Diary on the Salmon River," part 2, *Field and Stream* 28:6 (June 1923), 278.

Chapter Seven: On the Salmon River and in Warren, November 1919 to October 1924

1. Infoplease, "Top News Stories from 1920," available at http://www.infoplease.com/ year/1920 (accessed February 13, 2018), and Shmoop.com, "The 1920s Timeline," https:// www.shmoop.com/1920s/timeline (accessed February 13, 2018).

2. Macrohistory and World Timeline, "1921," available at http://www.fsmitha.com/time/1921 (accessed February 13, 2018).

3. Infoplease, "Top News Stories from 1921," available at https://www.infoplease.com/year/1921 (accessed February 14, 2018).

4. Infoplease, "Top News Stories from 1922," available at http://www.infoplease.com/year/1922 (accessed January 6, 2016).

5. Infoplease, "Top News Stories from 1923," available at http://www.infoplease.com/year/1923 (accessed January 6, 2016).

6. Infoplease, "Top News Stories from 1924," available at http://www.infoplease.com/year/1924 (accessed February 14, 2018). Stalin remained in power until 1953, 20 years after Polly's death.

7. Charles Shepp, [Diary], November 1, 1921, through December 31, 1923, photocopy, University of Idaho Library Special Collections, Manuscript Group [henceforth MG] 155, August 5, 1923. This diary is written in a notebook that folds over at the top. The top and bottom entries are often too pale to be readable.

8. *Payette Lake Star*, "Warren Notes," 'Lee Dick …,' 2(45)1, November 7, 1919. Lee Dick shouldn't be confused with Goon Dick, another Warren-area miner. Herb McDowell, who moved to Warren in 1923, age nearly eight, seems to "remember" Lee Dick, the Chinese doctor who left Warren for good in 1919, Herb McDowell, "From Our Past—Late 1800s

—Idaho Mining," 'Town Brings Memories for Ex-resident,' *Lewiston Morning Tribune*, May 17, 1987, E1. However, McDowell apparently obtained his information about earlier days in Warren from Otis Morris (1885-1972) when he interviewed Morris nearly 25 years earlier, Otis Morris, interview by Herb McDowell, tape recording, 1963, tape and partial transcript at Asian American Comparative Collection, University of Idaho, Moscow, and at University of Idaho Library Special Collections, Moscow. Lee Dick is rumored to have helped Charlie Bemis after he was shot in 1890, but Dick probably wasn't in Warren until 1901 (Chapter Two).

9. Bob "Highland" [Hilands in the 1920 census] was a placer miner near Riggins and later the owner of Campbell's Ferry Ranch, Johnny Carrey and Cort Conley, *River of No Return* (Cambridge, ID: Backeddy Books, 1978), 160, 163. Boyce is William (Bill or Billy) Boyce who discovered the War Eagle Mine in 1898, ibid., 214. In later years he lived with Gertrude Maxwell's parents in Elk City and told Gertrude stories about Charlie Bemis, Gertrude Maxwell, interview by Patrick J. McCarthy, September 5, 1980, transcript, Idaho County Historical Society, Grangeville, ID, and Idaho State Historical Society, Boise, OH449, 20. Boyce died about 1936 or 1937, ibid.

10. Charles Shepp, [Diary], July 1, 1919, through November 1, 1921, photocopy, University of Idaho Library Special Collections, MG 155, November 17, 27, 1919. On the 22nd, Shepp shaved his "mustash" off, ibid., November 22, 1919.

11. Ibid., December 12-16, 19, 22-23, 25, 28, 1919.

12. Ibid., December 30, 1919, and January 2, 5-6, 8, 10-11, 13, 21, 23, 28-30, 1920.

13. Ibid., February 1, 1920. The "rubbers" aren't likely to have been the rubber rings used for canning jars; if they were, he would have gotten them from Polly rather than from Charlie.

14. Ibid., February 5, 14, 16, 1920.

15. Ibid., February 27, 1920.

16. Ibid., March 4, 6, 13, 1920. "Bill Allen owned small store & postoffice @ Cal[l]end[e]r," Peter Klinkhammer, "Year Book 1954 [1958]," notes on 1910-1911 diary," [as told to Marybelle Filer], written in diary dated 1954; first entry changed to 1958, photocopy, University of Idaho Library Special Collections, MG 155, January 1, 1954 [1958]. IWW stands for Industrial Workers of the World, also known as Wobblies. This union formed in 1905 in opposition to the American Federation of Labor.

17. Shepp, [Diary], 1919-1921, March 26, 29, 1920.

18. US Census, *Fourteenth Census of the United States: 1920—Population*, Family Search, "United States Census, 1920," Idaho, Idaho County, Warren Precinct, Enumeration District 105, Sheet 1B, available at https://www.familysearch.org/ark:/61903/3:1:33SQ-GR6W-9TJ?i=1&cc=1488411 (accessed May 16, 2019).

19. US Census, *Fourteenth Census of the United States: 1920—Population*, Family Search, "United States Census, 1920," Idaho, Idaho County, Concord Precinct, Enumeration District 88, Sheet 1B, available at https://www.familysearch.org/ark:/61903/3:1:33S7-9R67-TVP?cc=1488411 (accessed May 16, 2019).

20. Shepp, [Diary], 1919-1921, April 2, 4, 6-8, 10, 13, 1920. John Becker was the owner of the Buck placer mine on Houston Creek in the Warren Mining District, Cheryl Helmers, *Warren Times: A Collection of News about Warren, Idaho* (Odessa, TX: The Author, 1988), April 11, 1919, and March 22, 1934. Mosberg is unknown.

21. Shepp, [Diary], 1919-1921, April 14, 21, 23-24. The Matzke brothers, Ed and Fred, lived on the Indian Creek Ranch, up the Salmon River from the Shepp Ranch, Carrey and Conley, *River of No Return*, 201.

22. Shepp, [Diary], 1919-1921, April 26-28, 1920.

23. Ibid., May 6-7, 9, 13, 16, 18, 25, 1920.

24. Ibid., June 13-14, 24-29, 1920. For the Cluthe Truss Company, maker of the Cluthe Automatic Massaging Truss, see Project Gutenberg, "Cluthe's Advice to the Ruptured," by

Chas. Cluthe and Sons (1912), available at http://www.gutenberg.org/files/19933/19933-h/19933-h.htm (accessed April 30, 2018).

25. Shepp, [Diary], 1919-1921, July 1-3, 5, 7, 1920. George Green died in his Warren cabin on July 3, 1920, aged 73, Helmers, *Warren Times*, July 15, 1920.

26. Ibid., July 9, 16, 19, 21-22, 29, 1920.

27. Ibid., August 2, 5-8, 10-11, 15, 19, 23, 27, 1920.

28. Ibid., August 28-29, 1920. At that time, W. R. Thurston was the manager of the Salt Lake City branch of the Mine & Smelter Supply Co., "Personal," *Mining and Scientific Press*, 123:3 (July 16, 1921), 104, col. 2.

29. Lee Charles Miller, "The Boat That Never Comes Back." *Outing* 79:6 (March 1922): 256-260, 287.

30. Ibid., 256.

31. Shepp, [Diary], 1919-1921, August 28-29, 1920, and Miller, "Boat That Never Comes Back," 256. Although the name "Harty" sounds masculine, she was the third woman of the three whom Shepp mentioned; Miller refers to Harty as "her," Miller, "Boat That Never Comes Back," 258, 259. From other evidence, Henry and Harty were New Yorkers Henry Jairus Munger (1883-1950) and his wife, Harty Millington Munger (1884-1968), "Trophies of Canadian Interior," *Salt Lake Tribune*, February 25, 1929, 18; My Heritage, "Henry Munger," available at https://www.myheritage.com/names/henry_munger (accessed February 20, 2018); and Find A Grave, "Harty Millington Munger," available at https://www.findagrave.com/memorial/68695823/harty-munger (accessed February 20, 2018).

32. In early 1920, Lee Charles Miller and Minnie W. Miller, of Salt Lake City, were "contemplating a trip down the Salmon River in Idaho" because "once a year or oftener the outdoor madness seizes them and they promptly forget home and office and hike for the wildest and most remote parts of the earth's surface," "Who's Who in Outing: Snapshots of Contributors in This Month's Issue," *Outing* 75:4 (January 1920), 194. Miller's articles on their adventures frequently appeared in *Outing*. Minnie Miller has an Idaho connection: she owned the Thousand Springs Ranch near Wendell, Idaho, from 1918 until 1954, where she raised prizewinning Guernsey cows and other livestock. Her ranch is now part of Ritter Island State Park, Thousand Springs, Idaho, The Idaho Heritage Trust, "Ritter Island State Park, Thousand Springs," available at http://idahoheritage.org/assets/popups/sc/sc_ritter.html (accessed October 10, 2018).

33. Miller, "Boat That Never Comes Back," 257.

34. Ibid., 258. Pete Klinkhammer wasn't at the Shepp Ranch when the boating party stopped at Polly's place.

35. Ibid..

36. Ibid., 260.

37. Lee Charles Miller, "Adventures of a Motion Picture Amateur." *Outing* 79:1 (October 1921), 18.

38. Since this city hasn't been mentioned elsewhere as Polly's possible place of origin, it is therefore suspect. Now romanized as Hankou, formerly Han-k'ou, it is located in Hubei province at the confluence of the Han and Yangtze rivers. "It is the largest of the three former cities (the other two being Hanyang and Wuchang) now constituting the Wuhan conurbation," *Encyclopædia Brittannica*, "China—Hankou," available at https://www.britannica.com/place/Hankou (accessed February 19, 2018).

39. Miller, "Adventures of a Motion Picture Amateur," 20.

40. No "tales" seemed to have mentioned Polly being "won in a poker game"; had there been any, Miller would surely have included that sensational information in his story.

41. The passage implies that Polly went out in 1902 (1920 minus 18 years) but nothing is known of that adventure. Perhaps that is when she visited Slate Creek. Charlie Shepp's diaries first mention the Bemises in early November 1902, Charles Shepp [Diary], November 1, 1902, through June 12, 1903, photocopy of typescript transcription, University of Idaho

Library Special Collections, MG 5209, November 8, 1902. If Polly did "go out" that year it would have been before November.

42. Polly's interactions with women were indeed extremely rare, so perhaps she had forgotten that "Mrs. Robinson & 2 kids" visited her for a couple of days in August 1907. In July 1912 Nellie Schultz and her family visited the Bemises off and on over several days.

43. This is a curious observation, considering that Polly crossed the Salmon River by boat many times. Of course, that was a rowboat, in a relatively calm portion of the Salmon River, compared with a powerful sweep boat, battling rapids.

44. Miller, "Adventures of a Motion Picture Amateur," 20, 41, 42. In the early 1960s, Armstead, Montana, was inundated by Hap Hawkins Lake that formed behind the Clark Canyon Dam.

45. Shepp, [Diary], 1919-1921, August 31, 1920. Orson James ran the James Ranch at James Creek, about three miles upstream from the Bemis Ranch and on the same side of the river, Carrey and Conley, *River of No Return*, 203. Warren resident Oscar Waller was later a Justice of the Peace for that community, Helmers, *Warren Times*, November 29, 1928.

46. Shepp, [Diary], 1919-1921, September 1-2, 4-5, 7, 9-10, 1920.

47. Ibid., September 11, 1920. Subtracting 67 from 1920 confirms, again, that Polly was born in 1853.

48. Ibid., September 12-13, 16-17, 19-21, 1920.

49. Ibid., September 21-22, 1920.

50. *Idaho Recorder*, "Salmon Locals," 'Members of the Portland ...,' 35(31):[5], September 10, 1920.

51. Shepp, [Diary], 1919-1921, September 23-28, 30, 1920.

52. Ibid., October 1, 4-6, 10, 14, 17, 1920.

53. Ibid., October 20, 1920. During the nineteenth and early twentieth centuries, the Ben Davis apple was "long hailed as a 'mortgage lifter.'" It "was an apple farmer's dream ... because the trees matured quickly and started to bear heavy crops of market-ready fruit in under ten years," Marta McDowell, *The World of Laura Ingalls Wilder: The Frontier Landscapes That Inspired the Little House Books* (Portland, OR: Timber Press, 2017), 233.

54. Shepp, [Diary], 1919-1921, October 21, 1920.

55. First a miner, John Long at his death was the "chairman of the board of county commissioners and one of the foremost citizens of Idaho [County]," Helmers, *Warren Times*, August 27, 1885; December 14, 1888; April 5, 1889; November 7, 1890; and October 14, 1920.

56. Shepp, [Diary], 1919-1921, October 22-23, 27-29, 31, 1920.

57. Ibid., November 1, 4, 9-10, 12, 14, 23-24, 27, 30, 1920.

58. Ibid.

59. Ibid., January 20, 31, 1921.

60. Ibid., February 1, 3-4, 10, 14, 21, 1921.

61. Ibid., March 2, 15, 23-24, 29-30, 1921.

62. Ibid., April 10, 17-18, 23-25, 1921. John Cunningham, the boatman, lived upriver at Butts Creek. He later boated with Monroe Hancock, particularly on the 1935 National Geographic Society's Salmon River expedition. Hancock's wife described Cunningham as "fit only for a rear sweep, since he could never make up his mind which way to go" around obstacles in the river, Carrey and Conley, *River of No Return*, 49-50, 109. Mooney is unknown.

63. Shepp, [Diary], 1919-1921, April 28, 1921.

64. Ibid., May 1-3, 6, 9, 13, 1921. Three months later, Polly received two dresses from Shepp's sister Nellie, ibid., August 4-5, 1921.

65. Klinkhammer, "Year Book 1954 [1958]," February 11-12, 1954 [1958].

66. Shepp, [Diary], 1919-1921, June 13, 20-23, 29-30, 1921.

67. A photo of Polly, captioned "Angel of the Salmon River," with accompanying, unattributed, text lauding Polly's nursing skills, appears in Charles Kelly, "He Won His Wife in a Poker Game," *The Pony Express* 36:9 (February 1970), 4; see Fig. 9.8, this volume.

68. Shepp, [Diary], 1919-1921, July 1-3, 5-6, 8, 11-13, 15, 1921. Dr. Kenyon is otherwise unknown.

69. Ibid., July 17, 1921. Helmers, *Warren Times*, April 11, 1919, provided Mitchell's first name and noted that he was mining on Rabbit Creek.

70. Shepp, [Diary], 1919-1921, July 19, 1921.

71. Ibid., July 21-22, 1921. Curiously, and incomprehensibly, M. Alfreda Elsensohn wrote, "Captain Guleke took Polly with him as a special guest," M. Alfreda Elsensohn, *Idaho County's Most Romantic Character: Polly Bemis* (Cottonwood, ID: Idaho Corporation of Benedictine Sisters, 1979), 34. Given that Charlie was bedridden, Polly surely wouldn't have just left him. And, how would she return? This statement was later interpreted as, "Captain Guleke took Polly with him as a guest on the remainder of the trip," Melanie Scoble, "Capt. Guleke: 'One of the West's Most Colorful Figures,'" *Patchwork: Pieces of Local History* (Salmon, ID: Salmon High School, 1989), 11. In any case, there is no such entry in Shepp's diary, which would definitely have mentioned Polly's absence. Furthermore, she was afraid of traveling in the sweep boats, Miller, "Adventures of a Motion Picture Amateur," 42.

72. *Idaho Recorder*, "Salmon Locals," 'Countess E. Gyzicka [*sic*] of Chicago ...,' 36(24):5, July 15, 1921.

73. Eleanor Gizycka, "Diary on the Salmon River," part 1, *Field and Stream* 28:1 (May 1923), 18.

74. Carrey and Conley, *River of No Return*, 45, and Cort Conley, e-mail message to author, May 26, 2017. According to Gertrude Maxwell, *My Yesterdays in Elk City* (Grangeville, ID: *Idaho County Free Press*, 1986), 122, Billy Boyce was the man second from the right. However, Boyce was not then in the vicinity. He had been staying at the Shepp Ranch during the first part of July 1921, but left for Dixie on Friday, July 15 and did not return until Sunday, August 14, Shepp, [Diary], 1919-1921, July 15 and August 14, 1921.

75. Eleanor Gizycka, "Diary on the Salmon River," part 2, *Field and Stream* 28:2 (June 1923), 187-188, 276-280.

76. Ibid., part 2, 278.

77. Ibid.

78. Ibid.

79. Shepp, [Diary], 1919-1921, July 22, 25, 27, 30-31, 1921.

80. *Idaho Recorder*, "Salmon Locals," 'W. B. Fowler completed a boat ...,' 36(26):5, July 29, 1921.

81. Shepp, [Diary], 1919-1921, August 13, 1921.

82. Ibid., August 2-3, 5-7, 1921.

83. Ibid., August 4-5, 1921. On August 4, 1899, a newspaper article described Anson S. Holmes as "an experienced and practical miner ... to whom is entrusted the entire direction of the working of the mines" for the French Creek Mining and Improvement Company then operating near Pierce, Idaho, *Lewiston Tribune*, "Flashback," 'French Creek Company,' June 16, 2014, 1D. In August 1923, when Polly Bemis visited Grangeville, she was a guest of Mrs. Anson Holmes, Helmers, *Warren Times*, August 16, 1923. Anson S., age 58, and Jennie L, age 51, lived in Grangeville when the 1920 census was taken, "United States Census, 1920," index and images, FamilySearch, available at https://familysearch.org/pal:/MM9.1.1/MDC5-1MX (accessed April 30, 2018), Anson S. Holmes, Grangeville, Idaho, Idaho, United States; citing sheet 2A, family 33, NARA microfilm publication T625, FHL microfilm 1820292. Jennie Holmes was born in France.

84. Shepp, [Diary], 1919-1921, August 5, 1921.

85. Ibid., August 8, 13-14, 17, 1921. Red Astrakhan was "An early cooking variety presumed to have originated in Russia, and imported her[e] from Sweden by way of England in 1835; it was at one time a very popular apple for home use. Its superior culinary qualities are its claim to fame. When it has ripened properly and aged a bit it is also a brisk, refreshing apple in hand. This variety has fallen a long way in popularity through no fault of its own, a victim of the cultural shift to fast food and processed food," Apple Journal, "Apple Uses," available at http://www.applejournal.com/use008.htm (accessed April 30, 2018), 8.

86. Shepp, [Diary], 1919-1921, August 18-19, 1921.

87. Ibid., August 18, 1921.

88. Jeffrey M. Fee, "Idaho's Chinese Mountain Gardens," in Hidden Heritage: Historical Archaeology of the Overseas Chinese, ed. Priscilla Wegars (Amityville, NY: Baywood, 1993), 69.

89. Johnny Carrey, interview with Priscilla Wegars, Riggins, ID, July 27, 2000, notes in Asian American Comparative Collection, University of Idaho, Moscow. Johnny visited Ah Kan "many times in his house"; this would have been in the fall and winter of 1922 or 1923. In the 1880s Kan owned 150 mules and 100 pack saddles. Kan died in March 1934, Helmers, Warren Times, March 15, 1934.

90. Shepp, [Diary], 1919-1921, August 21-23, 25, 1921. The milk was canned, not fresh, implying that the Bemises no longer owned a cow.

91. Ibid., August 28, 1921.

92. Ibid., September 3, 7, 10-12, 1921.

93. Ibid., September 13, 18, 24-29, 1921.

94. Ibid., October 8-9, 12, 1921. He also wrote his sister Nellie and sent for a box of cigars.

95. Ibid., October 13-15, 17-22, 1921.

96. Ibid., October 22, 1921.

97. Ibid.

98. Ibid., October 29-30, 1921.

99. Ibid., October 28, 31, 1921.

100. Charles Shepp, [Diary], November 1, 1921, through December 31, 1923, photocopy, University of Idaho Library Special Collections, MG 155, November 1, 7, 9, 12, 20-21, 24, 28, 1921. Shepp's cigars arrived on the 4th, ibid., November 4, 1921.

101. Ibid., December 3, 5, 17-19, 24-25, 27, 1921.

102. Ibid., January 2, 9-11, 13, 15, 17, 20, 23-26, 31, 1922.

103. Ibid., February 1, 7, 16-20, 22, 28, 1922.

104. Charles Shepp, [Diary], January 1, 1926, through June 23, 1927, photocopy, University of Idaho Library Special Collections, MG 155, August 24, 1926.

105. Shepp, [Diary], 1921-1923, March 8, 12-13, 15-24, 26, 1922.

106. Ibid., April 13, 17, 22, 24, 1922.

107. Ibid., April 25-28, 30, 1922.

108. Ibid., May 7, 1922. Dyer and Dwin are otherwise unknown. "Nefkin" is also unknown, but is probably Freeman Nethkin, who was a miner on Logan Creek in 1914, Helmers, Warren Times, April 30, 1914.

109. Shepp, [Diary], 1921-1923, May 8, 1922.

110. Ibid., May 11-12, 14-15, 16, 24, 1922.

111. Ibid., June 13, 20, 24-30, 1922.

112. Ibid., July 3-6, 18, 1922.

113. Ibid., July 7, 1922. Beck is unknown.

114. Ibid., July 8-10, 1922.

115. Ibid., July 17-18, 1922.

116. Ibid., July 19, 1922.

117. [Philinda Parry Robinson], "Irene Shepherd Parry: The Salmon River Boat Run—Salmon City to Riggins" [July 1922], [1]. Photocopy of unpublished manuscript, kindly provided to the author by Philinda Parry Robinson, daughter of Irene Shepherd, later Parry, who accompanied her father and the others on the trip. They were W. A. Durst, Theo. Wold, T. F. Wallace, F. C. Van Dusen, and F. J. Mulcahy, "business friends of R. E. Shepherd from Minneapolis." The group left Salmon City on July 8 and reached Riggins on July 21, ibid., [2]. Cort Conley provided Jack's full name, e-mail message to author, July 2, 2017; "Curly" is unknown.

118. F. J. Mulcahy, "[Diary]," July 19, [1922]. One page from a typed transcription of this diary was kindly provided to the author by Philinda Parry Robinson.

119. [Robinson], "Irene Shepherd Parry," [4].

120. Shepp, [Diary], 1921-1923, July 20, 27-29, 1922. Bancroft then ran the War Eagle Mine.

121. Ibid., August 3, 5-6, 8-9, 13, 1922.

122. Ibid., August 16, 1922.

123. Ibid., August 19, 21, 25, 27, 31, 1922.

124. *Idaho Daily Statesman*, "Polly Bemis of Warren's Diggins Sees City's Sights, for First Time," 61(8):2, August 4, 1924; *Idaho County Free Press*, "Polly Bemis Has Big Time on Visit to the State Capital," 40(13):5, August 7, 1924.

125. Shepp, [Diary], 1921-1923, August 30-31, 1922.

126. Ibid., September 4, 11-12, 15, 21, 1922.

127. Ibid., October 2-6, 1922. Julie was a mare; her eponym [the person for whom she was named] is unknown. She may have been jokingly named for Shepp's friend, Julius Hicks, mentioned in Chapter Six.

128. Ibid., October 6-8, 15, 20, 22, 1922.

129. Ibid., October 29, 1922.

130. *Idaho County Free Press*, "Woman of 70 Sees Railway First Time," 39(14):1, August 16, 1923. On page 1, above the masthead, is the teaser headline, "Polly Awakes after Half[-] Century Slumber in Mountains."

131. *Idaho Tri-Weekly Statesman*, "Northern Idaho," 12(107):2, March 30, 1876. Alfred Bemis is buried in the Warren Cemetery.

132. CDC: Centers for Disease Control and Infection, "Tuberculosis (TB)," available at http://www.cdc.gov/tb/topic/basics/exposed.htm (accessed April 30, 2018).

133. M. Alfreda Elsensohn, *Pioneer Days in Idaho County*, vol. 1 (Caxton, 1947); reprint, (Cottonwood, ID: Idaho Corporation of Benedictine Sisters, 1965), 94, citations are to the reprint edition, and M. Alfreda Elsensohn, "Fourth Academy Day at St Gertrude's, Cottonwood, Renews … Memories of Polly Bemis," *Spokesman-Review*, May 12, 1957, 3. There is no evidence that Frank McGrane, Sr., encountered Charlie Bemis at the time when Bemis had a chronic cough. McGrane probably obtained that information from Polly Bemis before her death in November 1933 during a visit to her with his wife when Polly was ill in Grangeville. McGrane related this information to Elsensohn in August 1942, Elsensohn, "Fourth Academy Day," 4.

134. Bowe, Chris, "The Light Myth," *The Adelaide Review*, July 2004, 3.

135. Terry Abraham and Priscilla Wegars, "Respecting the Dead: Chinese Cemeteries and Burial Practices in the Interior Pacific Northwest," in *Chinese American Death Rituals: Respecting the Ancestors*, ed. Sue Fawn Chung and Priscilla Wegars (Lanham, MD: AltaMira/Rowman & Littlefield, 2005), 152.

136. Samuel L. Couch, "Topophilia and Chinese Miners: Place Attachment in North Central Idaho" (Ph.D. dissertation, University of Idaho, Moscow, 1996), 64. "If a south face was impractical, the front of a structure symbolically represented south. The front/south should have an unimpeded view. Conversely, the back/north must be closed off," ibid.

137. Shepp, [Diary], 1921-1923, October 30-31, 1922.

138. Ibid., November 1, 1922.

139. Gayle Dixon, note to author, April 8, 2010, containing two photocopies of the 1917 map, with the notation, "The map is in a Land Classification book at the [Payette National Forest] Supervisor's Office [McCall, Idaho] (BB #14). The notes say that … 75 people lived in Warren at that time," [Payette National Forest], "Land Classification Book," BB #14, ['Map of Warren,'] 1917. The 1917 map doesn't show Bemis Creek, Warren Creek, or any roads. Those were inferred by comparing the 1917 map to modern maps of Warren. Bemis Creek was named for Charlie Bemis (Chapter Ten).

140. Shepp, [Diary], 1921-1923, November 2, 1922.

141. Charles J. Truscott, "U. S. Department of Agriculture, Forest Service, Field Notes of Homestead Entry Survey No. 817, Situated in the Idaho National Forest, Administrative District No. 4, in Section 12, Unsurveyed, Township 24 N., Range 6 E. of the Boise Base and Meridian, State of Idaho, Bemis Ranch, Warren Dist[rict]" (US Department of Agriculture, Forest Service, 1929), 2, 6. I am grateful to Larry Kingsbury for providing a photocopy of this survey.

142. Shepp, [Diary], 1921-1923, November 3-5, 1922.

143. Ibid., November 6, 8, 1922.

144. Ibid., February 15, 1923.

145. Ibid., February 22, 1923.

146. If any of these letters survive, which is doubtful, they haven't been found.

147. Peter Klinkhammer, "Year Book 1954 [1958]," January 10-11, 1954 [1958].

148. Shepp, [Diary], 1921-1923, April 18, 1923.

149. Ibid., April 19-21, 1923.

150. Ibid., April 24, 1923.

151. Ibid., May 9-10, 1923. "Neskin," mentioned earlier as "Nefkin," was probably Freeman Nethkin, a miner on Logan Creek in 1914, Helmers, *Warren Times*, April 30, 1914.

152. Shepp, [Diary], 1921-1923, May 11-12, 14-15, 18, 1923.

153. Ibid., May 20, 25, 1923.

154. Ibid., May 31, 1923. This is believed to be the last mention of Bemis Creek in the diaries. On November 18 Shepp began referring to it as Polly Creek, ibid., November 18, 1923.

155. Helmers, *Warren Times*, after May 17, 1923, "PC." In the "Footnote Code" at the end of her book, Helmers explains "PC" as "Personal Communication, letters, interviews, collections." However, there is no further identification provided for individual items so designated.

156. McDowell consistently stated that the family moved to Warren in 1922. However, another source says that it was the fall of 1923, Helmers, *Warren Times*, September 27, 1923. Although that information was from an unidentified personal communication to Helmers, it is probably more accurate. Conveniently for the McDowell family, Gus Kupper, Warren's butcher, died suddenly that same day, ibid., October 4, 1923, and the newly arrived family bought his house. The extensive index for *Warren Times* doesn't mention any of the McDowells until 1923.

157. Herb McDowell, "Questions for Herb McDowell, 3/10/97," from Priscilla Wegars, answers dated March 16, 1997, copy in Asian American Comparative Collection, University of Idaho, Moscow.

158. Johnny Carrey, replies to "Questions for Johnny Carrey, #4, 2/25/97," Question 5, US mail interview by Priscilla Wegars, and replies to "Questions for Johnny Carrey, #5, 3/31/97," Questions A1-4, US mail interview by Priscilla Wegars, copies in Asian American Comparative Collection, University of Idaho, Moscow.

159. Shepp, [Diary], 1921-1923, June 5, 1923.

160. Ibid., June 6, 1923. It is unclear whether he planted the cabbage at Polly's place or at his own ranch.

161. Ibid., June 23, 1923.
162. Idaho County, Deeds, "Book 50" [1921-1923] (Idaho County Courthouse, Auditor-Recorder, Grangeville, ID), 624-626, June 28, 1923.
163. Shepp, [Diary], 1921-1923, July 9, 1923.
164. Ibid., July 13, 18, 22-23, 25-28, 1923.
165. Ibid., July 11, 14, 18, 20, 22-23, 27-28, 30, 1923.
166. Carrey and Conley, *River of No Return*, 205.
167. Carrey and Conley, *River of No Return*.
168. Johnny Carrey, "Questions for Johnny Carrey, #1, November 10, 1996," Questions 1-8. US mail interview by Priscilla Wegars, copy in Asian American Comparative Collection, University of Idaho, Moscow. Gay died in June 1994, Johnny Carrey, "Questions for Johnny Carrey, #6, August 6, 1997," Question 7, US mail interview by Priscilla Wegars, copy in Asian American Comparative Collection, University of Idaho, Moscow.
169. Johnny Carrey, "Questions for Johnny Carrey, #3, January 14, 1997," Question 2, US mail interview by Priscilla Wegars, copy in Asian American Comparative Collection, University of Idaho, Moscow.
170. Johnny Carrey, interview by Priscilla Wegars, Riggins, ID, July 8, 1997, notes in Asian American Comparative Collection, University of Idaho.
171. Ibid.
172. Carrey, "Questions for Johnny Carrey, #1," Question 17.
173. Johnny Carrey, "Questions for Johnny Carrey, #4, February 25, 1997," Question 4, and John Carrey, "Moccasin Tracks of the Sheepeaters," in *Sheepeater Indian Campaign* (Chamberlain Basin Country) (Grang[e]ville, ID: *Idaho County Free Press*, 1968), 26.
174. Johnny Carrey, "Questions for Johnny Carrey, #8, September 24, 1997," Question 7, US mail interview by Priscilla Wegars, copy in Asian American Comparative Collection, University of Idaho, Moscow.
175. Pearl Carrey, interview by Priscilla Wegars, Riggins, ID, August 8, 2002, notes in Asian American Comparative Collection, University of Idaho, Moscow.
176. Johnny and Pearl Carrey, interview by Priscilla Wegars, Riggins, ID, April 12, 1997, notes in Asian American Comparative Collection, University of Idaho, Moscow.
177. Pearl Carrey, interview by Priscilla Wegars. The teacher was Esther Smith, Carrey, "Questions for Johnny Carrey, #5, Question C1.
178. Johnny Carrey, "Questions for Johnny Carrey, #2, November 23, 1996," Questions 1-2, US mail interview by Priscilla Wegars, copy in Asian American Comparative Collection, University of Idaho, Moscow.
179. Johnny Carrey, "Questions for Johnny Carrey, #8," Question 6.
180. Johnny Carrey, "Questions for Johnny Carrey, #8," handwritten note at bottom, dated September 29, 1997.
181. Johnny Carrey, comments on Ruthanne Lum McCunn, *Thousand Pieces of Gold* ([San Francisco]: Design Enterprises of San Francisco, 1981), 282, assisted by Pearl Carrey, reply after June 23, 1997.
182. Johnny Carrey, "Questions for Johnny Carrey, #7, August 25, 1997," Questions 5-6, US mail interview by Priscilla Wegars, copy in Asian American Comparative Collection, University of Idaho, Moscow.
183. Johnny Carrey, "Questions for Johnny Carrey, #1," Question 27, and "Questions for Johnny Carrey, #3," Question 6,
184. Carrey, "Questions for Johnny Carrey, #1," Question 22.
185. Carrey, "Questions for Johnny Carrey, #7," Question 7. In later years, Johnny marked a map with the approximate location of Polly's house.
186. Carrey, "Questions for Johnny Carrey, #1," Question 43.
187. Carrey, "Questions for Johnny Carrey, #2," Question 3.

188. Carrey, "Questions for Johnny Carrey, #1," Questions 44-45.
189. Carrey, "Questions for Johnny Carrey, #6," Question 1.
190. McCunn, *Thousand Pieces of Gold*, 279-281.
191. Carrey, "Questions for Johnny Carrey, #1," Question 49.
192. Carrey, comments on McCunn, *Thousand Pieces of Gold*, 279-285, assisted by Pearl Carrey, reply after June 23, 1997. Johnny said they didn't dye eggs and make cookies, bake together, use a stereoscope, or pick flowers, ibid., 283-284, and Johnny Carrey, interview by Priscilla Wegars, Riggins, ID, August 10, 1997, notes in Asian American Comparative Collection, University of Idaho, Moscow.
193. Johnny Carrey, "Questions for Johnny Carrey, #6," Questions 4-5, and Johnny Carrey, interview, August 10, 1997.
194. Johnny Carrey, interview by Priscilla Wegars, Riggins, ID, June 29, 1999, notes in Asian American Comparative Collection, University of Idaho, Moscow.
195. Carrey, "Questions for Johnny Carrey, #1," Questions 30, 34.
196. Carrey, "Questions for Johnny Carrey, #4," Question 11.
197. Carrey, "Questions for Johnny Carrey, #6," Question 6.
198. Johnny Carrey, interview by Priscilla Wegars, Riggins, ID, March 19, 1998, notes in Asian American Comparative Collection, University of Idaho, Moscow.
199. Ibid.
200. Carrey, "Questions for Johnny Carrey, #6," Question 2.
201. Johnny Carrey, interview, June 29, 1999. For more information on Sarah Eleanor "Granny" Hanthorn, see Helmers, *Warren Times*, index.
202. Carrey, "Questions for Johnny Carrey, #3," Question 9.
203. Ibid., Question 10.
204. Carrey, "Questions for Johnny Carrey, #1," Question 47; Carrey, "Questions for Johnny Carrey, #3," Question 10.
205. Carrey, "Questions for Johnny Carrey, #3," Questions 4, 11.
206. Ibid., Question 11.
207. Carrey, "Questions for Johnny Carrey, #4," Question 7, and Carrey, "Questions for Johnny Carrey, #5, Question B1.
208. Carrey, "Questions for Johnny Carrey, #5," Question B2.
209. McDowell, "Questions 3/10/97," [2].
210. Carrey, "Questions for Johnny Carrey, #1," Question 37.
211. Frances Zaunmiller, "Wedding Photo of Polly Bemis Reprinted for the First Time," *Idaho County Free Press*, 80(44):sec. 3, p. 6, May 11, 1967.
212. Ibid; see Fig 1.2 and Fig. 3.2, this volume.
213. Carrey, "Questions for Johnny Carrey, #3," January 14, 1997, Question 3; apparently, the school also had closed.
214. First, Johnny said he did visit her there, but offered no details, Carrey, "Questions for Johnny Carrey, #6," Question 3. Later he contradicted that statement, saying that he didn't visit Polly at her home on the Salmon River, Johnny Carrey, "Questions for Johnny Carrey, #9, March 16, 1999, Question 1, US mail interview by Priscilla Wegars, copy in Asian American Comparative Collection, University of Idaho, Moscow.
215. Herb McDowell, telephone interview with author, January 23, 1997, and annotated March 16, 1997, [1], copy in Asian American Comparative Collection, University of Idaho, Moscow.
216. McDowell, "Questions 3/10/97." As Johnny Carrey had done, Herb McDowell also marked a map with the approximate location of Polly's house.
217. Herb McDowell, "Polly Bemis," typescript, Historic 1680 Files, Cultural Resources, Payette National Forest, McCall, ID, 1987, [2].

218. Mcdowell, telephone interview, January 23, 1997, [2].

219. Carrey, "Questions for Johnny Carrey, #4," Question 10.

220. Jeffrey M. Fee, "Idaho's Chinese Mountain Gardens," in *Hidden Heritage: Historical Archaeology of the Overseas Chinese*, ed. Priscilla Wegars (Amityville, NY: Baywood, 1993), 74-75.

221. Herb McDowell, "Town Brings Memories." The Opium Exclusion Act, passed by Congress in 1909, prohibited the importation, possession, and use of opium prepared for smoking. Opium in medicines wasn't then forbidden.

222. Herb McDowell, "Early Mining Days in Warren," typescript, Historic 1680 Files, Cultural Resources, Payette National Forest, McCall, ID, 1987, [2].

223. E.g., Steven Martin, *Opium Fiend: A 21st Century Slave to a 19th Century Addiction, a Memoir* (New York: Villard, 2012), 4-11.

224. McDowell, "Town Brings Memories", and McDowell, "Early Mining Days in Warren," [2-3].

225. Carrey, "Questions for Johnny Carrey, #2," Question 4; Carrey, "Questions for Johnny Carrey, #4," Question 8; and Priscilla Wegars, *Polly Bemis: A Chinese American Pioneer* (Cambridge, ID: Backeddy Books, 2003), 19.

226. Otis Morris, interview by Herb McDowell; Herb McDowell, interview by Priscilla Wegars, Culdesac, ID, March 16, 1997, 3-4, notes in Asian American Comparative Collection, University of Idaho, Moscow.

227. Fee, "Idaho's Chinese Mountain Gardens," 74. A "poem from local folklore" described Ah Sam's "daily ritual": "In the wee hours of morning, over ice and snow, Comes Ah Sam from house to house, Blowing life back into dying coals," ibid., 75.

228. Shepp, [Diary], 1921-1923, August 1, 1923.

229. Ibid., August 5, 1923.

230. Ibid., August 9, 1923.

231. Ibid., August 10, 1923.

232. Helmers, *Warren Times*, April 11, 1919, and March 22, 1934.

233. M. Catherine Manderfeld, interview by author, The Historical Museum at St. Gertrude, Cottonwood, ID, July 9, 1997, quoting Fred Shiefer. Other information, provided earlier, indicates that Polly's rented house, from late 1922 until October 1924, was on Bemis Gulch. If Shiefer did live next door to Polly, it wasn't at the house where she was photographed, although he apparently owned that dwelling at a later time.

234. Shepp, [Diary], 1921-1923, August 12, 1923. Either Fred Burgdorf's wife, or Burgdorf himself, made furniture from "knotted wood," "Difficult Trip over Snow from Warren to M'Call," *Idaho County Free Press*, 37(33):[1], December 29, 1921, and *Lewiston Morning Tribune*, "Resort at Burgdorf Hot Springs Retains All Its Pioneer Charms; Discovered by Unknown Chinese," August 30, 1931, 5, available at https://news.google.com/newspapers?id=aZ1fAAAAIBAJ&sjid=ujEMAAAAIBAJ&pg=1574,4055996 (accessed February 22, 2018). The Chinese "discovery" was "along in the middle [18]'60s or thereabouts, tradition has it," *Lewiston Morning Tribune*, "Resort at Burgdorf Hot Springs." Some of the furniture is still visible inside the derelict hotel.

235. Many thanks to Heidi Barth, Pete Klinkhammer's great-niece, for sharing these two images. Although one is marked 1923 and the other is marked 1924, they were surely both taken at the same time, that is, on the 1923 trip.

236. Heidi Barth, e-mail message to author, April 26, 2014.

237. If it was either place, several photo replication experiments failed to locate the exact spot.

238. *Idaho County Free Press*, "Woman of 70 Sees Railway." Polly's trip to Slate Creek most likely occurred when she lived in Warren between 1872 and her move to the Salmon River in the fall of 1894, or between 1894 and 1902, before she appears in the Shepp diaries.

239. Ibid.

240. *Idaho Daily Statesman*, "Polly Bemis of Warren's Diggins"; *Idaho County Free Press*, "Polly Bemis Has Big Time." These articles, on Polly's visit to Boise in 1924, provide additional details about her visit to Grangeville the previous year.

241. *Idaho County Free Press*, "Woman of 70 Sees Railway."

242. Thanks to Denis Long for allowing me to copy this photograph.

243. Denis Long, notes from conversation with Priscilla Wegars, March 16, 2015.

244. Thanks to Eldene Wasem for information about Margaret Dysard. The Imperial Hotel opened in 1908 and burned in 1966.

245. Ibid. Warren got its first school in late August 1887, Helmers, *Warren Times*, September 2, 1887.

246. *Idaho County Free Press*, "Woman of 70 Sees Railway."

247. Ibid.

248. The first train arrived in Grangeville on Wednesday, December 9, 1908, *Idaho County Free Press*, "Train Service," 23(28):4, December 10, 1908. This helps confirm that Polly hadn't visited Grangeville between that date and August 1923.

249. This passage provides additional confirmation that Polly didn't leave her ranch after 1902 or 1903.

250. *Idaho County Free Press*, "Polly Awakened," 39(14):3, August 16, 1923.

251. Elsensohn, "Fourth Academy Day," 4.

252. Carrey, interview, August 10, 1997.

253. *Idaho County Free Press*, "Polly Returns to Warren after Happiest Days in Fifty Years," 39(15):1, August 23, 1923. Bertha Long's grandson-in-law, Bob Bunting, wrote that John and Bertha Long took Polly to see the train. "When the train approached, Polly saw the engine belching smoke and steam and was terrified. She thought the horrible Chinese dragon was coming to get her. She had heard the stories of the dragon when she was a child ...," Robert D. Bunting, letter to author, September 14, 2000 [1]. Actually, John Long couldn't have accompanied them because he died in mid-October 1920.

254. *Idaho County Free Press*, "Polly Returns to Warren." While it would be intriguing to know what film she watched, advertisements for upcoming films aren't present in the relevant newspapers consulted.

255. Al Wagner bought the Lyric in the late-1920s; it closed around 1934. Today's Blue Fox Theatre in Grangeville opened in 1930, Cinema Treasures, "Lyric Theatre," available at http://cinematreasures.org/theaters/44198 (accessed February 25, 2019); Eleanor (Poofy) Wagner, telephone conversation with author, October 3, 2018.

256. Elsensohn, "Fourth Academy Day," 3.

257. Mrs. John D. (Bertha) Long, "Polly Bemis, My Friend," *Idaho County Free Press*, 80th Anniversary Edition, 79(49):sec. [8], p. 1, June 16, 1966.

258. Elsensohn, "Fourth Academy Day," 3.

259. Bunting, letter to author, September 14, 2000, [2].

260. Chan Wallace, "King of Cougar Hunters Comes out of Wilds with Record Kill and Tale of Daring Adventures," *Lewiston Morning Tribune*, May 1, 1932, sec. 2, p. 1. A week later the *Idaho Sunday Statesman* published "Idaho Chinese Woman Awaits Time to Rejoin Ancestors," 68(42):sec. 2, p. 3, May 8, 1932. That article states that she went to Grangeville "two years ago," i.e., in 1930, but other details (Polly's first train sighting, automobile ride, and motion picture viewing) indicate that it was, instead, the trip that she took there in August 1923. Wallace's earlier article, cited above, states that Polly's Grangeville visit was "within the past few years, misinterpreted by the *Statesman* as "two years ago."

261. Nikki Sickels of the Idaho County Courthouse kindly looked for a possible agreement between Polly Bemis, Charlie Shepp, and Pete Klinkhammer, but didn't find one. According to Idaho state law, Polly, as a "resident alien," was allowed to inherit the Bemis Ranch, *Idaho Code 1932: Containing the General Laws of Idaho*, 4 volumes, (Indianapolis: Bobbs-

Merrill, 1932), vol. 1, Title 14, "Estates of Decedents," Chapter 1, "Succession," Section 116, 'Inheritance by Aliens.'

262. *Idaho County Free Press*, "Polly Returns to Warren."

263. *Salmon Herald*, "Idaho Has Lady Rip Van Winkle," 23(38):[9], September 19, 1923, copying the *Pocatello Tribune* of unknown date.

264. *Salmon Herald*, "Idaho Has Lady Rip Van Winkle."

265. Shepp, [Diary], 1921-1923, August 13, 21, 23, 1923.

266. Ibid., August 17-18, 1923.

267. Ibid., September 8-9, 1923.

268. Ibid., September 10, 1923.

269. Ibid., September 22, 1923.

270. Helmers, *Warren Times*, September 27, 1923.

271. Sue Johnson, e-mail message to author, March 18, 2017. McDowell was Arnie Johnson's uncle.

272. The author speculates that although Polly surely intended to make a dress out of the curtains, that may not have been possible to accomplish. Polly's sewing machine had burned in the 1922 fire [the metal head for it is in the Idaho State Museum in Boise (Chapter Ten)] and there is no record of her obtaining another one, so she probably didn't make a dress out of the material after all. Instead, she could well have reused the curtains in her own home once she moved back down to the Salmon River in the fall of 1924.

273. Shepp, [Diary], 1921-1923, October 4, 10, 13, 1923. Jake is unknown, but he spent some time helping out at the Shepp Ranch.

274. Ibid., October 25-26, 31, 1923.

275. Ibid., November 1, 1923.

276. Ibid., November 2-3, 1923.

277. Ibid., November 5-9, 1923.

278. Ibid., November 10, 15-17, 1923.

279. Ibid., November 18, 1923.

280. The former Bemis Creek on the Salmon River is different from the Bemis Creek in Warren; the two weren't physically connected.

281. See Fig. 5.6.

282. Shepp, [Diary], 1921-1923, November 20-22, 1923.

283. Ibid., November 23, 27-30, 1923.

284. Ibid., November 21-22, 1923.

285. Ibid., December 1, 3, 8, 1923.

286. Ibid., December 23, 1923.

287. Ibid., last page.

288. Charles Shepp, [Diary], January 1, 1924, through December 31, 1924, photocopy, University of Idaho Library Special Collections, MG 155, January 9, 1924. This diary is written in a notebook that folds over at the top. The top and bottom entries are sometimes too pale to be readable.

289. US Census, *Fourteenth Census of the United States*, Concord Precinct, Sheet 1B, "United States Census, 1920." Pete had a lengthy trapline "from the ranch to the Hump and down to Orogrande, with spur lines on the Clearwater drainage," Carrey and Conley, *River of No Return*, 215. Fur trapping could be quite lucrative; around World War I, a marten pelt brought nearly $100.00, ibid. Pete "was primarily interested in marten, mink, and fox"; ... "furs could be sold by mail to Sears-Roebuck," ibid.

290. Shepp, [Diary], 1924, March 4-7, 1924. Shepp's photo of the sawpit can be seen in Carrey and Conley, *River of No Return*, 209.

291. Jennifer Eastman Attebery, "National Register of Historic Places Registration Form: Bemis, Polly, House" (Boise: Idaho State Historical Society, 1987), [3].

292. Shepp, [Diary], 1924, March 10, 30-31, 1924.

293. Ibid., March 29, 1924.

294. Ibid., April 5, 9, 19, 21-23, 1924.

295. Ibid., April 24-26, 1924.

296. Ibid., March 2, April 4, 1924.

297. Ibid., May 3-4, 1924.

298. *Idaho County Free Press*, "Aged Chinaman Hits for Hills," 39(48):1, 8, April 10, 1924.

299. Helmers, *Warren Times*, January 12, 1922; April 10, 1924.

300. Ibid., March 1, 1917.

301. Ibid., May 9, 1918, and March 21, 1919.

302. Ibid., July 26, 1918. The mine was also known as the Dick & Woods placers [*sic*], ibid., September 19, 1919.

303. Ibid., March 21, 1919.

304. Ibid., April 15, December 16, 1920.

305. *Idaho County Free Press*, "Local News in Brief," 'Goon Dick Here,' 37(35):[4], January 12, 1922. During the winter, when water froze and placer mining couldn't take place, Chinese and other miners migrated to towns or cities to wait for spring.

306. *Idaho County Free Press*, "Local News in Brief," 'Dick Back,' 38(26):6, November 9, 1922. The *Free Press* had other mentions of Goon Dick's comings and goings on June 21 and October 11, 1923, and on October 23, 1924.

307. Helmers, *Warren Times*, November 9, 1922; June 21 and October 11, 1923.

308. *Idaho County Free Press*, "Aged Chinaman Hits for Hills."

309. Ibid. Whether true, or to tease the reporter, Goon Dick said that while in Seattle he "thoroughly enjoyed a party in which they feasted on stewed cats. 'Velly good,' was his comment. 'You eat 'em cat?,'" ibid., 8.

310. Shepp, [Diary], 1924, May 7-10, 12-13, 1924.

311. Ibid., May 14-17, 1924.

312. Ibid., May 18, 1924.

313. Ibid., May 20, 1924.

314. Ibid., June 1, 10, 1924.

315. Ibid., June 1, 10, 1924.

316. Ibid., July 2-8, 1924.

317. Ibid., July 9-10, 12, 1924.

318. Ibid., July 17-18, 1924.

319. Ibid., July 23, 25-26, 28, 1924.

320. Ibid., August 1, 3, 1924.

321. *Idaho Sunday Statesman*, "Romantic Figure of Warrens' Gold Camp Ill in Grangeville Hospital: Czizek Explodes Myth of Chinese Poker Bride," 70(9):sec. 2, p. 4, September 24, 1933.

322. *Evening Capital News*, "Hotel Arrivals," 53(18):10, August 4, 1924.

323. Supposedly Polly "got a big thrill out of being greeted by the streetcar conductor—and waved to a seat without charge—...," Rafe Gibbs, *Beckoning the Bold: Story of the Dawning of Idaho* (Moscow: University Press of Idaho, 1976), 103, but, alas, there is no corroborating evidence that she actually was allowed to ride for free.

324. *Idaho Daily Statesman*, "Polly Bemis of Warren's Diggins."

325. Ibid. The comment, "some very bad, shut eyes," seems to refer to the film that Polly viewed in Boise on Sunday, August 3, 1924. Of the choices available at Boise's three movie theaters

that day, two were westerns and one was a "silent comedy drama" titled, "Why Men Leave Home." It is not difficult to understand why Polly shut her eyes—a "teaser" for the film states, "Sweethearts, wives, husbands, you can learn how to win and keep love and to renew romance that is waning by the hints that you receive in this picture. It tells you why men leave home, but it also teaches you how to keep 'em there," Heritage Auctions, "2008 July 27 Sunday Internet Movie Poster Auction #58074," available at https://movieposters. ha.com/itm/drama/why-men-leave-home-first-national-1924-title-lobby-card-11-x-14-drama/a/58074-54448.s?ic4=GalleryView-Thumbnail-071515# (accessed March 12, 2019).

326. Ah Choy died in 1887. Earlier, To Hay died in 1880.

327. For more on Keathon, see Helmers, *Warren Times*, index. He is doubtless the same Bob "Caton" [*sic*] who, in 1885, "furnishes the camp [Warren] with vegetables from the [M]ain Salmon," *Idaho Semi-Weekly World*, "Warrens" 10(51):2, September 11, 1885.

328. *Idaho Daily Statesman*, "Polly Bemis of Warren's Diggins."

329. *Idaho County Free Press*, "Polly Bemis Has Big Time."

330. *Idaho Daily Statesman*, "Polly Bemis of Warren's Diggins."

331. Shepp, [Diary], 1924, August 5, 1924.

332. Ibid., August 6, 9, 1924.

333. Ibid., August 27, 1924.

334. Ibid., August 10, 22, 1924.

335. Ibid., August 11-14, 1924.

336. Ibid., August 11, 23, 1924.

337. Ibid., August 23-24, 26-27, 29, 1924.

338. Ibid., August 28, 1924.

339. Ibid., September 3-6, 1924.

340. Ibid., September 8, 1924.

341. Ibid., September 9-12, 1924.

342. Ibid., September 13, 1924.

343. Ibid., September 15, 1924.

344. Ibid., September 18-19, 1924.

345. Ibid., September 20-21, 1924.

346. Ibid., September 22-23, 1924.

347. Ibid., September 24-27, 1924.

348. Ibid., September 29-30, October 3-4, 6-8, 1924.

349. Ibid., October 2-4, 1924.

350. Ibid., October 8-9, 1924.

351. Ibid., October 9, 1924.

352. Frances Zaunmiller, "Polly Bemis, Part of Salmon River History," *Idaho County Free Press*, 80th Anniversary Edition, 79(49):sec. [8], p. 1, June 16, 1966. Later, Zaunmiller, now Wisner, wrote, "[One] morning … Peter noticed smoke coming from the Beamis [*sic*] chicken house. He and Shepp crossed the river to find Polly making breakfast over a campfire. 'You don't need to worry about me. I not bother anyone. but this is my home and I am going to live here. I don't like it in town,'" Frances Zaunmiller Wisner, "Simply River Women," *Incredible Idaho*, 3:4 (Spring 1972), 23.

353. Ibid.

354. Shepp, [Diary], 1924, October 10, 13, 1924.

355. Ibid., October 11, 1924.

356. Ibid., October 14, 1924.

357. Ibid., October 15-16, 1924.

358. Ibid., October 17, 1924.

Chapter Eight: Polly Bemis's Last Years, October 1924 to November 1933

1. Infoplease, "News and Events of 1925," available at http://www.infoplease.com/year/1925 (accessed June 4, 2018).

2. Infoplease, "News and Events of 1926," available at http://www.infoplease.com/year/1926 (accessed June 4, 2018).

3. Infoplease, "News and Events of 1927," available at http://www.infoplease.com/year/1927 (accessed June 4, 2018).

4. Infoplease, "News and Events of 1928," available at http://www.infoplease.com/year/1928 (accessed June 4, 2018.

5. Infoplease, "News and Events of 1929," available at http://www.infoplease.com/year/1929 (accessed June 4, 2018).

6. Infoplease, "News and Events of 1930," available at http://www.infoplease.com/year/1930 (accessed June 4, 2018).

7. Infoplease, "News and Events of 1931," available at http://www.infoplease.com/year/1931 (accessed June 4, 2018).

8. Infoplease, "News and Events of 1932," available at http://www.infoplease.com/year/1932 (accessed June 4, 2018).

9. Infoplease, "News and Events of 1933," available at http://www.infoplease.com/year/1933 (accessed June 4, 2018).

10. Charles Shepp, [Diary], January 1, 1924, through December 31, 1924, photocopy, University of Idaho Library Special Collections, Manuscript Group (henceforth MG) 155, October 17 and 19, 1924. This diary is written in a notebook that folds over at the top. The top and bottom entries are sometimes too pale to be readable.

11. Ibid., October 20, 30, 1924.

12. Ibid., November 2-3, 5, 7, 1924.

13. Ibid., November 3-4, 1924. Shepp was always so keen to vote that it is tempting to speculate that Pete might have voted twice, once on Shepp's behalf.

14. Ibid., November 10-13, 1924. The reference to "both doors hung & locks on" is curious, because there is no back door to the outside. Doors, plural, could refer to an interior door, but there would be no need for a lock on it, unless Polly wanted a bedroom door that locked. If she had overnight guests who slept downstairs on the floor, she might have wanted a locking bedroom door for security.

15. Ibid., November 22-23, 1924.

16. Ibid., November 27-28, 1924.

17. Ibid., November 24, 1924.

18. Cort Conley, e-mail message to author, November 3, 2014. I am grateful to Cort for this suggestion.

19. Shepp, [Diary], 1924, November 25, 1924.

20. M. Alfreda Elsensohn, "Fourth Academy Day at St. Gertrude's, Cottonwood, Renews ... Memories of Polly Bemis," *Spokesman-Review*, May 12, 1957, 4. The quotation, which is used without attribution, is almost identical to one in George Jarvis Bancroft's "China Polly—A Reminiscence," [handwritten title], typescript, ca. 1924; photocopy at Denver Public Library, Western History Department, Caroline Bancroft Family Papers, WH1089, Western History Collection. Elsensohn also used the quote elsewhere in her writings, with slight changes to it, e.g., *Idaho Chinese Lore* (Cottonwood, ID: Idaho Corporation of Benedictine Sisters, 1970), 85, and *Idaho County's Most Romantic Character: Polly Bemis*. (Cottonwood, ID: Idaho Corporation of Benedictine Sisters, 1979), 36, also unattributed to Bancroft.

21. Shepp, [Diary], 1924, November 29, 1924.

22. Ibid., December 8, 11-12, 15-16, 1924.

23. Ibid., December 24, 1924. "Church" may have been Norman Church, of Warren, who served a couple of months for killing a deer out of season, Cheryl Helmers, *Warren Times: A Collection of News about Warren, Idaho* (Odessa, TX: The Author, 1988), August 18 and October 13, 1921. He was a cousin of Ed and Fred Matzke, Johnny Carrey and Cort Conley, *River of No Return* (Cambridge, ID: Backeddy Books, 1978), 204. Boston Brown helped with construction of the Forest Service's road from Warren to Hayes Station. He also placer mined on War Eagle Mountain with the assistance of Warren Chinese pioneer Lee Dick, Helmers, *Warren Times*, January 25 and July 26, 1918; April 11, 1919.

24. Shepp, [Diary], 1924, December 25, 1924.

25. Ibid., December 19, 31, 1924.

26. Charles Shepp, [Diary], January 1, 1925, through December 31, 1925, photocopy, University of Idaho Library Special Collections, MG 155, January 2, 1925. This diary is written in a notebook that folds over at the top. The entries are occasionally too pale to be readable.

27. Ibid., January 2, 6, 22, 24, 1925.

28. Ibid., January 18, 1925. Charlie Matzke is unknown, but he was doubtless related to Fred and Ed Matzke, brothers who had settled on the Indian Creek Ranch, up the Salmon River from the Shepp Ranch, Carrey and Conley, *River of No Return*, 201.

29. Shepp, [Diary], 1925, January 16, 24-26, 1925.

30. Ibid., January 31, 1925.

31. Ibid., February 24, 1925.

32. Ibid., February 3, 14, 16-17, 19, 26, 28, and March 2, 1925.

33. Ibid., March 18, 22, 26-28, 30-31, 1925.

34. Ibid., April 1, 3-4, 1925.

35. Ibid., April 2, 1925.

36. Ibid., April 10, 1925. Once Harry Guleke's trips reached Riggins, the usual end to his journeys, he would sell the lumber from his scow to someone in the vicinity, for $5.00 or so, then make his way back to Salmon, Idaho, at times on foot. "Around 1925-28" … Guleke "stayed with Polly Bemis on his way down [the Salmon River] or back [up] the river. She'd cook him dinner or put him up for the night," Melanie Scoble, "Capt. Guleke: 'One of the West's Most Colorful Figures,'" in *Patchwork: Pieces of Local History* (Salmon, ID: Salmon High School, 1989). 12.

37. Shepp, [Diary], 1925, April 15-17, 1925.

38. Ibid., April 18, 25-26, 1925.

39. Ibid., April 27-29, 1925.

40. Ibid., May 1-6, 1925.

41. Ibid., May 8, 1925.

42. Ibid., May 16, 1925.

43. Ibid., May 17, 1925.

44. Ibid., June 1, 3-4, 6, 1925.

45. Ibid., June 11-13, 1925.

46. Ibid., June 15-20, 1925.

47. Ibid., June 20-21, 1925. Gus Schultz was a local miner whose wife, Nellie, was Polly's good friend. Joe Bryce is unknown.

48. Ibid., June 22-23, 26-27, 1925.

49. Ibid., July 11, 16 (both 106 degrees), July 8 (108 degrees), 1925.

50. Ibid., July 6, 9, 16-18, 1925.

51. Ibid., July 11-12, 1925. John Becker was the owner of the Buck placer mine on Houston Creek in the Warren Mining District, Helmers, *Warren Times*, April 11, 1919, and March 22, 1934. His sister, Elizabeth (Bessie) Becker was by then married to Jay A. Czizek, one

of Polly's boarders from when she lived in Warren in the early 1890s. Czizek was Idaho's first inspector of mines (1898), "Access Genealogy: A Free Genealogy Resource," http://www.accessgenealogy.com/idaho/biography-of-jay-a-czizek.htm (accessed June 4, 2018).

52. Shepp, [Diary], 1925, July 16-17, 1925.

53. Ibid., July 19, 1925.

54. Ibid., July 31, 1925.

55. Ibid., August 5, 6, 1925.

56. W. J. Ingling, "Boating Down Salmon River," *Salmon Herald*, 26(6):4, February 10, 1926; I am grateful to Cort Conley for calling this article to my attention. Ingling, a "Master Mechanic, Montana Division, Pocatello, Idaho," worked for the Union Pacific. His article first appeared in *Union Pacific Magazine*, February 1926. The trip was also news the previous August, when the group set off. The *Salmon Herald*, quoting from the *Pocatello Tribune*, reported that the participants were "two local [Pocatello] railroad officials and two Chicago men of prominence … A. C. Hinkley, superintendent of motive power of the Oregon Short Line system[;] W. J. Ingling, master mechanic of the Short Line system [; and] J. Will Johnson and Jerry Griffin of Chicago," *Salmon Herald*, "Boat Trip Down Salmon River," 25(31):2, August 5, 1925. The group took no firearms, but planned plenty of fishing; cameras were not mentioned, ibid.

57. Ingling, "Boating Down Salmon River."

58. Shepp, [Diary], 1925, August 4, 8, 15, 1925.

59. Ibid., August 7, 8, 1925. Sheep Creek is downriver from the Shepp Ranch.

60. Ibid., August 9, 1925. Bill Hart is otherwise unknown.

61. Ibid., August 10-11, 1925.

62. Ibid., August 12, 1925. Warren resident Oscar Waller was later a Justice of the Peace for that community, Helmers, *Warren Times*, November 29, 1928.

63. Ibid., July 26, August 15, 1925. The trail crew was based on the West Fork of Crooked Creek, ibid., July 26, 1925, and then moved downhill nearer the Shepp Ranch, ibid., August 5, 1925.

64. Ibid., August 20-21, 1925.

65. Ibid., August 23-24, 1925.

66. Ibid., August 25, 1925.

67. Ibid., August 29-30, 1925.

68. Ibid., August 30, 1925. "Rip" was probably Rippleman, ibid., May 4-5, 1925. Rippleman was then from the Wind River area; his first name and the name of his "pard" are both unknown.

69. Ibid., August 31, 1925. "Maples" may have been Charles Maples; later, in 1927, he lived in Riggins, Helmers, *Warren Times*, May 5, 1927.

70. Shepp, [Diary], 1925, September 2-3, 1925.

71. Helmers, *Warren Times*, August 18 and September 15, 1921.

72. Shepp, [Diary], 1925, September 5-7, 1925.

73. Ibid., September 8-9, 1925.

74. Shepp, [Diary], 1925, September 10-11, 1925.

75. Ibid., September 14-15, 1925.

76. *Idaho County Free Press*, "Forest Air Patrol in Grangeville," 41(19):10, September 17, 1925.

77. Shepp, [Diary], 1925, September 18, 22, 1925. A Montgomery Ward & Co. grocery catalogue for 1915 illustrates a 100-pound sack of "Corn Meal," noting that it can be used for making Johnny Cake, Corn Cakes, Hoe Cakes, Corn Meal Mush etc.," Montgomery Ward & Co., *Price List No. 352, Groceries, March April 1915* (New York: Montgomery Ward & Co., 1915), 44.

78. Shepp, [Diary], 1925, September 26-27, 1925.

79. Ibid., September 28. 30, 1925.

80. Ibid., October 1-3, 5, 12, 14-17, 1925.

81. Ibid., October 18, 22, 24, 1925.

82. Ibid., October 26-27, 1925. Monroe Hancock was a boat captain who had learned his trade from the legendary Harry Guleke, Carrey and Conley, *River of No Return*, 49.

83. Shepp, [Diary], 1925, October 30-31, 1925.

84. Ibid., November 1-2, 1925. Winesap apples are an attractive red color and are excellent for eating raw.

85. Ibid., November 3-9, 16, 18-21, 1925.

86. Ibid., November 26, 1925.

87. Ibid., December 2, 7-8, 10, 1925.

88. Ibid. Rippleman's first name, and the location of his ranch, are unknown.

89. Ibid., December 25, 1925.

90. Ibid., summarized from the last four pages. Modern equivalents for these prices range from 36 cents for an ear of corn to $7.13 for a melon, "The Inflation Calculator," available at http://www.westegg.com/inflation/infl.cgi (accessed June 4, 2018).

91. Charles Shepp, [Diary], January 1, 1926, through June 23, 1927, photocopy, University of Idaho Library Special Collections, MG 155, January 15, 1926. This diary is written in a notebook that folds over at the top. The entries are occasionally too pale to be readable. Moore was probably Jim Moore, a rancher who had a place near Campbell's Ferry, Carrey and Conley, *River of No Return*, 165-167.

92. Shepp, [Diary], 1926-1927, January 19, 1926.

93. Ibid., January 27, 1926.

94. Ibid., January 16, 1926.

95. Ibid., February 3, 9, 1926.

96. Ibid., February 21, 23, 1926.

97. Ibid., March 2, 25-26, 1926.

98. Ibid., March 4, 8, 19, 1926.

99. Ibid., April 2, 1926.

100. Ibid., April 7, 1926.

101. Ibid., April 8-10, 13-16, 1926.

102. Ibid., April 14, 1926.

103. Ibid., April 17-18, 1926.

104. Claire Chin, comment to Priscilla Wegars, July 2011. I am grateful to Claire for this suggestion.

105. Alaska Outdoors Supersite, "Forum, Alaska Living, Alaska Pantry, Porcupine Recipes?," available at http://forums.outdoorsdirectory.com/showthread.php/9734-Porcupine -Recipes (accessed June 4, 2018).

106. Shepp, [Diary], 1926-1927, April 19, 22-24, 1926.

107. Ibid., April 28-29, May 2, 1926.

108. Ibid., April 29, 1926.

109. Ibid., May 3-4, 1926.

110. Ibid., May 8, 12-13, 1926. The meat safe may be the screened cabinet with shelves that is now hanging on the outside front wall of Polly's cabin, under the porch roof.

111. Ibid., May 14-15, 1926.

112. Ibid., May 17, 27, 1926.

113. Space was mentioned earlier in the diaries, in connection with a US Forest Service trail or firefighting crew, but he didn't interact with Polly Bemis at that time. This person was probably Ralph S. Space. Space (1901-1993) "worked on the Clearwater [National Forest]

while going to college and ... was Forest Supervisor for nine years," from 1954-1963, Ralph S. Space, *The Clearwater Story: A History of the Clearwater National Forest* [revised edition], (n.p.: Forest Service, US Department of Agriculture, Northern Region-79-03, [1981]), title page, acknowledgments. Ralph Space's unprocessed papers, MA 2000-18 in the University of Idaho Library's Special Collections, unfortunately contain no information to confirm, or deny, Space's acquaintance with either Charlie Shepp or Polly Bemis.

114. Shepp, [Diary], 1926-1927, June 4, 1926.

115. Ibid., June 8-10, 1926.

116. Ibid., June 11, 1926.

117. Ibid., June 12-13, 1926.

118. Ibid., June 15, 18, 1926.

119. Ibid., June 20, 22-23, 26-29, 1926.

120. Ibid., June 28-29, 1926.

121. Ibid., June 30, July 1-3, 1926.

122. Ibid., July 5, 1926.

123. Ibid., July 7, 1926.

124. Ibid., July 16-17, 1926.

125. Ibid., July 21-23, 25, 1926.

126. Ibid., July 26-27, 30-31, 1926. In 2018 Polly's eggs would have cost $5.65 per dozen, "The Inflation Calculator."

127. Shepp, [Diary], 1926-1927, August 2-3, 7-8, 12-14, 16, 1926.

128. Ibid., August 18, 1926.

129. Although Shepp mentions taking people and horses across the river, he doesn't mention dogs. Nevertheless, some of the travelers surely had dogs, one of which was the likely culprit in impregnating Polly's pet. A coyote was possible, but not likely, and wolves had largely been exterminated from Idaho by 1926.

130. Shepp, [Diary], 1926-1927, August 19, 23, 1926.

131. Ibid., August 27, 29, 1926.

132. Ibid., August 25, 1926.

133. Ibid., September 3-4, 1926.

134. Ibid., September 5, 1926. Alex was probably a member of a trail crew; Shepp mentions him later as "Bill[,] Alex[,] & Rice up from trail camp, ibid., October 3, 1926. "Alex" could well have been Alec Blaine. In a 1968 interview, Pete Klinkhammer stated that Alec Blaine worked for the Forest Service in the summer and spent winters at the Shepp Ranch, Peter (Pete) Klinkhammer, interviewed by Jayne Brown, Shepp Ranch, 1968, transcribed by Bailey Cavender and checked by Priscilla Wegars, transcription in author's possession, 31-32. Blaine died in 1940 and is buried at the Shepp Ranch. Johnnie may have been Johnnie Steinhaus; Shepp mentions a later visit from him, with Pete, Shepp, [Diary], 1926-1927, September 18, 1926.

135. Ibid., September 5-6, 8, 1926.

136. Ibid., September 10, 13, 15, 17, 1926.

137. Ibid., September 19-20, 23, 25, 28, 1926. Polly's order, $9.40, would have cost more than $132.00 today, "The Inflation Calculator."

138. Shepp, [Diary], 1926-1927, October 4, 6, 1926.

139. Ibid., October 7, 10, 1926.

140. Ibid., October 13, 1926.

141. Ibid., October 14-16, 1926.

142. Ibid., October 17, 1926.

143. Ibid., October 18, 1926. Cort Conley suggests that Shepp weighed the produce either for crop-sharing reasons or for pride in production.

144. Ibid., October 19, 1926. Weidner was Henry Wesley Weidner of Payette, Idaho. He and his son, H. W. Weidner, Jr., were passengers rather than boatmen. They are mentioned in an *Idaho Daily Statesman* article dated July 7, 1927, as showing a moving picture, *The River of No Return*, based on Weidner's canoe trip down the Middle Fork of the Salmon River "17 years ago," *Idaho Daily Statesman*, "Salmon River Pictures to be Shown in City," 63(298):7, July 7, 1927. The same issue of the newspaper contained a quarter-page advertisement for the film, ibid., 9. Cort Conley commented, "Weidner, in 1911, made a trip down the Salmon River in a sweepboat he constructed. In 1921, he returned for a second trip, this time with a 14-foot folding canvas boat. Then in 1926, he made a canoe trip down the Middle Fork and Main Salmon, taking three and a half months, and using film from that trip and supplemented with footage from a 1927 sweepboat trip on the Main, exhibited a movie titled 'Trip of a Thousand Thrills'," Cort Conley, telephone conversation with author, February 5, 2019. See also Mary Mitiguy Miller, "A Rapid Run at River History: Films Explore Life on Salmon River during Depression," *Spokesman-Review*, 102(334):B4, B5, April 7, 1985.

145. Shepp, [Diary], 1926-1927, October 20-22, 1926.

146. Ibid., October 24, 28, 1926. "Alex" is probably Alec Blaine, and Parsons and Rice are otherwise unknown; they all worked for the Forest Service's trail crew, downriver from the Shepp Ranch, ibid., October 3, 1926.

147. Ibid., October 25, 1926. Mautrz is otherwise unknown.

148. Ibid., October 29, 31, 1926.

149. Ibid., November 7, 12, 17-19, 22-27, 1926.

150. Ibid., December 8-9, 25, 1926.

151. Ibid., December 27-31, 1926.

152. Charles Shepp, [Diary], January 1, 1926, through June 23, 1927, photocopy, University of Idaho Library Special Collections, MG 155, January 10, 1927. This diary is written in a notebook that folds over at the top. The entries are occasionally too pale to be readable. The illegible name looks like Heltan, Heltau, or Hilton; no person by that name has appeared in the diaries so far. "Oscar" is surely Oscar Waller.

153. Ibid., January 12, 1927.

154. Ibid., January 2, 21, 23, 25, 28, 30; February 2, 15; March 4, 1927.

155. Ibid., February 26-27, 1927.

156. Ibid., March 4-5, 1927. Ted Carpenter is otherwise unknown.

157. Ibid., March 11, 1927.

158. Ibid., March 15-16, 1927.

159. *Idaho County Free Press*, "Aged Chinaman Hits for Hills," 39(48):1, 8, April 10, 1924.

160. Helmers, *Warren Times*, October 23, 1924.

161. Ibid., August 19, 1926.

162. *Idaho County Free Press*, "China Dick Dies," 42(43):1, March 3, 1927. Helmers, *Warren Times*, March 3, 1927, reprints the newspaper account with some changes, notably stating the year of death incorrectly as 1926 rather than 1927. For information on Chinese exhumation practices, see Sue Fawn Chung and Priscilla Wegars, eds., *Chinese American Death Rituals: Respecting the Ancestors* (Lanham, MD: AltaMira/Rowman & Littlefield, 2005), index: exhumations.

163. Shepp, [Diary], 1926-1927, March 25-27, 1927.

164. Ibid., April 5-7, 9, 11-15, 1927.

165. Ibid., April 17-22, 1927.

166. Ibid., April 24, 1927.

167. Ibid., April 26, 28-30, 1927.

168. Ibid., May 1-4, 1927.

169. Ibid., May 6-11, 13, 1927.

170. Ibid., May 9, 18, 1927. Weidner was taking more footage for his film; see Note 144.

171. Ibid., May 14-15, 20-21, 31, 1927.

172. Ibid., June 1-23, 1927. At the end of the diary are several pages listing the call numbers of radio stations that Shepp received; he often wrote the city next to the entry. They included Vancouver, British Columbia, and Calgary, Alberta, Canada; Seattle and Walla Walla, Washington; Denver, Colorado; "Masula" [Missoula], Montana; Portland, Oregon; Los Angeles, San Francisco, and Oakland, California; and Ogden, Utah.

173. The University of Idaho Library Special Collections doesn't have a copy of any diary that might have existed for the time period from June 24, 1927, through January 3, 1928.

174. *Recorder Herald*, "Harry Guleke Wanted for 1928 River Trip," November 2, 1927. 1.

175. Cort Conley, letter to author, May 13, 2019, for the diary entry confirming that Polly smoked a pipe, and e-mail message to author, July 2, 2019, where Conley noted that L. F. Sonntag "was not a Dr."

176. Charles Shepp, [Diary], January 4, 1928, through December 31, 1928, photocopy, University of Idaho Library Special Collections, MG 155, January 8-9, 12-18, 1928. This diary is written in a notebook that folds over at the top. The entries are often too pale to be readable.

177. Ibid., January 11, 21, 1928.

178. Ibid., January 22-24, 28, 1928.

179. *Idaho County Free Press*, "Commissioner's Proceedings," 43(38):2, January 26, 1928. Ah Kan's name also appears on the list, "Quarterly Allowance for Indigents Not at the County Farm," in the amount of $40, ibid.

180. Shepp, [Diary], 1928, February 1, 3, 5-6, 1928.

181. Ibid., February 7-8, 17, 1928.

182. Ibid., March 1, 15, 18, 1928.

183. Ibid., April 12, 1928. This Parsons is otherwise unknown.

184. Ibid., April 18-19, 1928.

185. Ibid., April 23-26, 1928.

186. Ibid., May 6-9, June 1, 1928.

187. Ibid., June 3, 6, 11, 13-14, 16, 18-20, 22-25, 27-28, 1928.

188. Sometimes, too, the diary entries are ambiguous, in that it isn't clear if certain tasks were accomplished at Polly's place or at the Shepp Ranch.

189. Shepp, [Diary], 1928, July 2-3, 5, 7-8, 11-13, 1928.

190. *Recorder Herald*, "Marvelous Wild Life and Scenery on Salmon River," August 15, 1928, 1.

191. Ibid.

192. Shepp, [Diary], 1928, July 25, 30-31, 1928.

193. Ibid., August 3, 5, 1928. We can't tell why they went to Winchester's because most of that entry is illegible.

194. Ibid., August 10-15, 1928.

195. Ibid., August 10-20, 1928. Higgins is otherwise unknown.

196. Ibid., August 22-23, 25, 1928.

197. Ibid., August 26, 28, 30-31, 1928.

198. Ibid., September 2-4, 6-7, 11, 13, 17-18, 30, 1928.

199. Ibid., September 14-15, 1928.

200. Ibid., September 25, 1928.

201. Ibid., September 2, 13-14, 1928. Rudd is otherwise unknown.

202. Ibid., October 2, 14, 1928.

203. Ibid., October 7, 13, 19, 25, 31, 1928.

204. Ibid., November 4, 9, 13-15, 17, 19, 1928.
205. Ibid., November 25, 1928, and *Chicago Sunday Tribune*, "Coolidge Broadcasts His Thanksgiving Proclamation Today," November 25, 1928, part 1, p. 20, available at https://chicagotribune.newspapers.com/search/#dr_year=1928-1928&query=Coolidge +thanksgiving+proclamation&oquery=Coolidge+thanksgiving+proclamation+1928 (accessed June 4, 2018).
206. Shepp, [Diary], 1928, November 28-29, 1928. Alex was probably there also, but Pete had gone to Warren the previous day.
207. Ibid., December 2, 4, 14, 1928.
208. Ibid., December 16-17, 20, 22, 25-26, 1928.
209. Charles J. Truscott, "U. S. Department of Agriculture, Forest Service, Field Notes of Homestead Entry Survey No. 817, Situated in the Idaho National Forest, Administrative District No. 4, in Section 12, Unsurveyed, Township 24 N., Range 6 E. of the Boise Base and Meridian, State of Idaho, Bemis Ranch, Warren Dist[rict]" (US Department of Agriculture, Forest Service, 1929), cover page.
210. Charles Shepp, [Diary], July 13, 1929, through August 31, 1929, photocopy, University of Idaho Library Special Collections, MG 155, July 13, 1929. The entries in this diary are sometimes too pale to be readable. This diary, a slim notebook that folds from side to side, is probably a "freebie" from a business that Charlie Shepp patronized. On the flyleaf is a drawing of a nattily-attired couple, captioned, "Your Personality is Enhanced by Wearing Custom Tailored Clothes Made to Your Individual Measure"; Shepp might have found this rather amusing.
211. Shepp, [Diary], 1929, July 17, 20, 1929.
212. Ibid., July 24, 1929.
213. Ibid., July 26, 29-30, 1929.
214. Ibid., August 8-9, 1929.
215. Ibid., August 15-16, 1929.
216. Ibid., August 18, 25-26, 1929.
217. Charles Shepp, [Diary], September 1, 1929, through October 10, 1930, photocopy, University of Idaho Library Special Collections, MG 155, September 1, 8, 1929. This diary is written in an unused address book. The entries are sometimes too pale to be readable.
218. Hal L. Cohen, ed., *1922 Montgomery Ward Catalogue: Reprinted in Its Original Form*, (n.p., H. C. Publishers, 1969), 147. Oilcloth came in white, black, and various colorful patterns, and was sold by the yard.
219. Shepp, [Diary], 1929-1930, September 11, 1929.
220. Ibid., September 12-13, 18-19, 1929.
221. Ibid., September 21, 26-29, 1929.
222. Ibid., September 30, 1929.
223. Ibid., October 1-2, 1929.
224. Truscott, "Field Notes of Homestead Entry Survey No. 817," 5. Charlie Shepp's diary for that time period confirms this event, and that Pete Klinkhammer assisted with it, Shepp [Diary], 1929-1930, October 2-6, 1929.
225. Truscott, "Field Notes of Homestead Entry Survey No. 817," 2, 5-6. Current values would be more than $7,000, $728, and $2,100, respectively, "The Inflation Calculator."
226. Truscott, "Field Notes of Homestead Entry Survey No. 817," 6.
227. Shepp, [Diary], 1929-1930, October 3-6, 1929. First names of Farrell and Adams are unknown.
228. Ibid., October 7-8, 12, 14, 17-19, 1929.
229. Ibid., October 23, 1929.
230. Ibid., October 24-26, 30-31, 1929.

231. Ibid., November 2-3, 1929.

232. Ibid., November 13, 17, 26, 1929.

233. Ibid., December 4, 18, 25-31, 1929. Steinhaus is otherwise unknown.

234. Ibid., January 22, 26-27, 30, 1930.

235. Ibid., February 2-3, 5-6, 1930.

236. Ibid., February 13, 18-19, 1930.

237. Ibid., March 2, 16-17, 1930.

238. Ibid., March 27-29, 31, 1930.

239. Ibid., April 1-5, 1930.

240. Ibid., April 5-6, 10-11, 1930. Orson James settled at the James Ranch in 1901 and sold it to Norman Church 20 years later. Pete Klinkhammer was reportedly a subsequent owner of it, Carrey and Conley, *River of No Return*, 203-204.

241. Shepp, [Diary], 1929-1930, April 12, 28, 1930. For more information on this eclipse, see timeanddate.com, "Solar and Lunar Eclipses Worldwide—Period from 1930-1939," available at http://www.timeanddate.com/eclipse/list.html?starty=1930 (accessed June 4, 2018).

242. Shepp, [Diary], 1929-1930, April 19, 1930.

243. Ibid., April 13-19, 21-26, 29, 1930.

244. Ibid., April 29-30, 1930.

245. "United States Census, 1930," database with images, FamilySearch (https://www.family-search.org/ark:/61903/3:1:33S7-9RH9-8L5?cc=1810731, accessed April 24, 2020), Polly Bemis, Dixie, Idaho, Idaho, United States; citing ED 10, sheet 1A, line 32, family 18, NARA microfilm publication T626 (Washington D.C.: National Archives and Records Administration, 2002), roll 400; FHL microfilm 2,340,135.

246. Shepp, [Diary], 1929-1930, May 29, 1930. Condon, a long-time Warren-area resident, was a former trapper and schoolteacher; in 1936 he was elected Justice of the Peace and subsequently received a monthly allowance, in the form of store credit for food, from Idaho County, Helmers, *Warren Times*, April 23, 1914; February 8, 1918; November 19, 1936; January 13, 1938; March 16, 1939.

247. "United States Census, 1930," database with images, FamilySearch (https://www.family-search.org/ark:/61903/3:1:33SQ-GRH9-ZP9?cc=1810731 accessed April 24, 2020), Polly Bemis, Warren, Idaho, Idaho, United States; citing enumeration district (ED) ED 57, sheet 1A, line 50, family 27, NARA microfilm publication T626 (Washington D.C.: National Archives and Records Administration, 2002), roll 400; FHL microfilm 2,340,135.

248. Jan MacKell, *Red Light Women of the Rocky Mountains* (Albuquerque: University of New Mexico, 2009), 175. For one, Polly's residence was given as "Dixon" rather than Dixie. Please don't ask me what I think of Polly being called a "Chinagirl," ibid., 172, 173, or of her even being included in a book with this title!

249. Here, Polly's surname, spelled correctly on the document, was misread and entered as "Berris," "United States Census, 1930," database with images, FamilySearch (https://www.familysearch.org/ark:/61903/3:1:33S7-9RH3-8MG?i=2&cc=1810731, accessed April 24, 2020), Polly Berris, South Fork, Valley, Idaho, United States; citing enumeration district (ED) ED 13, sheet 2A, line 48, family 70, NARA microfilm publication T626 (Washington D.C.: National Archives and Records Administration, 2002), roll 404; FHL microfilm 2,340,139.

250. Shepp, [Diary], 1929-1930, May 1-3, 6-11, 1930.

251. Ibid., May 12-13, 1930.

252. Ibid., May 22-23, 1930. We know that Harvey and "Red" were from the Forest Service because in June Shepp wrote, "Harvey, Forest [Service] packer, got arm & shoulder broke by mule at station," ibid., June 20, 1930. Later that month Shepp "Sent voucher to Forest [Service] for blankets $73.50" [that he had washed for them], ibid., June 27, 1930.

253. Ibid., May 23-24, 26, 1930.

254. Ibid., May 27, 1930.

255. Ibid., May 30-31, 1930.

256. Shepp, [Diary], 1929-1930, June 1-2, 5, 10-12, 14, 16, 1930. Pete was on a "prospecting trip"; Shepp also "Heard big [gold?] strike made by trail crew on Crooked [C]reek," ibid., April 1-2, 1930.

257. Ibid., June 16, 18-19, 1930.

258. Ibid., June 21-22, 1930. Nothing else is known about the Hockinstines. Polly's previous visit from a woman was in February 1926, Shepp, [Diary], 1926-1927, February 9, 1926.

259. Ibid., June 23-26, 29, 1930. Raccoons were considered pests for the damage that they can do to crops and buildings.

260. Ibid., July 3-4, 16-19, 1930.

261. Ibid., July 25-26, 1930. On July 28, an "airplane went over," ibid., July 28, 1930.

262. Ibid., July 31, August 1-2, 1930.

263. Ibid., August 3-4, 1930. Eimers is unknown. Eugene Olmsted was the editor of Grangeville's *Idaho County Free Press* from at least July 1929 until at least December 1941, Helmers, *Warren Times*, July 11, 1929; December 4, 1941.

264. Shepp, [Diary], 1929-1930, August 5-8, 1930.

265. Ibid., August 15-16, 1930.

266. Ibid., August 19, 1930.

267. Ibid., August 22, 1930.

268. Ibid., August 26, 29, 31, 1930.

269. Ibid., September 5-6, 14, 23-24, 1930.

270. Ibid., September 24, 29-30, 1930. It may seem odd that the men didn't try to shoot one for the meat, since mountain sheep were more approachable than other game animals. In order to keep them from becoming skittish, however, they weren't regularly hunted except in times of great need (Cort Conley, telephone conversation with author, February 5, 2019).

271. Ibid., October 5, 7, 1930.

272. Charles Shepp, [Diary], October 11, 1930, through October 1, 1931, photocopy, University of Idaho Library Special Collections, MG 155, October 11, 1930. This diary is written in an unused address book. The entries are sometimes too pale to be readable. "Peewee" is unknown, other than he was probably a Forest Service employee. The name appears earlier in the diaries, with no connection to Polly. It is difficult to read, so it might be a surname, spelled differently, rather than a nickname.

273. Ibid., October 13-14, 19-20, 1930.

274. November 11, 14-15, 19, 1930. On the 19th, Shepp received a check for $73.50 for washing the Forest Service's blankets, ibid., November 19, 1930.

275. Ibid., November 29, 1930.

276. Ibid., December 2, 18, 24-25, 27-28, 1930.

277. Ibid., January 1, 6-8, 1931.

278. Ibid., January 9-10, 12-16, 19-25, 26-31, 1931.

279. Ibid., February 2-7, 9, 12, 19, 21, 1931.

280. Ibid., March 20, 1931. Justin McCarty is otherwise unknown; a Warren resident, he registered for the draft in February 1918, Helmers, *Warren Times*, February 7, 1918.

281. Shepp, [Diary], April 1-4, 6-7, 9, 1931.

282. Ibid., April 15, 18-21, 30, 1931.

283. Cort Conley, telephone conversation with author, February 5, 2019.

284. Ibid., May 1, 4-5, 10, 15-16, 24-25, 1931. Shinkle is otherwise unknown.

285. Ibid., May 28, 1931.

286. Ibid., June 1, 5, 8-10, 1931.

287. Ibid.

288. Ibid., June 20, 22-24, 27, 1931.

289. *Idaho Daily Statesman*, "Million-Dollar Gold Camp Sold at Auction for $900," 67(292):1, July 1, 1931; "the land was detached from the Idaho national forest ... several years ago, the land reverting to the interior department. The purchase was necessary for the residents to establish their claims which they had first made as 'squatters.'" However, because the town was "wiped out" in the 1904 fire, the Warren buildings must all have been less than 27 years old.

290. Shepp, [Diary], 1930-1931, July 1-3, 1931.

291. Ibid., July 3-4, 1931. The *Encyclopedia of Cleveland History* details the "Schmeling-Stribling Fight," available at http://ech.case.edu/cgi/article.pl?id=SF (accessed June 4, 2018): "The Schmeling-Stribling fight was the first heavyweight championship match waged in Cleveland, and the first sporting event to take place in the newly completed Cleveland Municipal Stadium on July 3, 1931. It featured Max Schmeling, German-born heavyweight champion, against William L. 'Young' Stribling, a seasoned veteran of 300 bouts. Known as 'Young' Stribling because he had entered the ring at age 14, the fight built his credibility but proved to be his only chance at the title. Schmeling had fought 53 bouts with only 4 losses, defeating Jack Sharkey for the heavyweight championship of the world and was slightly favored to win by East Coast bookies, although Stribling, also known as 'Willie the Wrecker,' was the popular favorite. Ticket prices ranged from $3 to $25. During the match Schmeling ... delivered a staggering right-hand punch in the 9th round. In the 10th round, Schmeling decked his opponent, who regained his footing by the 9 count, but the referee declared Schmeling the victor. The Cleveland fight was the summit of Stribling's career, as he died from injuries received in a motorcycle accident in 1933."

292. Shepp, [Diary], 1930-1931, July 13, 15, 19, 1931.

293. Yin Ma, ed., *China's Minority Nationalities* (Beijing: Foreign Languages Press, 1989), 76.

294. Shepp, [Diary], 1930-1931, July 20, 25, 1931.

295. Ibid., August 2-5, 1931.

296. Ibid., August 3-7, 1931. The planes would have been looking for the location and direction of the fire; aerial firefighting was more than 20 years into the future. Gjettrup and Newton are otherwise unknown. They were from the Portland, Oregon, area, ibid., August 31, 1931, although Gjettrup may have been from Spokane, Washington, Charles Shepp, [Diary], October 1, 1931, through October 19, 1932, photocopy, University of Idaho Library Special Collections, MG 155, inside front cover. This diary is written in an unused address book. The entries are occasionally a bit pale.

297. Shepp, [Diary], 1930-1931, August 8-10, 13-20, 22, 24, 26-28, 30, 1931.

298. Ibid., September 1-2, 5, 7, 1931.

299. Ibid., September 11, 14, 16, 21-22, 24-25, 1931.

300. Ibid., September 26, 1931.

301. Ibid., September 26-30, 1931.

302. Ibid., October 1, 1931.

303. Ibid., October 2, 4, 6-9, 1931.

304. Ibid., October 3-6, 1931.

305. Ibid., October 8, 1931.

306. Ibid., October 10-14, 1931.

307. Ibid., October 15, 1931. Nixon was probably Bert Nixon, a Forest Service employee for whom Nixon Creek was named; see Carrey and Conley, *River of No Return*, 132, and M. Alfreda Elsensohn, *Pioneer Days in Idaho County*, vol. 2 (Caldwell, ID: Caxton), 89-90. This identification is strengthened because, at the same time, Shepp received a $16 check for fighting fire.

308. Shepp, [Diary], 1931-1932, October 20, 23, 25-29, 31, 1931.
309. Ibid., November 5, 7, 9, 12, 14, 18, 20, 1931.
310. Ibid., November 21, 1931. Steinhaus is otherwise unknown.
311. Ibid., November 21, 24, 26, 29, 1931.
312. Ibid., December 1, 9, 11, 16, 1931.
313. Ibid., December 20-21, 25, 31, 1931.
314. Ibid., January 1, 1932. Homer is unknown.
315. Ibid.
316. Shav Glick, "67 Years Later, Tulane Prevails," January 1, 1999, available at *Los Angeles Times*, http://articles.latimes.com/1999/jan/01/sports/sp-59555 (accessed May 21, 2018).
317. Shepp, [Diary], 1931-1932, January 2-5, 1932.
318. Ibid. January 6, 1932.
319. Ibid. January 7-9, 11-17, 1932.
320. Elsensohn, *Pioneer Days in Idaho County*, vol. 2, 264.
321. Shepp, [Diary], 1931-1932, January 18, 1932.
322. Chan Wallace, "King of Cougar Hunters Comes out of Wilds with Record Kill and Tale of Daring Adventures," *Lewiston Morning Tribune*, May 1, 1932, sec. 2, p. 1. Reprinted, *Lewiston Tribune*, "King of Cougar Hunters Comes out of Wilds with Record Kill and Tale of Daring Adventures," May 2, 2016, D1. A shortened version of the story, mentioning only Lowe's visit to Polly Bemis, appeared in a Boise newspaper, *Idaho Sunday Statesman*, "Idaho Chinese Woman Awaits Time to Rejoin Ancestors," 68(42):sec. 2, p. 3, May 8, 1932.
323. Shepp, [Diary], January 19-21, 1932.
324. Ibid. January 22-28, 1932.
325. Ibid. February 1, 5-9, 1932.
326. Ibid. February 10-21, 1932.
327. Ibid. March 12, 1932. Meanwhile, on Sunday, March 6, Shepp wrote, "Telephone line broke between W[ar] E[agle Mine] & Dixie." While this has no direct connection with Polly Bemis, it indicates the communications network that existed between the Shepp Ranch and the "outside," ibid., March 6, 1932.
328. Ibid. March 21-22, 27, 1932. Hinkler is unknown.
329. Ibid. April 8-11, 14, 1932.
330. Ibid. April 12-13, 1932.
331. Ibid. April 19-22, 1932.
332. Ibid. May 4, 8-9, 17, 1932.
333. Ibid. June 4, 29-30, 1932.
334. Ibid. June 12, 23-24, 1932.
335. Ibid. July 1-10, 1932. Charlie's father, Gus Schultz, was a local miner who had helped bury Charlie Bemis in 1922.
336. Ibid. July 17, 19, 21, 23-24, 27, 1932.
337. Ibid., July 28-30, 1932. One man was Vernon H. McFarlane, 720 N. 10th St., Walla Walla. The other man, who wrote to Shepp the following month, was John Sanders, 724 N. 11th Ave., Walla Walla, ibid., August 22, 1932.
338. *Idaho County Free Press*, "Boating Party Gets Thrills on Salmon," 48(4):1-2, August 11, 1932. Elmer Keith and Harry Guleke had become partners in late 1930, Elmer Keith, *Keith: An Autobiography* (New York: Winchester Press, 1974), 167. Florence Schultz was the cook for the July-August 1931 trip, ibid., 175-176. Three weeks previously, at a creek one-fourth mile above Warren Creek, "a cloudburst washed a side of the mountain into the river and this backed the stream up for about four miles. Where placid water had been encountered in the past[,] Captain Guleke found a raging torrent," *Idaho County Free Press*, "Boating Party Gets Thrills on Salmon," 1; Keith, *Autobiography*, 175. Elmer

Keith described the excitement in encountering the new, "awful rapids," noting, "the next spring [1933], high waters took the dam out and the river was back to normal from the[n] on," ibid., 176.

339. Shepp, [Diary], 1931-1932, August 2-4, 1932.

340. Ibid., August 9, 12, 14-15, 19-20, 1932.

341. Ibid., August 26, 1932.

342. Ibid., August 30-31, 1932.

343. Ibid., September 1, 4, 1932.

344. Ibid., September 1, 4, 6-7, 9, 11, 1932.

345. Ibid., September 11-12, 17, 1932.

346. Ibid., September 18, 20, 21, 1932.

347. Ibid., September 23, 25-26, 28, 1932.

348. Ibid., September 23, 25, 26-27, 1932.

349. Ibid., October 2, 4, 1932.

350. Ibid., October 9, 14-15, 19, 1932.

351. Charles Shepp, [Diary], July 18, 1933, through November 30, 1934, photocopy, University of Idaho Library Special Collections, MG 155.

352. Ibid., July 19, 1933. "On our spuds" implies that the potatoes belonged to Shepp and Klinkhammer.

353. Ibid., July 20-23, 25, 27, 31, 1933.

354. Ibid., August 2-3, 1933. On the 2nd Shepp mentioned that "The Pidgeon [sic] which came here som[e] 10 days ago [not mentioned earlier in the diary] got a tag on its leg," ibid., August 2, 1933.

355. Ibid., August 4-6, 1933. "Halfway house" was probably Adams Camp, also called a "halfway station." It was about midway between "the Hump Country" and Grangeville, Klinkhammer, interview 7. Adams Camp was a "way station on the old Florence road, 28 miles south of Grangeville," Elsensohn, *Pioneer Days in Idaho County*, vol. 2, 255. Dating to 1862, it "was a favorite stopping place on the old Milner Road. ... Here at the camp, the road forks, one branch turning south to Florence, the other continuing eastward to Buffalo Hump," M. Alfreda Elsensohn, *Pioneer Days in Idaho County*, vol. 1 (Cottonwood, ID: Idaho Corporation of Benedictine Sisters, 1965), 246-247.

356. Steve Wassmuth, e-mail message to Cort Conley, October 28, 2013. Wassmuth interviewed Carol Sue Hauntz, Ailor's daughter; Cort Conley shared this e-mail message. Another account states, "She was brought out by her guardians on horseback over some of the most rugged mountain country in the nation. At the War Eagle Mine they were met by Glenn Ailor and the balance of the trip was made in his ambulance," *Idaho County Free Press*, "Many Myths Connected with Chinese Polly Bemis," 80th Anniversary Edition, 79(49):sec. [8], p. 8, June 16, 1966.

357. *Lewiston Morning Tribune*, "Polly Bemis Ill," August 8, 1933, 10 (9 hours), and Robert Bunting, presentation at Bicentennial Historical Museum, Grangeville, Idaho, August 30, 2000, 2 (11 hours), notes in author's possession.

358. Shepp, [Diary], 1933-1934, August 6-7, 1933.

359. *Lewiston Morning Tribune*, "Polly Bemis Ill."

360. *Idaho County Free Press*, "Polly Bemis Brot [sic] Out," 49(13):1, August 10, 1933.

361. Frances Zaunmiller Wisner, *My Mountains: Where the River Still Runs Downhill*. (Grangeville, ID: *Idaho County Free Press*, 1987), 208.

362. *Hartford Courant*, "Chinese Woman Who Wed Conn. Yankee Is Ill," August 10, 1933, 4.

363. *Evening Independent*, "Polly Bemis Is Ill," August 10, 1933, [sec.] 1A, p. 1. There could well be additional newspapers with the story of Polly's illness, but no systematic search was made for them.

364. Shepp, [Diary], 1933-1934, August 4-6, 11, 1933.

365. Ibid., August 14, 17-18, 19, 21-25, 29, 1933.

366. M. Alfreda Elsensohn, *Idaho Chinese Lore* (Cottonwood, ID: Idaho Corporation of Benedictine Sisters, 1971), 87.

367. Shepp, [Diary], 1933-1934, September 3, 8, 1933.

368. Ibid., September 13, 15, 18, 1933.

369. Elsensohn, *Idaho Chinese Lore*, 87, and Elsensohn, *Pioneer Days in Idaho County*, vol. 1, 94. Brackets indicate how the quote is slightly different in the two versions.

370. Elsensohn, *Idaho Chinese Lore*, 87; Elsensohn, "Fourth Academy Day, 4. Brackets indicate a slight difference in the quotes.

371. Bunting, presentation, 3. Marion Eisenhauer was Robert Bunting's wife; Bertha Long was her grandmother. Marion, born April 8, 1925, FamilySearch, "Marion Eisenhauer Bunting," available at https://familysearch.org/ark:/61903/1:1:K5TW-74L (accessed June 4, 2018), would have been about six and a half years old in 1933, rather than eight years old.

372. Mrs. John D. (Bertha) Long, "Polly Bemis, My Friend," *Idaho County Free Press*, 80th Anniversary Edition, 79(49):sec. [8], p. 1, June 16, 1966.

373. The Chinese man's identity is unknown. In late August 2000, nearly 70 years after Bob Bunting's visits to Polly in the County Hospital, he recalled that the Chinese man in the hospital with Polly was named Ah Kan [also called "China Can" and "Sleepy" Kan], Robert Bunting, presentation, 2. However, the man couldn't have been Ah Kan because Kan wasn't taken to the County Hospital in Grangeville until February 1934, three months after Polly's death, *Idaho County Free Press*, "Warren: Ah Kahn [*sic*, for Kan]" 49(41), February 22, 1934. Kan died there March 10, 1934, ibid., "Chinaman Dies," 49(44):1, March 15, 1934.

374. Robert D. Bunting, "Sweet Peas for Polly," photocopy of typescript, June 1, 1993, [1-2], Bicentennial Historical Museum, Grangeville, Idaho. The published version is slightly different in places, Robert Bunting, "Sweet Peas for Polly," *Nostalgia Magazine*, May 2000, 36-37.

375. *Idaho Sunday Statesman*, "Romantic Figure of Warrens' Gold Camp Ill in Grangeville Hospital," 70(9):sec. 2, p. 4. September 24, 1933.

376. *Lewiston Morning Tribune*, "Indian Girl, Not Polly Bemis, Was Poker Bride, Warren Man Declares," October 1, 1933, sec. 2, p. 6; *Idaho County Free Press*, "Poker Bride Myth Says Mining Man," 49(21):6, October 5, 1933.

377. Shepp, [Diary], 1933-1934, October 1, 5-7, 9, 11, 15, 21, 31, 1933.

378. Ibid., October 7, 1933.

379. Ibid., October 7, 25, 1933. Johnnie may have been named for Johnnie Steinhaus, ibid., November 22 and 29, 1933.

380. *Idaho County Free Press*, "Local News Items," 'From Dixie,' 19(23):5, October 19, 1933.

381. Shepp, [Diary], 1933-1934, October 9, 25, 1933.

382. I am grateful to Gayle Dixon for this information, Gayle Dixon in Kevin Gray, e-mail message to author, March 3, 2004; Idaho County Commissioners, "Commissioners Record, 13" [1932-1938], (Idaho County Courthouse, Grangeville, ID, October 10, 1933), 164.

383. Ibid.

384. Shepp, [Diary], 1933-1934, November 1-2, 5, 1933.

385. Lamont Johnson, "Old China Woman of Idaho Famous. Polly Bemis Seriously Ill in Grangeville Hospital. Career Nearly Ended. Patient Denies That She Was Won in Poker Game by Man Who Later Married Her," *Sunday Oregonian*, 52(45):sec. 5, pp. 1, 3, November 5, 1933. A teaser for this article appeared in the previous day's newspaper: "Brought from China to the United States as a slave girl, Polly Bemis as a young woman found herself married to a white man living in the wilds of the Salmon [R]iver country

of Idaho," *Morning Oregonian,* "The Strange Career of Polly Bemis," 72(22,776): sec. 1, p. 8, November 4, 1933, "Tomorrow's *Sunday Oregonian* will [trace] the career of this little Chinese woman, one of Idaho's most celebrated characters."

386. Johnson, "Old China Woman of Idaho Famous," 3.

387. Lamont Johnson, letter to Sister M. Alfreda [Elsensohn], December 30, 1958, The Historical Museum at St. Gertrude, Cottonwood, ID.

388. Personal contacts with Johnson's relatives and with various repositories didn't locate the letter.

389. Shepp, [Diary], 1933-1934, November 6, 1933.

390. Bunting, presentation, 1.

391. Bunting, "Sweet Peas for Polly," [3]. The Grangeville newspaper actually devoted some 18 column inches to Polly's death, plus a photograph of her, *Idaho County Free Press,* "Romantic Figure of Gold Rush Day Dead," 49(26):1-2, November 9, 1933. Searches of New York and San Francisco papers didn't locate front-page mentions of Polly's death. Curiously, one Idaho newspaper, in reporting on Polly's death, stated that she "was smuggled into the United States from Canada and somehow found her way to the gold camps around Florence and Warrens, ...," *Twin Falls Daily News,* "Polly Bemis, Romantic Figure of Gold Rush Days in Idaho, Dies at Age of 81," 16(183):1, November 7, 1933.

392. Shepp, [Diary], 1933-1934, November 6-8, 1933. The news about Polly must have come by telephone.

393. Judy Smith, "Polly Bemis," in *Tsceminicum (Meeting of the Waters) The Clearwater and The Snake Rivers,* ed. Gladys Swank and Nellie Woods, 74-77. (Lewiston, ID: Lewis-Clark Chapter Idaho Writers League, 196-?), 77.

394. [Idaho County], "Record and Bill of Items for the Funeral of Polly Bemis," November 6, 1933. Photocopy kindly provided to author by Carol Sue Hauntz, daughter of mortician Glenn Ailor.

395. Ibid. Chipman, the physician, is otherwise unknown. Rev. R. F. Jameson, who officiated at her burial, is mentioned in a later *Idaho County Free Press* article, "Many Myths Connected with Chinese Polly Bemis," 80th Anniversary Edition, 79(49):sec. [8], p. 8, June 16, 1966.

396. Robert Bunting, presentation, 2. Walker is otherwise unknown.

397. No reference to Polly's funeral was found in the minutes for the Grangeville City Council. If it was, instead, the County Commissioners, no record was found of their participation either.

398. [Idaho County], "Record and Bill of Items for the Funeral of Polly Bemis." Curiously, the date for the charges is given as November 6, rather than the burial date of November 8. Ailor Mortuary received an Idaho County payment "warrent" [*sic,* for warrant] on January 13, 1934. A notation at the bottom of the form reads "Paid in full" above "1/13/34."

399. Bunting, "Sweet Peas for Polly," [3]. The afternoon funeral was confirmed in the *Idaho County Free Press,* "Romantic Figure of Gold Rush Day Dead."

Chapter Nine: Exposing Myths and Inaccuracies about Polly Bemis

1. E.g., Benson Tong, in *Unsubmissive Women: Chinese Prostitutes in Nineteenth-Century San Francisco* (Norman: University of Oklahoma Press, 1994), 22-23, calls Polly "... perhaps the most legendary Chinese prostitute outside San Francisco," 22. Some of the other sources who also perpetuate the myth of Polly as a prostitute include Patricia Hogan, "Bemis, Polly" in *Encyclopedia of the American West,* ed. Charles Phillips and Alan Axelrod, vol. 1, p. 134 (New York: Simon & Schuster Macmillan, 1996); Wendolyn Spence Holland, *Sun Valley: An Extraordinary History* (Ketchum: The Idaho Press, 1998), 113; F. Ross Peterson, *Idaho, a Bicentennial History* (New York: W. W. Norton and Nashville: American Association for State and Local History, 1976), 59; and Rebecca Stefoff, *Women Pioneers*

(New York: Facts on File, 1995), 107-113. Judy Yung, in her otherwise-reliable *Chinese Women of America* (Seattle: University of Washington Press, 1983), 19, 23, places Polly in her "Prostitutes" chapter.

2. Tong, *Unsubmissive Women*, 22-23. In just two pages, Tong managed to include numerous inaccuracies about Polly. For example, she was not "thirteen" in 1872, Charlie Bemis was not "burned to death" in their house fire, and she did not provide "succor to the sick and ailing in the community of Grangeville City," ibid. Another book refers to Polly Bemis as a "probable prostitute"; like other Chinese prostitutes, who were "bright, tough, and able to overcome their initially bad situations," Polly exemplifies women who "escaped lives of subjection by marrying white men," Bennet Bronson and Chuimei Ho, *Coming Home in Gold Brocade: Chinese in Early Northwest North America* (Seattle: Chinese in Northwest America Research Committee, 2015), 189.

3. *Idaho Daily Statesman*, "Polly Bemis of Warren's Diggins Sees City's Sights, for First Time," 61(8):2, August 4, 1924.

4. Lamont Johnson, "Old China Woman of Idaho Famous. Polly Bemis Seriously Ill in Grangeville Hospital. Career Nearly Ended. Patient Denies That She Was Won in Poker Game by Man Who Later Married Her," *Sunday Oregonian*, 52(45):sec. 5, p. 1, November 5, 1933. During parts of 1923 and 1924, she had a restaurant in her Warren home.

5. US Bureau of the Census, *Tenth Census (1880), Idaho Schedules, Idaho County* (Washington, DC: National Archives, 1880), Washington Precinct, 3. When the previous census was taken, in 1870, Polly had not yet arrived in Warren, so the 1880 census is the first one that could have listed her.

6. Ibid.

7. Ibid. "Pekin[g]" is an earlier transliteration for what is now written as Beijing. Its use doesn't mean that Polly was actually from that city, but from somewhere in northern China.

8. Eleanor Gizycka, "Diary on the Salmon River," part 2, *Field and Stream* 28:6 (June 1923), 278.

9. Maria Jaschok, *Concubines and Bondservants: A Social History* (Hong Kong: Oxford University Press, 1988), 13; a "great market in human beings ... flourished ... in China and Hong Kong."

10. Alexander McLeod, *Pigtails and Gold Dust: A Panorama of Chinese Life in Early California* (Caldwell, ID: Caxton, 1948), 175.

11. Gizycka, "Diary on the Salmon River," 278.

12. Priscilla Wegars, "Polly Bemis: Lurid Life or Literary Legend?," in *Wild Women of the Old West*, Glenda Riley and Richard W. Etulain, eds. (Golden, CO: Fulcrum, 2003), 48.

13. Johnson, "Old China Woman of Idaho Famous," 1.

14. Kathleen Whalen Fry, "Rendering Polly: The Romanticization, Manipulation[,] and Decontextualization of One Chinese Woman's History in the American West," (master's thesis, Washington State University, Pullman, 2006), 23.

15. Ruthanne Lum McCunn, *Thousand Pieces of Gold* ([San Francisco]: Design Enterprises of San Francisco, 1981), reprint (Boston: Beacon Press, 1988).

16. E.g., M. Alfreda Elsensohn, *Idaho County's Most Romantic Character: Polly Bemis* (Cottonwood, ID: Idaho Corporation of Benedictine Sisters, 1979), 16-17; McCunn, *Thousand Pieces of Gold*, 105-106.

17. US Department of Internal Revenue, Internal Revenue Assessment Lists for the Territory of Idaho 1867-1874, Roll 1, "Annual, Monthly, and Special Lists 1867-74," Microfilm Publication T1209 (Washington, DC: National Archives and Records Service, 1977), 1870, [4]; 1871, [1].

18. M. Alfreda [Elsensohn], letter to Mr. Cox, March 7, 1943, Cottonwood, ID: The Historical Museum at St. Gertrude. Today, the word "Chinaman" is viewed as a racist term that should no longer be used because it recalls earlier days of anti-Chinese discrimination.

19. M. Alfreda Elsensohn, *Pioneer Days in Idaho County*, vol. 1 (Cottonwood, ID, Idaho Corporation of Benedictine Sisters, 1947), 94.

20. Polly's purchase price, $2,500, would be more than $56,000 today, "The Inflation Calculator," available at http://www.westegg.com/inflation/infl.cgi (accessed June 25, 2018).

21. US Bureau of the Census, *Ninth Census (1870), Idaho Schedules, Idaho County* (Washington, DC: National Archives, 1870), Washington Precinct, 9.

22. Emma Woo Louie, e-mail message to author about use of "Ah" before names, May 18, 2016, and her *Chinese American Names: Tradition and Transition* (Jefferson, NC: McFarland, 1998), 98-99, 111. Her website, "Chinese American Surnames," available at http://chineseamericansurnames.com/ (accessed June 19, 2018), has additional information.

23. US Bureau of the Census, *Ninth Census (1870), Idaho Schedules, Idaho County*, Washington Precinct, 7. It is unknown how wealth figures were obtained. It may have been self-reported, or possibly the census taker estimated it.

24. Gayle Dixon, e-mail message to author, April 16, 2014.

25. Idaho County, Deeds, "Deed Record 3 & 4" (Idaho County Courthouse, Auditor-Recorder, Grangeville, ID), [1870-1879]), 289-291 (D. B. McConnell to Ah King, 1875) and 345-346 (Ah King to Ah Hong, 1876; it was the identical property in Warren). Thanks to Gayle Dixon for copies of these documents.

26. *Idaho County Free Press*, "Our Solid Muldoons," 1(17):4, October 8, 1886.

27. *Idaho County Free Press*, " Our Solid Muldoons," 2(20):4, October 28, 1887. Other Chinese people or companies on the list included Chung Kee, $1,100; Fook Sing Co., $1,100; Lune Wah Co., $1,000; Quang Sing Hong, $3,520; and Shune Lee Co., $1,000.

28. "Patterson Store Ledger," Payette National Forest, McCall, Idaho, [1891, 1893-1895], [2]. Page 2 is continued from Page 1, which is headed, "E. E. Patterson" [Elmer E.] and "Bought of Kelly and Patterson," ibid., [1]. Kelly was William J. Kelly and Patterson was George L. Patterson, the two witnesses at the Bemis wedding on August 13, 1894. Ledger entries for 1891 give the store's name as Kelly and Brown, "Patterson Store Ledger," [10], and for 1893, Kelly and Morris, ibid., [13]. In October 1893, Fred Morris, Kelly's stepson, sold his share of the store and returned to Kansas, Cheryl Helmers, *Warren Times: A Collection of News about Warren, Idaho* (Odessa, TX: The Author, 1988), October 13, 1893. According to Jeffrey M. Fee, e-mail message to author, January 17, 2001, Warren resident Harry Vaux gave Fee a copy of the ledger pages. Vaux reportedly got the ledger from Otis Morris, younger stepson of William J. Kelly; Morris's mother married Kelly in 1891. Otis ran the store from at least 1934 on, Helmers, *Warren Times*, April 26, 1934.

29. *Idaho Sunday Statesman*, "Romantic Figure of Warrens' Gold Camp Ill in Grangeville Hospital: Czizek Explodes Myth of Chinese Poker Bride," 70(9):sec. 2, p. 4, September 24, 1933; also paraphrased in Johnson, "Old China Woman of Idaho Famous," 1.

30. "Chin Tan Sun's Millions," *Taranaki Herald*, 48(8), issue 11572, September 29, 1900, supplement, available at National Library of New Zealand, https://paperspast.natlib.govt.nz/newspapers/TH19000929.2.48# (accessed June 19, 2018). The article affirms that Chin Tan Sun was known as "Big Jim." He arrived in the United States about 1870 and made his way to Ogden, Utah. Although Idaho is not mentioned, could Warren have been his first stop, or was Warren's "Big Jim" a different person? I am grateful to Tina Huie for this reference, and to Bob Baldwin for his assistance.

31. C. Y. Lee, "China Polly," in his *Days of the Tong Wars* (New York: Ballantine, 1974), 77.

32. J. Loyal Adkison, "The Charles and Polly Bemis Story As Told to Me by Taylor Smith," typescript (Cottonwood, ID: The Historical Museum at St. Gertrude, [1950s?]), 3.

33. Charles Kelly, "He Won His Wife in a Poker Game, *The Pony Express* 36:9 (No. 429, February 1970), 3, 4.

34. Candy Moulton, "Renegade Roads, Riches for Chinese Miners: Following Their Intermountain West Trail from Boise, Idaho to Rock Springs, Wyoming," *True West* 58:4 (April 2011), 106.

35. Jeff C. Dorough, Joe D. Dorough, and Marybeth Dorough, *Women of the West*, vol. 1, *Frontier Life* ([Fresno, CA]: Dorough Enterprises, 1992), V-22.

36. Arlene J. Fitzgerald, "The Chinese Tong Wars—of California!" *Golden West* 8:4 (March 1972), 61. Supposedly, the four men had bought "Ah Toy" [Polly] in San Francisco for $40.00, and, once in Warren, "Shun Wo" later bought out the other three men. In 2019 dollars, $40 would be more than $830.00, "The Inflation Calculator."

37. Elsensohn, *Pioneer Days in Idaho County*, vol. 1, 97. Polly is briefly mentioned in a 1960 article as "Lalou Natoy," Hal G. Evarts, "The Pioneers of Lonely Canyon," *Saturday Evening Post*, 232(46), 132, May 14, 1960.

38. I am grateful to Gayle Dixon for this information, Gayle Dixon in Kevin Gray, e-mail message to author, March 3, 2004; Idaho County, Marriages, "Marriage Record, Probate Court" [1890-1911] (Idaho County Courthouse, Grangeville, ID), index - B, and 49. Thanks also to Samuel Couch for his assistance with clarifying these details.

39. Ibid., index - H.

40. Ibid., 49.

41. Emma Woo Louie, letter to author, June 7, 2000.

42. Fitzgerald, "The Chinese Tong Wars—of California!," 15, 61. Fitzgerald provides a unique explanation for how Charlie and Polly got together: "Bemis eventually married Ah Toy after her Chinese owner hired her out to him as his nurse," ibid., 15.

43. Wu Anqi (also Qi-An), e-mail message to author, November 24, 2002. Curiously, Ruthanne Lum McCunn received a contradictory reply to a similar question of the Institute. They referred her to a scholar in the Research Department on Northeastern and Inner Mongolian Nationalities who stated that "Lalu means 'Islam' and Nathoy, pronounced Nasoi, 'Long Life,'" McCunn, "Reclaiming Polly Bemis," in *Portraits of Women in the American West*, ed. Garceau-Hagen, 171.

44. Wu Chizhe, letter to author, February 7, 1998.

45. "Behind the Name: The Etymology and History of First Names," available at http://www .behindthename.com/ (accessed June 19, 2018). "Lalu" is not given. One article calls her "Lulu Nat Hoy," Kelly, "He Won His Wife in a Poker Game, 4, but that is surely a misreading of "Lalu Nathoy," as is another author's "Laula Nathoy," Roscoe LeGresley, "Polly Bemis: A Name Which Is Still Legendary along the Wild Salmon River," 1960s?, 1; typescript courtesy Jacqulyn LeGresley Haight, photocopy in Asian American Comparative Collection, University of Idaho, Moscow.

46. "Behind the Name: The Etymology and History of First Names."

47. Charles Shepp, [Diary], July 1, 1916, through June 3, 1917, photocopy, University of Idaho Library Special Collections, MG 155, April 21, 1917.

48. George J. Bancroft, "China Polly—A Reminiscence," [handwritten title], typescript; photocopy at Denver Public Library, L 29, Box 4, FF56, and at The Historical Museum at St. Gertrude, Cottonwood, ID [Manuscript A], and his "China Polly—A Reminiscence." [Handwritten title and (Lalu Nathoy 1862 [*sic*]-1933)], [Manuscript B], typescript, photocopy on oversize paper at Denver Public Library, L 29, Box 21, FF110, and at the Idaho State Historical Society, MS 2/13.

49. Bancroft, "China Polly," [Manuscript A], 5.

50. Elsensohn, *Pioneer Days in Idaho County*, vol. 1, 92-98.

51. Bancroft, "China Polly," [Manuscript B], 1.

52. Manuscripts A and B, 5.

53. Caroline Bancroft, "China Polly: From Dancing Girl to Western Idol," typescript, Denver Public Library, Western History Department, L 29, Box 21, FF110, [1953?].

54. Caroline Bancroft, "The Romance of China Polly," *Empire*, the magazine of the *Denver Post*, 4(47):48-49, November 29, 1953.

55. Bancroft, "China Polly."

56. Robert Seto Quan, *Lotus among the Magnolias: The Mississippi Chinese* (Jackson: University Press of Mississippi, 1982), 133.

57. Maxine (Max) Chan, conversation with Priscilla Wegars, July 22, 2000, notes in Asian American Comparative Collection, University of Idaho.

58. National Archives at Seattle, "Judgment: The United States vs. Polly Bemiss" [*sic*], Judgment Roll 181, Record Group 21, National Archives at Seattle, Seattle, Washington, 1896, 2. The page with the characters is numbered "2" but it is actually page [6]; there is an earlier page 2 in the document.

59. Casual conversations; individuals' names not recorded at the time.

60. E.g., Ben Bronson, e-mail to author, March 23, 2012, and Ruthanne Lum McCunn, "Reclaiming Polly Bemis: China's Daughter, Idaho's Legendary Pioneer," *Frontiers: A Journal of Women Studies* 24:1 (2003), 94, and Chinese in Northwest America Research Committee (CINARC), "Chinese Women in the Northwest," (scroll down to Polly Bemis), available at http://www.cinarc.org/Women.html#anchor_286 (accessed June 19, 2018); the site contains some inaccurate information, such as Polly's birth year [actually, 1853], arrival in the United States [actually 1872], and 1906 [actually 1896] for her Certificate of Registration.

61. E.g., Louie, *Chinese American Names*.

62. "Occam's (or Ockham's) razor is a principle attributed to the 14th-century logician and Franciscan friar William of Ockham," Surrey, England, "Physics FAQ," original by Phil Gibbs, 1996; updated by Sugihara Hiroshi, 1997, "What is Occam's Razor?," available at http://math.ucr.edu/home/baez/physics/General/occam.html (accessed June 27, 2018). A newspaper column by Eugene Robinson alerted me to the principle of Occam's razor, "Trump on Track to Make America Second Rate Again," *Lewiston Tribune*, December 18, 2016, 4F. The principle is that the "razor" slices away the competing theories.

63. Emma Woo Louie, letter to author, June 7, 2000.

64. Emma Woo Louie, e-mail message to author and to Ben Bronson, March 23, 2012.

65. Gorden Lee, personal communication to author, 1993.

66. *Nez Perce News*, "From Warrens and Florence," 1(50):1, August 11, 1881.

67. Johnny Carrey, "Questions for Johnny Carrey, #7, 8/25/97," Question 1, US mail interview by Priscilla Wegars, copy in Asian American Comparative Collection, University of Idaho, Moscow.

68. Evarts, "Pioneers of Lonely Canyon," 132.

69. Ibid.

70. Johnson, "Old China Woman of Idaho," 1. If Polly had heard the story in her lifetime, as seems possible, she and Charlie might have amused themselves and others with it, until, nearing death, she repudiated it.

71. Historian Margaret Day Allen, briefly writing about Polly Bemis, had not seen Johnson's article, since, in commenting about the poker game myth, she wrote, "Either she [Polly] or Bemis presumably would have disclosed to someone during their years together how much truth there was in the poker game story—had the question been asked. Since there is no evidence that it was, it is probably safe to assume that there was no such story until after Polly died," *Lewiston Country: An Armchair History* ([Lewiston, ID]: Nez Perce County Historical Society, 1990), 129.

72. Georganne Slifer, "Push-Pull-Push," paper written for Dr. Carlos Schwantes's Idaho and the Pacific Northwest history class, fall semester 1988, photocopy of typescript in Asian American Comparative Collection, University of Idaho, Moscow.

73. Slifer, "Push-Pull-Push," [10]. Lee Dick wasn't in Warren in 1890 (Chapter Two).

74. Otis Morris, interview by Herb McDowell, 1964. Tape and partial transcript at Asian American Comparative Collection, University of Idaho, Moscow, and at University of Idaho Library Special Collections, Moscow. Otis Morris was born October 30, 1885, and died October 24, 1972, "Find a Grave," available at http://www.findagrave.com/ (accessed June 19, 2018). On the tape, Morris states that he was 78 years old at the time of recording, so the date was most likely some time in 1964. Morris was five when his family moved to Warren in 1890, M. Alfreda Elsensohn, *Idaho Chinese Lore* (Cottonwood, ID: Idaho Corporation of Benedictine Sisters, 1970), 80. Morris was also the nephew of George Patterson, the other witness at the Bemises' 1894 wedding.

75. Morris, interview. William J. (W. J.) Kelly, who arrived in Warren in 1864, died on September 29, 1911, "Passing of a Warren Pioneer," *Idaho County Free Press*, 26[20]:1, October 12, 1911.

76. Morris, interview. Jay Czizek was one of Polly's former boarders.

77. Slifer, "Push-Pull-Push," [10].

78. Ibid.

79. According to Cort Conley, who knew Shiefer, "Fred had no interest in promoting a movie about her," Cort Conley, telephone conversation with author, February 7, 2019.

80. Herb McDowell, telephone interview with author, January 23, 1997, corrected March 16, 1997. Notes in author's possession.

81. Herb McDowell, telephone interview with author, January 10, 1997.

82. McDowell, telephone interview, January 23, 1997.

83. Herb McDowell, "People [Who] Lived in Warren or Had Interests in Mines in Warren," photocopy of handwritten list, Historic 1680 Files, Cultural Resources, Payette National Forest, McCall, ID, August 1987. Thanks to Larry Kingsbury for providing a copy of this document.

84. McDowell, telephone interview, January 23, 1997. In a later telephone interview McDowell said that Goldwyn used to take the kids fishing, Herb McDowell, telephone interview with author, September 16, 1997.

85. Taylor Smith, letter to M. Alfreda Elsensohn, August 26, 1958, The Historical Museum at St. Gertrude, Cottonwood, ID, 2. The five men were W. J. Kelly, Geo. [George] Patterson, Geo. [George] Reibold, "Three-fingered" Smith [Sylvester Smith], Poney [*sic*, for Pony, A. D.] Smead, "and others long gone," 2.

86. Lucille Moss, letter to author, June 12, 1997. Moss's father, Fred Biggerstaff, was the first "Forest Ranger" in the Chamberlain Basin and later owned a store in Warren, Helmers, *Warren Times*, December 1908/January 7, 1909, and November 14, 1919. Whether Biggerstaff was actually the District Ranger is unknown; technically, the title of Forest Ranger only applies to the person who is the District Ranger, Cort Conley, personal communication to Priscilla Wegars, 2018.

87. *Moscow-Pullman Daily News*, "Nygreen – 50th," October 18-19, 2003, 3D.

88. Gizycka, "Diary on the Salmon River," 278.

89. *Idaho County Free Press*, "Woman of 70 Sees Railway First Time," 39(14):1, August 16, 1923; *Idaho County Free Press*, "Polly Awakened," 39(14):3, August 16, 1923; *Idaho County Free Press*, "Polly Returns to Warren after Happiest Days in Fifty Years," 39(15):1, August 23, 1923.

90. *Idaho Daily Statesman*, "Polly Bemis of Warren's Diggins," and *Idaho County Free Press*, "Polly Bemis Has Big Time on Visit to the State Capital," 40(13):5, August 7, 1924.

91. Chan Wallace, "King of Cougar Hunters Comes out of Wilds with Record Kill and Tale of Daring Adventures," *Lewiston Morning Tribune*, May 1, 1932, sec. 2, p. 1. Reprinted with no byline, *Lewiston Tribune*, "King of Cougar Hunters Comes out of Wilds with Record Kill and Tale of Daring Adventures," May 2, 2016, D1.

92. Charles Shepp, [Diary], October 1, 1931, through October 19, 1932, photocopy, University of Idaho Library Special Collections, MG 155, January 18, 1932. This diary is written in an unused address book. The entries are occasionally a bit pale.

93. Wallace, "King of Cougar Hunters."

94. Ibid.

95. *Lewiston Morning Tribune*, "Polly Bemis Ill," August 8, 1933, 10.

96. Robert G. Bailey, *River of No Return (The Great Salmon River of Idaho): A Century of Central Idaho and Eastern Washington History and Development, Together with the Wars, Customs, Myths, and Legends of the Nez Perce Indians* (Lewiston, ID: Bailey-Blake Printing, 1935), revised (Lewiston, ID: R. G. Bailey Printing, 1947) and revision reprinted (Lewiston, ID: Lewiston Printing, 1983).

97. If Bailey was then, if ever, the editor of the *Lewiston Morning Tribune*, issues of the newspaper between 1932 and 1925 don't bear his name; they just mention "Tribune Publishing Co."

98. Bailey, *River of No Return*, 678. This and later citations are to the 1983 edition.

99. Ibid.. Bailey thus implies that the supposed poker game happened in 1872, shortly after Polly's arrival in Warren; she turned 19 in September 1872.

100. Ibid., 678-679.

101. Ibid., 679.

102. Bancroft's dates come from a handwritten addition to the undated, typed manuscript, "Central Idaho," by Geo. J. Bancroft. photocopy in Asian American Comparative Collection, University of Idaho, Moscow.

103. George J. Bancroft, "China Polly."

104. Shepp, [Diary], 1916-1917, April 21, 1917. The entry reads, "Bancroft & Curtis down from Warren to look at mine." In later years, Bancroft wrote that he and Wm. [William] H. Day, Jr., of Dubuque, Iowa, bought the War Eagle Mine in 1917 and "slowly developed it. Sickness and death delayed the game but the mine finally came in last summer [date unknown]. ... The mine is located on Crooked Creek about four miles from the Salmon [River]. It is midway between Warrens and Buffalo Hump," Bancroft, "Central Idaho," 2-3. The War Eagle Mine "was discovered by Bill Boyce in 1898, and several adits were driven to develop the vein. From 1928-1935 a hydro-power plant and mill were put into operation. The ore concentrates were hauled by mule to Dixie, then stored in Grangeville until a truck load was available for the smelter in Seattle," Johnny Carrey and Cort Conley, *River of No Return* (Cambridge, ID: Backeddy Books, 1978), 214.

105. Bancroft, "China Polly," 1-2. Subsequently, Bancroft actually specified that Polly had been a prostitute: "From the time that Polly married Bemis she became strictly a one-man-dog so far as her sexual relations were concerned ...," ibid., 4.

106. Bancroft, "China Polly," 2.

107. Shepp, [Diary], 1916-1917, April 21, 1917.

108. Bancroft, "China Polly," 2.

109. Ibid., 3.

110. Ibid.

111. *Idaho Sunday Statesman*, "Romantic Figure of Warrens' Gold Camp Ill in Grangeville Hospital," repeated as *Idaho County Free Press*, "Poker Bride Myth Says Mining Man," 49(21):6, October 5, 1933. "Molly" was Molly Smead, the wife of Amasa D. "Pony" Smead, the Justice of the Peace who married Polly and Charlie Bemis. The 1880 Warren census lists her as a 22-year-old Indian woman whose oldest child was seven years old. The children are all recorded as "HB," for "half-breed." Molly Smead was also not a "poker bride." Smead and his mining partners needed a cook, so traded a horse and some flour for her; she was just ten years old. Smead later bought the others out, and married her, Johnny Carrey, "Moccasin Tracks of the Sheepeaters," in *Sheepeater Indian Campaign (Chamberlain Basin Country)* (Grang[e]ville, ID: Idaho County Free Press, 1968), 38.

112. *Idaho Sunday Statesman*, "Romantic Figure of Warrens' Gold Camp Ill in Grangeville Hospital."

113. Johnson, "Old China Woman of Idaho."

114. Walter Mih, "The Life of Polly Bemis," *Asian American Comparative Collection Newsletter*, 32(3):6, September 2015.

115. Walter Mih, "The Life of Polly Bemis (continued from September 2015)", *Asian American Comparative Collection Newsletter*, 32(4):2, December 2015. Polly's owner could have "ordered" a woman to be sent to him from China. In that case; she would have been sold once, by her father, and not again until she arrived in Portland.

116. Jaschok, *Concubines and Bondservants*, 31.

117. Jenny Ashford, "[Polly Bemis]," formerly available at https:suite.io/jenny-ashford/3k6b2jz (accessed November 6, 2014). Photocopy in Asian American Comparative Collection, University of Idaho, Moscow.

118. Christopher Corbett, *The Poker Bride: The First Chinese in the Wild West* (New York: Atlantic Monthly Press, 2010), 5.

119. Eleanor Gizycka, "Diary on the Salmon River," part 2, *Field and Stream* 28:6 (June 1923), 278.

120. Ashford, "[Polly Bemis]."

121. Lori Otter and Karen Day, *Ida Visits 150 Years of Idaho* (Boise: ID: Idaho State Historical Society, 2013), 24.

122. Kathryn L. McKay, *Hidden Treasure: Historical Overview of the Dixie Mining District, Idaho County, Idaho* (Columbia Falls, MT: The author, 1996), 262.

123. Robert Bunting, "Sweet Peas for Polly," *Nostalgia Magazine*, May 2000, 36.

124. Kelly, "He Won His Wife in a Poker Game," 4. No information could be located on the need for permits to work on the Central Pacific Railroad. However, the Alien Registration Card, or "Green Card," today's Permanent Resident Card, was not issued until 1940, CitizenPath: Immigration Forms Made Simple, "History of the Green Card," available at https://citizenpath.com/history-green-card/ (accessed February 7, 2019). The Green Card "became coveted proof that the holder was entitled to live and work indefinitely in the United States."

125. Elsensohn, *Idaho County's Most Romantic Character*, 21-22.

126. E.g., Gizycka, "Diary on the Salmon River," 278; *Idaho Daily Statesman*, "Polly Bemis of Warren's Diggins"; *Idaho County Free Press*, "Polly Bemis Has Big Time" and "Woman of 70 Sees Railway"; Johnson, "Old China Woman of Idaho."

127. Fern Coble Trull, "The History of the Chinese in Idaho from 1864 to 1910" (master's thesis, University of Oregon, Eugene, 1946), 102.

128. *Idaho County Free Press*, "Warrens Notes," 'C. A. Bemis ...,' 8(51):4, May 25, 1894.

129. Idaho County, Mining Claims, "Placer Locations, Book 9" [1896-1899] (Idaho County Courthouse, Auditor-Recorder, Grangeville, ID), 522.

130. Evarts, "Pioneers of Lonely Canyon," 132.

131. Kelly, "He Won His Wife in a Poker Game," 4.

132. Bailey, *River of No Return*, 675.

133. *Idaho County Free Press*, "Polly Returns to Warren."

134. Tong, *Unsubmissive Women*, 23.

135. Elsensohn, *Idaho Chinese Lore*, 83-87 are the pages that Tong cited.

136. Peter (Pete) Klinkhammer, interviewed by Jayne Brown, Shepp Ranch, 1968, transcribed by Bailey Cavender and checked by Priscilla Wegars, transcription in author's possession, 12.

137. *Idaho County Free Press*, "Polly Bemis Qualified to Remain in U.S," 79[49]:sec. [8], p. 1, June 16, 1966.

138. *Idaho County Free Press*, "Many Myths Connected with Chinese Polly Bemis," 79[49]:sec. [8], p. 1, June 16, 1966.

139. Frances Zaunmiller Wisner, *My Mountains: Where the River Still Runs Downhill*, ed. Donna L. Henderson (Grangeville, ID: *Idaho County Free Press*, 1987).

140. Frances Zaunmiller Wisner, "History of Canyon of Salmon Would Fill Set of Books, But Frances Goes into Highlights," *Idaho County Free Press*, Bicentennial Edition, 90(3): 2A-5A, June 30, 1976, 3A, and Wisner, *My Mountains*, 208.

141. This phrase was codified in the California Alien Land Law of 1913 and in the US Immigration Act of 1924.

142. With China our ally in World War II, it was ridiculous that the US denied citizenship to people born in China. People born in Japan could only become naturalized following passage of the McCarran-Walter Act in 1952, *Densho Encyclopedia*, "Immigration Act of 1952," available at http://encyclopedia.densho.org/Immigration_Act_of_1952/ (accessed July 3, 2019).

Chapter Ten: Epilogue, Polly Bemis's Legacy

1. Charles Shepp, [Diary], July 18, 1933, through November 30, 1934, photocopy, University of Idaho Library Special Collections, Manuscript Group [henceforth MG] 155, November 10, 14, 16, 22, 29, 1933.

2. Ibid., December 6, 14, 21, 24, 28, 1933. According to Pete Klinkhammer, Alec Blaine worked for the Forest Service in the summer and spent winters at the Shepp Ranch, Peter (Pete) Klinkhammer, interviewed by Jayne Brown, Shepp Ranch, 1968, transcribed by Bailey Cavender and checked by Priscilla Wegars, transcription in author's possession, 31-32. Blaine died in 1940 and is buried at the Shepp Ranch.

3. Mrs. Chester Frost, "Ah Sam, Chinaman at Warren, Called," *Idaho County Free Press*, 49(33):1, December 28, 1933. Although this article states that Ah Sam "took out his naturalization papers when only 19 years old," that is unlikely because people born in China were not allowed to become naturalized until 1943. The Chinese Exclusion Act became law in 1882, about the same time that Ah Sam was 19.

4. *Idaho Daily Statesman*, "Mining Camp of Warren Mourns Loss of Its Mayor," 70(133):1, December 27, 1933. "China Sam" was the "aged Oriental 'mayor' of Warren and long time miner and handyman of the community …. For at least 50 years he is known to have picked away at a small mining claim and done odd jobs around town for his friends. He had been offered work by several mining companies but declined with thanks, preferring to be his own boss. For many years he has been the town caretaker. In the absence of families associated with gold dredging properties he has cared for their houses and gardens and took pride in the appearance of his town. For this community service he was dubbed 'mayor' and was so known to his many friends."

5. Frost, "Ah Sam, Chinaman at Warren, Called"; Ah Sam came to the United States when quite young …. He lived for some time near Portland, later coming to the Salmon River country where he placer mined for gold. During this time he began packing into the Warren country which he continued doing for many years, later making his home there. Then he want to Grangeville, where he owned a restaurant for a few years. After selling this he returned to Warren where he made his home until his death."

6. Shepp, [Diary], 1933-1934, January 2, 11, 16, 1934.

7. Ibid., February 1, 1934.

8. Cheryl Helmers, *Warren Times: A Collection of News about Warren, Idaho* (Odessa, TX: The Author, 1988), January 26, 1928.

9. Ibid., January 21, 1932. At least, that is what people perceived. More likely, he was trying to melt the snow off a path or trail, Cort Conley, note to author, 2018.

10. *Idaho County Free Press*, "Warren," 'Ah Kahn ...,' 49(41):3, February 22, 1934. "Chic Walker, pilot of the McCall airplane," took him out, *Idaho County Free Press*, "Chinaman Dies," 49(44):1, March 15, 1934.

11. Helmers, *Warren Times*, March 15, 1934.

12. *Idaho Daily Statesman*, "Golden Past of Warren Adds Spice of History to Fishermen's Jaunts," 101(362):4C, July 22, 1965.

13. *Idaho County Free Press*, "Chinaman Dies."

14. I am grateful to Gayle Dixon for this information, Gayle Dixon in Kevin Gray, e-mail message to author, March 3, 2004; Idaho County Commissioners, "Commissioners Record, 13" [1932-1938] (Idaho County Courthouse, Grangeville, ID, May 14, 1934), 223.

15. Ibid.

16. Shepp's exact death date is unknown. Ann Smothers Copp (1927-2009) lived on the Salmon River as a child and attended Charlie Shepp's burial; her father, Austin Smothers, dug Shepp's grave. Apparently, Charlie Bemis's grave wasn't well-marked, because Smothers dug down on top of Bemis's coffin. Not wanting to dig another grave in the rocky soil, he buried Charlie Shepp's casket on top of Charlie Bemis's. In later years, "Dad laughed about it." He thought it was especially funny because "Charlie Shepp and Charlie Bemis were mortal enemies." When asked what it was about, because they seem quite friendly in the Shepp diaries, Copp said it was "because of a mule"—i.e., they apparently disputed the ownership of a particular mule. Finally one of them shot it, but they remained enemies, Ann Smothers Copp, telephone conversation with author, Lewiston, ID, January 28, 1997. Later, Copp wrote that others who attended the burial were Ellis Winchester, Pete Klinkhammer, and another man named Charlie [possibly Charlie Schultz, son of Gus Schultz], Ann Smothers Copp, letter to author, undated, but after March 10, 1997. The Charlie she mentioned was probably the same person who "took care of Shepp" in 1936, Ann Smothers Copp, interview by author, Lewiston, ID, March 21, 1997.

17. Idaho County, Deeds, "Book 98" [1962-1963] (Idaho County Courthouse, Auditor-Recorder, Grangeville, ID), 56.

18. Johnny Carrey and Cort Conley, *River of No Return* (Cambridge, ID: Backeddy Books, 1978), 215. Fleming was a Salmon River prospector and placer miner, ibid., 228.

19. Sucheng Chan, *Asian Americans: An Interpretive History* (Boston: Twayne, 1991), 193, 194, 195, 197.

20. Ibid., 197.

21. Carrey and Conley, *River of No Return*, 215-216.

22. Ibid., 220.

23. Doug Tims, *Merciless Eden* (Boise, ID: Ferry Media, 2013), 305.

24. Frances Zaunmiller Wisner, *My Mountains: Where the River Still Runs Downhill* (Grangeville, ID: *Idaho County Free Press*, 1987), 30. Vern Wisner and Frances Zaunmiller married in 1963, Tims, *Merciless Eden*, 315.

25. Wisner, *My Mountains*, 39.

26. E.g., Roscoe LeGresley, "Polly Bemis: A Name Which Is Still Legendary along the Wild Salmon River," photocopy of typescript, 1960s?, courtesy Jacqulyn LeGresley Haight, Lewiston, ID.

27. Listing of the following citations does not imply endorsement of them; many perpetuate the usual myths about Polly Bemis. For newspapers, see, e.g., *Idaho County Free Press*, "Woman of 70 Sees Railway First Time," 39(14):1, August 16, 1923; *Idaho County Free Press*, "Polly Awakened," 39(14):3, August 16, 1923; *Idaho Daily Statesman*, "Polly Bemis of Warren's Diggins Sees City's Sights, for First Time," 61(8):2, August 4, 1924; Lamont Johnson, "Old China Woman of Idaho Famous," *Sunday Oregonian*, 52(45):sec. 5, pp. 1, 3, November 5, 1933; M. Alfreda Elsensohn, "Fourth Academy Day at St Gertrude's, Cottonwood, Renews ... Memories of Polly Bemis," *Spokesman-Review*, May 12, 1957, 3-4; Ann Adams. "The Legend of Polly Bemis Retold," *Idaho County Free Press*, 77(5):11,

August 15, 1963; and G. M. Campbell, "A Chinese Slave Girl Charmed an Idaho Town," *Salt Lake Tribune*, July 9, 1973, H3-H4. Magazine articles and journals include, e.g., Eleanor Gizycka, "Diary on the Salmon River," part 2, *Field and Stream* 28:6 (June 1923), 187-188, 276-280, reprinted in *Idaho Yesterdays*, 41(1):7-23, Spring 1997; Ladd Hamilton, "How Mr. Bemis Won the Chinese Slave Girl," *Saga* 8:5 (August 1954), 50-51, 59; Charles Kelly, "He Won His Wife in a Poker Game," *The Pony Express* 36:9 (February 1950), 3-5; Grace Roffey Pratt, "Charlie Bemis' Highest Prize," *Frontier Times* 36:1 (Winter 1961), 26-28, 38; Lee Ryland, "Redemption of Charley [*sic*] Bemis," *Real West* 5:22 (March 1962), 12-13, 52-54, and her "The Strange Winnings of Charlie Bemis," *Big West* 1:3 (December 1967), 32-33, 51-52; Fritz Timmen, "The Poker Hand That Won a Wife," *True Frontier* 1:9 (May 1969), 34-35, 61-62 (reprinted in *True Frontier*, Special Issue No. 3, 1972, 30-31, 58); Priscilla Wegars, "Charlie Bemis: Idaho's Most 'Significant Other,'" *Idaho Yesterdays* 44:3 (Fall 2000), 3-17; and Eleanor Wilson-Wagner, "Polly," *Central Idaho Magazine* 2, no. 1 (Spring/Summer 1988): 6-7, 26-27.

28. For book chapters and sections, most of which include erroneous information on Polly Bemis, see, e.g., M. Alfreda Elsensohn, "Polly Bemis, Legendary Heroine," in her *Idaho Chinese Lore* (Cottonwood, ID: Idaho Corporation of Benedictine Sisters, 1970), 81-88; C. Y. Lee, "China Polly," in his *Days of the Tong Wars* (New York: Ballantine, 1974), 66-83; and F. Ross Peterson, *Idaho: A Bicentennial History* (New York: W. W. Norton, 1976), 59. Collected biographies include, e.g., Helen Markley Miller, "Salmon River Polly," in her *Westering Women* (Garden City, NY: Doubleday, 1961), 119-128; Susan Sinnott, "Polly Bemis (Lalu Nathoy): Idaho Pioneer 1853-1833," in her *Extraordinary Asian Pacific Americans* (Chicago: Childrens Press, 1993); Rebecca Stefoff, "Polly Bemis, 'China Polly' of Idaho (1853-1933)," in her *Women Pioneers* (New York: Facts on File, 1995), 107-114; L. E. (Lynn E.) Bragg, "Polly Bemis 1853-1933 China Polly," in her *Remarkable Idaho Women* (Guilford, CT, TwoDot, 2001), 69-77; 39-41; and, recommended, Priscilla Wegars, "Polly Bemis: Lurid Life or Literary Legend?," in *Wild Women of the Old West*, ed. Glenda Riley and Richard W. Etulain (Golden, CO: Fulcrum. 2003), 45-68, 200-203.

29. Books are, e.g., M. Alfreda Elsensohn, *Idaho County's Most Romantic Character: Polly Bemis* (Cottonwood, ID: Idaho Corporation of Benedictine Sisters, 1979) and Priscilla Wegars, *Polly Bemis: A Chinese American Pioneer* (Cambridge, ID: Backeddy Books, 2003). Although Wegars's book "successfully corrected the romanticized notions of Polly," it was not immune to criticism; one author referred to it and its related lesson plans as "misguided attempts at using the children's book as an educational tool," because it used Polly "as an example of successful assimilation" [*sic*, for acculturation], making her seem like "the norm, rather than the exception," Katy Whalen Fry, "Polly Bemis Retold: The Truth behind Idaho's Most Celebrated Woman" (paper presented at the Pacific Northwest History Conference, Tacoma, WA, 2007), 3, 10. For fictional accounts of Polly's life, ones that repeat some of the myths about her, see Christopher Corbett, *The Poker Bride: The First Chinese in the Wild West* (New York: Atlantic Monthly Press, 2010) and Ruthanne Lum McCunn, *Thousand Pieces of Gold* ([San Francisco]: Design Enterprises of San Francisco, 1981). The latter book is so convincingly written that many people believe it is fact, rather than fiction, so in recent years, McCunn has obliged her readers with a scholarly essay listing her sources and explaining her interpretation of them. It has so far appeared, with some revisions, in journals and a book, e.g., Ruthanne Lum McCunn, "Reclaiming Polly Bemis: China's Daughter, Idaho's Legendary Pioneer," in *Frontiers: A Journal of Women Studies* 24:1 (2003), 76-100, and with the same title in Dee Garceau-Hagen's *Portraits of Women in the American West*, (New York: Routledge, 2005), 156-177. It was also published as "Reclaiming Polly Bemis," *Idaho Yesterdays* 46:1 (Spring/Summer 2005), 22-39, 67-69.

30. The film, *Thousand Pieces of Gold*, Nancy Kelly, director, was released on Public Broadcasting System's American Playhouse series in 1991. Cort Conley commented, "Like Johnny [Carrey] said after watching the movie, 'Polly never looked like that,'" Cort Conley, e-mail message to author, March 15, 2017. The Autry Museum of Western Heritage in Los Angeles, as part of its "fictional West" collections, now owns some of the film's props,

including "the dragon's head from the Chinese New Year celebration, the Golden Flower [of] Prosperity Chinese store sign, and the knife with which [Polly] scares off a would-be customer, threatens suicide, and reclaims her identity," Hugh Thompson, "Grants and Acquisitions," 'Acquisitions: Materials from the 1991 movie ...,' in *C&RL News*, June 1996, 382. Thanks to Terry Abraham for providing a copy of this article.

31. Scholarly works include, e.g., Cletus R. Edmunson, "A History of Warren, Idaho: Mining, Race, and Environment" (master's thesis, Boise State University, Boise, ID, 2012); Nancy Koehler Feichter, "The Chinese in the Inland Empire during the Nineteenth Century" (master's thesis, State College of Washington, Pullman, 1959); Fern Coble Trull, "History of the Chinese in Idaho from 1864 to 1910" (master's thesis, University of Oregon, Eugene, 1946); Melvin D. Wikoff, "Chinese in the Idaho County Gold Fields: 1864-1933" (master's thesis, Texas A & I University, Kingsville, 1972), 80-102; Yixian Xu, "Chinese Women in Idaho during the Anti-Chinese Movement before 1900" (master's thesis, University of Idaho, Moscow, 1994); and Li-hua Yu, "Chinese Immigrants in Idaho" (Ph.D. dissertation, University of Idaho, Moscow, 1991). One thesis that is entirely about Polly Bemis is Kathleen Whalen Fry, "Rendering Polly: The Romanticization, Manipulation[,] and Decontextualization of One Chinese Woman's History in the American West" (master's thesis, Washington State University, Pullman, 2006). Fry "deconstructs" the film, *Thousand Pieces of Gold* (1991), 12-33; Priscilla Wegars' children's book, *Polly Bemis: A Chinese American Pioneer* (2003), 34-47; and the exhibit on Polly Bemis at The Historical Museum at St. Gertrude in Cottonwood, Idaho, 48-64, to show how they "romanticize, manipulate[,] and decontextualize" Polly Bemis's "place in history," 65.

32. Artist Hung Liu has used photographs of Polly Bemis as the basis for attractive, but fanciful, images of her, e.g., Hung Liu, *Polly: Portrait of a Pioneer* (San Francisco: Rena Bransten Gallery, 2005); *The Vanishing: Re-Presenting the Chinese in the American West* (Ketchum and Sun Valley, ID: Sun Valley Center for the Arts, 2004), 10, 12; and Hung Liu, "Chinese in Idaho," available at http://www.hungliu.com/chinese-in-idaho.html (accessed July 17, 2018). Although there are no color images of Polly Bemis, one photograph of her was colorized for a book cover, Garceau-Hagen, *Portraits of Women in the American West*, cover. In 2013 Boise artist Molly Hill had a gallery exhibition in Boise entitled "Polly Bemis and Other Paintings." One of the artworks featured Hill's stylized interpretation of Polly Bemis, showing her seated in a chair with a fish on her head; see it at *Boise Weekly*, "Idaho Shakespeare Festival Announces 2013 Season and Molly Hill Debuts Work at Brumfield's Gallery," available at https://www.boiseweekly.com/boise/isf-announces-2013-season/Content?oid=2761936 (accessed July 9, 2018). I am grateful to Jane Brumfield for calling this exhibit to my attention.

33. Tracy Morrison and Gary Eller, with Bill Parsons, included Polly Bemis in their "Strong Women: A Celebration in Song of Notable Early Idaho Women and Idaho Women's History Month," performed at Weiser, Idaho, March 18, 2016, photocopy of e-mailed promotional poster in the Asian American Comparative Collection, University of Idaho, Moscow. In April 2006, David Lei attended a *guzheng* (Chinese zither) concert in the San Francisco area where performers played a piece called "Polly's Song from *Thousand Pieces of Gold*"; author Ruthanne Lum McCunn was in the audience, David Lei, e-mail message to author, April 27, 2006. Singer and songwriter Tracy Morrison's song, 'Polly Bemis,' is part of her "Historical Idaho Women Stories and Folksongs" presentation for the Idaho Humanities Council Speakers Bureau. Hear it on YouTube, available at https://www.youtube.com/watch?v=btybeYc20LU (accessed November 16, 2019).

34. G. L. [Geralyn] Horton, with research by Christina Chan and Judy Yung, *Unbinding Our Lives* [Tien Fu Wu, Mary Tape, Polly Bemis], 1992, available at Horton's StagePage.info, http://www.stagepage.info/oneactplayscripts/unbind.html (accessed July 17, 2018).

35. For scholarly critiques of the film, *Thousand Pieces of Gold*, see Hyun-Yi Kang, "The Desiring of Asian Female Bodies: Interracial Romance and Cinematic Subjection," *Visual Anthropology Review* 9:1 (Spring 1993), 9-11; Patricia Terry, "A Chinese Woman in the West: *Thousand Pieces of Gold* and the Revision of the Historic Frontier," *Literature Film*

Quarterly 22:4 (October 1994), 222-226; Janet H. Chu, "Film and Multiculturalism: Erasing Race in Nancy Kelly's *Thousand Pieces of Gold*," in *Changing Representations of Minorities East and West: Selected Essays*, ed. Larry E. Smith and John Rieder (Honolulu: College of Languages, Linguistics[,] and Literature, University of Hawaii, 1996), 75-97; and Peter X Feng, *Thousand Pieces of Gold* in his *Identities in Motion: Asian American Film and Video* (Durham, NC: Duke University, 2002), 42-51. In addition, Walter Hesford's "*Thousand Pieces of Gold*: Competing Fictions in the Representation of Chinese-American Experience," *Western American Literature* 31:1 (Spring 1996), 49-62, is an important comparison of the book and movie versions of *Thousand Pieces of Gold*; it includes information from Hesford's telephone interview with author Ruthanne Lum McCunn. For McCunn's published essay on her research, see Note 29, above.

36. Encyclopedias include, e.g., Anne Commire, ed., "Nathoy, Lalu (1853-1933)," in *Women in World History: A Biographical Encyclopedia*, vol. 11, Mek-N (Farmington Hills, MI: Yorkin, 1999-2001), 633; Marjorie King, "Nathoy, Lalu (Polly Bemis) (1853-1933)," in *Handbook of American Women's History*, 2nd ed., ed. Angela M. Howard and Frances M. Kavenik (Thousand Oaks, CA, Sage, 2000), 372-373; Kathleen Whalen Fry, "Bemis, Polly (1853-1933)," in *Asian American History and Culture: An Encyclopedia*, vol. 1, ed. Huping Ling and Allan Austin (Armonk, NY: M. E. Sharpe, 2010), 132; and Ellen J. Oettinger, "Bemis, Polly, 1852 [*sic*]-1933," in *The Mythical West: An Encyclopedia of Legend, Lore, and Popular Culture*, ed. Richard W. Slatta (Santa Barbara: ABC-CLIO, 2001), 39-41. Curiously, one Asian American encyclopedia presents two differing points of view about Polly Bemis. One is Ruthanne Lum McCunn, "Who Is Polly Bemis[?]: Two Perspectives, Bemis, Polly (Lalu Nathoy (1853-1933): Perspective 1," in *Asian Americans: An Encyclopedia of Social, Cultural, Economic, and Political History*, ed. Xiaojian Zhao and Edward J. W. Park (Santa Barbara: Greenwood, 2014), vol. 1, A-F, 143-145, and the other is Priscilla Wegars, "Who Is Polly Bemis[?]: Two Perspectives, Bemis, Polly (Lalu Nathoy (1853-1933): Perspective 2," in ibid., 145-146.

37. Internet resources include, e.g., Idaho Public Television, "Outdoor Idaho, Gold Rush Days and Ghost Towns, Warren," available at http://idahoptv.org/outdoors/shows/ghosttowns/warren.cfm (accessed July 17, 2018), and Kathleen Prouty, "Charlie and Polly Bemis in Warrens," USDA Forest Service, Payette National Forest, Heritage Program, July 2002, available at http://www.secesh.net/History/CharlieandPollyBemis.htm (accessed July 17, 2018). In their section "Chinese American Women: A History of Resilience and Resistance," The National Women's History Museum profiled Polly Bemis at https://www.nwhm.org/online-exhibits/chinese/16.html (accessed October 12, 2016; gone now). One "pay to view" is Peggy Robbins, "China Polly: Poker Bride," partly available at WorldandISchool.com, https://www.worldandischool.com/public/1991/november/school-resource19540.asp (accessed July 17, 2018); the complete version is Peggy Robbins, "China Polly: Poker Bride," *The World&I* 6:11 (November 1991), 650-655, photocopy in Asian American Comparative Collection, University of Idaho. Another was on a website called OutlawWomen.com which has since vanished from the Internet, although it can still be found at the Internet Archive, Wayback Machine, "Polly Bemis, Lalu Nathoy—The Poker Bride," available at https://web.archive.org/web/20030720083017/http://www.outlawwomen.com/PollyBemis.htm (accessed July 17, 2018). Thanks to Cort Conley, Mary Anne Davis, and Lyle Wirtanen for bringing the original site to my attention.

38. McCunn, *Thousand Pieces of Gold*.

39. Kelly, *Thousand Pieces of Gold*.

40. Ruthanne Lum McCunn, *Thousand Pieces of Gold* (Boston: Beacon Press, 1988), title page, [7]. All subsequent citations are to this edition.

41. Ibid., 20.

42. E.g., *Lewiston Morning Tribune*, advertisement for *Thousand Pieces of Gold*, April 18, 1991, 2B.

43. John McCarthy, "*Thousand Pieces of Gold*: Book's Author Wishes Success to the Film," *Lewiston Morning Tribune*, April 18, 1991, 1B, 6B, and Ruthanne Lum McCunn, letter to Jeff Fee, March 13, 1986, and letter to Concerned persons, March 18, 1986, copies in Asian American Comparative Collection, University of Idaho, Moscow.

44. John McCarthy, "The Stuff of Dreams: Actors Find Film a Chance to 'Live' Their Own Dreams," *Lewiston Morning Tribune*, April 19, 1991, 6A, 14A, and John McCarthy, "The Beauty of Idaho Nearly Took Away Chao's Speech," *Lewiston Morning Tribune*, April 26, 1991, 1E, 8E.

45. John McCarthy, "Film's Goal is Pursuit of Truth," *Lewiston Morning Tribune*, April 19, 1991, 6A, 14A.

46. John McCarthy, "*Thousand Pieces of Gold*: Book's Author Wishes Success to the Film."

47. McCunn, letter to Jeff Fee and letter to Concerned Persons.

48. Chan Wallace, "King of Cougar Hunters Comes out of Wilds with Record Kill and Tale of Daring Adventures," *Lewiston Morning Tribune*, May 1, 1932, sec. 2, p. 1.

49. *Lewiston Morning Tribune*, "Polly Bemis Ill," August 8, 1933, 10.

50. Robert G. Bailey, *River of No Return (The Great Salmon River of Idaho): A Century of Central Idaho and Eastern Washington History and Development, Together with the Wars, Customs, Myths, and Legends of the Nez Perce Indians* (Lewiston, ID: Bailey-Blake Printing, 1935), revised (Lewiston, ID: R. G. Bailey Printing, 1947) and revision reprinted (Lewiston, ID: Lewiston Printing, 1983), 679. The citation is to the 1983 edition.

51. LeGresley, "Polly Bemis."

52. Ibid., 3.

53. Hamilton, "How Mr. Bemis Won the Chinese Slave Girl," 50-51, 59.

54. Ibid., 50.

55. Ibid., 59. The "old men" had remarkable memories indeed! Supposedly, Bemis originally held the queen of hearts, queen of spades, ace of clubs, eight of spades, and three of hearts. He discarded the latter three cards and received another queen and two threes, suits unstated. His opponent originally held three jacks, the nine of diamonds, and the two of spades. He discarded the latter two, but what he received was not stated. Much later, to his credit, author Hamilton wrote, "it may be not at all true that Charley (*sic*) Bemis won her in a poker game" and that he [Hamilton] was "inclined to assume that there was no such story—until after Polly died," Ladd Hamilton, "That Famous Poker Game May Never Have Happened," *Lewiston Morning Tribune*, June 14, 1987, 7A.

56. Ryland, "Redemption of Charley [*sic*] Bemis," 12-13, 52-54.

57. Ryland, "Strange Winnings of Charlie Bemis," 32-33, 51-52.

58. Ryland, "Redemption of Charley [*sic*] Bemis," 12, 13; Ryland, "Strange Winnings of Charlie Bemis," 32, 33.

59. Ethel Kimball, "River Rat Pioneer," *True West* (November-December 1963), 30-31, 50, 52-53.

60. Ibid., 52. Although Kimball did not believe the story about Charlie winning Polly in a poker game, she nevertheless succumbed to the "legend told" assumption.

61. James D. Horan, "Johnny [*sic*] Bemis and China Polly," in *Desperate Women*, by James D. Horan (New York: G. P. Putnam's Sons, 1952), 310-314.

62. Ibid., 311.

63. J. Loyal Adkison, "The Charles and Polly Bemis Story As Told to Me by Taylor Smith," typescript (Cottonwood, ID: The Historical Museum at St. Gertrude, 1950s[?]). The approximate date is derived from the fact that the manuscript mentions Elsensohn's *Pioneer Days in Idaho County* (1947). Therefore, Adkison (1881-1965) must have written his manuscript between 1947 and 1965, most likely in the 1950s or early 1960s.

64. Adkison, "The Charles and Polly Bemis Story," 3.

65. Timmen, "The Poker Hand That Won a Wife," 35.

66. Charles Kelly, "He Won His Wife in a Poker Game," *The Pony Express*, 36:9 (February 1970, No. 429), 4. Kelly, described as the "Rocky Mountain's Top Historian," wrote about how a Chinese miner-turned-merchant named "Hong Kong" lost his gold dust, store, and "beautiful young wife" to Charlie Bemis in a poker game. This woman was "China Polly," whose Chinese name was "Lulu Nat Hoy."

67. Lee, "China Polly," 66-83.

68. Ibid., 83. A Note at the end of the article states, "China Polly as a poker stake has been disputed by a few other sources, but the ring of authenticity of James Horan's version in his *Desperate Women* seems to make other fragments of information fall into place in China Polly's puzzling life," ibid., 83.

69. Lee, "China Polly," 80.

70. McCunn, *Thousand Pieces of Gold*, 157.

71. Robbins, "China Polly: Poker Bride," 653.

72. Pratt, "Charlie Bemis' Highest Prize," 27.

73. Ibid., 27-28.

74. Ibid., 28.

75. Hamilton, "How Mr. Bemis Won the Chinese Slave Girl," 59.

76. Ryland, "Redemption of Charley [*sic*] Bemis," 13; Ryland, "The Strange Winnings of Charlie Bemis," 33.

77. Lee, "China Polly," 76-77, 79.

78. Elsensohn, *Idaho County's Most Romantic Character*, 17.

79. McCunn, *Thousand Pieces of Gold*, 118.

80. Robbins, "China Polly: Poker Bride," 650, 653.

81. Timmen, "The Poker Hand That Won a Wife," 61-62.

82. Lee, "China Polly," 77.

83. McCunn, *Thousand Pieces of Gold*, 116-117.

84. Robbins, "China Polly: Poker Bride," 651-652.

85. Dr. Fu Manchu, an "Oriental" master criminal, was the sinister title character in Sax Rohmer's (Arthur Henry Ward, 1883-1959) series of thriller novels, some of which were made into films.

86. Lee, "China Polly," 77.

87. Robbins, "China Polly: Poker Bride," 652.

88. Benson Tong, *Unsubmissive Women: Chinese Prostitutes in Nineteenth-Century San Francisco* (Norman, University of Oklahoma Press, 1994), 22-23.

89. Ibid., 22. One cannot help but wonder how Tong's account is superior to what he calls "popular authors" who have "stereotyped" Polly Bemis "as a 'harlot with a heart of gold' turned 'gentle tamer.'"

90. Hoobler, Dorothy and Thomas Hoobler, *The Chinese American Family Album* (New York: Oxford University Press, 1994), 56.

91. Ibid. The stream is indeed called Polly Creek, but Grangeville residents had nothing to do with the naming of it.

92. Peter Klinkhammer, "Year Book 1954 [1958]," notes on 1910-1911 diary [as told to Marybelle Filer], written in diary dated 1954; first entry changed to 1958, photocopy, University of Idaho Library Special Collections, MG 155, February 22-23, 1958; M. Alfreda Elsensohn, *Pioneer Days in Idaho County*, vol. 2 (Caldwell, ID, Caxton, 1951), 82.

93. Christopher Corbett, *The Poker Bride: The First Chinese in the Wild West* (New York: Atlantic Monthly Press, 2010).

94. E.g., Robbins, "China Polly: Poker Bride."

95. E.g., Melanie Kirkpatrick, "From Far East to American West," *The Wall Street Journal*, February 2, 2010, A3, available at https://www.wsj.com/articles/SB100014240527487040 22804575041481054004678, with comments by Priscilla Wegars (accessed July 17, 2018).

96. E.g., Terry Hong, "History Plays Fast and Loose with Facts," Arts & Entertainment, Nonfiction Review, *San Francisco Chronicle* and SFGate.com, "Nonfiction Review: 'Poker Bride,'" March 20, 2010, E2; "Problems with historical reliability begin with the cover, which features a young Asian woman with a 1920s 'flapper' haircut.'" ... "Not only are the 1920s not prominent in the book, but Bemis also couldn't have resembled the cover picture at any point in her life." ... "Why read a third-hand account about Bemis when more accurate choices exist," ibid. I am grateful to Dan Eisenstein for providing a copy of this review. *Poker Bride* spawned subsequent articles and book chapters with similar titles, e.g., Michael Rutter, "Polly Bemis: The Chinese Poker Bride," in his *Boudoirs to Brothels: The Intimate World of Wild West Women* (Helena, MT: Farcountry Press, 2014), 36-48. Thanks to Will Harmon of Farcountry Press for providing a copy of this book to the University of Idaho's Asian American Comparative Collection. *Poker Bride* was remaindered [discontinued] in 2013, Cort Conley, e-mail message to author, August 20, 2013.

97. Cort Conley, note to Priscilla Wegars, 2018.

98. Randy Stapilus, "Jim Campbell," published February 6, 2010, available at Ridenbaugh Press, http://www.ridenbaugh.com/?s=Jim+Campbell (accessed February 12, 2019).

99. Their "plan to build a lavish country club across the river from the Salmon River Resort Club site [at the Shepp Ranch] collapsed in 1983 because people perceived the club to be out of tune with the primitive and remote Salmon River area," *Ocala Star-Banner*, "Newton Partner in Resort Club in Wilderness Area," 119(505), 2A, July 22, 1984; *Sarasota Herald-Tribune*, "Newton's Partnership to Open River Resort," 59(293):2A, July 22, 1984.

100. "Wayne Newton Company Restores Polly Bemis Cabin on Salmon R.," *Idaho County Free Press*, 101(22):1, June 3, 1987. I am grateful to Carol Sue Hauntz for providing a copy of this article.

101. Jim Campbell, "Manager's Corner," *Salmon River Resort Club* 5:5 (July 1987):[1, 3], photocopy courtesy The Historical Museum at St. Gertrude, Cottonwood, ID.

102. Alice Koskela, "Polly Bemis Finally Rests at Homestead," *The Central Idaho Star-News*, 21(34):1, June 10, 1987; Jim Campbell, "Polly Bemis Returns Home," *Salmon River Resort Club* 5:5 (July 1987): [6], photocopy courtesy The Historical Museum at St. Gertrude, Cottonwood, ID. Polly's gravesite at Grangeville's Prairie View Cemetery has since been resold and another woman is buried there now. Apparently, "all of the other [grave] stones in the area are in the [19]30s" and the one at Polly's former grave is 1993, Cort Conley, e-mail message to author, January 13, 2014.

103. Leona Brown, "Salmon River Trip," July 19, 1959-July 26, 1959, 2. There is no suggestion that Polly wanted to be buried next to Charlie at the Shepp Ranch. Thanks to Vicky Murphy for providing copies of the journal and related materials. Besides Brown, other members of the party were Harold, LaVerne, and Kathleen Craig, and George, Pearl, and Vicki Taylor, ibid., 1.

104. Cort Conley, e-mail message to author, August 31, 2020.

105. Jeff Blackmer, interview by author, Noland-Blackmer Funeral Home [now Blackmer Funeral Home], Grangeville, ID, November 11, 1999. When asked, the Polly Bemis Ranch could not locate a copy of the disinterment permit.

106. Fred Noland, telephone conversation with author; date not recorded, but probably late 1999.

107. Marvin Ackerman, telephone conversation with author; date not recorded, but probably late 1999. Skeletally, "big leg bones" would indicate hard work. Also, Polly's feet had been bound in childhood and were later unbound; had the exhumation team known this, they might have examined her feet more closely. Finally, if her natural teeth had been present, they could have been examined for "pipe wear"; i.e., pipe-smoking leaves indentations on

the teeth where they have contacted the pipe stem over time, Thao T. Phung, Julia A. King, and Douglas H. Ubelaker, "Alcohol, Tobacco, and Excessive Animal Protein: The Question of an Adequate Diet in the Seventeenth-Century Chesapeake," *Historical Archaeology* 43:2 (2009), 73.

108. Cort Conley, e-mail message to author, January 11, 2017. Johnny Carrey, who knew Polly when he was a boy, also confirmed that she had false teeth, Johnny Carrey, interview by Priscilla Wegars, April 12, 1997, notes in Asian American Comparative Collection, University of Idaho, Moscow.

109. Campbell, "Polly Bemis Returns Home," [6].

110. Wegars, "Polly Bemis: Lurid Life or Literary Legend?," 66.

111. Roberta S. Greenwood, "Old Rituals in New Lands: Bringing the Ancestors to America," in *Chinese American Death Rituals: Respecting the Ancestors*, ed. Sue Fawn Chung and Priscilla Wegars (Lanham, MD: AltaMira/Rowman & Littlefield, 2005), 255.

112. I am grateful to Terry Abraham for this reminder.

113. Joanne Kaufman, "Hard Times in Wayne's World," *People*, 38(10), available at http://people.com/archive/hard-times-in-waynes-world-vol-38-no-10/ (accessed July 17, 2018).

114. "He left the backcountry in the 90s, and spent time after that in Las Vegas and Phoenix before settling, in this decade [2000s], in Costa Rica," Stapilus, "Jim Campbell."

115. "Polly Bemis Ranch," available at https://sites.google.com/pollybemis.com/pollybemis/home (accessed July 17, 2018).

116. The University of Idaho has since discontinued the Community Enrichment Program.

117. The trip description for the 2002 class is available at http://webpages.uidaho.edu/aacc/tour2002.htm (accessed July 17, 2018).

118. Elaine [Williams], "Touring the Salmon River: A Day in the Life of This Region's Tourism Promoters," blog post, May 7, 2009, from information provided by Kelly Dahlquist, regional tourism coordinator, North Central Idaho Travel Association, "Salmon River Sampler," April 27, 2009, formerly available at *Lewiston Tribune*, http://lmtribune.com/blogs/2009/05/07/touring-the-salmon-river (accessed May 8, 2009), copy in Asian American Comparative Collection, University of Idaho, Moscow.

119. Jennifer Eastman Attebery, "National Register of Historic Places Registration Form: Bemis, Polly, House" (Boise: Idaho State Historical Society, 1987), and National Register of Historic Places, "Bemis, Polly, House," available at http://npgallery.nps.gov/pdfhost/docs/NRHP/Text/87002152.pdf (accessed July 16, 2018). The nomination was Jim Campbell's idea, Cort Conley, note to Priscilla Wegars, 2018.

120. National Park Service, NPGallery, Digital Asset Management System, available at https://npgallery.nps.gov/AssetDetail/NRIS/87002152 (accessed July 9, 2018).

121. "Polly Bemis Ranch."

122. Attebery, "National Register of Historic Places Registration Form: Bemis, Polly, House," 3.

123. Idaho's Hall of Fame, "Bemis, Polly," available at https://idhalloffame.weebly.com/idaho.html (accessed July 16, 2018).

124. Ibid. Currently she is the only representative from Idaho County. A news story about that year's inductees repeated some of the misinformation about her, Dennis Sasse, "Idahoans Recognized by Hall of Fame," *Argonaut* 97(68):3, June 26, 1996.

125. Richard J. Beck, "Bemis, Polly 1853-1933 Warrens," *Famous Idahoans* [cover title, *100 Famous Idahoans*] (Moscow, ID: R. J. Beck, 1989), 8.

126. Mary Ann Newcomer, 'Idaho Gardens & Chinese Gardeners: Our Connection to the Beijing Olympics,' in "Gardens of the Wild Wild West," formerly available at http://www.gardensofthewildwildwest.com/index.php/2008/08/09/idaho-gardens-chinese-gardeners-our-connection-to-the-beijing-olympics/ (accessed April 11, 2017); copy available in Asian American Comparative Collection, University of Idaho, Moscow.

127. Pam Bradshaw, e-mail message to author, July 18, 2013; Wegars, *Polly Bemis: A Chinese American Pioneer.*

128. Idaho State Historical Society, "Essential Idaho: 150 Things That Make the Gem State Unique," in *A Year of Commemoration: 2013 Annual Report* (Boise, ID: Idaho State Historical Society, [2014]), [5]. For short, the exhibit was also called "Idaho at 150." A companion book to the exhibit has a brief, somewhat fanciful, paragraph about Polly Bemis, Lori Otter and Karen Day, *Ida Visits 150 Years of Idaho* (Boise: ID: Idaho State Historical Society, 2013), 24. Lori Otter is the wife of former Idaho governor C. L. "Butch" Otter.

129. Kathy Hedberg, 'Idaho County,' in Craig Clohessy, "Fame: The Most Famous Folks Who Have/Had Ties to This Region," *Lewiston Tribune*, October 9, 2016, 4A.

130. Miller served from October 1985 to October 1988. Rumsfeld's first tenure as Secretary of Defense lasted from 1975 to 1977. He occupied the same position again from 2001 to 2006.

131. Cort Conley, e-mail messages to author, February 7 and 8, 2017.

132. Public Law 101-249 provides for the granting of posthumous United States citizenship, "an honorary status commemorating the bravery and sacrifices of these persons; it does not convey any benefits under the Immigration and Nationality Act to any relative of the decedent," US Citizenship and Immigration Services, "N-644, Application for Posthumous Citizenship," https://www.uscis.gov/n-644 (accessed July 17, 2018).

133. Conley, e-mails, February 7 and 8, 2017.

134. Joshua Palmer, "Otter Tells Stories, Sings Songs[,] and Seals Deals in China," *Times-News*, June 12, 2010, Business 1.

135. Rocky Barker, "Ties More Than a Century Old Link Gem State, Guangdong," *Idaho Statesman*, June 10, 2010, A4. Polly supposedly was "born Lalu Nathoy." After she married Charlie Bemis, the couple "moved to a small ranch on the Salmon River," which now is a "large ranch named after her."

136. Ruthanne Lum McCunn, "Books by Ruthanne Lum McCunn," 'Translations and Non-US Editions,' available at http://mccunn.com/Trans.html (accessed July 16, 2018). An Indonesian edition is forthcoming.

137. The first two parts were "A Promise of Gold" and "Conquering the Sierras." Special thanks to Charlotte Sun of the Genesee Valley Daoist Hermitage for providing the University of Idaho's Asian American Comparative Collection with a flash drive of the film, and to Jim Huggins for converting it to DVDs.

138. Lucille Moss, telephone interview with author, June 23, 1997, [2].

139. Mrs. John D. (Bertha) Long, "Polly Bemis, My Friend," *Idaho County Free Press*, 80th Anniversary Edition, 79(49):sec. [8], p. 1, June 16, 1966.

140. *Idaho Daily Statesman*, "Polly Bemis of Warren's Diggins."

141. Elsensohn, "Fourth Academy Day," 4; information from J. C. Safley, former editor, owner, and publisher of the *Idaho County Free Press.*

142. Ibid., 3; information from J. C. Safley.

143. Gizycka, "Diary on the Salmon River," part 2, 276-280.

144. Ibid., 278.

145. Ibid. The photo of Polly with the Countess Gizycka river trip participants, and others, was reprinted in the *Idaho County Free Press*'s Bicentennial Edition on June 30, 1976. There, the man at the back, right ["a Countess, Gyzinski" [*sic*] is in front], is identified as "Charley" Bemis, but that's impossible, since Bemis was bedridden by then, Frances Zaunmiller Wisner, "History of Canyon of Salmon Would Fill Set of Books, But Frances Goes into Highlights," *Idaho County Free Press*, Bicentennial Edition, 90(3):5A, June 30, 1976.

146. *Idaho Daily Statesman*, "Polly Bemis of Warren's Diggins."

147. Klinkhammer, "Year Book 1954 [1958]," January 10, 1954 [1958].

148. Judy Smith, "Polly Bemis," in *Tsceminicum (Meeting of the Waters) The Clearwater and The Snake Rivers*, ed. Gladys Swank and Nellie Woods (Lewiston, ID: Lewis-Clark Chapter Idaho Writers League, 196-?), 77. The passage ends with, incredibly, "She [Polly] was also a switcher, or telephone operator, between the Nez Perce and the Payette Ranger stations," ibid.

149. Gertrude Maxwell, interview by Patrick J. McCarthy, September 5, 1980, transcript, Idaho County Historical Society, Grangeville, ID, and Idaho State Historical Society, Boise, OH449, 18. Maxwell's acquaintanceship with Polly Bemis is not confirmed by the Shepp diaries, but since those have gaps, it is possible that the two women did know one another. Charlie Bemis's good friend, William Boyce, lived with Maxwell's parents "for years" near the end of his life; Maxwell's mother had a cabin built for him. She died in 1933 and Boyce died in 1936 or 1937, ibid., 19-20.

150. Ibid., 19.

151. Ibid., 20.

152. Adkison, "The Charles and Polly Bemis Story," 5.

153. Ibid., 5.

154. Asia Home, "Chinese New Year 1853," available at https://www.asia-home.com/china/nouvel-an-chinois/year/1853/lang/en.php (accessed July 17, 2018).

155. The Metaphysical Zone, "Water Ox," available at http://www.metaphysicalzone.com/china/ox2.shtml (accessed July 17, 2018).

156. Tsemrinpoche.com, "The Ox and the Five Elements," available at http://www.tsem-rinpoche.com/tsem-tulku-rinpoche/horoscopes/the-ox-and-the-five-elements.html (accessed July 17, 2018).

157. Adkison, "The Charles and Polly Bemis Story," 1. Taylor Smith stated elsewhere, "Charley & Polley [sic] Were almost Like Father and Mother to me from 1890 untill [sic] they moved to Salmon River. I was at there [sic] wedding and about 6 feet from him when John Cox shot him ... (Taylor Smith, letter [to M. Alfreda Elsensohn], January 2, 1958, 1, copy at The Historical Museum at St. Gertrude, Cottonwood, ID.

158. Helmers, *Warren Times*, July 6, 1888; *Lewiston Morning Tribune*, "Warren Mail Carrier 55 Years Ago Goes Back over Old Golden Route and Finds Pioneer Glamour Gone," September 25, 1941, 12.

159. *Idaho County Free Press*, "Many Myths Connected with Chinese Polly Bemis," 79(49):sec. [8], p. 1, June 16, 1966.

160. Johnson, "Old China Woman of Idaho Famous."

161. Bailey 1983, *River of No Return*, 675-677.

162. Ibid., 679.

163. Ibid., 677-678.

164. Carrey and Conley, *River of No Return*, 222.

165. Johnson, "Old China Woman," 3.

166. Charles Kelly, "Charley [sic] Bemis, Who Won His Bride in a Poker Game" [photo], *The Pony Express* 36:9 (February 1970), 6.

167. Trull, "Chinese in Idaho," 103, quoting Will Shoup. It is not clear whether "fiddling" means playing his violin, or simply messing about.

168. M. Alfreda Elsensohn, *Pioneer Days in Idaho County*, vol. 1 (Caxton, 1947); reprint, (Cottonwood, ID: Idaho Corporation of Benedictine Sisters, 1965), 94; citations are to the reprint edition. The McGranes told this story to Alfreda Elsensohn in August 1942. Elsensohn later repeated the passage, stating it somewhat differently: "Charlie Bemis died so early because he was just lazy and wouldn't work any more," Elsensohn, *Pioneer Days*, vol. 2, 288, and "Charlie wouldn't have died so soon if he had hadn't been lazy. He just sat around till he was no account," Elsensohn, "Fourth Academy Day," 3.

169. I am grateful to Cort Conley for this suggestion.

170. Marybelle Filer, "Historic Shepp Ranch Now Hunters' and Fishermen's Mecca," *Idaho County Free Press*, 80th Anniversary Edition, 79(49):sec. [8], p. 5, June 16, 1966.

171. "Herbert R. McDowell, 82, Culdesac Rancher" [obituary], *Lewiston Morning Tribune*, January 28, 1998, 7A. Family history gives the date as 1922, but as discussed in Chapter Seven, the date was more likely 1923. Herb (and possibly his brothers as well) referred to Polly Bemis as "Aunt Polly," Larry Kingsbury, letter to author, February 20, 1998.

172. Herb McDowell, "Polly Bemis" (McCall, ID: Payette National Forest Cultural Resources, Historic 1680 files, 1987), 2. Thanks to Larry Kingsbury for providing a copy of this manuscript.

173. Peter Klinkhammer, "Year Book 1954 [1958]," April 3-4, 1958.

174. Ibid., April 5, 1958.

175. Polly Bemis Lessons, "Frequently-Asked Questions about Polly and Charlie Bemis," available at http://webpages.uidaho.edu/aacc/Lessons/FAQ.htm (accessed July 17, 2018).

176. For a list of what was available in the decades after the 1830s, see Janet Farrell Brodie, *Contraception and Abortion in Nineteenth-Century America* (Ithaca, NY: Cornell University Press, 1994), ix; thanks to David Valentine for suggesting this reference.

177. Andrea Tone, *Devices and Desires: A History of Contraceptives in America* (New York: Hill and Wang, 2001), 5. The Act read, in part, "… whoever, … shall sell … or shall offer to sell, or to lend, or to give away, or in any manner to exhibit, or shall otherwise publish or offer to publish in any manner, or shall have in his possession, for any such purpose or purposes, an obscene book, pamphlet, paper, writing, advertisement, circular, print, picture, drawing or other representation, figure, or image on or of paper or other material, or any cast instrument, or other article of an immoral nature, or any drug or medicine, or any article whatever, for the prevention of conception, [emphasis added] or for causing unlawful abortion, or shall advertise the same for sale, or shall write or print, or cause to be written or printed, any card, circular, book, pamphlet, advertisement, or notice of any kind, stating when, where, how, or of whom, or by what means, any of the articles in this section … can be purchased or obtained, or shall manufacture, draw, or print, or in any wise make any of such articles, shall be deemed guilty of a misdemeanor, and on conviction thereof in any court of the United States … he shall be imprisoned at hard labor in the penitentiary for not less than six months nor more than five years for each offense, or fined not less than one hundred dollars nor more than two thousand dollars, with costs of court," The Comstock Act 17 Stat. 598.

178. Tone, *Devices and Desires*, 26. "The most significant change in today's Comstock Act is the absence of any restrictions regarding contraceptive devices. Although court opinions began to undermine this aspect of the Comstock Act in the 1930s, Congress did not amend the act to delete references to contraception until 1971," Sandra Rierson, "Comstock Act (1873)," encyclopedia.com, available at http://www.encyclopedia.com/history/encyclopedias-almanacs-transcripts-and-maps/comstock-act-1873 (accessed July 17, 2018).

179. David Valentine, e-mail message to author, No. 1, December 7, 2016.

180. David Valentine, e-mail messages to author, No. 1, No. 2, No. 3, December 7, 2016, and Iris H. W. Engstrand and Mary F. Ward, "Rancho Guajome: An Architectural Legacy," *Journal of San Diego History* 41:4 (Fall 1995), available at http://www.sandiegohistory.org/journal/1995/october/archlegacy/ (accessed July 17, 2018), no page number, note 70. I am grateful to David Valentine for suggesting this reference.

181. Brodie, *Contraception and Abortion*, 206. Mary Hallock Foote moved to Idaho, near Boise, in 1884 and lived there for the next 12 years, "Mary Hallock Foote & Arthur De Wint Foote in Idaho," available at http://farrit.lili.org/people/mary-hallock-foote-arthur-de-wint-foote-in-idaho/ (accessed July 17, 2018).

182. Brodie, *Contraception and Abortion*, 210.

183. Ibid., 205.

184. Aine Collier, *The Humble Little Condom: A History* (Amherst, NY: Prometheus, 2007), 60.

185. Charlotte Furth, *A Flourishing Yin: Gender in China's Medical History, 960-1665* (Berkeley: University of California, 1999), 173. I am grateful to Yi-Li Wu for suggesting this reference.

186. Francesca Bray, "A Deathly Disorder: Understanding Women's Health in Late Imperial China," in *Knowledge and the Scholarly Medical Traditions*, ed. Don Bates (Cambridge, England: Cambridge University Press, 1995), 248-249. Although space does not allow a detailed discussion of traditional Chinese methods of contraception, most of which would not have been available to Polly Bemis in the United States, Matthew Sommer, "Abortion in Late Imperial China: Routine Birth Control or Crisis Intervention?," *Late Imperial China* 31:2 (December 2010), 111, states, "some people believed (and some continue to believe) that one or another remedy worked as a contraceptive or abortifacient—for example, tadpoles, snails, blister beetles, saltwater, water chestnuts" Sommer adds, "But that belief in itself cannot be taken as proof of efficacy." I am grateful to Yi-Li Wu for suggesting these references.

187. E.g., "... pennyroyal, sage, common groundpine, bistort or snakeweed, gladwin, brake fern, calamint, and honeysuckle ..."; how these were administered, whether in a tea or via douching, is not stated, Brodie, *Contraception and Abortion*, 42. "Anise (*Pimpinella anisum* L.) 'stimulates menstruation' and ... birthwort (*Aristolochia clementis* L. and other species) 'stimulates menstruation and expels a fetus.' In modern science reports, anise has been found to have abortifacient qualities Birthwort ... can act both as a contraceptive and as an abortifacient ...," John M. Riddle, *Eve's Herbs: A History of Contraception and Abortion in the West* (Cambridge, MA: Harvard University Press, 1997), 31. The seeds of Queen Anne's Lace are "a strong contraceptive if taken orally immediately after coitus," ibid., 50. I am grateful to Karen Kennedy for suggesting this reference.

188. Cynthia L. Cooper, "The Contraception Museum: A New Museum Reminds Us that Contraception Devices Are as Old as Sex Itself," available at Alternet, http://www.alternet. org/story/22062/the_contraception_museum (accessed July 17, 2018).

189. Brodie, *Contraception and Abortion*, 224-228.

190. Ibid., 226.

191. Klinkhammer, "Year Book 1954 [1958]," January 10, 1958.

192. Ibid., April 5-6, 1958.

193. Peter Hessler, *River Town* (New York: HarperCollins, 2001), 159.

194. Vardis Fisher and Opal Laurel Holmes, *Gold Rushes and Mining Camps of the Early American West* (Caldwell, ID: Caxton, 1968), 274.

195. Brown, "Salmon River Trip," 2.

196. Campbell, "Polly Bemis Returns Home," [6].

197. Shepp, [Diary], 1933-1934, November 6-8, 1933.

198. Robert D. Bunting, letter to author, September 14, 2000, [1].

199. The first-ever passenger train between Grangeville and Lewiston, Idaho, departed Grangeville on December 9, 1908, *Idaho County Free Press*, "Train Service," 23(28):4, December 10, 1908.

200. *Idaho County Free Press*, "Polly Returns to Warren after Happiest Days in Fifty Years," 39(15):1, August 23, 1923.

201. Gizycka, "Diary on the Salmon River," part 2, 278.

202. *Idaho Daily Statesman*, "Polly Bemis of Warren's Diggins."

203. F. J. Mulcahy, [Diary], July 19, [1922]. One page from a typed transcription of this diary was kindly provided to the author by Philinda Parry Robinson.

204. Lee Charles Miller, "Adventures of a Motion Picture Amateur," *Outing* 79:1 (October 1921), 42.

205. *Idaho County Free Press*, "Woman of 70 Sees Railway."

206. Charles Shepp, [Diary], August 4, 1909, through December 4, 1910, photocopy, University of Idaho Special Collections, MG 155, August 25, 1910.

207. Helmers, *Warren Times*, December 14, 1914.

208. Mrs. John D. (Bertha) Long, "Polly Bemis, My Friend," *Idaho County Free Press*, 80th Anniversary Edition, 79(49):sec. [8], p. 1, June 16, 1966.

209. Helmers, *Warren Times*, November 7, 1890.

210. Bunting, letter to author, September 14, 2000, [1].

211. Ibid., [2].

212. Long, "Polly Bemis, My Friend."

213. Ibid.

214. Mrs. Merle Kellogg, a niece of Pete Klinkhammer, donated the wedding ring. Marion Bunting donated the apron; it had belonged to her mother, Polly's friend Bertha Long. Thanks to Pam Northcutt for providing information on these two artifacts.

215. Idaho State Museum, Acquisition Record Sheet, Register, and Transfer of Ownership for #70-51.0, sewing machine; many thanks to Rachelle Littau for providing copies of these documents.

216. "Household Sewing Machines," formerly available at http://www.oocities.org/heartland/plains/3081/household.htm (accessed October 19, 2016), information reprinted "from *The Encyclopedia of Antique Sewing Machines*, 3rd Edition." This would explain why no Household sewing machines were located in the Sears, Roebuck or Montgomery Ward catalogues for the late 19th and early 20th centuries. Polly's sewing machine must have come from a store in Warren or Grangeville.

217. Charles Shepp, [Diary], November 13, 1905, through April 30, 1908, photocopy of typescript, University of Idaho Library Special Collections, MG 5209, February 22, 1908.

218. The Museum received the tennis shoes from Max Lyda of Grangeville in 1937, Idaho State Museum, Accession Ledger for object number 1937.020.0000. Many thanks to Rachelle Littau for providing copies of this document and to Nicole Inghilterra for object number clarification.

219. *Idaho County Free Press*, "Woman of 70 Sees Railway."

220. Charles Shepp, [Diary], January 1, 1912, through October 31, 1913, photocopy, University of Idaho Library Special Collections, MG 155, November 6, 1912.

221. Charles Shepp, [Diary], August 1, 1915, through June 30, 1916, photocopy, University of Idaho Library Special Collections, MG 155, September 6, 1915.

222. Sears, Roebuck, and Co., *1927 Edition of the Sears, Roebuck Catalogue*, ed. Alan Mirken, ([New York]: Bounty Books/Crown, 1970), 524.

223. Idaho State Museum, Acquisition Record and Transfer of Ownership for #1986.065.0001. Many thanks to Rachelle Littau for providing copies of these documents and for reference photos of the cap.

224. Cort Conley, *Idaho for the Curious* (Cambridge, ID: Backeddy Books, 1982), and Carrey and Conley, *River of No Return*.

225. It is Idaho State Historical Society number 2016.24.0000.

226. Campbell died in Costa Rica in February 2010, Stapilus, "Jim Campbell." Campbell probably obtained the tea kettle from Polly's cabin about 1974, the year that he bought the Shepp Ranch, Cort Conley, e-mail message to author, November 1, 2016, No. 2; later that "summer folks made off with [the] contents from her cabin." According to Conley, "We must have first see[n] the kettle in 1972 in the cabin and then Jim rescued it when he was owner of [the Shepp Ranch and] caretaker at Polly's, watering the hayfield. Then he bought Polly's [place] when he sold [the] Shepp [Ranch], so then he took it back across the river," Cort Conley, e-mail message to author, November 1, 2016, No. 1.

227. Boris Emmet, *Montgomery Ward & Co. Catalogue and Buyers' Guide: No. 57, Spring and Summer 1895* (New York: Dover, 1969), 428, col. 2. Although one might think that the

smaller base would allow the kettle to be inserted into the burner of a wood stove, that idea is impractical for several reasons, as Cort Conley has kindly explained; one being that too much soot would collect on the bottom of the kettle for it to be set down anywhere, Cort Conley, e-mail message to author, November 13, 2016.

228. Ibid., 427. A similar kettle is pictured in a competitor's catalogue, *The 1902 Edition of The Sears Roebuck Catalogue*, with an introduction by Cleveland Amory (New York: Bounty Books/Crown, 1969), 582. It would have cost 31 cents that year.

229. Emmet, *Montgomery Ward & Co. Catalogue*, 427.

230. Polly's kettle has the following approximate dimensions: "Without the lid it's approximately 6½ in. tall and the lid is approximately 1 in. high from the bottom edge to its highest point at the top center. The maximum diameter is approximately 9 in. to 9¼ in. It's difficult to get a height on it with the lid because the lid is bent/warped and no longer lies flat," Rachelle Littau, e-mail message to author, August 26, 2016. Many thanks to Rachelle for arranging for the kettle to be photographed, and for measuring it.

231. Jim Campbell, telephone conversation with author, Boise, ID, April 10, 1997.

232. *Clearwater Progress*, "Museum at St. Gertrude's Receives Donation of Artifacts," 50(47):5, June 14, 2000. A photograph accompanying the article showed the rocking chair. Campbell also donated a couple of Charlie Bemis's possessions, discussed later.

233. It is possible that some of his possessions are outside of Polly's house at the Polly Bemis Ranch on the Salmon River.

234. One is an undated, typed inventory labeled "Polly Bemis Collection in St. Gertrude's Museum" and the others were accession worksheets for individual items or groups of items.

235. "[Accession] Worksheet," The Historical Museum at St. Gertrude, Cottonwood, ID, July 1989, for "bonnet," object number 964.5.40, donor, Peter Klinkhammer, January 15, 1964. The bonnet measures 19 in. by 13 in.

236. "[Accession] Worksheet," The Historical Museum at St. Gertrude, Cottonwood, ID, July 1989, for "shawls," object numbers 943.39.7 and -.8, donor, Peter Klinkhammer, November 30, 1943. The first shawl measures 120 in. by 116 in. and the second shawl measures 64 in. by 21 in.

237. "[Accession] Worksheet," The Historical Museum at St. Gertrude, Cottonwood, ID, July 1989, for "dresses," object numbers 943.39.10 through -.12, donor, Peter Klinkhammer, November 30, 1943. Dress -.10 is 44 in. long and its material is "breaking at shoulders."

238. Ibid., for 943.39.11; it is 42 in. long and looks like it was never worn.

239. Ibid., for 943.39.12; it is 42 in. long. "Polly Bemis Collection in St. Gertrude's Museum," undated typed list, The Historical Museum at St. Gertrude, Cottonwood, ID, states, "looks as though it had not been worn."

240. "[Accession] Worksheet," The Historical Museum at St. Gertrude, Cottonwood, ID, October 1988, for "dress," object number 978.17.1, donor, Ann Smothers Copp, June 24, 1978. The dress is 45 in. long.

241. "Obituaries: Georgia A. Copp, 82, Lewiston," *Lewiston Tribune*, September 11, 2009, 5C.

242. Ann Smothers Copp, telephone conversation with author, January 28, 1997; interview by author, Lewiston, ID, March 21, 1997.

243. *Idaho County Free Press*, "Woman of 70 Sees Railway"; *Idaho Daily Statesman*, "Polly Bemis of Warren's Diggins."

244. As recounted earlier (Chapter Seven), she did recover the gold buttons that were on her "best" dress, and these were later stolen from the Historical Museum at St. Gertrude.

245. Charles Shepp, [Diary], November 1, 1921, through December 31, 1923, photocopy, University of Idaho Library Special Collections, Manuscript Group 155, August 16, 1922. This diary is written in a notebook that folds over at the top. The top and bottom entries are often too pale to be readable.

246. Ibid., October 29, 1922. Unlike for Polly, who died 11 years later in Grangeville, there is apparently no death certificate for her husband, BYU Idaho, Special Collections and Archives, "Idaho State Death Index, 1911-1956," available at http://abish.byu.edu/specialCollections/famhist/Death/searchForm.cfm (accessed February 26, 2019).

247. Shepp, [Diary], 1921-1923, November 6, 8, 1922.

248. See Chapter Seven, July 9, 1923.

249. *Idaho County Free Press*, "Polly Returns to Warren."

250. "[Accession] Worksheet," The Historical Museum at St. Gertrude, Cottonwood, ID, July 1989, for "1 sham/pillow cover," object number 964.5.1, donor, Peter Klinkhammer, January 15, 1964. It measures 21 in. by 54 in.

251. "[Accession] Worksheet," The Historical Museum at St. Gertrude, Cottonwood, ID, July 1989, for "doily," object numbers 964.5.2 through -.5, donor, Peter Klinkhammer, January 15, 1964. The doilies measure 8 in. by 7 in., 9 in. by 7 in., 7½ in by 8 in., and 8½ by 8½ in. respectively.

252. "[Accession] Worksheet," The Historical Museum at St. Gertrude, Cottonwood, ID, July 1989, for "lace fragment," object number 943.3.1, donor, Peter Klinkhammer, March 10, 1943. It measures 16 in. by 2 in.

253. "[Accession] Worksheet," The Historical Museum at St. Gertrude, Cottonwood, ID, July 1989, for "lace," object number 964.5.7, donor, Peter Klinkhammer, January 15, 1964. It measures 5 in. by 24 in. Sharp eyes will have noticed that there is no artifact numbered 964.5.6; that number seems to have been skipped at the time the objects were numbered individually, Shirley Gehring, e-mail message to author, March 3, 2017. Special thanks to Shirley for her gracious assistance with the author's many inquiries.

254. "[Accession] Worksheet," The Historical Museum at St. Gertrude, Cottonwood, ID, July 1989, for "mat, Table," object number 943.39.4, donor, Peter Klinkhammer, November 30, 1943. It measures 17 in. by 12 in.

255. "[Accession] Worksheet," The Historical Museum at St. Gertrude, Cottonwood, ID, July 1989, for "throw, Table," object number 943.39.5, donor, Peter Klinkhammer, November 30, 1943. It measures 30 in. by 28 in.

256. "[Accession] Worksheet," The Historical Museum at St. Gertrude, Cottonwood, ID, July 1989, for "Table Cover," object number 943.39.6, donor, Peter Klinkhammer, November 30, 1943. It measures 27 in. by 17 in.

257. "[Accession] Worksheet," The Historical Museum at St. Gertrude, Cottonwood, ID, July 1989, for "knife, Dinner" object numbers 964.5.19 through -.23, and -.48, donor, Peter Klinkhammer, January 15, 1964. The knives are 9 in. long and have "3 Chinese Chop marks [probably silver hallmarks] on each knife blade."

258. "[Accession] Worksheet," The Historical Museum at St. Gertrude, Cottonwood, ID, July 1989, for "fork," object numbers 964.5.24 through -.29, donor, Peter Klinkhammer, January 15, 1964. The forks are 7⅛ in. long.

259. "[Accession] Worksheet," The Historical Museum at St. Gertrude, Cottonwood, ID, July 1989, for "teaspoon," object numbers 964.5.30 through -.32 for the gold miner spoons and 964.5.33 through -.35 for the George Washington spoons, donor, Peter Klinkhammer, January 15, 1964. The spoons measure 5 in. long.

260. Spoon Planet. com, "Silver Spoon Museum—Exhibit Index," http://spoonplanet.com/exhibits.html (accessed July 17, 2018). Spoons identical to Polly's are clearly illustrated at 'Washington, George, spoons,' available at http://spoonplanet.com/washington.html (accessed July 17, 2018).

261. "[Accession] Worksheet," The Historical Museum at St. Gertrude, Cottonwood, ID, July 1989, for "tablespoon," object numbers 964.5.36 and -.37, donor, Peter Klinkhammer, January 15, 1964. The tablespoons measure 8⅛ in. long.

262. "[Accession] Worksheet," The Historical Museum at St. Gertrude, Cottonwood, ID, July 1989, for "Tablespoons," object numbers for the spoons are 943.39.2a-f, and for the case,

943.39.2g, donor, Peter Klinkhammer, November 30, 1943. The spoons measure 8 in. long. On the worksheet, the manufacturer's name is misspelled as "Rodin."

263. Sterling Flatware Fashions, "Partnerships and Corporations," 'E. V. Roddin & Co.,' available at http://www.sterlingflatwarefashions.com/Res/Part/R/RoddinEVCo.html (accessed July 17, 2018).

264. "[Accession] Worksheet," The Historical Museum at St. Gertrude, Cottonwood, ID, July 1989, for "ladle," object numbers 943.39.3a-c [including its two-piece box], donor, Peter Klinkhammer, November 30, 1943. The ladle measures 6½ in. long.

265. Silver Collection, "Rogers: A Dynasty of American Silver Manufacturers," available at http://www.silvercollection.it/ROGERSSILVERMANUFACTURERS.html (accessed July 17, 2018).

266. "[Accession] Worksheet," The Historical Museum at St. Gertrude, Cottonwood, ID, for "Polly Bemis' dough pot," object number 2001.1.1, donors, Cort Conley and Jim Campbell, accessioned November 4, 2001. It measures 6 in. high by about 6 in. in diameter and 3¾ in. across the mouth opening. Thanks to Shirley Gehring for clarification. Although the Museum received this and five other artifacts in 2000, the object numbers begin with 2001 because that is when the donors signed the paperwork transferring the items to the Museum.

267. "[Accession] Worksheet," The Historical Museum at St. Gertrude, Cottonwood, ID, for "Polly's rocking chair," object number 2001.1.6, donors, Cort Conley and Jim Campbell, accessioned November 4, 2001.

268. Charles Shepp, [Diary], November 1, 1921, through December 31, 1923, photocopy, University of Idaho Library Special Collections, MG 155, August 16, 1922.

269. "[Accession] Worksheet," The Historical Museum at St. Gertrude, Cottonwood, ID, for "Lace remnant," object number 2001.1.4, donors, Cort Conley and Jim Campbell, accessioned November 4, 2001. It measures 6½ in. by 5½ in.

270. "[Accession] Worksheet," The Historical Museum at St. Gertrude, Cottonwood, ID, July 1989, for "curtains, Window," object numbers 943.39.9a-c, donor, Peter Klinkhammer, November 30, 1943. The single curtain measures 46 in. by 84½ in. and the two panels each measure 29 in. by 78½ in.

271. "[Accession] Worksheet," The Historical Museum at St. Gertrude, Cottonwood, ID, July 1989, for "necklace," object number 964.5.38, donor, Peter Klinkhammer, January 15, 1964. The necklace is 12 in. long by ¾ in. wide. Two breaks in the chain have been mended. If the locket ever held any pictures, they are no longer present.

272. "[Accession] Worksheet," The Historical Museum at St. Gertrude, Cottonwood, ID, July 1989, for "pin," object numbers 964.5.41a and -.41b, donor, Peter Klinkhammer, January 15, 1964. The first pin measures 2 in. long and the second one measures 1¼ in. long. The pins are "worn, bent."

273. Women's ring sizes are typically smaller, but Polly may have needed a larger size to fit over a knuckle enlarged from hard work or arthritis.

274. "[Accession] Worksheet," The Historical Museum at St. Gertrude, Cottonwood, ID, July 1989, for "ring," object numbers 964.5.42 through -.47, donor, Peter Klinkhammer, January 15, 1964. Although -.42, the gold band, could be a wedding ring, Polly's wedding ring is reportedly in the Bicentennial Historical Museum at Grangeville, Idaho. One of the round turquoise stones is missing in -.45. Although this worksheet reads, "Made by Polly. She was a skilled goldsmith.," those statements are unproven.

275. "[Accession] Worksheet," The Historical Museum at St. Gertrude, Cottonwood, ID, for "Earrings, unfinished," object number 2001.1.3, donor, Jim Campbell via Cort Conley, accessioned November 4, 2001. Thanks to Shirley Gehring for clarification. Although these unfinished earrings are in the Museum's "Polly Nathoy Bemis Collection," they have no certain connection with Polly.

276. "[Accession] Worksheet," The Historical Museum at St. Gertrude, Cottonwood, ID, July 1989, for "hairpin," object number 964.5.11, donor, Peter Klinkhammer, January 15, 1964. The hairpin measures 4½ in. long by 1⅝ in. wide.

277. "[Accession] Worksheet," The Historical Museum at St. Gertrude, Cottonwood, ID, July 1989, for "hatpins," object numbers 964.5.8 through -.10, donor, Peter Klinkhammer, January 15, 1964. The hatpins measure 3 in., 5½ in., and 5¾ in. long, respectively.

278. "[Accession] Worksheet," The Historical Museum at St. Gertrude, Cottonwood, ID, July 1989, for "spoon, ear wax," object number 964.5.12, donor, Peter Klinkhammer, January 15, 1964. It measures 4¾ in. long.

279. "[Accession] Worksheet," The Historical Museum at St. Gertrude, Cottonwood, ID, July 1989, for "suitcase," object number 964.5.18, and 964.5.49 for the leather pouch, donor, Peter Klinkhammer, January 15, 1964. The handbag or suitcase measures 13 in. by 7.5 in. by 6 in., and the leather pouch measures "6 in. with 6 in. tie strings attached." The handbag/suitcase is marked "MT. MAY 5.81," possibly mistranscribed for PAT[ENT] MAY 5, [18]81].

280. "[Accession] Worksheet," The Historical Museum at St. Gertrude, July 1989, for "coins," i.e., "nine gold coins used as buttons on the dress of Poly [sic] Bemis (very valuable— stolen)." The buttons were numbered 949.8.1 through -.9, with "949" standing for 1949, the year of Peter Klinkhammer's donation.

281. Kathy Hedberg, "Buttons, Buttons: Who Has Polly's Buttons?" *Lewiston Tribune,* September 1, 2014, 1C, 5C. Thanks to Tom Trail for providing a copy of this article.

282. H[elen] M[arie] Newell, "A Merry Heart from China," photocopy of typed manuscript, The Historical Museum at St. Gertrude, Cottonwood, ID, n.d., but before 1987; at the time of writing, Polly Bemis was still buried in the Grangeville cemetery but her remains were exhumed in 1987 and reburied at her home on the Salmon River. According to former Museum director M. Catherine Manderfeld, "Sister Alfreda knew who did it [stole the buttons]," but the theft was "never reported or prosecuted." It was "hushed up" because it was "embarrassing." Years later, Manderfeld did not like to talk about it, even though the theft occurred before she began working with the Museum, M. Catherine Manderfeld, interview by author, The Historical Museum at St. Gertrude, Cottonwood, ID, March 17, 1997.

283. [Shirley Gehring], Technician, The Historical Museum at St. Gertrude, e-mail message to author, citing Sister Joan [Smith] for a date range of 1950 to 1960, March 11, 2014. Smith joined the Museum staff in 1988, "Our History: How the Historical Museum Came to Be," The Historical Museum at St. Gertrude, https://www.historicalmuseumatstgertrude.org/history.html (accessed July 17, 2018).

284. Elsensohn 1957, "Fourth Academy Day," 4. The Museum was in the high school's attic from 1931 to 1954, then in the basement from 1954 on. In 1980 it moved into the newly-constructed museum building, Joan Smith, "On the Threshold of a New Beginning: How the Historical Museum Came to Be," *Rediscover,* February 2014, 1-2.

285. "[Accession] Worksheet," The Historical Museum at St. Gertrude, Cottonwood, ID, July 1989, for "Certificate," object numbers 991.28.1 (marriage, 5 in. by 7¼ in.) and 991.28.3 (residence, 8⅜ in. by 8⅛ in.), with photocopies of both, donor, Peter Klinkhammer.

286. The Historical Museum at St. Gertrude, Cottonwood, ID, "Photos in Polly Bemis Collection," undated list in author's possession.

287. Cort Conley, e-mail message to author, March 4, 2017. Conley interviewed Miller [d. 1998] in Salt Lake City. Other members of the boating party were "Doc" Frazier and Frank Swain.

288. Campbell, "Manager's Corner," [3].

289. *Clearwater Progress,* "Museum at St. Gertrude's Receives Donation of Artifacts." A photograph accompanying the article depicts the saddle.

290. "[Accession] Worksheet," The Historical Museum at St. Gertrude, Cottonwood, ID, for "Bemis' saddle," object number 2001.1.5, donors [Cort Conley and Jim Campbell], accessioned November 4, 2001.

291. Ibid. [saddle worksheet]. A stamp for the maker reads "O. Owenhouse, Bozeman, Montana." That maker is obscure; an Internet search found only a T. J. Owenhouse who was a saddle maker in Bozeman before and after 1900, Owenhouse ACE Hardware, "Owenhouse Ace Hardware—The Helpful Place Since 1879," available at https://www. owenhouse.com/our-history/ (accessed July 17, 2018).

292. "[Accession] Worksheet," The Historical Museum at St. Gertrude, Cottonwood, ID, for "Charlie Bemis dice," object number 2001.1.2, donors, Cort Conley and Jim Campbell, accessioned November 4, 2001.

293. "[Accession] Worksheet," The Historical Museum at St. Gertrude, Cottonwood, ID, July 1989, for "scale, Balance," object numbers 943.39.1a-y, donor, Peter Klinkhammer, November 30, 1943. The scale measures 8½ in. across the bar that holds the pans.

294. "[Accession] Worksheet," The Historical Museum at St. Gertrude, Cottonwood, ID, July 1989, for "gold/bottle," object number 964.5.16a-b, donor, Peter Klinkhammer, January 15, 1964. The bottle measures 2¼ in. by 1⅜ in. by ¾ in.

295. "[Accession] Worksheet," The Historical Museum at St. Gertrude, Cottonwood, ID, July 1989, for "Ring," object number 964.5.13, donor, Peter Klinkhammer, January 15, 1964.

296. "[Accession] Worksheet," The Historical Museum at St. Gertrude, Cottonwood, ID, July 1989, for "Wire," object numbers 964.5.14a-c, donor, Peter Klinkhammer, January 15, 1964. The wire measures 6½ in., 9 in., and 22½ in. long.

297. "[Accession] Worksheet," The Historical Museum at St. Gertrude, Cottonwood, ID, July 1989, for "chain, watch," object number 964.5.39, donor, Peter Klinkhammer, January 15, 1964. The chain measures 10¾ in. long by ¹/₁₆ in. in diameter.

298. "[Accession] Worksheet," The Historical Museum at St. Gertrude, Cottonwood, ID, July 1989, for "charm/fob," object number 964.5.17, donor, Peter Klinkhammer, January 15, 1964. It measures just ¾ in. by ¾ in. by ⅝ in.

299. "Polly Bemis Collection in St. Gertrude's Museum," undated typed list, The Historical Museum at St. Gertrude, Cottonwood, ID.

300. "[Accession] Worksheet," The Historical Museum at St. Gertrude, Cottonwood, ID, October 1988, for "saddle, riding," object number 982.27.1, donor, Gertrude Maxwell, August 11, 1982. The saddle measures 26 in. long with a 7 in. horn and 23 in. stirrups.

301. Gertrude Maxwell, letter to Sister Alfreda [M. Alfreda Elsensohn], January 4, 1982, The Historical Museum at St. Gertrude, Cottonwood, ID, [2-3]. Maxwell used the saddle, repaired it when necessary, and had a friend make "a brass engraved legend to be riveted to the saddle." The object number for the saddle is 982.27.1, and Boyce reportedly acquired it from Bemis about 1914, "[Accession] Worksheet," "saddle, riding."

302. Ferris, Robert G., series ed., *Prospector, Cowhand, and Sodbuster: Historic Places Associated with the Mining, Ranching, and Farming Frontiers in the Trans-Mississippi West*, National Survey of Historic Sites and Buildings, vol. 11 (Washington, DC: National Park Service, 1967), 196.

303. Ibid., 47-48. The Chisholm Trail later branched off to other Kansas towns, such as Newton and Wichita, as the railroads reached them and as the "farmers' frontier" advanced west, blocking direct access to Abilene, Kansas, ibid., 48, 52-53. In 1867, the Kansas Pacific Railroad reached Abilene. Cattle dealer Joseph McCoy established grazing and shipping facilities there to appeal to Texas cattle ranchers for whom the railroad was the most practical way of getting their beef to eastern and northern markets, ibid., 47-48.

304. The Chisholm Trail was largely replaced by the Western Trail, developed in 1874 to accommodate cattle drives from Texas to Ogallala, Nebraska, where the Union Pacific Railroad had established cattle shipping facilities, ibid., 203.

305. "Researchers at the University of Idaho's Asian American Comparative Collection (AACC) are currently engaged in conversations with the owners of the Polly Bemis Ranch about running an archaeological project on the property. The proposed project, should it be approved, would focus on documenting any structural or artifactual evidence left from Polly's first cabin or from the Bemises' use of the surrounding property," Renae Campbell, e-mail message to author, March 20, 2020.

306. Lawrence A. Kingsbury, *Midvale Telephone Exchange Inc. Buried Telephone Cable Archaeological Investigations at the Historic Warren Townsite East Main Street Commercial District* PY-62 10-IH-1082 ([McCall, ID]: Payette National Forest, 1993), 1.

307. Ibid., 2, and Mark D. Smith, Renee A. Hill, and Steven E. Stoddard, *Archaeological Investigation at the Historic Warren Townsite* PY-62 10-IH-1082 PY94-892, (N.p.: n.p., 1993), 3, and Map 4. The lots had been renumbered from when Bemis owned them.

308. Smith, Hill, and Stoddard, *Archaeological Investigation at the Historic Warren Townsite*, 3-4, 6. There is an inconsistency in the location of Auger Hole #4. It is described as being "[f]ronting Lot 19, the location of the pre-1904 Warren Hotel," ibid., 6; elsewhere, however, the authors place the Warren Hotel on Lot 18, ibid., 2. Because there was originally a building, Comer's Barber Shop, on Lot 19, between Charlie Bemis's house on Lot 20 and the Warren Hotel, the hotel was indeed located on Lot 18.

309. Kingsbury, *Midvale Telephone Exchange*, 4-8. For examples of similar objects, visit soda .sou.edu/chinese (accessed December 1, 2019).

310. Smith, Hill, and Stoddard, *Archaeological Investigation at the Historic Warren Townsite*, 4, 8, and Fig. 2. To account for the fact that a previous building was seemingly in the present street, former Payette National Forest Archaeologist Larry Kingsbury speculated that the 1904 fire obliterated the previous lot boundaries, or that debris from the fire was cleared out into the street, Kingsbury, *Midvale Telephone Exchange*, 3.

311. Smith, Hill, and Stoddard, *Archaeological Investigation at the Historic Warren Townsite*, 2.

312. US Census 1880:Washington Precinct, 3.

313. If a pipe stem were to be found archaeologically, perhaps it could be tested to see if it bears Polly's DNA—or maybe Charlie's—if samples could be obtained for them.

314. Idaho State Historical Society, "Transfer of Ownership" form, Mrs. M. Dale Stilwell, No. 70-51, March 30, 1970.

315. Gary Swift, a former employee at the Salmon River Resort Club, stated that the "original (burned) cabin [was] up above [the] present cabin – [there are] bushes there now," Lynda and Gary Swift, interview by author and Terry Abraham, New Meadows, ID, September 23, 2000, 1.

316. Shepp, [Diary], 1921-1923, November 1, 1923.

317. US Geological Survey, Warren, Idaho, Provisional Edition 1989 [map] (Denver: US Geological Survey, 1989). "Bemos [*sic*] Gulch Street" appears on a 1921 map of Warren, Plat of the Townsite of Warren, Embracing the N. ½ of the N. E. ¼; and the N. ½ of the S. E. ¼ of the N. E. ¼ of Section 11, T[ownship] 22 N., R[ange] 6 E. Boise Meridian[,] Idaho, surveyed by Robert A. Farmer and Gerald A. Sorrels (Bureau of Land Management, Cottonwood, ID, and Idaho County Courthouse, Grangeville, ID, 1921).

318. *Idaho Sunday Statesman*, "Romantic Figure of Warrens' Gold Camp Ill in Grangeville Hospital: Czizek Explodes Myth of Chinese Poker Bride," 70(9):sec. 2, p. 4, September 24, 1933, "Charlie Bemis was the son of [Alfred] Bemis for whom Bemis' [P]oint, the richest property in Warrens, was named."

319. Harry Sinclair Drago, *Notorious Ladies of the Frontier* (New York: Dodd, Mead, 1969), 152.

320. "Bemis Lookout," Elsensohn, *Pioneer Days*, vol. 2, 288; "Bemis Mountain," Ethel Kimball, "River Rat Pioneer," 53.

321. Laila Boone, *Idaho Place Names: A Geographical Dictionary* (Moscow: University of Idaho, 1988), 300.

322. Ibid.

323. Cort Conley, e-mail message to author, November 22, 2002; Waj Nasser, "Whitewater [*sic*] Pizza and Pasta," *Boise Weekly*, November 3, 2004, available at http://m.boiseweekly .com/boise/whitewater-pizza-and-pasta/Content?oid=927151 (accessed July 17, 2018); and allmenus.com, "White Water Pizza and Pasta," https://www.allmenus.com/id /meridian/225062-white-water-pizza-and-pasta/menu/ (accessed July 17, 2018). The restaurant is now closed.

324. Author's notes from restaurant menu, April 2011.

325. Author's collection.

326. Marietta James collection; thanks to Ron James for information.

327. Polly always wore a plain apron, so of these two dolls, the first one is more authentically dressed. The second doll's checked apron appears to have been made from the same fabric used for the first doll's dress. Neither apron is the bib-type, which Polly most often wore.

328. Wendy Heiken, telephone conversation with author, The Historical Museum at St. Gertrude, Cottonwood, ID, January 29, 1997.

329. Darla Anglen-Whitley, ed., "Always Moving Closer to God," *St. Gertrude's Canticle: A Journal of Our Life* (Autumn 2003), 5. The Museum has an earlier photograph, date unknown but thought to be in the 1990s, depicting "Sister Mercedes Martzen with her collection of dolls that she handcrafted," 2017.7.4.

330. Sue Johnson, e-mail messages to author, March 17 and April 14, 2017. The dress's print was intended to mimic "the end designs on old flour sacks or even feather ticking." The apron evokes possible manufacture "from pieces of Charlie's old jeans." Of the three dolls, this one is dressed most authentically, particularly with respect to the plain bib apron fastened to the dress with safety pins.

331. Sue Johnson, e-mail message to author, March 17, 2017. The Museum's doll is 999.5.1.

332. Fry, "Rendering Polly," 65.

333. Adkison, "The Charles and Polly Bemis Story," 5. This quote, and others from Adkison, are unfortunately used without attribution in Elsensohn, *Idaho County's Most Romantic Character*, 22.

334. Adkison, "The Charles and Polly Bemis Story," 4.

Appendix

1. If Charlie Shepp kept earlier diaries, none seem to have survived. A transcription of the first extant one begins on November 1, 1902.

2. "Four-eyed" Smith probably wore glasses. His first name is unknown.

3. Charles Shepp, [Diary], November 1, 1902, through June 12, 1903, photocopy of typescript, transcribed by Marian Sweeney, 1981, University of Idaho Library Special Collections, MG 5209, November 8, 1902. Egan's identity is not known; Hump was a community in the Buffalo Hump Mining District, north of the Salmon River. Bemis and Egan were actually visiting Smith and Williams, who owned the ranch at that time. The phrase, "I was over river," means that Shepp visited the Bemises; they lived directly opposite Smith and Williams.

4. Shepp's exact death date is unknown. However, his last diary entry was on November 20, 1937.

5. Johnny Carrey and Cort Conley, *River of No Return* (Cambridge, ID, Backeddy Books, 1978), 216, 219.

6. The Filers sold the Shepp Ranch to a group of investors in 1969, and Jim Campbell bought it in 1973, ibid., 220. Campbell owned it until 1979; subsequent owners were Paul Resnick (1980-2003), and Tim and Madeleine Turnbull (2003-2020), "Shepp Ranch Managers Retire after 34 Years," *Idaho County Free Press*, December 16, 2015, available at https://www.idahocountyfreepress.com/news/shepp-ranch-managers-retire-after-years

/article_ca537469-1cbb-5457-94c9-df50d0a573fe.html (accessed February 10, 2020). The current owners are Andrew and Jonathon Braxton (2020 to present), Cort Conley, e-mail message to author, June 29, 2020.

7. Marian Sweeney, transcriber, "Charlie Shepp: Diaries," 'Introduction,' prepared in 1981, University of Idaho Library Special Collections, Moscow, Manuscript Group 5209.

8. Note that by 1981 the original diaries were "in several places," not mentioned. In 1997 I learned that then-owner Paul Resnick had the original diaries in a safe at his home in Beverly Hills, California. I contacted him to see if he had any diaries for the time periods missing in the transcribed and/or photocopied diary holdings at the University of Idaho, but he did not provide that information. Resnick sold the Shepp Ranch in 2003 but I don't know if the present owners have the original diaries.

9. Sweeney, "Charlie Shepp: Diaries." 'Introduction.' [1].

10. Sweeney, writing in 1981, was apparently unaware of a recently published, helpful resource. Carrey and Conley's *River of No Return* (1978) contains brief vignettes about many of the people mentioned in the Shepp diaries. A later book, Cheryl Helmers's *Warren Times: A Collection of News about Warren, Idaho* (Odessa, TX: The Author, 1988), has been equally helpful in identifying many of Shepp's friends and acquaintances.

11. Sweeney, "Charlie Shepp: Diaries."

12. Charles Shepp, [Diaries], July 14, 1903, through June 8, 1904, and June 23, 1909, through 1971, photocopies, University of Idaho Library Special Collections, Moscow, MG 155. Priscilla Wegars transcribed those portions of these diaries that were relevant to Polly and Charlie Bemis through early 1934. These partial transcriptions will ultimately be housed in the Asian American Comparative Collection (AACC), Alfred W. Bowers Laboratory of Anthropology, University of Idaho, Moscow.

References Cited

For letters, interviews, Internet citations, and museum worksheets, see Endnotes.

Abraham, Terry, and Priscilla Wegars. "Respecting the Dead: Chinese Cemeteries and Burial Practices in the Interior Pacific Northwest." In *Chinese American Death Rituals: Respecting the Ancestors*, ed. Sue Fawn Chung and Priscilla Wegars, 147-173. Lanham, MD: AltaMira/Rowman & Littlefield, 2005.

Adams, Ann. "The Legend of Polly Bemis Retold." *Idaho County Free Press* (Grangeville, ID), 77(5):11, August 15, 1963.

Adkison, J. Loyal. "The Charles and Polly Bemis Story As Told to Me by Taylor Smith." Typescript. Cottonwood, ID: The Historical Museum at St. Gertrude, [1950s?].

Ailor Mortuary. "Record and Bill of Items for the Funeral of Polly Bemis," November 8, 1933. Courtesy Carol Sue Hauntz, Grangeville, ID.

Allen, Margaret Day. *Lewiston Country: An Armchair History*. [Lewiston, ID]: Nez Perce County Historical Society, 1990.

American Brewers' Review. "Breweries Closed." 20, no. 1 (January 1906): 75.

Anglen-Whitney, Darla, ed. "Always Moving Closer to God." *St. Gertrude's Canticle: A Journal of Our Life* (Autumn 2003): 5. Cottonwood, ID: Monastery of St. Gertrude.

Attebery, Jennifer Eastman. "National Register of Historic Places Registration Form: Bemis, Polly, House." Boise: Idaho State Historical Society, 1987.

Bailey, Robert G. *River of No Return (The Great Salmon River of Idaho): A Century of Central Idaho and Eastern Washington History and Development, Together with the Wars, Customs, Myths, and Legends of the Nez Perce Indians*. Lewiston, ID: Bailey-Blake Printing, 1935.

——. *River of No Return (The Great Salmon River of Idaho): A Century of Central Idaho and Eastern Washington History and Development, Together with the Wars, Customs, Myths, and Legends of the Nez Perce Indians*. Rev. ed. Lewiston, ID: R. G. Bailey Printing, 1947.

——. *River of No Return (The Great Salmon River of Idaho): A Century of Central Idaho and Eastern Washington History and Development, Together with the Wars, Customs Myths, and Legends of the Nez Perce Indians*. Reprint of 1947 revision. Lewiston, ID: Lewiston Printing, 1983.

Bancroft, Caroline. "China Polly: From Dancing Girl to Western Idol." 1953? Typescript, annotated by author. Caroline Bancroft Family Papers, WH1089, Western History Collection, The Denver Public Library.

——. "The Romance of China Polly." *Empire* [the magazine of the *Denver Post*] 4, no. 47 (November 29, 1953): 48-49.

Bancroft, George J[arvis]. "Central Idaho." N.d., but before 1945. Typescript, annotated by author and by Caroline Bancroft. Caroline Bancroft Family Papers, WH1089, Western History Collection, The Denver Public Library.

——. "China Polly - A Reminiscence." 1924? Typescript with handwritten title. Caroline Bancroft Family Papers, WH1089, Western History Collection, The Denver Public Library.

——. "China Polly - A Reminiscence." 1924? Typescript, photocopy of previous ms. on oversize paper with handwritten title and (Lalu Nathoy 1862 [*sic*]-1933) and annotations by Caroline Bancroft. Caroline Bancroft Family Papers, WH1089, Western History Collection, The Denver Public Library.

——. "Pioneering the Salmon." N.d., but after 1936. Typescript. Caroline Bancroft Family Papers, WH1089, Western History Collection, The Denver Public Library.

——. "The Way to War Eagle." N.d., but before 1945. Typescript. Caroline Bancroft Family Papers, WH1089, Western History Collection, The Denver Public Library.

Barker, Rocky. "Ties More than a Century Old Link Gem State, Guangdong." *Idaho Statesman*, (Boise, ID), June 10, 2010, A1, A4.

Beck, Richard J. "Bemis, Polly 1853-1933 Warrens." *Famous Idahoans* [cover title, *100 Famous Idahoans*] Moscow, ID: R. J. Beck, 1989, 8.

Beers, Burton F. *China in Old Photographs, 1860-1910*. New York: Charles Scribner's Sons, 1978.

Bemis Marriage Certificate. "Marriage Certificate for Chas. A. Bemis and Polly Hathoy." August 13, 1894. The Historical Museum at St. Gertrude, Cottonwood, ID.

Beurdeley, Michel, Kristofer Schipper, Chang Fu-jui, and Jacques Pimpaneau. *Chinese Erotic Art*. Translated from the French by Diana Imber. Fribourg, Switzerland, Office du Livre, S.A, 1969. Reprint, [Secaucus, NJ]: Chartwell Books, [1969?].

Blake, C. Fred. "Foot-Binding in Neo-Confucian China and the Appropriation of Female Labor." *Signs: Journal of Women in Culture and Society* 19, no. 3 (Spring 1994): 700, 703.

Boone, Lalia. *Idaho Place Names: A Geographical Dictionary*. Moscow, ID: University of Idaho Press, 1988.

Bowe, Chris. "The Light Myth." *The Adelaide Review* (Adelaide, South Australia), July 2004.

Bragg, L(ynn). E. "Polly Bemis 1853-1933 China Polly." In her *Remarkable Idaho Women*, 69-77. Guilford, CT: TwoDot, 2001.

Brands, H[enry] W[illiam]. *The Man Who Saved the Union: Ulysses S. Grant in War and Peace*. New York: Doubleday, 2012.

Bray, Francesca. "A Deathly Disorder: Understanding Women's Health in Late Imperial China." In *Knowledge and the Scholarly Medical Traditions*, ed. Don Bates, 235-250. Cambridge, England: Cambridge University Press, 1995.

Brodie, Janet Farrell. *Contraception and Abortion in Nineteenth-Century America*. Ithaca, NY: Cornell University Press, 1994.

Bronson, Bennet, and Chuimei Ho. *Coming Home in Gold Brocade: Chinese in Early Northwest North America*. Seattle: Chinese in Northwest America Research Committee, 2015.

Brown, Leona. "Salmon River Trip," [July 19, 1959-July 26, 1959]. Copy in Asian American Comparative Collection, University of Idaho, Moscow.

Browne, J. Ross. See US House of Representatives, 1867.

Bunting, Robert D. "Sweet Peas for Polly." Photocopy of typescript. Bicentennial Historical Museum, Grangeville, ID, June 1, 1993.

——. "Sweet Peas for Polly." *Nostalgia Magazine* (May 2000): 36-37.

——. Presentation on Polly Bemis. Bicentennial Historical Museum, Grangeville, ID, August 30, 2000. Notes in Wegars's possession.

Busto, Rudy V. 'The Gospel According to Rice: The Next Asian American Christianity.' In "Asian American Religions in a Globalized World," ed. Sylvia Chan-Malik and Khyati Y. Joshi, 59-79, *Amerasia Journal* 40, no. 1 (2014).

Caldwell Tribune. Caldwell, ID. "Buffalo Hump." 17(19):3. April 1, 1899.

——. "Buffalo Hump." 17(23):3. April 29, 1899.

Campbell, G. M. "A Chinese Slave Girl Charmed an Idaho Town." *Salt Lake Tribune*, July 9, 1973, H3-4.

Campbell, Jim. "Manager's Corner." *Salmon River Resort Club* 5, no. 5 (July 1987): [1-5].

——. "Polly Bemis Returns Home." *Salmon River Resort Club* 5, no. 5 (July 1987): [6].

Carrey, Johnny. "Moccasin Tracks of the Sheepeaters." In *Sheepeater Indian Campaign (Chamberlain Basin Country)*, 26-69. Grang[e]ville, ID: *Idaho County Free Press*, 1968.

Carrey, Johnny, and Cort Conley. *River of No Return.* Cambridge, ID: Backeddy Books, 1978.

Cenarussa, Pete T., compiler. *Idaho Blue Book: 1991-1992.* Eleventh edition. Boise: State of Idaho, 1991.

——. *Idaho Blue Book*: 1997-1998. Fourteenth edition. Boise: State of Idaho, 1997.

Chan, Sucheng. *Asian Americans: An Interpretive History.* Boston: Twayne, 1991.

Chang, Pang-Mei Natasha. *Bound Feet and Western Dress.* New York: Doubleday, 1996.

Chu, Janet H. "Film and Multiculturalism: Erasing Race in Nancy Kelly's *Thousand Pieces of Gold*." In *Changing Representations of Minorities East and West: Selected Essays*, ed. Larry E. Smith and John Rieder, 75-97. Honolulu: College of Languages, Linguistics[,] and Literature, University of Hawaii, 1996.

Chung, Sue Fawn, and Priscilla Wegars, eds. *Chinese American Death Rituals: Respecting the Ancestors.* Lanham, MD: AltaMira/Rowman & Littlefield, 2005.

Clearwater Progress. Kamiah, ID. "Museum at St. Gertrude's Receives Donation of Artifacts." 50(47):5. June 14, 2000.

Clifford, Cha[rle]s. "Warrens Notes." 'China new year' *Idaho County Free Press*, 2(40):1, March 16, 1888.

Collier, Aine. *The Humble Little Condom: A History.* Amherst, NY: Prometheus, 2007.

Commire, Anne, ed. "Nathoy, Lalu (1853-1933)." In *Women in World History: A Biographical Encyclopedia*, vol. 11, Mek-N, 633. Farmington Hills, MI: Yorkin, 1999-2001.

Conley, Cort. *Idaho for the Curious.* Cambridge, ID: Backeddy Books, 1982.

Coolidge, Mary Roberts. *Chinese Immigration.* New York: Henry Holt, 1909.

Corbett, Christopher. *The Poker Bride: The First Chinese in the Wild West.* New York: *Atlantic Monthly* Press, 2010.

Couch, Samuel L. "Topophilia and Chinese Miners: Place Attachment in North Central Idaho." Ph.D. dissertation, University of Idaho, Moscow, 1996.

Davin, Delia. "Women in the Countryside of China." In *Women in Chinese Society*, ed. Margery Wolf and Roxane Witke, 243-273. Stanford, CA: Stanford University Press, 1975.

Dorman, Robert L. "The Creation and Destruction of the 1890 Federal Census." *American Archivist* 71, no. 2 (Fall/Winter 2008): 350-383.

Dorough, Jeff C., Joe D. Dorough, and Marybeth Dorough. *Women of the West*, vol. 1, *Frontier Life*, V-21-23. [Fresno, CA]: Dorough Enterprises, 1992.

Drago, Harry Sinclair. *Notorious Ladies of the Frontier.* New York: Dodd, Mead, 1969.

Draper, Thomas Waln-Morgan. *The Bemis History and Genealogy: Being an Account, in Greater Part, of the Descendants of Joseph Bemis of Watertown, Massachusetts.* San Francisco: Stanley-Taylor, 1900.

Edmunson, Cletus R. "A History of Warren, Idaho: Mining, Race, and Environment." Master's thesis, Boise State University, Boise, ID, 2012.

Elsensohn, M. Alfreda. *Pioneer Days in Idaho County.* Vol. 1. Caldwell, ID: Caxton, 1947. Reprint, Cottonwood, ID: Idaho Corporation of Benedictine Sisters, 1965.

——. *Pioneer Days in Idaho County.* Vol. 2. Caldwell, ID: Caxton, 1951.

——. "Fourth Academy Day at St Gertrude's, Cottonwood, Renews ... Memories of Polly Bemis." *Spokesman-Review* (Spokane, WA), May 12, 1957, 3-4.

——. *Idaho Chinese Lore.* Cottonwood, ID: Idaho Corporation of Benedictine Sisters, 1970.

——. *Idaho County's Most Romantic Character: Polly Bemis.* Cottonwood, ID: Idaho Corporation of Benedictine Sisters, 1979.

Encyclopedia of World Biography. 2nd ed. V. 12, Orozco to Radisson, Pinchback, Pinckney Benton Stewart, 306-308. V. 16, Vitoria to Zworykin, Woodhull, Victoria, 371-372. Detroit: Gale, 1998.

Evarts, Hal G. "The Pioneers of Lonely Canyon." *Saturday Evening Post* 232, no. 46 (May 14, 1960): 34, 128, 130, 132.

Evening Capital News. Boise, ID. "Hotel Arrivals: Idanha." 53(18):10. August 4, 1924.

Evening Independent. St. Petersburg, FL. "Polly Bemis Is Ill." August 10, 1933, [sec.] 1A, p. 1.

Fahey, John R. "The Buffalo Hump." *Pacific Northwesterner* 6, no. 2 (Spring 1962): 17-24.

Fang, H. S. Y., and F. Y. K. Yu. "Foot Binding in Chinese Women." *Canadian Journal of Surgery* 3 (April 1960): 195-202.

Farm Conveniences: A Practical Hand-Book for the Farm. New York, Orange Judd, 1884. Reprinted 1906, 1907.

Feichter, Nancy Koehler. "The Chinese in the Inland Empire during the Nineteenth Century." Master's thesis, State College of Washington, Pullman, 1959.

Fee, Jeffrey M. "A Dragon in the Eagle's Land: Chinese in an Idaho Wilderness, Warren Mining District, ca. 1870-1900." Master's thesis, University of Idaho, Moscow, 1991.

———. "Idaho's Chinese Mountain Gardens." In *Hidden Heritage: Historical Archaeology of the Overseas Chinese,* ed. Priscilla Wegars, 65-96. Amityville, NY: Baywood, 1993.

Feng, Jicai. *The Three-Inch Golden Lotus.* Honolulu: University of Hawaii Press, 1986.

Feng, Peter X. "*Thousand Pieces of Gold.*" In his *Identities in Motion: Asian American Film and Video,* 42-51. Durham, NC: Duke University, 2002.

Ferris, Robert G., series ed. *Prospector, Cowhand, and Sodbuster: Historic Places Associated with the Mining, Ranching, and Farming Frontiers in the Trans-Mississippi West.* Vol. 11. The National Survey of Historic Sites and Buildings. Washington, DC: National Park Service, 1967.

Fielde, Adele M. *Pagoda Shadows: Studies from Life in China.* Boston: W. G. Corthell, 1884.

Filer, Marybelle. "Historic Shepp Ranch Now Hunters' and Fishermen's Mecca." *Idaho County Free Press,* (Grangeville, ID), 80th Anniversary Edition, 79(49):sec. [8], p. 5, June 16, 1966.

Fisher, Vardis, and Opal Laurel Holmes. *Gold Rushes and Mining Camps of the Early American West.* Caldwell, ID: Caxton, 1968.

Fitzgerald, Arlene J. "The Chinese Tong Wars-of California!" *Golden West* 8, no. 4 (March 1972), 4, 12-15, 60-61.

French, Hiram T. *History of Idaho: A Narrative Account of Its Historical Progress, Its People and Its Principal Interests.* Vol. 1. Chicago: Lewis Publishing Company, 1914.

Frost, Mrs. Chester. "Ah Sam, Chinaman at Warren, Called." *Idaho County Free Press,* 49(33):1, December 28, 1933.

Fry, Kathleen Whalen. "Rendering Polly: The Romanticization, Manipulation[,] and Decontextualization of One Chinese Woman's History in the American West." Master's thesis, Washington State University, Pullman, 2006.

———. "Bemis, Polly (1853-1933)." In *Asian American History and Culture: An Encyclopedia,* Vol. 1, ed. Huping Ling and Allan Austin, 132. Armonk, NY: M. E. Sharpe, 2010.

Fry, Katy [Kathleen] Whalen. "Polly Bemis Retold: The Truth behind Idaho's Most Celebrated Woman." Paper presented at the Pacific Northwest History Conference, Tacoma, WA, 2007.

Furth, Charlotte. *A Flourishing Yin: Gender in China's Medical History, 960-1665.* Berkeley: University of California Press, 1999.

Garceau-Hagen, Dee, ed. *Portraits of Women in the American West.* New York: Routledge, 2005.

Gates, Hill. "The Commoditization of Chinese Women." *Signs: Journal of Women in Culture and Society* 14, no. 4 (Summer 1989): 799-832.

Genesee News. Genesee, ID. "Fire Burns Hump." 17(2):4, August 4, 1905.

Gibbs, Rafe. *Beckoning the Bold: Story of the Dawning of Idaho*. Moscow, ID: University Press of Idaho. 1976.

Gizycka, Eleanor. "Diary on the Salmon River." Parts 1 and 2. *Field and Stream*, 28, no. 1 (May 1923): 18-20, 113-115; ibid., 28, no. 2 (June 1923): 187-188, 276-280. Reprinted in *Idaho Yesterdays* 41, no. 1 (Spring 1997): 7-23.

Grangeville Globe. Grangeville, ID. "High Water Damages." 10(28):[4]. June 7, 1917.

Greenwood, Roberta S. "Old Rituals in New Lands: Bringing the Ancestors to America." In *Chinese American Death Rituals: Respecting the Ancestors*, ed. Sue Fawn Chung and Priscilla Wegars, 241-262. Lanham, MD: AltaMira/Rowman & Littlefield, 2005.

Gronewold, Sue. "Beautiful Merchandise: Prostitution in China 1860-1936." *Women & History* no. 1 (Spring 1982): 1-114. New York: Institute for Research in History and Haworth Press.

Hailey, John. *The History of Idaho*. Boise: Syms-York, 1910.

Hamilton, Ladd. "How Mr. Bemis Won the Chinese Slave Girl." *Saga: True Adventures for Men* 8, no. 5 (August 1954): 50-51, 59.

———. "That Famous Poker Game May Never Have Happened." *Lewiston Morning Tribune* (Lewiston, ID), June 14, 1987, 7A.

Handlin, Joanna F. "Lü K'un's New Audience: The Influence of Women's Literacy on Sixteenth-Century Thought." In *Women in Chinese Society*, ed. Margery Wolf and Roxane Witke, 13-38. Stanford, CA: Stanford University Press, 1975.

Hartford Courant. Hartford, CT. "Chinese Woman Who Wed Conn. Yankee Is Ill." August 10, 1933, 4.

Hedberg, Kathy. "Buttons, Buttons: Who Has Polly's Buttons?" *Lewiston Tribune* (Lewiston, ID), September 1, 2014, 1C, 5C.

———. 'Idaho County.' In Craig Clohessy, "Fame: The Most Famous Folks Who Have/Had Ties to This Region." *Lewiston Tribune* (Lewiston, ID), October 9, 2016, 4A.

Helmers, Cheryl. *Warren, Idaho: Historical Sketches*. Odessa, TX: The Author, 1986.

———. *Warren Times: A Collection of News about Warren, Idaho*. Odessa, TX: The Author. 1988.

Hesford, Walter. "*Thousand Pieces of Gold*: Competing Fictions in the Representation of Chinese-American Experience." *Western American Literature* 31, no. 1 (Spring 1996): 49-62.

Hessler, Peter. *River Town*. New York: HarperCollins, 2001.

Historical Museum at St. Gertrude. "Polly Bemis Collection in The Historical Museum at St. Gertrude." N.d. Typescript. The Historical Museum at St. Gertrude, Cottonwood, ID.

———. St. Gertrude's Museum. [Brochure]. N.d. Cottonwood, ID: The Historical Museum at St. Gertrude.

Hofen, Leo. "History of Idaho County Idaho Ter[ritory]." Handwritten manuscript. Bancroft Library, University of California, Berkeley, 1879, and microfilm, Idaho State Historical Society, Boise, MF109.

Hogan, Patricia. "Bemis, Polly." In *Encyclopedia of the American West*, ed. Charles Phillips and Alan Axelrod. Vol. 1, p. 134. New York: Simon & Schuster Macmillan, 1996.

Holland, Wendolyn Spence. *Sun Valley: An Extraordinary History*. Ketchum: The Idaho Press, 1998.

Hong, Terry. "History Plays Fast and Loose with Facts." Arts & Entertainment, Nonfiction Review, *San Francisco Chronicle* (San Francisco, CA), March 20, 2010, E2.

Hoobler, Dorothy, and Thomas Hoobler. *The Chinese American Family Album*. New York: Oxford University Press, 1994.

Horan, James D. *Desperate Women*. New York: G. P. Putnam's Sons, 1952.

Idaho Code 1932: Containing the General Laws of Idaho. 4 volumes. Indianapolis: Bobbs-Merrill, 1932.

Idaho County, Assessments. "Assessment Book for 1870." Idaho County Courthouse, Assessor, Grangeville, ID.

Idaho County, Assessment Roll. "Assessment Roll, Idaho County, Idaho, 1889." Idaho County Courthouse, Assessor, Grangeville, ID.

——. "Assessment Roll and Delinquent [Tax] List 1891." Idaho County. Idaho County Courthouse, Assessor, Grangeville, ID.

——. "Assessment Roll and Delinquent [Tax] List 1892." Idaho County. Idaho County Courthouse, Assessor, Grangeville, ID.

——. "Assessment Roll and Delinquent Tax List, 1893." Idaho County. Idaho County Courthouse, Assessor, Grangeville, ID.

——. "Assessment Roll and Delinquent Tax List, 1894." Idaho County. Idaho County Courthouse, Assessor, Grangeville, ID.

——. "Assessment Roll and Delinquent Tax List, 1897." Idaho County. Idaho County Courthouse, Assessor, Grangeville, ID.

——. "Assessment Roll and Delinquent Tax List, 1898." Idaho County. Idaho County Courthouse, Assessor, Grangeville, ID.

——. "Assessment Roll and Delinquent Tax List, 1899." Idaho County. Idaho County Courthouse, Assessor, Grangeville, ID.

——. "Assessment Roll and Delinquent Tax List, 1900." Idaho County. Idaho County Courthouse, Assessor, Grangeville, ID.

——. "Assessment Roll and Delinquent Tax List, 1901." Idaho County. Idaho County Courthouse, Assessor, Grangeville, ID.

——. "Assessment Roll and Delinquent Tax List, 1902." Idaho County. Idaho County Courthouse, Assessor, Grangeville, ID.

——. "Assessment Roll and Delinquent Tax List, 1903." Idaho County. Idaho County Courthouse, Assessor, Grangeville, ID.

——. "Assessment Roll and Delinquent Tax List, 1904." Idaho County. Idaho County Courthouse, Assessor, Grangeville, ID.

——. "Assessment Roll and Delinquent Tax List, 1905." Idaho County. Idaho County Courthouse, Assessor, Grangeville, ID.

——. "Assessment Roll and Delinquent Tax List, 1907." Idaho County. Idaho County Courthouse, Assessor, Grangeville, ID.

——. "Assessment Roll A-G," "Taxes Delinquent List, 1909." Idaho County Courthouse, Assessor's Office, Grangeville, ID.

Idaho County, Bills of Sale. "Book 1." [1862-1893]. Idaho County Courthouse, Auditor-Recorder, Grangeville, ID.

Idaho County, Commissioners. "Commissioners Record, Book 2." 1869-1877. Idaho County Courthouse, Auditor-Recorder, Grangeville, ID.

——. "Commissioners' Minutes, Book 7." 1903-1906. Idaho County Courthouse, Auditor-Recorder, Grangeville, ID.

——. "Commissioners Record, 13." [1932-1938]. Idaho County Courthouse, Auditor-Recorder, Grangeville, ID.

Idaho County, Deaths. "Mortality Schedule, 1880." Idaho County Courthouse, Grangeville, ID.

Idaho County, Deeds. "Deed Record 3 & 4." [1870-1879]. Idaho County Courthouse, Auditor-Recorder, Grangeville, ID.

——. "Book 5." [1878-1885]. Idaho County Courthouse, Auditor-Recorder, Grangeville, ID.

——. "Book 7." [1888-1891]. Idaho County Courthouse, Auditor-Recorder, Grangeville, ID.

——. "Book 10." [1894-1897]. Idaho County Courthouse, Auditor-Recorder, Grangeville, ID.

——. "Deed Record 12." [1897-1899]. Idaho County Courthouse, Auditor-Recorder, Grangeville, ID.

——. "Book 50." [1921-1923]. Idaho County Courthouse, Auditor-Recorder, Grangeville, ID.

——. "Book 98." [1962-1963]. Idaho County Courthouse, Auditor-Recorder, Grangeville, ID.

Idaho County, Delinquent Taxes. "Taxes Delinquent List." 1909. Idaho County Courthouse, Assessor, Grangeville, ID.

Idaho County, District Court Case Files. "Case No. 29." 1891. Idaho County Courthouse, Magistrate Court, Grangeville, ID.

Idaho County, District Court Minutes. "Minutes, Book 2." [1884-1896]. Idaho County Courthouse, Magistrate Court, Grangeville, ID.

Idaho County, Marriages. "Marriage Record 1." [1877-1929]. Includes marriages 1874-1879 transcribed in 1879 from an older record, now lost. Idaho County Courthouse, Auditor-Recorder, Grangeville, ID.

——. "Marriage Record, Probate Court." [1890-1911]. Idaho County Courthouse, Auditor-Recorder, Grangeville, ID.

Idaho County, Mining Claims. "Mining Locations, Book 1." [1866-1887]. Idaho County Courthouse, Auditor-Recorder, Grangeville, ID.

——. "Quartz Locations, Book 2." [1886-1890]. Idaho County Courthouse, Auditor-Recorder, Grangeville, ID.

——. "Record of Locations, Book 3." [1888-1892]. Idaho County Courthouse, Auditor-Recorder, Grangeville, ID.

——. "[Record of] Mining [Location Notices], Book 6." [1893-1896]. Idaho County Courthouse, Auditor-Recorder, Grangeville, ID.

——. "Placer Locations, Book 9." [1896-1899]. Idaho County Courthouse, Auditor-Recorder, Grangeville, ID.

——. "Record of Mining Claims, Placer, Book 46." [1906-1911]. Idaho County Courthouse, Auditor-Recorder, Grangeville, ID.

Idaho County, Mining Deeds. "Record of Mining Deeds, Book 1." [1895-1897]. Idaho County Courthouse, Auditor-Recorder, Grangeville, ID.

Idaho County, Miscellaneous Records. "Book 12." [1881-1894]. Idaho County Courthouse, Auditor-Recorder, Grangeville, ID.

——. "Book 13." [1894-1903]. Idaho County Courthouse, Auditor-Recorder, Grangeville, ID.

Idaho County, Mortgages. "Book 1." [1862-1876]. Idaho County Courthouse, Auditor-Recorder, Grangeville, ID.

Idaho County, Probate. "Probate Records." [1865-1880]. Idaho State Historical Society, Boise. Idaho County, Microfilm 11/2.

Idaho County Free Press. Grangeville, ID. "County Matters." 1(1):1. June 18, 1886.

——. "Our Warrens Letter." By N[orman] B. W[illey]. 1(3):1. July 2, 1886.

——. "Our Solid Muldoons." 1(17):4. October 8, 1886.

——. "Our Warrens Letter." By N[orman] B. W[illey]. 1(51):4. June 3, 1887.

——. "Sidewalk Prattle," 'Nelson Miller, ….' 2(11):1. August 26, 1887.

——. "Warrens Notes." By A. F. P[arker]. 2(12):1. September 2, 1887.

——. "Correspondence." By A. F. P[arker]. 2(12):4. September 2, 1887.

——. "Sidewalk Prattle." By A. F. P[arker]. 2(15):1. September 23, 1887.

——. "Our Solid Muldoons." 2(20):4. October 28, 1887.

——. "Warren Notes." 2(21):1. November 4, 1887.

——. "Our Solid Muldoons." 3(24):1. November 23, 1888.

——. "Our Weekly Round-Up," 'Several Chinese pack trains ….' 3(24):1. November 23, 1888.

——. "Our Weekly Round-Up." 3(47):1. May 3, 1889.

——. "How Warrens Celebrated." 4(5):1. July 12, 1889.

——. "Through the courtesy of Chas. Wood …." 4(33):1. January 24, 1890. From *Guerilla Corkscrew.*

——. "Shooting Affray in Warrens." 5(15):1. September 19, 1890.

——. "Dr. Bibby returned from Warrens …." 5(16):1. September 26, 1890.

——. "Cox in Jail." 5(17):1. October 3, 1890.

——. "Our Weekly Round-Up," 'The preliminary examination …' 5(20):1. October 24, 1890.

——. "Mountain Notes," 'We saw Bemis …' 5(20):1. October 24, 1890.

——. "Mountain Notes," 'R. Besse is running …' 5(20):1. October 24, 1890.

——. "Our Weekly Warrens Budget." 5(25):1. November 28, 1890.

——. "Our Warrens Letter: December 29, '90." 5(30):1. January 2, 1891.

——. "Our Warrens Letter." 5(31):1. January 9, 1891.

——. "Our Warrens Letter." 5(38):1. February 27, 1891.

——. "Our Weekly Round-Up," 'The China pack train …' 5(51):1. May 29, 1891.

——. "Warrens is Coming to the Front." 6(2):1. June 19, 1891.

——. "Court Calendar." 6(2):4. June 19, 1891.

——. "Our District Court. Clearing the Calendar." 6(4):1. July 3, 1891.

——. "Our Weekly Round-Up," 'Harry Serrens and Dr. Troll …' 6(4):1. July 3, 1891.

——. "Town and Country News," 'Johnnie Cox …' 6(8):1. July 31, 1891.

——. "The Session of District Court." 6(20):1. October 23, 1891.

——. "District Court Adjourned." 6(21):1. October 30, 1891.

——. "Town and Country News," 'Johnnie Cox …' 6(33):1. January 22, 1892.

——. "Sheriff's Sale." 6(41):4. March 18, 1892.

——. "Town and Country News," 'Harry Serren has purchased …' 6[44]:1. April 8, 1892.

——. "Johnny Cox has been released …." 7(33):1. January 20, 1893.

——. "John P. Cox was released …." 7(34):1. January 27, 1893.

——. "Record of the Week," 'Photographer Hanson, of the Elite [G]allery …' 8(44):1. April 6, 1894.

——. "Record of the Week," 'Photographer Hanson is in Warrens …' 8(48):1. May 4, 1894.

——. "Record of the Week," 'This is the last day of grace …' 8(48):1. May 4, 1894.

——. "Record of the Week," 'Photographer Hanson is back …' 8(51):1. May 25, 1894.

——. "Warrens Notes," 'C. A. Bemis …' 8(51):4. May 25, 1894.

——. "The last of the Chinese certificates …." 10(45):1. April 10, 1896.

——. "County Fathers. [Ful]l Proceedings of the [Boar]d of County Commission[ers] July Term 1900. Tenth Term Day." 15(10):2. August 10, 1900.

——. "Disastrous Conflagration." 20(15):1. September 15, 1904.

——. "Fire Burns Hump." 24(8)1. July 27, 1905.

——. "Train Service." 23(28):4. December 10, 1908.

——. "Passing of a Warren Pioneer." 26(20):1. October 12, 1911.

——. "Central Idaho Scenes Filmed for Movies." 34(6):1. June 26, 1919.

——. "Thrill after Thrill on Voyage in Boat down Salmon River." 34(14):1. August 21, 1919.

——. "Unique Mountain Folk are Met in 200-Mile Voyage on Salmon River." 35(19):1. September 25, 1919.

——. "Difficult Trip over Snow from Warren to M'Call." 37(33):[1]. December 29, 1921.

——. "Local News in Brief," 'Goon Dick Here.' 37(35):[4]. January 12, 1922.

——. "Local News in Brief," 'Dick Back.' 38(26):6. November 9, 1922.

——. "Woman of 70 Sees Railway First Time." 39(14):1. August 16, 1923.

——. "Polly Awakened." 39(14):3. August 16, 1923.

——. "Polly Returns to Warren after Happiest Days in Fifty Years." 39(15):1. August 23, 1923.

——. "Aged Chinaman Hits for Hills." 39(48):1, 8. April 10, 1924.

——. "Polly Bemis Has Big Time on Visit to the State Capital." 40(13):1, 5. August 7, 1924.

——. "Forest Air Patrol in Grangeville." 41(19):10. September 17, 1925.

——. "China Dick Dies." 42(43):1. March 3, 1927.

——. "Commissioner's Proceedings." 43(38):2. January 26, 1928.

——. "Boating Party Gets Thrills on Salmon." 48(4):1-2. August 11, 1932.

——. "Polly Bemis Brot [sic] Out." 49(13):1. August 10, 1933.

——. "Poker Bride Myth Says Mining Man." 49(21):6. October 5, 1933.

——. "Local News Items," 'From Dixie.' 19(23):5. October 19, 1933.

——. "Romantic Figure of Gold Rush Day Dead." 49(26):1, 2. November 9, 1933.

——. "Warren," 'Ah Kahn' 49(41). February 22, 1934.

——. "Chinaman Dies." 49(44):1. March 15, 1934.

——. "Fifty Years Ago." 55(19):8. September 19, 1940.

——. "Many Myths Connected with Chinese Polly Bemis." 80th Anniversary Edition, 79(49):sec. [8], pp. 1, 8. June 16, 1966.

——. "Polly Bemis Qualified to Remain in U.S." 80th Anniversary Edition, 79(49):sec. [8], p. 1. June 16, 1966.

——. "Wayne Newton Company Restores Polly Bemis Cabin on Salmon R." 101(22):1. June 3, 1987.

Idaho Daily Statesman. Boise, ID. "Polly Bemis of Warren's Diggins Sees City's Sights, for First Time." 61(8):2. August 4, 1924.

——. "Salmon River Pictures to be Shown in City." 63(298):7. July 7, 1927.

——. "Million-Dollar Gold Camp Sold at Auction for $900." 67(292):1. July 1, 1931.

——. "Mining Camp of Warren Mourns Loss of Its Mayor." 70(133):1. December 27, 1933.

——. "Golden Past of Warren Adds Spice of History to Fishermen's Jaunts." 10(362):4C. July 22, 1965.

Idaho Recorder. Salmon, ID. "Salmon Locals," 'Members of the Portland' 35(31):[5]. September 10, 1920.

——. "Salmon Locals," 'Countess E. Gyzicka [sic]' 36(24):5. July 15, 1921.

——. "Salmon Locals," 'W. B. Fowler completed a boat' 36(26):5. July 29, 1921.

Idaho Semi-Weekly World. Idaho City, ID. "Sketches of Travel in Idaho. Number III." 2(32):2. August 29, 1868.

——. "Sketches of Travel in Idaho. Number IV." 2(33):2. September 2, 1868.

——. "Hanging." 4(77):1. December 2, 1879.

——. "Warrens." 10(51):2. September 11, 1885.

Idaho State Historical Society. "Essential Idaho: 150 Things That Make the Gem State Unique." In *A Year of Commemoration: 2013 Annual Report.* Boise, ID: Idaho State Historical Society, [2014]: [5].

Idaho Sunday Statesman. Boise, ID. "Idaho Chinese Woman Awaits Time to Rejoin Ancestors." 68(42):sec. 2, p. 3. May 8, 1932.

——. "Romantic Figure of Warrens' Gold Camp Ill in Grangeville Hospital." 70(9):sec. 2, p. 4. September 24, 1933.

Idaho Tri-Weekly Statesman. Boise, ID. "Items from the Lewiston *Signal*," 'Several buildings' 8(145):2. June 25, 1872.

——. "Items from the Lewiston *Signal*," 'The first pack trains' 8(148):3. July 2, 1872.

——. "Items from the Lewiston *Signal*," 'A correspondent' 8(153):2. July 13, 1872.

——. "Northern Idaho," '... Death of an Old Pioneer-Stock' 12(107):2. March 30, 1876.

——. "Local Intelligence," 'Mr. Al Thompson' 16(48):3. November 8, 1879.

Ingling, W. J. "Boating Down Salmon River." *Salmon Herald* (Salmon, ID), 26(6):4, February 10, 1926.

Jackson, Beverley. *Splendid Slippers: A Thousand Years of an Erotic Tradition*. Berkeley: Ten Speed Press, 1997.

Jaschok, Maria. *Concubines and Bondservants: A Social History*. Hong Kong: Oxford University Press, 1988.

Johnson, Lamont. "Old China Woman of Idaho Famous." *Sunday Oregonian* (Portland, OR), 52(45):sec. 5, pp. 1, 3. November 5, 1933.

Kang, L. Hyun-Yi. "The Desiring of Asian Female Bodies: Interracial Romance and Cinematic Subjection." *Visual Anthropology Review* 9, no. 1 (Spring 1993): 5-21.

Keith, Elmer. *Keith: An Autobiography*. New York: Winchester Press, 1974.

Kelly, Charles. "He Won His Wife in a Poker Game." *The Pony Express* 36, no. 9 (February 1970): 3-6.

Kelly, Nancy, director. *Thousand Pieces of Gold*. For Public Broadcasting System's American Playhouse series. 1991.

Kemp, Charles L. "History of Idaho County: A History of Exploration[,] Adventure[,] and Discovery." *The Standard* (Grangeville, ID), Industrial Edition. December 1904.

Kimball, Ethel. "River Rat Pioneer." *True West* 11, no. 2 (November-December 1963): 30-31, 50, 52-53.

King, Marjorie. "Nathoy, Lalu (Polly Bemis) (1853-1933)." In *Handbook of American Women's History*, 2nd ed., ed. Angela M. Howard and Frances M. Kavenik, 372-373. Thousand Oaks, CA, Sage, 2000.

Kingsbury, Lawrence A. *Midvale Telephone Exchange Inc. Buried Telephone Cable Archaeological Investigations at the Historic Warren Townsite East Main Street Commercial District PY-62 10-IH-1082*. [McCall, ID]: Payette National Forest, 1993.

——. *Ah Toy: A Successful 19th Century Chinese Entrepreneur*. [McCall, ID]: Payette National Forest, 1994.

Kingston, Maxine Hong. *The Woman Warrior: Memoirs of a Girlhood among Ghosts*. New York: Alfred A. Knopf, 1976. Vintage Books Edition, New York: Random House, 1977.

Klinkhammer, Peter. "Year Book 1954 [1958]." Notes on 1910-1911 diary [as told to Marybelle Filer], written in diary dated 1954; first entry changed to 1958. Photocopy. University of Idaho Library Special Collections, Moscow, ID, Manuscript Group 155.

Ko, Dorothy. *Every Step a Lotus: Shoes for Bound Feet*. Berkeley: University of California Press, 2001.

——. *Cinderella's Sisters: A Revisionist History of Footbinding*. Berkeley: University of California Press, 2005.

Koonce, Steven J. *Idaho Beer: From Grain to Glass in the Gem State*. Charleston, SC: American Palate, 2014.

Koskela, Alice. "Polly Bemis Finally Rests at Homestead." *Central Idaho Star-News* (McCall, ID), 21(34):1. June 10, 1987.

La Fargue, Thomas Edward. *China's First Hundred: Educational Mission Students in the United States, 1872-1881*. Pullman, WA: Washington State University Press, 1987.

Lee, C. Y. "China Polly." In his *Days of the Tong Wars*, 66-83. New York: Ballantine, 1987.

LeGresley, Roscoe. "Polly Bemis: A Name Which Is Still Legendary along the Wild Salmon River." Typescript courtesy Jacqulyn LeGresley Haight, Lewiston, Idaho, 1960s? Photocopy in Asian American Comparative Collection, University of Idaho, Moscow.

Levy, Howard S. *Chinese Footbinding: The History of a Curious Erotic Custom*. New York: Bell, 1967.

Lewiston Morning Tribune. Lewiston, ID. "Warrens is Wakening." 2(3):1. September 12, 1893.

——. "Resort at Burgdorf Hot Springs Retains All Its Pioneer Charms; Discovered by Unknown Chinese." August 30, 1931, 5.

——. "Polly Bemis Ill." August 8, 1933, 10.

——. "Indian Girl, Not Polly Bemis, Was Poker Bride, Warren Man Declares." October 1, 1933, sec. 2, p. 6.

——. "Warren Mail Carrier 55 Years Ago Goes Back over Old Golden Route and Finds Pioneer Glamour Gone." September 25, 1941, 12.

——. "Negro-Indian Marriages Not Barred by Law." October 4, 1957, 4.

——. [Advertisement for film, *Thousand Pieces of Gold.*] April 18, 1991, 2B.

——. "Herbert R. McDowell, 82, Culdesac Rancher" [obituary]. January 28, 1998, 7A.

Lewiston Teller. Lewiston, ID. "Local Intelligence," 'In Town.' 2(26):3. April 13, 1878.

——. "Local Intelligence," 'Personal.' 2(32):3. May 24, 1878.

——. "Trip to Warrens." 2(51):3. October 4, 1878.

——. "Hanging." 4(6):2. November 21, 1879.

——. "Friend Benson." By Hexter. 7(3):3. October 26, 1882.

——. "Suicide of Chas. Johnson." 7(3):3. October 26, 1882.

——. "Tellings of the Week," 'News of a shooting affray' 14(52):1. September 25, 1890.

——. "Johnny Cox Captured." 15(1):1. October 2, 1890.

Lewiston Tribune. Lewiston, ID.

——. "Flashback: French Creek Company." [August 4, 1899]. June 16, 2014, 1D.

——. "Flashback: The Town of Dixie." [March 6, 1901]. July 8, 2013, D1.

——. "King of Cougar Hunters Comes out of Wilds with Record Kill and Tale of Daring Adventures." May 2, 2016, D1.

——. "Obituaries: Georgia A. Copp, 82, Lewiston." September 11, 2009, 5C.

Lewiston Twice-a-Week Tribune. Lewiston, ID. "Chinamen Receive Certificates." 4(55):1. April 4, 1896.

Liu, Hung. *Polly: Portrait of a Pioneer.* San Francisco: Rena Bransten Gallery, 2005.

Loftus, Bill. "Salmon River Museum Dedicated to Pioneer Polly Bemis." *Lewiston Morning Tribune* (Lewiston, ID), June 6, 1987, 6A, 12A.

Long, Mrs. John D. (Bertha). "Polly Bemis, My Friend." *Idaho County Free Press* (Grangeville, ID), 80th Anniversary Edition, 79(49):sec. [8], p. 1, June 16, 1966.

Louie, Emma Woo. *Chinese American Names: Tradition and Transition.* Jefferson, NC: McFarland 1998.

Ma, Yin, ed. *China's Minority Nationalities.* Beijing: Foreign Languages Press, 1989.

MacKell, Jan. *Red Light Women of the Rocky Mountains.* Albuquerque: University of New Mexico Press, 2009.

Marshall, R. B. *Profile Surveys in Snake River Basin, Idaho.* US Geological Survey, Water-Supply Paper 347. Washington, DC: Government Printing Office, 1914.

Martin, Steven. *Opium Fiend: A 21st Century Slave to a 19th Century Addiction, a Memoir.* New York: Villard, 2012.

Maxwell, Gertrude. *My Yesterdays in Elk City.* Grangeville, ID: *Idaho County Free Press,* 1986.

Mayflower Mining and Milling Company. Warren, Idaho County, Idaho. "Open Account Book." [1890-1894]. Copy at Payette National Forest, Warren, Idaho.

McCarthy, John. "*Thousand Pieces of Gold*: Book's Author Wishes Success to the Film." *Lewiston Morning Tribune* (Lewiston, ID), April 18, 1991, 1B, 6B.

——. "Film's Goal is Pursuit of Truth." *Lewiston Morning Tribune* (Lewiston, ID), April 19, 1991, 6A, 14A.

——. "The Stuff of Dreams: Actors Find Film a Chance to 'Live' Their Own Dreams," *Lewiston Morning Tribune* (Lewiston, ID), April 19, 1991, 6A, 14A.

——. "The Beauty of Idaho Nearly Took Away Chao's Speech." *Lewiston Morning Tribune* (Lewiston, ID), April 26, 1991, 1E, 8E.

Mcconkey, J. D. "A Trip to Warrens." *Idaho County Free Press* (Grangeville, ID), 3(11):4, 1. August 24, 1888.

McCunn, Ruthanne Lum. *Thousand Pieces of Gold.* [San Francisco]: Design Enterprises of San Francisco, 1981. Reprint, Boston: Beacon Press, 1988.

——. "Reclaiming Polly Bemis: China's Daughter, Idaho's Legendary Pioneer." *Frontiers: A Journal of Women Studies* 24, no. 1 (2003): 76-100; *Idaho Yesterdays* 46, no. 1 (Spring/Summer 2005): 22-39, 67-69; and in *Portraits of Women in the American West*, ed. Dee Garceau-Hagen, 156-177. New York: Routledge, 2005.

——. "Who Is Polly Bemis[?]: Two Perspectives, Bemis, Polly (Lalu Nathoy (1853-1933): Perspective 1." In *Asian Americans: An Encyclopedia of Social, Cultural, Economic, and Political History*, ed. Xiaojian Zhao and Edward J. W. Park, vol. 1, A-F, 143-145. Santa Barbara: Greenwood, 2014.

McDowell, Herb. "Early Mining Days in Warren." 1987. Typescript. Historic 1680 Files, Cultural Resources, Payette National Forest, McCall, ID.

——. "From Our Past - Late 1800s - Idaho Mining." 'Town Brings Memories for Ex-Resident.' *Lewiston Morning Tribune* (Lewiston, ID), May 17, 1987, E1.

——. ["People (Who) Lived in Warren or Had Interests in Mines in Warren"]. August 1987. Photocopy of handwritten list. Historic 1680 Files, Cultural Resources, Payette National Forest, McCall, ID.

——. "Polly Bemis." August 1987. Typescript. Historic 1680 Files, Cultural Resources, Payette National Forest, McCall, ID.

McDowell, Marta. *The World of Laura Ingalls Wilder: The Frontier Landscapes That Inspired the Little House Books.* Portland, OR: Timber Press, 2017.

McIntyre, Rob. "A Survey of Musical Activity in the Mining Camps of Idaho through June of 1865." Master's thesis, University of Idaho, Moscow, 1993.

McKay, Kathryn L. *Hidden Treasure: Historical Overview of the Dixie Mining District, Idaho County, Idaho.* Columbia Falls, MT: The Author, 1996.

McKenney, L. M. *Business Directory of the Pacific States and Territories, for 1878, ... of the Principal Towns of California, Nevada, Oregon, Washington, Utah, Montana, Idaho, Arizona and British Columbia,* San Francisco: L. M. McKenney, 1878.

McLeod, Alexander. *Pigtails and Gold Dust: A Panorama of Chinese Life in Early California.* Caldwell, ID: Caxton, 1948.

Mih, Walter. "The Life of Polly Bemis." *Asian American Comparative Collection Newsletter* 32, no. 3 (September 2015): 5-6.

——. "The Life of Polly Bemis (continued from September 2015)." *Asian American Comparative Collection Newsletter* 32, no. 4 (December 2015): 2.

Miller, Helen Markley. "Salmon River Polly." In her *Westering Women*, 119-128. Garden City, NY: Doubleday, 1961.

Miller, Lee Charles. "Adventures of a Motion Picture Amateur." *Outing* 79, no. 1 (October 1921): 18-20, 41, 42, 44.

——. "The Boat That Never Comes Back." *Outing* 79, no. 6 (March 1922): 256-260, 287.

Miller, Mary Mitiguy. "A Rapid Run at River History: Films Explore Life on Salmon River during Depression." *Spokesman-Review* (Spokane, WA) 102(334): B4, B5, April 7, 1985.

Mining and Scientific Press. San Francisco, CA. "Idaho," 'Several arastras [sic]' 17(1):7. July 4, 1868.

——. "Idaho," 'Lewiston *Journal.*' 17(18):278. October 31, 1868.

——. "Idaho," 'North Idaho.' 19(26):404. December 25, 1869.

——. "Idaho," 'Northern Idaho.' 20(8):116. February 19, 1870.

——. "Idaho," 'Warren's.' 21(22):365. November 26, 1870.

——. "Personal." 123 (3):104. July 16, 1921.

Minshall, G. Wayne. *Wilderness Brothers: Prospecting, Horse Packing, & Homesteading on the Western Frontier*. [Inkom, ID]: Streamside Scribe Press, 2012.

Montgomery Ward & Co[mpany]. *Catalogue and Buyers' Guide: No. 57, Spring and Summer 1895*. Reprint, ed. Boris Emmet. New York: Dover, 1969.

——. *Price List No. 352: Groceries, March April 1915*. New York: Montgomery Ward & Co., 1915.

——. *Pure Food Groceries May June 1918: Price List No. 571*. Chicago, IL: Montgomery Ward & Co. 1918.

——. *1922 Montgomery Ward Catalogue: Reprinted in Its Original Form*. Ed. Hal L. Cohen. N.p., H. C. Publishers, 1969.

Morning Oregonian. Portland, OR. "The Strange Career of Polly Bemis." 72(22,776):sec. 1, p. 8. November 4, 1933.

Morrison, Tracy, and Gary Eller, with Bill Parsons. E-mailed poster for "Strong Women: A Celebration in Song of Notable Early Idaho Women and Idaho Women's History Month." Performed at Weiser, Idaho, March 18, 2016. Photocopy in Asian American Comparative Collection, University of Idaho, Moscow.

Moscow-Pullman Daily News. Moscow, ID. "Nygreen – 50th." October 18-19, 2003, 3D.

Moulton, Candy. "Renegade Roads, Riches for Chinese Miners: Following Their Intermountain West Trail from Boise, Idaho[,] to Rock Springs, Wyoming." *True West* 58, no. 4 (April 2011): 104-109.

Mulcahy, F. J. [Diary]. July 19, [1922]. From Philinda Parry Robinson. Photocopy of relevant page in Asian American Comparative Collection, University of Idaho, Moscow.

Mulligan, Hugh A. "The Salmon: Lonely Splendor." *Lewiston Morning Tribune* (Lewiston, ID). October 6, 1963: sec. 2, p. 1.

National Archives at Seattle, "Judgment: The United States vs. Polly Bemiss [*sic*]." 1896. Judgment Roll 181, Record Group 21. National Archives at Seattle, Seattle, Washington.

New York Herald. New York, NY. "List of Letters." November 2, 1861, 3.

Nez Perce News. Lewiston, ID. "On the Wing." 1(49):1. August 4, 1881.

——. "From Warrens and Florence." 1(50):1. August 11, 1881.

——. "From Warrens." 5(51):1. August 13, 1885.

——. "Warrens." 5(52):4. August 20, 1885.

Newell, H[elen] M[arie]. "A Merry Heart from China." N. d. Photocopy of typed manuscript. The Historical Museum at St. Gertrude, Cottonwood, ID.

Noble, Bruce J., Jr., and Robert Spude. Guidelines for Identifying, Evaluating, and Registering Historic Mining Properties. *National Register Bulletin*, 42. Washington, DC: US Department of the Interior, National Park Service, Interagency Resources Division, National Register of Historic Places, 1992.

Ocala Star-Banner. Ocala, FL. "Newton Partner in Resort Club in Wilderness Area." 119(505): 2A. July 22, 1984.

Oettinger, Ellen J. "Bemis, Polly, 1852 [*sic*]-1933." In *The Mythical West: An Encyclopedia of Legend, Lore, and Popular Culture*, ed. Richard W. Slatta, 39-41. Santa Barbara: ABC-CLIO, 2001.

Ohai, Jean. "Family History for Chinese Americans." In *World Conference on Records: Preserving Our Heritage*, August 12-15, 1980, Vol. 11: "Asian and African Family and Local History," 1-13. Salt Lake City: Family History Library, 1980.

Otter, Lori, and Karen Day. *Ida Visits 150 Years of Idaho*. Boise: ID: Idaho State Historical Society, 2013.

Outing. "Who's Who in *Outing*: Snapshots of Contributors in This Month's Issue." 7, no. 4 (January 1920): 194.

Palmer, Joshua. "Otter Tells Stories, Sings Songs[,] and Seals Deals in China." *Times-News*, (Twin Falls, ID), June 12, 2010, Business 1.

"Patterson Store Ledger." Photocopy of 22 pages. Payette National Forest, McCall, Idaho, [1891, 1893-1895]. Copy in Asian American Comparative Collection, University of Idaho, Moscow.

Payette Lake Star. McCall, ID. "Report of Rossiter W. Raymond on the Mining Condition of the Washington, Now Warren, District of Idaho, 1876-7." 2(24):5. June 13, 1919.

——. "Warren Notes," 'Lee Dick ….' 2(45):1. November 7, 1919.

[Payette National Forest]. "Land Classification Book." ['Map of Warren.'] 1917. (BB#14). McCall, ID: Supervisor's Office.

Peterson, F. Ross. *Idaho: A Bicentennial History.* New York: W. W. Norton, and Nashville, TN: American Association for State and Local History, 1976.

Phung, Thao T., Julia A. King, and Douglas H. Ubelaker. "Alcohol, Tobacco, and Excessive Animal Protein: The Question of an Adequate Diet in the Seventeenth-Century Chesapeake." *Historical Archaeology* 43, no. 2 (2009): 61-82.

Plat of the Townsite of Warren, Embracing the N. ½ of the N. E. ¼; and the N. ½ of the S. E. ¼ of the N. E. ¼ of Section 11, T[ownship] 22 N., R[ange] 6 E. Boise Meridian[,] Idaho. Surveyed by Robert A. Farmer and Gerald A. Sorrels, 1921. Copies at Bureau of Land Management, Cottonwood, ID, and Idaho County Courthouse, Grangeville, ID.

Polk, R. L. and Company. *Oregon, Washington and Idaho Gazetteer and Business Directory 1889-90.* Portland, OR: R. L. Polk and Company, 1889.

——. *Idaho Gazetteer and Business Directory, for 1891-92.* Portland, OR: R. L. Polk and Company, 1891.

Pratt, Grace Roffey. "Charlie Bemis' Highest Prize." *Frontier Times* 36, no. 1 (Winter 1961): 26-28, 38.

Quan, Robert Seto. *Lotus among the Magnolias: The Mississippi Chinese.* Jackson: University Press of Mississippi, 1982.

Raymond, Rossiter. See *Payette Lake Star,* 1919, and US House of Representatives, 1873.

Recorder Herald. Salmon, ID. "Harry Guleke Wanted for 1928 River Trip." November 2, 1927, 1.

——. "Marvelous Wild Life and Scenery on Salmon River." August 15, 1928, 1.

Reddy, Sheila D. *The Color of Deep Water: The Story of Polly Bemis.* McCall, ID: Heritage Program, Payette National Forest, US Department of Agriculture, Intermountain Region, 1994.

Riddle, John M. *Eve's Herbs: A History of Contraception and Abortion in the West.* Cambridge, MA: Harvard University Press, 1997.

Robbins, Peggy. "China Polly: Poker Bride." *The World&I* 6, no. 11 (November 1991): 650-655.

Robinson, Eugene. "Trump on Track to Make America Second Rate Again." *Lewiston Tribune* (Lewiston, ID), December 18, 2016, 4F.

[Robinson, Philinda Parry]. "Irene Shepherd Parry: The Salmon River Boat Run - Salmon City to Riggins [July 1922]." Photocopy of unpublished manuscript. In Asian American Comparative Collection, University of Idaho, Moscow.

Ronnenberg, Herman. *Beer and Brewing in the Inland Northwest: 1850 to 1950.* Moscow, ID: University of Idaho Press, 1993.

Rouse, Wendy L. "'What We Didn't Understand': A History of Chinese Death Ritual in China and California." In *Chinese American Death Rituals: Respecting the Ancestors,* ed. Sue Fawn Chung and Priscilla Wegars, 19-45. Lanham, MD: AltaMira/Rowman & Littlefield, 2005.

Rutter, Michael. "Polly Bemis: The Chinese Poker Bride." In his *Boudoirs to Brothels: The Intimate World of Wild West Women,* 36-48. Helena, MT: Farcountry Press, 2014.

Ryland, Lee. "Redemption of Charley [sic] Bemis." *Real West* 5, no. 22 (March 1962): 12-13, 52-54.

——. "The Strange Winnings of Charlie Bemis." *Big West* 1, no. 3 (December 1967): 32-33, 51-52.

Salmon Herald. Salmon, ID. "Idaho Has Lady Rip Van Winkle." 23(38):[9]. September 19, 1923.

Salt Lake Tribune. Salt Lake City, UT. "Trophies of Canadian Interior." February 25, 1929, 18.

Sandburg, Everett A. "Partnership Born in Gold Rush." *The Pacific Northwesterner* 22, no. 2 (Spring 1978): 17-32.

Sarasota Herald-Tribune. Sarasota, FL. "Newton's Partnership to Open River Resort." 59(293):2A. July 22, 1984.

Sasse, Dennis. "Idahoans Recognized by Hall of Fame." [University of Idaho] *Argonaut* (Moscow, ID), 97(68):3. June 26, 1996.

Sayers, Dorothy L., with Robert Eustace. *The Documents in the Case*. New York: Harper & Row, 1930. Reprinted, New York: Avon, 1968.

Schulz, Peter D. "Work Camps or Ethnic Villages? The Chinese Shrimp Camps of San Francisco Bay." *Society for California Archaeology* 9 (1996): 170-178.

Scoble, Melanie. "Capt. Guleke: 'One of the West's Most Colorful Figures.'" In *Patchwork: Pieces of Local History*, 3-12. Salmon, ID: Salmon High School, 1989.

Sears, Roebuck and Co[mpany]. *The 1902 Edition of The Sears Roebuck Catalogue*. Reprint, with an introduction by Cleveland Amory. New York: Bounty Books/Crown, 1969.

———. *1908 Catalogue No. 117 the Great Price Maker*. Reprint, ed. Joseph J. Schroeder, Jr. Chicago: Gun Digest, 1969.

———. *1927 Edition of the Sears, Roebuck Catalogue*. Reprint, ed. Alan Mirken. [New York]: Bounty Books/Crown, 1970.

Shepp, Charles. [Diary]. November 1, 1902, through June 12, 1903. Photocopy of typescript. Transcript prepared by Marian Sweeney, 1981, No. 1. University of Idaho Library Special Collections, Moscow, ID, Manuscript Group 5209.

———. [Diary]. July 14, 1903, through June 8, 1904. Photocopy. University of Idaho Library Special Collections, Moscow, ID, Manuscript Group 155.

———. [Diary]. October 30, 1904, through October 21, 1905. Photocopy of typescript. Transcript prepared by Marian Sweeney, 1981, No. 2. University of Idaho Library Special Collections, Moscow, ID, Manuscript Group 5209.

———. [Diary]. November 13, 1905, through April 30, 1908. Photocopy of typescript. Transcript prepared by Marian Sweeney, 1981, No. 3. University of Idaho Library Special Collections, Moscow, ID, Manuscript Group 5209.

———. [Diary]. May 1, 1908, through June 22, 1909. Photocopy of typescript. Transcript prepared by Marian Sweeney, 1981, No. 4. University of Idaho Library Special Collections, Moscow, ID, Manuscript Group 5209.

———. [Diary]. August 4, 1909, through December 4, 1910. Photocopy. University of Idaho Library Special Collections, Moscow, ID, Manuscript Group 155.

———. [Diary]. December 1, 1910, through December 31, 1911. Photocopy. University of Idaho Library Special Collections, Moscow, ID, Manuscript Group 155.

———. [Diary]. January 1, 1912, through October 31, 1913. Photocopy. University of Idaho Library Special Collections, Moscow, ID, Manuscript Group 155.

———. [Diary]. November 1, 1913, through March 31, 1915. Photocopy. University of Idaho Library Special Collections, Moscow, ID, Manuscript Group 155.

———. [Diary]. August 1, 1915, through June 30, 1916. Photocopy. University of Idaho Library Special Collections, Moscow, ID, Manuscript Group 155.

———. [Diary]. July 1, 1916, through June 3, 1917. Photocopy. University of Idaho Library Special Collections, Moscow, ID, Manuscript Group 155.

———. [Diary]. June 1, 1917, through December 31, 1917. Photocopy. University of Idaho Library Special Collections, Moscow, ID, Manuscript Group 155.

———. [Diary]. January 1, 1918, through June 30, 1919. Photocopy. University of Idaho Library Special Collections, Moscow, ID, Manuscript Group 155.

——. [Diary]. July 1, 1919, through November 1, 1921. Photocopy. University of Idaho Library Special Collections, Moscow, ID, Manuscript Group 155.

——. [Diary]. November 1, 1921, through December 31, 1923. Photocopy. University of Idaho Library Special Collections, Moscow, ID, Manuscript Group 155.

——. [Diary]. January 1, 1924, through December 31, 1924. Photocopy. University of Idaho Library Special Collections, Moscow, ID, Manuscript Group 155.

——. [Diary]. January 1, 1925, through December 31, 1925. Photocopy. University of Idaho Library Special Collections, Moscow, ID, Manuscript Group 155.

——. [Diary]. January 1, 1926, through June 23, 1927. Photocopy. University of Idaho Library Special Collections, Moscow, ID, Manuscript Group 155.

——. [Diary]. January 4, 1928, through December 31, 1928. Photocopy. University of Idaho Library Special Collections, Moscow, ID, Manuscript Group 155.

——. [Diary]. July 13, 1929, through August 31, 1929. Photocopy. University of Idaho Library Special Collections, Moscow, ID, Manuscript Group 155.

——. [Diary]. September 1, 1929, through October 10, 1930. Photocopy. University of Idaho Library Special Collections, Moscow, ID, Manuscript Group 155.

——. [Diary]. October 11, 1930, through October 1, 1931. Photocopy. University of Idaho Library Special Collections, Moscow, ID, Manuscript Group 155.

——. [Diary]. October 1, 1931, through October 19, 1932. Photocopy. University of Idaho Library Special Collections, Moscow, ID, Manuscript Group 155.

——. [Diary]. July 18, 1933, through November 30, 1934. Photocopy. University of Idaho Library Special Collections, Moscow, ID, Manuscript Group 155.

Shepp Ranch Diary. 1955-1956. Photocopy. University of Idaho Library Special Collections, Moscow, ID, Manuscript Group 155.

Sinnott, Susan. "Polly Bemis (Lalu Nathoy): Idaho Pioneer 1853-1833." In her *Extraordinary Asian Pacific Americans*, 39-41. Chicago: Childrens Press, 1993.

Slifer, Georganne. "Push-Pull-Push." Paper written for Dr. Carlos Schwantes's Idaho and the Pacific Northwest history class, fall semester 1988. Photocopy of typescript in Asian American Comparative Collection, University of Idaho, Moscow.

Smith, Joan. "On the Threshold of a New Beginning: How the Historical Museum Came to Be." *Rediscover* (February 2014): 1-2.

Smith, Judy. "Polly Bemis." In *Tsceminicum (Meeting of the Waters) The Clearwater and The Snake Rivers*, ed. Gladys Swank and Nellie Woods, 74-77. Lewiston, ID: Lewis-Clark Chapter Idaho Writers League, 196-?.

Smith, Mark D., Renee A. Hill, and Steven E. Stoddard. *Archaeological Investigation at the Historic Warren Townsite PY-62 10-IH-1082 PY94-892*. N.p: n.p., 1993. Copy in Asian American Comparative Collection, University of Idaho, Moscow.

Sommer, Matthew. "Abortion in Late Imperial China: Routine Birth Control or Crisis Intervention?" *Late Imperial China* 31, no. 2 (December 2010): 97-165.

South Windsor, CT, Hartford County. "Vital Records: Birth, Death, Marriage. Acc[oun] t [of] Births from 1st Aug. 1849 to 1st Aug. 1850." Microfilmed 1982. Salt Lake City: Genealogical Society.

Space, Ralph S. *The Clearwater Story: A History of the Clearwater National Forest*. [Revised edition.] N.p.: Forest Service, US Department of Agriculture, Northern Region-79-03, [1981].

The Standard. Grangeville, ID. "Warren." 1(10):5. May 31, 1899.

——. "Warren Is a Lively Little Burg." 4(30):1. July 24, 1902.

——. "Thunder Mountain News." 5(10):1. March 5, 1903.

Stefoff, Rebecca. "Polly Bemis, 'China Polly' of Idaho (1853-1933)." In her *Women Pioneers*, 107-114. New York: Facts on File, 1995.

Stiles, Henry R. *The History and Genealogies of Ancient Windsor, Connecticut; Including East Windsor, South Windsor, Bloomfield[,] Windsor Locks, and Ellington. 1635-1891.* Vol. II. Genealogies and Biographies. Hartford, CT: Case, Lockwood, and Brainard, 1892.

Sweeney, Marian, transcriber. See Charles Shepp, [Diary], nos. 1 through 4. Photocopies of typed transcripts, University of Idaho Library Special Collections, Moscow, ID, Manuscript Group 5209.

Terry, Patricia. "A Chinese Woman in the West: *Thousand Pieces of Gold* and the Revision of the Historic Frontier." *Literature Film Quarterly* 22, no. 4 (October 1994): 222-226.

Thompson, Hugh. "Grants and Acquisitions," 'Acquisitions: Materials from the 1991 movie' *C&RL News* (June 1996): 382.

Timmen, Fritz. "The Poker Hand That Won a Wife." *True Frontier* 1, no. 9 (May 1969): 34-35, 61-62. Reprinted in *True Frontier* Special Issue No. 3 (1972): 30-31, 58.

Tims, Doug. *Merciless Eden.* Boise, ID: Ferry Media, 2013.

Tone, Andrea. *Devices and Desires: A History of Contraceptives in America.* New York: Hill and Wang, 2001.

Tong, Benson, *Unsubmissive Women: Chinese Prostitutes in Nineteenth-Century San Francisco,* Norman, OK: University of Oklahoma Press, 1994.

Trull, Fern Coble. "The History of the Chinese in Idaho from 1864 to 1910." Master's thesis, University of Oregon, Eugene, 1946.

Truscott, Charles J. "US Department of Agriculture, Forest Service, Field Notes of Homestead Entry Survey No. 817, Situated in the Idaho National Forest, Administrative District No. 4, in Section 12, Unsurveyed, Township 24 N., Range 6 E. of the Boise Base and Meridian, State of Idaho, Bemis Ranch, Warren Dist[rict]." US Department of Agriculture, Forest Service, 1929. Copy obtained from Cultural Resources, Payette National Forest, McCall, ID.

Tsai, Shih-shan Henry. *China and the Overseas Chinese in the United States, 1868-1911.* Fayetteville: University of Arkansas Press, 1983.

Twin Falls Daily News. Twin Falls, ID. "Polly Bemis, Romantic Figure of Gold Rush Days in Idaho, Dies at Age of 81." 16(183):1. November 7, 1933.

US Bureau of Immigration. "Chinese Census, District of Montana and Idaho, June 30, 1905." University of Idaho Library, Moscow, ID.

US Bureau of the Census [US Census]. *Population Schedules of the Sixth Census of the United States 1840.* Connecticut. Hartford County. East Hartford. Microfilm. Washington, DC: National Archives.

——. *Population Schedules of the Seventh Census of the United States 1850.* Connecticut. Hartford County (part). South Windsor. Microfilm. Washington, DC: National Archives.

——. *Population Schedules of the Eighth Census of the United States 1860.* Connecticut. Hartford County (part). South Windsor. Microfilm. Washington, DC: National Archives.

——. *Ninth Census of the United States (1870),* Idaho Schedules, Idaho County. Washington, DC: National Archives. Microfilm. University of Idaho Library, Moscow, ID.

——. *Tenth Census of the United States (1880),* Idaho Schedules, Idaho County. Washington, DC: National Archives. Microfilm. University of Idaho Library, Moscow, ID.

——. *Twelfth Census of Population 1900,* Idaho Vol. 3. Idaho County. Washington, DC: National Archives. Microfilm. University of Idaho Library, Moscow, ID.

——. *Thirteenth Census of the United States: 1910* – Population, Idaho, Idaho County, Concord Precinct, Concord Village. Washington, DC: Department of Commerce and Labor – Bureau of the Census. Microfilm. University of Idaho Library, Moscow, ID.

——. *Fourteenth Census of the United States: 1920* – Population, Idaho, Idaho County, Bureau of the Census. Microfilm. University of Idaho Library, Moscow, ID.

US Department of Internal Revenue. *Internal Revenue Assessment Lists for the Territory of Idaho 1867-1874.* Roll 1, "Annual, Monthly, and Special Lists 1867-74." Microfilm Publication

T1209. Washington, DC: National Archives and Records Service, 1977. Available at University of Idaho Library, Moscow, ID.

US Geological Survey [USGS]. *Warren, Idaho Provisional Edition 1989* [map]. Denver: US Geological Survey, 1989.

US House of Representatives [US House]. *Letter from the Secretary of the Treasury, Transmitting a Report upon the Mineral Resources of the States and Territories West of the Rocky Mountains.* [Report of J. Ross Browne, Special Commissioner, for 1866]. 39th Congress, 2nd Session, House Executive Document No. 29, Serial Set No. 1289. Washington, DC: Government Printing Office, 1867.

———. *Statistics of Mines and Mining in the States and Territories West of the Rocky Mountains; Being the 5th Annual Report of Rossiter W. Raymond, United States Commissioner of Mining Statistics.* 42nd Congress, 3rd Session, House Executive Document No. 210, Serial Set No. 1567. Washington, DC: Government Printing Office, 1873.

US Penitentiary, Boise City, Idaho. "Description of Convict." October 31, 1891.

The Vanishing: Re-Presenting the Chinese in the American West. Ketchum and Sun Valley, ID: Sun Valley Center for the Arts, 2004.

Wallace, Chan. "King of Cougar Hunters Comes out of Wilds with Record Kill and Tale of Daring Adventures." *Lewiston Morning Tribune* (Lewiston, ID). May 1, 1932, sec. 2, p. 1.

Weeks, Leroy T. "In the Mountains." *Idaho County Free Press* (Grangeville, ID). 2(11):1. August 26, 1887.

Wegars, Priscilla. "Charlie Bemis: Idaho's Most 'Significant Other.'" *Idaho Yesterdays* 44, no. 3 (Fall 2000): 3-17.

———. "The Ah Hee Diggings near Granite, Oregon." In *Contributions to the Archaeology of Oregon*, ed. Lou Ann Speulda and Gary C. Bowyer, 31-48. Association of Oregon Archaeologists, Occasional Papers No. 7. Eugene, OR, State Museum of Anthropology, University of Oregon, 2002.

———. "Polly Bemis: Lurid Life or Literary Legend?" In *Wild Women of the Old West*, ed. Glenda Riley and Richard W. Etulain, 45-68, 200-203. Golden, CO: Fulcrum, 2003.

———. *Polly Bemis: A Chinese American Pioneer.* Cambridge, ID: Backeddy Books. 2003.

———. "Who Is Polly Bemis[?]: Two Perspectives, Bemis, Polly (Lalu Nathoy (1853-1933): Perspective 2." In *Asian Americans: An Encyclopedia of Social, Cultural, Economic, and Political History*, ed. Xiaojian Zhao and Edward J. W. Park, vol. 1, A-F, 145-146. Santa Barbara: Greenwood, 2014.

Wells, Merle W. *Rush to Idaho.* Bulletin No. 19. Moscow, ID: Idaho Bureau of Mines & Geology, [1961].

———. *An Atlas of Idaho Territory 1863-1890.* [Boise]: Idaho State Historical Society, [1978].

The Western Brewer: and Journal of the Barley, Malt[,] and Hop Trades. "Breweries Closed." 31, no. 1 (January 1906): 38.

Wikoff, Melvin D. "Chinese in the Idaho County Gold Fields: 1864-1933." Master's thesis, Texas A & I University, Kingsville, 1972.

Williams, Gene F., transcriber, editor, and indexer. *Idaho Territorial Voters Poll Lists 1863.* Parts I, II. Boise: Williams Printing, 1996.

Wilson-Wagner, Eleanor. "Polly." *Central Idaho Magazine* 2, no. 1 (Spring/Summer 1988): 6-7, 26-27.

Wisner, Frances Zaunmiller. [See also Zaunmiller, Frances.] "Simply River Women." *Incredible Idaho* 3, no. 4 (Spring 1972): 23-26.

———. "History of Canyon of Salmon Would Fill Set of Books, But Frances Goes into Highlights." *Idaho County Free Press* (Grangeville, ID). Bicentennial Edition. 90(3): 2A-5A. June 30, 1976.

———. *My Mountains: Where the River Still Runs Downhill.* Ed. Donna L. Henderson. Grangeville, ID: *Idaho County Free Press*, 1987.

Xu, Yixian. "Chinese Women in Idaho during the Anti-Chinese Movement before 1900." Master's thesis, University of Idaho, Moscow, 1994.

Yu, Li-hua. "Chinese Immigrants in Idaho." Ph.D. dissertation, Bowling Green State University, Bowling Green, Ohio, 1991.

Yung, Judy. *Chinese Women of America*. Seattle: University of Washington Press, 1983.

Zaunmiller, Frances [See also Wisner, Frances]. "Polly Bemis, Part of Salmon River History." *Idaho County Free Press*, (Grangeville, ID), 80th Anniversary Edition. 79(49):sec. [8], p. 1. June 16, 1966.

——. "Wedding Photo of Polly Bemis Reprinted for the First Time." *Idaho County Free Press*, (Grangeville, ID). 80(44):sec. 3, p. 6. May 11, 1967.

INDEX

A number in **boldface** indicates a related illustration. For US towns and cities, *see under* the appropriate state.

of the Salmon River, 177, 254, 303, 326, 443n144
Polly Bemis in, **189**, 189-191
See also Thousand Pieces of Gold (film)
Finley, Monroe, 8, 9, **9**, 369n52, 369-370n58
Finley, William, 369-370n58
Fisher, Vardis, 336-337
fishing
 Chinese camps for, in California, 36
 for pike, 87
 for steelhead ("red sides"), 303
 for sturgeon, 268
 for trout (bull trout, Dolly Vardens), 97-98, 165, 214, 399n182
 tackle for, 76, 94, **116**, 155
 See also under Bemis, Charles; Bemis, Polly
Fitzgerald, Arlene J., 455n36, 455n42
"flapper," 21-22, 231, 327, 378n152, 467n96
Fleming, _____ ("Shorty"), 316, 461n18
Flint, William R. (Claud?), 165, 419n93
Florida
 St. Petersburg, 278
Fook Sing Company, 37, 454n27
footbinding, 3-4, **4-5**, 5-6, 21, 367nn19-20
 See also under Bemis, Polly
Foote, Arthur De Wint, 335
Foote, Mary Hallock, 335, 471n181
Ford, Tom, 80, 400n189
Forest Air Patrol. *See under* airplanes
Foster, Amanda and Daniel, 9-10, 370n62
Fowler, W. B., 198
Frazier, _____ ("Doc"), 477n287
Freeman, _____, 41
Freidenrich, Aaron, 23, 423n173
 See also Alexander and Freidenrich
"Frenchy," 84, 85, 401n232
frequently asked questions (about the Bemises), 334-337
Frost, _____ (Mrs. Chester), 460n3, 460n5
Fry, Kathleen Whalen, 357, 462n29, 463n31
Fu Manchu, Dr., 321, 466n85
Fuller, Wilber, 166, **166**, 168

G
Gallagher, Tom, 89, 394n33, 404n347
 See also Tom _____
Gambs (Gans), Andy, 98, 405n358

gardens, 17, 71, 133, 163
 at the Bemis Ranch, 56, 63, 71, 103, 116, 140, 243
 hailstorm destroys, 87
 harvesting/selling, 93-96 passim, 179, 230, 271, 275, 333-334, 336
 irrigation of, 86, 188, 268, 274, 336
 plants grown, 74
 trees, 74-75
 at the Shepp Ranch, 108, 118, 137, 195, 242, 406-407n405
Bemis, Polly's, in Warren, 214
Chinese, 18, 23, 37, 38, 353, 375n116
Gates, Hill, 5
Geary Act (1892), 52, 54, 58, 59, 389-390n68
Gee (Chinese man), 38
genealogy
 Bemis family, 369n50, 370n61-63
 Chinese, 366n8
Gibbs, Rafe, 385n106, 396n54, 436n323
Gillespie, B. W., 422n166
Gizycka, Eleanor, 196-197, **197**, 198, **198**, 327
Gjettrup, Lars, 270, 448n296
Goddard, _____, 125, 151, 411n86
gold buttons. *See* Bemis, Polly, clothing of
Goldwyn, Sam, 303, 457n84
Goodpastor, Bert, 80, 400n188
Goon Dick, 100-101, 227-229, 253
 death of, 253, 405n377
 opium and, 229
 visits the Bemises, 101
grafting trees. *See under* trees, grafting of
Gray, Charley, **213**
Green, G. A., Dr. (dentist), 173, 421n138
Green, George, 150-154, 156, 157, 158, 164, 173
 death of, 187-188, 416n8, 425n25
Griffin, Jerry D., 243, 440n56
Griffith, Joseph, 14
Gronewald, Sue, 376n134
Grostein, Henry R., 35, 49
Grostein and Binnard, 23, 34, 380n18, 382n55
Guleke, Harry, 152, **177**, 188, 439n36, 449-450n338
 Bailey, Robert G. and, 80
 Bemis, Charlie and Polly and, 170, 173, 175, 176, 179